Photographic Materials and Processes

	19 - 1 9 - 1 9		
8			

•

Photographic Materials and Processes

Leslie Stroebel John Compton Ira Current Richard Zakia

COLLEGE LIBRARY GOLLEGE OF TECHNOROGY GARNARVON ROAD SOUTHEND-ON-SEA, ESSEX

Focal Press Boston London

Essex County Library

Focal Press is an imprint of Butterworth Publishers.

Book and cover design: Clifford Stoltze Illustrations: J. Wesley Morningstar

Copyright © 1986 by Leslie Stroebel, John Compton, Ira Current, and Richard Zakia All rights reserved.

FV 92088 X

No part of this publication may be reproduced, stored in a retrieval system, or transmitted, in any form or by any means, electronic, mechanical, photocopying, recording, or otherwise, without the prior written permission of the publisher.

Library of Congress Cataloging in Publication Data Main entry under title:

Photographic materials and processes.

Bibliography: p. Includes index. 1. Photography. I. Stroebel, Leslie D. TR145.P47 1985 770 85-1543 ISBN 0-240-51752-0

Butterworth Publishers 80 Montvale Avenue Stoneham, MA 02180

109876543

770 STR

Printed in the United States of America

1.3	Patterns of Variation	4
1.4	The Normal Distribution	5
1.5	Populations vs. Samples	7
1.6	Calculation of the Mean	8
1.7	Calculation of the Standard Deviation	9
1.8	Description of the Normal Distribution	10
1.9	The Concept of Control Charts	11
1.10	The Preparation of Control Charts	13
1.11	Control Charts Based on the Mean and the	
	Range	16
1.12	Specifications and Naturally Determined	
	Control Limits	19
1.12	Department welleds and Audicedie	
	Evaluations	21
1.14	Paired Comparisons	24
1.15	Test Conditions	25
	References	26

Variability and Quality Control in

Introduction to the Concept of Variability

xvii

2	Photographic Sensitometry	27
2.1	Introduction to Tone Reproduction	29
2.2	Photographic Exposure	32
2.3	Processing	35
2.4	Density Measurement	39
2.5	Characteristic Curves	42
2.6	Log Exposure Range	46
2.7	Exposure Latitude	47
2.8	Gamma	49
2.9	Average Gradient	50
2.10	Contrast Index	51
2.11	Film Speed	52
2.12	Analysis of Negative Curves	57
2.13	Analysis of Photographic Paper Curves	58
2.14	Paper Contrast	60
2.15	Condenser and Diffusion Enlargers	63
2.16	The Effects of Enlarger Flare and Scattered	
	Light	64
2.17	Testing Enlargers for Flare Light	64
2.18	Paper Speeds	68
2.19	Determination of Printing Conditions	69
2.20	Analysis of Positive Film Curves	71
2.21	Analysis of Reversal Film Curves	72
2.22	Introduction to Photographic Effects	73
2.23	Reciprocity Effects	73
2.24	Low Illuminance Film Reciprocity	74
2.25	High Illuminance Film Reciprocity	75
2.26	Black-and-White Paper Reciprocity	75
2.27	Color Paper Reciprocity	76
2.28	Color Film Reciprocity	76
2.29	Intermittency Effect	78

Preface

Photography

Sources of Variation

1.1

1.2

Contents

2.30	Clayden Effect	78
2.31	Herschel Effect	78
2.32	Latensification and Hypersensitization	79
2.33	Sabattier Effect	80
2.34	Solarization	82
2.35	Micro-Edge Effects	83
2.36	Adjacency Effects	84
2.37	Color Interimage Effects	84
2.30	Development Effects	85
2.39	X-Ray Fog Static Electricity Fog	86 87
2.40	References	87
3	Camera and Printing Exposure	91
3.1	Camera Exposure vs. Photographic Exposure	93
3.2	F-Numbers	93
3.3	Calculating F-Numbers	93
3.4	Whole Stops	94
3.5	Maximum Diaphragm Openings	95
3.6	Minimum Diaphragm Openings	95
3.7	Intermediate F-Numbers	97
3.8	Limitations of the F-Number System	97
3.9	Lens Transmittance	98
3.10	Other Calibration Systems	99
3.11 3.12	Exposure Time Lens Shutters	99
3.12	Effective Exposure Time	101 101
3.14	Shutter Efficiency	101
3.15	Focal-Plane Shutters	102
3.16	Electronic Shutters	105
3.17	Shutter Speed Markings	104
3.18	Shutter Testing	107
3.19	Camera Exposure Latitude	110
3.20	Alternatives to Exposure Meters	112
3.21	Exposure Meters	112
3.22	Reflected-Light/Incident-Light Exposure Meters	114
3.23	Meter Scales	117
3.24	Light Ratios	118
3.25	Meter Accuracy and Testing	120
3.26	Methods of Using Reflected-Light Exposure	
	Meters	124
3.27	Incident-Light Readings	130
3.28	Footcandle and Lux Measurements	132
3.29	Degree of Development and Effective Film	
0.00	Speed	133
3.30	Flash Guide Numbers	134
3.31	Flash Meters	134
3.32 3.33	Color-Temperature Meters	135
3.33	Printing Meters Electronic Printers	136
0.04	References	138 139
4	Photographic Optics	141
4.1	Image Formation with a Pinhole	143
4.2	Image Formation with a Lens	145
		170

4.3	Graphical Drawings	148
4.4	Lens Formulas	151
4.5	Perspective	152
4.6	Linear Perspective	153
4.7	Object Distance and Image Size	153
4.8	Focal Length and Image Size	156
4.9	Changing Object Distance and Focal Length	157
4.10	Viewing Distance	158
4.11	The Wide-Angle Effect	159
4.12	Depth of Field	160
4.13	Permissible Circle of Confusion	160
4.14	Depth of Field Controls	162
4.15	Depth of Field and f-Number	163
4.16	Depth of Field and Object Distance	163
4.17	Depth of Field and Focal Length	164
4.18	Calculating Depth of Field	165
4.19	Depth of Focus	165
4.20	View Camera Movements	166
4.21	Perpendicular Movements	166
1 77	Back Movements and Image Shape	168
1.23	Back Movements and Image Sharpness	170
4.24	Lens Movements and Image Sharpness	171
4.25	Lens Types	173
4.26	Telephoto Lenses	173
4.27	Catadioptric Lenses	174
4.28	Wide-Angle Lenses	175
4.29	Reversed Telephoto Wide-Angle Lenses	176
4.30	Supplementary Lenses	176
4.31	Special Supplementary Lenses	178
4.32	Convertible Lenses	178
4.33	Zoom Lenses	179
4.34	Macro-Zoom Lenses Macro and Process Lenses	180
4.35 4.36	Soft-Focus Lenses	180 180
4.37	Anamorphic Lenses	180
4.37	Enlarger Lenses	180
4.39	Projector Lenses	182
4.40	Lens Shortcomings	183
4.41	Diffraction	184
4.42	Spherical Aberration	184
4.43	Coma	185
4.44	Curvature of Field	185
4.45	Astigmatism	186
4.46	Chromatic Aberrations	186
4.47	Distortion	186
4.48	Image Illuminance	186
4.49	Lens Testing	188
4.50	Testing Flare	190
	References	192

5

Light and Photometry

5.1	The Nature of Light	197
5.2	Light Waves	197
5.3	The Electromagnetic Spectrum	198
5.4	The Visible Spectrum	199

6

5.5	Solid-Object Sources and the Heat-Light	
	Relationship	200
5.6	Vapor Sources and the Effect of Electrical	
	Discharge	202
5.7	Luminescence	203
5.8	The Use of Color Temperature	204
5.9	The Mired Scale	205
5.10	Color-Rendering Index	206
5.11	The Polarization of Light	207
5.12	Practical Sources of Light and Their Properties	208
5.13	Lasers	219
5.14	The Language of Light	220
5.15	The Measurement of Intensity	221
5.16	The Measurement of Flux	222
5.17	The Measurement of Illuminance	223
5.18	The Measurement of Luminance	225
	References	227

Chemistry for Photographers 231

6.1	Silver Systems	233
6.2	Negative and Positive	233
6.3	Modification of Silver Images	234
6.4	Washing	234
6.5	Drying	234
6.6	Other Photographic Systems	234
6.7	Basic Chemistry	235
6.8	The Periodic Table	235
6.9	Atoms	235
6.10	Valence	239
6.11	Atomic Weight	239
6.12	Chemical Reactions	239
6.13	Oxidation/Reduction	240
6.14	Acid/Base	240
6.15	Ionization	241
6.16	рH	241
6.17	pH of "Normal" Solutions	242
6.18	pH Meters	242
6.19	pH Indicators	243
6.20	Complexes	244
6.21	Solutions	245
6.22	Specific Gravity	246
6.23	Sequestering and Chelating Agents	246
	References	247

7 Photographic Emulsions, Films, and Papers

7.1	Photographic Emulsions	251
7.2	Image-Support Systems	251
7.3	Film Supports	253
7.4	Safety Base Films	253
7.5	Polyester Film Bases	254
7.6	Film Structure	255
7.7	Physical Properties of Films	255

7.8	Thinner Emulsions	255
7.9	Surface Coatings	256
7.10	Retouching Capability	256
7.11	Film Friction	257
7.12	Static Discharges	257
7.13	Color Films	257
7.14	X-Ray Films	259
7.15	Other Coatings on Two Sides	259
7.16	Paper Bases	259
7.17	Brighteners	260
7.18	Glossy Papers	260
7.19	Expansion and Shrinkage	261
7.20	Paper Weight and Thickness	262
7.21	The Gelatin Colloid	262
7.22	Properties of Gelatin	263
7.23	Sources of Gelatin	263
7.24	Chemical Nature of Gelatin	264
7.25	Physical Properties of Gelatin	264
7.26	Emulsion Making	266
7.27	Emulsion Composition	267
7.28	Emultion Characteristics	267
7.29 7.30	Grain Size, Sensitivity, and Contrast	268
7.30	Grain Composition	269
7.31	Spectral Sensitivity	269 270
7.32	Crystal Structure Defects	270
7.34	Emulsion Precipitation	270
7.35	Ripening	271
7.36	POP Emulsions	271
7.37	Washed Emulsions	272
7.38	After-Ripening	272
7.39	Multiple Coatings	272
7.40	Effects of Development on Developers	273
7.41	Dye Sensitization	274
7.42	Coating Finals	275
7.43	Subbing	275
7.44	Coating	275
7.45	Formation of the Latent Image	276
7.46	Photographic Effects	278
7.47	Latent-Image Stability	281
7.48	Some Alternative Systems	282
7.49	Calotype Process	283
7.50	Daguerreotype	284
7.51	Cyanotype	284
7.52	Albumen Paper	285
7.53	Wet Collodion	285
7.54	Ambrotype	286
7.55	Carbon	286
7.56	Carbro	287
7.57	Gum Bichromate	287
7.58	Platinum Process	288
7.59	Kallitype	289
7.60	Electrophotography	289
7.61	Thermography	290
7.62	Diazo	291
7.63	Television	292

8

9

7.64	Charged Coupled Devices	292
7.65	Dye Transfer	293
7.66	Diffusion Transfer	293
	References	294

Black-and-White Photographic Development

8.1	Negative Development	299
8.2	Direct-Positive Images	299
8.3	Reversal Processing	299
8.4	Mechanism of Development	300
8.5	Constitution of Typical Developers	300
8.6	Developing Agents	301
8.7	Hydroquinone	302
8.8	Metol	302
8.9	MQ Developers	303
8.10	Color Developers	303
8.11	Accelerators	304
8.12	Preservatives	304
8.13	Restrainers	305
8.14	Anti-Foggants	305
8.15	Other Development Accelerators	305
8.16	Concentration of Developer	306
8.17	Development Time	306
8.18	Developer Temperature	307
8.19	Developer Agitation	308
8.20	Replenishment	308
8.21	Paper Processing	310
8.22	Analysis of Developers	310
8.23	Specific Black-and-White Processes	311
8.24	KODAK Developer DK-50 for Films	310
8.25	KODAK Developer D-76 for Fine Grain	312
8.26	KODAK Developer DK-20 for Fine Grain	313
8.27	KODAK Developer D-72 for Paper	313
8.28	KODAK Developer D-85 for High Contrast	313
	References	314

Post-Development and Archival Considerations

315

9.1	Stop Baths	317
9.2	Indicator Stop Baths	317
9.3	Dichroic Fog	318
9.4	Timing Layers	318
9.5	Fixing Baths	318
9.6	Fixing	319
9.7	Cost Factors	320
9.8	Replenishment	320
9.9	Rejuvenation and Maintenance of Fixing Baths	322
9.10	Washing	322
9.11	Hypo Eliminators and Washing Aids	323
9.12	Preparation for Drying	323
9.13	Drying	234
9.14	Drying Prints	324

Print-Drying Problems	324
Color Changes	325
Preservation of Photographs	325
Archival Considerations	326
Alternative Methods	328
Toning	328
Sepia Tones	329
Developer Modification and Tone	329
Bleach and Redevelopment Toning	330
Hypo Alum Toner	330
Gold Toner for Blue Tones	331
Iron Blue Toner	331
Other Toning Methods	332
Selective Area Toning	332
Reduction and Intensification	332
Reducers	333
Intensifiers	336
Print Modification	337
Nonchemical Treatment	337
Marking to Reduce Contrast	337
Masking to Increase Contrast	337
Highlight Masks	338
References	338
	Color Changes Preservation of Photographs Archival Considerations Alternative Methods Toning Sepia Tones Developer Modification and Tone Bleach and Redevelopment Toning Hypo Alum Toner Gold Toner for Blue Tones Iron Blue Toner Other Toning Methods Selective Area Toning Reduction and Intensification Reducers Intensifiers Print Modification Nonchemical Treatment Macking to Reduce Contrast Masking to Increase Contrast Highlight Masks

10 Color Processes

339

10.1	Tricolor Photography	341
10.2	Chromogenic Processes	342
10.3	Negative Color Films	342
10.4	Reversal Color Films	343
10.5	Films with Incorporated Couplers	344
10.6	Films without Incorporated Couplers	345
10.7	Color Paper for Prints from Negatives	346
10.8	Reversal Color Paper	346
10.9	Dye Bleach	346
10.10	Dye Transfer	348
10.11	Polaroid Instant Photography	349
10.12	KODAK Instant Color Film/KODAMATIC	
	Instant Color Film	349
10.13	Photo Color Transfer Process	350
10.14	Color Television	350
	References	351

11 Tone Reproduction

11.1	Purposes of Tone Reproduction	355
11.2	Objective and Subjective Tone Reproduction	355
11.3	Objective Tone-Reproduction/Preferred	
	Photographs	356
11.4	Objective Tone-Reproduction Analysis	358
11.5	Optical Flare	358
11.6	The Making of the Negative	362
11.7	The Making of the Positive	364
11.8	Generation of the Tone-Reproduction Curve	365

11.9	The Effect of Changes in Various Stages of the	
	System	369
11.10	Applications of the Tone-Reproduction System	373
11.11	Tone Reproduction and the Zone System	379
	References	385

12 Micro-Image Evaluation 387

12.1	Image Characteristics	389
12.2	Graininess/Granularity	389
12.3	Measuring Graininess	392
12.4	Grain Size and Image Color	394
12.5	Granularity	394
12.6	Minimizing Graininess	395
12.7	Graininess of Color Films	397
12.8	Sharpness/Acutance	397
12.9	Acutance	398
12.10	Resolving Power	399
12.11	Resolving-Power Variables	401
12.12	Resolving-Power Categories	403
12.13	Resolving Power and Graininess	403
12.14	Resolving Power and Acutance	404
12.15	Modulation Transfer Function (MTF)	405
12.16	Photographic Definition	407
12.17	Point Spread Function	407
12.18	Line Spread Function	408
12.19	Edge Spread Function	408
12.20	Chemical Spread Function	409
12.21	Pixels	409
12.22	T-Grain Emulsions	412
	References	413

13 Visual Perception

13.1	Post-Stimulus Perception	417
13.2	Perception of Stimulus Attributes	420
13.3	Color Hue	421
13.4	Color Lightness	422
13.5	Color Saturation	427
13.6	Shape	428
13.7	Depth	431
13.8	Size	433
13.9	Sharpness	434
13.10	Motion	435
	References	437

14	Filters	441
14.1	Filters	443
14.2	Color Filters	443
14.3	Ultraviolet and Infrared Filters	448
14.4	Filters for Color Photography	450
14.5	Spectrophotometric Absorption Curves	452
14.6	Neutral-Density Filters	453

14.7	Interference Filters	455
14.8	Polarizing Filters	458
14.9	Safelight Filters	462
14.10	Densitometer Filters	463
14.11	Light-Meter Filters	464
14.12	Viewing Filters	464
	References	465

15Color and Colorimetry467

15.1	Introduction	469
15.2	Spectrophotometers	470
15.3	Spectrophotometric Curves	471
15.4	Color Densitometers	471
15.5	Color Densities	472
15.6	Physical, Psychophysical, and Psychological	
	Measurements	473
15.7	Color Chain	474
15.8	Color Mode	474
15.9	Primary Colors	477
15.10	Color Acceluors	4/11
15.11	Neutrals	479
15.12	Color-Vision Theory	480
15.13	Object-Color Specification Systems	482
15.14	Munsell System: Brief History	483
15.15	Munsell System of Color Specification	484
15.16	Munsell Color Materials	489
15.17	Ostwald System of Color Specification	489
15.18	Pantone [®] System of Color Specification	490
15.19	Color Matching	490
15.20	Color Mixtures	491
15.21	CIE System of Color Specification	492
15.22	CIE History and Standards	492
15.23	Tristimulus Distribution Functions	493
15.24	CIE System: Colorimeters	494
15.25	Visual Colorimeters	494
15.26	Photoelectric Colorimeters	494
15.27	CIE System: Calculations	495
15.28	Determining Tristimulus Values X, Y, Z	497
15.29	Chromaticity Coordinates	497
15.30	CIE Chromaticity Diagram	498
15.31	Plotting x and y Values	499
15.32	CIE Dominant Wavelength and Purity	499
15.33	The Third CIE Dimension, Luminance Y	500
15.34	Color Names	500
15.35	Nonspectral Colors	503
15.36	Other Applications	504
15.37	TV Vectorscope	505
	References	505

16 Color Reproduction

and the second value of th	-	1
	Ø B	
-	v	

16.1	Objectives of Color Reproduction	509
16.2	Additive and Subtractive Color Formation	510
16.3	The Recording of Color (Analysis Stage)	514

16.4	The Production of Color (Synthesis Stage)	517
16.5	Spectral Sensitivity	520
16.6	Dye Characteristics	522
16.7	Contrast- and Color-Correcting Masks	523
16.8	Color-Negative Masking	525
16.9	Color Densities	528
16.10	Sensitometry of Color Photographic Materials	532
16.11	Reversal Color Films	533
16.12	Negative Color Films	534
16.13	Color Paper	537
16.14	Transmission Color Print Materials	538
16.15	Internegative Color Films	539
16.16	Reversal Reflection Color Print Materials	540
16.17	Reversal Color Duplicating Films	540
16.18	Accuracy of Color Reproduction	541
16.19	False-Color Systems	545
	References	547

Bibliography	549
Books	551
ANSI Publications	557
Eastman Kodak Company Publications	560
Periodicals	564
Appendix: Basic Logarithms	567
Index	575
About the Authors	587

Preface

This book is an introduction to the technology of photography. It is intended for the serious student who wants to understand how the photographic process works, and how to control its many elements to obtain desired results. Designed specifically as a textbook for a first-year course, "Materials and Processes of Photography," at the Rochester Institute of Technology, this volume covers what is considered to be the minimum amount of photographic technology necessary for students who have selected photography as a career. An attempt has been made to write the book in such a way that the reader can comprehend the contents without being enrolled in a related photographic course, and no more than a high-school education is presumed.

Technology is commonly defined as applied science. Thus much of this book's contents consists of photographic concepts based on scientific principles, with an emphasis on concepts with practical applications to picture making. The major scientific disciplines represented are physics, mathematics, chemistry, psychology, and physiology. Since we are applying principles from these sciences to the subject of photography, however, we will be more concerned with topics such as photographic sensitometry, photographic optim, photographic such as photographic sensitometry, photographic optim, photographic charactery, visual perception, photometry, colorimetry, and photographic quality control.

Most photographers and students of photography appreciate the contribution of technology to the picture-making process, but there are those who maintain that technology and picture making (at least of the expressive kind) are at best unrelated and at worst incompatible. They even cite findings that some people are dominated by the left (analytical/scientific) hemisphere of their brains and others by the right (holistic/attistic) hemisphere. Despite obvious examples of such onesided dominance, the two halves of the brain do work together, and most of us can deal with technical as well as artistic matters in the real world to the extent dictated by our interests, education, and occupations. There are many examples of people who excel in both areas.

Although this book does not deal with photography as an art form, it does deal with esthetics, in two ways. First, by providing the knowledge to control the numerous attributes of the photographic image, technology enables the photographer to achieve desired effects. For example, graininess of the photographic image can be affected by every step of the process, from choice of subject to choice of printing paper. Information on how to control graininess is presented without value judgment, leaving it to the photographer to vary the graininess as seems appropriate for each picture-making situation.

Second, by providing the photographer with data that have previously been correlated with viewer responses to photographs representing variations of those data, technology reduces the number of photographs that are unacceptable due to related esthetic considerations. For example, published film speeds enable photographers to obtain a high proportion of correctly exposed photographs. Exposure failure occurs due to deviation from one or more of the conditions under which the tests were conducted, and, when this happens, technological procedures can be used to enable the photographer to arrive at an adjusted or personalized exposure index.

Further, the principles presented for the appreciation and understanding of how photographic images are produced, reproduced, and controlled are common to other systems of visual imaging including motion pictures, video, electrophotography, computer graphics, and graphic arts printing.

Preface

Five specific objectives of this book are that the reader will:

- **1.** be able to understand and apply published information about photographic equipment and materials (such as manufacturers' data sheets);
- **2.** learn how to obtain reliable information about the subject, equipment, materials, and process involved in making photographs (such as how to determine the accuracy of an exposure meter);
- **3.** learn to solve technical problems involved in the production of photographs (such as how to use controlled fogging to change image contrast);
- **4.** build a technical foundation for the more advanced formal and/or informal study of photography and related imaging systems; and
- **5.** learn the basics of how the process of visual perception operates, and learn to anticipate and compensate for variations in visual perception (such as those associated with adaptation, defective color vision, and visual memory) in making photographs.

Variability and Quality Control in Photography

1.1 Introduction to the Concept of Variability

Photographers are by necessity experimenters. Although they are not thought of as scientists operating in a research atmosphere, they most certainly are experimenters: Every time an exposure is made, and the negative is processed, a genuine experiment has been made. There is no way the photographer can precisely predict the outcome of such an experiment in advance of doing the work. The objectives of the experiment derive from the purpose of the assignment, and the procedures flow from the photographer's technical abilities. The success of the experiment will be determined by evaluating the results. Finally, conclusions are reached after interpreting the results, which in turn shape the performance for the next assignment/experiment. It is the last step in the sequence, namely the interpretation of test results and the conclusions reached, that we will be concerned with in this section.

A great deal of what is written about the practice of photography consists of opinions. When someone states that "black-andwhite photographs are more artistic than color photographs" or that white photographs are more artistic than color photographs" or that an expression of personal judgment. Such statements are properly referred to as *subjective* because they arise from personal attitudes. Because opinions are statements of personal feelings, they are neither right nor wrong and, consequently, are always valid. The problem with subjective opinions is that they lead to conclusions that are not easily tested and analyzed. Therefore, when one relies solely on personal opinion, the possibilities for obtaining new insights into the photographic process become very limited.

Because of the potential ambiguity of subjective opinions, it is often preferable to use numerical expressions that have been derived from measurements. Such numbers can be considered *objective* in that they are generated outside of personal attitudes and opinions. For example, the blackness of a photographic image can be measured with a densitometer and the result stated as a density value. Such a numerical expression of its appearance can be obtained by independent workers and therefore verified. Although there may be many subjective opinions about the blackness of the image, there can be only one objective statement based on the measurements. Consequently, a goal of anyone who is experimenting is to test opinions with facts that usually are derived from measurements.

Whenever an experiment is performed and a result obtained, there is a great temptation to form a conclusion. For example, a sample roll of a new brand of film is tested and found to give unacceptable results; most photographers would not bother to purchase another roll. On the other hand, if the temperature of a processing bath was found to be 68° in the bottom of the tank, many people would act as if it were the same everywhere. Such conclusions should be resisted because of a fundamental fact of nature: No two things or events are ever exactly alike. No two persons (not even so-called identical twins) are exactly alike; no two snowflakes are ever identical. Photographically speaking, no two rolls of the same brand of film are exactly alike. No two frames on the same roll, no two areas within the same frame and indeed no two silver halide crystals are ever truly identical. If the inspection is close enough, differences will always be found. Stated more directly: *variability always exists*.

1.2 Sources of Variation

In addition to these differences, time creates variations in the properties of an object. The photographic speed of a roll of film is not now what it was yesterday, nor will it be the same in a few months. Using this point of view, an "object," say a roll of film, is really a set of events that are unique and will never be duplicated. As the Greek philosopher Heraclitus long ago said, "You cannot step in the same river twice."

With this view of the real world, it should be obvious that an essential task of the photographer/experimenter is to determine the amount of variability affecting the materials and processes being used. This will require that *at least two* separate measurements be made before reaching a conclusion about the characteristics of an object or process. A photographer who ignores variability will form erroneous conclusions about photographic materials and processes, and will likely be plagued by inconsistent results.

1.2 Sources of Variation

In an imaginary gambling situation where a perfect roulette wheel is operated with perfect fairness, the outcome of any particular spin of the wheel is completely unpredictable. It can be said that, under these ideal circumstances, the behavior of the ball is determined by *random* or *chance* causes. These terms mean that there are countless factors influencing the behavior of the wheel, each of which is so small that it could not be identified as a significant factor. Consequently, these numerous small factors are grouped together and identified as chance effects; and their result is termed *chance-caused variability*. In addition to being present in games of chance, chance-caused variation occurs in all forms of natural and human undertakings.

Consider, on the other hand, a rigged roulette wheel, arranged so that the operator has complete control over the path of the ball. Under these circumstances there would be a reason (the decision of the operator) for the fall of the ball into any particular slot. With this condition it is said that there is an *assignable cause* for the behavior of the ball.

The distinction between these types of effects—chance and assignable cause—is important, because it will influence the actions taken. For example, your desire to play the roulette wheel would quite likely disappear if you believed the operator was influencing the results. A similar dilemma arises when, for example, an electronic flash fails to fire. The film is advanced and a second photograph is taken and again the flash fails. If this procedure is continued, it would be based upon the assumption that it was only a chance-caused problem. On the other hand, if the equipment were examined for defects, the photographer would be taking action with the belief that there was an assignable cause for the failure of the flash.

In other words, when it is believed that chance alone is determining the outcome of an event, the resulting variation is accepted as being natural to the system and likely no action will be taken. However, if it is believed that variability is due to an assignable cause, definite steps are taken to identify the problem so that it can be removed and the system returned to a natural (chance-governed) condition. Consequently, it is very important to be able to distinguish chance-caused from assignable-caused results.

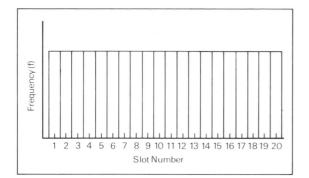

Figure 1–1 Rectangular pattern of variability from the expected long-term performance of a perfect roulette wheel. Each number has an equal chance of occurring.

1.3 Patterns of Variation

Although there is no possibility of predicting the outcome of a single turn of a fair roulette wheel, there is an underlying *pattern* of variation for its long-term performance. If the ball has the same likelihood of dropping into each of the slots, then over a large series of plays each of the numbers should occur as frequently as any other. Thus, the *expected* pattern of variability for the long-term performance of the roulette wheel could be described by a graph as shown in Figure 1-1. This is called a *frequency distribution* graph because it displays the expected frequency of occurrence for each of the possible outcomes. In this case, it is termed a *rectangular distribution*, which arises any time there is an equal probability of occurrence for every outcome. Every one of the 20 slots has an equal chance of receiving the ball.

Suppose now that the roulette wheel is spun many times so that the *actual* pattern of variation can be compared to the *expected* distribution. If the wheel is actually operated 200 times, it is highly unlikely that each number will occur exactly 10 times. Instead, a pattern similar to that shown in Figure 1–2 will probably arise, indicating that the actual distribution only approximates that of the expected (or theoretical) months. It would likely be concluded from these results that the wheel is honest. However, if the actual distribution of 200 trials appeared as shown in Figure 1–3, there would be good cause to suspect something abnormal was happening.

Thus, a basic method for judging the nature of variation in a system is to collect enough data to construct a frequency distribution (sometimes referred to as a frequency histogram) and compare its shape to that which is expected for the process. If the shapes are similar, the process is behaving properly. A significant difference indicates an abnormal condition that would usually be identified and corrected.

In the game of dice, if a single die is thrown repeatedly in a random manner, a rectangular distribution is also to be expected. In

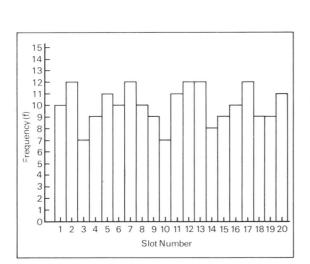

Figure 1-2 Pattern of variability from the actual performance of a roulette wheel indicating that only chance differences are occurring. Although theoretically each number has an equal chance of occurrence, some numbers occur more frequently over the short run.

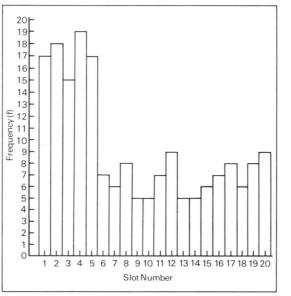

Figure 1-3 Pattern of variability from the actual performance of a roulette wheel indicating assignable-cause influence. The lower numbers are occurring with much greater frequency.

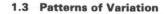

Figure 1–4 Triangular pattern of variability from the expected long-term performance of two randomly thrown dice.

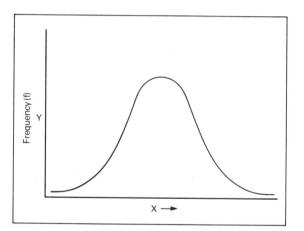

Figure 1-5 Expected pattern of variation when there is a multiplicity of outcomes with chance governing the process. This bell-shaped curve is called the normal distribution.

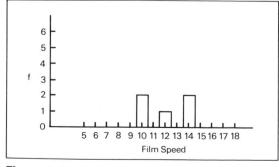

Figure 1–6 Frequency bistogram of film speeds (five samples).

other words, each of the six numbers is equally likely to appear on every roll. For the total of two dice, a quite different pattern is expected since the probability of rolling a seven is greater than for any other number. In other words, there are more combinations that total seven than any other number (1+6, 2+5, 3+4, 4+3, 5+2, 6+1). The expected pattern is referred to as triangular distribution and is shown in Figure 1-4.

If this concept is extended to the totals of three dice, five dice, etc., the expected distributions begin to look like the symmetrical bell-shaped curve shown in Figure 1–5. This frequency pattern is called the *normal distribution*. It is of exceptional importance because whenever there is a multiplicity of outcomes with many factors affecting each occurrence (as there almost always is in real-life events), this is the pattern suggested by chance. Consequently, when evaluating the results of tests and experiments using photographic materials, the normal distribution of data is the expected condition. If the results of the tests give something other than this bell-shaped pattern, it is an indication of assignable-cause problems and appropriate action should be taken.

Notice that to obtain a useful picture of the pattern of variation, more than a few samples must be collected. Statistical theory suggests that *at least 30 samples* should be used to construct the distribution before making any inferences, because the pattern that develops as additional samples are taken tends to stabilize at 30. For example, a slow film was tested and five samples gave speeds of 10, 12, 10, 14, and 14, producing the histogram shown in Figure 1–6. Although the resulting pattern is not a bell-shaped curve, there are too few samples to draw a valid conclusion. An additional 25 samples added to the first five could give the distribution illustrated in Figure 1–7. Here the pattern approximates the normal distribution, indicating that the differences in film speeds are only the result of chance-caused effects.

Suppose the results of testing 40 different shutters at the same marked shutter speed gave a set of data distributed as shown in Figure 1–8. The pattern exhibited differs markedly from the normal distribution; thus it is inferred that something unusual is occurring. The two peaks in the histogram suggest the presence of two sources (or populations) of data, such as two different types of shutters.

Consider the histogram shown in Figure 1–9, which is the result of testing the same meter 35 times against a standard light source. Notice that the distribution is asymmetrical—the left-hand "tail" is longer than that on the right. Again, it should be concluded that there is an assignable cause in the system. Perhaps because of a mechanical problem the needle is unable to go above a given position, hence the lack of data on the high side. In both of these instances, because the

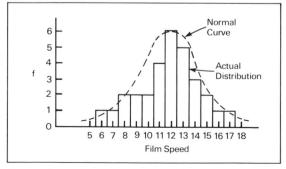

Figure 1–7 Frequency histogram of film speeds (30 samples).

1.5 Populations vs. Samples

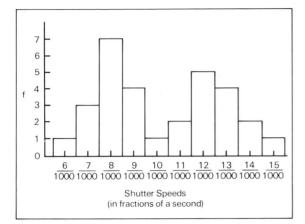

Figure 1–8 Frequency histogram of 40 different sbutters tested at the same marked shutter speed of 1/125 (8/1000) second.

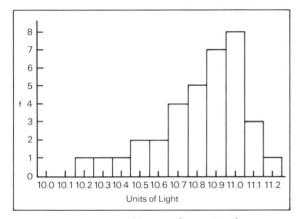

Figure 1-9 Frequency bistogram from testing the same meter against a standard source 35 times.

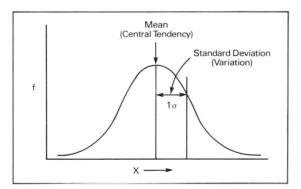

Figure 1–10 I heoretical normal distribution illustrating the relationship between the mean and the standard deviation.

bell-shaped distribution did not occur, a search for the assignable cause is necessary.

1.4 The Normal Distribution

After a histogram has been inspected and found to approximate the normal distribution, it is possible to compute two numbers that will completely describe the important characteristics of the process.

The first of these is the arithmetical average or mean. This value is obtained by adding all of the sample data together and dividing by the number of samples taken. The resulting number is the value around which the rest of the data tend to cluster. In other words, it is a measure of the central tendency of the distribution. There are two other measures of central tendency that are sometimes used to describe a set of data. The mode, which is defined as the most frequently occurring value in a data set, is located at the peak of the histogram. The median is that value which divides the data set into two equal halves. Of all three measures of central tendency, the average is by far the most often used. It is sometimes useful to represent variability with the simpler concept of the relationship between the smallest value and the largest value in A BEE OF data. Por data that are incontrol with interval wales, such as temperature, length, and weight, the difference between the largest and smallest values is identified as a range. For data that are measured with ratio scales, such as the contrast of a scene, the largest value divided by the smallest value is identified as a ratio. Thus the contrast of a certain scene might be expressed as having a luminance ratio of 128 to 1.

The second number of interest is called the *standard deviation* and represents a measure of the variability of the system. To obtain this number, each piece of data is compared to the average (or mean) and the average difference or deviation for all of the data is determined. This value is a measure of the width of the normal distribution. If the normal distribution is very narrow, the variation is small; if it is very wide, the variation is large. Thus, the standard deviation is a direct measure of the *amount of variability* in a normal distribution.

Figure 1–10 illustrates the relationship between the average and the standard deviation for a hypothetical normal distribution. Notice that if the distribution should shift left or right, this would be reflected in a change of the average since it means that the central position of the system has changed. If the width of the distribution were to become narrower or wider, the standard deviation would change because the amount of variability in the system would be changing. Taken together, these two values can provide a useful set of numbers for describing the characteristics of any system tested.

1.5 Populations vs. Samples

At this point, it is necessary to distinguish between populations and samples. If, for example, a new brand of developer were being marketed, it would be intelligent to test it prior to use. To obtain a crude estimate of the variability affecting this product, at least two samples should be tested. If it is desired to determine the pattern of variation, at least 30 should be tested. Even if 30 tests were performed (which would be quite a task) there would be countless more bottles that were not tested. Thus the term *population* refers to all possible members of a set of objects or events. Additional examples of populations are: the ages of all United States citizens; the weights at birth of all newborns; the ISO/ASA speeds of all sheets of Brand X film; the temperatures at all possible points in a tank of developer; the accuracy of a shutter over its entire lifetime.

In each case, an extremely large number of measurements would have to be made to discover the population characteristics. Seldom, if ever, are all members of a population examined, primarily because it is usually impossible to do so. Further, by examining a properly selected group of *samples* from the population, almost as much insight can be obtained as if all members had been evaluated. Herein lies the value of understanding some basic statistical methods. By obtaining a relatively small number of representative samples, inferences can be made about the characteristics of the population. Such is the basis of much scientific investigation, as well as political polls.

If the sample is to be truly representative, it must be selected from the population with great care. The principle to be followed is this: Every member of the population must have an equal chance of being selected. When taking sample density readings from a roll of film after processing, for example, it is dangerous to obtain the data always from both ends and the middle. It is also dangerous never to obtain data from the ends and the middle. The samples must be selected so that in the long term data are obtained from all parts of the roll with no area being consistently skipped.

Although this principle appears simple, the method for carrying it out is not. The most common approach for ensuring that all members of the population have been given an equal opportunity is to use a *random sampling* method. Random means "without systematic pattern" or "without bias." Human beings do not behave in random ways but are strongly biased by time patterns and past experiences. Consequently, special techniques must be employed to avoid the nonrandom selection of samples. Techniques such as drawing numbered tags from a box, using playing cards, tossing coins, etc., can be used to minimize bias in obtaining samples. Tables of random numbers are also very useful in more complex situations.

It should be obvious, then, that there is a distinction between the average of the population and the average of the sample data. The symbol μ (Greek letter *mu*) is used to refer to the population average, while the symbol \overline{X} (X bar) is used for the sample average. Likewise there is a difference between the standard deviation of the population and that of the sample data. The symbol σ (Greek letter *sigma*) is employed for the standard deviation of the population, and the symbol *s* identifies the sample standard deviation. If the sample data are representative of that in the population, \overline{X} and *s* will approximate μ and σ , respectively. Also, as the number of samples taken increases, the conclusions reached become more reliable. Table 1–1 displays the symbols and formulas employed.

1.6 Calculation of the Mean

To determine the mean of a population or sample, all of the data are simply added together and divided by the number of pieces of data. For example, suppose that three tests of the resolving power of a film produced the following data: 59 lines/mm, 55 lines/mm, and 51 lines/mm. Using the formula $\overline{X} = \Sigma X/n$ (where the symbol Σ means "sum of ") the steps are:

- **1.** Add up all of the X values (59 + 55 + 51 = 165).
- **2.** Divide the total by the number of X values (n) (165 \div 3 = 55.0).

1.7 Calculation of the Standard Deviation

Terms	Population (Parameter)	Sample (Statistic)
Number of observations	N	n
Mean (average)	μ (mu)	\overline{x}
Standard deviation	σ (sigma)	s
A single observation	X	X
Formulas		
Mean (average)	$\Sigma X/N$	$\sum X/n$
Standard deviation	$\sqrt{\frac{\Sigma(X - \mu)^2}{N}}$	(Formula I) $\sqrt{\frac{\Sigma(X - \overline{X})^2}{n - 1}}$
	,	(Formula II) $\sqrt{\frac{n\Sigma X^2 - (\Sigma X)^2}{n(n-1)}}$

Table 1-1	Statistical	symbols.
-----------	-------------	----------

Notice that the mean is carried to one more decimal place than the original data. Thus, the mean resolving power for this experiment is 55.0 lines/mm.

1.7 Calculation of the Standard Deviation

Although the formulas for determining the standard deviation contain more terms, the calculations are relatively easy to do if taken step by step. To continue the example given above with resolving powers of 59, 55, and 51 lines/mm requires the use of one of the formulas for the sample standard deviation.

Formula 1:

- **1.** Determine the mean. Here \overline{X} was found to be 55.0.
- 2. Determine the absolute difference (ignoring the sign) between each X value and the mean. In order, the differences are 4, 0, and 4.
- **3.** Square each of the differences. The squares are 16, 0, and 16, respectively.
- **4.** Add the squares. The total is 32. This is the numerator of the fraction under the radical sign.
- 5. Divide the total by the sample size minus $1(n 1 = 2; 32 \div 2 = 16)$.
- 6. Finally, find the square root of this value. $\sqrt{16} = 4.0$. The standard deviation is therefore 4.0 lines/mm correctly taken to the same number of decimal places as the mean.

It is often convenient to set up the calculations in tabular form as shown:

Formula I

$$s = \sqrt{\frac{\Sigma(X - \overline{X})^{2}}{n - 1}}$$
(Step 2)
(Step 3)
(X - X)
55
0
(X - X)
16
55
0
0
0
(X - X)
16
55
0
0
0
(X - X)
16
55
0
0
0
(Step 3)
(X - X)
16
55
0
0
(Step 4)
(Step 4)
(Step 4)
(Step 5)
(Step 5)
(Step 5)
(Step 4)
(Step 4)
(Step 4)
(Step 4)
(Step 5)
(Step 5)
(Step 5)
(Step 5)
(Step 5)
(Step 4)
(Step 4)
(Step 4)
(Step 5)
(Step 5)
(Step 5)
(Step 5)
(Step 5)
(Step 6)
(Step 6)

1.8 Description of the Normal Distribution

Formula II:

This formula is mathematically identical to the previous formula but is sometimes preferred because it avoids the rounding-off problem and is easier to program with computers. Using the same sample data as before, the steps are:

- 1. Determine the sum of the X values. It is 165.
- **2.** Square the sum of the X values $(165^2 = 27, 225)$.
- **3.** Square each of the X values. The squares of 59, 55, and 51 are 3,481, 3,025, and 2,601, respectively.
- 4. Determine the sum of the squares. The total is 9,107.
- 5. Multiply the sum of the squares by the sample size $(9, 107 \times 3)$ = 27,321).
- 6. Subtract the answer in step 2 from that in step 5 (27,321 27,225 = 96).
- 7. Divide this answer by the sample size multiplied by one less than the sample size $(3 \times 2 = 6; 96 \div 6 = 16)$.
- 8. Find the square root of this number ($\sqrt{16} = 4.0$).

Again, expressed in tabular form it is:

Formula II:

$$s = \sqrt{\frac{n\Sigma X^2 - (\Sigma X)^2}{n(n-1)}}$$
(Step 3)

$$\frac{X}{59} \frac{X^2}{3,481}$$
55 3,025

$$\frac{51}{55} \frac{2,601}{(Step 1)}$$
(Step 4)

$$n\Sigma X^2 = 3 \times 9,107 = 27,321$$
(Step 1)

$$n\Sigma X^2 = 3 \times 9,107 = 27,321$$
(Step 5)

$$165^2 = 27,225$$
(Step 2)

$$27,321 - 27,225 = 96$$
(Step 6)

$$96 \div 6 = 16 \sqrt{16} = 4.0 = s.$$
(Step 7)
(Step 8)

1.8 Description of the Normal Distribution

The graph of the normal distribution model is a bell-shaped curve that extends indefinitely in both directions. Although it may not be apparent from looking at Figure 1–11, the curve comes closer and closer to the horizontal axis without ever reaching it, no matter how far it is extended in either direction away from the average.

An important feature of the normal distribution is that it is symmetrical around its mean. In other words, if the curve in Figure 1-11 were folded along the line labeled μ , the two halves of the curve would coincide. Thus, to know the mean (μ) is to know the number that divides the population into two equal halves. Additionally, it can be seen that μ identifies the maximum point of the distribution. Consequently, the mean (μ) represents the best measure of the central tendency of the population.

When describing the spread of the normal distribution, the standard deviation (σ) is most useful. The standard deviation (σ) locates the point of inflection on the normal curve. This is the point where

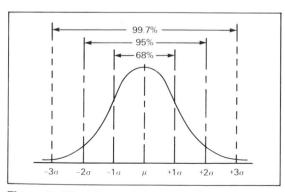

Figure 1–11 The normal distribution illustrating areas contained under the curve for ± 1 , 2, and 3.

1.9 The Concept of Control Charts

the line stops curving downward and begins to curve outward away from the mean. Since the curve is symmetrical, this position will be located at equal distances on either side of the mean (μ). The total area contained under the curve would include all members of the population and is therefore equal to 100%. The standard deviation (σ) can be used to describe various portions of the population in conjunction with μ as follows:

- 1. The inflection points lie at $\pm 1\sigma$ from the mean (μ). Between the inflection points are found approximately 68% of all members of the population. About 32% will be located beyond these points with 16% on the left and 16% on the right.
- 2. Between $\pm 2\sigma$ from the mean occur approximately 95% of the population. About 5% will be located beyond these points equally distributed on either side.
- **3.** Between $\pm 3\sigma$ from the mean are found nearly 99.7% of the population. Only 0.3% will lie outside of these points.
- **4.** As the distances on either side of the mean become greater, the percentage of the population contained therain librarium instance. However, it will never reach 100% because the curve never touches the horizontal axis.

Thus, a normal curve is completely specified by the two numbers, or parameters, μ and σ . In effect, μ locates the position of the curve along the X axis, and σ specifies the spread of the curve. If the sample data obtained approximate the shape of the normal curve, and the sample size is large enough, the calculated values of \overline{X} and sfor the sample can be used the same way as were μ and σ for the population.

For example, suppose the repeated testing of a light meter against a standard source produced a set of data that approximated the normal distribution, and \overline{X} is found to be 15.0 and s is equal to 1.0. With this information, it can be inferred that 68% of the readings will be between 14.0 and 16.0 due to chance, 95% of the readings will be between 13.0 and 17.0 due to chance, 99.7% of the readings will be between 12.0 and 18.0 due to chance, while only 0.3% will be less than 12.0 and greater than 18.0 due to chance.

If the meter were to be checked again and give a reading of 13.5 (1.5 standard deviations from the mean), the decision most probably would be that the meter was operating normally. In other words, the amount of variation in the reading is not greater than that which is suggested by chance. However, if the meter gave a reading of 18.5 (3.5 standard deviations from the mean), this would be viewed as an unusual occurrence and one that would call for a careful study of the equipment. This is because the difference is now greater than that which is suggested by chance, since only 0.3% of the readings will exceed $\pm 3s$ due to chance.

This method of describing the characteristics of the materials and processes of photography minimizes guesswork and allows decisions to be made from facts.

1.9 The Concept of Control Charts

Thus far, it has been shown how a photographic process or system can be evaluated through the use of a frequency histogram. By collecting 30 or more samples and inspecting the pattern of variation

 Table 1-2
 Density measurements made on 30 successive

 control stript developed in an automatic film processor

Day	Density	Day	Density
1	1.20	16	1.80
2	1.80	17	1.90
3	1.70	18	2.00
4	1.80	19	1.60
5	2.00	20	1.50
6	1.90	21	1.70
7	1.40	22	1.70
8	2.20	23	1.70
9	1.60	24	1.90
10	1.50	25	1.80
11	1.80	26	1.70
12	1.70	27	1.60
13	1.60	28	1.50
14	1.70	29	1.40
15	2.10	30	1.30

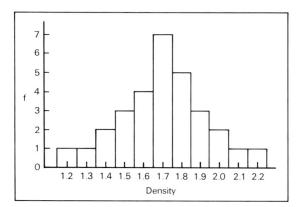

Figure 1–12 Frequency histogram from density values in Table 1–2. The distribution appears to be normal.

Figure 1–13 Time plot of the density values in Table 1-2. Notice the lack of stability shown in the last six points (downward trend).

in the histogram, conclusions can be reached about the basic properties of the event being studied. Although this approach gives excellent insight into the overall process capability, it is often desirable (or sometimes necessary) to have knowledge of the current operating properties of the process. In other words, it is often important to monitor the ongoing behavior of a process that may change from time to time so that a decision can be made about the current running level. Here, the term *process* is used to mean any sequence of events. For example, a process may be as simple as the repetitive operation of a shutter or light meter. Or a process may be more complicated, such as the running of an automatic film processor or an automatic printer. A person can also be thought of as a very complex "human process" that is subject to changing with time.

It is almost always desirable for a process, however defined, to be stable. It is hoped that film of a given kind is the "same" roll after roll; that an automatic processor gives the same development at a given setting day after day, and that a shutter gives the "same" exposure time repeatedly at the same setting. However, what is desired and what a process produces are not necessarily the same. It is known that any process will vary to some extent just because of chance-caused differences. What is needed is the answer to a more basic question: Is the process stable? The most direct method for obtaining an answer to this question involves the use of a *control chart*.

The control chart is similar in concept to the histogram with the important exception that the data are displayed as a function of time. For example, the data shown in Table 1–2 are density values from 30 control strips run through an automatic film processor over a 30-day interval. The histogram from these data is shown in Figure 1– 12; the densities appear to be normally distributed. However, if a time plot of the process is made, as shown in Figure 1–13, it is obvious that the immediate past performance has not been stable. The last six points indicate that the process is in a downward trend and, therefore, it should no longer be used to develop film. Thus it is evident that for a process to be "in control" it must be operating at a *stable level* in addition to being chance governed.

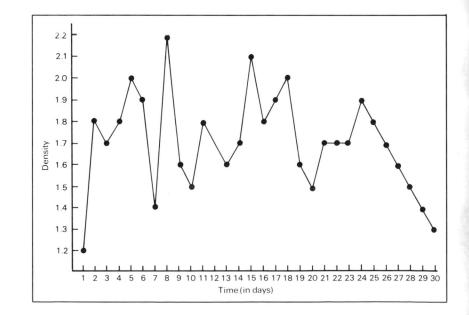

1.10 The Preparation of Control Charts

the same fashion. If the process behaves in the future as it did in the past when it was "in control," the data should randomly fluctuate between the limit lines 99.7% of the time. Only 0.3% of the time (or 3 times out of 1,000) will the results exceed these limits due to chance alone.

Figure 1–15 illustrates a variety of nonchance patterns as follows:

- 1. Point out of control: A point exceeding the control limits. With the limits placed at $\pm 3s$, a point will fall outside these boundaries only 3 times in 1,000 just due to chance. Consequently, the odds overwhelmingly indicate that an assignable cause is present and corrective action should be taken.
- 2. *Trend:* A series of points in a downward or upward pattern. Although none of these points fall outside of the limits, the pattern is nonrandom and thus a signal that other than chance causes are affecting the outcome. At least five such points are necessary for sufficient confidence in such a decision.
- **3.** *Run:* A series of points all below or above the mean (\overline{X}) . The question is whether or not a process could give results such as these due only to chance. When five or more successive points fall either below or above the average, the odds are small that it is only the result of chance. Look for a problem.
- 4. Cycling: A series of points alternating above and below the mean.

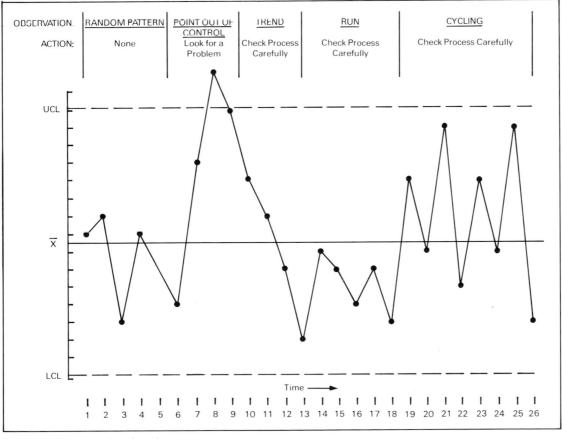

Figure 1-15 A variety of nonchance patterns.

1.10 The Preparation of Control Charts

Typically a control chart shows a central line, representing the estimate of the process mean (\overline{X}) , and limit lines, representing the range of variation expected due to chance-caused effects. The limit lines are derived from an estimate of the natural process variation such as the standard deviation. Figure 1–14 shows a control chart where the data are plotted in sequence. Notice that if all of the data points were accumulated in a pile at the left of the plot, a normal distribution would result. Here the limit lines have been placed at three standard deviations (3s) above and below the mean. If the process is in control, the points should fluctuate *randomly* between these limits approximately 99.7% of the time. Any departure from these conditions constitutes a signal that assignable-cause problems are at play and that corrective action should be taken.

1.10 The Preparation of Control Charts

The most basic method of control-chart evaluation is that which is based on measurements made one at a time and plotted on the control chart as *individual observations*. When the process being investigated is new, or when the past performance is unknown, it is necessary to obtain enough data to verify the presence of a normal distribution. Therefore, at least 30 samples must be collected initially. If it appears that the process is principally chance governed, the next step is to plot the data in order of occurrence on a time scale. If the time plot appears to be stable, the central line can be located at the mean (\overline{X}) of the data. The control limits are then determined by computing the standard deviation, multiplying it by 3 and adding it to and subtracting it from the \overline{X} value. The central and limit lines are then extended forward in time, and data continues to be collected in

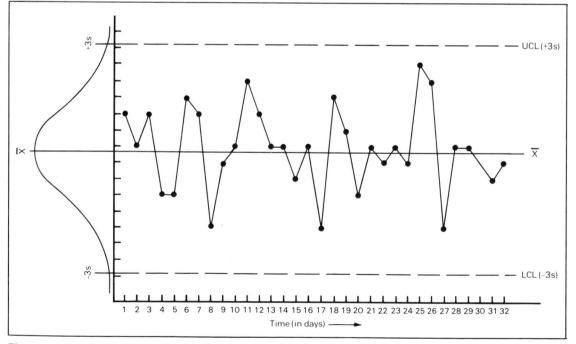

Figure 1–14 Control chart exhibiting a stable, chancegoverned pattern.

This pattern appears random at first glance, but because of the predictable, saw-toothed variation, an assignable cause is indicated. At least seven alternating points are needed to verify this problem because the pattern is similar to that suggested by chance.

The following example illustrates the application of the control-chart method to the evaluation of photographic equipment. A given camera was used to make important photographs every day and so its operating characteristics had to be stable and at the correct level. To determine this, the shutter was checked daily at a setting of 1/100 second on a shutter tester.

The results of 30 trials showed a normal distribution with a mean of 1/100 (0.01) and a standard deviation of 1/1000 (0.001). The data were first converted to percent differences from the mean value of 1/100 and changed to exposure differences in tenth-of-a-stop intervals. A time chart of these data was constructed with the control limits placed at three standard deviations (of stops) above and below the mean, as shown in Figure 1–16. The graph indicated that the shutter was performing in a stable fashion and at the proper level of 1/100 second (111) the mean have the mean at the proper level of 1/100 second (111) the mean have the mean at the proper level of 1/100 second (111) the mean have the mean at the proper level of 1/100 second (111) the mean have the mean at the proper level of 1/100 second (111) the mean have the mean at the proper level of 1/100 second (111) the mean have the mean at the proper level of 1/100 second (111) the mean have the mean at the proper level of 1/100 second (111) the mean have the mean at the proper level of 1/100 second (111) the mean have the mean at the proper level of 1/100 second (111) the mean have the mean at the proper level of 1/100 second (111) the mean have the mean at the proper level of 1/100 second (111) the mean have the mean at the proper level of 1/100 second (111) the mean have the mean at the proper level of 1/100 second (111) the mean have the m

By day 40, it was concluded that this camera should no longer be used because the deviation in tenths of a stop was significantly different from its past performance, since the deviation was running near -0.5. This means that the shutter speed was actually operating at a speed that was one-half stop faster than the mean (i.e., 1/140instead of 1/100). If this shutter were used in its current condition, it would lead to underexposure by about one-half stop.

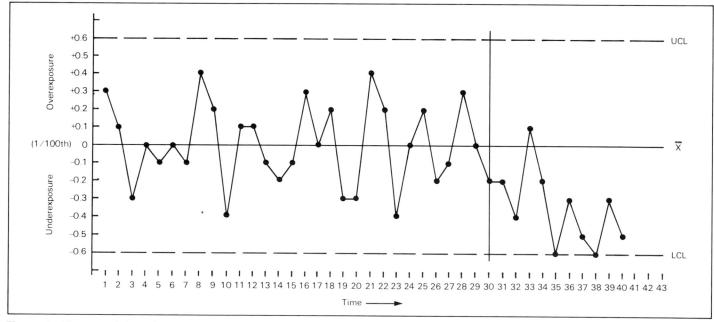

Figure 1–16 Control chart of individual testings of the 1/100-second shutter speed setting of a camera plotted as tenthof-a-stop deviations from the mean (1/100).

1.11 Control Charts Based on the Mean and the Range

It is desirable in many ongoing operations to select samples in small groups of two, three, or more items. The mean for each subgroup is found and the resulting values are plotted as control-chart points. There are many important benefits of this approach. First, subgroup means tend to be normally distributed regardless of the distribution of the individual pieces of data. Sometimes referred to as "the law of averages," this principle signifies that sample averages (means), because they reflect central tendency, always fit the model of the normal distribution. The resulting benefit is that when working with subgroup means, there is no need to construct the histogram. Thus the use of the standard deviation is automatically justified.

Second, with the data organized into separate subgroups, an estimate of the range for each can be obtained. The range is the absolute difference between the largest and smallest values in the subgroup and constitutes a crude measure of the variation. By taking many subgroups, many independent estimates of the range are obtained that can be averaged to give the average range (\overline{R}) , which is a good estimate of the population range. By using some predetermined coefficients, the average range (\overline{R}) can be used to locate the limit lines for the control chart. Thus there are fewer calculations associated with this technique.

These are the procedures to be followed for the construction of \overline{X} and R charts:

1. The data are collected in logical subdivisions called subgroups. Each subgroup must contain at least two samples, with four or five being used most commonly. A minimum of 10 separate subgroups is required initially to determine process stability. The data in Table 1–3 are from density measurements made on control

Table 1–3 Density measurements made on 60 successive control strips processed in subgroups of four each.

Day	\mathbf{X}_{1}	\mathbf{X}_2	\mathbf{X}_3	\mathbf{X}_4	Σx	$\overline{\mathbf{X}}$	R
1	1.20	1.30	1.60	0.90	5.0	1.25	0.70
2	0.50	0.80	0.90	1.20	3.4	0.85	0.70
3 4	1.10	1.10	1.00	0.50	3.7	0.93	0.60
	0.80	1.10	1.00	1.20	4.1	1.03	0.40
5	0.80	1.00	0.60	1.20	3.6	0.90	0.60
6	0.70	1.10	0.60	0.90	3.3	0.83	0.50
7	1.20	0.80	1.00	1.10	4.1	1.28	0.40
8	0.90	1.10	0.40	0.30	3.0	0.75	0.80
9	0.40	0.70	0.30	1.00	2.4	0.60	0.70
10	0.90	0.90	0.20	1.20	3.2	0.80	1.00
11	1.00	1.20	1.30	1.00	4.5	1.13	0.30
12	1.10	0.30	1.60	0.60	3.6	0.90	1.30
13	0.50	1.60	1.10	1.20	4.4	1.10	1.10
14	1.50	1.20	0.60	0.80	4.1	1.03	0.90
15	1.30	1.60	1.10	1.50	5.4	1.35	0.50
Centerline Lower con <i>Chart of ra</i> Upper cor	$\begin{array}{l} \text{verages} \\ \text{ntrol } \underset{e}{\lim it} = \\ e = \overline{X} = 0. \\ \text{ntrol } \underset{e}{\lim it} = \\ anges \\ \text{ntrol } \underset{e}{\lim it} = \\ \end{array}$	$4.73 \div 15$ $\overline{X} + A_2 \overline{R}$ 98 $\overline{X} - A_2 \overline{R}$ $D_4 \overline{R} = 2$	= 0.98; = 0.98 = 0.98	- 0.729 (0	$\div 15 =$.70) = 1.	49	
Centerline	e = R = 0.7	70					

1.11 Control Charts Based on the Mean and the Range

strips that were developed in an automatic processor. Here, four strips were processed each day so that the subgroup size is n = 4.

- **2.** Compute the mean and range for each subgroup. In Table 1-3 these values are shown in the \overline{X} and R columns.
- **3.** Compute the average of the means (\overline{X}) and the average range (\overline{R}) from all subgroups. These values will be used as the center lines for the control charts. Here,

 $\overline{\overline{X}} = 0.98$ and $\overline{R} = 0.70$.

- 4. Make a time plot of the subgroup averages employing \overline{X} as the centerline and make a second time plot of the subgroup ranges using \overline{R} as the center line. The same time scale should be used for both as shown in Figure 1–17. These plots must exhibit stability before going farther. Any nonrandom patterns, as described above, indicate that the process is not behaving normally. Control limits should not be determined from an unstable process. When the process exhibits stability, the limit lines may be found.
- 5. Calculate the upper and lower control limits for both charts. In this approach, a set of producermined coefficients is used in con-

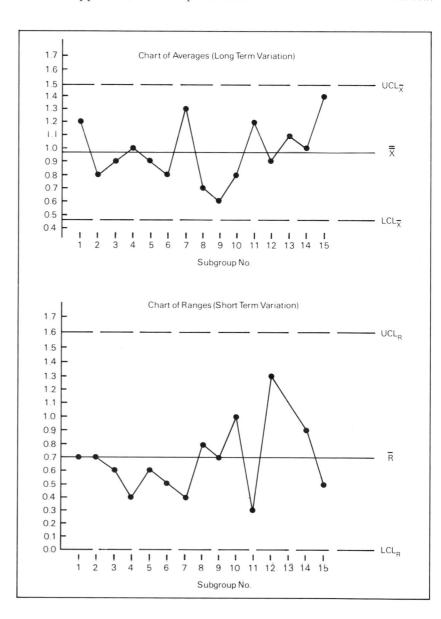

Figure 1–17 Control charts of \overline{X} and R from data in Table 1–3.

1.11 Control Charts Based on the Mean and the Range

Table 1-4 Factors for computing control limit lines for \overline{X} and R charts.

Number in Subgroup	A_2	D ₃	D_4
2	1.880	0	3.267
3	1.023	0	2.575
4	0.729	0	2.282
5	0.577	0	2.115
6	0.483	0	2.004
7	0.419	0.076	1.924
8	0.373	0.136	1.864

junction with \overline{R} to locate the limits $\pm 3s$. These coefficients are given in Table 1-4. The generalized formulas for the chart of averages are:

 $\overline{\overline{\mathbf{X}}} + A_2\overline{R} =$ Upper control limit (+3s)

 $\overline{\overline{\mathbf{X}}}$ = Center line

 $\overline{\overline{\mathbf{X}}} - A_2 \overline{R}$ = Lower control limit (-3s).

The generalized form for the chart of ranges is:

 $D_4\overline{R} = Upper \text{ control limit } (+3s)$

 \overline{R} = Center line

 $D_3\overline{R}$ = Lower control limit (-3s).

In this example, the value of coefficient A_2 is 0.729 because there are four members in each subgroup while \overline{R} was found to be 0.70. These two values are multiplied to give 0.51. This value is then added to and subtracted from \overline{X} to give the upper and lower control limits for the chart of averages. The value of coefficient D_4 with a subgroup size of 4 is 2.282. When multiplied by \overline{R} (in this example, 0.70), the upper limit for the chart of ranges is located at 1.60. The lower limit for this chart would be located at zero because the value of coefficient D_3 for n = 4 is 0.0. Thus, 0.0 × 0.70 = 0.0.

6. The center and limit lines are extended forward in time, and data continues to be collected in the same fashion, i.e., in subgroups of 4, with evidence of abnormal variations sought.

Notice, in this technique, that there are two different types of information being presented to the investigator. The chart of means gives information about the *level* of each subgroup, while the chart of ranges shows the *variation* within each subgroup. It is convenient to think of this as *long-term variability* (chart of means) vs. *short-term variability* (chart of ranges). Both are important to know. In this example, the chart of means is displaying the average daily level of the automatic processor and the plotted points show the between-day variation. The chart of ranges, on the other hand, displays the variations occurring during each day, and the points show the within-day variability.

To illustrate the use of \overline{X} and R control charts, consider the problem of keeping the temperature as close to the aim value of 100.0 F as possible. However, the concept of chance-caused variation tells us that the temperature will not be the same everywhere in the tank. Consequently, the temperature is taken at two different positions within the tank every time the developer is used. This results in a subgroup size of n = 2. Ten such subgroups were collected, with the data shown in Table 1–5 resulting. \overline{X} and R charts are constructed as discussed before and as shown in Figure 1–18. The pattern of points 1 through 10 appears to be random and in control on both charts. The limit lines are extended forward and temperature measurements continue to be made in the same fashion with the new data added to the chart.

The \overline{X} chart exhibits a stable, in-control process, meaning that the average temperature of the tank is approximately the same, run after run. However, the Range Chart shows a definite upward trend beginning with point 13. This increase in the range indicates that the variation of temperatures within the tank is unusually large but the lower temperatures offset the higher ones, giving an average that is close to the aim. Consequently, even though the average temperature is at the correct level, this process should be corrected because of the

1.12 Specifications and Naturally Determined Control Limits

Subgroup	\mathbf{X}_{1}	\mathbf{X}_2	$\overline{\mathbf{X}}$	R
1	98.50	101.50	100.00	3.0
2	99.00	101.50	100.25	2.5
3	100.00	102.00	101.00	2.0
4	100.50	98.00	99.25	2.5
5	99.50	99.50	99.50	0
6	100.00	98.00	99.00	2.0
7	100.00	97.00	98.50	3.0
8	98.00	99.00	98.50	1.0
9	102.00	100.50	101.25	1.5
10	100.50	100.50	100.50	0
		80; $\overline{R} = 1.75$ $D_3 = 0; D_4 =$	3.267	
Chart of <u>av</u> erages:	_			
$\text{UCL} = \overline{X} + A_2 \overline{R}$	R = 99.80 + 1.880 (
		Centerlin	$e = \overline{X} = 99.8$	0

Table 1-5 Temperature readings from a five-gallon tank of color developer

Charl of alterages: $UCL = \overline{X} + A_2\overline{R} = 99.80 + 1.880 (1.75) = 99.80 + 3.30 = 103.10$ $Centerline = \overline{X} = 99.80$ $LCL = \overline{X} - A_2\overline{R} = 99.80 - 1.880 (1.75) = 99.80 - 3.30 = 96.50$ *Chart of ranges:* $UCL = D_4\overline{R} = 3.267 (1.75) = 5.70$ $Centerline = \overline{R} = 1.75$ $LCL = D_4\overline{R} = 0 (1.75) - 0.00$

tremendous variation of temperatures within the tank. Some pieces of film will be developed at much higher temperatures than others within the same tank. The results most certainly would be unacceptable.

The successful application of \overline{X} and R charts rests greatly upon the method for selecting the subgroups. The subgroups should be chosen so that the variation between subgroups is comparable to the variation within the subgroup. If the variation within the subgroup is unusually small or unusually large, the estimate of \overline{R} that is obtained will be unreasonable and, therefore, all of the control limits will be inaccurate—either unrealistically narrow or wide. However, when the method for subgrouping is based upon thoughtful, rational decisions, there is no technique more powerful for the evaluation of a process.

1.12 Specifications and Naturally Determined Control Limits

Instructions for processing color film often call for maintaining the solution temperature at $100 \pm 1/4$ degree Fahrenheit and using development times at ± 15 seconds. These plus and minus values are referred to as specifications or tolerances. They represent the allowable error for the measurement being described; they have been derived from what someone says the process must do. It is hoped that they are given to help avoid unwanted problems; nevertheless, they are based upon what is *desired*. It is important that they be distinguished from the concept of control limits, which are derived from what the process is actually doing. For example, it may be desired that the temperature of the color developer be maintained at $100 \pm 1/4$, but the ability to achieve this is a different matter altogether. What happens in practice is best determined by taking some samples and plotting either a histogram or a time chart. If the variations appear to be chance caused, the calculation of the mean and the standard deviation will provide a good measure of what is actually occurring.

Suppose, for example, that a study of the temperatures in a tank of color developer produced a normal distribution with a mean of

1.12 Specifications and Naturally Determined Control Limits

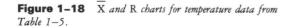

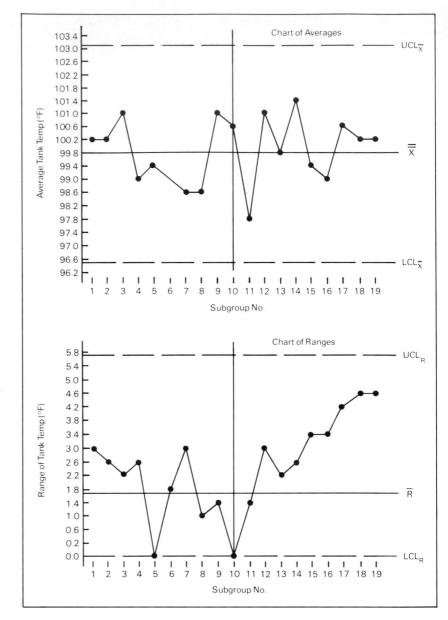

100.0 and a standard deviation of 1/4. Under these conditions, the developer temperature would lie between 100 1/4 and 99 3/4 about 68% of the time; between 100 1/2 and 99 1/2 about 95% of the time, and between 100 3/4 and 99 1/4 about 99.7% of the time. Consequently, this process would be out of specification approximately 32% of the time, with the upper spec at 100 1/4 and the lower spec at 99 3/4 ($100 \pm 1/4$). This is illustrated in Figure 1–19. Notice that the standard deviation would have to be considerably smaller than 1/4 for this process to meet the specifications most of the time. This example is also based on the assumption that the process mean was exactly at 100.0, which is an unlikely condition.

If the total tolerance for a process were exactly equal to a $\pm 3s$ spread, the process would meet specification about 99.7% of the time. Thus the best condition exists when the naturally occurring variation, as described by $\pm 3s$, is well within the specification limits. When the specification limits are within the $\pm 3s$ spread of a process,

1.13 Measurement Methods and Subjective Evaluations

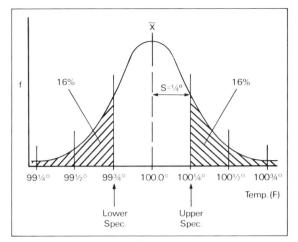

Figure 1–19 Normal distribution of temperatures with $\mathbf{X} = 100.00^{\circ}$ and $\mathbf{s} = 1/4^{\circ}$. Approximately 16% of the results will be below spec and 16% above spec, giving a total of JDN out of atom.

the specs will be exceeded a significant portion of the time by chance effects alone.

A convenient method for converting a set of specifications into an estimate of the standard deviation needed to meet them is to find the total tolerance and divide by 6. This approach assumes that the total tolerance would be equal to a ± 3 standard-deviation spread and that the process to be used is normally distributed with the process average set exactly on the aim value. Consequently, in the previous example, where the specifications were given as $100 \pm 1/4$, the total tolerance is equal to 1/2. Dividing this value by 6 gives 1/12. Thus the standard deviation needed for this process to be in spec most of the time is about 1/12.

Specifications are a necessary part of any set of directions because they indicate how closely the directions must be followed. To be told that a given piece of film should be developed for five minutes, for example, gives no indication of how accurate that measurement must be. The techniques used to time 5 minutes $\pm 1/2$ second would be considerably different from those used to obtain 5 minutes ± 30 seconds. When such tolerances are unavailable from the manufacturor's data, experiments should be done to determine them. Remember, whether or not a given process can meet these specifications is determined by the amount of variation actually occurring, not what is desired.

1.13 Measurement Methods and Subjective Evaluations

All the concepts addressed thus far have dealt with data resulting from objective measurements. Variables such as density, temperature, weight, and shutter speed are evaluated by using measuring instruments, and the results are expressed in relation to scales of numbers. These numbers are assigned on the basis of standardized units such as degrees Fahrenheit, centimeters, grams, etc. Such measurements are referred to as objective because they are derived from an external source (the measuring instrument) and are verifiable by other people using similar instruments.

Although objective measurements are commonly used to describe the physical properties of photographic materials and processes, they cannot be used to give information about the human perceptions of such properties. For example, when considering the tonal quality of a black-and-white print, reflection density measurements can be used to describe the print densities and contrast. However, these data will give little insight into the way a person would perceive the tonal quality of the print, as that is a subjective experience. Obviously, the subjective quality of the photographic image is the final test of most photographic endeavors, thus it can be extremely useful to learn the meaningful relationships between objective measurements and subjective perceptions.

When one works with subjective concepts, it is the perception of the physical event that is being considered rather than the physical event itself. Nevertheless, numbers may be assigned to these perceptions to allow for their scaling and evaluation. Measurement, in the broadest sense, can be defined as the assignment of numbers to objects, events, or perceptions according to rules. The fact that numbers can be assigned under different rules leads to the use of different kinds of scales. All measurement scales can be classified as one of the following.

1.13 Measurement Methods and Subjective Evaluations

1.13.1 Nominal Scale

Nominal scales are essentially categories that are labeled with names, as when photographs are placed into categories such as portrait, landscape, indoor scene, outdoor scene, etc. A nominal scale would also be obtained through the assigning of numbers to baseball players since the number serves as a name. This is the most primitive of measurement scales, and therefore such data are not very descriptive.

1.13.2 Ordinal Scale

Ordinal scales are those in which categories are ordered along some variable and numbers are used to represent the relative position of each category. When the results of a horse race are given as first, second, and third, an ordinal scale is being used. If photographs were rated according to their acceptability, the following ordinal scale could be used: (1) excellent, (2) acceptable, and (3) unacceptable. Notice that there is no attempt to indicate how much better (or worse) the images are, just as there is no distance differentiation made between the winner of a horse race and the runner-up. All that is expressed is the order of finish. This approach is often referred to as rank-order or, more simply, "ranking" and is frequently used for scaling subjective responses. The use of the graininess categories—extremely fine, very fine, fine, medium, moderately coarse, and coarse—constitutes an ordinal scale.

1.13.3 Interval Scale

An interval scale is a refinement of the ordinal scale whereby the numbers given to categories represent both the order of the categories and the magnitude of the differences between categories. Arithmetically equal differences on an interval scale represent equal differences in the property being measured. Therefore, such scales can be thought of as linear since they possess a simple, direct relationship to the object being measured. The Fahrenheit and Celsius temperature scales are excellent examples of interval scales; thus, a temperature of 80 F is midway between temperatures of 70 F and 90 F. The interval scale is truly a quantitative scale.

1.13.4 Ratio Scale

Numbers on ratio scales increase by a constant multiple rather than by a constant difference as with interval scales. Thus, with the ratio scale of numbers 1-2-4-8-16, etc., the multiplying factor is 2. Incident-light exposure meters that measure directly in lux of footcandles, and reflected-light exposure meters that measure directly in candelas per square meter or candelas per square foot, typically have ratio scales where each higher number represents a doubling of the light being measured. Some exposure meters use arbitrary numbers rather than actual light units on the measuring scale. If the arbitrary numbers are 1-2-3-4-5, etc., the scale is an interval scale.

Thus the type of scale is determined entirely by the progression of the numbers, and not by what the numbers represent. A meter could even have two sets of numbers on the same calibrated scale, one a ratio scale of light units and the other an interval scale of arbitrary numbers. Other examples of ratio scales are shutter speeds (1-1/2-1/4-1/8-1/15, etc.) where the factor is 2; f-numbers (f/2-2.8-4-5.6-8, etc.) where the factor is the square root of 2 or approximately 1.4, and ASA film speeds (100-125-160-200-250, etc.)where the factor is the cube root of 2 or approximately 1.26.

Interval scales of numbers are somewhat easier to work with than ratio scales, especially when the ratio-scale sequence is extended and the numbers become very large (e.g., 64—128—256—512—

1,024, etc.) or very small (but never reaching zero). Converting the numbers in a ratio scale to logarithms changes the ratio scale to an interval scale. For example, the ratio scale 10-100-1000-10,000 converted to logarithms becomes the interval scale 1-2-3-4. This simplification is a major reason why logarithms are used so commonly in photography, where density (log opacity) is used in preference to opacity, and log exposure is used in preference to exposure in constructing characteristic (D-log H) curves. DIN film speeds are logarithms and form an interval scale compared to ratio-scale ASA film speeds. The ISO film speed system uses dual scales (e.g., ISO $100/21^\circ$) where the first number is based on an arithmetic scale and the second is based on a logarithmic scale. The APEX exposure system is also based on logarithms to produce simple interval scales (1-2-3-4-5, etc.) for shutter speed, lens aperture, film speed, light, and exposure values.

1.13.5 Exponential Scale

In addition to the four types of scales discussed above nominal, ordinal, interval, and ratio—which cover all of the normal subjective measurement requirements related to visual perception and most of the objective measurements used in photography, there is another type of scale. The sequence of numbers 2-4-16-256, etc., is extended by squaring each number to obtain the next. This is called an exponential scale since each number is raised to the second power or has the exponent of 2.

Table 1-6 relates many types of photographic data to the appropriate measurement scale.

Type of Scale	Examples of Photographic Data
1. Nominal	A. Emulsion identification numbers.
	B. Classification of photographs into categories.
	C. Serial numbers on cameras.
	D. Social security numbers of famous photographers.
	E. Names of colors, such as red, green, and blue.
2. Ordinal	A. The scaling or grading of photographs along a rank order such
	as first, second, and third place or A, B, C, etc.
	B. The rating of the graininess of photographs using the categories microfine, extremely fine, very fine, fine, medium, moderately coarse, and coarse.
	C. The ordering of photographs along a continuum such as
	lightest to darkest, largest to smallest, flat to contrasty.
3. Interval	A. Temperature readings; degrees on a thermometer.
	B. Hue, value, and chroma numbers in the Munsell Color
	Notation System.
	C. Wavelength (nanometers) of electromagnetic radiation.
	D. Contrast index values.
í. Ratio	A. Shutter speeds.
	B. F-numbers.
	C. Exposures in a sensitometer.
	D. ISO/ASA film speeds.
5. Exponential ^a	A. Depth of field vs. object distance.
	B. Depth of field vs. focal length.
	C. Illuminance vs. distance from a source (inverse-square law).
	D Cosine law of light falloff in a camera.

 Table 1-6
 Types of measurement scales

"Although these represent exponential relationships, numbers are not normally presented in exponential scales due to the difficulty of interpolating.

1.14 Paired Comparisons

One of the most basic techniques for evaluating subjective judgment is to present the observer with two objects (for example, two photographic images) and require a choice to be made on the basis of a previously defined characteristic. The two alternatives may be presented simultaneously or successively, and no ties are permitted.

In its simplest application, this method is used to compare only two samples, but it can also be applied in experiments designed to make many comparisons within a multiple of samples. The results are expressed as the number of times each sample was preferred for all observers. If one of the two samples is selected a significantly greater percentage of the time, the assumption may be made that it is superior relative to the characteristic being evaluated.

For example, consider the problem of evaluating two blackand-white films for their graininess. Since graininess is a subjective concept (see Section 12.2), a test must be performed using visual judgment. The two films are exposed to the same test object and processed to give the same contrast. Enlargements are made from each negative to the same magnification on the same grade of paper. The two images are presented side by side and each observer is asked to choose the image with the finer grain. A minimum of 20 observers is usually needed to provide sufficient reliability for this type of experiment.

If the results of such an experiment are 10 to 10, then it is concluded that there is no difference between the two samples. But if the results are 20 to 0, it can be concluded that one of the images actually had finer grain. A problem arises with a score such as 12 to 8 because such a score could be the result of chance differences only. Thus the purpose of this test is to distinguish between differences due only to chance and those resulting from a true difference.

The conclusions from these tests must be based upon the probabilities of chance differences. Table 1-7 may serve as a guide for making such decisions. Column n refers to the number of observers. The columns titled Confidence Level identify the degree of confidence indicated when it is concluded that a true difference exists. The numbers in the body of the table give the maximum allowable number of times that the less frequent score may occur. Therefore, in this example where 20 observers were used, the less frequently selected photograph may be chosen only five times if 95% confidence is desired in concluding that a difference exists. If a higher level of confidence is desired, say 99%, then the less frequently selected photograph can be chosen only three times. Notice that a score of 12 to 8 would lead to the conclusion that there was no significant difference between the two images even at the lower 90% confidence level. The price that is paid to obtain greater confidence in the decision is that a greater difference must be shown between the two samples. If the number of observers were increased to 50, then only a 32-18 vote (or approximately a 2:1 ratio) would be needed. The increase in sample size provides greater sensitivity, which allows for better discrimination.

The paired comparison approach may be extended to include more than two samples or objects. If three or more objects are to be compared, the observer must be presented with all possible pairings. Again, a choice must be made each time. Such a method produces a rank order for the objects judged. This technique leads to the use of an ordinal scale of measurement.

 Table 1-7
 Maximum allowable number of wins for the less-frequently chosen object in a paired comparison test.

		Confidence Leve	el
n	90%	95%	99%
8	1	0	0
9	1	1	0
10	1	1	0
12	2	2	1
14	3	2	1
16	4	3	2
18	5	4	3
20	5	5	3
25	7	7	5
30	10	9	7
40	14	13	11
50	18	17	15
75	29	28	25
100	41	39	36

1.15 Test Conditions

labi	Table 1-8 Results from preference test.						
	Pair	Preference					
1.	A vs. B	В					
2.	A vs. C	С					
3.	A vs. D	A					
4.	B vs. C	В					
5.	B vs. D	В					
6.	C vs. D	С					

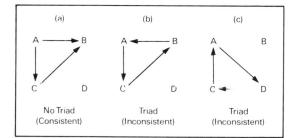

Figure 1–20 Location of triads (inconsistencies)

 Table 1-9
 Number of wins and rank order of preference test results

Number of Wins							
Α					1		
В					3		
С					2		
D					0		
	P0		C 2 Order al Scale)	B 			

Consider, for example, the same negative printed on four different brands of black-and-white paper; the desire is to determine which print looks best. The prints are identified by the letters A, B, C, and D. The observer is presented with all possible pairings and each time is asked to state a preference. With four prints there is a total of six possible pairings. The results of such a test are shown in Table 1-8.

Before the rankings can be determined it is necessary to find out if the observer's judgments were consistent. Inconsistency is shown by the presence of one or more triads in the results. These triads (or inconsistencies) can be located by arranging the letters in a triangle and connecting them with short straight lines as shown in Figure 1-20. In example A, when prints A and B were compared, B was preferred so an arrow is drawn toward B. When prints A and C were compared, C was preferred so an arrow is drawn toward C. Likewise, for prints B and C, B was chosen and the arrow points toward it. The resulting pattern illustrates a consistent set of judgments. If, however, the three arrows move in a clockwise or counterclockwise direction as seen in Figures 1-20B and C, an Inconsistency has been named. In Figure 1-20C for example, when prints A and C were compared, A was preferred, thus A is better than C. When prints A and D were compared. In order for judgments to be valid, they must be consistent. D was preferred; thus D is better than A. However, when prints C and D were compared, C was selected as being better, which is inconsistent with the earlier decisions.

Once a judge has been shown to be consistent, the rank order of preference can be determined. This is achieved simply by determining the number of times each print was selected. The data for this example are summarized in Table 1–9. The prints also may be located along a scale based upon their number of wins. In this example, print B was judged to be the best as it has the highest rank. Prints C, A, and D were the runners-up in that order. Thus simple statements of preference have been transformed into a rank order along an ordinal scale. In this example, only one observer was used; however, it would be possible to have many observers and average the results. Practically any subjective characteristic can be evaluated in this fashion.

1.15 Test Conditions

When performing subjective evaluations, perhaps the single greatest problem to overcome is the influence of the experimental conditions. It is critical that an observer's judgments be based only upon the properties of the objects being evaluated and not some outside factor such as a natural bias. For example, it is known that observers tend to prefer images placed on the left-hand side over images on the right. Also, images located above tend to be preferred over images placed below. In addition, there is a learning effect that occurs as a test continues. Consequently, images presented later in a test will be judged differently from those seen earlier, since the observer will be more experienced. The most common method for avoiding these difficulties is the randomizing of items; i.e., the item to be judged must not be viewed consistently in the same position in space or time. If true randomization is achieved, each item will have an equal chance of being chosen, and the choice will be primarily the result of the observer's opinion of the item's inherent qualities.

References

American National Standards Institute, Control Chart Method of Analyzing Data (ANSI Z1.2-1958, R1969).

- ——, Control Chart Method of Controlling Quality During Production (ANSI Z1.3–1958, R1969).
- —, Guide for Quality Control (ANSI Z1.1–1958, R1969).
- ——, Sampling Procedures and Tables for Inspection by Attributes (ANSI Z1.4–1971, Military Standard 105).
- Besterfield, Quality Control: A Practical Approach.
- Burr, Statistical Quality Control Methods.
- Conover, Practical Non-Parametric Statistics.

Duncan, Quality Control and Industrial Statistics. 3rd ed.

Eastman Kodak Company, Index to Process Monitoring Aids (Z-99A).

——, Addendum to Kodak Process Monitoring Aids (Z-99B).

- _____, The Crossover Procedure (Z-99C).
- ——, Monitoring System for Processing Kodak Ektachrome 40 and 160 Movie Films (Type A) in the Kodak Ektachrome Autoprocessor, Model 1 (Z-107).
- ——, Physical Quality Rating Program for Kodak Ektachrome Slide and Movie Films (Z-111).
- ——, Monitoring System for Processing Kodak Ektachrome Aerial Films, Process EA-5 (Z-113).
- ———, Physical Quality Reference Standards for Reversal Color Films (Z-117).
- ——, Using Process E-6 (includes monitoring procedures) (Z-119U).
- ——, Using Process C-41 (includes monitoring procedures) (Z-121).
 - ——, Using Kodak Ektaprint 2 Chemicals (includes monitoring procedures) (Z-122).
- ------, Using Kodak Ektaprint R-100 Chemicals (includes monitoring procedures) (Z-123).
 - —, Process Monitoring of Kodak Black-and-White Films (Z-126).
- Feigenbaum, Total Quality Control.

Freund, Statistics: A First Course.

Grant and Leavenworth, Statistical Quality Control.

Juran, Quality Control Handbook.

Juran and Gryna, Quality Planning and Analysis.

Knowler et al., Quality Control by Statistical Methods.

Ott, Process Quality Control.

Rickmers and Todd, Statistics, an Introduction.

Rochester Institute of Technology Technical Education Center, Quality Control: Application and Use in the Graphic Arts Industry, Vol. II.

Photographic Sensitometry

Figure 2–1 Black box model of approach to the photographic process.

Figure 2–2 Graphic model for a tone-reproduction study.

2.1 Introduction to Tone Reproduction

Photographers generally consider the images they produce as blending visual creativity with technical expertise. That these two elements are given equal attention is not surprising in view of the history of art and photography. The most successful and creative artists have generally not been limited by a lack of technical capability. Indeed, the ability to control the medium is an important trait among successful artists.

The study of sensitometry provides the necessary understanding of the technical characteristics of photographic films and papers. It deals with all aspects of the photographic process from the original subject to the finished image. Within that process are many steps and, consequently, many opportunities for control. In order to learn some of the fundamental conditions of black-and-white photography, the steps have been simplified to those shown in Figure 2–1. In this case it is assumed that the photographic process performs in a "black box" fashion and is always capable of technical excellence. Thus, attention may be focused on the properties of the subject and the resulting print In this lashion we can obtain an unswer to a question of the added by photographers: "How well were the tones in the scene reproduced in the print?"

Perhaps the most obvious way of answering this question is to return to the original scene with print in hand and make a subjective judgment. There are many problems with this approach, among them the transitory nature of most subjects and the lack of proper viewing conditions for the print. In addition, it is most difficult to obtain specific information with this method.

The alternative approach is to obtain objective data that are representative of the tones in the scene and the tones in the print. It is convenient to think of the subject tones as *input data* and the print tones as *output data*. Once these data are in hand, we can objectively describe the subject and the print, and then compare them. A graphical representation as shown in Figure 2-2 is appropriate. The shape of the resulting plot will indicate the tone-reproduction characteristics for this process.

To obtain objective data about the subject, we need some way of measuring the tones it contains. Subject tones in this context refer to those larger surface areas of the scene that are easily seen and are measurable, such as those of walls, floors, table tops, clothing, faces, etc. We might also think of these tonal values as lightness differences. In the photographic lexicon these are referred to as reflectances or reflected-light values. Areas of low lightness or reflectance are shadow tones, while those of high lightness are the highlight tones. The technical name for these reflected-light values is *luminance*, which is a measure of the intensity of the light per unit area. The basic unit of measurement is the candela per square foot. Therefore, the shadow areas have low luminance values while the highlights have high luminance values.

Most photoelectric meters are equipped to measure the subject luminances by using the meter in the reflected-light mode and pointing it at the area to be measured. The readings are usually in the form of arbitrary units that are proportional to the luminance in candelas per square floot. It is important that the **metur's angle** of niom he relatively narrow if small surface areas are to be measured. Special "spot" meters with angles of view as small as one degree are available.

2.1 Introduction to Tone Reproduction

If only two tones in the subject are measured, the darkest and the lightest, it is possible to determine the scene ratio by dividing the smaller into the larger. For example, if the shadows have a luminance of 2 candelas per square foot and the highlights have 200 candelas per square foot, the ratio would be 100:1. This means that the highlights are reflecting 100 times as much light as the shadows. The luminance ratio provides valuable information about the overall *contrast* of the scene. By measuring numerous outdoor scenes, the average luminance ratio was found to be approximately 160:1. Consequently, scenes with ratios close to this are referred to as *average* or normal in contrast. If the subject luminance ratio significantly exceeds 160:1, the scene has more than normal contrast and is referred to as a *contrasty* subject. Those subjects with a lower luminance ratio have less than normal contrast and are referred to as being *flat*.

Additionally, some intermediate tones can be measured to give data relative to the important midtone regions. No more than 8 to 10 measurements are necessary to give sufficient data about the larger tonal areas of the subject, with the two extreme values being the most important.

Since one of the purposes for studying the tone-reproduction characteristics of a photographic system is to judge its ability to make visually acceptable images, luminance data are usually transformed into logarithms. The reason for using logarithms is associated with the nature of the human visual system. Experimental evidence indicates that the visual process responds in a nearly logarithmic fashion. Therefore, by taking the logarithms of the subject luminances we have subject (input) data that correspond to the appearance of the scene. Table 2-1 illustrates the relationship between the subject luminances and subject log luminances for a variety of scene contrasts. The methods for finding the logarithm of a number and the antilog (arithmetic value) of a logarithm are addressed in the Appendix. Nevertheless, as shown in Table 2-1, the shadow tones invariably have smaller luminances than the highlights.

An alternative method for obtaining input data about the subject is to use a *reflection gray scale* as a standardized reference. A gray scale is nothing more than an organized set of subject tones conveniently displayed with known tonal values. These tonal values have been premeasured on a reflection densitometer, and the values shown are reflection densities. Most gray scales have a total luminance ratio of approximately 100:1 and, therefore, are close to being representative of average outdoor scenes. As input data, the only significant difference between gray-scale data and subject log luminance values is that the numbers run opposite to each other. This is because reflection density is a measure of the amount of darkening occurring in an image, while luminance is a measure of the amount of light emanating from a surface. Therefore the two concepts are reciprocally related. Although the con-

 Table 2-1
 Relationship between subject luminance ratios and log subject luminance ranges.

Shadow Luminance	Highlight Luminance	Subject Luminance Ratio	Log Subject Luminance Range
2 c/ft ²	200 c/ft ²	100:1	2.0
0.5 ″	500 ″	1000:1	3.0
3 ″	600 ″	200:1	2.3
2 ″	100 ″	50:1	1.7
2.5 "	350 "	160:1	2.2
5 ″	100 ″	20:1	1.3

Figure 2-3 Numerical values for input and output

Figure 2-4 Theoretically ideal (facsimile) tone reproduction.

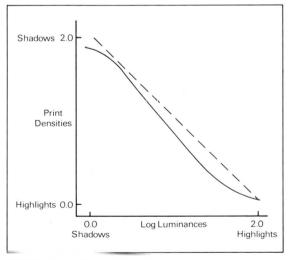

Figure 2-5 Preferred (uim) tone reproduction currie (pictorial subject).

cept of density will be addressed in detail later, it is important to note that the reflection densities of the gray scale are themselves logarithms, since, by definition, reflection density is the logarithm of the reciprocal of the reflectance.

When seeking how to obtain objective output data about a print, the obvious answer is again the use of a reflection densitometer. With this instrument, we measure the same tonal areas of the print that were measured in the scene. If a gray scale were included in the scene, the measurements would be taken from the reproduction of it in the print. Since density is a logarithmic concept, the resulting data will automatically be in logarithmic form. Thus both the input and the output data are logarithmic values.

We are about ready now to undertake a tone-reproduction study. The sequence of events is as follows:

- 1. Obtain input data by measuring subject luminances OR include a gray scale.
- 2. Expose and process the film normally and make a print.
- **3.** Obtain output data by measuring the reflection densities on the prime.
- 4. Compare the print with the subject by plotting the input-output relationship (i.e., a tone-reproduction graph).

The graphic framework of Figure 2-2 can be labeled and numbered in line with the previous discussion as shown in Figure 2-3. The shadows will be plotted in the upper left portion of the graph while the highlights will plot in the lower right. Regardless of whether gray-scale data or subject log luminances are used as input, the shadows are plotted on the left side and the highlights on the right.

Before we examine what the process is actually capable of producing, let's hypothesize about the ideal possibilities. One way to think of an ideal reproduction is to consider a print where the tones exactly match those in the scene. Such a result might be more accurately labeled a facsimile reproduction. This is represented in a tonereproduction graph in Figure 2-4. The 45° line indicates that for every tone in the subject there is a matching tone in the print, and that the tonal differences of the subject have been exactly maintained in the print. In pictorial photographic systems, this condition is impossible to achieve because of the tonal distortions introduced by the camera optics, film, enlarger optics, and paper. Therefore a literal translation of subject to print is unobtainable in pictorial photography. In fact, even if facsimile reproduction were possible, experiments indicate that viewers would not prefer it. It is important to note, then, the difference between an ideal reproduction and a preferred reproduction. Obviously, we are more interested in making prints that are preferred.

Figure 2–5 shows the typical tone-reproduction curve resulting when the photographic process is run so that it produces a pictorial print that is judged excellent by a large number of people. Notice that the shape is decidedly different from the 45° line that has been drawn in for reference. In general, where the slope is less than the 45° line there is a compression of tones, and where the slope is greater than 45° there is an expansion of tones. Figure 2–5 indicates that the shadow tones have been somewhat compressed. This is not to say that the reproduction is unusual or abnormal but merely that the photographic process contains some inescapable nonlinear characteristics that do not eliminate the possibility of excellent results.

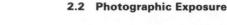

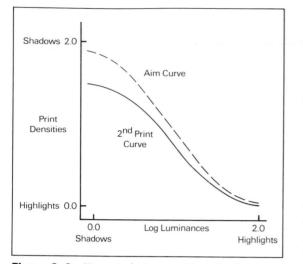

Figure 2-6 Tone reproduction curves for preferred and inferior prints.

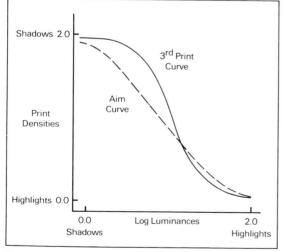

Figure 2–7 Tone-reproduction curves for preferred and inferior prints.

Notice that the tone-reproduction curve in Figure 2–5 does not reach higher than a print (output) density of 2.0. This illustrates an unavoidable limitation in the photographic process when the end product is a reflection print. Black-and-white photographic papers cannot exceed an output density range of much more than 2.1, or a little greater than a 100:1 ratio. Therefore, the contrast of subjects with luminance ratios greater than 100:1 will necessarily suffer tonal compression in the reproduction. This limitation is primarily the result of first surface reflections of the light illuminating the print and so is not greatly different between papers of similar surface characteristics.

The curve shown in Figure 2–5 is associated with a print that a large number of observers would categorize as excellent. Consequently, it is referred to as the *preferred* (or *aim*) curve because we strive to match it through the system we employ. The preferred curve has been included in Figure 2–6 for comparison. The second print shows less slope in the shadows and midtones than the aim curve, which indicates that there is too much compression of the tones in these regions. In other words, the second print is lacking in contrast in the shadows and midtones and, in the photographer's vocabulary, would be called a flat print. Notice that the curve was compared to the aim curve and *not* the 45° line.

The tone-reproduction curve for a third print is illustrated in Figure 2–7. Again the aim curve has been included for comparison. The highlight region appears to match closely the aim curve, indicating proper highlight reproduction. However, the midtone slope is considerably steeper than that of the aim, indicating that the midtones have excessive contrast. The shadow region is characterized by a very low slope (practically zero), indicating little or no separation of tone or detail. Most photographers would label this a contrasty print, but notice that it is only the midtones that are contrasty. Indeed, the shadow region would be called flat because of the lack of detail. This leads to an important generalization regarding the interpretation of tonereproduction curves: rather than judge overall print quality, evaluate shadow, midtone and highlight reproduction separately.

Although we have characterized the second and third prints as inferior to the first, it should be realized that the judgments relate only to the separation of tones in the larger surface areas. Tonereproduction graphs will not tell you whether you will like the print. This is a matter of individual taste and preference, which cannot be addressed objectively. However, it does allow for the meaningful evaluation of print quality for photographs based upon a reference derived from a majority opinion of excellence. By having some understanding of what we are aiming for in tone reproduction (i.e., print quality), the steps in the photographic process will make more sense. We shall now consider those steps.

2.2 Photographic Exposure

When a camera is focused on a subject and the shutter is opened, a variety of light levels fall on the image plane at the back of the camera. In the shadow areas the level of light will be quite low; for the highlights the level will be great. In fact, for every different subject tone (luminance) there will be a different light level in the image at the film plane. These light levels are referred to as *illuminances* since we are dealing with the light incident on the film plane, as opposed to luminances, which are related to the light reflected from subject surfaces. In effect, the subject luminances in front of the camera become image illuminances at the back of the camera. The camera's shutter speed determines the length of time the image light will be allowed to fall on the film.

In photographic applications, the term exposure(H) is defined as a measure of the quantity of light received by the photographic material. Two variables define this quantity. The first is the illuminance (E), the level of light falling on the surface. This concept is expressed in meter-candles (an equivalent term is *lux*), with 1 meter-candle being equal to the amount of light falling on a point 1 meter away from a 1-candlepower source. The second variable is the length of time (symbol T) the illuminance is allowed to fall on the film, and is expressed in seconds. Consequently, exposure is expressed in meter-candle-seconds (or lux-seconds) and is calculated by the formula $H = E \times T$. For example, a gray card registering an illuminance on the film plane of 2 meter-candles photographed at a shutter speed of 1/100 second would are an emposure of U.U.I mater could be second (1/100-37 % 11 (12) In many references the formula is given as: $E = I \times T$, where E is the symbol used for exposure, I for illuminance, and T for time. However, in 1972 the symbols were changed to those given first, for the purpose of international standardization. The relationship remains the same.

In most ordinary picture-making situations, using this definition, the film receives a multitude of exposures each time the shutter is tripped, with each different exposure related to a different subject tone. It is also important to note that expressing exposure as a combination of camera settings, such as 1/60 at f/11, is not consistent with the accepted definition. In fact, if only the shutter speed and aperture are known, it is impossible to determine the exposure the film received because the image illuminance values are missing. In practice, a photoelectric meter is typically used to measure the subject luminance, and the meter converts the input to an f-number-shutter speed combination that is appropriate for the film being used.

When testing a photographic emulsion to determine its sensitometric characteristics, it is necessary to make an accurately known set of exposures. Although cameras are the principal instruments used to expose film in practice, they are not the best choice for film-testing purposes. If the film is to receive a set of known exposures, the illuminances and times must in turn be known, since the exposure will be calculated from them. Because of light falloff and flare problems at the back of the camera, it is most difficult (if not impossible) to calculate accurate illuminance values from subject luminances and the f-number. Although some large-format cameras can be equipped with a meter having a probe to make readings of small areas, the illumination is never uniform at the film plane. Additionally, the shutter speeds marked on most cameras may not correlate closely with the actual exposure times. Unless the shutter has been pretested and found to be consistent and accurate, reliable information about the exposure time will not be obtained. Devices specifically designed to expose film for testing purposes are called sensitometers.

A sensitometer consists of three major parts as shown in Figure 2-8: a suitable light source, a step tablet, and a shutter. Sensitometers and cameras are similar in that they are both used to expose film. A sensitometer, however, has its own light source and subject

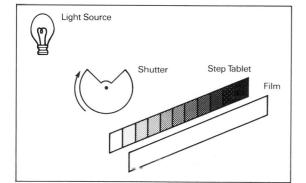

Figure 2-8 The major parts of a sensitometer.

(step tablet). Because a sensitometer is not a camera and is not a direct part of the picture-making process, great care is taken so that it simulates actual picture-making conditions. For example, the light source is chosen so that the color of light it produces matches that which is used in reality. Since the most commonly encountered light is daylight, sensitometric light sources that approximate its color quality are used. Usually, a tungsten lamp with appropriate filtration is used because it can be precisely calibrated and is very stable over its lifetime. Some sensitometers make use of a xenon-filled flashtube (electronic-flash) source, which does not require filtration since its spectral output already is close to the color of daylight. Whatever source is used, the illumination reaching the film plane is very uniform and can be measured easily.

The step tablet serves as the subject for the sensitometer. Its purpose is to convert the single level of light produced by the lamp into many different levels or illuminances. This simulates the condition in the camera where the film receives varying illuminances due to the tonal differences in the scene. A step tablet is a series of calibrated filters with uniform density increments, which may be made by incorporating particles of carbon in gelatin and copying them onto photographic film. Such transmission density step tablets can be purchased in a variety of sizes and formats. The most commonly used step tablet varies in density from approximately 0.10 to 3.10. When such a tablet is placed in the light path, the light will be attenuated over a log range of 3.0 (3.10 - 0.10 = 3.00). Since densities are logarithmic values, the illuminances reaching the film plane will have a log range of 3.0. By taking the antilog of 3.0, we find that the ratio of illuminances will be 1000:1, which means that the highest illuminance is 1,000 times that of the lowest illuminance. Therefore, with such a step tablet in the sensitometer, the film will receive a ratio of illuminances far greater than that typically encountered in the camera, which is desirable for testing purposes.

If the tablet contains 11 different equally spaced steps, there will be 10 increments or intervals. Since the total density range is 3.0, the step-to-step difference can be determined by dividing 3.0 by 10, giving 0.30. This means that the steps get progressively denser in 0.30 increments. The antilog of 0.30 is 2, indicating a 2X factor change between successive steps (recalling that addition of logs corresponds to multiplication of antilogs). The step-to-step exposure change is equivalent to one stop, and the entire range covered is equal to 10 stops.

If a one-stop exposure change between steps is too large, a 21-step tablet may be used. It has 20 increments over the 3.0 range yielding a step-to-step density difference of 0.15, or exactly half that of the previous tablet. The result is a one-half stop change in exposure between successive steps, yet still covering a 10-stop range. Regardless of which tablet is used, the light-stopping abilities (densities) of the steps can be measured and, therefore, the illuminance on the film behind each patch accurately known. It is necessary to note here that the step tablet should be as neutral as possible to avoid altering the color of the exposing light. Although step tablets made on photographic film are not entirely neutral, they are sufficiently so for most nonstandard testing.

The shutter in a sensitometer performs the same task as the one in the camera: to control the length of time for which the light will strike the film. The shutter in a sensitometer usually is powered by a synchronous motor that operates in a repeatable fashion. A variety of exposure times can be achieved by using differing gear ratios and slit sizes. The actual exposure time should be representative of the times used in practice. Theoretically, any combination of illuminance and time giving equal numerical exposures could be used if the emulsion response depended only on the total light received. Because the film responds differently to long and very short exposure times, an effect identified as reciprocity law failure, an appropriate shutter speed must be selected to avoid the effect or an exposure adjustment will be needed. Where the exposing source is a xenon flashtube, the flash duration governs the length of exposure time.

For the most part, photographers do not own or have access to sensitometers. Therefore, the use of a camera for sensitometrically testing film is often unavoidable. In this case a reflection gray scale may be photographed and used as a test object. As seen earlier, reflection gray scales contain tonal values conveniently displayed from light to dark, and they are probably the most common test objects used in photography. Commercially available gray scales have a density range of approximately 2.0, which means a luminance ratio of 100:1 or about seven stops from the lightest to the darkest patch. The actual log values (reflection densities) are usually marked for each patch. If the gray scale her 10 different parches, then the film will receive 10 different exposures when the shutter is tripped.

This approach to sensitometry invariably leads to less precision in the resulting data for many reasons. First, when the gray scale is photographed, a nonlinear error is introduced as a result of optical flare in the camera, and there is a lack of image illuminance uniformity due to light falloff toward the corners. Further, the lighting of the original gray scale must be uniform and arranged to prevent reflections, including the subtle uniform reflections of light-colored walls or ceilings.

2.3 Processing

After the film has been properly exposed, the next major step is to process the image. The most important phase of the processing operation is the development step. When exposed film is developed, the latent image is amplified by as much as 10 million to 1 billion times. It is this tremendous amplification ability that makes the silver halide system of photography so attractive, where even weak exposures can yield usable images. The result is a system with great sensitivity or, in the photographer's vocabulary, a *fast* film.

Of the four major factors in development—time, temperature, developer composition, and agitation—the last is the most difficult to standardize. The temperature of processing baths can be maintained at a constant level to an accuracy of $\pm 1/10^{\circ}$ F. The use of a reliable timer allows the length of development time to be controlled to within a few seconds. Prepackaged chemicals have considerably reduced the problems involved in consistent developer composition. Proper agitation is difficult to achieve because, as we will see, there are at least two functions it must serve, and it must be different for different systems.

One of the critical problems in the development of the latent image to metallic silver is obtaining uniform density in uniformly exposed large and small areas. Variations of density in uniformly exposed areas are usually damaging to image quality and are almost always due to nonuniform development. Proper agitation of the developing solution

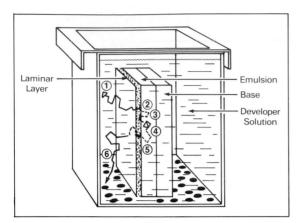

Figure 2–9 Stagnant tank (zero-agitation) development. The numbers correspond to the sequence of events described in the text.

is the best safeguard of uniformity. Let us examine the effects of developing film with a total lack of agitation. Figure 2–9 illustrates such a "stagnant tank" condition. The sequence of events is as follows:

- **1.** As the emulsion is immersed, the molecules of developer move around the tank in random fashion.
- **2.** Since the concentration of developing agent is high in the developer and low in the emulsion, a transfer of the developing agent into the emulsion occurs. This transfer is called diffusion.
- **3.** As the developing agent continues to diffuse into the emulsion it becomes attached to silver halide crystals.
- **4.** If the crystals have received an exposure to light, a chemical reaction occurs that produces metallic silver (the image) and developer reaction byproducts.
- **5.** The developer reaction byproducts diffuse through and eventually out of the emulsion and into the developer solution.
- 6. Since some of these byproducts are heavier than the developer solution, they tend to drift downward and collect on the bottom of the tank, creating an exhausted layer of developer.

Notice that the physical activity is completely based on the process of diffusion; diffusion of developing agents into the emulsion, and diffusion of development byproducts out of the emulsion. Clearly, agitation can have nothing directly to do with this process of diffusion, a random molecular activity determined by the temperature and alkalinity of the developer, among other things.

We attempt to control the concentration of chemicals at the emulsion surface by agitation. There is always a relatively undisturbed thin layer of developer lying on the surface of the emulsion that is essentially stuck to the gelatin. This layer acts as a barrier, and as it becomes thicker, the process of diffusion is slowed. This explains why development times must be extended when little or no agitation is used during processing. Because this barrier (sometimes referred to as laminar) layer is not the same thickness everywhere, it explains why improper agitation typically leads to uneven densities in uniformly exposed areas. In order for the barrier layer to be minimized, the fresh developer must make contact with the emulsion with a fair degree of force. Consequently, excellent agitation is characterized by vigorousness.

An additional function of agitation is to maintain the uniformity of the processing solution's chemical composition and temperature. Since the development byproducts tend to settle to the bottom of the tank, the agitational motions used should produce a random mix of both fresh and exhausted developer. With this achieved, every part of the emulsion will have access to developer of the same composition. This is why it is generally not desirable to agitate film in a tray or tank in the same direction every time. The result of such nonrandom, directional movement is a lack of uniformity in the image.

None of the agitation methods commonly used completely meet the requirements of vigor and randomness due to factors such as cost, productivity, and ease of operation. The test of proper agitation ultimately rests with the type of image quality desired. In most cases, the typically used methods of tray, tank, and machine processing give acceptable results. However, when problems occur, most likely they are the result of deficiencies in one or both of these two characteristics: vigor and randomness.

One final thought: Your processing method (developer formula, time, temperature, and agitation) is unique to you. Although you may be following a set of recommended procedures, fundamental styles of working are different for each individual. Indeed, as seen in an earlier chapter, the laws of variability tell us that no two persons can operate in identical ways. Consequently, you must follow your usual processing technique when testing the sensitometric properties of emulsions. To the extent that you handle the test images differently than you do your pictorial images, the data will have less validity. This is in part why the manufacturer's recommendations represent only a starting point for your work. You can be sure that the methods employed by the manufacturer are not identical to the ones you use.

There are various methods for processing photographic films and papers, each with strengths and weaknesses. Some of the more commonly encountered techniques are illustrated in Figure 2-10 and summarized below:

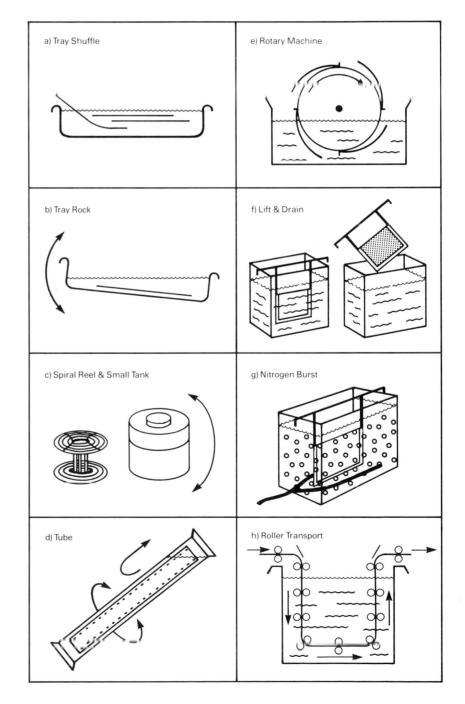

Figure 2–10 Methods of agitation.

- A. Tray shuffling of sheet film and paper. As shown in Figure 2-10A, the sheets are immersed in the solution and then shuffled from bottom to top by hand. Although this method provides good agitation, damage to the emulsion can easily result from the handling. Presoaking the sheets in water can help decrease the tendency for them to stick together.
- **B.** *Tray rocking* of sheet film and paper. Here, the sheets lie flat and rigid in the bottom of the tray and the agitation occurs through rocking the tray. The sheets can either be taped to the tray (emulsion side up) or slid under retainers that hold down the corners. Vigorous and random agitation can result if care is taken to avoid directional patterns that occur when the tray is lifted from the same side each time. The main drawback to this method is the limited number of sheets that can be accommodated at a time.
- C. Spiral reel and tank for roll film. The film is wound on a reel and placed in a small tank; some tanks hold as many as five reels. The tanks are light tight, so once the lid is on the processing may be done under white lights. The solution is poured through a lighttrapped opening in the lid and the agitation occurs by lifting and tilting the tank and moving it in a swirling pattern. Some tanks have a spindle that fits through the lid into the reel, so that the film is agitated by spinning the reel. The tanks that can be inverted can provide good agitation with the proper technique. The most commonly encountered problem with this method is the unevenness of density that can occur at the sprocket holes in 35mm film. If the agitation is too vigorous or continuous, the developer flows rapidly through the holes and edge of the reel, causing a localized unevenness of agitation and the resulting variation in density. In tanks with only a spindle for movement of the film, the agitation is weak and highly directional, which can result in streaks.
- **D.** *Tube rocking* for roll film. The film's entire length is inserted into a long, narrow tube, similar to those used to hold golf clubs in a bag. Each end of the tube is capped with a rubber stopper. After the film is loaded, solution is poured in one end, not quite filling the tube, which is then stoppered. Agitation occurs by gently rocking the tube, allowing the air bubble to move from one end to the other and the solution to flow over the film surface. This method of processing roll film provides vigorous agitation and eliminates the sprocket-hole problem referred to above, resulting in very uniform density levels. The primary weaknesses are that greater amounts of solution are required than in a small tank, and a limited number of rolls can be processed at one time.
- **E.** Drum rotation for sheets or rolls. The film is affixed to the exterior of a drum, emulsion side out, and the drum is placed in a trough. The solution partially fills the trough and the drum is rotated through it, picking up solution as it turns. Although somewhat directional, such a method gives very uniform agitation and requires only small amounts of solution. Rolls of film also may be wound around the drum spirally and processed in a similar manner. If the drum and trough are large, this method is highly productive, compared to the previous methods. With another type of drum the film is placed inside, emulsion side in. As the drum is rotated, the film moves through the pool of developer at the bottom.
- **F.** Lift and drain in tanks. Sheet film is loaded into film hangers and roll film onto spiral reels and stacked on a spindle. The hangers and/or reels are lowered into the solution in the tank. With deep

tanks, roll film can be suspended from one end (with a weight attached to the other end). Agitation occurs by lifting the film out of the developer, allowing it to drain, and returning it to the tank. Although this approach is simple and gives relatively high productivity, the low level of agitation can lead to bromide streaks (see Section 2.38). As with all forms of manual agitation, operator variability can be a significant source of nonuniformity.

- **G.** Nitrogen burst. The film is stationary in the solution and agitation is provided by gas bubbles rising from the bottom of the tank. The nitrogen, which has no chemical effect on the developer, is intermittently released at the bottom of the tank through a series of perforated tubes. The pressure with which the nitrogen is released and the spacing of the holes and perforated tubes control the bubble pattern. This system provides quite vigorous and uniform agitation when operating properly. Occasionally, the perforations in the distributing tubes become plugged, leading to uneven bubbling patterns and nonuniformity in the resulting tubes.
- **H.** *Roller transport.* Both sheet and roll film are transported and squeegeed by a series of rollers. This method is the basis of many automatic machine processors and provides very high productivity. The agitation provided by the squeezing effect of the rollers and the movement of the film through the solution create vigorous agitation. However, such a design may produce directional effects and involves a large capital expenditure.

Uniformity of development, either within a given piece of film or between sheets or rolls of film, and for any of the methods, depends to a considerable extent on the degree of development. As the degree is increased and gamma infinity is approached, variations in time, temperature, and agitation have a decreased effect on image density and contrast. Thus it is more difficult to obtain uniform and consistent development of films that are developed to a low contrast index (as when photographing high-contrast scenes) than when developing to a higher contrast index. Since photographic papers and lithographic films are processed in high-activity developers and reach gamma infinity quickly, uniformity of development is less of a problem with these materials.

2.4 Density Measurement

The most common method for determining the effect of exposure and processing on a sensitometric strip is to measure its lightstopping ability. Such information, properly collected, will give excellent insight into the visual and printing characteristics of the image. When light strikes a photographic film image, some of it is reflected backwards, some is absorbed by the black grains of silver, and some is scattered (i.e., has its angle of travel changed) as a result of bouncing off grains. This is illustrated in Figure 2–11. The light-stopping ability of a silver photographic image is determined by a combination of these three optical occurrences. Notice that the light transmitted through the sample is distributed over a wide angle primarily as a result of the bouncing or scattering effect of the silver grains. For the present, we will consider only the amount of transmitted light in relation to the amount of incident light on the sample.

Figure 2–11 Distribution of transmitted light rays caused by light scattering.

2.4 Density Measurement

Basically, the transmittance (T) of a sample is the ratio of the transmitted light to that which is incident. Therefore:

Transmittance
$$(T) = \frac{\text{Transmitted light}}{\text{Incident light}}$$
.

Consider, for example, the situation in Figure 2–12 where there are 100 units of light incident on the sample and 50 units are transmitted. Thus the transmittance (T) = 50/100, which is 0.50 or $\frac{1}{2}$ or 50%. While this approach seems logical and direct, the disadvantage is that the number (transmittance) describing light-stopping ability becomes smaller as the light-stopping ability increases. For samples where the light-stopping ability is great, the transmittance is small.

To overcome this shortcoming, we can calculate the opacity (0) of a sample, which is the ratio of incident light to transmitted light, and thus a reciprocal of the transmittance. The formula is:

Opacity (O) =
$$\frac{\text{Incident light}}{\text{Transmitted light}}$$
 OR Opacity = $\frac{1}{T}$.

In the example shown in Figure 2–12, the opacity (0) = 100/50, or 2. Because opacity is the reciprocal of transmittance, the numbers denoting an image's light-stopping ability will increase as that ability increases, providing a more logical relationship. However, the potential awkwardness of opacity is revealed when considering the effects of equal increases in light stopping ability:

	Light-Stopping Ability	
(Expressed in Thickness of		
Sample)	Opacity/	Increments
1	2	
		> 2
2	4	
		> 4
3	8	
		> 8
4	16	
		>16
5	32	

Notice that as the thickness of the sample increases (and therefore, the light-stopping ability) in equal amounts by adding one sample atop another, the differences between the opacities are unequal as they become progressively greater. The opacities form a geometric (ratio) progression that becomes inconveniently large as the light-stopping ability increases. For example, ten thicknesses would give an opacity of 1,024.

To compensate for this problem there is yet a third expression of the photographic effect called *density*. Density (D) is defined as the logarithm of the opacity. Thus:

Density (D) = log of opacity OR Density = log of
$$\frac{1}{\tau}$$
.

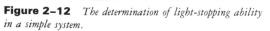

The density of the sample in Figure 2-12 is found as the log of 2, or

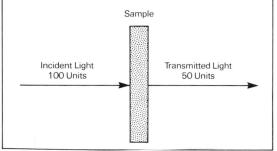

Opacity/Increments	Density/Increments
2	0.30
> 2	>0.30
4	0.60
> 4	>0.30
8	0.90
> 8	>0.30
16	1.20
> 16	>0.30
32	1.50

0.30. Extending the work from the previous table, the densities of the samples are:

The concept of density provides us with a numerical description of the image that is directly proportional to the amount of actual light-stopping ability. An added benefit is that, as stated earlier, the visual system has a nearly logarithmic response, so our data will bear a relationship to the image's appearance.

Now that we have considered expressions of the image's light-stopping ability, let us turn our attention to the practical problems of actually measuring the effect. Of the *conditions* of measurement, two are most important.

The first difficulty involves the measurement of the transmitted light. As shown in Figure 2–11, transmitted light rays form a distribution as a result of bouncing off the silver grains. This distribution of transmitted light will be wider for coarse-grained images than for fine grained images because the larger grain size provides a greater surface area over which the bouncing can occur. Consequently, coarse-grained images scatter more light than fine-grained images.

Regardless of the grain size, the basic question is: Where should the measurement of transmitted light be made? If, as shown in Figure 2–13, the receptor is placed far from the sample, only light transmitted over a very narrow angle will be recorded; this is called *specular* measurement. Alternatively, when the receptor is placed in contact with the sample, all the transmitted light will be collected, with the angle of collection being very large; this is referred to as a *diffuse* measurement. The specular density will be different from the diffuse density taken from the same sample.

For the companies that design and manufacture densitometers this difference between specular and diffuse density is a major concern, as it is for those who hope to apply their test results to a real picture-making situation. The answer lies in the principle that the testing conditions should simulate those used in practice. Therefore, if the negative is to be printed on a contact printer where the receptor (photographic paper) is in direct contact with the image, then the densitometer to be used should be similarly designed. For those negatives to be projection printed, the receptor will be far from the image, which indicates the opposite condition. These conditions represent extremes from very diffuse to very specular. Almost all commercially available densitometers are designed to provide an intermediate result termed a *diffuse density* (as opposed to double diffuse density).

It is important to realize that density measurements may come from an instrument that does not exactly simulate the particular photographic system being used. Trial and error is usually necessary to determine the appropriateness of the data. The relationship between

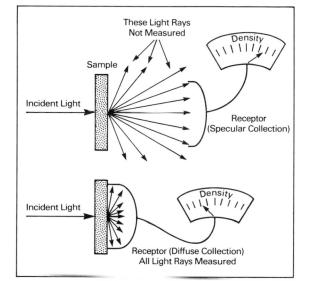

Figure 2–13 Two different conditions for measuring transmitted light.

the diffuse density and the specular density for a given sample may be determined and is called the Callier Coefficient or Q factor. Therefore:

 $Q = \frac{\text{Specular density}}{\text{Diffuse density}}$

Although an understanding of the relationship between specular and diffuse density is necessary, the actual determination of Q is difficult because it is affected by many variables such as density level, grain size, and development conditions. In practice, different photographic systems will have different Q factors; and if the sensitometric results are to be successfully applied, these factors should be at least approximately known.

The second problem associated with the actual conditions of density measurement is the color response of the densitometer. Photocells are typically used in densitometers to sense the light being transmitted. The color-response characteristics of all photocells are not alike. Further, the color response of most photocells is unlike that of photographic printing papers. This would not be a significant problem if all the images being measured were perfectly neutral. However, we often measure negatives that are decidedly non-neutral as a result of using a fine-grain developer, a staining developer, or some after-treatment of the negative. Indeed, when measuring the densities of color negatives, we never encounter neutral images.

At this point it is appropriate to ask: How will the densities be used? If the purpose is to predict the printing characteristics of a negative, the spectral response characteristics of the printing paper sl ould be simulated. To determine the visual appearance of the image, the spectral response of the human eye should be simulated. In the first case the result is called a *printing density*, in the second a *visual density*. These may be achieved by using certain filters in conjunction with the photocells. All commercially available densitometers are equipped to read visual density (sometimes referred to as black-and-white density). Only those specially equipped with the proper filters will read printing densities.

Modern solid-state photoelectric densitometers are excellent measuring devices capable of reading densities over a wide range with a high degree of accuracy. No matter how sophisticated the instrument may be, however, if the conditions of measurement do not simulate the photographic system being used, the resulting data will lack validity.

2.5 Characteristic Curves

In order to evaluate and understand the results of a sensitometric test, it is necessary to plot the densities occurring on the test strip in relation to the exposures that were received. The data contained in Table 2–2 illustrate the relationship between the input (exposure) data and output (density) data for a sensitometric test of a typical blackand-white negative film. It can be seen that each of the 11 densities produced is the result of a known exposure. The input data are given as both exposure and log exposure. When graphing the relationship, log exposure is used in preference to actual exposure to describe the input values because it tends to conveniently compress the input scale. The use of a logarithmic scale also makes it easier to determine exposure ratios, which are an important part of the evaluation process. Table 2–

2.5 Characteristic Curves

Density of the Original Step Tablet	Actual Exposure (H) (lux-sec.)	Actual Log H	Relative Log H	Step Number	Densities of the Resulting Strip
3.10	0.0064	3.80	0.00	1	0.18
2.80	0.0128	2.10	0.30	2	0.25
2.50	0.0256	2.40	0.60	3	0.39
2.20	0.0512	2.70	0.90	4	0.54
1.90	0.1024	1.00	1.20	5	0.78
1.60	0.2048	1.30	1.50	6	1.03
1.30	0.4096	1.60	1.80	7	1.28
1.00	0.8192	1.90	2.10	8	1.55
0.70	1.6384	0.20	2.40	9	1.73
0.40	3.2768	0.50	2.70	10	1.83
0.10	6.5536	0.80	3.00	11	1.85

Table 2-2 Relationship between exposure, log exposure, and the resulting density in a set of sensitometric exposures.

2 shows that exposures less than 1.0 lux-second are described by negative logarithms. Although the use of logarithms is addressed in the Appendix, it should be noted that negative logs are frequently encountered in achiever because the higher sensitivity of modern-day emulsions requires only small amounts of exposure to yield image density. Consequently, sensitometric exposures of less than 1.0 luxsecond are common.

Notice in Table 2–2 that the differences in log exposure are 0.30 each, which is the result of using an 11-step tablet containing step-to-step density differences of 0.30. When plotting the data, actual log exposures or relative log exposures may be used as input data, depending upon what is known about the exposure conditions. The resulting graph will show log (or relative log) exposure on the horizontal axis as input and density on the vertical axis as output. Such a plot is referred to as a *characteristic curve* or D-log H curve. Older references call it the H&D curve after Hurter and Driffield, who first described the technique in the late 1800s, and later the D-log E curve. Figure 2–14 shows the curve resulting from a plot of the data in Table 2–2.

The curve in Figure 2-14 is typical of negative-working camera films. It can be conveniently divided into four major sections as follows:

- **A.** Base plus fog: This is the area to the left of point A and is the combination of the density of the emulsion support (base) and the density arising from the development of some unexposed silver halide crystals (fog). Here the curve is horizontal and incapable of recording subject detail or tonal differences.
- **B.** *Toe.* This is the section between points *A* and *B* and is characterized by low density and constantly increasing slope as exposure increases. Different subject tones will be reproduced as small density differences. It is in this area that shadow detail in the subject is normally placed.
- **C.** Straight line. This portion, extending from point B to point C, is a middle-density region where the slope is constant everywhere. It is also here that the slope of the curve is steepest; thus the subject tones are reproduced with the greatest separation (contrast). For many emulsions, however, the middle section of the curve is quite nonlinear, as will be seen later.
- **D.** Shoulder. Located between points C and D, this is the portion where the density is high but the slope is decreasing with increases in exposure. Ultimately the slope approaches zero, where it is

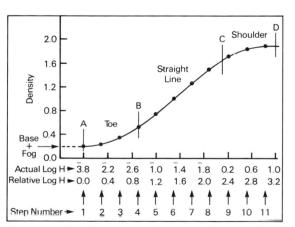

Figure 2–14 The characteristic curve resulting from the data in Table 2-2.

2.5 Characteristic Curves

again impossible to record subject detail. Consequently, this section is avoided when exposing pictorial films.

The characteristic curve displays a "picture" of the film's ability to respond to increasing amounts of exposure as a result of a specific set of development and image-measurement conditions. It represents the single most commonly used method for illustrating the sensitometric properties of photographic materials and should be clearly understood.

For now we will assume that the subject tones are directly related to the log exposure axis of the graph. If a uniformly illuminated gray card is photographed, it will have only a single luminance value and give a single level of light (illuminance) at the camera back. When the shutter is tripped, the illuminance is multiplied by the exposure time, producing a single exposure value. Therefore, the exposure of that gray card can be represented by a single position along the log exposure axis as seen in Figure 2-15A. If the same gray card is used to make a second photograph but the exposure is increased by a factor of 100 (either by using a wider aperture or a slower shutter speed or both) the second exposure will be located to the right of the first at a distance equivalent to 2.0 in logs (i.e., the logarithm of 100) and is shown in Figure 2-15B. If a third photograph is made of the gray card under the same conditions as the first except that the aperture is closed down one stop (exposure reduced by a factor of two), the resulting log exposure will fall to the left of the first as seen in Figure 2-15C. The separation will be 0.30, which is the log of 2, the equivalent of one stop.

Assume now that we are photographing the face of a model with highlight and shadow areas, illuminated so that the lighter side has eight times the luminance of the darker side, giving a subjectluminance ratio of 8:1. Since there are now two tones in the scene, there will be two image illuminances and, ultimately, two different exposures with one trip of the shutter. Figure 2–16A shows that these two input values will be separated by the log of 8, which is 0.90. If a second photograph is made of this subject, giving one stop more exposure, both log exposures will shift to the right a distance of 0.30 in logs but still will be separated by 0.90 because the subject luminances have not changed, as shown in Figure 2–16B.

Therefore, the tones of the subject can be related to the log exposure axis of the characteristic curve. As shown above, the ratio of the subject luminances (highlights to shadows) plays a major part in determining the ratio of exposures (or range of log exposures) the film will receive. Also, by changing the camera settings or the level of light on the subject, the level of the exposures may be increased or decreased (shifted right or left) on the log exposure axis.

It should be noted here that the concepts discussed above are only approximately correct because of the image distortion introduced by the optical flare in the camera. What is important at this point is that the conceptual relationship between subject luminances and log exposures be clearly understood. Methods of compensating for flare-related distortions will be introduced later. It should be apparent that errors made in the placement of the subject tones relative to the log exposure axis when the film is exposed can seldom be corrected in later stages of the process.

In reference to the simple two-tone scene described above, exposure and processing produce two different densities. The values of the two densities can be found by extending lines up from the two log

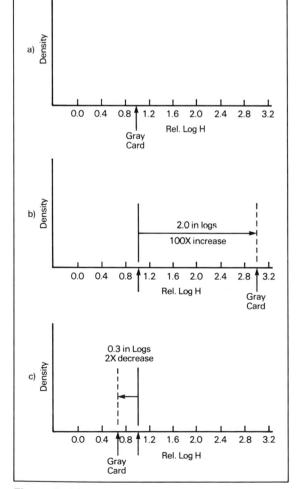

Figure 2–15 Exposure changes and their relationship to the log exposure axis.

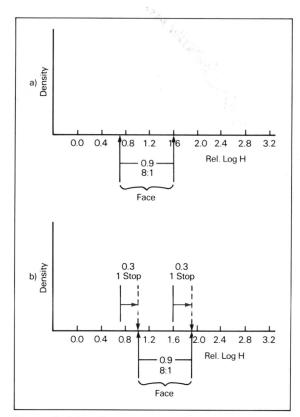

Figure 2-16 Changes in exposure for a simple two-tone scone as related to the log exposure axis.

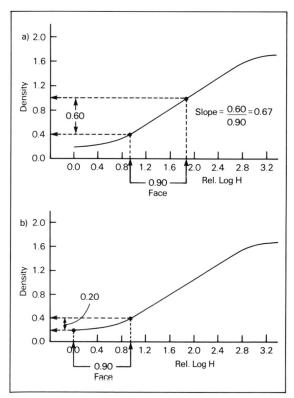

Figure 2–17 Relationship between log exposure and density for two different sections of the characteristic curve.

exposure positions to the characteristic curve and then to the left until they intersect the density axis. This is illustrated in Figure 2–17A, which shows both log exposures falling on the straight-line section. The actual values of the densities are less important than the density difference because these relate to tonal separation or contrast. Therefore, density differences describe the amount of shadow, midtone, and highlight detail in the negative. In this example the log exposures are separated by 0.90 (an exposure ratio of 8:1), while the resulting densities show a difference of only 0.60. This compression occurs because the slope of the straight-line section is less than 1.0 (45°). In fact, the actual slope may be computed by comparing the output density difference to the input log exposure difference. This leads to the generalized form for finding the slope:

> Slope = $\frac{\text{Density difference}}{\text{Log exposure difference}}$ OR Slope = $\frac{\Delta D}{\Delta \text{Log H}}$

For the situation shown in Figure 2–17A the ΔD is 0.60 and the $\Delta \log$ H is 0.90; 0.60/0.90 is equal to 0.67, which is the slope of the straightline region. This number (slope) is related to the steepness of the curve and describes the rate at which density will increase as a result of increasing the exposure. A slope of 1.0 indicates that a change in log exposure will yield an equal change in density. With a slope of 0.50, the change in density is only half as great as the change in log exposure. A slope of 2.0 means that the change in density is twice as great as the change in log exposure. The relationship can be restated as follows: Slope relates the negative contrast (density differences) to the subject contrast (log exposure difference). However, this relationship only applies to the straight-line section of the characteristic curve if indeed there is one.

Where the section of the graph is a curve, as in the toe, there is no simple relationship between log exposure and density. Figure 2-17B shows the same two-toned scene placed entirely on the toe portion of the curve. In other words, the subject was given less exposure, as these log exposures are located to the left of the first. The resulting density difference is 0.20, which is considerably less than the first (0.60) because the slope in the toe is quite low. This means that there is far less tonal separation in this negative than in the first; it has less contrast. If the slope were calculated as before, the resulting number would be related to an imaginary straight line drawn between the two density points and would not describe the actual slopes in the toe, which are everywhere different.

It should be clear from this discussion that the contrast (density difference) of the negative can be changed by changing the camera exposure. This will be the case either when there is no straightline portion whatever or when the exposures are placed in a nonlinear area such as the toe and shoulder. If the subject tones are placed in the straight-line portion, they will be reproduced in the negative with the greatest possible separation (contrast). As the exposures become less and move into the toe region, the density differences of the shadows will rapidly decrease and the shadow contrast will be reduced. If the exposures are increased and move into the shoulder region, the density differences of the highlights are quickly reduced, causing a loss of highlight contrast.

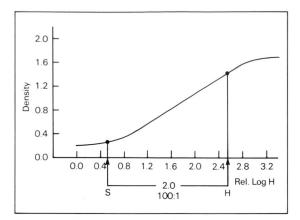

Figure 2–18 Proper placement of log exposures for an average-contrast scene.

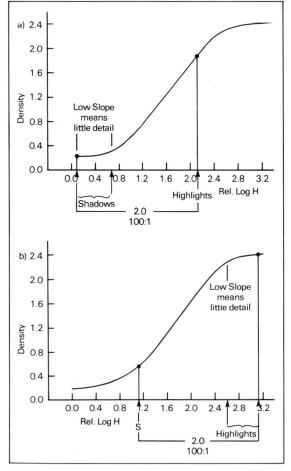

Figure 2-19 The relationship between slopes and density differences for underexposure and overexposure conditions (with more than normal development).

In practice, the camera is likely to be aimed at scenes that range from about 20:1 to nearly 800:1, with 160:1 being average. Experience shows that excellent negatives are produced when the shadow exposures are placed in the toe of the curve while the midtones and highlights fall in the midsection as shown in Figure 2–18. The shoulder section is almost always avoided because of the longer printing times required and the resulting loss of image quality. Most camera speed pictorial films can accept these ranges and give excellent results. Occasionally, however, scenes with excessive contrast (1,000:1 or greater) are encountered. Special emulsions and developers are generally needed so that proper shadow and highlight detail are maintained in the negative.

Total negative contrast (the density difference between the thinnest and densest areas, also known as the density range) is largely determined by:

- 1. The subject contrast, which determines to a good first approximation the log H range on the horizontal axis of the D-log H curve.
- 2. The placement of this range of log exposures, determined by the camera settings.
- **3.** The shape of the specific characteristic curve, which is mainly determined by the choice of emulsion and the development conditions.

The total negative contrast is a number similar in concept to the log of the subject luminance ratio. It describes the log range of output (i.e., the density range) as a result of the previously mentioned conditions. For pictorial photographic negative emulsions, a total negative contrast of approximately 1.1 is considered normal (for diffusion enlargers) and is based on the printing characteristics of the negative. If the total negative contrast reaches 1.6, the negative is considered to have excessive contrast and probably is unprintable, even on a grade one paper. When the total negative contrast is on the order of 0.4, it also will be nearly unprintable but because it is too flat for even a grade five printing paper.

Shadow detail, midtone contrast and highlight detail are important, as noted earlier. A negative can have a large total negative contrast and still be totally lacking in shadow detail, as shown in Figure 2-19A. Likewise, the total negative contrast may be great but the highlights are blocked up, as in Figure 2-19B. Thus we reach again the concept of *slope* as a measure of contrast in different parts of the film D-log H curve, and therefore in different parts of the negative (shadows, midtones, and highlights). A slope of 1.0 means the subject contrast is exactly duplicated in the negative. A lesser slope means the contrast relationship is determined by the way the negative will be used and, in most cases, the way it will be printed, including the grade of paper that will be used. Interestingly, a "normal"-contrast negative actually has significantly less contrast than the original subject.

2.6 Log Exposure Range

In light of the relationship between subject luminances, camera exposures, and to the densities of the resulting negative, it should be realized that excellent images can only be made if all the subject tones fall on the characteristic curve where there is sufficient

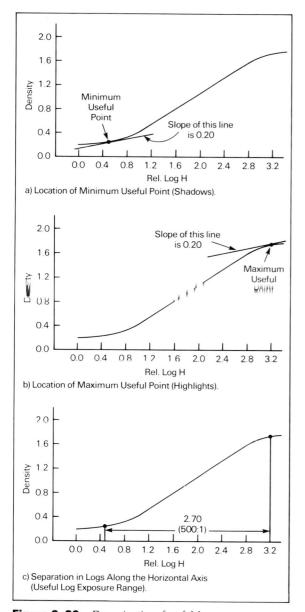

Figure 2-20 Determination of useful log exposure range. (A) Location of minimum useful point (shadows). (B) Location of maximum useful point (highlights). (C) Separation in logs along the horizontal axis (useful log exposure range).

slope. One of the most important measures of the sensitometric properties of the film is the useful log exposure range. This is the range of log exposures over which the emulsion can produce adequate separation of densities and is based on the minimum slope required to achieve it. For example, as the camera exposure decreases, the subject tones move farther to the left into the toe and ultimately reach an area where the curve is completely flat (zero slope), resulting in a loss of detail in that portion-typically the shadows-of the negative. The smallest slope necessary to preserve acceptable shadow detail is located at a point on the toe that is the minimum useful point. Experiments using pictorial subjects indicate that the minimum useful point in the toe occurs where the slope is not less than 0.20, as illustrated in Figure 2-20A. Since one cannot find the slope of a point, the 0.20 refers to the slope of a line tangent to (just touching) the toe. For most camera-speed pictorial films this point of tangency usually falls at a density of not less than 0.10 above the base-plus-fog density and is referred to as the minimum useful density.

Inthe human of the maximum maximum maximum on the shoulder is known with less accuracy, partly because proper reproduction of the shadows is more important and partly because the highlight area of most scenes falls short of the shoulder portion. However, experience indicates that the minimum useful slope on the shoulder is also approximately 0.20 and is found as shown in Figure 2–20B. Since the shape of the upper portion of the curve is highly dependent upon the degree of development, no generalization can be made about the maximum useful density for the curve.

Figure 2–20C illustrates the concept of useful log exposure range, which is the distance along the horizontal axis between the minimum and maximum useful points. In this example the log range is 2.70, which means the useful exposure ratio is about 500:1 (antilog of 2.70 = 500). As long as the subject tones are placed between these points, the resulting negative will have acceptable detail in all areas. If the ratio of subject tones is so great that it exceeds the useful exposure ratio, either the shadows or the highlights will lack detail in the negative. Consequently, the useful log exposure range is a basic measure of the ability of a given film-developer combination to adequately record the subject tones.

2.7 Exposure Latitude

Associated with the useful log exposure range is the concept of *exposure latitude*, which relates to the margin for error in the camera exposure. For example, suppose we were using the film-developer combination resulting in the curve shown in Figure 2–20C to photograph a subject with a luminance ratio of 50:1. The subject will provide a log exposure range of 1.70 (log of 50 = 1.70). The useful log exposure range of the film-developer combination is 2.70, leaving a difference in logs of 1.00 (2.70 - 1.70 = 1.00). This means there is a 1.00 log interval "left over" that represents our margin for error. If the darkest shadow in the subject is to be placed at the minimum useful point as shown in Figure 2–21A, the underexposure latitude is zero, while the overexposure latitude is 1.00 in logs, or a factor of 10, or 3 1/3 stops. When the lightest highlight is to be placed at the maximum useful point, the conditions are exactly reversed as illustrated in Figure 2–21B. If the subject exposures are placed directly in the middle of

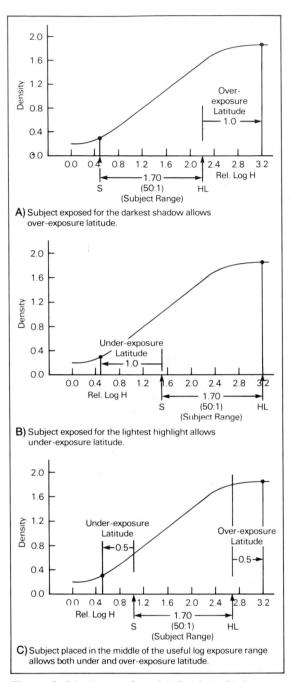

Figure 2-21 Exposure latitude: The relationship between subject log luminance range and the useful log exposure range. (A) Subject exposed for the darkest shadow allows overexposure latitude. (B) Subject exposed for the lightest highlight allows underexposure latitude. (C) Subject placed in the middle of the useful log exposure range allows both underexposure and overexposure latitude.

the useful log exposure range as in Figure 2–21C, the under- and overexposure latitude will be equal (1.00/2 = 0.50).

In practice, the shadows of the scene are usually placed at the minimum useful point because this allows for the highest effective film speed. The result is that exposure latitude in the camera is typically overexposure latitude only. Most camera-speed pictorial films have the capability of properly recording scenes with luminance ratios of up to 500:1. As the subject luminance ratio becomes greater, the exposure latitude becomes smaller, which creates a need for more accurate camera exposures. When the subject-luminance ratios become excessive (greater than 500:1), special films and developers are required if excellent images are to be produced. (The effect of camera flare light on image contrast will be considered later.)

Thus far we have considered only those properties that have been related to one curve and one development time. If a variety of development times are used with some less and some greater than the "normal," a family of characteristic curves can be plotted as in Figure 2-22. Notice that all of the curves exhibit the same general shape. The following generalizations may be made:

- **1.** Each curve shows a greater density in all areas as development time increases. Notice that base-plus-fog density is similarly affected.
- **2.** The slope in the toe section is small and relatively unaffected by increases in development.
- **3.** The slope of the midsection increases greatly as development time is increased.
- **4.** The slope in the shoulder remains small for all development times, even though the density level changes dramatically.
- 5. The useful log exposure range gradually becomes smaller as the development time increases, as a result of the higher slope of the straight line and a more prominent shoulder.

Subject tones placed in the toe section of the curve will always be reproduced as small densities but, more significantly, with only slight separation of tone (contrast) regardless of the development time. When the subject tones are placed in the middle part of the curve, changes in development time will have a significant effect on the density differences produced. It is in the straight-line region where the photographer has the greatest control over contrast with development. Those subject tones placed in the shoulder section will result in high density levels, but again with only little separation of tone for all development times.

Since most pictorial photographic situations involve only the toe and midsection of the characteristic curve, it can be seen in practice that the darker tones (shadows) should govern camera exposure determination, while the lighter tones (highlights) should govern the degree of development. This idea is consistent with a common saying among photographers: "Expose for the shadows and develop for the highlights." It should also be apparent that underexposure will shift the shadow tones farther to the left in the toe, where even lengthy development times will not produce a steep enough slope for the detail to be recorded. Further, the increase in development time will adversely affect the midtone and highlight reproduction by giving them unacceptably high contrast. This is typically the result when photographers attempt to "push" their film speed by underexposing and overdeveloping. This condition is illustrated in Figures 2–18 and 2–19A. Figure 2–18 shows

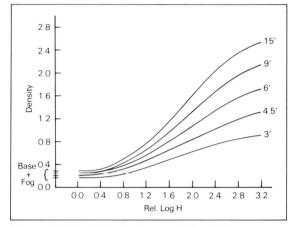

Figure 2–22 A family of curves for five different development times.

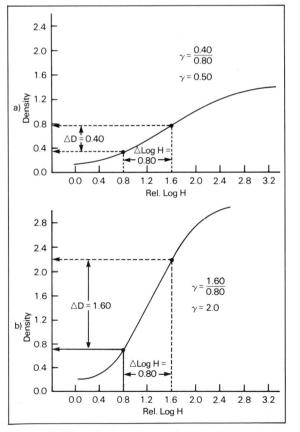

Figure 2-23 The determination of gamma for two different film samples.

the result of the proper placement of subject tones for a nearly averagecontrast scene with normal development. Figure 2–19A shows the same scene but with the subject tones given less exposure, which places the shadow tones far into the toe region. The steeper slope of this curve is caused by an extended development time with the result being an obvious lack of shadow detail and excessive midtone and highlight contrast. The negative could well be unprintable on even the lowest contrast grade of paper.

2.8 Gamma

Of the several available measures of the contrast of photographic materials, *gamma* has the longest record of use. Gamma (γ) is defined as the slope of the straight-line section of the D-log H curve. The formula is as follows:

$$\gamma = \frac{\Delta D}{\Delta \text{Log H}}$$

where ΔD = the density difference between any two points on the straight-line portion of the curve; and

 Δ Log H = the log exposure difference between the two points chosen.

Examples of the determination of gamma are shown in Figure 2–23A and B for two different development times. Gamma is considered to be an excellent measure of development contrast because it is the slope of the straight-line portion that is most sensitive to development changes. It can also be used to predict the density differences that will result in the negative for exposures that fall on the straight-line section. For example, the curve in Figure 2–23A exhibits a gamma of 0.50, which means that the density difference in the negative will be one-half that of the log exposure range. Likewise, in Figure 2–23B where the gamma is 2.0, the density difference will be twice as large as the log exposure range. It is assumed in both cases that all of the exposures are on the straight line part of the D-log H curve.

If the gammas of all of the curves in Figure 2-22 are measured and plotted against the time of development, the curve shown in Figure 2-24 results. This is referred to as a time-gamma chart and illustrates the relationship between the slope of the straight line and

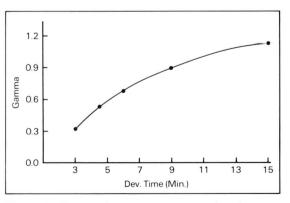

Figure 2–24 Development time vs. gamma chart for family of curves in Figure 2–22.

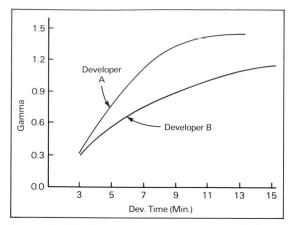

Figure 2-25 Development time vs. gamma chart for fastworking (A) and slow-working (B) developers on the same emulsion type.

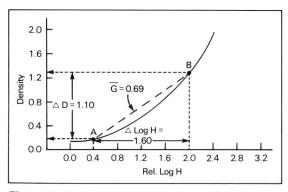

Figure 2–26 Determination of average gradient between two points on the curve.

the development conditions. For short development times, the gamma changes very rapidly, and as the time of development lengthens, the gamma increases more gradually. At some point in time, the maximum gamma of which this film-development combination is capable will be reached. This point is labeled gamma infinity and appears to be about 1.10 for these data. Since for this developer gamma increases greatly during short development times, extra care must be taken to minimize processing variability if consistent results are to be achieved. However, if longer times are used, the amount of development-time latitude (margin for error in developing time) increases.

The time-gamma curves shown in Figure 2–25 represent the use of two different developers on the same film. In order to ease the development time latitude problem, it is better to choose a developer for which the gamma changes slowly as a function of development time. For this example, developer A works at a faster rate than developer B and would therefore require more attention to the processing details of time, temperature, and agitation if an intermediate value of gamma is desired.

It is important to note here that gamma and negative contrast are different concepts. Gamma refers to the amount of development an emulsion receives, while negative contrast is concerned with density differences. Developing to a large gamma does not necessarily mean that a contrasty negative will result. The reason for this is that many factors in the photographic process affect the contrast of the negative, including the subject's range of tones and the placement of the exposures on the D-log H curve.

2.9 Average Gradient

In many cases, photographic materials do not provide a straight midsection, and in others there may be two straight-line sections with different slopes. Clearly, a single measure of gamma has little significance for these materials. Even for films exhibiting a single straight line, the useful portion of the curve usually includes part of the toe in addition to the straight line. In these situations where gamma cannot be used as a measure of slope, the concept of *average gradient* is substituted. An average gradient (\overline{G}) is basically the slope of an artificial straight line connecting any two points on the curve, as illustrated in Figure 2–26. The D-log H curve shown here has no straight-line section, but the average gradient can be computed for the artificial line connecting points A and B by using the basic slope formula where slope = $\Delta D/\Delta \log$ H. For this example, then: $\Delta D = 1.10$, $\Delta \log$ H = 1.60, therefore:

$$\overline{G}(A \text{ to } B) = \frac{1.10}{1.60}$$

= 0.69

The resulting number is a measure of the average contrast over the specified portion of the curve. Notice that this method can produce a variety of slopes by using different sections of the curve. Therefore, when interpreting average gradient data, one should be careful to note the section of the curve used.

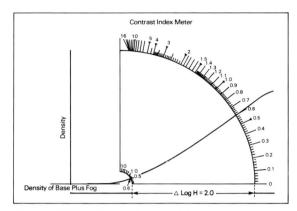

Figure 2–27 The use of a contrast index meter.

2.10 Contrast Index

Another method for measuring the contrast of photographic emulsions is to determine the contrast index of the characteristic curve. *Contrast index* is an average gradient method with the added feature that the slope is always measured over the most useful portion of the curve. This approach evolved from an evaluation of the printing characteristics of a large number of excellent negatives made on a wide variety of emulsions. The result was a method for locating the most likely used minimum and maximum points on the curve and the determination of the average slope between them.

The actual determination of contrast index requires the use of a transparent meter as an overlay on the D-log H curve. The meter is aligned with the log exposure and density axes and moved left or right until the curve crosses the small arc on the left side at the same numerical value as it does on the larger arc at the right. The number is the contrast index. The meter and its proper use on a characteristic curve are illustrated in Figure 2-27.

An alternative method is, first, to locate a point on the too that is 0.10 above base plus fog density. Using a compass, strike an arc with the center at this point and a radius of 2.0 in logs so that it intersects the upper portion of the curve. Then draw a straight line between these two points and determine its slope. The resulting number will be a close approximation of the contrast index.

In the manufacturer's published data for a film, contrast index is used almost exclusively as a measure of development contrast. This is because contrast index is a measure of the slope over the area of the curve that will most likely be used when the negative is made. Therefore, unlike gamma, contrast index is an excellent measure of the relationship between the entire log exposure range of the subject and the entire density range of the negative, provided the subject has been exposed on the correct portion of the curve. This means that if the contrast index is 0.50, the total negative contrast (total density difference) will be just one-half the subject log exposure range. For example, an average outdoor scene has a luminance ratio of approximately 160:1 and will provide a log exposure range of nearly 2.20 (log of 160) to the film. A correctly exposed negative, processed to a contrast index of 0.50, will have a total negative contrast of 0.50 \times 2.20 or 1.10, and will print easily on a normal grade of paper with a diffusion enlarger.

The important point here is that the required contrast index may be changed to suit the subject log luminance range. Thus if the scene is excessively contrasty, development to a low contrast index will generate a negative that will print on a normal grade of paper. On the other hand, if the scene is unusually flat, the film may be developed to a high contrast index to obtain a normal-contrast negative. The relationship is this:

Required contrast index = $\frac{\text{Desired density range of negative}}{\text{Log subject luminance range}}$

As stated before, this relationship assumes correct placement of the exposures on the characteristic curve, as well as no camera flare. An appropriate correction for typical flare conditions would be to subtract 0.40 from the subject log luminance range. For example, if a scene with a log luminance range of 2.20 (160:1) has been correctly exposed

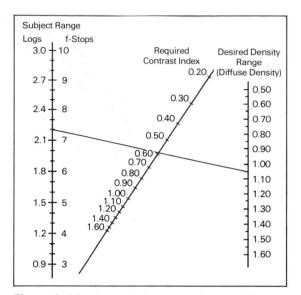

Figure 2–28 Contrast-index nomograph (corrected for average flare conditions).

and a density range of 1.05 in the negative is desired, the required contrast index would be found as follows:

Required contrast index	=	Desired density range of negative
contrast muex		Log subject luminance range – 0.40
	=	$\frac{1.05}{2.2 - 0.4}$
	=	<u>1.05</u> 1.80
	=	0.58.

Rather than making these calculations, the nomograph in Figure 2-28 may be used. The subject luminance ratio is located on the vertical line at the left and is expressed in both logs and f-stops. The desired density range is represented by the vertical line at the right. The scene's log subject luminance range is located on the left-hand line and the desired density range on the right, and then a straight line is drawn between them. The number at which the line crosses the diagonal axis is the required contrast index. The nomograph has already been corrected for a normal amount of camera flare. For those situations where there has been significant under- or overexposure, this method will not give reliable data. The example used here to illustrate the normal relationship between subject log luminance range, contrast index, and negative density range is based on the assumption of a normal contrast scene of 160:1 (7 1/3 stops), an average flare factor of 2.5, and the desire to produce a negative with a density range of 1.05. The recommendations in other references may vary slightly, depending on the exact values used for these variables.

To translate the required contrast index into the necessary development time requires that a development time-contrast index chart be derived from your own test results. This graph will be similar in shape to the time-gamma chart shown previously. To successfully apply this (or any) approach to exposure and development control demands that close attention be given to all details of processing, with the goals being accuracy and repeatability. Sloppiness in the processing stage will most likely lead to results that are at best unpredictable.

2.11 Film Speed

Thus far in our discussion of sensitometry and its application to the picture-making effort we have yet to study that concept from which the term *sensitometry* was derived. This is the measurement of the emulsion sensitivity to light or, more commonly, the film speed. The concept of film speed and its relationship to the determination of the proper camera exposure should be clearly understood because, as we have seen, significant errors in the exposure of the film often cannot be rectified by any subsequent steps in the process.

A film speed (sometimes called photographic speed) is simply a number representing the average sensitivity of an emulsion under a given set of test conditions. The number is most commonly intended for use with photoelectric exposure meters to determine the camera settings that yield acceptable negatives and transparencies. Film speed and exposure are

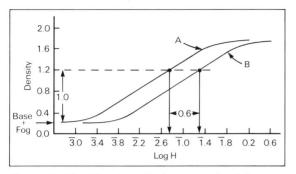

Figure 2–29 The relationship between speed and the position of the characteristic curve along the log H axis.

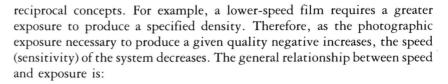

Speed =
$$\frac{1}{H}$$

where H = the exposure in lux-seconds to achieve a certain result.

With this relationship in mind, we can begin to study the use of characteristic curves for speed determinations. Consider the two curves shown in Figure 2–29, which represent two different films, A and B. Suppose we wish to compare film speeds based upon their ability to produce a density of 1.0 above base plus fog. Notice that film A requires a log exposure of $\overline{2.70}$, which means an exposure of 0.05 lux-seconds (antilog of 2.70 = 0.05), while film B requires a log exposure of 1.30, meaning an exposure of 0.20 lux-seconds (antilog of $\overline{1.3} = 0.20$). Using the formula shown previously we have:

Speed of A = $\frac{1}{0.05}$ Speed of B = $\frac{1}{0.20}$ = 20 = 5.

The speed of film A is four times as great as that of film B because A needs only one-fourth the exposure as B to achieve the same density. In fact, it should be evident by inspecting the curves that film A requires two stops (0.60 log difference) less exposure than film B and is therefore the faster film. Since the two curves are everywhere separated by 0.60 in logs, film A will exhibit four times the speed of B regardless of the density level chosen for comparison. This example shows that the concept of speed relates to the position of the characteristic curve relative to the log exposure axis. Emulsions whose curves sit far to the left have higher speeds than those positioned to the right.

In addition to the actual position of the curve along the log exposure axis, the shape of the curve plays an important role in the determination of film speed. The interrelationship between speed and curve shape is illustrated in Figure 2–30, where the curves for two different emulsions are shown. Emulsion A is characterized by a long toe section and a moderate slope in the straight-line region, while emulsion B shows a short toe and a very steep midsection. If the speeds were based upon the exposure necessary to produce 0.10 above base plus fog, emulsion B would be faster because it would require less exposure at that point. When comparing the speeds at a density of 0.60 above base plus fog, the two emulsions show the same sensitivity, as they both require the same exposure. However, if the speed were based upon a density of 1.20 above base plus fog, the situation reverses, with A being faster than B.

Since the shape of the characteristic curve is an expression of its contrast, it is obvious that a meaningful film-speed method must include a specification of the curve shape. Likewise, if two films are to be compared on the basis of speed it is necessary that both be developed

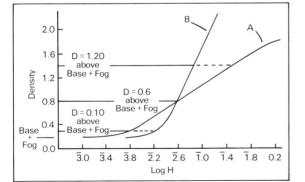

Figure 2-30 The relationship between speed and the shape of the characteristic curve.

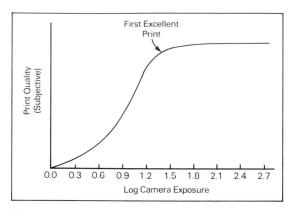

Figure 2–31 Relationship between print quality and camera exposure of the negative.

to the same contrast (slope) for the comparison to be meaningful. The situation is the same for the measurement of an emulsion's speed using two different developers. Merely following the manufacturer's recommendations will not ensure that the images have been developed to the same contrast. The characteristic curve for each should be drawn and the two compared.

In the previous example the speeds of the two films were compared at a specific density level in each case. This point on the curves is referred to as the speed point and is an important part of the speed method. This point must be selected on the basis of its relationship to acceptable negatives, which are in turn judged by their ability to give acceptable prints. Indeed, it makes good sense to evaluate negative quality on the basis of the resulting prints.

In a basic study of the relationship between the camera exposure given to a series of negatives, and the visual quality of the resulting prints for an outdoor pictorial scene, the curve in Figure 2-31 resulted. The subjective quality of the print increases dramatically as the camera exposure of the negative increases but reaches a plateau at the point labeled "First Excellent Print." Until this point, there has been insufficient exposure of the negatives for them to produce excellent prints. After this point, the print quality remains high as camera exposure increases. All of the prints judged were straight contact prints. The people who judged the prints were positive in their opinion of quality and nearly unanimous in their use of shadow detail as the critical factor in identifying excellent prints. Invariably, the prints of lesser quality lacked good shadow detail. The plot in Figure 2-31 indicates that once the minimum amount of camera exposure needed to make an excellent print is provided, there is little improvement of print quality as a result of increasing the exposure. In other words, the minimum camera exposure is good enough.

When evaluating the sensitometric properties of the negative that produced the "First Excellent Print" in this experiment, it was found that the shadows were placed well into the toe section of the curve and that the negatives with a shadow density less than 0.10 above base plus fog yielded prints of inferior quality due to a lack of shadow detail. This experiment has been repeated many times using different emulsions and developers with similar results. Consequently, the point used for the determination of ISO (ASA) pictorial film speed is located at a density of 0.10 above base plus fog because this has been shown to be the minimum useful density for good shadow-detail reproduction. Finding the minimum useful density and, consequently, the minimum useful exposure will indicate the highest useful film speed because of the reciprocal relationship between exposure and film speed.

The experiment that led to the selection of 0.10 above base plus fog as the speed point was the result of photographing a pictorial subject using conventional emulsions and developers with the goal of producing a pictorial photograph. For other situations, as in the use of microfilm for document copying or electron beam recording, the conditions of use will be drastically different, and the resulting speed points will be located in different positions. This is the main reason why it is impossible to compare the speeds in one system to those of another. For example, one cannot sensibly compare the speed of a high contrast litho film to that of a pictorial negative film because the conditions of use are completely different.

Most pictorial negative films have film speed ratings com-

 Table 2-3
 ISO (ASA) and ISO (DIN) standard speed

 values

ASA (Arithmetic)	DIN (Logarithmic)	
6	9°	
8	10°	
10	11°	
12	12°	
16	13°	
20	14°	
25	15°	
32	16°	
40	17°	
50	18°	
64	19°	
80	20°	
100	21°	
125	22°	
160	23°	
200	24°	
250	25°	
320	26°	
(100	חקב	
500	28°	
650	29°	
800	30°	
1000	31°	
1250	32°	
1600	33°	
2000	34°	
2500	35°	
3200	36°	
4000	37°	
5000	38°	
6400	39°	

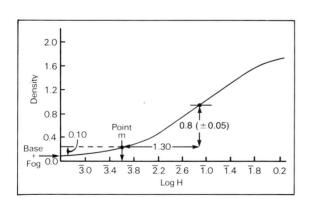

Figure 2–32 The determination of ISO (ASA) speed for a specific sample.

puted by the manufacturer and published as ISO (ASA) values. This means that the speed has been determined in accordance with the procedures described by the American National Standards Institute and the International Standards Organization. Both organizations are nonprofit operations that exist for the purpose of providing standard procedures and practices to minimize variations in testing. Since there are many sources for variation in the determination of film speed, it is highly desirable to have an agreed-upon method that is accepted by a majority as the "best" technique. This technique prescribes, among other items, the type of exposing light (daylight), the exposure time (1 second to 1/1,000 second), the developer composition (a formula devised for testing purposes that is not commercially available), the type of agitation, and the amount of development (an average gradient of approximately 0.62). Once all these conditions have been met, the speed point is located at a density of 0.10 above base plus fog and the following formula is used:

$$ISO (\Delta S\Delta) = \frac{1}{H_m} \times 0.9$$

where H_m = the exposure in lux-seconds that gives a density of 0.10 above base plus fog;

0.8 = a constant that introduces a safety factor of 1.2 into the resulting speed value. The film is actually $1.2 \times$ faster than the published value, which guards against underexposure.

ISO (ASA) speeds are rounded to the nearest third of a stop using the standard values listed in Table 2–3. Therefore, each ISO (ASA) speed value has a tolerance of $\pm 1/6$ stop. Consider the curve shown in Figure 2–32, which is the result of following the ISO (ASA) standard procedures. The determination of speed is as follows:

- 1. Locate point m at 0.10 above the base plus fog density, which in this case is at a gross density of 0.20.
- **2.** Beginning at point m, move a distance of 1.30 in log units to the right along the log exposure axis.
- **3.** From this position, move up a distance of 0.8 in density units, and if the curve crosses at this point (± 0.05) , the proper contrast has been achieved and the speed may be computed at point *m*. If not, the test must be rerun using a development time that yields the proper curve shape.

In this example, the curve shape is correct, and the log exposure at the speed point is $\overline{3}.63$. By taking the antilog of this value, the exposure is found to be 0.00426 lux-second. Substituting, we have:

ISO (ASA)
$$= \frac{1}{0.00426} \times 0.8$$

 $= 234.74 \times 0.8$
 $= 187.79$

Using the values in Table 2-3, the ISO (ASA) speed would be expressed as 200. The manufacturer's published values for a given film type are

determined by sampling many emulsion batches and averaging the test results.

The consequence of this approach is a set of film speeds that mean the same thing for all pictorial negative films regardless of the manufacturer. A speed of ISO (ASA) 125 means the same for Brand X as it does for Brand Y because the same test conditions existed. It also means that a given emulsion has only one ISO (ASA) speed, and this value cannot be changed as a result of using a special developer because the conditions of testing have been specified. Any change in these conditions means the standard has not been followed, and, therefore, by definition the ISO (ASA) speed cannot be found. In practice, most photographers will necessarily use conditions different from those outlined in the Standard. For example, if tungsten light is used or a specialpurpose developer tried, the circumstances of practice no longer match those of the test. This is an unavoidable pitfall of the ISO (ASA) published speeds; once the "best" method has been agreed upon and standardized, the speeds are only valid for those conditions. It is common for film manufacturers to publish both daylight and tungsten speeds for some nonpanchromatic emulsions.

2.11.1 Logarithmic Film Speeds

In Europe and Great Britain the standard film speeds have been expressed as DIN values since 1961. The initials stand for Deutsche Industrie Norm, which is the standards organization of Germany. The method for locating the speed point is identical to the ISO (ASA) method; however, the speeds are expressed in logarithmic values, rather than arithmetic values, using the following formula:

 $ISO (DIN) = 10 \times log (I/H_m)$

where H_m = the exposure in lux-seconds that gives a density of 0.10 above base plus fog.

Using the data from Figure 2-31 we have:

ISO (DIN) = $10 \times \log (1/0.00426)$ = $10 \times \log (235)$ = 10×2.37 = 23.7.

Referring to Table 2-3 in the DIN column, the closest standard value is 24. Thus the speed of this sample is expressed as DIN 24. Notice that a change of three units in the DIN system is equivalent to a $2 \times$ change in the arithmetic film speed. Also, the DIN speeds are spaced at 1/3-stop intervals as are the ISO (ASA) speeds.

A given film has a multitude of potential speed values that vary with every significant aspect of the photographic system, including the color of exposing light, processing, aging, environmental conditions, manner of use, and the type of image quality desired. For these reasons, it is intelligent for a photographer to consider the published speeds only as a starting point for the determination of a "working" speed that applies to the conditions of practice.

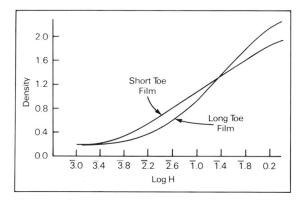

Figure 2–33 Characteristic curves for short-toe and longtoe films developed to approximately the same contrast index.

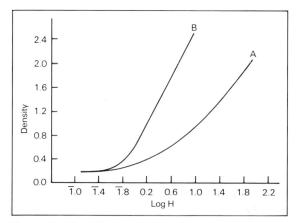

Figure 2–34 Characteristic curves for two types of continuous-tone copy films.

2.12 Analysis of Negative Curves

When surveying the wide variety of black-and-white negative working emulsions available, it becomes an imposing task to describe the properties of each. Fortunately this diverse collection of emulsions can be organized on the basis of contrast (as seen in the curve shape) and film speed. Although there are other considerations for the grouping of films, such as format and image structure, it seems appropriate at this point to consider the sensitometric properties, as they have the greatest influence upon the intended use of the cmulsion. Negative working films can be categorized as follows:

2.12.1 Normal-Contrast Films

Normal-contrast films have sensitometric properties similar to those we have already studied. They are intended for making negatives of pictorial subjects with the ultimate goal being a reflection print. They are characterized as medium-contrast films, and they produce contrast indexes of approximately 0.60 with normal development. These films may possess either a short or long toe section as shown in Figure 2-33. In a short-toe film the midsection is reached quickly and shows a long straight line. In practice, this means that a slight amount of underexposure will greatly reduce shadow detail while slight overexposure rapidly increases shadow detail. Since the midsection is long and straight, exposure changes do not affect the midtone and highlight contrast. When considering the long-toe film, small increases or decreases in camera exposure will have only a slight effect on shadow contrast, allowing for more underexposure latitude. However, since the midsection of these materials is seldom a straight line, small changes in the camera exposure can translate into significant changes in midtone and highlight contrast.

Normal-contrast films may also be classified on the basis of their speed. The slowest medium-contrast emulsions have an ISO (ASA) speed of 32 while the fastest are on the order of 4000. Associated with the film speed is the ever-present problem of grain size, with the general relationship that as film speed increases, so does the grain size.

When curves are drawn for long-toe emulsions, a "hump" sometimes appears in the midsection. This anomaly is the result of a double-coated emulsion where the shoulder of one leaves off and the toe of the next begins. By combining two different emulsions, both the speed and useful log exposure range can be increased.

2.12.2 Continuous-Tone Copy Films

These materials are used to copy photographic prints and artwork. These films are also useful when a positive transparency is to be made from a negative (or vice versa). It is important to note that the subject luminance characteristics of these types of subjects are considerably different from those of an original scene. For example, the luminance ratio of a black-and-white glossy print seldom exceeds 100:1 and is often much less. Additionally, the luminance differences within the shadows and within the highlights of the print are significantly less than in an original scene. The same conditions exist for paintings and other artwork. Since the subjects are inherently low in contrast, continuous-tone copy films generally have slopes of 1.0 and greater to compensate and are classified as high-contrast emulsions.

Figure 2-34 illustrates two types of continuous-tone copy films. Emulsion A exhibits a curve without a straight-line section, and

the slope constantly increases as the exposure increases. This is an extremely useful characteristic for two reasons. First, the highlights in the print will fall on the right-hand portion of the curve where the slope is the greatest, ensuring that the subtle differences in the highlights of the original print will be maintained in the copy negative. Second, because the slope shows large changes as a result of exposure, the contrast may be readily governed by exposure as well as development.

Emulsion B is the type that would be used to make a positive transparency from a negative. Since the resulting image is intended for direct viewing, the slope is greater to provide sufficient visual contrast. The slopes for these films are typically 2.0 or more. The steeper slope means that the useful log exposure range will be short and the tolerance for exposure errors will be quite small. For these materials the midsection is relatively straight and easily controlled by development. Generally, developers with greater-than-normal activity are used.

Since these materials are not used to generate original pictorial negatives, and the conditions of use differ markedly from the standard, ISO (ASA) speed values are meaningless. The manufacturer usually supplies speed data in the form of an *exposure index* that is derived under test conditions (i.e, light sources and developers) similar to those used in practice. The speed points are typically located in the upper midsection near a density of 1.5 because it relates to proper highlight reproduction.

2.12.3 Line-Copy Films

When photographing a line drawing or printed text, an extremely high-contrast emulsion is necessary. These materials are referred to as either line-copy or lithographic (from the graphic-arts vocabulary) films with a typical characteristic curve displayed in Figure 2-35. Slopes of 5.0 and above are common. The extremely steep slope is needed to expand the very short range of exposures received by the film in practice. Although most people think of line drawings and printed text material as high-contrast subject matter, in reality the contrast is quite low. For example, the reflectance ratio of a highquality printed text seldom exceeds 40:1, and for newsprint it is about 10:1. This is because the inks used do not give a deep black, and the paper is never perfectly white. The lack of intermediate gray tones is the primary reason why these materials are referred to as high contrast. When these ratios are compared to that of an average outdoor scene, it becomes obvious why line-copy films require such a steep slope. Consequently, the useful log exposure range is very short, resulting in an almost total lack of exposure latitude.

The film speeds for such emulsions are derived from practical tests using the same light sources and developers to be used in practice. The manufacturer gives this information as a point of reference at which the user can begin his own tests. Because the developers employed for these films are very powerful, the photographic speed is highly dependent upon the development conditions.

2.13 Analysis of Photographic Paper Curves

The procedures involved in the sensitometric testing of photographic papers are essentially the same as those used for negative materials. The details of the testing conditions are changed to more

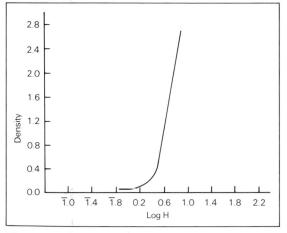

Figure 2–35 Typical characteristic curve for a line-copy film.

closely simulate practice. For example, tungsten light is used in the sensitometer because that is the source with which most printers are equipped. Also, exposure times are longer (usually between 0.10 and 10 seconds) to approximate those given in practice because reciprocity law failure affects print emulsions as well as films. For cases where a sensitometer is unavailable, a transmission step table may be either contact or projection printed with the actual printer to be used in production. Care must be taken to ensure uniformity of illumination on the easel and accuracy of the timer. If the step tablet is projection printed, optical flare will cause problems similar to those encountered when using a camera and reflection gray scale, as exposure relationships between steps will be distorted. When processing photographic papers, close attention must be given to the details of time, temperature, and agitation because development times are generally short and density is produced quickly.

In the evaluation of photographic papers it is necessary to measure reflection densities. Reflection density is defined as the logmitlim of the reciprocal of reflectance (R), where.

Reflectance (R) = $\frac{\text{Light reflected from the image}}{\text{Light reflected from the base}}$

Thus

reflection density $(D_r) = \text{Log} \frac{1}{R}$

The design of a densitometer that measures reflection density necessarily differs from that of a transmission instrument. Since prints are usually illuminated at an angle of approximately 45° and viewed on a plane nearly perpendicular to the image, the American National Standards Institute has standardized this illumination and collection geometry, and all reflection densitometers are based upon it. If the instrument is zeroed on an unexposed, developed, and fixed-out piece of photographic paper, the base plus fog automatically will be subtracted from all future readings. When the instrument is calibrated on a reference white such as magnesium oxide, the readings will include the base plus fog density. Both approaches are commonly used.

Figure 2-36 contains a characteristic curve typical of a photographic paper emulsion. The major differences between this curve and that of a pictorial film are as follows:

- 1. The toe portion is usually longer and extends to a higher density.
- 2. The slope in the midsection is much steeper, and the straight-line portion is short if present at all.
- **3.** The shoulder quickly reaches a maximum density, which is seldom more than 2.1.

Because of these conditions, the useful log exposure range of photographic paper is substantially less than that of pictorial film. However, it should be remembered that the purpose of photographic paper is to receive the transmitted tones of the negative as input, while the purpose of negative film is to receive the reflected tones of the original scene as input. When evaluating the contrast of photographic papers, two types of information are important: the total density (output) range and the useful log exposure (input) range.

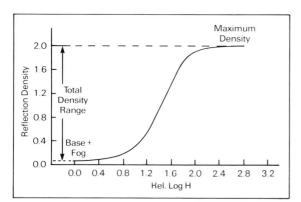

Figure 2–36 Typical characteristic curve for a black-andwhite photographic paper.

2.14 Paper Contrast

The total density range of a paper is the range from paper base plus fog to the maximum obtainable density (sometimes called maximum black) at the top of the shoulder, as illustrated in Figure 2–36. The minimum density (base plus fog) is determined by the whiteness of the support and the fog picked up during processing. Reflection densities of 0.01 to 0.03 are typical minimum densities. The maximum obtainable density is in part governed by the emulsion type but primarily controlled by the print's surface characteristics. A glossy-surface paper with a good ferrotype finish can give a maximum density of about 2.10, while an unferrotyped finish on the same surface produces a density of about 1.90. Resin-coated papers seldom exceed 2.0. Mat surface papers show a maximum density of about 1.60.

The limit on print density is associated with first-surface reflections, as shown in Figure 2-37. In a typical print-viewing situation, the print is illuminated at 45° and viewed on the perpendicular. For the maximum black patch with the glossy surface, the first-surface reflection is very directional, with the angle of reflectance nearly equal to the angle of incidence. With the eye positioned as shown, the fraction of the light being reflected will not be detected. Since the incident light is either absorbed by the image or reflected at an angle where it is not readily seen, the patch appears black and consequently has a high density. When considering the maximum black patch with a mat surface, it can be seen that the first-surface reflection is quite diffuse and some light will be reflected back to the eye regardless of the viewing angle. The result is a washingout of the maximum black and a corresponding loss in maximum density. The effect on curve shape of different surfaces for the same grade of paper is shown in Figure 2-38, which demonstrates that the greatest change occurs in the shoulder. The practical consequence of this condition is that the output range of a photographic paper is controlled primarily by the surface characteristics.

Unlike the negative film emulsions studied previously, the contrast of photographic papers is not readily controlled by development. Since development occurs rapidly as a result of using a high-activity developer, the basic curve shape is essentially determined after a brief period. The curves in Figure 2–39 result from varying development time, with $1\frac{1}{2}$ minutes considered normal. Although it is apparent that the slope of the curves is changing, development times of less than one minute tend to give a lowered maximum density with a mottled appearance and, therefore, unusable images. At a development time of one minute the curve shape is nearly fixed, with increases

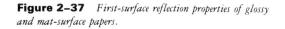

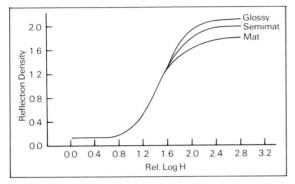

Figure 2–38 The effect of surface characteristics on the curve shape for the same grade of paper.

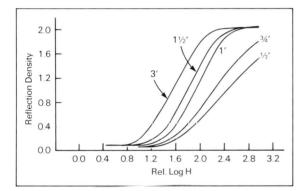

Figure 2–39 The effect of different development times on curve shape for the same grade of paper.

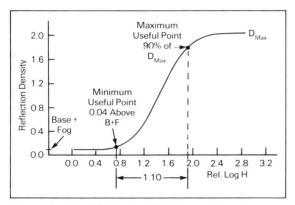

Figure 2-40 The location of minimum and maximum useful points, and the resulting useful log exposure range.

in development time merely shifting the curve to the left. Thus extended development times don't change the contrast of photographic papers but do increase the speed up to about one stop. If the development time becomes too long, the fog density increases and makes the highlights appear unacceptably gray.

The effects of changing development time on photographic papers may be summarized as follows:

- 1. Underdevelopment is to be avoided because of the lack of maximum black and the possibility of mottling.
- 2. Overdevelopment can be used to increase the speed by as much as one stop, but care must be taken to avoid an unacceptable increase in fog density, which ruins the white areas of the print.
- **3.** Since the curve shape is determined early in development, changes in development conditions cannot compensate for an incorrectly chosen grade of paper.

Thus far in our analysis of photographic paper curves we have only considered the output (density) characteristics. To evaluate the input properties requires a determination of the paper's useful log exposure range. This concept is similar to that applied to camera films in that minimum and maximum useful points must be located on the curve. The location of these points is based upon the visual quality of the highlights and shadows produced in the print. Because the tones in the negative are reversed in the print, the highlights are reproduced in the toe area and the shadows in the shoulder of the paper's characteristic curve. Therefore, the minimum useful point in the toe will be based upon proper highlight reproduction. Experiments show that nonspecular highlights in a subject, such as reflections from white surfaces, should be reproduced with a density slightly greater than the base white of the paper. A density of 0.04 above base plus fog is sufficient to give a just-noticeable tonal difference above the base white of the paper, and it identifies the minimum useful point in the toe as shown in Figure 2-40. The base white of the paper is the tone that is reserved for reproducing light sources or the specular (glare) reflections from polished metal or other shiny surfaces. Since these are the brightest parts of the subject, it makes sense that they should be printed at the lightest tone possible.

When considering the reproduction of shadows and thus the maximum useful point, it is necessary to determine the desired amount of shadow detail. Again, many experiments indicate that black-and-white prints judged as excellent consistently exhibit good shadow detail. Those same experiments show that the maximum density of the print was not used to reproduce the shadow detail. Rather, a point farther down on the shoulder is used where there is sufficient slope for main-taining tonal separation. This point is typically located at a density equal to 90% of the maximum density and denotes the maximum useful point on the curve. However, portions of a scene that are very dark and contain no detail of interest are printed at the maximum density so that they may be reproduced as a solid black in the print. To summarize:

- 1. The minimum useful point in the toe is based upon the reproduction of nonspecular highlights and is located at a density of 0.04 above the paper's base plus fog.
- 2. The maximum useful point in the shoulder is based upon the

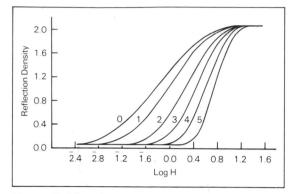

Figure 2–41 Characteristic curves for a family of papers of different contrast grades with the same surface.

reproduction of shadow detail and is located at a density equal to 90% of the maximum density.

3. The log exposure interval between the two points is defined as the useful log exposure range (sometimes just log exposure range) of the paper. For example, in Figure 2-40 the log exposure range was determined to be 1.10.

The characteristic curves for a family of papers of different contrast grades are illustrated in Figure 2-41. The major difference between the curves is in the range of log exposures over which they extend. A grade 0 emulsion (sometimes referred to as a "soft" paper) responds over a long range of log exposures, while a grade 5 (sometimes referred to as a "hard" paper) covers a much shorter log range. All of the grades are capable of generating the same range of densities (output) because they all show the same minimum and maximum densities, which is the case when the paper surfaces are the same. The contrast grade numbers 0, 1, 2, 3, 4, and 5 represent a system for classifying the contrast of a paper based upon the log exposure range. Some manufacturers use the ANSI standard terms for describing emulsion contrasts. Table 2-4 contains the contrast-grade numbers and ANSI standard terms that relate to the log exposure range. Notice that each grade of paper can have a variety of log exposure ranges. For example, a grade 2 paper can have a log exposure range of 0.95 to 1.15, which no doubt explains at least some of the differences between papers of the same grade and surface from different manufacturers.

The current American National Standard governing the sensitometric properties of black-and-white reflection print materials specifies the use of the *Standard Paper Range Number* (R) in lieu of the useful log exposure range. The value of R is determined by multiplying the useful log exposure range (rounded to the nearest 0.10) by 100. For example, if the useful log exposure range for a certain grade of paper were 1.07, it would be rounded to 1.10 and multiplied by 100, giving R = 110. If the digit in the hundredths position is 5 or higher, the number is rounded up; if it is 4 or lower, it is rounded down. The resulting R value has no standard relationship to the grade numbers assigned by the manufacturers to their products and, therefore, does not reduce the differences between the same grade of paper from different manufacturers.

It should be evident by now that the density range of the negative relates to the log exposure range of the paper it is to be printed on. In fact, the negative's density range actually determines the range of log exposures the paper will receive, and thus the paper grade re-

Table 2-4 Relationship between paper grade, paper log exposure range and density range of negatives for diffusion and condenser enlargers.

0				
Contrast Grade Number of Paper	ANSI Descriptive Term	Log Exposure Range of Paper	Density Range of Negative Usually Suitable for Each Log Exposure Range or Grade Number (Diffusion Enlarger)	Density Range of Negative Usually Suitable for Each Log Exposure Range or Grade Number (Condenser Enlarger)
0	Very Soft	1.40 to 1.70	1.41 and higher	1.06 and higher
1	Soft	1.15 to 1.40	1.15 to 1.40	0.86 to 1.08
2	Medium	0.95 to 1.14	0.95 to 1.14	0.71 to 0.85
3	Hard	0.80 to 0.94	0.80 to 0.94	0.60 to 0.70
4	Very Hard	0.65 to 0.79	0.65 to 0.79	0.49 to 0.59
5	Extra Hard	0.50 to 0.64	0.64 and lower	0.48 and lower

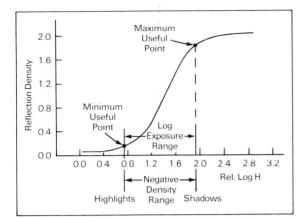

Figure 2-42 The relationship between the density range of the negative and the useful log exposure range of the paper for a correctly exposed print.

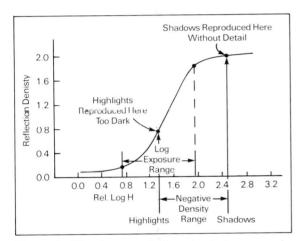

Figure 2-43 Correct match of negative density range and paper log exposure range, with print overexposed by two stops.

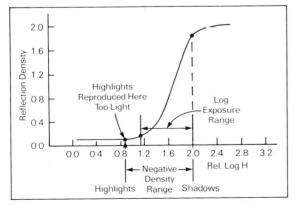

Figure 2-44 Negative printed on a paper grade that is too bard, printed for the shadows.

quired. A contrasty negative is characterized by a large density range, and so it requires a soft grade of paper that can respond over an equally large range of log exposures. On the other hand, a flat negative has a narrow density range, and it requires a hard grade of paper with a short log exposure range so that a full scale of tones will result with excellent shadow and highlight reproduction.

This situation is illustrated in Figure 2–42, where the density range of the negative is the same as the log exposure range of the paper, and the print has been correctly exposed. The nonspecular highlight in the negative will produce a density of approximately 0.04 above the base white of the paper, and the detailed shadow area of the negative will generate a density near 90% of the maximum black.

If the same negative and paper grade were used again, with a two-stop increase in print exposure, the condition illustrated in Figure 2-43 occurs. The result is a print without tonal separation in the shadows, as the shadow densities in the negative are located too far into the shoulder of the paper. Also, the highlights will be too dark because the highlight densities in the negativo will print too high with THE THE At the paper curve. If the same negative is primed on a grade of paper that is too hard, the condition in Figure 2-44 results. Here the print exposure has been adjusted to give adequate shadow detail, as the shadow densities of the negative are printing at the maximum useful point. However, the highlight densities extend far to the left of the minimum useful point with a complete blocking up of the print highlights. If the print exposure is increased to give better highlight reproduction, the shadows will print too far into the shoulder and begin to block up. Consequently, the odds of achieving a good print with this combination are slim. At this point we can summarize by saying that for pictorial images, the best print quality will generally occur when the density range of the negative equals the log exposure range of the paper, and the print is correctly exposed.

2.15 Condenser and Diffusion Enlargers

When the density range of the negative is known, the data in Table 2–4 can be used to select the correct paper grade. Notice that a grade 2 paper, which is often referred to as a "normal" grade, falls in the middle of the system and is used for printing negatives of intermediate (normal) contrast. Most development recommendations for the negative are based upon the goal of generating a negative with a normal density range allowing the use of a grade 2 paper.

There are two basic types of enlargers: diffusion and condenser. The diffusion enlarger employs a large integrating sphere or ground glass to illuminate the negative with scattered light, and is classified as a diffuse system. The condenser enlarger makes use of a set of lenses (condensers) above the negative so that the light from the bulb will be more concentrated when it strikes the negative, and is thus a specular system. When determining a negative's density range for the purpose of selecting the proper grade of paper, the similarity between the optical designs of the densitometer and the enlarger should be considered.

Since nearly all commercially available densitometers measure diffuse density, the resulting values usually can be directly applied to diffusion enlargers. However, as discussed earlier in this chapter, black-and-white negatives have greater density and contrast in a specular

2.16 The Effects of Enlarger Flare and Scattered Light

system. Consequently, the densities obtained from a diffuse-reading densitometer must be adjusted upward to convert them to specular densities. The exact value of this conversion factor (also referred to as a Q-factor) will depend primarily on the specularity of the enlarger and is best determined by testing the specific equipment. Many tests of condenser enlargers indicate that this factor is approximately 1.3. This means, for example, that a negative with a diffuse density range of 1.10 will actually have a density range of 1.43 (1.10 \times 1.3) in a condenser enlarger. To compensate for this discrepancy, Table 2-4 lists the diffuse density ranges for negatives when printing in either diffusion or condenser enlargers. Notice that the diffuse density range of a negative to be printed on a grade 2 paper in a diffusion enlarger can be between 0.95 and 1.14, while the diffuse density range of a negative to be printed on a grade 2 paper in a condenser enlarger is between 0.71 and 0.85. This is important to remember when determining the development time necessary to produce a "normal"-contrast negative. The aim diffuse density range of a negative to be printed using a condenser enlarger is approximately 0.81.

The contrast-index nomograph in Figure 2–28 contains desired density ranges for both diffusion and condenser enlargers. For example, if an average outdoor scene (ratio = 160:1; log range = 2.2) is being photographed and it is desired to have the negative printed on a grade 2 paper in a diffusion enlarger, a density range of 1.05 is desired. In this case the nomograph indicates that a contrast index of 0.58 is required. When the same scene is photographed with a desire to print on a grade 2 paper in a condenser enlarger, the aim density range is 0.81. Here, the nomograph calls for a contrast index of 0.47with a shorter development time necessary. To summarize, the development time necessary to produce a "normal"-contrast negative is highly dependent upon the grade of paper being used and the enlarger's optical characteristics.

2.16 The Effects of Enlarger Flare and Scattered Light

Flare light has the effect of reducing contrast in the enlarger as well as in the camera. With cameras, shadow contrast and detail are reduced by flare, but with enlargers the highlights are most affected.

Flare light in an enlarger originates with the light that bounces around inside the enlarger body and lens before reaching the printing paper as a uniform level of light. The amount of enlarger flare light will vary with the efficiency of the lens coating and the enlarger light-baffling system, and with the proportion of shadow-to-highlight areas in the negative. It will also depend upon whether the opening in the negative carrier is masked down to the area of the negative that is actually being printed. Because enlarger flare reduces the contrast primarily in the highlight areas, it has a more damaging effect on the image quality when it is excessive than camera flare, which reduces contrast mostly in the shadow areas.

2.17 Testing Enlargers for Flare Light

The existence of flare light in an enlarger can be demonstrated easily. Place a small piece of opaque black cardboard in a glass negative carrier without masking off the excess area around the card. Now make

Figure 2-45 Although a square black card placed in the enlarger's negative carrier transmitted no light, considerable flare light fell on the corresponding area of the easel. The white ring was produced by placing an opaque object on the enlarging paper to protect it from the flare light.

a print using a typical combination of exposure time and f-number. Since the black cardboard transmits no light, any light reaching the easel in the corresponding area can be attributed to flare. Figure 2–45, made in this way, shows considerable density in the image area of the square card compared to the smaller area, which was protected by an opaque object on the paper. Masking down the area around the black card in the negative carrier will reduce the amount of flare light reaching the paper. Masking off the entire surround will reduce the flare light to zero.

Figure 2-46 illustrates the effect of masking down the area around a negative. A $2\frac{1}{4} \times 2\frac{1}{4}$ -inch negative was placed in the glass carrier of a 5×7 -inch condenser enlarger. This provided a large unmasked area around the negative and considerable flare light. The difference in contrast between this print (left) and the comparison print (right), which was masked off, is obvious. Even allowing the 1/4-inch clear border on the negative to remain uncovered can result in sufficient flare light to produce a noticeable change in contrast. In fact, when enlarging a small area of a negative, a difference in contrast may be observed botween masking down in the smaller area that is actually being printed.

An enlarger can also be tested for flare light under normal printing conditions by placing a small opaque object on a negative in the carrier. The object should be small enough so that it does not significantly reduce the total amount of light transmitted through the negative. It will be easier to detect small amounts of density produced by flare light if a second opaque object is placed on the printing paper. This second object should cover half of the projected spot of the object on the negative.

Figure 2-46 The print on the left was made without must be used unumerative in a glass negative carrier. The increased contrast in the print on the right was produced by masking off the excess area.

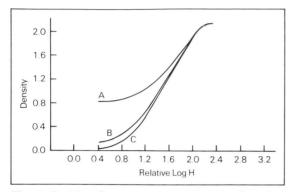

Figure 2-47 Characteristic curves showing the effects of masking off the area around a step tablet in an enlarger negative carrier. (A) No masking. (B) Masked down to 1/4 inch of the step tablet. (C) Masked down to the edge of the step tablet.

More can be learned about the nature of enlarger flare by making projection prints from a step tablet with and without masking off the area around the step tablet. A side-by-side comparison of the prints will reveal differences between the two images. Measuring the density of each step with a reflection densitometer enables the construction of characteristic curves demonstrating the differences graphically, as shown in Figure 2-47.

Curve A represents a high-flare situation where the area around the step tablet was not masked off. The excess area was masked down to within a quarter of an inch of the step tablet for curve B, and completely masked for curve C. It is evident that the enlarger flare most affects the print's lighter tones, and that the flare density increases dramatically with the size of the unmasked area around the step tablet.

In some prints the decreased image contrast produced by enlarger flare light results in improved image quality. In these prints the contrast would have been too high without the flare light. Thus the availability of controlled, variable flare light can be useful.

Flashing, which produces effects similar to those of flare, has long been used to control image contrast. The use of flashing as a contrast control in projection printing is limited by its inconvenience. Flashing usually requires removing the negative from the enlarger or setting up a separate light source for the flashing exposure.

A convenient, controllable flare or flashing feature, similar to that used on some slide copiers, would be a useful addition to enlargers. The same effect can be achieved conveniently with an enlarger equipped with adjustable masking blades and a glass negative carrier. This is accomplished by uncovering as much area around the negative as necessary to produce the desired amount of flare light. Flare light introduced in this way is distributed uniformly over the entire print area. Without adjustable masking blades, the same effect can be achieved with a series of different-size masks made from black paper or cardboard.

Controlled flare was used to reduce excessive print contrast in Figure 2–48. The first print, which is too contrasty, was made on grade 3 paper with the area around the negative masked off. The second print was made on the same grade of paper with the controlled addition of flare light achieved by uncovering part of the area around the negative. The third print was made on the next lower grade of paper with complete masking. The flare light introduced for the second print reduced the contrast about the equivalent of one paper grade without any noticeable loss of quality. Attempts to reduce the contrast by larger amounts usually result in unattractive grayed-over highlights. This technique is especially useful in obtaining in-between grades of contrast with graded paper.

Condenser enlargers produce higher printing contrast because with the specular (directional) illumination characteristic of such enlargers, the silver in the negative image scatters light away from the path through the lens by an amount that increases with the density a phenomenon known as the Callier effect. Thus there is little scattering in the thin areas and much in the dense areas, increasing the effective density of the dense areas and therefore the contrast of the projected image.

Two important factors influence the extent of the difference in print contrast obtained with condenser and diffusion enlargers due to the Callier effect. The first is that coarse-grained negatives scatter light more than fine-grained negatives. Anything that contributes to black-and-white negative graininess (including type of film, developer,

2.17 Testing Enlargers for Flare Light

Figure 2-48 The two prints at the top were both made on contrast grade 3 paper, but the basic exposure was reduced and a flashing exposure was added to decrease the contrast of the top right print. The print on the bottom was made on contrast grade 2 paper without flashing.

exposure level, and degree of development) will increase the light scattering by the negative image and, consequently, the print contrast occurring with condenser enlargers. Experimental determination of Callier factors for a fine-grained film (Kodak Panatomic-X) and a coarsegrain film (Kodak 2475 Recording) produced values of 1.16 and 1.40, respectively. (A Callier factor of 1.00 represents an absence of the Callier effect and therefore no difference in print contrast between condenser and diffusion enlargers.)

The second factor that affects the degree of scattering is the extent to which the illumination in the condenser enlarger is specular. The highest degree of specular light would be obtained with a point source of light and condenser lenses that focus all the light from the source at the enlarger lens. Opal bulbs, which are commonly used in

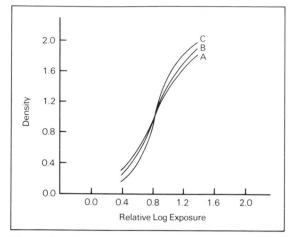

Figure 2-49 Tone reproduction curves for three prints made from the same coarse-grained negative on the same enlarging paper. (A) Diffusion enlarger. (B) Condenser enlarger with opal bulb. (C) Condenser enlarger with clear bulb.

Figure 2-50 Two prints from the same negative on the same enlarging paper. The print on the left was made with a diffusion enlarger, the one on the right with a condenser enlarger equipped with a clear bulb.

condenser enlargers, reduce the specular nature of the light. It is also possible to put a piece of ground glass above the condenser lenses to further diffuse the light when such an effect is desired. Since specular light makes graininess, dust, and scratches on the negative more obvious on the print, highly specular light is seldom desired in an enlarger except for certain technical applications where it is necessary to reveal maximum negative detail.

The curves in Figure 2–49 show the difference in print contrast between a diffusion enlarger and a condenser enlarger equipped first with an opal bulb and then with a clear bulb, using a negative made on a coarse-grained film. A similar picture comparison is shown in Figure 2–50 for the diffusion enlarger and the condenser enlarger with the clear bulb.

When comparing the two effects discussed above—flare light, which reduces print contrast, and the Callier effect, which increases print contrast—it is evident that they have opposite effects on print contrast. It should be noted, however, that the Callier effect increases the contrast proportionally from the shadows to the highlights in much the same manner as a higher contrast grade of printing paper increases the contrast. Flare light, on the other hand, reduces the contrast mostly in the highlight areas. The difference in tone reproduction between reducing contrast in this manner and using a lower contrast grade of paper becomes obvious only when the proportion of the exposure contributed by the non-image-forming light is sizable.

2.18 Paper Speeds

The speed of a photographic paper is inversely related to the minimum exposure necessary to achieve an excellent print. As was shown to be the case in the earlier discussion of pictorial film speeds, experimental evidence indicates that print exposure should be based upon *shadow detail reproduction*. Since the shadows fall on the shoulder

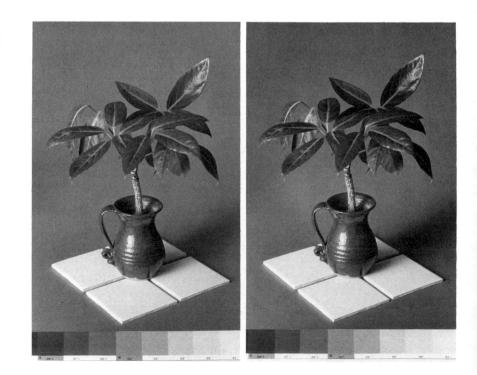

2.19 Determination of Printing Conditions

 Table 2-5
 Speeds for a family of paper grades.

Contrast Grade Number of Paper	Shadow Speed	ANSI Paper Speed
0	5000	1600
1	4000	1000
2	2500	500
3	2000	300
4	1600	200
5	1280	160

of the paper curve, the maximum useful point, located at 90% of the maximum density, is used as the speed point. The speed is referred to as a "shadow" speed, with the following formula being used:

Shadow speed =
$$\frac{1}{H} \times 10,000$$
,

where H = the exposure in lux-seconds needed to generate a density that is 90% of D max;

10,000 = a large constant that will convert the speed values to a convenient size.

The shadow speeds of the curves for the family of paper grades illustrated in Figure 2-41 are shown in Table 2-5, which indicates that the shadow speed decreases as the contrast of the paper (paper grade) increases. This means that a grade 4 paper is slower than a grade 2, and appropriate compensation must be made in the exposure time when changing paper grades. The actual speeds of various brands of the same grades of paper will be different, but the general relationship is that the higher the paper grade, the slower the speed.

An alternative method for determining the paper speed is based upon the exposure necessary to produce a *midtone* with a density of 0.60 above base plus fog. This is the current ANSI standard procedure for deriving the paper speed and is predicated on the assumption that proper midtone reproduction is most important. The resulting speed value is called the *ANSI Paper Speed* (sometimes ASAP) and is based on the following formula:

ANSI Paper Speed = $\frac{1}{H} \times 1,000$

where H = the exposure in lux-seconds needed to generate a density of 0.60 above base plus fog;

1,000 = a large constant that will convert the speed value to a convenient size.

The ANSI Paper Speeds for the curves in Figure 2-41 are shown in Table 2-5. The relationship between paper grade and speed is the same as before except that the differences in speed between paper grades are larger. Consequently, when changing paper grades, exposure corrections based upon ANSI Paper Speed differences will necessarily be different from those derived from shadow speeds. Some brands of photographic paper show curves similar to those illustrated in Figure 2-51. Since all the curves cross at a density of 0.60 above base plus fog, they will all show the same ANSI Paper Speed. The shadow speed obviously will be different since the position of the shoulder is changing. When printing to a midtone with these emulsions, no change in print exposure would be required as a function of changing paper grades. However, when printing for the shadows, significant changes in print exposure would be needed when changing grades.

2.19 Determination of Printing Conditions

The contrast data shown in Table 2-4 and the speed data in Table 2-5 provide practical information for determining proper printing conditions. For example, if we were printing a negative having

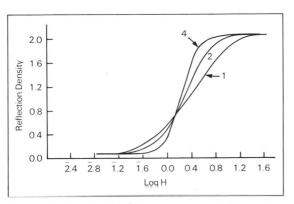

Figure 2-51 Family of paper contrast grades showing the same ANSI paper speed but different shadow speeds.

2.19 Determination of Printing Conditions

a shadow density of 0.40 and a highlight density of 1.50 on a diffusion enlarger, the density range of the negative would be 1.10 (1.50 - 0.40) and a grade 2 paper would be needed. If, as a result of trial and error, we determined that a printing time of 20 seconds at f/8 produced an excellent print, these conditions could be used to predict the printing characteristics of a wide variety of negatives.

Consider a second negative with a shadow density of 0.70 and a highlight density of 1.80, to be printed with the same enlarger. Since the density range of 1.10 (1.80 - 0.70) is the same as that of the first negative, a grade 2 paper is appropriate here as well. However, the second negative is denser than the first by 0.30, and the printing time must be increased to compensate for the additional light-stopping ability. The factor is found by taking the antilog of the density difference as follows: antilog of 0.30 = 2.0. Thus the second negative should be given twice the print exposure of the first, which may be achieved by doubling the printing time to 40 seconds or opening the aperture one stop to f/5.6.

Suppose a third negative has a shadow density of 0.40 and a highlight density of 1.75 and is to be printed on the same enlarger. Referring to Table 2–4, a grade 1 paper is needed to accommodate the 1.35 density range of this negative. Since we believe it is better to print for the shadows, we must compare the shadow speeds of the two emulsions. Table 2–5 indicates that a grade 1 paper has a shadow speed of 4000 while the grade 2 has a shadow speed of 2500. Thus the grade 1 paper will need less print exposure as dictated by the ratio of two speeds: 4,000/2,500 = 1.6. This means that the initial printing time of 20 seconds should be divided by 1.6 to give the correct printing time for the new grade of paper. Since the shadow density of this negative is the same as the first, no compensation is required for density level.

If a fourth negative has a shadow density of 0.60 and a highlight density of 1.45 and is to be printed with a diffusion enlarger, a grade 3 paper is needed. Now we must compensate for two changes since both the shadow densities and the paper speeds are different. This negative has 0.20 more density than the first and therefore will require 1.6 times (antilog of 0.2 = 1.6) the original exposure. The speed of the grade 3 paper is 2000 compared to 2500 for the grade 2, giving a ratio of 2,500/2,000 = 1.25. Since the new paper grade is slower than the first, the exposure must be increased for this factor also. Therefore, the printing time for the fourth negative is found by multiplying the old printing time by both factors: $1.6 \times 1.25 \times 20$ seconds = 40 seconds.

This approach to predicting the printing conditions of specific negatives will work for either a condenser or a diffusion enlarger. The key is to obtain a set of standard data initially by trial and error with the enlarger to be used for future negatives, and to obtain the contrast and speed data for the emulsions on which they are to be printed. Since the manufacturer's data were quite likely derived under different conditions, it is imperative that the sensitometric properties of the emulsions be determined under the conditions of practice. When these conditions have been met, such "off-easel" densitometry of negatives provides a highly accurate and productive method for printing negatives. In addition, the negative can be placed in the enlarger and projected onto the easel, where the shadows and highlights may be measured with a special "enlarging" meter. Such "on-easel" densitometry involves the same concepts as previously discussed except that

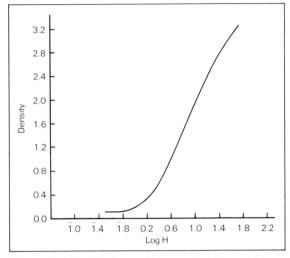

Figure 2–52 The characteristic curve of a film positive emulsion.

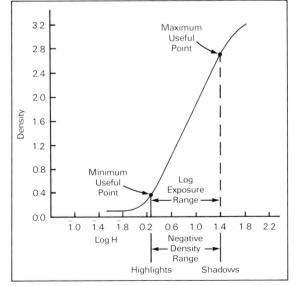

Figure 2-53 The relationship between the density range of the negative and the useful log exposure range of the film positive emulsion for a correctly exposed image.

2.20 Analysis of Positive Film Curves

this technique automatically compensates for the specularity of the enlarger since the measurements are made where the image of the negative comes to a focus at the easel.

2.20 Analysis of Positive Film Curves

An alternative to printing on photographic paper is to use a relatively high-contrast film, which will yield a positive transparent image that can be viewed by either back illumination or projection. The films used for this purpose are called *film positive emulsions* or release print films. They typically have slow speed, very fine grain and inherently high contrast with gammas varying between 1.8 and 2.8, depending upon the developer formulation and development time. The characteristic curve for such an emulsion is shown in Figure 2–52, where it can be seen that the slope is quite steep.

In principle, the production of film positives from negatives is similar to that of reflection prints except that the contrast of the emulsion being printed upon can be controlled readily by development. This eliminates the need for various contrast grades. Experience indicurve illum ille milliminin meneral point on the lillin positive curve for good highlight reproduction is approximately 0.30 above the density of base plus fog. If the highlights are reproduced with a greater density than this, they appear too dark, and if the density is any less, they look "washed out." Although these films are capable of achieving densities over 3.0, the shadows are best reproduced at densities of 2.7 and less depending upon the contrast of the negative. Since the density range of which the film positive is capable is far greater than that of photographic paper, subjects with high luminance ratios can be faithfully reproduced. The relationship between the density range of the negative and the film positive curve is illustrated in Figure 2-53 for a correctly exposed and processed image. Notice that the slopes in both the highlight and shadow regions of the curve are greater than those of a photographic paper. The resulting film positive will have greater tonal separation in those areas than a reflection print made from the same negative.

There is no standard method for determining the speed of positive films, but speed points based upon either highlight or shadow reproduction are commonly used to calculate speed values. The highlight method involves determining the exposure necessary to produce 0.3 above base plus fog density using the following formula:

Speed =
$$\frac{1}{H} \times 1,000$$
 .

The midtone method employs the same formula, except that the exposure necessary to generate a density of 1.0 above base plus fog is used. Shadow speeds are seldom used for these films because the steep slope in the shadow region of the curve assures that good shadow detail will be maintained. Therefore, print exposures are generally based upon either highlight detail or midtone density. Regardless of which speed method is used, the speed of film positive emulsions are highly dependent upon the degree of development. Figure 2–54 shows a family of curves for different development times of a film positive emulsion. The curve shifts to the left, indicating an increase in speed, as development time lengthens. Thus close attention must be given to the details of development if consistent results are to be obtained.

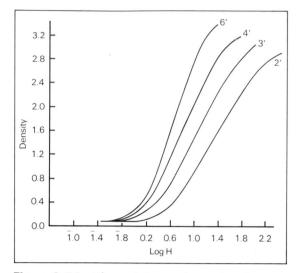

Figure 2–54 Characteristic curves for a variety of development times of a film positive emulsion.

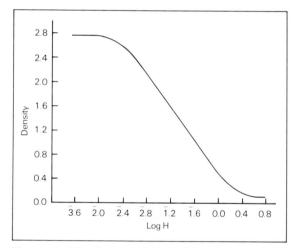

Figure 2–55 Characteristic curve of a reversally processed film.

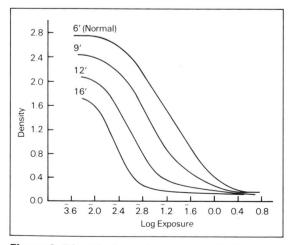

Figure 2–56 The characteristic curves resulting from different first development times for reversally processed film.

By printing on film positive emulsions, the photographer can overcome the single greatest limitation of the negative-positive system: the low maximum density produced by photographic papers. The wider density range of the film positive results in images with greater physical and visual contrast. Not only will the tonal range appear greater, but the shadows and highlights will have more detail and brilliance. Ideally, film positives should be viewed on a transparency illuminator in a darkened room with the surround masked off to obtain the greatest visual contrast. If the image is placed in a projector and viewed on a screen under typical conditions, the image contrast is drastically reduced as a result of both optical flare and ambient room light reaching the screen. Even under these conditions, the contrast of projected images still exceeds that of reflection print images.

2.21 Analysis of Reversal Film Curves

The generation of a positive, transparent image may also be accomplished through a procedure called *reversal processing*. In this method, a film that was exposed in the camera is first developed to a negative, without fixing. In the next step, a bleach bath dissolves the negative silver image leaving unexposed silver halide in amounts opposite to those of the negative. This unexposed silver halide is exposed (fogged) by flashing to light (or is chemically fogged) and then developed to give the desired positive image. The second development is followed by fixation, washing and drying. The result is a black-andwhite transparency produced on the original film exposed in the camera.

The characteristic curves for reversal materials are plotted in the same manner as those of negative working emulsions except that the direction of the curve is reversed. This is necessary because with reversal materials the density decreases as the exposure becomes larger. Consequently, the shadows and darker tones are reproduced as high densities while the highlights and lighter tones yield small densities. The D-log H curve for a typical reversally processed film is shown in Figure 2-55. The curve exhibits a steep middle section, which is necessary to give sufficient contrast to the image, since it will be viewed directly. This results in a shortened useful log exposure range, meaning that the exposure latitude is small and scenes with excessive contrast cannot be properly reproduced. In fact, most reversally processed emulsions do not exceed a 1.90 useful log exposure range. Although many negative working films may be reversally processed, emulsion manufacturers usually design or designate specific films to be processed using the reversal method.

Since the reversal process involves more major steps than the negative process, the influence of processing changes on the curve shape is more difficult to ascertain. The effect of varying the time of first development while all other steps are held constant is illustrated in Figure 2-56. The first development time has a significant effect upon all of the sensitometric parameters of the film. As the first development time is lengthened, the maximum density of the positive image becomes lower due to an increase in the fog density at the negative stage. The minimum density also decreases slightly because of the increase in the shoulder density at the negative stage. Increases in the slope of the curve are most noticeable in the toe region, indicating a small gain in contrast.

The effect on speed of altering the first development time is shown in Figure 2-57. The speed point was located at a density of

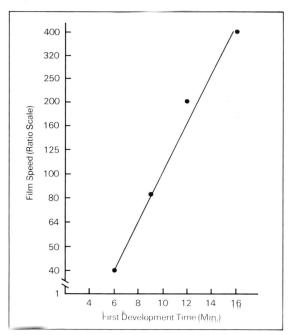

Figure 2–57 First development time vs. film speed for reversally processed film.

1.0 above base plus fog, and the speed was calculated using the following formula:

Speed =
$$\frac{1}{H} \times 10$$
.

The graph indicates that the speed of reversally processed films can be increased by up to 10 times by lengthening the time in the first developer. However, the speed increase is coupled with a decrease in the maximum obtainable density, which results in poor shadow reproduction. When the maximum density falls below 2.0 for transparencies, shadow-detail reproduction is usually unacceptable. The increased contrast in the midtones may also contribute to an inferior result.

2.22 Introduction to Photographic Effects

Most of the time, the response characteristics of photographic matchals and processes are quite predictable based upon the principles discussed thus far. However, there are conditions where the resulting photographic image does not have the characteristics that were anticipated. Although the making of photographs is a relatively simple task, the response properties of photographic materials are quite complicated. An understanding of conditions that can lead to unexpected results will be most beneficial in mastering the photographic process. Some of these photographic effects are considered in the sections which follow.

2.23 Reciprocity Effects

In 1862, two scientists, Robert Wilhelm Bunsen and Henry Enfield Roscoe, proposed a general law for photochemical reactions stating that the end result of a primary photochemical reaction is simply dependent upon the total energy used, regardless of the rate at which the energy is supplied. Photography involves a photochemical reaction in which light is used to expose film or paper to form a usable latent image, and chemistry is used to develop a visible silver or dye image. The end product (density), however, is not dependent simply upon the total energy (exposure), but also on how that exposure is distributed in terms of illuminance and time. For example, two pieces of film can receive equal exposures that may result in different densities because the exposure times and illuminances are quite different. Exposure (H)is a product of illuminance (E) and time (t). An illuminance of 2 lux for 1/100 second produces the same exposure (.02 lux-seconds) as an illuminance of .002 lux for 10 seconds. Because the response may be different for these two exposures, the reciprocity law of Bunsen and Roscoe is said to have failed.

Early literature described this situation as "reciprocity law failure" (RLF). Current literature simply refers to it as "reciprocity failure" or "reciprocity effect" to distinguish it from Bunsen and Roscoe's reciprocity law, which holds true for *primary* photochemical reactions such as print-out images on silver chloride printing-out paper. The law is also valid for x-ray and gamma-ray exposures with silver halide emulsions and light exposures with certain non-silver processes such as diazo and selenium electrostatic processes. Reciprocity failure in photography simply means that the *response* (density) of a photographic material cannot be predicted solely from the total exposure a film has received (except over a small range

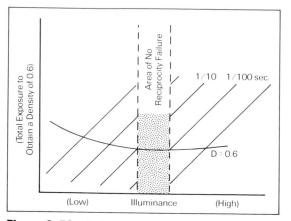

Figure 2–58 Reciprocity curve. A straight horizontal line would represent no reciprocity failure.

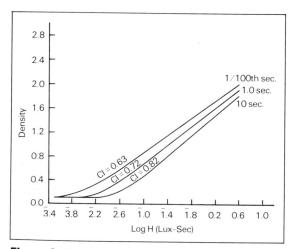

Figure 2–59 Low-illuminance (long exposure time) reciprocity failure.

of exposure times). For pictorial films, the range over which reciprocity failure is negligible is from about 1/10 second to about 1/1,000 second. Beyond these time limits, reciprocal combinations of exposure time and illuminance, which give the same total exposure, will not give the same density response. As an example, if a meter indicates camera exposure settings of f/5.6 and 1/30 second, but because greater depth of field is needed the lens is stopped down to f/45 and the film is exposed for two seconds, the resulting densities will not be the same even though the combinations of camera settings were equivalent. The two-second exposure will result in a thinner negative. Density will be less for exposure times longer than 1/100 second or shorter than 1/100 second. In other words, the film will be underexposed even though the subject was metered correctly, the right camera settings were used, and development was correct. This is an example of reciprocity failure or the reciprocity effect.

In addition to the loss in density already noted, reciprocity failure can change image contrast. The extent of the changes in density and contrast depends upon the combination of illuminance and exposure time and the charactersitics of the emulsion. The reciprocity curve in Figure 2–58 shows the relationship between the total exposure (on the vertical axis) required to obtain a given density of 0.6 and the various combinations of illuminance (horizontal axis) and time (45° lines). If there were no reciprocity failure, the curve would be a straight horizontal line, and the same exposure, regardless of the reciprocal combinations of illuminance and time used, would give the same density. This is true over a limited range of illuminances and times as indicated by the bottom part of the curve, which is almost flat. (Although reciprocity curves will generally differ from one product to the next, they will have the same shape except for certain special emulsions.) (Also see Section 7.46.)

2.24 Low-Illuminance Film Reciprocity

Reciprocity failure is often encountered in low-light-level photography, and it is commonly the reason for thin, underexposed negatives. The sensitometric effect of low-illuminance reciprocity failure for a pictorial film can be seen in Figure 2–59. All three films were given the same exposure, employing reciprocal values of illuminance and time to allow the use of three different exposure times. The same conditions of development were used for each. If there were no reciprocity failure, the three curves would have the same shape and be superimposed. The fact that the 1-second and 10-second curves are displaced downward indicates a progressive loss of film speed as the exposure time increases. In other words, when using exposure times of one second and longer for this emulsion, additional exposure is required to obtain the expected image *density*.

Adjustments need to be made in development as well as exposure for long exposure times at low light levels. The reason for this can be seen in Figure 2-59. In addition to the displacement of the curves, the curves differ in slope.

As the exposure times reach one second and longer, there is a significant increase in slope and thus image contrast. Whereas an exposure time of 1/100 second with normal development produced a contrast index of 0.63, an exposure time of 10 seconds with the same normal development produced a negative with a contrast index of 0.82 about a 30% increase in contrast. This is caused by the fact that lowintensity reciprocity failure affects the lower density areas more than

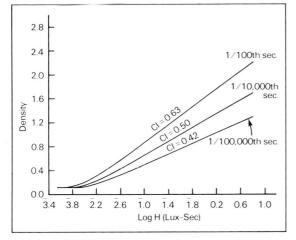

Figure 2–60 *Higb-illuminance (short exposure time) reciprocity failure.*

Figure 2–61 Each set of strips received the same equivalent exposure, but for different combinations of time and illuminance. The set to the right exhibits more reciprocity effect. the higher density areas. Thus, in order to obtain the expected image contrast in the negative, a *reduction* in development is necessary. Since altering the degree of development also affects density, the reciprocity failure exposure factor will be larger than it would be if the degree of development is not adjusted for the anticipated increase in contrast with long exposure times.

Low-illuminance reciprocity failure requires an *increase* in exposure along with a *decrease* in development to adjust for contrast. If only the exposure correction is made, the negative may have to be printed on a lower grade of paper than usual to adjust for the increase in contrast index of the negative.

2.25 High-Illuminance Film Reciprocity

Exposure of films for times shorter than 1/1,000 second, as with some electronic flash units, results in decreased density. The decrease is largest in the highlight areas, with negative-type films producing a lower-contrast image. An exposure increase and an *increase* in decembrance of the number of the compensate for thils.

The characteristic curves in Figure 2–60 illustrate the effect of high-illuminance reciprocity failure. All three films received the same total exposures, using reciprocal values of illuminance and time to obtain shorter exposure times. Development conditions were kept constant. Notice that the 1/10,000- and 1/100,000-second curves are also displaced downward, indicating a loss of film speed. It is important to notice that under these conditions the curve shape changes in a manner opposite to that with low illuminance. Specifically, the slope of the curve decreases at exposure times of 1/10,000 second and less, indicating a loss of contrast. Observe, however, that contrast increases with increasing exposure time, for both low illuminance and high illuminance reciprocity failure. If only an exposure adjustment is made, the negative would have to be printed on a higher contrast grade of paper to adjust for the loss of contrast in the negative.

2.26 Black-and-White Paper Reciprocity

Since reciprocity effects are exhibited by *all* photographic emulsions, they can be seen easily by printing on any photographic paper and using a series of increasing exposure times, as shown in Figure 2–61. A photographic step tablet was first printed at a relatively

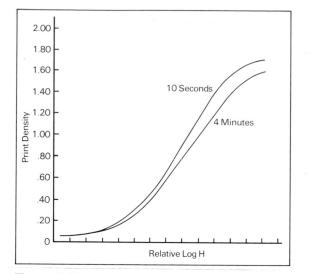

Figure 2-62 Excessively long printing times result in a decrease in paper contrast as well as speed. (The loss in paper speed has been adjusted to emphasize the loss in contrast.)

short exposure time of 10 seconds at f/5.6, then for each subsequent print the exposure time was increased as the illuminance was proportionally decreased by stopping the lens down and adding neutral density filters. The density decreased progressively even though *each test strip received the same series of photographic exposures*—as the illuminance decreased, the exposure time increased, and the development remained the same.

Noticeable reciprocity failure with printing papers is seldom encountered when using normal negatives. It is a problem, however, when printing a severely overexposed and/or overdeveloped negative to a large magnification. With the aperture wide open, the usual way to increase exposure is by lengthening print exposure *time*. Because of reciprocity failure, increasing print exposure times does not give the expected increase in image density.

Reciprocity failure also presents a problem when a highdensity area in the negative has to be manipulated by "burning-in" or where high magnifications are required such as in printing photo murals or in printing small areas of a negative to a large print size.

In addition to a loss in speed with printing-paper reciprocity failure one can also expect a loss in contrast. This is illustrated in Figure 2-62. The 240-second (four-minute) curve has been adjusted for the speed loss so that the loss in contrast is more apparent. Whereas one can expect reciprocity failure to cause an increase in contrast for films exposed for relatively long times (low illuminances), a decrease in contrast for print papers can be expected.

2.27 Color Paper Reciprocity

Figure 2–63 shows six color prints made from the same color negative. The prints received identical total exposures but with increasing exposure times (4, 8, 16, 32, 64, 128 seconds) and decreasing illuminances. Color balance and print density were based on the foursecond exposure time used for print No. 1. At about 16 seconds the overall density begins to drop and continues to drop as the exposure time increases. Over a range of four seconds to just over one minute, however, there is no noticeable shift in color balance. In terms of reciprocity effect this is an exceptionally good color printing paper. No filters are required to adjust for long printing *times*, simply an increase in exposure.

2.28 Color Film Reciprocity

Figure 2-64 illustrates reciprocity failure curves for a color reversal film. The curves represent constant density lines for the cyan, magenta, and yellow dye layers of the film. Multilayer color films require the balancing of at least three different emulsions so that their

> Figure 2-63 Reciprocity effect for Ektacolor Printing Paper. All the prints received the same total exposure but the exposure times for each print increased by a factor of two (4, 8, 16, 32, 64, 128 seconds). Although there is a decrease in density as print exposure times are extended to one minute, there is no significant shift in color balance. (Photographs by Gary Hadlock.)

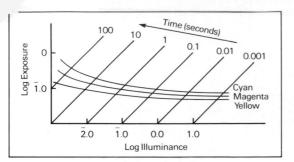

Figure 2-64 Reciprocity failure for a reversal color film. The reciprocity characteristics are made to match over a limited range of exposure times. Beyond those times the three different emulsions exhibit different degrees of reciprocity failure.

reciprocity failure characteristics, over an extended range of exposure times, are similar. For the color film represented in Figure 2–64, the reciprocity failure characteristics are similar over a range of exposure times between approximately 1/10 and 1/1,000 second. (This assumes that processing is in accordance with the manufacturer's recommendations.) When exposure times longer than 1/10 second are used, adjustments to the exposure given each of the three layers must be made. This is usually done by adding the proper color filter and increasing the exposure.

2.29 Intermittency Effect

A discontinuous exposure of 1/50 second + 1/50 + 1/50+ 1/50 + 1/50 at a given illuminance may not produce the same density as a continuous exposure of 5/50 or 1/10 second at that same illuminance, even though the total exposure for the discontinuous (intermittent) exposure is the same as that of the continuous exposure.

During an intermittent exposure, the total exposure consists of a series of on and off-times. As the off-times get shorter and shorter, a point is reached at which the photographic emulsion no longer distinguishes between the intermittent exposure and the continuous exposure with the same total amount of light. (A similar phenomenon occurs in the human visual system. A television picture looks continuous even though the individual phosphors are not on continuously. The same is true for fluorescent lights, which are perceived as continuous even though they emit light intermittently.)

An intermittent exposure and a continuous exposure of the same *average* illuminance produce equal densities when the frequency of the exposures reaches or exceeds a certain critical value. This value will vary with the illuminance level.

With color materials, the intermittency effect can cause the same color balance problems as reciprocity failure does, since each of the three emulsion layers can react differently. (Also see Section 7.46.)

2.30 Clayden Effect

A high-intensity exposure of short duration followed by a low-intensity exposure of long duration can cause a reversal of an image. A classic example is "black lightning" photography, illustrated in Figure 2–65. A high-intensity bolt of lightning was followed by a lowintensity afterglow while the camera shutter was left open.

The occurrence of the Clayden effect is somewhat unpredictable because it depends on the emulsion used. Practical applications of the Clayden effect include the making of prescreened lithographic film and other types of masking. The purchased lithographic film contains a first high-intensity exposure through a halftone screen, which locally desensitizes the film for the later image exposure. When the image exposure is made, it is reproduced as a halftone dot pattern.

2.31 Herschel Effect

Originally, the term *Herschel effect* was used to describe the destruction of a visible print-out image by a second exposure to red light. The term now is associated with the partial destruction of a latent image when given a second exposure to red light or infrared radiation. The effect is best observed with materials that have little or no sensitivity

Figure 2–65 The Clayden effect ("Black Lightning"). A high-intensity exposure followed by a low-intensity exposure can result in a reversal of density. (Courtesy of Kodak Museum, Harrow, England.)

to red or infrared radiation. Only photographic papers and films that are "colorblind" (blue sensitive) or orthochromatic (blue and green sensitive) meet this requirement.

2.32 Latensification and Hypersensitization

Latensification and hypersensitization are ways in which the effective speed of a photographic material can sometimes be increased. These effects are accomplished by giving the photographic material a uniform fogging exposure or by soaking it in a chemical solution. The treatment is similar for both latensification and hypersensitization. The sequence in which the treatment is given distinguishes the two effects. If the treatment is given *before* the image exposure is made, the term *hypersensitization* is used. When the treatment is given *after* the image exposure is made, the term *latensification* (latent-image intensification) is used.

A relatively new technique for hypersensitization called "gashypering" was reported in *Sky and Telescope*.¹ Film such as Kodak 2415

¹Everhart, E., 1981.

soaked in a forming gas mixture of about 92% nitrogen and 8% hydrogen for several hours at 63 C significantly reduces the reciprocity effect associated with long exposure times. At exposure times on the order of 20 minutes, a speed correction of about 8X can be realized. Figure 2–66 compares a Kodak Spectroscopic film type 103a-0 with a gas-hypersensitized 2415 film. The speeds are comparable at the exposure times used. The 2415 film shows much better resolution (320 lines/mm vs. about 80) and considerably less granularity (an rms granularity of 8 vs. 30).

2.33 Sabattier Effect

Photographic film or paper that is partially exposed to imageforming light and partially developed (but not fixed) can, if re-exposed with uniform illumination, developed and fixed, result in a partial reversal of tones. The reversal is most noticeable in the areas receiving the least exposure: the shadow areas for film and the highlight areas for paper. In addition to a partial reversal, the edge or contour of a

Figure 2-66 Photographs of the 12th-magnitude spiral galaxy NGC 7606 in Aquarius taken on Kodak Spectroscopic Plate Type 103a-0 (left) and hypersensitized Kodak 2415 film (right). Note the improved resolution and decreased graininess with the 2415 film. (Photographs by Dr. Edgar Everhart, University of Denver.)

shape is often strongly enhanced. This dark line effect, referred to as a Mackie line, and partial reversal of tones can be seen in Figure 2– 67. To obtain the Sabattier effect, no special equipment or solutions of any kind are required:

- 1. Give the film or paper a somewhat less than normal image exposure.
- 2. Develop for about half the normal development time.
- 3. Rinse in water (do not use a stop-bath or fixing solution).
- 4. Reexpose by fogging to light for a brief time.
- 5. Return the film or paper to the developer and develop for the other half of the normal time.
- 6. Rinse, fix, wash, and dry as you normally would.

(For single sheets of film or paper the rinse step can be eliminated. The second exposure can be made while the film or paper is in the developer. Allow the solution to settle for about 10 seconds, however, before making the second exposure.)

Some experimentation may be required to get the desired results. The ratios of first to second exposure and first to second developing times are important variables. Figure 2-68 shows that decreasing the first development time and increasing the second development time while keeping the fogging re-exposure constant increases the amount of tone reversal.

The Sabattier effect can appear if the fogging exposure is accidentally given during first development, as with unsafe "safelights." Applications of this effect have mainly been associated with interesting

Figure 2-67 The Sabattier effect (top). Note the partial reversal of tones and the black line along some of the contour.

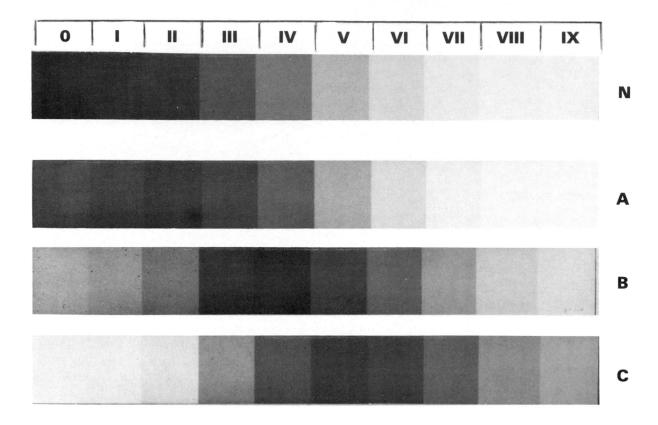

Figure 2-68 Gray scales showing the Sabattier effect. Gray scale prints made from Kodak Super XX Pan Film processed for various combinations of first and second development times. (Films all received the same first and second exposures.)

	Development Times					
Gray Scale	1st Dev.	2nd Dev.	Total (minutes)			
N	6	0	6			
Α	4	2	6			
В	3	3	6			
С	2	4	6			

pictorial effects, but the line effect has been used, for example, to enhance the sharpness of spectrographic images. When the Sabattier effect is used with color negative or reversal materials, changes in hues, lightness, and saturation can be produced by varying the spectral energy distributions of the two exposures.²

2.34 Solarization

Increasing exposure increases density until a maximum density is reached. Extreme overexposure can result in a loss of density and reversal of the heavily exposed areas. Figure 2–69 shows a severely overexposed negative that resulted in a complete reversal of the sun. The degree of solarization depends on the particular film or paper and the developer used.

²Kodak, 1984, p. 64.

Figure 2-69 An example of solarization due to extreme overexposure of the sun. Photography by Les Stroebel.

2.35 Micro-Edge Effects

Edge effects can be studied by examining what occurs within an emulsion at the edge or boundary between high and low exposures, noting that edge effects apply only for micro-distances of less than 1mm. The sequence of events that takes place is illustrated in Figure 2-70. During development, the high-exposure area produces a high concentration of reaction products, which restricts development in the area of high exposure and, by diffusion, in the adjacent area of low exposure. In the low-exposure area, there is a low concentration of reaction products and a high concentration of fresh developer. The diffusion of fresh developer from the low-exposure area to the adjacent high-exposure area will cause less decrease in density just inside the high-exposure area. Density is actually decreased on both sides of the edge (Figure 2-70C), but the contrast is higher near the edge than elsewhere in the high- and low-exposure areas. This contrast amplification on a microscale at the edge is seen as an increase in contrast on a macroscale that includes the larger areas.

The schematic illustration in Figure 2-70C corresponds to the microdensitometer trace of density vs. distance in Figure 2-71.

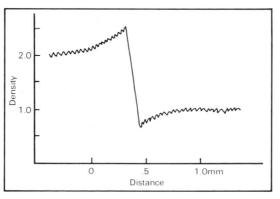

Figure 2-71 Edge effects. A microdensitometer trace of an image shows an increase in the density difference at the very edge. (The film was developed without agitation to maximize the effect.) The denser used is identified as a border effect and the thinner area is known as a fringe effect.

△ Unexposed △ Exposed 1 mm After Exposure **Reaction Products** Fresh Developer **A** ^ **A** ^ **A** A **A A A A A A** 1 mm B During Development Mackie Line 1 mm C The Developed Edge Image

Figure 2–70 Stylized cross section of film that has been exposed and developed to show how the exchange of fresh developer and reaction products of development increases the density difference at the very edge of an image.

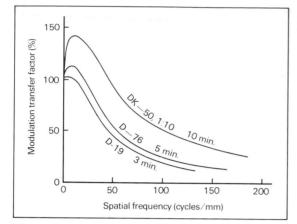

Figure 2-72 Modulation transfer functions for Kodak Plus-X pan film developed in Kodak developers D-19 and D-76 with brush agitation and in dilute Kodak developer DK-50 without agitation. (Thomas, W., 1973, p. 956)

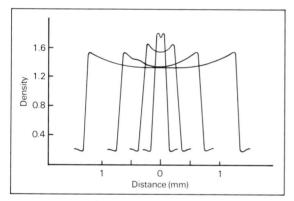

Figure 2-73 The Eberhard effect. A microdensitometer trace showing how areas of different size given the same exposure and development produce different densities. The bighest density is reached at an image width of about 0.1 mm.

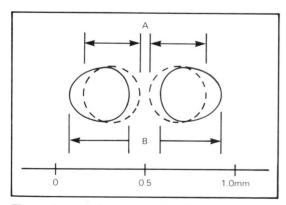

Figure 2-74 The Kostinsky effect. Development is restricted in the area between two small images adjacent to each other. This results in a slight displacement (from A to B) and distortion of the images. (The dotted line represents the optical image, solid lines the developed image.)

The increase in density on the high-density side of the edge appears as a faint dark line and is called a *border effect*, while the decrease in density on the low-density side is seen as a corresponding faint light line and is called a *fringe effect*. Since these effects are a characteristic of the photographic process, they cannot be eliminated; nonetheless, they can be minimized or maximized. Maximization increases contrast, acutance, and modulation transfer functions (MTF) at low frequencies as shown in Figure 2–72. When photography is used as a photometric instrument, edge effects should be minimized, since they not only affect the change of density at the edges, but, as we shall see, they also can alter the shape of adjacent small images.

2.36 Adjacency Effects

When two or more edges are adjacent and in micro-proximity, the interaction results enhance the contrast of both edges. The Eberhard effect, illustrated in Figure 2–73, shows microdensitometer traces across four photographic line images of decreasing width from about 2,000 microns (2mm) to several microns. Note the enhancement of the edges and the increase in density as the line images narrow.

When two or more very small images of high exposure are adjacent to an area of low exposure, the shape of the developed image will change, and the distance between image centers will increase with increased development. This has been named the Kostinsky effect. Such effects are encountered in photographing close spectrum lines and double stars. They also can be a problem in resolving-power measurements. Figure 2-74 is a representation of how two small areas of similar shape might be altered.

2.37 Color Interimage Effects

Since conventional color films and papers begin as blackand-white silver halide emulsions, they are vulnerable to the same microdevelopment edge effects and adjacency effects under discussion. The problem, of course, is somewhat aggravated since color films consist of three stacked emulsion layers that first record a scene in terms of three silver images, and are then converted to three dye images colored cyan, magenta, and yellow. One development effect peculiar to color materials is the *interimage effect*.

If a color film or paper is given a separate exposure only to red, green, or blue light, the density response of the corresponding cyan, magenta, or yellow dye layer may not be the same as that with the same amount of red, green, or blue light produced by a white light exposure; this effect is shown in Figure 2–75. A sample of film was exposed to narrow-band red light and developed, and another sample was exposed to broad-band white light and developed. Density plots are in terms of analytical equivalent neutral densities (ENDs). A separate exposure to red light produces a cyan dye curve more contrasty and having a higher slope than the one produced with white light. Similar results could be expected for the magenta and yellow layers. The practical consequence is that one cannot predict the behavior of film under the variety of practical exposure conditions from simple white-light sensitometric tests.

Film is seldom exposed to white light, but rather to objects that reflect portions of the incident white light. Red, green, or blue

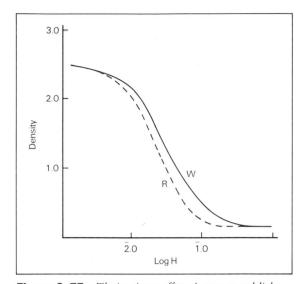

Figure 2-75 The interimage effect. A separate red-light exposure (R) produces a cyan curve different from the one produced by a white-light exposure (W). In each case the film received the terms $\frac{1}{2} + \frac{1}{2} + \frac{1}{2}$

Figure 2-76 Bromide streaks.

objects simply reflect the red, green and blue components of white light. Neutral (white, gray, black) objects reflect "equal" amounts of the red, green, and blue light contained in the white-light source. Picture a scene in which a young lady wearing a gray sweater is holding a bouquet of red roses. Assume that the areas on the film exposed to the gray sweater and red roses receive "equal" amounts of red light. In this situation the amount of cyan dye formed would be different: more for the red roses in a color negative film, less in a color reversal film. The reason is that for the red roses, little exposure is given to the yellow and magenta layers in the color negative, and, therefore, little development occurs in that immediate area for the yellow and magenta layers. The fresh developer is available for the nearly exclusive use of the cyan layer. This, however, is not the situation for the cyan layer in the area exposed to the gray sweater. Here all three layers are exposed, and they compete for the fresh developer.

2.38 Development Effects

One of the harmonic in monoport is bronning (such as potassium bromide), which acts to inhibit or restrain development. High concentrations of bromide restrainer are formed in areas of high exposure. Unless the concentration is dispersed by effective agitation, the restrainer will tend to restrict further development in these areas of the film, and, because of diffusion, it will restrict development in the areas immediately adjacent. This results in low-density streaks or streamers (*bromide streaks*), Figure 2–76. When dark streaks are caused

Figure 2–77 Directional effects. Curve A: Dense end of the sensitometric strip leads; opposite for curve B.

Figure 2-78 Sprocket hole effect.

by poor agitation it is because areas of low exposure provide additional fresh developer for adjacent areas, thereby increasing development in those areas. Dark streamers ooze from areas of low exposure and density, while light streamers result from nearby areas of heavy exposure and high density.

If film is made to move in a single direction during processing, and if the agitation is inadequate, the leading edge of the film will receive greater development than the trailing edge. To test for this directional effect, place two sensitometric step-tablet exposures side by side on film, with the heavily exposed end leading on one, the heavily exposed end trailing on the other. The result of such a test is shown in Figure 2-77.

Films with perforated edges, such as motion picture films and 35mm still-camera films, present a special problem. As the film passes through the developer, the sprocket holes cause increased local agitation and, therefore, increased density around the holes (see Figure 2-78). If there is adequate agitation, however, the increased local agitation or turbulence has little effect. Good agitation of such films is particularly important when either a density sound track or telemetering information is contained along the side of the film.

2.39 X-Ray Fog

Photographic film and paper can be fogged by X-radiation, including the low-level X-radiation given off by detection equipment found in airports. In the U.S., such equipment is regulated by law to produce no more than a relatively low level of one milliroentgen of radiation. (A roentgen is a unit of X-radiation named in honor of Wilhelm Konrad Roentgen, who discovered the radiation in 1895 and designated it X because he was not sure what it was.)

Film or paper that has been fogged by X-rays may exhibit a faint sharp-edged "shadow" if any object is in contact with or close to the emulsion (see Figure 2–79). This is particularly noticeable in uniform areas. The "shadows" projected by the X-rays that are blocked by objects in their path will appear as *lighter* areas on a negative and *darker* areas on the print as well as on reversal-type materials.

The danger of X-ray damage to photographic film is slight for those who fly in the U.S. and other countries using low-level Xradiation. Several factors, however, can contribute to a visible fogging of film:

- 1. Film that has had repeated screening is more likely to exhibit fog since exposures are cumulative.
- 2. Some overseas airports use a higher level of radiation than the one milliroentgen used in the U.S.
- **3.** Equipment may not be properly adjusted and give off more X-ray exposure than it should.
- **4.** Some film is more sensitive to X-rays than others. For example, color films rated at 400 or higher are more susceptible to X-ray fog than similarly rated black-and-white films.

Lead-lined film pouches help protect against X-ray fog. The surest way to avoid any risk of X-ray fog, however, is not to have film or paper pass through detection equipment. In U.S. airports and those Figure 2-79 X-ray marks.

of some other countries one can choose to have carry-on luggage inspected by a security agent.

2.40 Static Electricity Fog

Photographic film passing through a film cartridge, or over rollers in a camera, processing machine or rewinding setup, can acquire high electrostatic charges due to friction. When the accumulated static electricity is discharged, the air becomes ionized, producing light and heat. The result of this phenomenon is the appearance of *static marks* on film (see Figure 2–80). Static discharges are easily observed in a darkroom when the adhesive that secures roll film to a spool is quickly pulled from the film. To avoid such discharges, handle film carefully and wind slowly. Avoid winding film rapidly when the humidity is very low. People who have a tendency to produce static electricity when handling film can minimize this by wearing shoes with leather soles instead of rubber.

References

American National Standards Institute, Annular 45:0 (or 0:45 Optical

Reflection Measurements (Reflection Density) (PH2.17-1977).

- , Automatic Exposure Control for Cameras (PH2.15-1964, R1976).
- ------, Black-and-White Photographic Films, Plates, and Papers, Method for Manual Processing (PH4.29-1975).
- —, Density Measurements, Spectral Conditions (ASC PH2.18-1984).
- ——, Exposure-Time Markings for Still-Picture Cameras (PH3.32-1972).
- , General-Purpose Photographic Exposure Meters (Photoelectric Type) (PH3.49-1971).

References

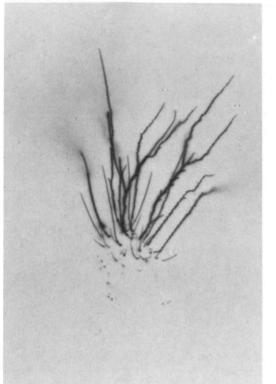

Figure 2–80 Static discharge between film and nearby object or objects. Left, negatively charged film; right, positively charged film. ([©] Eastman Kodak Company 1976.)

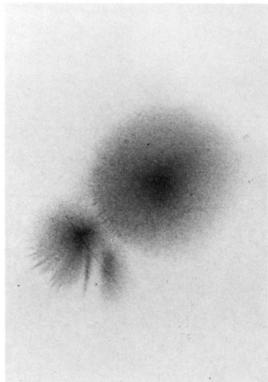

—, Photographic Exposure Guide (PH2.7-1985).

- —, Sensitometry and Grading of Black-and-White Silver Halide Photographic Papers for Continuous Tone Reflection Prints (PH2.2-1981).
- ——, Simulated Daylight and Incandescent Tungsten Illuminants (PH2.29-1982).

——, Speed of Photographic Negative Materials (Monochrome, Continuous-Tone), Method for Determining (PH2.5-1979).

—, Terms, Symbols, and Notation for Optical Transmission and Reflection Measurements (Optical Density) (PH2.36-1974).

Baines and Bomback, The Science of Photography.

- Berg, Exposure: Theory and Practice, pp. 184-212, 249-51.
- Blaker, Photography, Art and Technique, pp. 229-53, 370-75.
- Carroll, Higgins, and James, Introduction to Photographic Theory, pp. 13, 105–18, 137–56.
- Clerc, Photographic Theory and Practice.
- Current, I. "Sensitometry of High-Speed Print-out Papers." Photographic Science and Engineering 7 (March-April 1963): pp. 104– 8.
- Dunn and Wakefield, Exposure Manual.
- Eastman Kodak Co, Basic Photographic Sensitometry Workbook (Z-22-ED).
 - ——, Black-and-White Transparencies with Kodak Panatomic-X Film (FX135) (F-19).
- ———, Cinematographer's Field Guide—Motion Picture Camera Films (H-2).

——, Contrast Index—A Criterion of Development (F-14).

References

-----, Darkroom Expressions, 1984, p. 64.

——, Gaseous-Burst Agitation in Processing (E-57).

——, A Glossary of Photographic Terms (AA-9).

- —, Kodak Color Dataguide (R-19).
 - ——, Kodak Darkroom Dataguide (R-20).

—, Kodak Filters for Scientific and Technical Uses (B-3).

- —, Kodak Neutral Density Attenuators (P-114).
- ——, Kodak Opposed Gray Scale (Q-18).
- ------, Kodak Plates and Films for Scientific Photography (P-315), pp. 7, 14-16, 20-22.
 - -----, Kodak Professional Black-and-White Films (F-5), pp. 27–28, 34.
- ------, Kodak Professional Photoguide (R-28).

, Practical Densitometry (E-59).

- ------, Quality Enlarging with Kodak B/W Papers (G-1).
- ——, Reciprocity Data: Kodak Professional Black-and-White Films (O-2).
- ——, Selection and Use of Kodak and Eastman Motion Picture Films (Nution 1) Industry Enderstainment Mudicine Television Fullwation Government) (H-1).
- ------, Using Opposed Gray Scales (As a Visual Check on Exposure and Development) (Q-18A).
 - -----, What is B/W Quality (G-4).
- Everhart, E. "Adventures in Fine-Grain Astrophotography." Sky and Telescope (February 1981): pp. 100-104.
- Fritsche, Faults in Photography, Causes and Corrections, pp. 53-54, 81, 105, 116, 200-203, 210, 242-46, 304, 330.
- Jacobson and Jacobson, Developing: The Technique of The Negative, pp. 256, 394-400.
- Jacobson et al., The Manual of Photography.
- Jacobson and Manneheim, Enlarging: The Technique of the Positive.

James, The Theory of the Photographic Process.

- Levy, M. "Wide-Latitude Photography." Photographic Science and Engineering 11:1 (January-February 1967).
- Lobel and Dubois, Basic Sensitometry.
- Neblette, Fundamentals of Photography.
- Penrose, Man Ray, pp. 114-25.
- Schwalberg, B. "Kodak Technical Pan Film." *Popular Photography* (February 1981): pp. 95–99, 158.
- Schwalberg, B. "X-Rayted." Popular Photography (August 1982): pp. 71-73, 112-13.
- Thomas, SPSE Handbook of Photographic Science and Engineering, pp. 405–430, 720–21, 953–56.
- Todd, Sensitometry: A Self-Teaching Text.

Todd and Zakia, Photographic Sensitometry, pp. 95-134.

Vieth, Sensitometric Testing Methods.

Wakefield, Practical Sensitometry.

Walls and Attridge, Basic Photo Science.

Camera and Printing Exposure

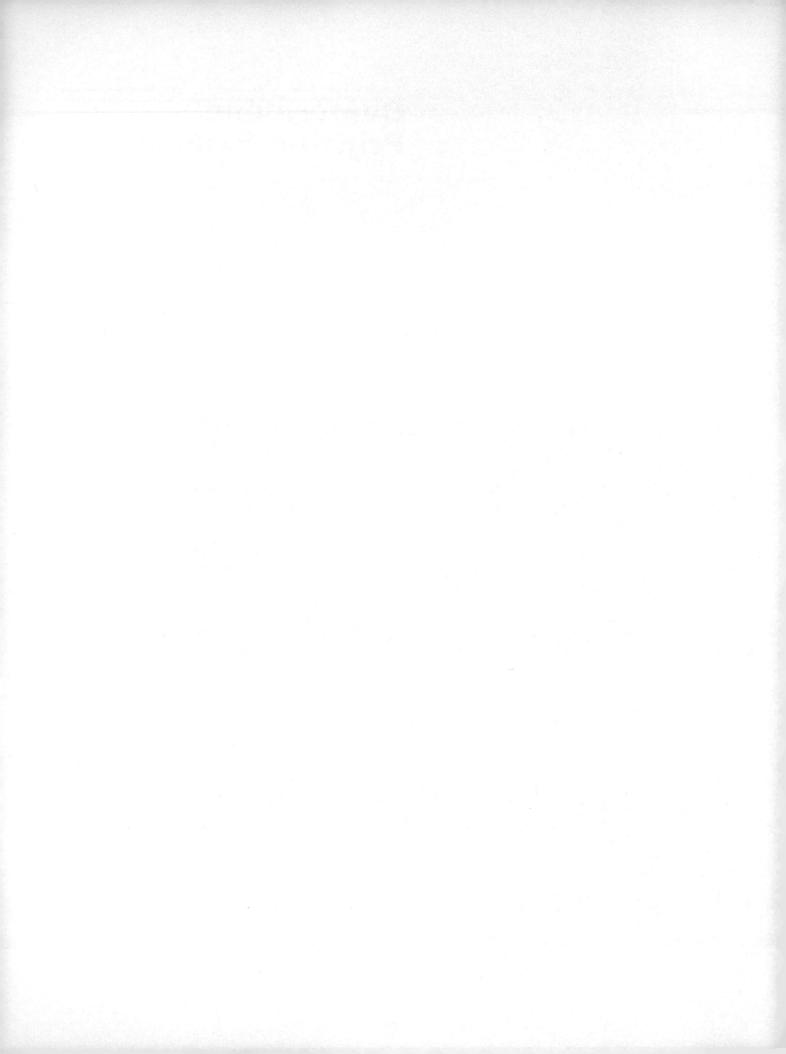

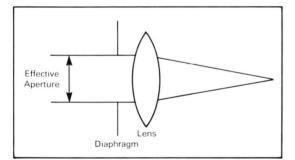

Figure 3–1 When a diaphragm is located in front of a lens, the effective aperture is the same as the aperture or diaphragm opening.

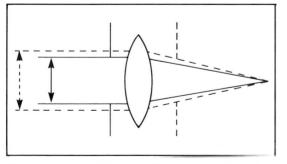

Figure 3–2 A diaphragm will transmit more light when located behind the lens than in front.

3.1 Camera Exposure vs. Photographic Exposure

The term *camera exposure* refers to the combination of shutter speed and f-number used to expose film in a camera. Although the terms camera exposure and photographic exposure are related, they are not synonyms. Photographic exposure is defined as the quantity of light per unit area received by film or other photosensitive material, and it is calculated by multiplying the illuminance and the time. The relationship is commonly expressed as $H = E \times t$. Assuming that a camera shutter is accurate, the shutter setting is a measure of exposure time, but the f-number setting is not a measure of the illuminance. In a typical picture-making situation, the film receives many different photographic exposures in different areas. Opening the diaphragm by one stop doubles all the different illuminances that constitute the light image on the film. Thus the f-number and shutter settings on a camera enable the photographer to control the photographic exposures received by the film, even though the quantitative values of those exposures are not Improve. The function of an exposure meter is to indicate a combination of f-number and shutter speed settings that will produce a correctly exposed photograph, taking into account the amount of light falling on or reflected by the subject and the speed of the photographic material being exposed.

3.2 F-Numbers

Relative aperture is another name for f-number. The word relative suggests that the value of the relative aperture or f-number depends upon two things-these are the *focal length* of the lens and the effective aberture. The effective aperture is defined as the diameter of the entering beam of light that will just fill the opening in the diaphragm of a camera lens or other optical system. (The diameter of the opening in the diaphragm is known as the *aperture*.) When the diaphragm is located in front of a lens, the effective aperture is the same as the aperture, as illustrated in Figure 3-1. Rarely is the diaphragm located in front of a photographic lens, which makes it necessary to take into account any change in direction of the light rays between the time they enter the lens and when they pass through the diaphragm opening. Since a lens compresses the entering beam of light into a converging cone, a diaphragm with a fixed aperture will transmit more light when it is positioned behind the lens than in front (see Figure 3-2). Reversing a lens of this type, with the diaphragm in front of or behind the elements, on a camera will change the f-number, the amount of light transmitted, and therefore the required exposure time. Most lenses containing two or more elements have the diaphragm located between the elements. If the lens is of symmetrical design, so that the arrangement of elements is the same on both sides of the diaphragm, reversing the lens on the camera will not affect the f-number.

3.3 Calculating F-Numbers

F-numbers are calculated by dividing the lens focal length by the effective aperture, or F-N = f/D. Since the effective aperture is rarely the same size as the aperture (the physical opening in the diaphragm), the diameter of the entering beam of light that just fills

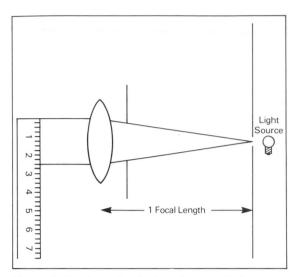

Figure 3-3 A procedure for determining the effective aperture is to place a point source of light one focal length behind the lens and measure the diameter of the beam of light that emerges from the front of the lens.

the diaphragm opening must be measured. One procedure is to place a point source of light one focal length behind the lens so that the beam of light emerging at the front of the lens is restricted by the diaphragm to the same size as an entering beam that just fills the diaphragm opening (see Figure 3-3). The diameter of the beam of light can be measured with a ruler in front of the lens, or a permanent record can be made by exposing a piece of photographic paper to the beam of light by placing the paper in a lens cap on the front of the lens.

An approximation of the effective aperture can be made without the point source of light by placing a ruler across the front of the lens and measuring the diameter of the diaphragm opening as seen through the lens from the front. (Some error may be introduced due to parallax, especially if the eye is placed close to the ruler.) This procedure can be very precise if performed on an optical bench where the distance between the edges of the diaphragm opening is measured with a calibrated traveling microscope.

The focal length of a simple lens can be determined by focusing the lens on a distant object, such as the sun, and measuring the distance from the middle of the lens to the sharp image. (A more precise procedure is described in the following chapter.) Thus if the focal length of an uncalibrated lens is found to be eight inches, and the diameter of the effective aperture at the maximum opening is one inch, the f-number is the focal length divided by the effective aperture-8/1, or f/8. Note that when the lens is stopped down so that the effective aperture becomes smaller, 1/2 inch, for example, the f-number becomes larger since $\frac{8}{1/2}$ is f/16. Not only do f-numbers become larger

as the amount of light transmitted by the lens becomes smaller, but the relationship is not a simple inverse ratio. The reason for this unfortunate situation is that the f-number is based on the diameter of the entering beam of light, whereas the relative amount of light transmitted is based on the area of a cross-section of the beam of light. The relationship between the area and the diameter of a circle is A = $\frac{\pi \times D^2}{4}$. Thus the amount of light transmitted by a lens varies directly

with the diameter squared and inversely with the f-number squared.

Whole Stops 3.4

Photographers find it useful to know the series of f-numbers that represents whole stops: f/0.7, 1.0, 1.4, 2.0, 2.8, 4, 5.6, 8, 11, 16, 22, 32, 45, 64. The series can be extended in either direction by noting that the factor for adjacent numbers is the square root of 2, or approximately 1.4. Also, by remembering any two adjacent numbers the series can be extended by noting that alternate numbers vary by a factor of 2, with a small adjustment between 5.6 and 11, and between 22 and 45, to compensate for the cumulative effect of fractional units.

Each time the diaphragm is stopped down one stop (e.g., from f/8 to f/11), the amount of light transmitted is divided by two, and the exposure time required to obtain the same photographic exposure on the film is multiplied by two. Thus with a lens that has a range of f-numbers from f/2 to f/16, the illuminance ratio at the two extreme settings is 64:1, and the ratio of the corresponding exposure times is 1:64. It is usually not necessary to calculate exposure times

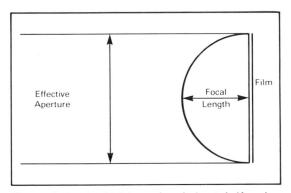

Figure 3–4 An fl0.5 lens, where the lens is half a sphere. The focal length is the radius of the sphere, and the effective aperture is the diameter.

for different f-numbers since the calculator dials on most exposure meters are designed to provide this information. The ratio of the exposure times at f/2 and f/16 in this example can be calculated by noting the series of whole stops (2, 2.8, 4, 5.6, 8, 11, 16) and doubling the exposure time for each stop change (1, 2, 4, 8, 16, 32, 64). A more elegant method is to calculate the ratio on the basis that the exposure time varies in direct proportion to the f-number squared. Thus $2^2/16^2$ or $(2/16)^2$ or $(1/8)^2$ equals 1/64. This method is especially useful when it is necessary to calculate exposure times for f-numbers that are not whole stops. It is not uncommon for the f-number of the largest opening on a lens to be between whole stops—for example, f/1.2, 1.7, 2.2, or 4.5.

3.5 Maximum Diaphragm Openings

The f-number range on most camera lenses is approximately seven stops. A typical 35mm camera lens may have, for example, a range from f/1.4 to f/16 (seven stops), and a typical view camera lens may have a range from N/J. O to 1/1/ tone stops). Incre has been a constant demand for lens designers over the years to make faster and faster lenses. In the 1940s f/2 lenses were considered fast for 35mm cameras. Now f/0.7 lenses are mass-produced, a gain of three stops. The fastest one-element lens that can be made with conventional optical design is f/0.5. Such a lens would be half a glass sphere with the film in contact with the flat surface, as illustrated in Figure 3-4. The focal length of this lens is the distance from the front surface to the film, or the radius of the sphere; and the effective aperture is the diameter of the sphere. Thus the f-number is the radius divided by the diameter, or 0.5. One problem involved in making fast lenses in the longer focal lengths is that the diameter of the lens must be very large. To obtain a speed of f/1 with a 10-inch focal length lens would require the lens to have a diameter of 10 inches. It should be noted also that the depth of field becomes smaller at large diaphragm openings. The depth of field at f/0.5 is only about one quarter the depth of field at f/2.

The need to make photographs under very low light levels, such as moonlight and even starlight for surveillance and other purposes, has led photographic engineers to explore alternatives to the difficult task of further increasing the speed of lenses and films. The most successful are "image-intensifiers," which can electronically amplify the light image formed by the camera lens by as much as $30,000 \times .$ To achieve the same effect by designing a lens faster than f/0.7, would require an f-number of f/0.004, which represents an increase in speed of approximately 15 stops. To achieve the same effect by making film faster than ISO $400/27^{\circ}$ would require the film to have a speed of ISO $12,000,000/72^{\circ}$. With image intensifiers that are now available, it is necessary to trade off some resolution of fine detail for the increase in speed.

3.6 Minimum Diaphragm Openings

Since depth of field increases as a lens is stopped down, it would seem desirable to mark f-numbers down to very small openings on all lenses. In 1932 a group of photographers including Ansel Adams, Imogen Cunningham and Edward Weston formed an organization called Group f/64, with the name implying that they favored making pho-

3.6 Minimum Diaphragm Openings

Figure 3–5 Photograph made in 1921 by Ralph Steiner, originator of the East Coast f/180 School, using a pinhole in combination with a camera lens. (Photograph by Ralph Steiner.)

tographs in which everything was sharp.¹ Later, Ralph Steiner used a pinhole with his camera lenses and began his own "East Coast f/180 School" (see Figure 3-5).²

Although stopping down increases depth of field, it also increases the diffraction of light, which tends to reduce image sharpness overall. With a lens stopped down to f/64, the maximum resolving power that can be obtained-no matter how good the lens or accurate the focusing—is approximately 28 lines/mm. For an 8×10 -inch camera this is quite good because 10 lines/mm is considered adequate in a print viewed at a distance of 10 inches. Stopping a 35mm camera down to f/64 would produce the same resolving power of 28 lines/mm in the negative, but since the negative must be enlarged eight times to obtain an 8×10 -inch print, the resolving power in the print would be only 28/8, or 3.5 lines/mm. (The calculation of diffraction-limited resolving power is discussed in the following chapter.) Lens manufacturers normally do not calibrate lenses for 35mm cameras for openings smaller than f/22 because at that opening the diffraction-limited resolving power is approximately 80 lines/mm in the negative or 10 lines/mm in an 8×10 -inch print (see Figure 3-6).

¹Newhall, B., 1984, p. 128. ²Steiner, R., 1978, p. 9.

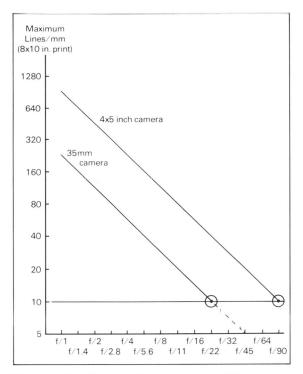

Figure 3-6 The sloping lines show that the diffractionlimited resolving power decreases as a lens is stopped down. A just-acceptable resolving power of 10 lines/mm is reached at f|22 with a 35mm camera and at f|90 with a 4 × 5-inch camera. Resolving-power values are based on 8 × 10-inch prints, which represent a magnification of 2 for 4 × 5-inch negatives and 8 for 35mm negatives.

3.7 Intermediate F-Numbers

There are situations where it is necessary to know the fnumber of divisions smaller than whole stops, such as 1/3, 1/2, or 2/3 stop larger or smaller than a given f-number. (Some lenses have click-stops to obtain 1/2-stop settings, and most exposure meters have 1/3-stop markings on their scales and calculator dials.) Intermediate values can be determined easily on instruments having interval scales, such as thermometers and balances for weighing chemicals, by measuring or estimating between markings or numbers. The f-number series, on the other hand, is a ratio scale in which each number is determined by multiplying or dividing the preceding number by a constant factor-the square root of 2 (approximately 1.4) for whole stops. For 1/2 stops the factor is the square root of 1.5 (1.22). For 1/ 3 stops the factor is the square root of 1.33 (1.15), and for 2/3 stops the factor is the square root of 1.67 (1.29). Multiplying f/2, for example, by these factors to determine f-numbers that represent stopping down by 1/3, 1/2, 2/3, and 1 stop, the f-numbers are f/2.30, f/2.45, f/2.58, and f/2.8.

3.8 Limitations of the F-Number System

F-numbers quite accurately indicate changes in the amount of light transmitted by a lens and, therefore, changes in the exposure received by film in a camera. However, they cannot be relied upon to provide the correct exposure based on exposure meter readings of the light falling on a subject or reflected by a subject. The most obvious shortcoming of the f-number system is that it is based on the focal length of the lens. The only time the film is located one focal length from the lens is when the camera is focused on infinity, and cameras are rarely focused on infinity.

As a result, it is necessary to make an exposure adjustment when the image distance is larger than one focal length—that is, when the camera is focused on objects that are closer than infinity. In practice, it is usually not necessary to make any adjustment until the camera is focused on a distance equal to 10 times the lens focal length or closer. At an object distance of 10 focal lengths, the exposure error would be 23% or about one-quarter stop if no adjustment were made. With short focal length lenses 10 focal lengths is a small distance, only 20 inches, for example, with a normal 50mm or 2-inch focal length lens on a 35mm camera. With a normal 12-inch focal length lens on an 8×10 inch view camera, on the other hand, 10 focal lengths amount to an object distance of 10 feet. Thus it is dangerous to think that an exposure correction is necessary only when the camera is focused on a very close object.

There are various methods for making the adjustment when photographing objects within the 10-focal-length range. One method is to calculate the *effective f-number*, and then determine the exposure time for that number rather than for the f-number marked on the lens. The effective f-number is found by multiplying the marked f-number by the ratio of the image distance to the focal length, or

Effective f-number = f-number $\times \frac{\text{Image distance}}{\text{Focal length}}$

With lenses of normal design, the image distance is ap-

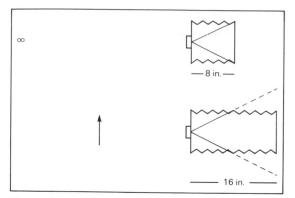

Figure 3-7 F-numbers are based on an image distance of one focal length (above). Doubling the image distance to photograph a close-up object produces an effective f-number that is double the marked f-number; that is, a lens set at f/8 acts as though it is set at f/16.

Figure 3-8 The f-number of the lens (left) is calculated by dividing the focal length (8 inches) by the effective aperture (2 inches). The T-number is found by dividing the focal length by the diameter of the opening in the opaque card on the right that transmits the same amount of light (1.42 inches).

proximately the distance from the center of the lens to the film plane. (The procedure for determining the image distance with telephoto and other special lenses is covered in the next chapter.) Thus if the image distance is 16 inches (406 mm) for a closeup photograph with a 4×5 -inch view camera equipped with an 8-inch (203 mm) focal length lens, the effective f-number when the lens is set at f/11 is f/11 \times 16/8 = f/22. When an exposure meter reading is made, the exposure time for f/22 would be used even though the lens is set at f/11. Since f/22 is two stops from f/11, the exposure meter will indicate four times the uncorrected exposure time at f/11 (see Figure 3-7).

An alternative method of determining the exposure correction is to divide the image distance by the focal length and square the result. In the example above, the exposure factor equals $(16/8)^2$ or 4. In this case the correction can be applied either by using the indicated exposure time and opening the diaphragm two stops from f/11 to f/5.6, or by multiplying the exposure time indicated for f/11 by 4.

3.9 Lens Transmittance

A second shortcoming of f-numbers is that they do not take into account differences between lenses with respect to the amount of light lost due to absorption and reflection by the lens elements. The introduction of antireflection coating of lenses has reduced variability between lenses due to this factor, but in situations where accurate exposures are essential an adjustment is appropriate. An early zoom lens for 35 mm cameras was approximately three-quarters of a stop slower than indicated by the f-number due to the large number of elements, even though they were coated.

The *T*-number system of calibrating lenses was devised as an alternative to the f-number system in order to use transmittance as a basis, so that any two lenses set at the same T-number would transmit the same amount of light under identical conditions. As a simple example, if a lens marked f/2 in the f-number system transmits only one-half the light that falls on the lens, it would be recalibrated as T/2.8. When an exposure meter reading is made, the exposure time is then selected for f/2.8 rather than for f/2, and the longer exposure time would exactly compensate for the loss of light due to absorption and reflection. T-number is defined as the f-number of an ideal lens of 100% transmittance that would produce the same image illuminance on axis as the lens under test at the given aperture (see Figure 3–8).³

T-numbers have been used most widely with professional motion-picture camera lenses. It is common practice to photograph a scene with two or more motion-picture cameras simultaneously from different angles or with different focal length lenses in sequence with one camera. Differences in exposure become obvious when the shots made with the different lenses are shown sequentially. Early attempts to calibrate still-camera lenses with T-numbers failed to win public acceptance because a T/2.2 lens was perceived as being slower than an f/2 lens even though the two lenses were identical.

Exposure errors resulting from the f-number system shortcomings described above (the adjustment necessary when increasing the lens-to-film distance beyond one focal length, and the loss of light due to absorption and reflection) can be avoided by taking the exposure meter reading at the film plane, or at least behind the lens, rather than

³Stroebel, L. and Todd, H., 1974, p. 200.

measuring the light falling on or reflected by the subject. Behind-lens metering is now widely used in 35 mm single-lens reflex cameras and is available for view cameras. An additional advantage claimed for some behind-lens meters is that they also compensate for the addition of filters to the lens. Such compensation is accurate only when the meter's response to different colors corresponds to the response of the film being used. This is rarely so.

3.10 Other Calibration Systems

There have been attempts to substitute a sequence of numbers that is simpler than the square root of 2 factor used in the f-number system for the series of whole stops on lenses. In the early days of photography some lenses were calibrated according to the Uniform Standard or US system, whereby the numbers doubled with each whole stop—4, 8, 16, 32, etc.—with US 16 and f/16 being equivalent. More recently the Additive System of Photographic Exposure (APEX) was devised using a series of consecutive integers—1, 2, 3, 4, etc. fin Full of the implicit minimum in hypoting photographic ma torials, namely aperture, time, exposure, luminame, and film speed. With the APEX system an aperture value of 2 corresponds to f/2.

3.11 Exposure Time

Photographers can vary either of two factors to alter the exposure received by the film or other light-sensitive material, namely illuminance or time. In many picture-making situations the photographer has a choice of any of a number of combinations of f-numbers and shutter speeds, all of which will produce the same level of photographic exposure but with different depth-of-field and action-stopping characteristics.

In the early days of photography shutters were not necessary because the slow speed of the light-sensitive materials required exposure times of many seconds or minutes. Even today, shutters are seldom used on enlargers because the print exposure times are typically long enough to be controlled manually or with a separate timer that turns the enlarger light off after the specified exposure time has elapsed. With the fast films and lenses available today, some manufacturers are equipping their cameras with shutters that can produce exposure times as short as 1/8,000 second.

Photographers cannot always select a shutter speed solely on the basis of the exposure time that will produce the correct exposure. When photographing a rapidly moving object it may be necessary to use a very short exposure time to prevent objectionable blurring of the image, and occasionally a photographer will select a slow shutter speed to obtain a blurred image (see Figure 3–9).

Unwanted lack of sharpness frequently results from handholding cameras at the slower shutter speeds, especially with long focal length lenses. The rule of thumb is that it is unsafe to hand-hold a camera with an exposure time longer than the reciprocal of the focal length of the lens in millimeters—for example, 1/50 second with a 50 mm lens and 1/500 second with a 500 mm lens. A Mamiya camera introduced in 1980 features a buzzer that warns the user when the shutter is set for a longer exposure time than is considered safe for hand-holding the camera, with an automatic adjustment for different focal length lenses.

Figure 3–9 With moving objects the exposure time is usually determined by the amount of blur or sharpness desired rather than the requirements for correct exposure. In the first three photographs a falling ball was exposed at shutter speeds of 1/250, 1/15, and 1/4 second. An exposure time of two seconds (at fl90) was used for the photograph of the moving water to obtain a smooth, blurred effect (photograph by John Johnson.).

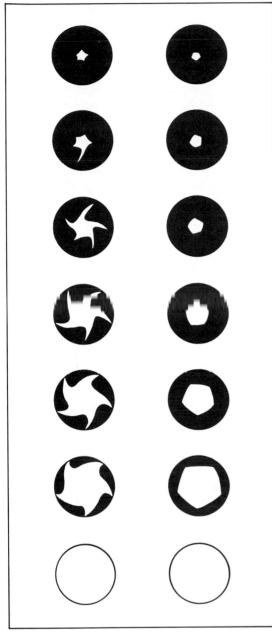

Figure 3-10 On the right are the diaphragm openings for the whole stops on a typical lens. On the left are the positions of the shutter blades at which the diaphragm openings are just completely uncovered. Since the smaller openings are uncovered sooner and stay uncovered longer, the effective exposure time is longer than with a larger opening and the same shutter setting.

3.12 Lens Shutters

Most shutters fall into one of two categories: *lens* (or *front*) shutters and *focal-plane* (or *back*) shutters. The ideal position for a lens shutter is between the elements close to the optical center, which is also the ideal position for the diaphragm; such shutters are commonly referred to as *between-the-lens* shutters.

There is no reason why a single set of overlapping blades cannot serve the dual functions of a shutter and a diaphragm. The requirements are that a sufficient number of blades must be used to produce an opening having an appropriate shape, and that it can be calibrated in terms of a suitable range of f-numbers. A combination shutter-diaphragm of this type is used on a Bronica single-lens reflex camera introduced in 1980. This concept is not new, however, as such combination shutter-diaphragms can be seen on some early cameras in photographic museums. Inexpensive cameras having one-element lenses must have the shutter located either in front of or behind the lens. Universal shutters, which can be used with a variety of barrel-mounted lenses, must also be placed in front of or behind the lens. The member of placing a shutter in united in front of or behind the lens.

3.13 Effective Exposure Time

If one could construct a perfect shutter, the blades would uncover the entire lens, or the entire diaphragm opening, simultaneously. A high-speed motion picture of the operation of a lens shutter shows the blades uncovering the center of the lens first and then gradually uncovering more and more of the lens. At the higher shutter speeds, the shutter blades no sooner uncover the outer edges of the lens than they again cover them at the beginning of the closing operation. Thus the center of the lens is uncovered for a longer time than are the edges, and the total amount of light that is supposed to be transmitted by a lens is actually transmitted only during the time that the diaphragm opening is completely uncovered by the shutter blades (see Figure 3-10). If we used a light meter to measure the change in the amount of light transmitted by a lens during the operation of the shutter, we would find that the reading would increase during the opening stage, remain constant while the shutter blades remained fully open, and decrease during the closing stage. Figure 3-11 shows the change of illuminance with time in the form of a graph.

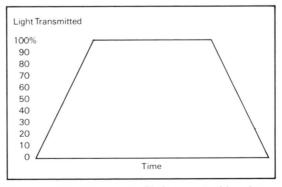

Figure 3-11 The amount of light transmitted by a lens increases as the shutter blades open, remains constant as long as the diaphragm opening is completely uncovered, and decreases as the shutter blades close.

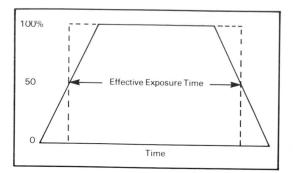

Figure 3-12 Shutters are calibrated from the half-open position to the half-closed position. The total exposure time is longer than the effective exposure time to compensate for the loss of light during the opening and closing stages of the cycle.

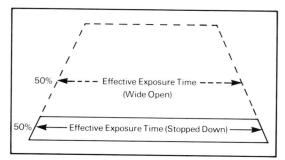

Figure 3–13 When a lens is stopped down, the smaller opening is uncovered sooner and remains uncovered longer, increasing the effective exposure time from half open to half closed.

If lens manufacturers calibrated shutters from the time they start to open until they are completely closed again, the loss of light during the opening and closing parts of the cycle would lead to underexposure—in other words, the effective exposure time is shorter than the total exposure time. To avoid this problem, shutters are calibrated from the half-open position to the half-closed position, as illustrated in Figure 3-12. Thus the loss of light during the opening and closing operations is compensated for by the fact that the total exposure time is longer than the time marked on the shutter. Shutters are normally calibrated from the half-open to the half-closed positions of the shutter blades with the diaphragm wide open.

Unfortunately, when the diaphragm is stopped down, the smaller opening is uncovered sooner and remains completely uncovered longer. As a result, the half-open to half-closed time (which is the effective exposure time) increases as the diaphragm is stopped down, even though the shutter blades are opening and closing exactly the same as when the diaphragm was wide open (see Figure 3-13).

Shutters that are calibrated with the diaphragm wide open, as is the practice, tend to overexpose film at small diaphragm openings due to the increase in the effective exposure time. The error is small at slow shutter speeds but approaches double the indicated exposure, or the equivalent of a one-stop error, at combinations of high shutter speeds and small diaphragm openings. Compensation for this error should be made by stopping down farther than an exposure meter reading indicates for the selected shutter speed, or by selecting the f-number specified for the effective exposure time rather than the marked time. Table 3-1 indicates the correction needed for different combinations of shutter speeds and diaphragm openings.

3.14 Shutter Efficiency

Shutter efficiency is a measure of the performance of an actual shutter in comparison with that of a theoretically perfect shutter that opens instantaneously and closes instantaneously. Shutter efficiency represents the amount of light transmitted by the actual shutter divided by the amount that would be transmitted by the perfect shutter. The

				S	topped Down				
Maximum Aperture	1	2	3	4	5	6	7	8	- Stops
f/1.4 f/2 f/2.8 f/4 f/5.6 f/8	f/2 f/2.8 f/4 f/5.6 f/8 f/11	f/2.8 f/4 f/5.6 f/8 f/11 f/16	f/4 f/5.6 f/8 f/11 f/16 f/22	f/5.6 f/8 f/11 f/16 f/22 f/32	f/8 f/11 f/16 f/22 f/32 f/45	f/11 f/16 f/22 f/32 f/45 f/64	f/16 f/22 f/32 f/45 f/64 f/00	f/22 f/32 f/45 f/64 f/90	51005
<i>Exposure Time</i> ^a 1/60 1/125 1/250 1/500	$ \begin{array}{c} 0 \\ 0 \\ -\frac{1}{4} \\ \frac{1}{2} \end{array} $	0 1/4 1/4 3/4	0 $\frac{1}{\sqrt{4}}$ $\frac{1}{\sqrt{2}}$ 1	0 $\frac{1}{\sqrt{4}}$ $\frac{1}{\sqrt{2}}$ 1	0 1/4 1/2 1	$ \begin{array}{c} 0 - \frac{1}{4} \\ \frac{1}{4} \\ \frac{1}{2} \\ 1 \end{array} $		f/128	

Table 3–1 Top: Chart for determining the number of stops between a given f-number and the f-number at the maximum diaphragm opening. Bottom: The reduction in exposure (in stops) required to compensate for the increase in the effective exposure time with various combinations of f-numbers and exposure times.

"Additional stopping down required to compensate for changes in shutter efficiency with between-the-lens shutters.

as the exposure time increases because the light lost during the opening and closing stages represents a smaller proportion of the total amount of light.

calculations are usually made by measuring the areas under the curves for the two shutters. For a given shutter, the efficiency increases as the exposure time increases because the light lost during the opening and closing stages represents a smaller proportion of the total amount of light (see Figure 3–14). The efficiency also increases as the diaphragm is stopped down because the smaller opening is completely uncovered sooner and remains uncovered longer.

For a given shutter the shutter efficiency can vary from a little under 100% with a long exposure time and a small diaphragm opening to a little over 50% with a short exposure time and a large diaphragm opening (see Figure 3–15). With respect to correct film exposure, shutter efficiency does not correlate directly with the shutter's accuracy because shutter speeds are calibrated from the half-open to half-closed positions with the diaphragm wide open. Another factor in shutter efficiency of an actual shutter is how quickly the shutter blades reach the fully open position and how quickly they close, represented by the slope of the corresponding parts of the curve, as shown in Figure $\mathfrak{F} = 16$.

3.15 Focal-Plane Shutters

The basic design of the focal-plane shutter is a slit in opaque material placed close to the film that moves across the film from edge to edge. Exposure could be altered with early focal-plane shutters by selecting one of several slit widths in the shutter curtain and selecting one of a number of spring tensions that controlled the speed of the slit's movement. Rewinding the curtain before inserting the dark slide in the film holder resulted in fogged film. Modern focal-plane shutters have an adjustable opening between two curtains (or blades) with a

Figure 3-15 Top. With a short exposure time and a large diaphragm opening, the shutter efficiency can be as low as 50%. Bottom: Shutter efficiency can approach 100% with a long exposure time and a small diaphragm opening.

Figure 3–16 A shutter that opens and closes slowly (top) has lower shutter efficiency than one that opens and closes quickly (bottom).

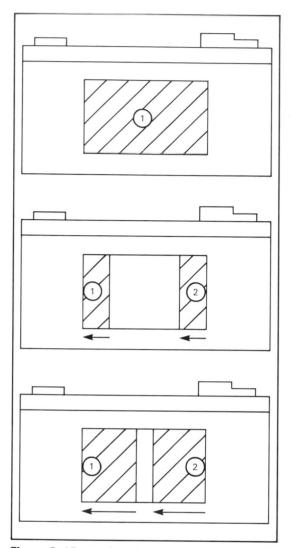

Figure 3-17 At slower shutter speeds, curtain 1, which protects the film from light before the shutter is tripped, completely uncovers the film before curtain 2 begins to cover it again. At higher shutter speeds, curtain 2 begins to cover the film before it is completely uncovered. The space between the two curtains decreases as the shutter speed increases.

self-capping feature to eliminate the slit when the curtain is rewound (see Figure 3-17).

A basic advantage of focal-plane shutters over between-thelens shutters is that the shutter can be built into the camera and used with interchangeable lenses rather than incorporating a shutter in each lens. A second advantage is that stopping a lens down has little effect on the effective exposure time so that compensation is not necessary as with between-the-lens shutters. Actually, the focal-plane curtain would have to be in contact with the film to totally eliminate any change in the effective exposure time, but in most cameras the curtain is sufficiently close to the film so that the change can be ignored (see Figure 3-18). A third advantage is that it has been easier to obtain high shutter speeds with focal-plane shutters than with between-the-lens shutters.

Disadvantages of focal-plane shutters are: Changes in speed of the slit across the film result in uneven exposure (see Figure 3–19), images of rapidly moving objects are distorted in shape, and it is more difficult to synchronize flash and electronic flash at higher shutter speeds (see Figure 3–20).

3.16 Electronic Shutters

For a typical mechanical between-the-lens shutter, the power to open and close the shutter is provided by a spring that is placed under tension, and the timing is controlled by a watch-type gear train. Early-focal plane shutters on sheet-film cameras provided the photographer with two controls over the exposure time: variable tension on the spring that controlled the movement rate of the focal-plane curtain, and a choice of various slit widths in the curtain.

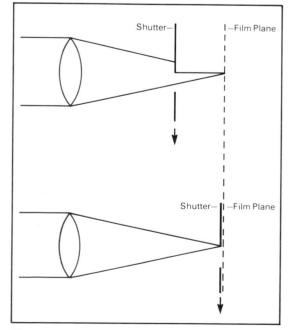

Figure 3–18 Separating a focal-plane shutter from the film (top) produces a gradual uncovering and covering of the cone of light and a change in the effective exposure time as the diaphragm is stopped down. Placing the focal-plane shutter close to the film (bottom) eliminates this problem.

Figure 3–19 Cold weather caused this focal-plane shutter to malfunction, producing variations of exposure from side to side.

Electronic shutters can be divided into two categories: those using electronics to control the timing with a spring-activated shutter (more properly called electromechanical shutters) and those using electronics for both the timing and the power to activate the shutter. Electronically controlled focal-plane shutters and between-the-lens shutters (on the mass-produced Polaroid Auto-100 camera) were introduced in 1963.

The timing of electronic shutters is normally controlled by a capacitor charged by a current from a battery, which can be altered with a variable resistor, causing the shutter to close when the capacitor is filled. By adding a camera exposure meter to the circuit, the exposure time is controlled automatically by the amount of light received by the meter photocell. One way electricity is used to open and close a shutter is with solenoids, where a magnetic field produced by current flowing through a coil moves a plunger and the shutter. The liquid Kerr cell, used for scientific photography, is an electronic shutter that is capable of providing exposure times as short as 1 billionth of a second (see Figure 3-21).

3.17 Shutter-Speed Markings

Most modern cameras have shutter-speed markings that vary by a factor of 2 in the series: 1, 1/2, 1/4, 1/8, 1/15, 1/30, 1/60, 1/125, 1/250, 1/500, 1/1,000, 1/2,000 second. Some shutters include times longer than 1 second. Most older shutters used a different sequence, such as 1, 1/2, 1/5, 1/10, 1/25, 1/50, 1/100, 1/200, 1/500 second. Exposure meter dials generally use the factor-of-2 series of shutter speeds, but some also include special marks to indicate speeds in the older series. Mechanical shutters generally are not designed to be used between the marked settings. Many will produce intermediate speeds but not necessarily in proportion to the position between the marked settings. Electronically controlled shutters coupled to exposure meters in certain cameras allow the photographer to select the f-number, and the meter then selects an appropriate shutter speed, sometimes on a continuum that produces intermediate speeds such as 1/97 second. Figure 3-20 Electronic-flash illumination used with a camera having a focal-plane shutter at shutter speeds of 1/60 second (top), 1/125 second (center), and 1/250 second (bottom). At speeds higher than 1/60 second the second curtain begins to cover the film before the first curtain has completely uncovered it. The maximum shutter speed that can be used with electronic flash has gradually increased with newer model cameras. At the present time, 1/250 second is the maximum speed.

Figure 3-21 A Kerr cell electronic shutter.

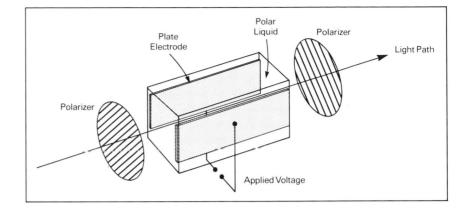

With the Additive System of Photographic Exposure (APEX) a time value of 0 corresponds to a shutter speed of 1 second, and each increase of 1 in time value represents a division of the exposure time by a The almost and the presents a division of the exposure time has a fine down.

Time Value	Shutter Speed (in seconds)
0	1
1	1/2
2	1/4
3	1/8
4	1/15
5	1/30
6	1/60
7	1/125
8	1/250
9	1/500
10	1/1,000

3.18 Shutter Testing

The discussion above concerning effective exposure times with between-the-lens shutters is based on a shutter that has been accurately calibrated (at the maximum diaphragm opening) and is in perfect working condition. Some shutter manufacturers do not guarantee their shutters to be any more accurate than $\pm 40\%$ of the marked speed. In past years it has been possible to test 100 shutters selected at random representing various brands and periods of use without finding more than one or two that were accurate within $\pm 5\%$ at every setting. Shutters with electronic timing control tend to be more accurate than mechanical shutters, where the timing depends upon gear trains, springs and cams, but the accuracy of any shutter should not be taken for granted. Shutter variability for 140 35 mm single-lens reflex cameras is illustrated by the frequency histogram in Figure 3-22.

The most satisfactory method of resting a shutter is with an electronic shutter tester that displays the shutter's opening and closing as a line on an oscilloscope where deviations from 100% accuracy can be determined from a calibrated grid, or where the effective exposure

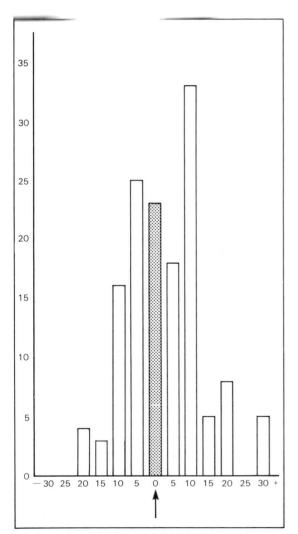

Figure 3-22 The shutters on 140 35mm cameras were tested at a setting of 1/125 second. The range of variability is from 20% underexposure to 30% overexposure. The conversion data in Table 3-2 indicate that -20% and +30% are both equivalent to a 1/3-stop change in exposure, producing a range of 2/3 stop.

			Stops	
Over	Ratio Actual/Marked	Log Ratio	(Log/0.3)	
0%	1.0	0.00	0.00	
10%	1.1	0.04	0.13	
20%	1.2	0.08	0.27	
30%	1.3	0.11	0.34 (1/3)	
40%	1.4	0.15	0.50 (1/2)	
50%	1.5	0.17	0.58	
60%	1.6	0.20	0.67 (2/3)	
70%	1.7	0.23	0.77	
80%	1.8	0.25	0.85	
90%	1.9	0.28	0.93	
100%	2.0	0.30	1.00 (1)	
300%	4.0	0.60	2.00 (2)	
700%	8.0	0.90	3.00 (3)	
				Stops
Under	Ratio Actual/Marked	Log (Bar) Ratio	Log (Neg) Ratio	(Log/0.3)
0%	1.0	0.00	-0.00	0.00
10%	0.9	1.954	-0.046	0.15
20%	0.8	1.903	-0.097	0.32 (1/3)
30%	0.7	1.845	-0.155	$0.52(\frac{1}{2})$
40%	0.6	1.778	-0.222	0.74(3/4)
50%	0.5	1.699	-0.301	1.00(1)
60%	0.4	1.602	-0.398	1.33
70%	0.3	1.477	-0.523	1.74
80%	0.2	1.301	-0.699	2.33
90%	0.1	1.000	-1.000	3.33
100%	0.0			

Table 3–2 Conversion of percentage over- and underexposure to stops. This conversion table (see Figure 3–22) indicates that -20% and +30% are both equivalent to a $\frac{1}{3}$ -stop change in exposure.

time is presented as a digital readout (Figure 3–23). Such instruments are capable of being very accurate since they can be calibrated with the 60-cycle alternating current with which they are normally used. Such testers can also be used to determine the change in the effective exposure time of between-the-lens shutters as the diaphragm is stopped down, and to check the consistency of focal-plane shutters across the film (see Figures 3–24 and 3–25). Shutter-speed settings that are found to be inaccurate still can be used by recording the test results and then using

Figure 3–23 An electronic shutter tester that displays the shutter's operation as a trace on an oscilloscope.

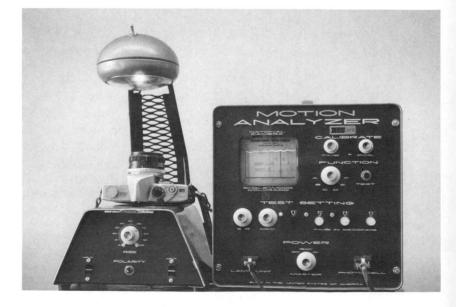

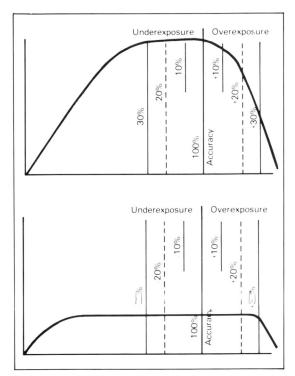

Figure 3-24 The two shutter-tester traces reveal the change in the effective speed of a between-the-lens shutter at a shutter setting of 1/250 second with the diaphragm at the maximum aperture of f/4 (top) and stopped down to f/11.

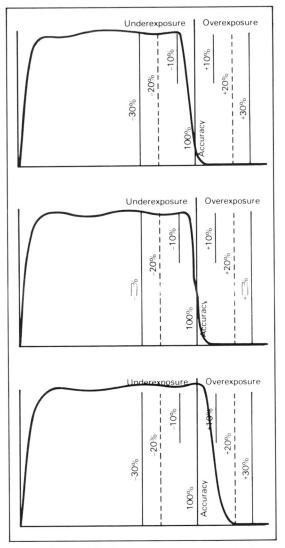

Figure 3–25 The three traces reveal the change in the effective speed of a focal-plane shutter at (from top) the right edge, center, and left edge of the film aperture. The shutter was set at 1/60 second, and the shutter traveled from right to left.

the appropriate f-number for the actual shutter speed rather than for the marked speed.

In the absence of a shutter tester, a practical test can be conducted by exposing film in the camera at each setting provided certain precautions are taken. It is best to use reversal color film since it has a small exposure latitude that permits small changes in exposure to be detected. A subject having a normal range of tones should be used with front illumination. The exposure meter used should be tested against a standard light source or against a number of other meters or one meter of known accuracy, and care must be taken to make an accurate meter reading. With between-the-lens shutters the diaphragm must be wide open, but different shutter speeds can be tested by using neutral-density filters, adding 0.3 in density each time the exposure time is doubled. With focal-plane shutters it is safe to stop down the diaphragm one stop for each change of shutter speed. Finally, it is important to be sure the film is processed normally, and the transparencies should be viewed under standardized viewing conditions.

3.19 Camera Exposure Latitude

Assuming that in each picture-making situation there is a combination of f-number and shutter speed that produces the optimum level of exposure, photographers should know what will happen to the image quality if the level of exposure is either increased or decreased. It is optimistic to think that all the various factors calibrated to determine the "correct" exposure are 100% accurate—film-speed rating, exposure meter, shutter, and f-number—and that there is no human error involved in the process, but for now the assumption will be made that there are no such inaccuracies. The range over which the exposure can be increased and decreased from the "correct" exposure and still produce acceptable results is known as the *exposure latitude*.

As exposure is decreased from the optimum level, the darker areas or shadows of the scene will first lose contrast and then detail. As the exposure continues to be reduced, the detail will be lost in progressively lighter areas of the scene, and eventually there will be no image, even in the lightest areas or highlights of the scene (see Figure 3-26).

On the overexposure side, the first noticeable change is commonly an increase in shadow contrast (and therefore an increase in overall contrast). Overexposure also produces a decrease in image definition or, more specifically, an increase in graininess, a decrease in sharpness, and a decrease in detail. These changes may be apparent only with small-format images magnified considerably in printing. As the exposure continues to be increased, the image contrast will decrease, first in the highlight areas and then toward progressively darker areas of the scene. Seldom is all detail lost with overexposure of negative-type films, although extreme overexposure can result in a partial or complete reversal of tones known as solarization, discussed in Section 2.34.

Overall changes in contrast due to underexposure or overexposure can be compensated for at the printing stage with black-andwhite negatives, but local loss of contrast and detail are not correctable. The penalties for underexposure (loss of shadow contrast and detail) occur more quickly and are more severe than the penalties for overexposure (modest change in contrast and decrease of definition), leading to the long-standing admonition "It is safer to overexpose than to underexpose" (see Figure 3–27). Stated in terms of exposure latitude, there is more exposure latitude on the overexposure side than on the underexposure side. These statements apply to conventional black-andwhite and color negative films.

With reversal-type films the exposure latitude is small in both directions, especially when the slide, transparency, or motionpicture film exposed in the camera is the final image to be viewed often juxtaposed spatially or temporally with other images, making relatively small density differences apparent. Changes of $\pm 1/2$ stop in exposure are commonly considered to be the maximum tolerable, with the possible exception of images that are viewed in isolation (as in an otherwise darkened room), viewed in comparison to other images equally underexposed or overexposed, or are to be reproduced photographically or photomechanically. Compensation in reproducing slides and transparencies is generally more successful when they are slightly dark (underexposed) than when they are too light, but this depends to some extent on the relative importance of highlight and shadow detail in each photograph. Because reversal color films have so little exposure latitude, they are especially useful for testing exposure systems.

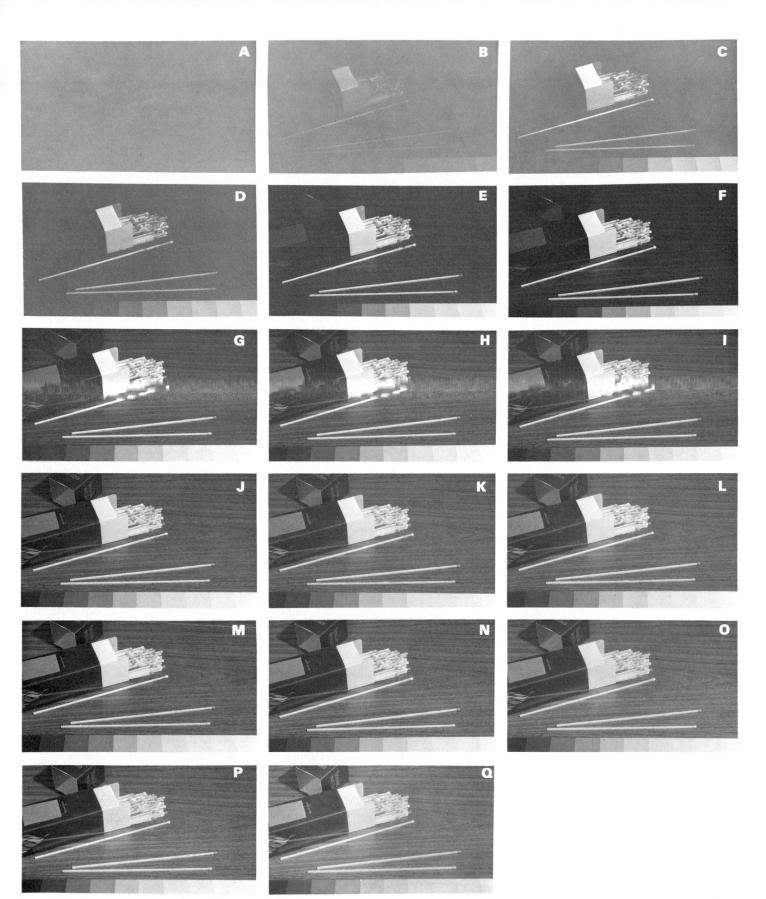

Figure 3–26 Prints made on normal-contrast paper from negatives that received different exposures, ranging from 1/128 normal to 512 times normal in one-stop increments. Print H was made from the normally exposed negative. There is less latitude on the underexposed side due to the loss of shadow detail and the rapid loss of contrast than on the overexposed side.

Figure 3-27 The effects of underexposure and overexposure on negative contrast are shown in this curve. Contrast decreases rapidly with underexposure, and overexposure first produces an increase in contrast before it declines at a more gradual rate. The data were obtained from the negatives used for Figure 3-26.

Load and unload your camera in subdued light.

DAYLIGHT EXPOSURE: Cameras with automatic exposure controls—Set film speed at ISO (ASA) 100. Cameras with manual adjustments—Determine exposure setting with an exposure meter set for ISO (ASA) 100 or use the table below.

KODACOLOR II Film

Bright or Hazy Sun Light Sand or Snow	1/125 sec. f/16					
Bright or Hazy Sun (Distinct Shadows)	1/125 sec. f/11*					
Weak Hazy Sun (Soft Shadows)	1/125 sec. f/8					
Cloudy Bright (No Shadows)	1/125 sec. f/5.6					
Open Shade or Hea Overcast	1/125 sec. f/4					
*f/5.6 for backlighted clo	se-ups					
Light	Film S	Filter				
DAYLIGHT	ISO (ASA	None				
3400 K photolamps	ISO (ASA	No. 80B				
3200 K tungsten	ISO (ASA) 25† No. 80					
†For through-the-lens exposure meters, see camera manual. Courtesy of Eastman Kodak Company						

Figure 3–28 Daylight exposure table. (Courtesy of Eastman Kodak Company.)

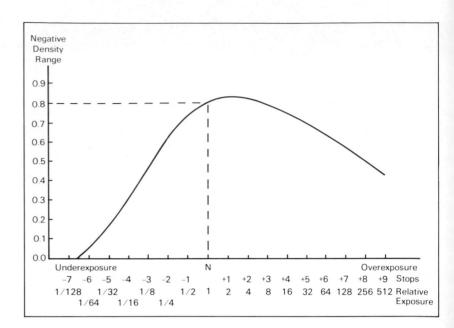

3.20 Alternatives to Exposure Meters

Although most photographers, professional and amateur alike, consider exposure meters to be as indispensable to photography as cameras, there are other methods for determining the correct cameraexposure settings. Even trial and error can be used appropriately when a lighting condition remains constant and will be encountered again.

One of the most constant of lighting conditions is direct sunlight between the mid-morning to mid-afternoon hours. A widely used rule for this lighting condition is that the correct exposure is obtained by using a shutter speed equal to the reciprocal of the ISO arithmetic speed of the film at a relative aperture of f/16. With an ISO $125/22^{\circ}$ film, for example, the camera exposure would be 1/125 second at f/16. Data sheets supplied with some films include exposure information for other outdoor lighting conditions including hazy sun, light overcast, and heavy overcast (see Figure 3–28). Exposure tables also have been used successfully for tungsten lamps, flashlamps, and electronic flash units where the lamp output and lamp-to-subject distance are constant or are measurable.

One of the most ambitious projects to provide exposure information for a variety of natural lighting conditions is the American National Standard *Photographic Exposure Guide*, ANSI PH2.7-1985. The exposure data for daylight are based on the latitude, time of day, sky conditions, subject classification, and direction of the lighting. Also included are data for aerial photography, underwater photography, photography by moonlight; and photographs of sunsets, rainbows, lightning, lunar and solar eclipses, and aurora borealis. Certain manmade and artificial lighting conditions are also covered, including fireworks and television screens.

3.21 Exposure Meters

In the past many different types of light-measuring devices or exposure meters have been used, but nearly all contemporary exposure meters are of the photoelectric type. Selenium-cell exposure meters were introduced around 1930. Selenium cells are known as photovoltaic

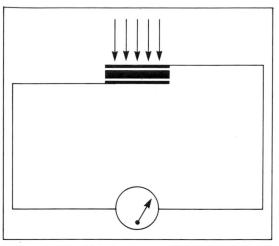

Figure 3–29 Light falling on a selenium photovoltaic cell generates an electric current that is measured by an ammeter.

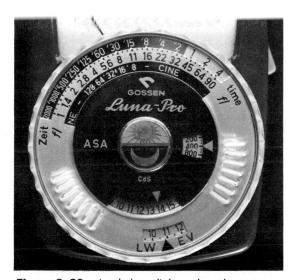

Figure 3–30 A calculator dial translates the meter readings into combinations of shutter and f-number settings, or exposure values, taking the film speed into account.

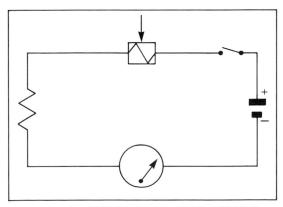

Figure 3–31 Light falling on a cadmium sulfide cell reduces the resistance in a circuit containing a hattery A switch prevents the battery from being drained when the meter is not being used.

cells because light falling on the cell generates an electric current (see Figure 3–29). The current causes a pointer to move across a calibrated scale. A calculator dial translates the scale value into combinations of shutter and f-number settings, taking the film speed into account (see Figure 3–30).

Cadmium sulfide (CdS)-cell meters were introduced around 1960. Light falling on this type of cell alters the resistance in a circuit containing a battery; this type of sensor is called a photoconductor (see Figure 3-31). The major disadvantage of the selenium photovoltaictype exposure meters is low sensitivity. The lowest light-level reading that can be made with one popular selenium meter corresponds to an exposure time of 15 seconds at f/16 with an ISO setting of $100/21^{\circ}$. The lowest reading on a widely used cadmium sulfide photoconductortype meter is one hour at f/16-a ratio of sensitivities of 1:240. The high sensitivity of cadmium sulfide cells makes it possible to use relatively small cells, a desirable feature for behind-lens metering in smallformat cameras. Built-in camera meters typically bypass the calculator used on hand meters by a coupling arrangement whereby the photogrephor adjusts the foundar arring in the stanter spour meriod to ault the meter reading, or the adjustment is made automatically (see Figure 3-32).

Selenium meters are also subject to fatigue, whereby the needle slowly drifts toward a lower value when the cell is exposed to strong light for a prolonged period, but this is seldom a problem in practice. Cadmium sulfide meters, on the other hand, are plagued with memory—the meter remembers bright light and is reluctant to drop down to the correct reading in dim light after having been used in

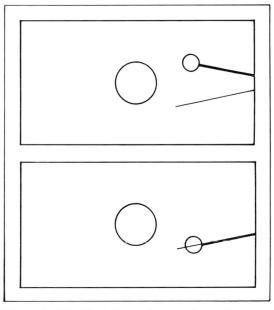

Figure 3-32 The indicators for a matched-needle exposure meter system as they appear in the viewfinder of a single-lens reflex camera before adjusting the controls (top) and after. The needle position is determined by the scene luminance, and the loop position is determined by the aperture, shutter, and filmspeed settings. With shutter-priority systems the photographer selects the shutter speed, and the exposure meter automatically selects the aporture sotting. With aperture-priority systems the photographer selects the f-number, and the exposure meter selects the shutter speed.

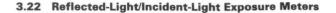

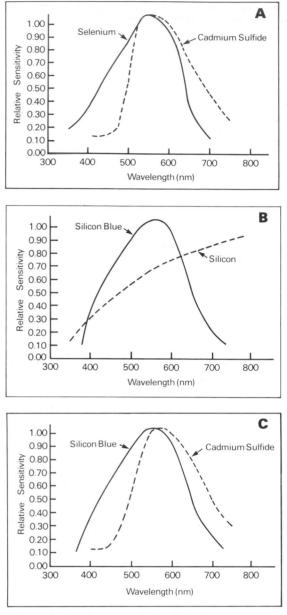

Figure 3-33 Spectral sensitivity of selenium, cadmium, sulfide, and silicon exposure-meter cells. (A) Spectral sensitivity curves for selenium cells and cadmium sulfide cells. Cadmium sulfide cells have much higher overall sensitivity, which is not revealed because the curve heights have been adjusted, but the spectral sensitivity of selenium cells more closely matches that of panchromatic films. (B) Silicon cells have high red sensitivity and low blue sensitivity. but the spectral sensitivity balance is improved in silicon blue cells through the use of filters. (C) A comparison of the spectral sensitivity of silicon blue cells and cadmium sulfide cells.

bright light, sometimes requiring 20 seconds or longer to reach the correct reading.

Ideally, the spectral sensitivity of exposure-meter cells would closely resemble the spectral sensitivity of typical panchromatic films, but unfortunately none of them do. The curves in Figure 3–33 show the spectral sensitivity of selenium, cadmium sulfide, silicon, and silicon blue cells. Variations of spectral sensitivity will be found among cells of the same type due to manufacturing controls, including the use of filters over the cells; and minor variations are even found among meters of the same brand and model due to the variability inherent in all manufacturing processes.

Blue filters, as used in silicon blue meters, can compensate for the cells' inherently low blue sensitivity. However, full correction is not an attractive option, since the filter simply absorbs the colors of light to which the cells are more sensitive, thereby reducing overall sensitivity. Silicon cells, which were introduced in the 1970s, share the high sensitivity of cadmium sulfide cells without the disadvantage of memory. Meter manufacturers are continuing to develop new types of photoelectric cells, such as silicon photodiode and gallium arsenide phosphide photodiode, in an effort to achieve further improvements in performance.

High red sensitivity and low blue sensitivity of a meter cell, compared to the sensitivity of panchromatic film, can cause a difference in density of negatives exposed outdoors and indoors because of the difference in the color temperature of the light sources. A further complication is that the film may not have exactly the same speed with the two types of illumination even though only a single film speed is published for both. The greatest danger of incorrect exposure due to poor spectral response, however, occurs when reflected-light meter readings are taken from strongly colored subject areas and when color filters are used over the camera lens with behind-lens meters. With a meter having high red sensitivity, metering through a red filter would lead to underexposure of the film (see Figure 3–34).

3.22 Reflected-Light/Incident-Light Exposure Meters

Strictly speaking, all exposure meters can measure only one thing: the light that actually falls on the photoelectric cell. By adjusting the angle over which the cell receives light, and by using neutraldensity filters that transmit only a desired proportion of the light (or by incorporating a corresponding adjustment in the calibration system), it is possible for the photographer to obtain correct exposure information (a) when the cell is aimed at the subject as a reflected-light meter; (b) when the cell is placed near the subject and aimed at the camera as an incident-light meter, and (c) when the cell is placed behind the lens in a camera where it receives a sample of the image-forming light that falls on or is reflected by the film.

Reflected-light exposure meters are calibrated to produce the correct exposure when the reading is taken from a medium-tone area. An 18%-reflectance gray card is widely used as an artificial or substitute midtone. Some hand-held reflected-light meters have acceptance angles that are approximately the same as the angle of view of a camera equipped with a normal focal length lens, which is approximately 53°,

Figure 3-34 Copy photographs of a black-and-white print and gray scale, exposed according to a through-the-lens exposure meter. The top photograph, made with no filter, is correctly exposed. The bottom photograph, made through a red filter, is underexposed due to the high red sensitivity of the cadmium sulfide cell, which produced a false high reading.

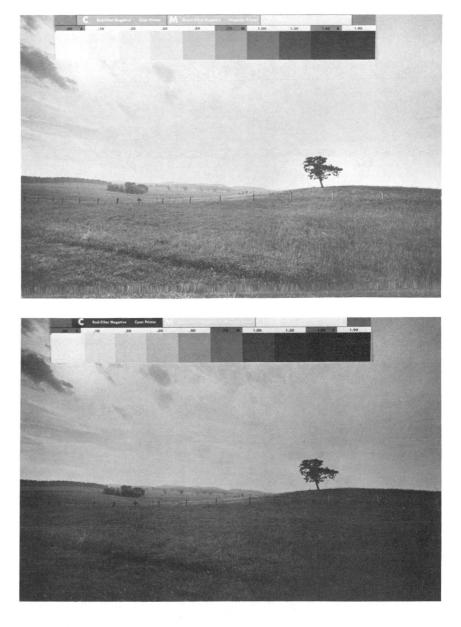

although 30° is more typical. The acceptance angle of reflected-light exposure meters is defined as the angle where the response is one-half the on-axis response.⁴

When a reflected-light meter is aimed at a scene from the camera position, it integrates the light from the scene's various parts and gives an average reading. Such a reading will produce the correct exposure only with scenes that have a balance of light and dark tones around an appropriate midtone. The meter can be moved closer to the subject to make a reading from a single subject area or from a substitute midtone area. An alternative is to limit the angle of acceptance so that a smaller subject area can be measured from the camera position. Spot attachments are available for some reflected-light meters, and some meters are designed as spot meters with angles of acceptance as small

⁴ANSI, PH2.12, p. 14.

as 1° (see Figure 3–35). Fiber-optics probes are also offered as accessories for some meters, permitting readings to be made from very small areas.

A more appropriate description of reflected-light exposure meters is *luminance* meters, since such meters are used to measure other than reflected light, including light transmitted by transparent and translucent objects (such as stained-glass windows) and light emitted by objects (such as night advertising signs and molten metal). Also, some persons prefer to use the term *light* meter rather than exposure meter, but the terms *reflected-light meter* and *exposure meter* have become entrenched in the photographic vocabulary through common usage. Actually, since the spectral response curves of exposure meters do not (and should not) match the spectral response curve of the standard observer, the meters do not truly measure light.

Behind-lens meters also can be designed either to integrate the light over a large angle to provide an average reading, or to measure the light from smaller areas. Some cameras have "center-weighted" meter systems, others measure off-center areas, and some average separate readings from different areas, such as sky and foreground with a typical landscape composition (see Figure 3-36).

If a hand exposure meter is to be used for both reflectedlight and incident-light readings, an adjustment must be made when the meter is turned around so that the cell is receiving the higher level of light falling on the subject rather than just the 18% that is reflected

Figure 3-35 The white circle on the post on the right represents the approximate area measured with a 1° spot meter on a photograph made with a normal focal length lens where the angle of view is approximately 53° .

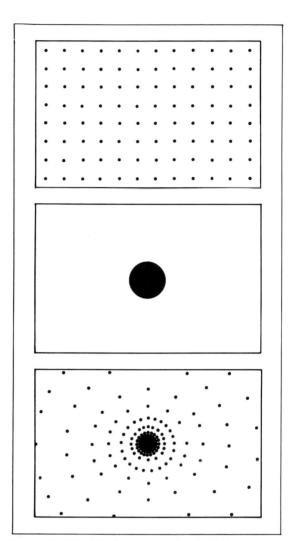

Figure 3-36 The three most popular distributions of exposure-meter sensitivity within the picture area in 35 mm single-lens reflex cameras are: averaging (top), spot (middle), and center-weighted (bottom).

from a typical scene. Dividing 100% by 18% produces a ratio of approximately 5.6:1. Therefore, a neutral-density filter that transmits 1/5.6 of the light, placed over the cell, would convert the reflected-light meter to an incident-light meter that would produce the same exposure with a subject that reflects 18% of the incident light (see Figure 3-37).

It is appropriate to use a flat receptor on incident-light meters that are to be used for photographic copying, so that the illuminance will vary on the meter cell and the flat original exactly the same when the direction of the lighting changes. Such a meter is identified as a *cosine-corrected* meter because the cosine law of illumination states that the illuminance changes in proportion to the trigonometric cosine of the angle between the light path and a perpendicular to the surface. Copying lights are typically placed at an angle of 45° rather than near the camera, to avoid glare reflections. The cosine of 45° is approximately 0.7, which means the illuminance on the original and the cosinecorrected meter cell will be only 0.7 what it would be if the lights were placed directly in front of the original on the lens axis at the same distance (see Figure 3=38)

Some general purpose onposure meters provide a flat diffusor to place over the cell that transmits the proportion of light needed to convert the meter to an incident-light meter, as well as to provide cosine-corrected readings for copying purposes. Since the cosine of 90° is zero, flat receptors could not be used with side-lighted and backlighted three-dimensional subjects and scenes with the meter aimed at the camera. Such a meter could be aimed at the key light provided that a suitable adjustment is made, with a calculator dial for example, to compensate for the change in effectiveness of the illumination, from 100% for front lighting to 50% for 90° side lighting to 0% for 180° back lighting.

In 1940, however, Don Norwood introduced a more satisfactory solution: an incident-light exposure meter with a hemispherical diffusor over the cell that automatically compensated for changes in the direction of the key light with the meter aimed at the camera.⁵ The Norwood exposure meter operated on the principle that as the key light was moved toward the side from a front-lighted position, it illuminated less and less of the hemispherical diffusor, producing proportionally lower readings. With 90° side lighting, for example, the key light illuminated half the diffusor, and the illuminance reading was 50% of the front-lighted reading—the equivalent of a one-stop change in the camera exposure settings (see Figure 3-39). Today almost all meter manufacturers have adopted the hemispherical diffusor for incidentlight exposure meters intended for use with three-dimensional subjects and scenes. With some, however, care must be taken in positioning the meter so that the meter body does not shield the diffusor from the key light in back-lighted situations.

3.23 Meter Scales

Early photoelectric exposure meters were commonly calibrated in photometric units such as footcandles for illuminance and candelas per square foot for luminance readings, or in numbers that

⁵Norwood, D., 1950, pp. 585-602.

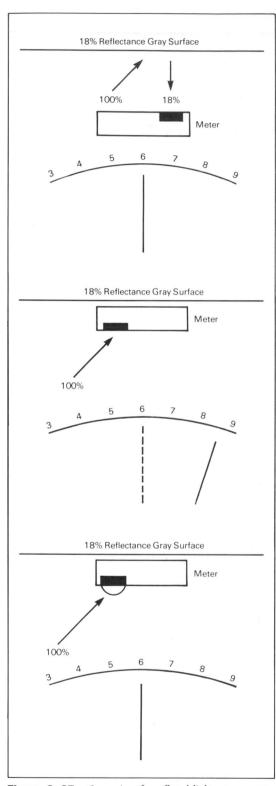

Figure 3-37 Conversion of a reflected-light exposure meter to an incident-light exposure meter. (Top) A reflected-light exposure meter measures 18% of the incident light reflected from a subject of average reflectance. (Middle) A reflected-light exposure meter used as an incident-light exposure meter, without modification, measures 100% of the incident light and produces a false high reading. (Bottom) Adding a diffuser that transmits 18% of the incident light produces the same correct reading as that obtained with the reflected-light exposure meter.

represented relative photometric units. The numbers on these meters formed ratio scales such as 1-2-4-8-16, etc., so that each higher number represented a doubling of the light, or the equivalent of a one-stop change (see Figure 3–40). Some other types of markings have been used, including f-numbers that correspond to whole-stop changes, but most contemporary meters with calibrated scales use a simple interval series of numbers such as 1-2-3-4-5-6, etc., where each higher number again represents a doubling of the light, or a one-stop change (see Figure 3–41).

If the numbers on a meter interval scale are *light values* in the additive system of photographic exposure (APEX), then the relationship of the four factors involved in camera exposure—f-number, exposure time, scene illuminance, and film speed—is expressed as:

Aperture value + Time value = Light value + Speed value

= Exposure value, or

$$A_{v} + T_{v} = L_{v} + S_{v} = E_{v}.$$

Thus with a meter reading light value of 5 (30 foot-lamberts) and a film speed value of 5 (ISO 100) the exposure value is 5 + 5 or 10. Therefore, any combination of aperture and time values that adds up to 10 can be used, such as an aperture value of 3 (f/2.8) and a time value of 7 (1/125 second). The values for other f-numbers, exposure times, film speeds, and scene illuminance readings are given in Table 3–3. Most interval-scale meters use an arbitrary set of numbers beginning with 1 for the lowest mark on the scale rather than using APEX light-value numbers, but some do include exposure value (E_v) numbers—a combination of light values (L_v) and film-speed values (S_v)—on the calculator dial or elsewhere.

3.24 Light Ratios

Since exposure-meter readings are commonly used to determine lighting ratios and scene luminance ranges or ratios, it is important to note the difference between ratio (1-2-4-8) scales and interval (1-2-3-4) scales on meters and to be able to use either. With a ratio scale meter the scene luminance ratio can be determined by taking reflected-light readings from the highlight and shadow areas and dividing the larger number by the smaller. For example, 256 (highlight) divided by 2 (shadow) is 128, or a luminance ratio of 128:1. Similarly, the lighting ratio for a studio portrait can be determined by taking an incident-light or a reflected-light reading for the key light plus the fill light and a second reading for the fill light alone, so that readings of 60 and 15, for example, represent a 4:1 lighting ratio. A comparison of shadow and highlight reflected-light readings is shown below for the two types of scales:

 $1 - \underbrace{2}_{2} - 4 - 8 - 16 - 32 - 64 - 128 - \underbrace{256}_{2} - 512$ $1 - \underbrace{2}_{2} - 3 - 4 - 5 - 6 - 7 - 8 - \underbrace{9}_{H} - 10$

Figure 3-38 The cosine law of illumination. (A) According to the cosine law of illumination, the illuminance for light falling on a flat surface varies with the cosine of the angle of incidence—a relationship represented by the solid curve. The broken lines indicate the relative illuminance for 45° copy lighting. (B) Both flat (cosinecorrected) and hemispherical diffusers are provided with this exposure meter.

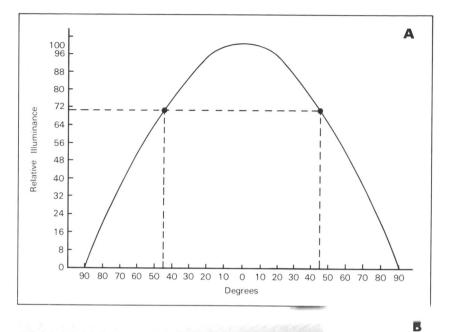

The 128:1 luminance ratio scene on the ratio scale can most conveniently be expressed as a 7-stop (9 - 2) scene on the interval scale. Seven stops can be converted to a 128:1 ratio by raising 2 to the seventh power, 2^7 (i.e., $2 \times 2 \times 2 \times 2 \times 2 \times 2 \times 2 \times 2) = 128$ (Using logarithms, $/ \times \log 2 = 7 \times 0.3 - 2.1$, and the antilog of 2.1 is approximately 128.)

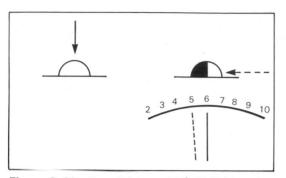

Figure 3–39 Front lighting and 90° side lighting of a bemispherical diffuser, resulting in a one-stop decrease in the meter reading.

Figure 3-40 The numbers on this meter dial are proportional to the amount of light falling on the cell. Since each number is double the next lower number, the numbers form a ratio scale.

Figure 3-41 Even though the numbers on this meter dial form an interval scale with equal increments of 1, each number represents double the amount of light of the next lower number.

3.25 Meter Accuracy and Testing

It is unrealistic to assume that all exposure meters are accurate, even when they are new. As emphasized in Chapter 1, variability affects all aspects of the photographic process, including different exposure meters produced by the same manufacturer that are supposed to be identical. The important question is whether the variability is small enough so that it can be ignored, or whether some compensation should be made. How much error should be tolerated in an exposure meter is not an easy question to answer, since the exposure latitude in a specific picture-making situation depends upon a number of factors, including the type of film being used and how critical the viewer of the resulting image will be. In any event, photographers commonly test their new meters against other meters of known performance, and professional photographers usually feel insecure unless they have more than one meter in their possession at all times.

Calibrated light sources are available for testing exposure meters and other light meters, but because of their cost they are more suitable for use by manufacturers and testing laboratories than by individual exposure-meter owners. Sunlight can be used as a standard light source provided the various factors that can affect the illuminance, such as time of day and sky conditions, are taken into account. If one only wants to make a comparison between a certain exposure meter and other meters, preferably of known performance, a light source merely needs to be constant and does not need to be calibrated. A transparency illuminator is especially well suited to being used for comparing ex-

Table 3-3 Conver	rsion form	nulas an	d data for	the aperi	ture value,	time value,	light vali	ue, and spe	ed value in	the additiv	e system of	photographi	c exposure (APEX).
$A_V = \operatorname{Log}_2 (F-N)^2$	A_{v}	0	1	2	3	4	5	6	7	8	9	10	
	F-N	1	1.4	2	2.8	4	5.6	8	11	16	22	32	
$T_v = \text{Log}_2 1/T$	T_v T	0	1	2	3	4	5	6	7	8	9	10	
	T	1	1/2	1/4	1/8	1/15	1/30	1/60	1/125	1/250	1/500	1/1000	Second
$B_v = \text{Log}_2 B/6$	B_{v}	0	1	2	3	4	5	6	7	8	9	10	
	$B_V B$	0 6	12	25	50	100	200	400	800	1600	3200	6400	Footcandles
$S_v = \text{Log}_2 S/3$	S_{v}	0	1	2	3	4	5	6	7	8	9	10	
02	S	0 3	6	12	25	50	100	200	400	800	1600	3200	ASA
												(Arithme	etic)

Figure 3–42 A transparency illuminator being used as a standard light source to check the calibration of an exposure meter.

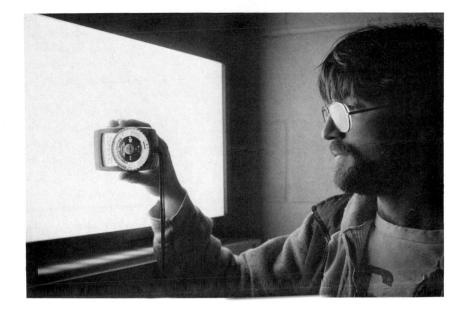

posure meters, since placing the meters against the center of the illuminator eliminates variability due to differences in angle of acceptance, distance from the light source, and shadows of the meters (see Figure 3-42).

The frequency histogram in Figure 3-43 shows the result of a comparison of approximately 200 new and used exposure mctcrs of various brands. All meters were set for the same film speed, and the indicated exposure times for a relative aperture of f/16 were recorded. Even though the total range of exposure times corresponds to a ratio of approximately 16:1, the equivalent of four stops, about 90% of the readings fell within a 2:1 ratio, or a one-stop range. Since all of the meters that had zero settings were properly zeroed, the only method of compensating automatically for consistently high or consistently low readings is to make an adjustment in the film-speed setting. Thus if a meter reads one stop too high, it should be set for one-half the published arithmetic film speed.

Unfortunately, meters that prove to be accurate when checked against a standard light source may still be inaccurate under certain conditions. For example, the meter may be accurate at one position on the scale and inaccurate at higher and lower positions; it may have high or low sensitivity to certain colors of light, and it may be subject to errors due to memory or fatigue.

Beginning at the high end of a meter scale, the reading should drop by the equivalent of one stop each time the light being measured is reduced by a factor of two. One method of reducing the light level in this manner is to insert a neutral-density filter between the light source and the meter cell. An ND 0.3 filter transmits onehalf of the light, an ND 0.6 filter transmits one-quarter of the light, an ND 0.9 filter transmits one-eighth of the light, etc. It should be noted, however, that most neutral-density filters do not reduce ultraviolet and infrared radiation by the same proportions, so that meter sensitivity to either of these types of radiation can affect the results, although any such deviations should be cumulative in a systematic manner throughout the scale. Infrared cutoff filters have been incorporated in some exposure meters to reduce the problem of measuring radiation to which most photographic films are not sensitive. Infrared

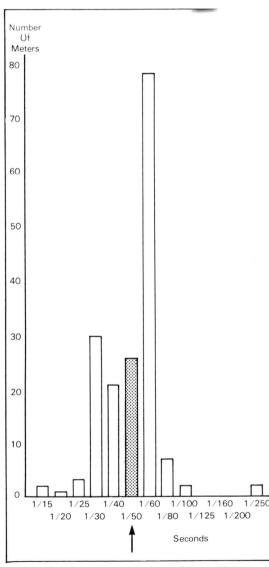

Figure 3–43 Frequency histogram showing the results of the testing of approximately 200 exposure meters on a standard light source. Although the variability represents a range of four stops, 90% of the meters fell within a one-stop range.

absorbing filters can also be added to an illuminator used for testing meters, which will eliminate difficulties due to the transmission of infrared radiation by neutral-density filters. Meters that have separate scales for high and low light levels should produce the same reading in the overlap region on the two scales.

Another method of testing an exposure meter is to expose film in a camera according to a meter reading and to make additional exposures bracketing the indicated exposure by one-third- or one-halfstop changes, and then adjust the film-speed setting to compensate for any difference between the metered cxposure and the best exposure based on the photographic results. Photographers sometimes refer to this testing process as deriving a personalized exposure index. Since photographers do not always come up with consistent results when they repeat this test, it is important to note the possible influence of the following factors:

- 1. Development. Deviating from the developing conditions specified in the standard used by the film manufacturer in arriving at the published film speed can cause a change in the effective speed. One film manufacturer recommends giving black-and-white film one-half stop more exposure when it is going to be developed to the lower contrast index specified for printing with a condenser enlarger, compared to printing with a diffusion enlarger. Finegrained developers can reduce the effective film speed even when films are developed to the same contrast index as with other developers. Push-processing is offered as an optional service for some color films; the degree of development is increased or decreased to compensate for exposing the film at a higher- or lowerthan-normal exposure index (see Table 3-4).
- 2. Increased lens-to-film distance. Since f-numbers are calculated for an image distance of one focal length, increasing the lens-to-film distance by focusing on objects closer than infinity reduces the illumination level at the film. The exposure

factor =
$$\left(\frac{\text{image distance}}{\text{focal length}}\right)^2$$
. (See Section 3.8.)

3. Reciprocity law failure. The effective speeds of films change with changes in exposure time, typically decreasing with exposure times longer than 1/10 second and with the very short times encountered with electronic flash. Exposure data for compensating for reciprocity law failure are shown in Table 3–5.

Table 3-4 Recommended adjustments in the first developer step of Process E-6 for Kodak Ektachrome films for camera exposures ranging from three stops underexposure to four stops overexposure.

	First Development							
Camera Exposure	Time Adjustments	0 r	Temperature Adjustments					
Three Stops Under	Increase by 10 min.		Increase by 16 F					
Two Stops Under	Increase by 51/2 min.		Increase by 12 F					
One Stop Under	Increase by 2 min.		Increase by 8 F					
Normal	None		None					
One Stop Over	Decrease by 2 min.		Decrease by 6 F					
Two Stops Over	Not Recommended		Decrease by 13 F					
Three Stops Over	Not Recommended		Decrease by 16 F					
Four Stops Over	Not Recommended		Decrease by 19 F					

© Eastman Kodak Company 1982

	Table A	Table B	
Indicated Exposure Time	Time Factor	Time Factor	Developing Time Adjustment
1 sec.	1.25	2	- 10%
5 sec.	1.5	4	- 15%
10 sec.	1.8	5	-20%
100 sec.	3.0	12	- 30%
5 min.	4.0	Not Recommended	
10 min.	5.0	Not Recommended	
20 min.	6.0	Not Recommended	
40 min.	8.0	Not Recommended	

Table 3–5 The dramatic difference in reciprocity-law failure characteristics of different films is illustrated by these two tables. Table A is a general-purpose table that has been in use for many years and still applies to some contemporary films. Table B is recommended for most Kodak continuous-tone films currently being manufactured.

- 4. Shutter accuracy. Shutters are seldom 100% accurate at all settings and are frequently faster than rated at some settings and slower than rated at influent Efficience spanne combination by changes in temperature and also over time with or without use. (See Section 3.18.)
- **5.** Shutter efficiency. Between-the-lens shutters that are accurate at the maximum diaphragm opening, where they are calibrated by the manufacturer, tend to overexpose the film when used at smaller openings because the smaller opening is uncovered sooner and remains uncovered longer as the shutter blades open and close—producing a longer effective exposure time. (see Section 3.14.)
- **6.** Flare. Camera flare light typically consists of a uniform amount of light superimposed on the image-forming light received by the film. More than the normal amount of flare light produces the effect of overexposure, and less than the normal amount produces the effect of underexposure. If the degree of film development is increased to compensate for the loss of contrast with high-flare situations, the effect of overexposure is exaggerated even more. (See Section 2.16.)
- **7.** Lens transmittance. Image illuminance can vary significantly among different lenses set at the same f-number due to variations in the amount of light absorbed and reflected. Efficient lens coatings reduce but do not eliminate this source of variability when there are large differences in the number of lens elements. (See Section 3.9.)
- 8. Film speed. Since published film speeds are rounded off to numbers that correspond to thirds of a stop, two films with the same rating could vary by as much as ± 1/6 stop or a total of 1/3 stop (see Table 3-6). In addition, the speed of films can change with time following manufacture. To minimize these sources of variability, photographers sometimes buy a large quantity of film of the same emulsion number and store it in a freezer. (See Section 2.11.)
- **9.** *Filters.* Even though it is obvious that adding a color filter or polarizing filter to a camera lens will absorb light and require exposure compensation, it is not so obvious that the more-or-less clear ultraviolet filters some photographers leave on their lenses also have some effect on the exposure.
- **10.** Color temperature of the light source. Negatives made indoors and outdoors on the same black-and-white film may have different densities due to the difference in color temperature of the light

Table 3-6 Published film speeds are rounded off to numbers that correspond to thirds of a stop. Two films having the same rating could vary in speed by as much as $\frac{1}{6}$ stop in opposite directions for a total of $\frac{1}{3}$ stop.

American National	
Standard Speed	
(ASA)	
3200	
2500	
2000	
1600	
1250	
1000	
800	
640	
500	
400	
320	
250	
200	
160	
125	
100	
80	
64	
50	
40	
32	
25	
20	
16	
12	
10	
8	
6	

3.26 Methods of Using Reflected-Light Exposure Meters

sources. This would not be a problem if the spectral response of the exposure meter exactly matched the spectral sensitivity of the film. Some photometers are supplied with filters that alter the spectral quality of the illumination so that the response of a given filter-meter combination approximates that of a designated system, such as human vision. Photographers should not expect a close match between photographic exposure meters and photographic films.

Until a photographer has gained enough experience to keep a mental checklist of the above factors that can affect image density, it is appropriate to keep and use a written checklist.

3.26 Methods of Using Reflected-Light Exposure Meters

Not only do photographers have a choice between reflectedlight and incident-light exposure meter readings, but they also have a choice of various types of reflected-light readings. The types of reflectedlight readings that will be considered here are midtone, keytone and Zone System, calculated midtone, camera position, and behind-lens camera meter readings.

3.26.1 Midtone Readings

It may strike some readers as strange that, whereas film speeds for conventional black-and-white films are based on a point on the toe of the characteristic curve where the density is 0.1 above base plus fog density, which corresponds to the darkest area in a scene where detail is desired, exposure-meter manufacturers calibrate the meters to produce the best results when reflected-light readings are taken from midtone areas. Meter users who are not happy with this arrangement can make an exposure adjustment (or, in effect, recalibrate the meter) so that the correct exposure is obtained when the reflected-light reading is taken from the darkest area of the scene, the lightest area, or any area between these two extremes. This type of control is part of the keytone method and the Zone System.

Since reflected-light meters are calibrated for midtone readings, however, it follows that any area used for a reflected-light reading will be reproduced as a midtone on the film, even if the area is the lightest or darkest area in the scene, if no adjustment is made. To illustrate with negative-type film, taking a reflected-light reading from a white subject area will cause this area to be recorded as a mediumtone density, which is considerably thinner than it would be in a correctly exposed negative. In other words, the negative will be underexposed. In terms of the film characteristic curve, all of the tones will be moved to the left on the log exposure axis, causing the midtone of the scene to move from the straight line down onto the toe, and the shadows to move from the toe onto the base-plus-fog part of the curve where detail will be lost.

A typical white surface reflects about 90% of the incident light, which is five times as much as is reflected from an 18%-reflectance gray card, so that taking the reading from a white area causes the film to be underexposed by a factor of five, or a little more than two stops. With the negative-positive process this underexposed negative still can be printed so that the white area from which the reading was taken appears white; but the loss of contrast, and especially the loss of detail

Figure 3-44 Reflected-light exposure meter readings. (Left) The black-and-white plaster cats correspond in reflectance to the two ends of a gray scale, the gray cat represents a midtone. A reflected-light meter reading from the gray cat reproduces it as a realistic medium gray and produces the best exposure for the entire scene. In the original Polaroid print there is tonal separation of all 10 steps in the gray scale and divide in the from planes of ull three tuns—attomupp not in the minimum minimum of 100 states and attorn in the minimum minimum of 100 states and attorn in the minimum minimum of 100 states and attorn in the minimum minimum of 100 states and attorn in the minimum minimum of 100 states and the place tuns—attorney from the white cat. (Middle) A reflected-light reading from the white cat results in it being reproduced as a medium gray rather than white, and the photograph as a whole is underexposed. (Right) A reflected-light reading from the black cat results in it being reproduced as a medium gray rather than black, and the photograph as a whole is overexposed.

Figure 3–45 A gray surface with a reflectance of 18%, or a reflection density of about 0.74, is perceived as being midway between white and black and serves as an appropriate photographic midtone.

in the darker areas, cannot be fully corrected. With reversal color films where the slide or transparency is the end product, and with instant or one-step picture materials that produce prints directly, taking a reflected-light reading from a white area again reproduces that area or a modium from white human in dwarm than at model to which normal exposure. Since such reversal materials have little exposure latitude, they are especially useful for demonstrating the differences in results of the various methods of using exposure meters.

The photographs in Figure 3-44 illustrate the results when reflected-light readings are taken from a midtone area, a light area, and a dark area. It can be observed that the areas from which the readings were taken are all reproduced as the same medium density but that the overall effect is satisfactory only when the reading was taken from the midtone area.

One of the problems with the midtone reflected-light method is the difficulty of selecting an appropriate medium-tone area from which to take the reading. If we think in terms of a copying situation in which the subject tones range from white to black, as in a gray scale, a gray that appears to be midway between white and black will have a reflectance of about 18%, or a density of about 0.74 (see Figure 3-45). (A procedure for determining this visual midtone is discussed in section 13.4.)

Since the photographic midtone agrees with the visual mid-

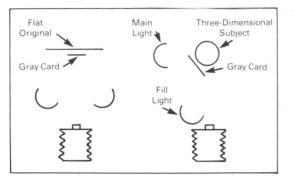

Figure 3-46 In copying setups the gray card should be positioned parallel to the original. With three-dimensional subjects the gray card should be angled midway between the main light and the camera.

tone, it is appropriate to use an 18%-reflectance gray card as an artificial midtone; such neutral test cards are made for this purpose. In copying situations the neutral test card should be positioned parallel to the original so that the change in illuminance with the angle of the light sources, as specified by the cosine law of illumination, is the same on the original and the test card.

A neutral test card can be used as an artificial midtone with three-dimensional subjects as well, provided the card is now aimed midway between the camera and the dominant light source rather than directly at the camera (see Figure 3-46). Even though neutral test cards have a more or less dull surface, care must be used, when taking reflected-light meter readings, to angle the meter so as to avoid mirrorlike reflections of the light source. It is also advisable to position the meter close enough to avoid including any lighter or darker area behind the card but not so close as to produce a shadow on the card. Spot attachments or spot meters make it possible to obtain accurate readings at greater distances than with conventional reflected-light meters.

3.26.2 Keytone and Zone System Readings

White-card film speeds were commonly provided on film data sheets in addition to the conventional film speeds in past years, and are still provided for some films designed especially for copying. Since a typical white surface reflects about 90% of the light, or five times as much as the 18%-reflectance neutral test card, the white-card film speed would be only one-fifth the gray-card film speed with arithmetic film speeds.

Reasons for using a white-card exposure meter reading in preference to a gray-card reading are that white surfaces are more readily available than 18%-reflectance gray surfaces, and in low light levels it might be possible to obtain a white-card reading when an exposure meter is not sufficiently sensitive to obtain a reading from a gray card. An alternative to changing the film-speed setting on the exposure meter for white-card readings is to place a marker in the appropriate position on the meter calculator dial and then set that marker rather than the normal marker opposite the meter reading.

When it is especially important to retain shadow detail in a photograph, the keytone method can be used: A reflected-light meter reading is taken from the shadow area and an appropriate mark is made on the calculator dial opposite that reading. (If no adjustment were made, the shadow area would be reproduced as a medium tone, and the negative overall would be much too dense.) The original Weston exposure meter had a U-Position or shadow marker four stops below the normal arrow. The same effect can be obtained with any reflectedlight exposure meter by reading the shadow area and then giving the film one sixteenth the exposure or four stops less exposure than that indicated by the normal marker.

A logical extension of the keytone method, beyond calibrating the calculator dial for white-card or highlight readings and for shadow readings, is to calibrate it for each stop between these limits. Such a calibration is an important part of the Zone System, whereby seven gray patches of varying densities are associated with the sevenstop range on the meter dial that represents a normal scene having a luminance ratio of about 1:128. The lightest and darkest patches represent the useful density range of the printing paper, and each patch indicates the predicted density on the print for the corresponding luminance value in the scene. The photographer, however, is not limited

Figure 3-47 Silhouettes and semisilhouettes are dramatic examples of situations where facsimile tone reproduction is not the objective, as with this photograph of white golf balls. With the Zone System, the photographer can determine the reproduction tone for a given subject area at the time the film is exposed.

SHADOW	1 8 sec.
	1/15
	1 30
MIDTONE	1/60
	1/125
	1 250
HIGHLIGHT	1/500
HIGHLIGHT	1 500
	MIDTONE

Figure 3-48 The calculated midtone is found with a shutter-priority system (left) by noting the f-number that is midway between the f-numbers indicated for a shadow reading and a highlight reading. With an aperture-priority system (right) the shutter speed midway between the indicated speeds for shadow and highlight readings is selected.

to striving for a faithful tone reproduction. If, for example, it is desired to depict snow somewhat darker than normal to emphasize the texture, the patch having the desired density is placed opposite the meter reading from the snow. This procedure is especially useful when using color transparency film where the transparency is the end product, and therefore printing controls are not available (see Figure 3-47). Adjusting film development to compensate for high-contrast and low-contrast scenes is also an important feature of the Zone System.

3.26.3 Calculated Midtone Readings

In practice it is often difficult to scan a scene and subjectively select an appropriate midtone area from which to take a reflected-light exposure meter reading. The scene may contain light and dark tones but no midtones, and even if there is an appropriate midtone area, it may be difficult to identify due to the influence of the colors of objects, an imbalance in the size of light and dark areas, local brightness adaptation of the visual system, and other factors. An objective method of arriving at a midtone reading is to take separate readings from the lightent and darks a an as attered former to Attained and on a back milddle value.

Some care is necessary because the middle value is not an arithmetic average of the highlight and shadow luminances. The scales on most hand meters are set up so that each higher major marking and number represent a doubling of the luminance, or the equivalent of a one-stop change. If the meter has an interval scale of numbers (1-2-3-4-5-6-7), and if the shadow reading is 1 and the highlight reading is 7, the calculated midtone value is the middle number, 4. With such interval scales the same midtone value is obtained by adding the highlight and shadow values and dividing by 2: $\frac{7+1}{2} = 4$. If the meter

has a ratio scale of numbers (1-2-4-8-16-32-64), and the shadow reading is 1 and the highlight reading 64, the calculated midtone value is again the middle number, in this example 8. Attempting to calculate the midtone value by averaging the shadow and highlight readings with the ratio scale would result in a large error since the arithmetic average of 1 and 64 is 32.5, not 8.

No change in procedure is required for hand meters or behind-lens meters that read directly in f-numbers (for a given shutter speed) or in shutter speeds (for a given f-number), since both scales are ratio. Therefore a correct midtone value is obtained by taking a shadow reading and a highlight reading and selecting the middle number on the f-number or shutter-speed scale (see Figure 3-48).

A bonus of the calculated-midtone method is that by taking readings in the darkest and lightest areas where detail is desired, it is easy to determine whether or not the scene is normal in contrast. The original Weston exposure meter had shadow and highlight markings on the calculator dial to indicate that the luminance ratio for an average scene is 1:128 (or a luminance range of seven stops or seven zones). Later studies suggested a slightly higher ratio of 1:160, which still rounds off to seven stops in terms of whole stops.

Various options are open to the photographer if, for example, a scene is discovered to be considerably more contrasty than the average scene:

A. By adjusting the exposure, detail can be retained in either the highlights or the shadows by sacrificing detail in the other areas.

3.26 Methods of Using Reflected-Light Exposure Meters

Figure 3-49 Camera-position reflected-light readings. (Top) Camera-position reflected-light exposure meter readings produce the best results with scenes that are balanced in light and dark tones. (Photograph by John Johnson.) (Middle) Predominately light scenes produce inflated meter readings, which result in underexposure. (Photograph by John Johnson.)

(Bottom) Dark scenes produce false low readings which result in overexposure. (Photograph by Yu Yin Tsang.)

- **B.** It is possible in some situations to reduce the luminance ratio with a fill light or a reflector, in which case the midtone value should be recalculated.
- **C.** Negative contrast can be lowered by reducing film development so that the negative will print on normal-contrast paper. Since the effective film speed varies with the degree of development, it is necessary to make an adjustment in the film speed or the exposure.
- **D.** Since conventional negative-type films have more exposure latitude than required for an average scene, the contrast adjustment can be postponed to the printing stage. The excess latitude is mostly on the overexposed side, however, so an exposure adjustment may be required to retain shadow detail.
- **E.** With reversal-type color films, contrast can be reduced with controlled flashing. Some slide copiers are designed to provide this option. The same effect can be achieved with any camera by giving the film a second exposure, using an out-of-focus image of a gray card and an appropriate reduction of the exposure.

Other terms applied to exposure methods that are similar or identical in concept to the calculated-midtone method are *brightness*range, luminance-range, luminance-range.

3.26.4 Camera-Position Readings

The camera-position or integrated-light method consists of aiming a reflected-light exposure meter at the scene from the camera position. Assuming that the meter's angle of acceptance is about the same as the angle of view of the camera-lens combination, the meter provides a single reading that represents an average of the luminances of the different subject areas being included in the photograph. Correct exposures should result with scenes that are well balanced with respect to light and dark areas. Scenes in which light areas predominate produce false high readings, which lead to underexposure. Scenes in which dark tones prevail produce false low readings and overexposure (see Figure 3-49).

A large proportion of photographs made on negative-type films using this method are satisfactory because most of the scenes photographed are reasonably well balanced in light and dark areas, because of the generous exposure latitude of the film, and perhaps even because of the generous acceptance latitude of the photographers. It is not difficult to recognize scenes that deviate dramatically from a balance of light and dark areas, where corrective action should be taken. Also, exposure-meter instruction manuals usually caution the user to tilt the meter downward to avoid including bright sky areas in outdoor meter readings.

3.26.5 Camera Meters

Although selenium-cell photovoltaic-type exposure meters have been built into small-format cameras, the introduction of the more sensitive cadmium sulfide cell and other meters of the photoconductive type made it possible to reduce the cells to a more appropriate size. Camera meters can be divided into two basic types: those with the cell mounted on the surface of the front of the camera and those with the cell located behind the camera lens (see Figure 3-50). Meters with surface-mounted cells perform in a manner similar to that of a reflectedlight hand meter that is aimed at the subject from the camera position to make an integrated-light reading. The angle of acceptance of the surface-mounted cell can be controlled with a baffle or lens, and the

Figure 3–50 Surface-mounted exposure-meter cell on a between-the-lens shutter 35 mm camera.

meter can be coupled with the camera-lens diaphragm or shutter. It is possible to place a diffusor over the cell and take incident-light readings by turning the camera around and holding it in front of the subject, but this has not been a widely used feature.

Behind-lens meters are better suited to focal-plane shutter cameras than to cameras having between-the-lens shutters that—at least with small format cameras—are open only when the film is being exposed. There has been considerable experimentation with the location, size, and shape of the behind-lens cell or cells. Cells have been placed in various positions on the prism of single-lens reflex cameras, on the mirror, behind the mirror, and off to one side where the cells receive and measure light reflected from a mirror or beam splitter, the shutter curtain, or even the film itself (see Figure 3–51).

Many technical problems had to be solved with behind-lens meters, such as preventing light that enters the viewfinder from behind the camera from reaching the cell; preventing polarization of the image light being measured (which would give inaccurate readings when a polarizing filter is placed on the camera lens), and compensating for the change in the size of the diaphragm opening between the time the light is measured and when the film is exposed. There are also many variations concerning the size, shape, and location of the picture area being measured, including integrated, center-weighted, off-center weighted, spot, and multiple cells.

Although behind-lens meters generally offer less precision with respect to measuring the light from selected parts of a scene, and although they are restricted to reflected-light type readings, they offer certain advantages over hand meters in addition to convenience. Since behind-lens meters essentially measure the light falling on the film, variations in the light due to increasing the lens-to-film distance for closeup photography, flare light, and variations in transmittance of different lenses set at the same f-number are automatically compensated for. Some camera manufacturers also claim that their meters compensate for the absorption of light by color filters placed over the lens, but until the spectral response of the meter cells is brought into closer agreement with the spectral sensitivity of typical panchromatic films than they are at the present time, they should not be depended upon for this function.

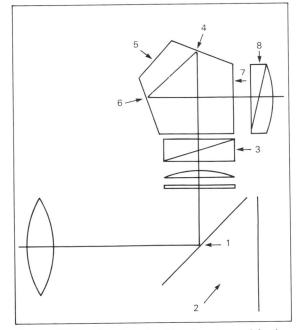

Figure 3–51 A variety of positions have heen used for the exposure-meter cell in single-lens reflex cameras by different manufacturers.

1. Behind the mirror. Measures direct light from the lens through clear lines or partially transmitting mirror.

2. Behind the mirror. Measures light reflected from the film during the exposure.

3. Between the focusing screen and the pentaprism. Measures light diverted by a beam-splitter.

4-7. On the pentaprism.

8. On the eyepiece. Measures light diverted by a beam-splitter. Difficulties of behind-the-lens metering can include inflated readings due to light entering the eyepiece from the rear, false readings with polarizing filters due to polarization of light by the metering system, and inconsistencies in diverting a fixed proportion of light to the meter cell.

Figure 3–52 A view-camera exposure meter that uses a movable probe to obtain readings in selected areas at the film plane.

3.27 Incident-Light Readings

In addition to this use with small-format cameras, behindlens meters are also available for use with view cameras. By attaching the light-sensitive cell to the end of a movable probe in a film-holder type frame, the cell can be positioned to take readings in any selected area while observing the image on the ground glass, or multiple readings can be taken for the calculated midtone method (see Figure 3-52).

3.27 Incident-Light Readings

Incident-light meter readings have long been popular with professional motion-picture and still photographers, because such readings can be made quickly and give dependable results. Typical instructions for using an incident-light exposure meter are simply to hold the meter in front of the subject and aim it at the camera. There is no need to ponder whether the scene has an equal balance of light and dark areas because the meter measures the light falling on the subject rather than the light reflected by the subject, and the meter is calibrated for a subject having a range of tones from black to white with a medium tone of 18% reflectance. In addition, there is no need to worry about the position of the dominant light source with incident-light meters having hemispherical diffusors because such meters automatically compensate for changes in the direction of the light and the corresponding change in the relative sizes of highlight and shadow areas.

Instruction manuals for exposure meters sometimes warn the user that the meter can only measure light, it can't think for the photographer; this applies to incident-light as well as reflected-light exposure meters. One potential source of error is associated with the time-saving observation that when the light falling on the subject is the same as that falling on the camera, as when both are in direct sunlight, the reading can be taken at the camera position. It is obvious that when the camera is in the shade of a tree or building, whereas the subject is in direct sunlight, the incident-light reading must be taken in the sunlight; but it is not so obvious, when a light source is close to the subject, that readings can be dramatically different at the subject and one foot in front of the subject. Thus, the closer the light source is to the subject, the more important it is to take the incident-light meter reading as close to the subject as possible. The inverse-square law of illumination can be ignored with sunlight because of the great distance of the sun, but it should not be ignored indoors when a light source is within a few yards of the subject.

Although the point has already been made that it is not necessary to consider the balance of light and dark areas in a scene for incident-light readings, it is advisable to modify the exposure indicated by an incident-light meter when the main subject is either very light or very dark in tone. It is advisable to increase the exposure by onehalf to one stop with black or very dark objects and to decrease the exposure by one-half to one stop with white or very light objects. Since it is possible to hold detail in an entire gray scale or a scene containing both white and black areas, even with reversal color films, which have limited exposure latitude, it is necessary to explain why the exposure should be adjusted when the subject is predominantly light or dark.

Referring to the characteristic curve for a reversal-type film shown in Figure 3-53, it will be noted that the white end of a correctly exposed gray scale falls on the toe and the black end falls on the shoulder. Some contrast is therefore lost in both of these areas, compared to the

3.27 Incident-Light Readings

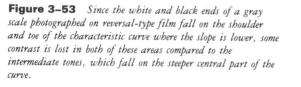

intermediate tones, which fall on the central part of the curve. This compression of contrast in the lightest and darkest areas is acceptable when they are relatively small in area; but when either becomes the main area of interest, it is better to adjust the exposure to move that area onto or closer to the straight line in order to increase the detail and contrast (see Figure 3-54).

No single method of using an exposure meter is appropriate for all picture-making situations. Incident-light readings cannot be made when the image-forming light is either emitted or transmitted by the subject rather than being reflected. Examples of emitted light are molten metal, flames, and fluorescent and phosphorescent objects. Transmitted light is encountered when transparent or translucent materials are illuminated from behind, as with stained-glass windows, some night advertising signs, a photographic transparency placed on an illuminator for copying, and sunsets.

There are, on the other hand, situations where incident-light meter readings are more appropriate than reflected-light readings. Probably the most commonly encountered situation of this type is where the subject or the subject areas are too small to be read accurately even with a narrow-angle spot-type reflected-light meter. This problem occurs not only in the fields of closeup photography and photomacrography but also when photographing a detailed object such as a black line drawing on a white background, where the light and dark tones are not balanced in size and the individual areas are too small to be measured (see Figure 3-55).

In most picture-making situations the photographer has the choice of making either reflected-light or incident-light exposure meter readings. With meters that are designed to be used in both modes, it

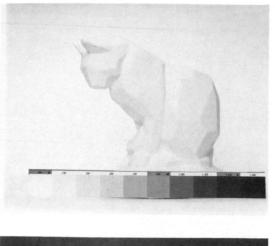

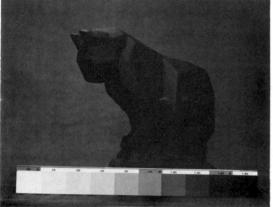

Figure 3-54 Although incident-light meter readings (or reflected-light meter readings from a neutral test card) produce the optimum exposure for subjects having a normal range of tones as represented by a gray scale, exposure adjustments are recommended for high-key scenes and for low-key scenes. (Top left) White object on light background with normal exposure. (Top right) One stop less exposure. (Bottom left) Black object on dark background with normal exposure. (Bottom right) One and one-half stops more exposure.

is a valuable exercise for the photographer to make comparison readings. When the readings do not agree, comparison photographs will reveal which method is superior in that type of situation. Reflected-light readings from an 18%-reflectance neutral test card are essentially the same as incident-light readings and should consistently indicate the same camera exposure.

3.28 Footcandle and Lux Measurements

Some incident-light exposure meters are designed for the additional function of measuring illuminance in photometric units of footcandles and/or lux (metercandles). Such information is not needed for conventional picture making because the meter translates the readings directly into combinations of f-numbers and shutter speeds. However, there are photographic applications for illuminance measurements in photometric units; these include setting up viewing conditions according to ANSI, ISO, or other standards, and measuring light received by photographic film or paper for sensitometric purposes (see Figure 3–56).

Figure 3–55 A situation where it would be difficult to obtain a dependable reflected-light exposure meter reading due to the small size and the light tone of the push pin.

Batt. Contr 2 Batt. Mallory PX 625 o. PX 13 nur bei Lichtmessung for Incident Light only Lux Scale Scale appi appi 12 350 32 65 0.17 .016 0,35 032 13 700 1400 130 14 15 16 17 0.7 .065 1.4 13 2800 260 5500 500 28 26 55 11000 1000 18 2000 22000 11 22 19 44000 4000 20 8800 8000 GERMANY (WEST) 563950

Figure 3–56 A conversion table on the back of an exposure meter for converting meter-reading scale numbers into lux (metercandles) or footcandles.

3.29 Degree of Development and Effective Film Speed

Published film speeds for black-and-white films are based on a specified degree of development. Developing the film to a higher contrast index tends to increase the film's effective speed, up to a limit, and developing to a lower contrast index tends to decrease the effective speed. In practice it is not uncommon for photographers to develop film to higher and lower contrast indexes than those indicated in the film speed standard.

Film development is sometimes altered to compensate for the difference in printing contrast between condenser and diffusion enlargers, to compensate for variations in scene contrast, and to compensate for variations in the amount of camera flare light in different situations. Adjustments in the effective film speed can be made either by altering the film-speed setting on the exposure meter, or by using the published film speed and then incorporating the correction in the choice of camera shutter speed and f-number settings.

The nomograph shown in Figure 3-57 makes it possible for the photographer to determine the recommended development contrast index and the exposure adjustment needed to compensate for changes in the type of enlarger, scene contrast, and flare light. Lines have been drawn on the nomograph for an example in which a condenser enlarger is used, the subject has a luminance range of eight stops, and the camera flare is moderate. The scale on the right side indicates that the film

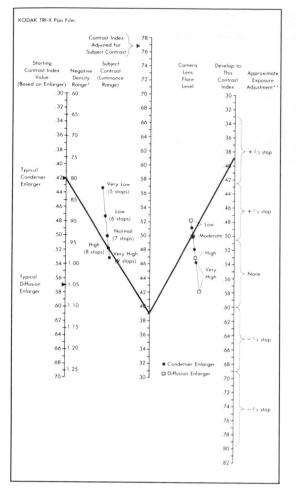

© Eastman Kodak Company 1976

 These are the typical negative density ranges that result when normal luminance range subjects (7 stops range) are exposed with moderate flare level lenses and developed to the contrast index shown in the left scale.

** Some film and developer combinations may require more or less exposure adjustment than these average values shown here, especially when the adjusted contrast index is less than .45 or greater than .65. Some of the finest-grain developers cause a loss in film speed that must be considered in addition to the losses caused by developing to a lower contrast index.

Figure 3-57 Contrast-control nomograph. ([©] Eastman Kodak Company 1976.) should be developed to a contrast index of 0.39, and the exposure should be increased by two-thirds of a stop. Testing procedures for deriving personalized development and exposure data for these variables are provided in some of the Zone System references listed in the bibliography.

3.30 Flash Guide Numbers

Guide numbers provide a means of determining the f-number setting required for correct exposure with flash and electronic-flash light sources. The guide number can be defined as the product of the f-number and the distance that produce the correct exposure for a given set of conditions, including the light source, reflector, film speed, shutter speed, and reflectance of the surroundings. In practice, the guide number is divided by the flash-to-subject distance to determine the correct f-number; or if the photographer wants to use a certain f-number, the guide number is divided by the f-number to determine the correct flash-to-subject distance. Since the guide-number system is based on the assumption that the illumination from the flash follows the inverse-square law, which in turn is based on a point source of light without a reflector, some variation in exposure may be encountered at small and large distances.

Additional complications are encountered in attempting to determine the correct exposure with guide numbers when using bounce flash (where the reflectance of the reflecting surface must be taken into account) and multiple flash (where the cumulative effect of two or more flash sources at different distances and angles, and sometimes different intensities, must be calculated).

3.31 Flash Meters

There has been little demand for exposure meters to be used with expendable flashbulbs, as it would be necessary to fire a flashbulb for the measurement before firing a second flashbulb to expose the film. Conventional exposure meters cannot be used with flash and electronic flash since the meters are designed to measure the light from a source of constant intensity rather than a source of rapidly changing intensity and short duration. Electronic-flash meters work on the principle of measuring the total amount of light that falls on the photocell over an appropriately short period of time by charging a capacitor and then measuring the charge (see Figure 3-58). Some electronic-flash meters have required a sync cord connection with the flash unit to be able to measure only the light from the flash plus ambient light for the approximate period that the camera shutter would be open. Other meters are able to achieve this without a physical connection with the flash unit, and meters are now available that can be used both as a conventional exposure meter and as an electronic-flash meter. Whereas certain electronic-flash meters can be adjusted to integrate the flash plus ambient light over a time interval equal to the selected shutter speed. others operate only over a fixed instantaneous interval, such as 1/60 second.

An alternative to measuring the light from an electronicflash unit with a preliminary trial flash and a meter is to measure the light reflected from the subject by a sensor built into the flash unit and then terminate the flash when the sensor system indicates the film

Figure 3-58 An electronic-flash exposure meter.

3.32 Color-Temperature Meters

has received the correct amount of light. The process by which the duration of the flash is shortened to provide the correct exposure is called *quenching*. Early quenching systems achieved the effect by dumping the remaining capacitor charge when sufficient light had been emitted, thus wasting the unused charge and shortening battery life. More recent units have incorporated a means of breaking the circuit between the capacitor and the tube when a signal is received from the metering system, without wasting the remaining charge in the capacitor. When quench-controlled electronic-flash units are used for closeup photography, the flash duration tends to be extremely short. The short duration provides excellent action-stopping capabilities for the photographing of rapidly moving objects; but due to reciprocity effects the density, contrast, and color balance of the photographic image can be affected (see Figure 3-59).

3.32 Color-Temperature Meters

conversion chart or dial based on the relative values of the two readings. One type of color-temperature meter contains two photocells and circuits, with a red filter over one cell and a blue filter over the other, and a calibrated dial to indicate the relative currents in the

Figure 3-59 A bullet photographed in the process of cutting a playing card in balf demonstrates the action-stopping capability of short-duration electronic-flash light sources. (Photograph by Andrew Davidhazy.)

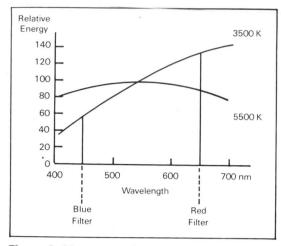

Figure 3-60 In a two-filter color-temperature meter the relative amounts of blue light and red light are measured. The ratio of blue to red is approximately 1:1 for the 5500 K illumination, but approximately 1:2.4 for the 3500 K illumination.

two circuits in terms of degrees Kelvin or mireds (see Figure 3-60). Color-temperature meters of this type work satisfactorily only with light sources that approximate a black body such as tungsten lamps. Three-filter (red, green, and blue) color-temperature meters provide more useful information with other types of light sources.

3.33 Printing Meters

Photographers in the past did not feel a great need for printing meters to determine print-exposure times because it is a fairly simple procedure to make a test strip that incorporates a number of different exposures, and then select an appropriate exposure time, and perhaps a different contrast grade of paper, on the basis of the developed teststrip image. Photofinishing and custom-printing labs, and other largevolume producers of photographic prints, however, have discovered that considerable savings can be made in both time and materials, often with a concomitant improvement in image quality, when light metrology is introduced into the printing darkroom.

If an enlarger and a camera are compared, the negative or transparency in the enlarger corresponds to the subject, and the paper in the easel corresponds to the film in the camera. Obvious differences are that the negative or transparency is always illuminated from behind so that transmitted light is used to form the image, and the bellows or housing on the enlarger connects the "subject" and the lens rather than the lens and the sensitized material. Because the space between the negative and the lens is enclosed, it would be difficult to take exposure-meter readings that would correspond to any of the hand meter readings, reflected-light or incident-light, for a camera exposure.

Before writing off meter readings of the negative or transparency as being impracticable, we should note that since the light source in the enlarger remains constant, it would be possible to make exposure adjustments when switching from one negative or transparency to another if it were known how much more or less light would be absorbed by the new negative or transparency than by the old one. This of course can be determined by taking density readings from the negatives or transparencies before placing them in the enlarger. If a midtone area in a new negative is 0.3 denser than a midtone area in a negative already printed, it is known that the amount of light transmitted will be reduced by a factor of 2 (the antilog of 0.3). Thus the exposure time should be doubled, or the enlarger-lens diaphragm should be opened one stop, to compensate for the density difference. This type of procedure is referred to as off-easel analysis.

In addition to determining the correct exposure, density readings of the thinnest and densest areas on black-and-white negatives where detail is desired on the print make it possible to select an appropriate contrast grade of printing paper. (See Section 2.19.) Also, by taking density readings of a neutral or other known subject reference area on color negatives and transparencies, the necessary change in color filtration in the enlarger can be predicted when making color prints.

A more sophisticated version of off-easel analysis was introduced in 1968 with the Kodak Video Color Analyzer, which produces a positive color video image from a color negative. The color balance and lightness of the video image can be altered to satisfy the viewer by adjusting the additive red, green, and blue light components. The calibration settings are then translated into exposure and color filtration **Figure 3–61** A Video Color Analyzer, which produces a positive color video image from a color negative. (Courtesy of Eastman Kodak company.)

settings for the enlarger to produce a print having the desired characteristics (see Figure 3-61).

Meter readings taken at the easel or under the enlarger lens correspond to behind-lens meter readings in cameras. Various meters have been designed for this purpose, and attachments to convert conventional exposure meters to this use are available (see Figure 3–62). A major advantage of measuring the light on-easel is that all factors that affect the quantity and quality of the image-forming light are taken into account, including the enlarger illumination system, the negative or transparency, any filters in the optical system, the scale of reproduction, and flare light. It is feasible for the meter manufacturer to

Figure 3–62 A color analyzer for making projectionprinting on-easel meter readings.

calibrate the meter for the published speeds of printing materials in the same way that exposure meters for cameras are calibrated for film speeds, but the usual procedure has been for the user to calibrate the meter for a specific printing material after having made an acceptable print by the trial and error method.

If an enlarging meter is capable of measuring small areas of the projected image, readings can be taken in the lightest and darkest areas to determine the contrast grade of printing paper to use with black-and-white negatives; and the correct exposure can be determined from a reading in any standardized area—highlight, shadow, estimated midtone, or calculated midtone. Exposure adjustments can be made either by changing the exposure time as indicated by a calculator dial or using the null system of adjusting the diaphragm in the enlarger lens to obtain a constant reading on the meter.

Automatic metering systems are also available, whereby measurement of the light occurs as the photographic paper is being exposed, using a sample of the image light from a beam splitter in the optical system or light reflected from a selected area of the photographic paper. By coupling the light sensor system with an electrical switch, the exposure can be terminated at the proper time to produce the correct exposure. This system is somewhat analogous to the automatic quenching of electronic-flash illumination with cameras—in slow motion.

Including a neutral test card in color photographs simplifies the task of determining the correct color filtration in the enlarger when making color prints by taking meter readings of the red, green, and blue light in the projected image of the neutral test card. Meters that are specifically designed for this purpose are usually referred to as color analyzers, even though they also typically function as enlarging exposure meters. It is not essential to include a neutral test card in each color photograph; one such image in each batch of color negatives made on film with the same emulsion number, exposed under the same conditions, and processed at the same time is usually sufficient. In the absence of a neutral test card other surfaces in the scene, such as a white area, a black area, or a skin area, can be used as a standard.

An alternative to measuring one or more small tonal areas in the projected image is to integrate and average the light over a large area. Some meter photocells are designed to be placed directly under the enlarger lens, where a diffusor integrates all the light transmitted by the lens. Although this is a less precise method of determining exposure and color filtration than measuring the image of a neutral test card, it is capable of producing a high percentage of acceptable prints.

3.34 Electronic Printers

Electronic enlargers and contact printers typically use a cathode ray tube with a flying spot scanner as the light source. Thus the photographic printing material is not exposed simultaneously over the entire picture area as with a conventional enlarger or contact printer, but rather is exposed from one edge to the other as a small spot of light moves along closely spaced lines in the same manner that an image is formed in a television picture tube. If the spot of light incident on the negative or transparency remained constant in intensity in an electronic printer, the results would be similar to those obtained with a conventional enlarger or contact printer having a uniform light source. By measuring the light transmitted by a negative or transparency from the flying spot with a photocell, however, it is possible to alter the intensity of the spot light source in response to variations in image density, and therefore to alter the contrast of the resulting print image.

The light can be measured and controlled during the exposure by using a beam splitter in the optical system that diverts a small proportion of the light to a photocell. Information from the lightsensing system is then fed into a computer that can be adjusted to vary the amount, and even the direction, of change in the intensity of the spot in response to differential absorption by the separate image areas of the negative or transparency.

Thus, in printing a contrasty negative the computer can be instructed to increase the spot intensity for dense areas and to decrease it for thin areas. Since the photocell does not detect density differences in the negative that are smaller in area than the flying spot, the contrast of the fine detail in the negative is not reduced on the print—an advantage over using a lower contrast grade of paper with a conventional enlarger. The computer can reverse the procedure with a low-contrast negative so that the intensity of the spot is decreased for dense areas in the negative and increased for thin areas. The LogEtronic Corporation pioneered the work in this area and marketed the first sluttening in larger. Electronic scanners have increased in sophistication and are now being used for color printing and masking, image enhancement, and the creation of anamorphic images (see Figure 3–63).

References

Adams, The Camera.

Adams, The Negative.

- ANSI, Apertures and Related Quantities Pertaining to Photographic Lenses, Methods of Designating and Measuring (PH3.29-1979).
- ———, Distribution of Illuminance over the Field of a Photographic Objective, Method of Determining (PH3.22-1958, R1979).
- , Automatic Exposure Control for Cameras (PH2.15-1964, R1976).
- ------, Exposure-Time Markings for Still-Picture Cameras (PH3.32-1972).
- ------, Internal Synchronization of Front Shutters, Classifying and Testing (PH3.18-1957, R1970).
 - , Shutter Tests for Still-Picture Cameras (PH3.48-1972).

Figure 3–63 An operator at the controls of an electronic color scanner used to make separation negatives from color transparencies.

References

—, General-Purpose Photographic Exposure Meters (Photoelectric Type) (PH3.49-1971).

-----, Photographic Electronic Flash Equipment, Method for Measuring and Designating the Performance of (PH3.40-1977).

-----, Photographic Enlargers, Methods for Testing (PH3.31-1974).

-----, Photographic Flash Lamps, Method for Testing (PH2.13-1965).

——, Exposure Guide Numbers for Photographic Lamps, Method for Determining (PH2.4-1965, R1971).

—, Photographic Exposure Guide (PH2.7-1985).

Blaker, Field Photography.

—, Photography: Art and Technique.

Dowdell and Zakia, Zone Systemizer.

Dunn. Exposure Manual.

Eastman Kodak Co, Close-Up Photography and Photomacrography (N-12).

-----, Exposure with Portable Flash Units (AC-37).

—, How Safe Is Your Safelight? (K-4).

——, Kodak Color Dataguide (R-19).

—, Kodak Darkroom Dataguide (R-20).

—, Kodak Master Photoguide (AR-21).

—, Kodak Neutral Density Attenuators (P-114).

——, Kodak Polycontrast Filter Computer (G-11).

------, Kodak Professional Black-and-White Films (F-5).

, Kodak Professional Photoguide (R-28).

------, Manipulating Exposure Times (Q-130).

—, Motion Picture Production—Reading an Exposure Meter (VI-25).

——, Photographing Television Images (AC-10).

——, Photography Through the Microscope (P-2).

—, Quality Enlarging with Kodak B/W Papers (G-1).

—, Reciprocity Data: Kodak Color Films (E-1).

—, Reciprocity Data: Kodak Professional Black-and-White Films (0-2).

Focal Press, Focal Encyclopedia of Photography.

Gassan, Handbook for Contemporary Photography.

Jacobson et al., The Manual of Photography.

Langford, Advanced Photography.

—, Basic Photography.

Morgan, Vestal, and Broecker, Leica Manual.

Newhall, The History of Photography.

Norwood, "Light Measurement for Exposure Control." Journal of the SMPTE, Vol. 54 (1950), pp. 585-602.

Spencer, The Focal Dictionary of Photographic Technologies.

Steiner, Ralph Steiner, A Point of View.

Stimson, Photometry and Radiometry for Engineers.

Stroebel, View Camera Technique.

Stroebel and Todd, Dictionary of Contemporary Photography.

Towers, Electronics and the Photographer.

Upton and Upton, Photography.

White, Zakia, and Lorenz, The New Zone System Manual.

Photographic Optics

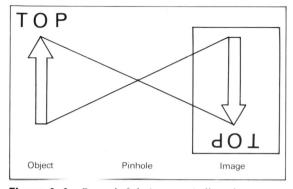

Figure 4–1 Reversal of the image vertically and horizontally by the crossing of the light rays at the pinhole produces correct reading of the lettering if viewed upside down.

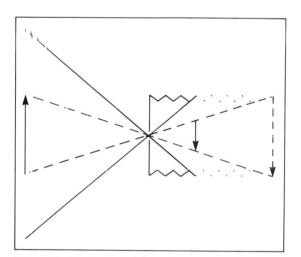

Figure 4–2 As the pinhole-to-film distance increases, the image size increases and the angle of view decreases.

 Table 4–1
 Optimum pinhole diameters for different pinholefilm distances.

(Distance) f	(Diameter) D	(F-Number) F–N	
1 in.	1/140 in.	f/140	
2 in.	1/100 in.	ť/200	
4 in.	1/70 in.	f/280	
8 in.	1/50 in.	f/400	
16 in.	1/35 in.	f/560	
$D = \frac{\sqrt{f}}{141} \text{ (in.)}$			
$D = \frac{\sqrt{f}}{28} (\text{mm.})$			
$F-N = \frac{f}{D}$			

4.1 Image Formation with a Pinhole

The pinhole, as an image-forming device, has played an important role in the evolution of the modern camera. The observation of images formed by a small opening in an otherwise darkened room goes back at least to Aristotle's time, about 350 B.C.; and, indeed, the pinhole camera still fascinates many of today's photography students because of the simplicity with which it forms an image. The darkened room, or camera obscura, evolved into a portable room that could be moved about and yet was large enough to accommodate a person. The portable room in turn shrank to a portable box with a small opening and tracing paper, used as a drawing aid. By about 1570 the pinhole was replaced by a simple lens that produced a brighter image, which was easier to trace. The name *camera obscura* survived all these changes.

Pinholes are able to form images because light travels in a straight line. Thus for each point on an object, a reflected ray of light passing through the pinhole can fall on only one spot on the ground glass or film. Since light rays from the top and bottom of the scene and from the two sides cross at the pinhole, the image is reversed torically and hardwardly or the distribution of the ground glass if it is viewed upside down (see Figure 4–1) and on film images viewed through the base.

There are two basic variables with a pinhole camera—the pinhole-to-film or image distance and the diameter of the pinhole. If a pinhole is used on a view camera or other camera having a bellows, it is the equivalent of a zoom lens because the image size will increase in direct proportion to the pinhole-to-film distance. The angle of view, on the other hand, will decrease as the image distance increases (see Figure 4–2). Since a pinhole does not focus light as a lens does, changing the image distance has little effect on the sharpness of the image; but when the image is examined critically, it is found that there is an optimum pinhole-to-film distance for a pinhole of a given diameter.

Increasing the size of a pinhole from the optimum allows more light to pass through, therefore increasing the illuminance at the film plane and decreasing the required exposure time, but it also reduces the image sharpness. Decreasing the pinhole size, however, does not increase image sharpness. When the size is decreased beyond the optimum size for the specified pinhole-to-film distance, diffraction causes a decrease in sharpness (see Figure 4–3). The optimum pinhole size can be calculated with the formula

$$D = \frac{\sqrt{1}}{141}$$

where D is the diameter of the pinhole in inches and f is the pinhole-tofilm distance in inches (see Table 4–1).¹ Thus, for a pinhole-to-film distance of eight inches, the diameter of the optimum size pinhole is about 1/50 inch. A No. 10 needle will produce a pinhole of approximately this size.

If millimeters are used as the unit of measurement, the following formula should be used:

$$D=\frac{\sqrt{f}}{28}$$

¹When photographing relatively close subjects, the value of *t* should be determined by substituting the object distance (u) and the image distance (v) in the formula 1/f = 1/u + 1/v.

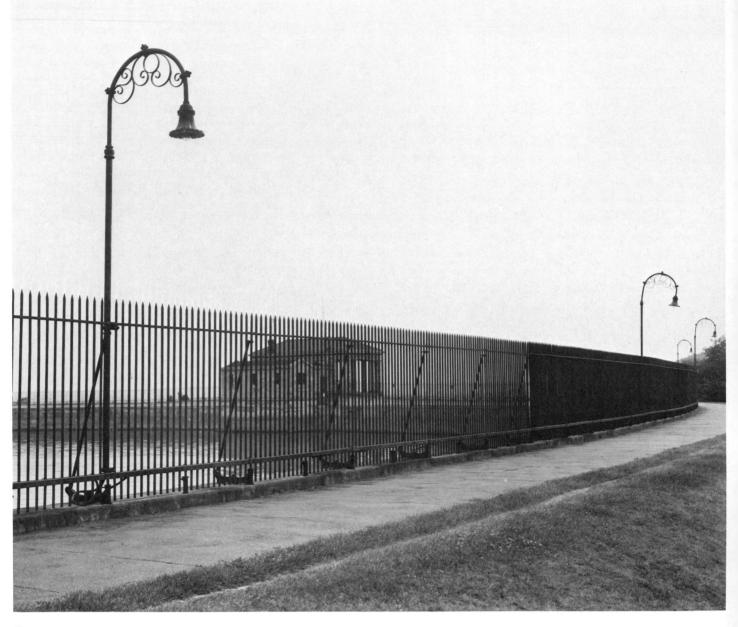

Α

A basic formula that takes into account the wavelength of the light is $D = \sqrt{2.5\lambda f}$, where λ is the average wavelength of the exposing radiation in millimeters. For white-light and panchromatic film a value of 500 nm (.00050mm) is used. The optimum pinhole size is somewhat smaller for photographs made with ultraviolet radiation and somewhat larger for photographs made with infrared radiation. Doubling the wavelength or the pinhole-to-film distance will increase the size of the optimum pinhole by a factor of the square root of 2 or 1.4. Various references do not agree on the constant in the formula, and the 2.5 constant used above represents an average value.

Pinholes are usually made by pushing a needle through a piece of thin, opaque material, such as black paper, or drilling a hole in very thin metal. It is also possible to make a pinhole by crossing a vertical slit in one piece of thin material with a horizontal slit in another. The fact that this pinhole is square rather than round is of no great

Figure 4–3 Photograph A was made with a camera lens. Three additional photographs were made with pinholes of different sizes, and an area on the left was cropped in printing to compare image sharpness. The pinhole sizes were one-balf the optimum size (B), the calculated optimum size (C), and two times the optimum size (D).

importance. Placing the vertical and horizontal slits at different distances from the film produces different scales of reproduction for the vertical and horizontal dimensions of objects being photographed, i.e., an anamorphic image. Since the vertical slit controls the horizontal image formation, placing the vertical slit at double the distance of the horizontal slit from the film will produce a horizontally elongated or stretched image with a 2:1 ratio of the two dimensions (see Figure 4-4).

Figure 4-4 An anamorphic pinhole photograph (right) made with a vertical slit placed 1% times as fur from the film as a horizontal slit. The comparison photograph was made with a camera lens.

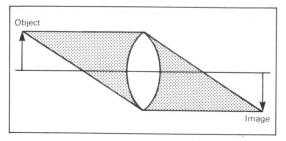

Figure 4-5 Image formation with a positive lens.

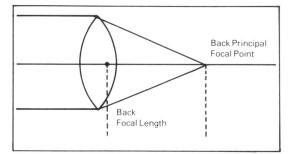

Figure 4–6 The back focal length is the distance between the back nodal point and the image of an infinitely distant object.

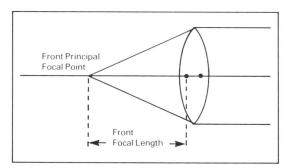

Figure 4–7 The front focal length is found by reversing the direction of light through the lens.

Figure 4-8 Three types of positive lenses—biconvex (left), plano-convex, and positive meniscus.

4.2 Image Formation with a Lens

A positive lens produces an image by refracting light so that all the light rays falling on the front surface of the lens from an object point converge to a point behind the lens (see Figure 4–5). If the object point is at infinity or a large distance, the light rays will enter the lens traveling parallel to each other, and the image point where they come to a focus is referred to as the *principal focal point*. The *focal length* can then be determined by measuring the distance from the principal focal point to the *back nodal point*—roughly the middle of a single-element lens (see Figure 4–6). Reversing the direction of light through the lens with a distant object on the right produces a second principal focal point and a second focal length to the left of the lens, as well as a second nodal point (see Figure 4–7). The two sets of terms are distinguished by the adjectives *object* (or *front*) and *image* (or *back*)—e.g., front principal focal point and back principal focal point.

All positive lenses are thicker at the center than at the edges and must have one convex surface, but the other surface can be convex, flat, or concave (see Figure 4–8). The curved surfaces are usually spherical, like the outside (convex) or inside (concave) surface of a hollow ball. Actually, this is not the best shape for forming a sharp image, but it has been widely used because lenses having flat and spherical surfaces are easier to mass produce than those having other curved surfaces, such as parabolic. If the curvature of a spherical lens surface is extended to produce a complete sphere, the center of that sphere is then identified as the *center of curvature* of the lens surface. A straight line drawn through the two centers of curvature of the two lens surfaces is identified as the *lens axis* (see Figure 4–9). If one of the surfaces is flat, the lens axis is a straight line through the one center of curvature and perpendicular to the flat surface.

The optical center of a lens is a point on the lens axis where an off-axis undeviated ray of light crosses the lens axis. All rays of light that pass through the optical center are undeviated—i.e., they leave the lens traveling parallel to the direction of entry (see Figure 4–10). *Object distance* and *image distance* can be measured to the optical center when great precision is not needed; but when precision is required the object distance is measured from the object to the front (or object) nodal point, and the image distance is measured to the back (or image) nodal point.

The *front nodal point* can be located on a drawing by extending an entering undeviated ray of light in a straight line until it intersects the lens axis, and the *back nodal point* by extending the departing ray of light backward in a straight line until it intersects the lens axis, as

Figure 4–9 The lens axis is a straight line through the centers of curvature of the lens surfaces.

Figure 4–10 All rays of light passing through the optical center leave the lens traveling parallel to the direction of entry.

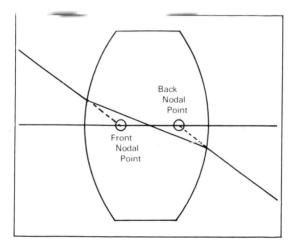

Figure 4–11 The nodal points can be located by extending the entering and departing parts of an undeviated ray of light in straight lines until they intersect the lens axis.

shown in Figure 4-11. A convention (which is not always observed) is to place objects to the left of lenses in drawings and images to the right, so that the light travels in the same direction that our eyes move when reading.

Nodal points can also be located experimentally with actual lenses. The lens is first placed in a nodal slide, which is a device that enables a lens to be pivoted at various positions along its axis. For crude measurements, a simple trough with a pivot on the bottom is adequate (see Figure 4-12). Professional optical benches are used when greater precision is required (see Figure 4-13). The lens is first focused on a distant light source or the equivalent using a collimator with a light source placed at an appropriate closer distance, with the front of the lens facing the light source. The lens is then pivoted from side to side while the image is observed. If the image does not move as the lens is pivoted, the lens is being pivoted about its back (image) nodal point. If the image does move, however, the lens is moved either toward or away from the light source, the image is brought into focus by moving the focusing screen or the microscope, and the lens is again pivoted. This procedure is repeated until the inner mutality submonthly when the 10110 is provided. The front (object) nodal point is determined in the same way with the lens reversed so that the front of the lens is facing the image rather than the light source. A knowledge of the location of the nodal points can be useful, and it is unfortunate that the manufacturers of photographic lenses do not mark or otherwise indicate the location of the two nodal points on their lenses.

Three practical applications for knowledge of the location of the nodal points are:

1. When accuracy is required, the object distance must be measured from the object to the front nodal point, and the image distance from the image to the back nodal point. Accurate determination of the focal length requires measuring the distance from the sharp image of a distant object to the back nodal point. Measurements to the nodal points are also made when using lens formulas to determine image size and scale of reproduction (see Figure 4–14).

Figure 4–12 A simple nodal slide. The line on the side identifies the location of the pivot point on the bottom.

Figure 4–13 A professional optical hench, which permits the aerial image formed by a lens to be examined with a microscope.

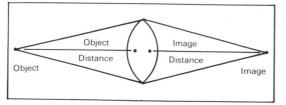

Figure 4–14 For an object point on the lens axis, object distance is measured to the front nodal point, and image distance is measured from the image to the back nodal point.

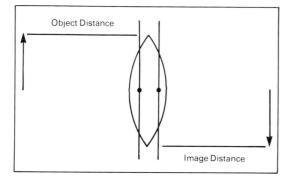

Figure 4–15 For an object point off the lens axis, object and image distances are measured in a direction that is parallel to the lens axis, to the corresponding nodal planes.

Figure 4–16 Ideally, view cameras would permit the lens pivot point to be adjusted so that all lenses could be rotated about the back nodal point.

4.3 Graphical Drawings

With conventional lenses that are relatively thin, little error will be introduced by measuring to the physical center of the lens rather than to the appropriate nodal point. With thick lenses and some lenses of special design—such as telephoto, retrofocus, and zoom lenses—considerable error can be introduced by measuring to the center of the lens. With the latter types of lenses, the nodal points can be some distance from the physical center of the lens, and may even be in front of or behind the lens. When distances are measured for objects or images that are not on the lens axis, the correct procedure is to measure the distance parallel to the lens axis to the appropriate nodal plane rather than to the nodal point. The *nodal plane* is a plane that is perpendicular to the lens axis and that includes the nodal point (see Figure 4-15).

- If a view-camera lens can be mounted on the camera so that it tilts 2. and swings about the rear nodal point, the image will remain in the same position on the ground glass as these adjustments are made to control the plane of sharp focus. Otherwise the image will move up or down as the lens is tilted and sideways as it is swung, requiring realignment of the camera to restore the original composition. Unfortunately, little consideration is given to this factor in the design of most view cameras and the fact that the nodal points are at different positions with various types of lenses complicates the task. Although a sliding adjustment, as on a nodal slide, is the ideal solution, some improvement may be obtained with certain lenses by using a recessed lens board, a lens cone, or by reversing the lens standard (on modular view cameras having that feature) to change the position of the lens in relation to the pivot point on the camera (see Figure 4-16).
- **3.** The task of making graphical drawings to illustrate image formation with lenses is greatly simplified by the use of nodal points and planes rather than lens elements. Whereas lens designers must consider the effect that each surface of each element in a lens has on a large number of light rays, many problems involving image and object sizes and distances can be illustrated and solved by using the nodal planes to represent the lens in the drawing, regardless of the number of lens elements. This procedure will be used in the following section.

4.3 Graphical Drawings

Graphical drawings are useful in that they not only illustrate image formation with lenses in simplified form, but they can be used as an alternative to mathematical formulas to solve problems involving image formation. The two drawings in Figure 4–17 show a comparison between the use of lens elements and the use of nodal planes. In the so-called thin-lens treatment, the two nodal planes are considered to be close enough to each other so that they can be combined into a single plane without significant loss of accuracy. If the drawing is to be used to solve a problem, rather than as a schematic illustration of image formation, the drawing must be made either actual size or to a known scale. The original drawing in Figure 4–18 was actual size. The steps involved in making a graphical drawing are:

- 1. Draw a straight horizontal line to represent the lens axis.
- 2. Draw a straight vertical line to represent the lens.

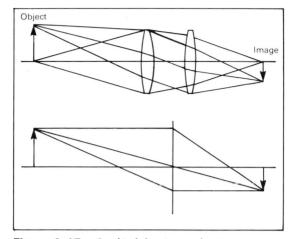

Figure 4–17 Graphical drawings to show image formation using the lens elements (top) and the simpler thin-lens procedure (bottom).

- **3.** Place marks on the lens axis one focal length to the left and one focal length to the right of the lens. In this example, the focal length was one inch.
- **4.** Draw the object at the correct distance from the lens. In this example, the object was two inches tall and was located two inches from the lens.
- **5.** Draw the first ray of light from the top of the object straight through the optical center of the lens, i.e., the intersection of the lens axis and the nodal plane.
- 6. Draw the second ray, on a parallel to the lens axis, to the nodal plane, then through the back principal focal point.
- 7. Draw the third ray through the front principal focal point to the nodal plane, then parallel to the lens axis.
- **8.** The intersection of the three rays represents the image of the top of the object. Draw a vertical line from that intersection to the lens axis to represent the entire (inverted) image of the object.

With a ruler, we could determine the correct size and position of the image from the original drawing. The image size was two human image intervention incluses. From this we can generalize that placing an object two focal lengths in front of any lens produces a same-size image two focal lengths behind the lens.

This same drawing could be used as a one-quarter-scale drawing of a 4-inch focal length lens with an 8-inch-tall object located at an object distance of 8 inches. To determine the image size and image

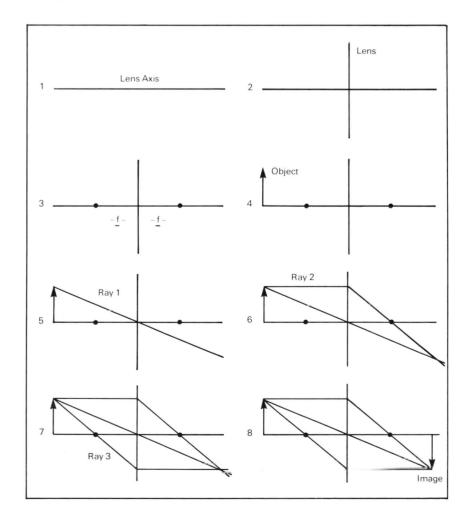

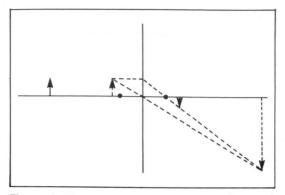

Figure 4–19 Moving an object closer to the lens results in an increase in both image distance and image size.

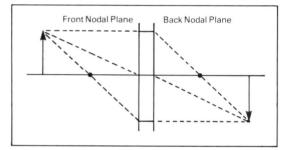

Figure 4–20 The nodal planes are separated by an appropriate distance for thick-lens graphical drawings.

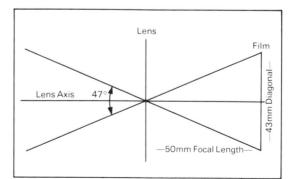

Figure 4-21 The angle of view of a lens-film combination can be determined by drawing a line with the length equal to the film diagonal at a distance of one focal length from the lens. The angle formed by the extreme rays of light can be measured with a protractor.

distance, the corresponding dimensions on the drawing are multiplied by 4 to compensate for the drawing's scale. Thus the image size is 2 inches $\times 4 = 8$ inches, and the image distance is 2 inches $\times 4 = 8$ inches.

Changing the distance between the object and the lens produces a change in the position where the image is formed. The relationship is an inverse one, so that as the object distance decreases the image distance increases. Since the two distances are interdependent and interchangeable, they are commonly referred to as conjugate distances. Image size also changes as the object and image distances change. Moving an object closer to the lens results in an increase in both the image distance and the image size. These relationships are illustrated in Figure 4-19.

The closest an object can be placed to a lens and still obtain a real image is theoretically slightly more than one focal length. Placing an object at exactly one focal length from the lens causes the light rays from an object point to leave the lens traveling parallel to each other so that we can think of an image only as being formed at infinity. In practice, the closest an object can be placed to a camera lens and still obtain a sharp image is determined by the maximum distance the film can be placed from the lens. Problems of this type can be solved with graphical drawings. If the maximum image distance is three inches for a camera equipped with a two-inch focal length lens, an actual-size or scale drawing is made starting with the image located three inches to the right of the lens. Three rays of light are then drawn back through the lens, using the same rules as before, to determine the location of the object.

With lenses that are too thick to be considered as thin lenses, or where greater accuracy is required, only small modifications of the thin-lens treatment are required. If it is known that the front and back nodal planes are separated by a distance of one inch in a certain lens, two vertical lines are drawn on the lens axis, to represent the two nodal planes, separated by the appropriate actual or scale distance. Then the three rays of light are drawn from an object point to the front nodal plane, as before, but they are drawn parallel to the lens axis between the two nodal planes before they converge to form the image (see Figure 4-20).

Angle of view can be determined with graphical drawings in addition to image and object distances and sizes. The term angle of view should not be confused with angle of coverage, a measure of the covering power of lenses that will be considered later in this chapter. Angle of view is a measure of how much of the scene will be recorded on the film as determined by the lens focal length and the film size. Angle of view is usually determined for the diagonal of the film, which is the longest dimension, although two angles of view are sometimes specified—one for the film's vertical dimension and one for the horizontal dimension. A horizontal line is drawn for the lens axis and a vertical line is drawn to represent the nodal planes, as with the thin-lens treatment above. A second vertical line is drawn one focal length (actual or scale distance) to the right of the nodal planes. The second vertical line represents the film diagonal, so it must be the correct actual or scale length.

The drawing in Figure 4-21 represents a 50 mm focal length lens on a 35 mm camera, where the diagonal of the negative image area is approximately 43 mm. Lines drawn from the rear nodal point (i.e., the intersection of the nodal planes and the lens axis) to opposite

4.4 Lens Formulas

corners of the film form an angle that can be measured with a protractor. No compensation is necessary for the drawing's scale, since there are 360° in a circle no matter how large the circle is drawn. The angle of view in this example is approximately 47° .

Two other focal length lenses, 15 mm and 135 mm, are represented in the drawing in Figure 4–22. The measured angles of view are approximately 110° and 18° . It should be apparent from these drawings that substituting a shorter focal length lens on a given camera will increase the angle of view, whereas substituting a smaller film, as in using a reducing back on a large-format camera, will decrease the angle of view. Angle of view is determined with the film placed one focal length behind the lens, which corresponds to focusing on infinity. When a camera is focused on nearer objects, the lens-to-film distance increases, and the *effective* angle of view decreases.

4.4 Lens Formulas

Graphical drawings are especially helpful for beginning photographers because they make it easy to visualize the relationships involved. With experience, it becomes more efficient to solve problems relating to distances and sizes using mathematical formulas. Most problems of this nature that are encountered by practicing photographers can be solved by using these four simple formulas:

1.
$$1/f = 1/u + 1/v$$

2. $R - v/u$
3. $R = \frac{v - f}{f}$
4. $R = \frac{f}{u - f}$

where f = focal length u = object distance v = image distance and

R = scale of reproduction,

which is image size/object size, or I/O.

Thus I/O can be substituted for R in any of the formulas. Problems are typically solved by selecting the formula that contains two known factors plus the unknown. No two formulas contain the same three terms.

The focal length of an unmarked lens can be determined with formula No. 1 by forming a sharp image of an object, measuring the object and image distances, and solving the formula for f. Thus, if the object and image distances are both 8 inches, the focal length is

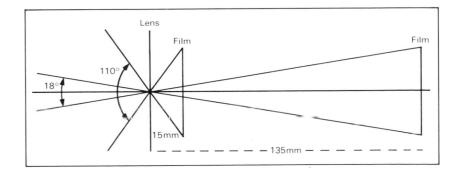

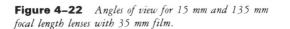

Figure 4–23 Since object and image distances are interchangeable, sharp images can be formed with a lens in two different positions between object and film.

4 inches. The formula illustrates the inverse relationship between the conjugate distances u and v, whereby moving a camera closer to an object requires increasing the lens-to-film distance to keep the image in sharp focus.

It also illustrates that u and v are interchangeable, which means that sharp images can be formed with a lens in two different positions between an object and the film. For example, if a sharp image is formed when a lens is 8 inches from the object and 4 inches from the film, another (and larger) sharp image will be formed when the lens is placed 4 inches from the object and 8 inches from the film (see Figure 4–23). Exceptions to the statement that sharp images can be formed with a lens in two different positions are (a) when the object and image distances are the same, which produces an image that is the same size as the object; and (b) when an object distance is larger than the maximum bellows extension on the camera, so that the lens cannot be moved far enough away from the film to form the second sharp image.

A problem commonly encountered by photographers is determining how large a scale of reproduction (R) can be obtained with a certain camera-lens combination. If a view camera has a maximum bellows extension (ν) of 16 inches and is equipped with an 8-inch focal length (f) lens, formula No. 3 would be selected: $R = (\nu - f)/f =$ (16-8)/8 = 1, where the image is the same size as the object. Although we would substitute a longer focal length lens to obtain a larger image of a distant object when the camera cannot be moved closer (see formula No. 4), a shorter focal length lens would be substituted to obtain a larger image in closeup work where the maximum bellows extension is the limiting factor. Replacing the 8-inch lens above with a 2-inch lens would increase the scale of reproduction from 1 to (16-2)/2 = 7.

4.5 Perspective

Perspective refers to the appearance of depth when a threedimensional scene is represented in a two-dimensional image such as a photograph, or when a scene is viewed directly. Photographers have a number of ways of creating the appearance of depth in photographs, including the following:

Depth of Field. Use of a limited depth of field, so that the images of objects in front of and behind the point focused on are unsharp, creates a stronger appearance of depth or perspective than when the entire scene appears sharp.

Lighting. Depth can be emphasized with lighting that produces a gradation of tones on curved surfaces, a separation of tones between the planes of box-shaped objects, and between objects and backgrounds; and that casts shadows of objects on the foreground or background.

Overlap. Arranging a scene so that a nearby object obscures part of a more distant object provides the viewer with a powerful clue as to the relative distances of the objects.

Aerial Haze. The scattering of light that occurs in the atmosphere makes distant objects appear lighter and less contrasty than nearby objects. Thick fog and smoke can create the illusion of depth with relatively small differences in distance.

Color. Red is referred to as an advancing color and blue as a receding color. In the absence of conflicting depth clues, a blue surface tends to appear farther away than a red surface at the same distance.

4.7 Object Distance and Image Size

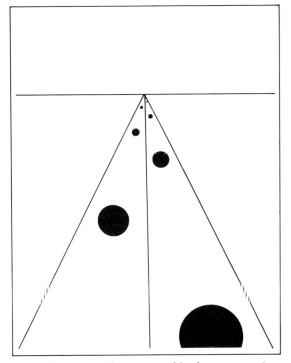

Figure 4–24 Depth is represented by the convergence of parallel subject lines and decreasing image size.

Stereophotography. Viewing two photographs taken from slightly different positions so that the left eye sees one and the right eye sees the other produces a realistic effect with strong depth clues similar to those produced with binocular vision and three-dimensional objects.

Holography. With a single photographic image, holograms present different images to the left and right eyes, as with stereo pairs, but they also produce motion parallax for objects at different distances when the viewer moves laterally.

Linear Perspective. Linear perspective is exemplified by the convergence of parallel subject lines, and the decrease in image size as the object distance increases. Linear perspective is so effective in representing depth in two-dimensional images that it is often the only type of depth clue provided by artists when making simple line drawings (see Figure 4-24).

46 Linear Perspective

In photographs, changes in linear perspective are commonly associated with changes in camera position and focal length of camera lenses. If the definition of linear perspective were limited to the relative image size of objects at different distances (or the angle of convergence of parallel subject lines) the photographer's control would be limited to the choice of camera position (i.e., object distance). If changes in the appearance of linear perspective were included even when there is no change in the relative image sizes of objects at different distances, then lens focal length would have to be included as a control.

Two basic assumptions important to an understanding of the control of linear perspective are that image size is directly proportional to focal length, and that image size is inversely proportional to object distance.

4.7 Object Distance and Image Size

Placing two objects of equal size at distances of 1 foot and 2 feet from a camera lens produces images which vary in size in a 2:1 ratio. Since image size varies inversely with object distance, the smaller of the two images corresponds to the object at the larger distance. *Actual* image sizes could be determined for given object size, focal length and object distances with either graphical drawings or lens formulas, but for now we will be concerned only with *relative* image sizes.

Linear perspective is based on the ratio of image sizes for objects at different distances. Figure 4-25 shows two objects of equal size at distance ratios of 1:2, 1:3, and 1:4. The sizes of the resulting images are in ratios of 2:1, 3:1, and 4:1. Thus, with movable objects the relative image sizes and linear perspective can be controlled easily by changing the positions of the objects. Most of the time, however, we photograph objects that cannot be moved easily, and therefore we must resort to moving the camera or changing the focal length of the lens if we want to alter image size.

Starting with two objects at a distance ratio of 1:2 from the camera, moving the camera farther away to double the distance from the closer object does not double the distance to the farther object, and therefore the ratio of the image sizes will not remain the same. Since

4.7 Object Distance and Image Size

Figure 4–25 Image size is inversely proportional to object distance. The ratios of the object distances from top to bottom are 2:1, 3:1, and 4:1.

the ratio of object distances changes from 1:2 to 2:3 by moving the camera, the ratio of image sizes changes from 2:1 to 3:2 (or $1\frac{1}{2}$:1) (see Figure 4–26). Moving the camera farther away not only reduces the size of both images but also makes them more nearly equal in size. The two images can never be made exactly equal in size, no matter how far the camera is moved away, but with very large object distances the differences in size can become insignificant. The linear perspective produced by moving the camera farther from the objects is referred to

Figure 4–26 Doubling the distance from the camera to the near object changes the ratio of distances to the two objects from 1:2 to 2:3.

as a weaker perspective than that produced with the camera in the original position. Thus, weak perspective can be ascribed to a picture in which image size decreases more slowly with increasing object distance than expected. Another aspect of weak perspective is that space appears to be compressed, as though there were less distance between nearer and farther objects than actually exists (see Figure 4-27).

Conversely, moving a camera closer to two objects increases the image size of the nearer object more rapidly than that of the farther object, producing a stronger perspective. For example, with objects at a distance ratio of 1:2, moving the camera in to one-half the original distance to the near object doubles its image size but reduces the distance to the farther object from 2 to $1\frac{1}{2}$, therefore increasing the image size of the farther object to only $1\frac{1}{3}$ times its original size. Moving the camera closer to the subject produces a stronger linear perspective whereby image size decreases more rapidly with increasing object distance, and the space between the closer and farther objects appears to increase. Strong perspective is especially flattering to architectural photographs of small rooms because it makes the rooms appear more spacious.

waries inversely with object distance: This relationship holds as long as

Figure 4–27 Space appears to be compressed in the bottom photograph, made with a 1500 mm lens, compared to the top photograph, made with a 50 mm lens from a closer position.

4.8 Focal Length and Image Size

the lens-to-film distance remains the same for the two objects. It will not hold when the back of a view camera is swung or tilted. Indeed, the purpose of these adjustments is to control the shape of the image. Neither will the relationship hold when separate photographs are made of each of the two objects and the camera is focused in turn on each object distance, changing the lens-to-film distance. This is of significance mostly with closeup photography. For example, with objects at distances of 8 inches and 16 inches from a camera equipped with a 4inch focal length lens, the ratio of image sizes is 2:1 when the objects are photographed together but 3:1 when they are photographed separately and the camera is refocused. To solve this problem for other object distances, use the lens formula R = f/(u - f).

4.8 Focal Length and Image Size

Serious photographers have more than one focal length lens per camera in order to control image size and the corresponding angle of view. As stated above, image size is directly proportional to focal length. Thus, if an image of a building is 1/2-inch high in a photograph made with a 50 mm focal length lens on a 35 mm camera, substituting a 100 mm focal length lens will produce an image of the building that is 1 inch high. Since this is a direct rather than inverse relationship, doubling the focal length will double the image size. Also, since doubling the focal length will double the size of all parts of the image, it will not change the ratio of image sizes for objects at different distances (see Figure 4–28). This can be demonstrated convincingly with a camera equipped with a zoom or variable focal length lens. As the focal length is changed, one can see the overall image change in size, but the relative sizes of images of objects at different distances remain the same. (Al-

Figure 4–28 Photographs made from the same position with 135 mm (left), 55 mm (middle), and 28 mm (right) focal length lenses. Image size changes in proportion to focal length, but relative sizes for objects at different distances remain constant.

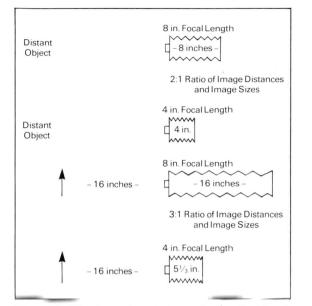

Figure 4-29 Image size is proportional to lens focal length with distant objects (top). With small object distances the ratio of the image sizes is larger than the ratio of the focal lengths (bottom).

though the relative sizes remain the same, the linear perspective may appear to change, a phenomenon we will examine in the section on viewing distance.)

There is also an exception to the assumption that image size is directly proportional to focal length. The assumption holds when the image distance is approximately equal to the focal length—that is, when photographing objects at moderate to large distances. When photographing objects at close distances, the lens-to-film distance must be increased to focus the image, and the size relationship with different focal length lenses deviates from that predicted by the assumption. For example, with an object at a distance of 16 inches from a camera equipped first with an 8-inch focal length lens and then with a 4-inch focal length lens, the ratio of image sizes will be 3:1, rather than the expected 2:1. The same lens formula R = f/(u - f) is used to solve this problem (see Figure 4–29).

1.0 Ultanying Object Distance and Focal Length

Photographers commonly change focal length and object distance simultaneously to control linear perspective and overall image size. For example, if the perspective appeared too strong and unflattering in a portrait made with a normal focal length lens, the photographer would substitute a longer focal length lens and move the camera farther from the subject to obtain about the same size image but one with weaker perspective. Because short focal length wide-angle lenses tend to be used with the camera placed close to the subject, and long focal length telephoto lenses tend to be used with the camera at relatively large distances, strong perspective is often associated with wide-angle lenses although it is the camera position and not the focal length or type of lens that produces the abnormal linear perspective.

The change in linear perspective with a change in object distance is seen most vividly when a corresponding change is made in the focal length to keep an important part of the scene the same size. In Figure 4–30, for example, the focal length of the lenses and the camera positions were adjusted to keep the images of the nearer object the same size, and the difference in linear perspective is revealed by the difference in size of the images of the farther object.

In situations where a certain linear perspective contributes significantly to the photograph's effectiveness, the correct procedure is first to select the camera position that produces the desired perspective, and then to select the focal length lens that produces the desired image size. For example, if the photographer wants to frame a building with a tree branch in the foreground, the camera must be placed in the position that produces the desired size and position relationships between the branch and the building. The lens is then selected that forms an image of an appropriate size. A zoom lens offers the advantage of providing any focal length between the limits. With fixed focal length lenses, if the desired focal length is not available, and changing the camera position would reduce the effectiveness due to the change in perspective, the best procedure is to use the next shorter focal length lens available and then enlarge and crop the image.

Cameras cannot always be placed at the distance selected on the basis of linear perspective. Whenever photographs are made indoors,

4.10 Viewing Distance

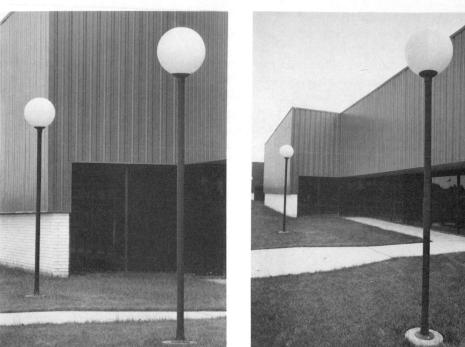

Figure 4-30 Photographs made with a 135 mm focal length lens (left) and a 28 mm focal length lens (right) with the camera moved closer to match the image size of the foreground object. The change in the relative sizes of the two objects is due to the change in the camera position.

there are physical limitations on how far away the camera can be placed from the subject. Fortunately, the strong perspective that results from using short focal length wide-angle lenses at the necessarily close camera positions enhances rather than detracts from the appearance of many architectural and other subjects. There are also many situations where the camera must be placed at a greater distance from the subject than would be desired. This, of course, applies to certain sports activities where cameras cannot be located so close that they interfere with the sporting event, block the view of spectators, or endanger the photographer.

Not all subjects are such that the perspective changes with object distance. Since two-dimensional objects have no depth, photographs of such objects reveal no change in the relative size of different parts of the image with changes in camera distance. Also, photographic copies of paintings, photographs, printed matter, etc., made from a close position with a short focal length wide-angle lens, and from a distant position with a long focal length telephoto lens, should be identical.

4.10 Viewing Distance

It would seem that the distance at which we view photographs should have no effect on linear perspective, since a 2:1 size ratio of images of objects at different distances will not be altered by changes in the viewing distance. In practice, however, changes in viewing distance can have a significant effect on the perspective, provided the photographs contain good depth clues. Photographs of two-dimensional objects appear to change little with respect to linear perspective when viewing distance is changed, whereas those containing dominant objects in the foreground and background or receding parallel lines can change dramatically.

We seldom experience unnatural-appearing linear perspec-

tive in real life. Abnormally strong or weak perspective tends to occur only when we look at photographs or other two-dimensional representations of three-dimensional objects or scenes. The reason perspective appears normal when we view a three-dimensional scene directly is that as we change the viewing distance, the perspective and the image size change simultaneously in an appropriate manner. Because we normally know whether we are close to or far away from the scene we are viewing, the corresponding large or small differences in apparent size of objects at different distances seems normal for the viewing distance. (It is possible to deceive viewers about the size or shape of objects or their distances, but we will discuss such illusions later.)

To illustrate how the situation changes when we view photographs rather than actual three-dimensional scenes, assume that two photographs are made of the same scene, one with a normal focal length lens and the other with a short focal length lens with the camera moved closer to match the image size of a foreground object (see Figure 4– 30). Looking at the two photographs, viewers suppose that they are at the same distance from the two scenes because the foreground objects are the same size, but if the perspective appears normal in the first photograph, the thromost perspective in the second photograph will appear abnormal for what is assumed to be the same object distance. Viewers can make the perspective appear normal in the second photograph, however, by reducing the viewing distance. The so-called "correct" viewing distance is equal to the focal length of the camera lens (or, more precisely, the image distance) for contact prints, or the focal length multiplied by the magnification for enlarged prints.

The correct viewing distance for a contact print of an 8×10 inch negative exposed with a 12-inch focal length lens is 12 inches. Since we tend to view photographs from a distance about equal to the diagonal, the perspective would appear normal to most viewers. If the 12-inch lens were replaced with a 6-inch focal length lens, the print would have to be viewed from a distance of 6 inches for the perspective to appear normal. When the print is viewed from a comfortable distance of 12 inches, the perspective will appear too strong. Conversely, the perspective in a photograph made with a 24-inch focal length lens would appear too weak when viewed from a distance of 12 inches. It is fortunate that people tend to view photographs from standardized distances rather than adjusting the viewing distance to make the perspective appear normal, for that would deprive photographers of one of their most useful techniques for making dramatic and effective photographs.

4.11 The Wide-Angle Effect

Closely related to the way a change in viewing distance can change the perspective of photographs is the influence of viewing distance on the so-called wide-angle effect. The wide-angle effect is characterized by what appear to be distorted image shapes for threedimensional objects near the corners of photographs. This effect is especially noticeable in group portraits where heads appear to be stretched out of shape in directions radiating away from the lens axis or the center of the photograph. Thus, heads near the sides seem to be too wide, those near the top and bottom seem to be too long, and those near the corners appear to be stretched diagonally (see Figure 4-31).

Such stretching occurs because rays of light from off-axis

Figure 4–31 The image of a spherical light globe in this cropped section of a photograph taken with a short focal length lens is stretched approximately 60% in a direction away from the lens axis.

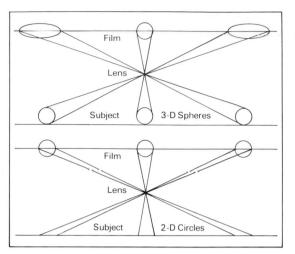

Figure 4–32 The wide-angle effect results in elongation of off-axis images of three-dimensional objects (top). Images of two-dimensional objects such as circles in a painting or photograph are not affected (bottom).

objects strike the film at oblique angles rather than at a right angle, as occurs at the lens axis. If the subject consists of balls or other spherical objects, the amount of stretching can be calculated in relation to the angle formed by the light rays that form the image and the lens axis. Thus, at an off-axis angle of 25° the image is stretched about 10%, and at 45° the image is stretched about 42%. (The image size of off-axis objects changes in proportion to the secant of the angle formed by the central image-forming ray of light with the lens axis. The reciprocal of the cosine of the angle may be substituted for the secant.) Normal focal length lenses, where the focal length is about equal to the diagonal of the film, have an angle of view of approximately 50° , or a half angle of 25° .

Why don't we notice the 10% stretching that occurs with normal focal length lenses? It is not because a 10% change in the shape of a circle is too small to be noticed, but rather that when the photograph is placed at the correct viewing distance, the eye is looking at the images at the edges at the same off-axis angle as the angle of the light rays that formed the image in the camera. Thus, the elliptical image of the spherical object is seen as a circle when the ellipse is viewed obliquely. The effect would be the same even with the more extreme stretching produced with short focal length wide-angle lenses if the photographs were viewed at the so-called correct viewing distance. Since the correct viewing distance is uncomfortably close for photographs made with short focal length lenses, people tend to view them from too great a distance, where the stretching is apparent.

One might question why the wide-angle effect does not occur when photographing circles drawn on paper as it does when photographing three-dimensional objects. The distinction is that if one looks at a row of balls from the position of the camera lens, the outline shape of all of the balls will appear circular, whether they are on or off axis, but off-axis circles drawn on paper will appear elliptical in shape because they are viewed obliquely. The compression that produces the ellipse when the circle is viewed from the lens is exactly compensated for by stretching when the image is formed because the light falls on the film at the same oblique angle at which it leaves the drawing (see Figure 4-32).

4.12 Depth of Field

Camera lenses can be focused on only one object distance at a time. Theoretically, objects in front of and behind the object distance focused on will not be imaged sharply on the film. In practice, acceptably sharp focus is seldom limited to a single plane. Instead, objects somewhat closer and farther away appear sharp. Depth of field is defined as the range of object distances within which objects are imaged with acceptable sharpness (Figure 4–33A). Depth of field is not limited to the plane focused on because the human eye has limited resolving power, so that a circle up to a certain size appears as a point. The largest circle that appears as a point is referred to as the permissible circle of confusion.

4.13 Permissible Circle of Confusion

The size of the largest circle that appears as a point depends upon the viewing distance. For this reason permissible circles of confusion are generally specified for a viewing distance of 10 inches, and

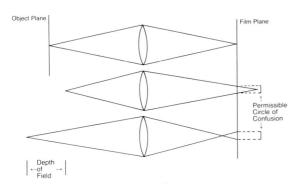

Figure 4–33A Depth of field is the range of distances within which objects are imaged with acceptable sharpness. At the limits, object points are imaged as permissible circles of confusion.

Figure 4–33B Depth-of-field scales and tables can be checked by photographing an object at an angle with markers placed at the point focused on and at the indicated near and far limits of the depth of field. A 6×8 -inch or larger print should be made so that it can be viewed from the "correct" viewing distance.

1/100 inch is commonly cited as an appropriate value for the diameter. It is apparent that even at a fixed distance the size of the permissible circle of confusion will vary with such factors as differences in individual evesight, the tonal contrast between the circle and the background, the level of illumination, and the viewers' criteria for sharpness. Nevertheless, when a lens manufacturer prepares a depth-of-field table or scale for a lens, these variables must be ignored. A single value is selected for the permissible circle of confusion that seems appropriate for the typical user of the lens. Although many photographic books that include the subject of depth of field accept 1/100 inch as being appropriate, it should not be surprising that there is less agreement among lens manufacturers. A study involving a small sample of cameras designed for advanced amateurs and professional photographers revealed that values ranging from 1/70 to 1/200 inch were used-approximately a 3:1 ratio. Two different methods will be considered for evaluating depth-of-field scales and tables for specific lenses.

One procedure is to photograph a flat surface that has good detail at an angle of approximately 45° , placing markers at the point focused on and at the near and far limits of the depth of field as indicated by the depth of held as indicated by the depth of held as indicated by the depth of held as indicated and the model, and depth of held as indicated the photograph should be made at an intermediate t-number, with additional exposures bracketing the f-number one and two stops on both sides, with appropriate adjustments in the exposure time. A variation of this procedure is to use three movable objects in place of the flat surface, focusing on one and placing the other two at the near and far limits of the depth of field as indicated by the scale or table.

To judge the results, 6×8 -inch or larger prints should be made without cropping and viewed from a distance equal to the diagonal of the prints. The diagonal of a 6×8 -inch print is 10 inches, which is considered to be the closest distance at which most people can comfortably view photographs or read. If the photograph made at the fnumber specified by the depth-of-field scale or table has either too little or too much depth of field when viewed at the correct distance, the photograph that best meets the viewer's expectation should be identified from the bracketing series. A corresponding adjustment can be made when using the depth-of-field scale or table in the future.

The second procedure involves determining the diameter of the permissible circle of confusion used by the lens manufacturer in calculating the depth-of-field scale or table. It is not necessary to expose any film with this procedure. Instead, substitute values for the terms on the right side of the formula $C = f^{2}/(N \times H)$ and solve for C, where C is the diameter of the permissible circle of confusion on the film, f is the focal length of the lens, N is any selected f-number, and H is the hyperfocal distance at that f-number.

Hyperfocal distance can be defined in either of two ways: (a) the closest distance that appears sharp when a lens is focused on infinity; or (b) the closest distance that can be focused on and have an object at infinity appear sharp. Although the two procedures are different, the results will be essentially the same. We should also note that when a lens is focused on the hyperfocal distance, the depth of field extends from inifinity to one half the hyperfocal distance (see Figure 4–34). If we select f/16 as the f-number with a 2 inch (50 mm) focal length lens, the hyperfocal distance can be determined either from a depth-of-field table or from a depth-of-field scale on the lens or camera by noting the near distance sharp at f/16 when the lens is focused on infinity. (If the near-limit marker on a DOF scale falls between two **Figure 4–34** The byperfocal distance is the closest distance that appears sharp when a lens is focused on infinity (top), or the closest distance that can be focused on and have an object at infinity appear sharp (bottom).

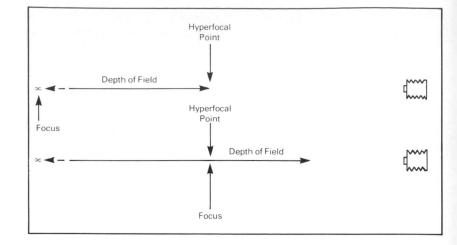

widely separated numbers, making accurate estimation difficult, set infinity opposite the far-limit marker and multiply the distance opposite the near-limit marker by two, as illustrated in Figure 4-35.)

Since the circle of confusion is commonly expressed as a fraction of an inch, the hyperfocal distance and the focal length must be in inches. The hyperfocal distance at f/16 for the lens illustrated is 24 feet or 288 inches. Substituting these values in the formula $C = f^{2}/(N \times H)$ produces $2^{2}/16 \times 288$ or 1/1,152 inch. This is the size of the permissible circle of confusion on the negative, but a 35 mm negative must be magnified six times to make a 6×8 -inch print to be viewed at 10 inches. Thus, $6 \times 1/1,152 = 1/192$ inch, or approximately half as large a permissible circle of confusion as the 1/100-inch value commonly used.

It is important to note that the size of the permissible circle of confusion used by a lens manufacturer in computing a depth-of-field table or scale tells us nothing about the quality of the lens itself. The manufacturer can arbitrarily select any value, and in practice a size is selected that is deemed appropriate for the typical user of the lens. If a second depth-of-field scale is made for the lens in the preceding example based on a circle with a diameter of 1/100 inch rather than approximately 1/200 inch, the new scale would indicate that it is necessary to stop down only to f/8 in a situation where the original scale specified f/16. Lens definition, however, is determined by the quality of the image for the object focused on, not the near and far limits of the indicated depth of field.

4.14 Depth-of-Field Controls

Photographers have three basic controls over depth of field: f-number, object distance, and focal length. Since viewing distance also affects the apparent sharpness of objects in front of and behind the object focused on, it is generally assumed that photographs will be viewed at a distance about equal to the diagonal of the picture. At this distance, depth of field will not be affected by making different-size prints from the same negative. For example, the circles of confusion at the near and far limits of the depth of field will be twice as large on a 16×20 -inch print as on an 8×10 -inch print from the same negative, but the larger print would be viewed from double the distance, making the two prints appear to have the same depth of field. If the larger print were viewed from the same distance as the smaller print, it would

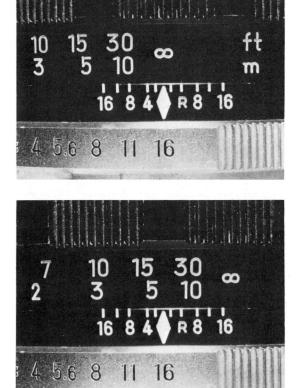

Figure 4–35 The hyperfocal distance can be determined from a depth-of-field scale either by focusing on infinity and noting the near distance sharp at the specified f-number (top) or by setting infinity opposite the far-distance sharp marker and multiplying the near distance sharp by two (bottom).

Figure 4–36 Since depth of field varies in proportion to the object distance squared, photographs made at a scale of reproduction of 1:1 and larger tend to have a shallow depth of field.

Figure 4-37 Focusing on the hyperfocal distance produces a depth of field that extends from infinity to one-balf the hyperfocal distance. (Photograph by John Johnson.)

4.16 Depth of Field and Object Distance

appear to have less depth of field. Cropping when enlarging will decrease the depth of field because the print size and viewing distance will not increase in proportion to the magnification.

4.15 Depth of Field and f-Number

Fortunately, the relationship between f-number and depth of field is a simple one, whereby doubling the f-number doubles the depth of field. In other words, depth of field is directly proportional to the f-number, or $D_1/D_2 = N_1/N_2$. Thus, if a certain lens has a range of f-numbers from f/2 to f/22, the ratio of the depth of field at these settings would be $D_1/D_2 = f/22/f/2 = 11/1$. Changing the f-number is generally the most convenient method of controlling depth of field, but occasionally insufficient depth of field is obtained with a lens stopped down to the smallest diaphragm opening or too much depth of field is obtained with a lens wide open. In these circumstances other controls must be considered.

4 16 Depth of Field and Object Distance

Depth of field increases rapidly as the distance between the camera and the subject increases. For example, doubling the object distance makes the depth of field four times as large. The differences in depth of field with very small and very large object distances are dramatic. In photomacrography, where the camera is at a distance of two focal lengths or less from the subject, the depth of field at a large aperture sometimes appears to be confined to a single plane (see Figure 4-36).

At the other extreme, by focusing on the hyperfocal distance, depth of field extends from infinity to within a few feet of the camera with some lenses (see Figure 4–37). The mathematical relationship between depth of field and object distance (provided the object distance does not exceed the hyperfocal distance) is represented by the formula $D_1/D_2 = U_1^2/U_2^2$. For example, if two photographs are made with the

4.17 Depth of Field and Focal Length

camera 5 feet and 20 feet from the subject, the ratio of the depths of field will be

$$\frac{D_1}{D_2} = \frac{20^2}{5^2} \text{ or } \left(\frac{20}{5}\right)^2 = \frac{16}{1}.$$

If, however, object distance is increased to obtain a larger depth of field when a camera lens cannot be stopped down far enough, it is necessary to take into account the enlarging and cropping required to obtain the same image size as with the camera in the original position. There is still a net gain in depth of field in moving the camera farther from the subject, even though some of the increase is lost when the image is cropped in printing. The net gain is represented by the formula $D_1/D_2 = U_1/U_2$, which is the same as the preceding formula with the square sign removed.

Special scanning techniques have been devised to overcome the shallow depth of field limitations encountered in the areas of photomacrography, photomicrography, and electron micrography. The scanning technique for photomacrography and photomicrography consists of illuminating the object with a thin sheet of light in a plane that is parallel to the film plane. The camera is focused on the light plane and the subject is moved through the light plane, toward the camera. Exposure occurs only when the various parts of the subject move through the light plane, which is always in focus.

4.17 Depth of Field and Focal Length

There is an inverse relationship between focal length and depth of field, so that as focal length increases, depth of field decreases. Before specifying the relationship more exactly, however, it is necessary to distinguish between situations where the different focal length lenses are used on different format cameras, such as 35 mm and 8×10 -inch, and where the lenses are used on the same camera. When a large-format camera and a small-format camera are each equipped with a normal focal length lens, i.e., one with a focal length about equal to the film diagonal, the depth of field will be inversely proportional to the focal length. For example, a 2-inch (50 mm) focal length lens on a 35 mm camera will produce about six times the depth of field of a 12-inch (305 mm) lens on an 8×10-inch camera. Even though enlarging negatives does not affect the depth of field, it is easier to compare the depth of field on two prints when they are the same size. Thus it would be appropriate to make an 8×10 -inch enlargement from the 35 mm negative and a contact print from the 8×10 -inch negative. The above relationship of depth of field and focal length is expressed as

$$\frac{D_1}{D_2}=\frac{f_2}{f_1}.$$

Using the same two lenses on one camera produces a more dramatic difference in depth of field. It is now necessary to square the focal lengths so that

$$\frac{D_1}{D_2} = \frac{f_2^2}{f_1^2}.$$

Comparing the depth of field produced with 50 mm and 300 mm focal length lenses on a 35 mm camera, the ratio of the focal lengths is 1:6, and the ratio of the depths of field is 36:1. The great increase in depth

of field with the shorter lens evaporates, however, if the camera is moved closer to the subject to obtain the same size image on the film as with the longer lens. In this example the camera would be placed at distances having a ratio of 1:6 to obtain the same image size with the 50 mm and 300 mm lenses, and we recall that depth of field increases with the distance squared, so that the $36 \times$ increase obtained with the shorter lens would be exactly offset by the reduction in object distance.

There is still a net gain in using a shorter focal length lens on the same camera if the negative is enlarged and cropped to obtain the same image size and cropping on a print as that produced with a longer lens. This is essentially the same situation as using different format cameras, each with a normal focal length lens.

4.18 Calculating Depth of Field

It is seldom necessary for photographers to calculate depth of held, since depth of field scales are supported on the tens or camera body with most small-format cameras, and depth-of-field tables are generally available for lenses used on large-format cameras. There are advantages in being familiar with the formulas and procedure when a depth-of-field scale or table is not available for a certain lens, or when it has been determined that the size of the permissible circle of confusion used in computing the scale or table was larger or smaller than is appropriate for the photographer. In addition, the formulas provide a means of checking the relationships between depth of field and fnumber, object distance, and focal length discussed above, which are approximations within limits.

Three basic formulas are used to compute depth of field; one to determine the hyperfocal distance, one to determine the far distance sharp, and one to determine the near distance sharp. The depth of field is found by subtracting the near distance sharp from the far distance sharp. The first formula is the same as the one given previously to determine the permissible circle of confusion, but in different form since we now want to insert our own value for the circle and find the corresponding hyperfocal distance.

- H = f²/(N × C), where again H is hyperfocal distance, f is focal length, N is f-number, and C is the diameter of the permissible circle of confusion on the negative. If one is starting with the size of the circle desired on a 6×8-inch print, such as 1/200 inch, this value must be divided by the magnification.
- **2.** $DN = H \times U/(H + U)$, where DN is the near distance sharp and U is object distance.
- **3.** $DF = H \times U/(H U)$, where DF is the far distance sharp. Subtract DN from DF to determine the depth of field.

4.19 Depth of Focus

Depth of focus can be defined as the focusing latitude when photographing a two-dimensional subject. In other words, it is the distance the film plane can be moved in both directions from the optimum focus before the circles of confusion for the image of an object point match the permissible circle of confusion used to calculate depth of field. It is important to note that for depth-of-field calculations it is assumed the film occupies a single flat plane, and for depth-of-focus calculations it is assumed that the subject occupies a single flat plane

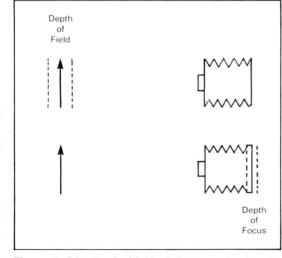

Figure 4-38 Depth-of-field calculations are based on the assumption that the two-dimensional film is in the position of optimum focus (top). Depth of focus calculations are based on the assumption that the subject is limited to a two-dimensional plane (bottom).

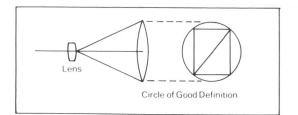

Figure 4-39 The diameter of the circle of good definition of a lens must be at least as large as the diagonal of the film

(see Figure 4–38). If a three-dimensional object completely fills the depth-of-field space, there is only one position for the film, and there is in effect no depth of focus and no tolerance for focusing errors.

With a two-dimensional subject, the depth of focus can be found by multiplying the permissible circle of confusion by the fnumber by 2. Thus, using 1/200 inch for the permissible circle of confusion on a 6×8 -inch print or 1/1,200 inch on a 35 mm negative, the depth of focus is $C \times N \times 2 = 1/1,200 \times f/2 \times 2 = 1/300$ inch. It can be seen from this formula that depth of focus varies in direct proportion to the f-number, as does depth of field.

Whereas depth of field decreases as a camera is moved closer to the subject, depth of focus increases. This is because as the object distance decreases, the lens-to-film distance must be increased to keep the image in sharp focus, and this increases the effective f-number. It is the effective f-number, not the marked f-number, that is used in the formula.

Whereas increasing focal length decreases depth of field, it has no effect on depth of focus. The explanation is that at the same fnumber the diameter of the effective aperture and the lens-to-film distance both change in proportion to changes in focal length so that the shape of the cone of light falling on the film remains unchanged. Since focal length does not appear in the formula $C \times N \times 2$, it has no effect on depth of focus.

Although changing film size would not seem to affect depth of focus, using a smaller film reduces the correct viewing distance and, therefore, the permissible circle of confusion. Substituting a smaller value for C in the formula $C \times N \times 2$ reduces the depth of focus.

4.20 View-Camera Movements

Most cameras have a focusing adjustment with which the distance between the lens and the film plane can be varied. View cameras have three additional types of adjustments that affect the image: (a) movement of the lens or film in a direction perpendicular to the lens axis to control placement of the image on the film: (b) alteration of the angle of the lensboard to control the angle of the plane of sharp focus; and (c) alteration of the angle of the plane of sharp focus.

4.21 Perpendicular Movements

Although most photographs are rectangular, lenses form images within a circular area at the film plane. To obtain photographs having good definition in the corners as well as in the center, this circular image area must have a diameter at least as large as the diagonal of the film (see Figure 4–39). The circular area within which satisfactory image definition can be obtained is called the *circle of good definition*. The circle of good definition is one measure of the covering power of a lens. Somewhat larger than the circle of good definition is the *circle of illumination*. No light will reach the film plane outside the circle of illumination.

In the doughnut-shaped ring between the circle of good definition and the circle of illumination an image will be formed, but it will not be acceptably sharp. The image in this area will appear to be out of focus, but it cannot be brought into focus by adjusting the lens-to-film distance. If the diameter of the circle of illumination is smaller than the film diagonal, it will be possible to detect the edge Figure 4-40 Edges of the circle of good definition and the circle of illumination of a camera lens at the maximum aperture (left) and the minimum aperture (right). Stopping down increases the size of the circle of good definition and the abruptness of the transition from the illuminated area to the nonilluminated area.

of the circle of good definition (where the image becomes unsharp) and the edge of the the two definition (where the image is bound) considered the corners of the negative or the print (see Figure 4–40). The transition from one area to the next may be gradual or abrupt and the difference in size of the two circles may range from small to considerable.

If, on the other hand, the circle of good definition is somewhat larger than the film, it will be possible to select different parts of the image within the circle to record on the film—provided the camera has the appropriate movements. View cameras typically have rising-falling adjustments to move the lens and/or the film up and down, and lateral shifts to move the lens and/or film from side to side. Using the vertical or horizontal adjustments on the back of the camera results in movement of the film in relation to a stationary circle of good definition. Using the corresponding adjustments on the front of the camera results in movement of the lens and the circle of good definition in relation to the film, which remains stationary. Thus, shifting the lens to the left is essentially the same as shifting the back to the right, and shifting both a distance of two inches in opposite directions, for example, is equivalent to shifting either one four inches.

Rising-falling fronts were the first adjustment added to the early ancestors of the modern view camera after focusing adjustments. It was realized that the rising front makes it possible to include the tops of buildings in photographs without tilting the camera up, which caused the vertical lines in the subject to converge in the image (see Figure 4–41). The rising-falling front was later used on most handheld press cameras, and, more recently, lenses that can be shifted vertically, horizontally, or diagonally have been provided for 35 mm cameras. Corresponding adjustments are not normally found on enlargers because a similar effect can be obtained by moving the easel, or by moving the negative in the enlarger.

It was mentioned that the circle of good definition is one measure of the covering power of a lens. A disadvantage of designating the covering power in terms of the circle of good definition is that the size of the circle increases as the object distance is reduced and the lensto-film distance is increased to keep the image in sharp focus. A dramatic example of this change can be observed when an object is placed two focal lengths in front of a camera to obtain a 1.1 scale of reproduction. The image distance will also be two focal lengths, and the diameter of the circle of good definition will be twice as large as when

Figure 4-41 Tilting a camera up causes vertical subject lines to converge toward the top. (Photograph by John Johnson.)

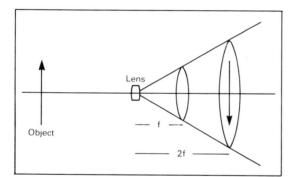

Figure 4-42 Changes in object and image distances do not affect the angle of coverage of a lens.

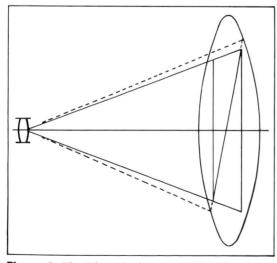

Figure 4-43 The angle of coverage of a lens must be at least as large as the angle of view for the lens-film combination.

the camera is focused on a distant object. With lenses of normal design the diameter of the circle of good definition can be expected to be about equal to the focal length with the camera focused on infinity and with the lens diaphragm wide open. Stopping down the lens tends to increase the size of the circle modestly, usually not more than 20%.

Angle of Coverage is a second measure of the covering power of a lens, and can be determined by drawing straight lines from opposite sides of the circle of good definition to the back nodal point of the lens. Changes in object and image distances do not affect the angle of coverage (see Figure 4–42). Lenses of normal design typically have an angle of coverage of a little more than 50° with the diaphragm wide open, and slightly larger with the diaphragm stopped down. The angle of coverage of a lens must be at least as large as the angle of view of the lens-film combination when the lens is in the normal position (see Figure 4–43). When a front rising-falling, lateral shift, tilt, or swing adjustment is used, the angle of coverage must be correspondingly larger. Increased angular covering power is also needed for back risingfalling and lateral shift adjustments, but not for back tilt and swing adjustments.

4.22 Back Movements and Image Shape

When the front of a long building or box-shaped object is photographed at an oblique angle, the near end is taller than the far end in the photograph, and the horizontal lines converge toward the far end. In the section on linear perspective (4.6), it was noted that the ratio of image sizes of objects that are equal in size but at different distances can be controlled by decreasing or increasing the distance between the camera and the objects. Moving the camera farther away decreases the ratio, that is, makes the images more nearly equal in size, but they cannot be made exactly equal no matter how far away the camera is placed. If, however, the back of the camera is swung (i.e., rotated about a vertical axis) parallel to the front of the object, the near

Figure 4-44 Photographing a book at an angle to show the front edge and one end causes the horizontal lines to converge with increasing distance (top). Swinging the back of the camera parallel to the front edge of the book eliminates the convergence of the horizontal lines in that plane (bottom).

and far ends will be the same size and the horizontal lines will be parallel in the photograph regardless of the camera-to-object distance (see Figure 4–44). Conversely, the ratio of image sizes and the convergence of the horizontal lines can be increased by swinging the back of the camera in the other direction, away from being parallel to the front of the object.

The change in image shape that occurs when the back is swung can be explained with the lens formula R = V/U (scale of reproduction equals image distance divided by object distance). When the back is in the normal or zero position, the image distance (measured to the film plane, as must be done when dealing with image size whether or not the images are in exact focus) is the same for both ends of the object, and the scale of reproduction will vary inversely with the object distance. In this situation the assumption holds that image size varies inversely with object distance. Swinging the back parallel to the front of the object changes the image distances for the two ends of the object. Since the rays of light cross at the lens, the image distance is decreased for the near end of the object and increased for the far end. It can be domonstructed with geometry that when the back is parallel with the subject, the image distances will be in the same proportion as the object distances, and V/U (and therefore image size) will be the same for the two ends. It should be noted that image and object distances are measured parallel to the lens axis or perpendicular to the back nodal plane, which is approximated by the lens board in the examples in this section (see Figure 4-45).

Numbers can be substituted for the object and image distances in the formula R = V/U to illustrate the effect of swinging the back of the camera. Using object distances of 50 feet and 100 feet for the two ends of the object and 6 inches and 12 inches for the corresponding image distances, the scale of reproduction for the near end is 0.5 foot/50 feet = 1/100 and for the far end is 1 foot/100 feet = 1/ 100 also. With the back in the zero position and an image distance of

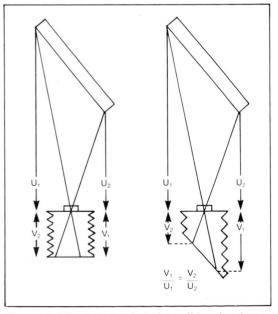

Figure 4-45 Swinging the back parallel to the subject makes the scale of reproduction (image distance/object distance) the same for the two ends, and thereby eliminates convergence of horizontal subject lines in the photograph.

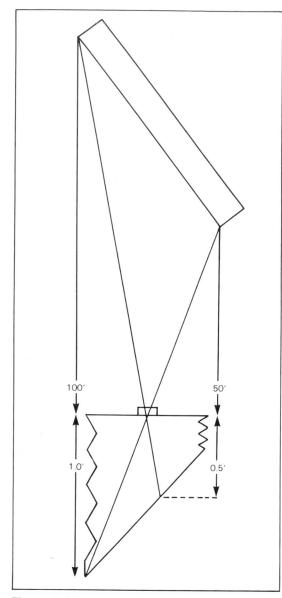

Figure 4-46 Swinging the camera back away from being parallel to the subject increases the convergence of the horizontal lines. The relative heights of the two ends of the building would be changed from 1:2 to 1:4 by swinging the back.

eight inches for both ends, the scale of reproduction is 1/75 for the near end and 1/150 for the far end, or a 2:1 ratio of image sizes for the two ends of the object. Swinging the back in the opposite direction to exaggerate convergence of the horizontal lines produces a scale of reproduction of 1 foot/50 feet = 1/50 for the near end and 0.5 foot/ 100 feet = 1/200 for the far end or a 4:1 ratio of image sizes for the two ends (see Figure 4–46).

Swinging the back of the camera parallel to the front of a object results in the back being swung away from being parallel with the end of the object. Thus it is not possible, nor would it be desirable, to make the horizontal lines parallel on the front and the end of the object simultaneously. Reducing the convergence on one side increases the convergence on the other side. No general rules can be given to cover all situations, but increasing the convergence of the horizontal lines on the long side of an object will increase its apparent length. When the camera is displaced only slightly from being directly in front of an object, the results may be more attractive with the horizontal lines on the front made parallel. In many situations, however, the results are most attractive when no change is made in the convergence of horizontal subject lines.

Tilting a camera upward to photograph a tall building causes the vertical subject lines to converge in the photograph for the same reason as do horizontal lines, since the top of the building is at a greater distance from the camera than the bottom. To make the image lines parallel in this situation, the back is tilted (rotated about a horizontal axis) until it is parallel to the vertical subject lines, and the convergence can be exaggerated by tilting the back in the opposite direction. It would even be possible to make the top of the building appear to be larger than the bottom by overcorrecting, that is, by tilting the back to the vertical position and beyond. There has been a much stronger tradition of "correcting" converging vertical lines than converging horizontal lines, especially in the fields of photography where view cameras are commonly used, including architectural photography and catalog photography.

Cameras that have a rising-falling type of adjustment for the lens, including some 35 mm cameras and press cameras, can keep vertical subject lines parallel in photographs by setting up the camera with the back perpendicular to the ground and then raising the lens if the subject is above the camera or lowering the lens if the camera is above the subject.

Swinging and tilting the lens on a view camera will not alter the convergence of subject lines or the shape of the image. This might seem surprising since these adjustments do alter object and image distances (which are measured perpendicularly to the nodal planes, not directly to the nodal points on the lens axis). The explanation is that as a lens is swung to reduce the object distance for an object on the left side of the scene being photographed, the corresponding image distance on the right side of the camera is being reduced at the same rate. Therefore, the ratio V/U—image distance to object distance remains unchanged and the image size is unaffected.

4.23 Back Movements and Image Sharpness

In situations where the swing and tilt adjustments on the camera back are not needed to control the convergence of parallel subject

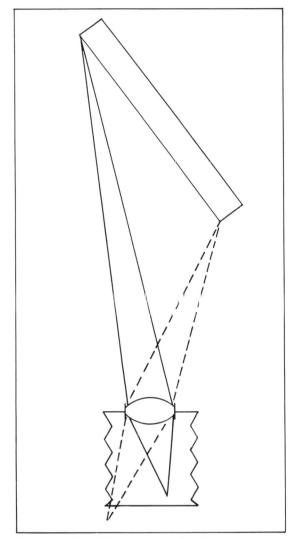

Figure 4-47 When a camera is focused on an intermediate distance, the image of the far end comes to a focus in front of the film, and the image of the near end comes to a focus behind the film.

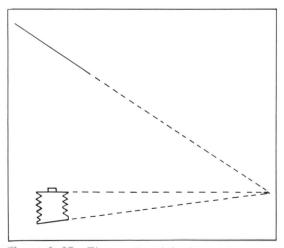

Figure 4-48 The convergence of the planes of the subject, the lensboard, and the film illustrates the Scheimpflug rule for controlling the angle of the plane of sharp focus.

lines or to otherwise control image shape, they can be used to control the angle of the plane of sharp focus in object space. Whereas only the back adjustments can be used to control image shape, either the back or lens adjustments can be used to control the angle of the plane of sharp focus. When both image shape and sharpness must be controlled, the back adjustments are used for shape (since there is no other choice) and the lens adjustments are used for sharpness. When image sharpness is the only concern, there are situations where it is better to use the back adjustments than the lens adjustments, such as when the lens has insufficient excess covering power to allow it to be tilted or swung.

Figure 4-47 illustrates that the image of a distant object on the left comes to a focus closer behind the lens than the image of a nearby object on the right, as specified by the lens formula 1/f = 1/U + 1/V, where the conjugate object and image distances vary inversely. In the absence of tilt and swing adjustments it would be necessary to focus the camera on some intermediate object distance and stop down the lens diaphragm to increase the depth of field if the images of both objects are to appear sharp; and it is not always possible to abtain an much input of the dimended while this provided to conform to the image plane defined by the two in-focus images. The back is swung in a direction away from being parallel to the object plane containing the two object points—the opposite direction to that used to prevent convergence of parallel lines in the same object plane.

Another method of determining which direction to swing or tilt the camera back, to cause the plane of sharp focus to conform to a subject plane at an oblique angle, is to remember that the plane of the subject, the plane of the lensboard, and the plane of the back must meet at a common location. In other words, note where the subject plane and the plane of the lensboard meet, and then swing or tilt the back so that the film plane intersects the other two planes at the same position (see Figure 4-48).

This relationship of the plane of the subject, the plane of the lensboard, and the plane of sharp focus in image space is known as the Scheimpflug rule. The only situation in which the three planes should not converge to produce a sharp image is when all three are parallel, as in copying. It is not as easy to determine the position where the planes converge with the actual camera in picture-making situations as it is with drawings, but the Scheimpflug rule makes it clear in which direction the back should be swung or tilted. Also, it is often possible for the photographer to position himself where the planes of the subject and the lensboard converge and then have someone adjust the angle of the camera back until it also lines up with his eye. When the back is swung or tilted for the purpose of controlling the angle of the plane of sharp focus, the shape of the image will also be changed, and the photographer should be alert to possible adverse effects.

4.24 Lens Movements and Image Sharpness

The Scheimpflug rule indicates that if the back of the camera is left in the zero position with a subject that is at an oblique angle, the lensboard can be swung (or tilted) to obtain convergence of the three planes at a common location. The lensboard is swung toward a position parallel to the subject plane to obtain a sharp image, whereas the back of the camera was swung in the opposite direction.

4.24 Lens Movements and Image Sharpness

Swinging or tilting a lens causes the circle of good definition, which is centered about the lens axis, to move also. Thus, if the circle of good definition of a certain lens is just large enough to cover the film in a camera with the lens in the zero position, changing the angle of the lens will move the circle of good definition so that part of the film will lie outside the circle. It is therefore advisable to use a longer focal length lens, having a larger circle of good definition, with a view camera. If a shorter focal length lens is needed to obtain the desired angle of view and image size, a wide-angle lens should be used.

The explanation for the fact that swinging or tilting the lens alters the angle of the plane of sharp focus in object and image spaces is based on the lens formula 1/f = 1/U + 1/V. As noted earlier, the image of a distant object on the left comes to a focus in front of the film on the right, and the image of a nearby object comes to a focus behind the film when the camera is focused on an intermediate distance with the lensboard and the back in their normal positions. Swinging the lensboard toward the plane of the objects decreases the object distance for the object on the left and increases the object distance for the object on the right (since the distances are measured perpendicularly to the lensboard), as shown in Figure 4-49. Decreasing the object distance increases the image distance, thereby moving the sharp image of the object on the left closer to the film. If the lens is swung to the angle indicated by the Scheimpflug rule, the sharp image will be formed at the film plane. The converse occurs for the closer object on the right. When the back adjustments are used to control image shape and the lens adjustments are used to control the angle of the plane of sharp focus, it is important to swing or tilt the back first and then the lens rather than in the reverse order.

So far it has been assumed that only a single plane in object space will be imaged sharply, ignoring depth of field. When the lens or back is swung or tilted, the camera is actually focused on different object distances from side to side or from top to bottom in one photograph. Since depth of field increases in proportion to the object distance squared, the near and far limits of the depth-of-field pattern will be curved surfaces rather than flat planes. Figure 4-50 illustrates the depth-of-field pattern obtained when tilts or swings are used, with the straight line representing the plane of sharp focus and the curved lines representing the near and far limits of depth of field at two different f-numbers.

Figure 4-49 Swinging a camera lens toward the subject plane decreases the object distance for the far end and increases the object distance for the near end. The corresponding changes in image distances make it possible to have the images of both ends come to a focus at the film plane.

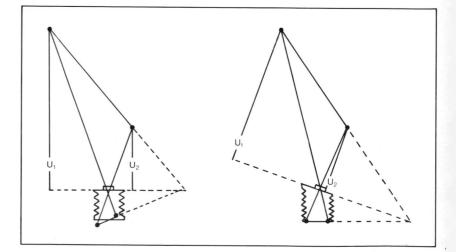

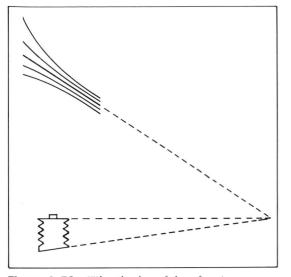

Figure 4-50 When the plane of sharp focus is at an angle, as represented by the straight subject line, the near and far limits of depth of field are curved lines, shown here for two upplying hummbers.

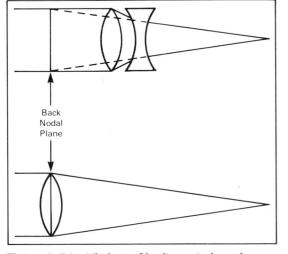

Figure 4–51 The lens-to-film distance is shorter for a telephoto lens (top) than for a normal-type lens (bottom) of the same focal length.

4.25 Lens Types

Descriptive names applied to different types of camera lenses include normal, telephoto, catadioptric, wide-angle, reversed telephoto (retrofocus), supplementary, convertible, zoom, macro, macro-zoom, process, soft focus, and anamorphic. There are considerable variations among so-called normal lenses, especially in the characteristics of focal length, speed, image quality, and price. The characteristic most common to normal-type lenses is an angular covering power of about 53°, which is just sufficient to cover the film when the focal length is equal to the film diagonal. The rule of thumb that recommends using a lens having a focal length about equal to the film diagonal is reasonable for normal-type lenses with most cameras, but longer focal length normal-type lenses should be used with view cameras to provide sufficient covering power to accommodate the camera movements. In the past many cameras were built with the lens permanently attached, the implication being that one lens should be able to satisfy all picture-taking needs. Most contemporary cameras are constructed so that other lenses can be substituted, enabling photographers to take advantage of the great variety of special-purpose lenses available

4.26 Telephoto Lenses

Telescopes and microscopes were invented to enable us to see distant objects as well as small objects more clearly. Photographers often want to record larger images of these distant and small objects than can be produced with lenses of normal focal length and design. We know that the image size of a distant object is directly proportional to the focal length. Thus, to obtain an image that is six times as large as that produced by a normal lens, the focal length must be increased by a factor of six, but the lens-to-film distance will also be increased six times unless the lens design is modified. The lens-to-film distance is shorter with telephoto lenses than with normal lenses of the same focal length. Compactness is the advantage of equipping a camera with a telephoto lens rather than a normal-type lens of the same focal length. Photographs made with the two lenses, however, would be the same with respect to image size, angle of view, linear perspective, and depth of field.

The basic design for a telephoto lens is a positive element in front of and separated from a negative element (see Figure 4-51). When a telephoto lens and a normal-type lens of the same focal length are focused on a distant object point, both images will come to a focus one focal length behind the respective back (image) nodal planes; but the lens-to-image distance will be smaller with the telephoto lens. The reason for the reduced lens-to-image distance is that the back nodal plane is located in front of the lens with telephoto lenses rather than near the center, as with normal lenses. It is easy to locate the position of the back nodal plane in a ray tracing of a telephoto lens focused on a distant object point, as in the preceding figure, by reversing the converging rays of light in straight lines back through the lens until they meet the entering parallel rays of light. To determine the position of the back nodal point with an actual telephoto lens, the lens can be pivoted about various positions along the lens axis on a nodal slide until the image of a distant object remains stationary; or the lens and camera can be focused on infinity, whereby the back nodal point will be located exactly one focal length in front of the film plane. The

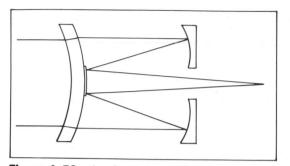

Figure 4–52 Catadioptric lenses make use of folded optics to obtain long focal lengths in relatively short lens barrels.

position of the back nodal plane should be noted in relation to the front edge of the lens barrel, since this relationship will remain constant. If the back nodal plane is found to be located two inches forward of the front of a telephoto lens, two inches should be added to the distance from the front of the lens to the film any time the image distance (V) is used in a calculation, such as to determine scale of reproduction or the exposure correction for closeup photography. Although telephoto lenses are not generally used for closeup photography, the closeup range begins at an object distance of about 10 times the focal length, which can be a considerable distance with a long focal length telephoto lense.

Although two terms have been used to indicate the extent to which a telephoto lens differs from a normal lens with respect to distances from the film, neither is very useful for the practicing photographer. Telephoto power is the focal length of a telephoto lens divided by the focal length of the normal lens supplied with the camera. Telephoto ratio, which sometimes is also referred to as telephoto power, is the focal length of a telephoto lens divided by the back focal distance (the distance from the film to the back surface of the lens when focused on infinity). The back surface is sometimes well in front of the mounting flange with telephoto lenses for small-format cameras, and well behind the mounting flange and lensboard with telephoto lenses for largeformat cameras. A more useful ratio would be the focal length divided by the flange focal distance—a ratio properly identified as the effective power of the telephoto lens, since it more realistically represents the reduction in lens-to-film distance attributable to the telephoto design.

4.27 Catadioptric Lenses

Notwithstanding the shorter lens-to-film distance obtained with telephoto lenses compared to normal lenses of the same focal length, the distance becomes inconveniently large with very long focal length telephoto lenses. Catadioptric lenses achieve a dramatic improvement in compactness through the use of folded optics. They combine glass elements and mirrors to form the image. The name catadioptric is derived from dioptrics (the optics of refracting elements) and catoptrics (the optics of reflecting surfaces). Figure 4-52 illustrates the principle of image formation with a catadioptric lens. A beam of light from a distant point passes through the glass element, except for the opaque circle in the center; it is reflected by the concave mirror and again by the smaller mirror on the back of the glass element, and it passes through the opening in the concave mirror to form the image on the film. The glass element and the opaque stop reduce aberrations inherent in the mirror system. Additional glass elements are commonly used between the small mirror and the film.

Location of the image nodal plane and the focal length of a catadioptric lens can be determined by the same methods described above for telephoto lenses. When the converging light rays that form the image on the film are reversed in straight lines on a ray tracing until they meet the entering rays of light, it can be seen that the image nodal plane is located a considerable distance in front of the lens, and the lens-to-film distance is small compared to the focal length (see Figure 4-53).

Catadioptric lenses are capable of producing images having excellent definition. There are also disadvantages with this type of lens. Due to the long focal length, the lens diameter would have to be very **Figure 4–53** The image nodal plane and the focal length of a catadioptric lens can be determined by reversing the converging rays of light that form the image in straight lines until they meet the corresponding entering rays.

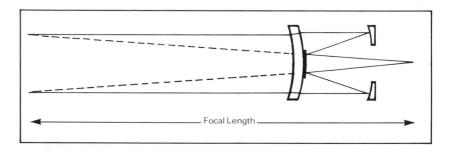

large to match the low f-numbers commonplace on lenses of normal design. Since a variable diaphragm cannot be used with this type of lens, exposure must be controlled with the shutter or by using neutraldensity filters, and there is no control over depth of field. An additional disadvantage is that f-numbers calculated by dividing the focal length by the effective aperture do not take into consideration the light that is blocked by the mirrored spot in the center of the glass element.

4.28 Wide-Angle Lenses

Two especially important reasons for substituting a shorter focal length lens on a camera equipped with a lens of normal focal length and design are: (a) the need to include a larger area of a scene in a photograph from a given camera position, and (b) the need to obtain a larger scale of reproduction when photographing small objects and the maximum lens-to-film distance capability of the camera is the limiting factor. In the latter situation a shorter focal length lens of normal design can be used satisfactorily because the diameter of the circle of good definition of the lens increases in proportion to the lensto-film distance, which is necessarily larger for closeup photography and photomacrography. The same shorter focal length lens would not have sufficient covering power to photograph more distant scenes where the lens-to-film distance is about equal to the focal length.

A wide-angle lens can be defined as a lens having an angular covering power significantly larger than the approximately 53° angle of coverage provided by a normal-type lens, or as having a circle of good definition with a diameter considerably larger than the focal length when focused on infinity (see Figure 4–54). Wide-angle lenses are not restricted to short focal length lenses. It would be appropriate to use a wide-angle lens with a focal length equal to the film diagonal on a view camera where the extra covering power is needed to accommodate the view camera movements.

There is no distinctive basic design for wide-angle lenses comparable to the arrangement of positive and negative elements in telephoto lenses, except for that of the reversed telephoto wide-angle lenses. Early wide-angle lenses tended toward symmetry about the diaphragm, with few elements, and they usually had to be stopped down somewhat to obtain an image with satisfactory definition. Most but not all modern wide-angle lenses have a considerable number of elements, and they generally produce good definition even at the maximum aperture, with much less falloff of illumination toward the corners than the earlier lenses.

Wide-angle lenses of the fisheye type are capable of covering angles up to 180° , but only by recording off-axis straight subject lines as curved lines in the image. At this time, rectilinear wide-angle lenses are available that cover an angle of 110° with a 15 mm focal length

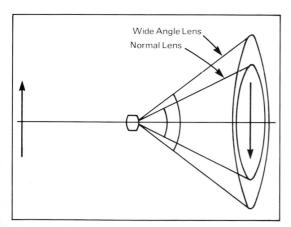

Figure 4–54 The covering power of a wide-angle lens compared to that of a normal-type lens of the same focal length. The images formed by the two lenses would be the same size.

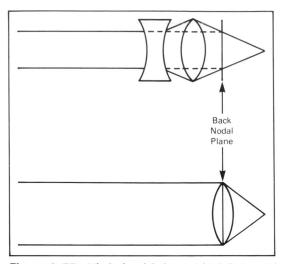

Figure 4–55 The back nodal plane is behind the lens with reversed-telephoto wide-angle lenses, providing a larger lens-tofilm distance than for a normal-type lens of the same focal length.

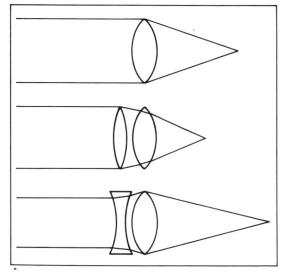

Figure 4–56 The effective focal length of a camera lens can be decreased by adding a positive supplementary lens (center), and increased by adding a negative supplementary lens (bottom).

on a 35 mm camera. There is no minimum angle of coverage that a lens must have to qualify as a wide-angle lens—the label is used at the discretion of the manufacturer. A 35 mm focal length wide-angle lens for a 35 mm camera, for example, only needs to have a 63° angle of coverage.

4.29 Reversed Telephoto Wide-Angle Lenses

Problems may be encountered when using short focal length wide-angle lenses of conventional design due to the concomitant short lens-to-film distances. With view cameras, the short distance between the front and back standards can interfere with focusing or use of the swing, tilt, and other camera movements due to bellows bind. Viewcamera manufacturers and users have found various ways of avoiding or minimizing these difficulties, as by using recessed lensboards with wide-angle lenses and substituting flexible bag bellows for the stiffer accordion type. With single-lens reflex cameras the placement of a short focal length lens close to the film plane can interfere with the operation of the mirror, requiring the mirror to be locked in the up position, which makes the viewing system inoperative. The shutter and viewing mechanisms in motion-picture cameras may also prevent short focal length wide-angle lenses from being placed as close to the film plane as required.

The lens designer's solution to the problems mentioned above is to reverse the arrangement of the elements in a telephoto lens, placing a negative element or group in front of and separated from a positive element or group. This design places the image nodal plane behind the lens (or near the back surface), which in effect moves the lens farther away from the film (see Figure 4–55). Lenses of this type are at different times referred to as *reversed telephoto*, *inverted telephoto*, and *retrofocus* wideangle lenses. They have largely replaced the more traditional type of wide-angle lenses for small-format reflex cameras, but they have not yet invaded the large-format camera market.

4.30 Supplementary Lenses

Because camera lenses are expensive, photographers sometimes look for less costly alternatives to purchasing additional lenses when their general-purpose lens is not adequate. Supplementary lenses can be used to increase the versatility of a camera lens. Adding a positive supplementary lens produces the equivalent of a shorter focal length lens, and adding a negative supplementary lens produces the equivalent of a longer focal length lens. If the supplementary lens is positioned close to the front surface of the camera lens, the focal length of the combination can be computed with reasonable accuracy with the formula $1/f_c = 1/f + 1/f_s$, where f_c is the focal length of the combination, f is the focal length of the camera lens, and f_s is the focal length of the supplementary lens. For example, adding a positive 6-inch supplementary lens to a 2-inch (50 mm) camera lens produces a combined focal length of 1¹/₂ inch (38 mm). Adding a negative 6-inch supplementary lens produces a combined focal length of 3 inches (75 mm) (see Figure 4-56). If the lenses are separated by a space (D), use the following formula:

$$1/f_c = \frac{1}{f} + \frac{1}{f_s} - \frac{d}{f \times f_s}$$

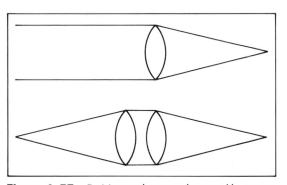

Figure 4–57 Positive supplementary lenses enable cameras to focus on near objects without increasing the lens-to-film distance.

Figure 4–58 Making a 1:1-scale reproduction photograph by increasing the lens-to-film distance (center) requires a $4 \times$ increase in the camera exposure. Using a supplementary lens (bottom) requires no increase in exposure.

Supplementary lenses are commonly calibrated in diopters, where the power in diopters equals the reciprocal of the focal length in meters, or D = 1/f. To convert from diopters to focal length, use the formula f = 1/D. For example, with a 2 diopter lens, $f = \frac{1}{2}$ meter or 500 mm. With a 4-diopter lens, $f = \frac{1}{4}$ meter or 250 mm. An advantage of using diopters is that the power of the combination of a camera lens and a supplementary lens is the sum of the individual diopters, or $D_c = D + D_s$.

Adding a positive supplementary lens in effect reduces the focal length of the camera lens, but does not convert it into a wideangle lens. Therefore, the covering power of the combination may be insufficient to permit use with distant scenes. As long as the combined lenses are not moved closer to the film than the camera lens alone would be when focused on infinity, the covering power of the combination should be adequate. Figure 4–57 illustrates that when a camera is focused on infinity and a positive supplementary lens is added, the point of sharpest focus in object space moves from infinity to a distance of one focal length of the supplementary lens from the camera. Thus, to photograph a small object from a distance of six inches sharp focus would be obtained with a six-meth focal length positive supplementary lens on any camera focused on infinity, regardless of the focal length of the camera length of the camera length of the camera length of the camera focused on infinity, regardless of the focal length of the camera length of the camera length of the camera length of the camera length of the focal length focus of the focal length of the focal length focus of the focal length focus of the focal length focus length focus of the focal length focus focal length focus length focus length focus focal length focus length f

When photographing small objects, there can be an advantage in using a supplementary lens rather than increasing the lens-tofilm distance with the camera lens alone (when the camera has sufficient focusing latitude). The aberrations in normal-type camera lenses are generally corrected for moderately large object distances, but the corrections do not hold with small object distances and the corresponding large image distances. There is the additional advantage that the camera exposure does not have to be increased when the camera is focused on infinity and a supplementary lens is added. If 1:1-scale reproduction photographs were made with the two procedures, four times the camera exposure would be required using the camera lens alone with the increased lens-to-film distance (see Figure 4–58).

Single-element supplementary lenses can be expected to introduce aberrations, but with the camera lens stopped down to a small opening the results may be quite satisfactory. Multiple-element sup-

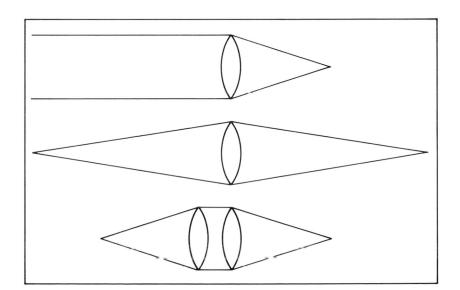

plementary lenses capable of producing high-quality images at large apertures exist, but they are relatively expensive. Commonly overlooked is the possibility of using a second camera lens as a highly corrected supplementary lens. The second lens should be turned around so that it is facing the camera to permit the light rays from the nearby object to enter and leave the lens at the same angles but in the reverse direction, as when it is used alone in the usual way with a distant object. This procedure retains the aberration corrections built into the lens. It is important to center the reversed second lens on the camera lens so that the two lens axes coincide.

4.31 Special Supplementary Lenses

Certain other multiple-element attachments are available to modify the image-forming capabilities of camera lenses. Some of these are not generally referred to as supplementary lenses but rather by terms such as *extender* (or *converter*), *afocal attachment*, and *monocular attachment*.

Extenders are negative lenses containing one or more elements that are used behind the camera lens to increase the focal length. They are commonly referred to as *tele-extenders*, as they are most effective when used with telephoto or other longer-than-normal focal length lenses and produce a telephoto effect with the addition of a negative lens behind the positive camera lens. A given tele-extender will increase the focal length of whatever camera lens it is used with by the same factor, such as $2 \times$, and some are variable to produce different factors.

Afocal attachments combine positive and negative elements having appropriate focal lengths and separation between them so that rays of light entering the attachment from a distant object point leave traveling parallel, as in a Galilean telescope. Since the attachment does not form a real image, it has no focal length, hence the name afocal. Afocal attachments do alter the focal length of the camera lens, however, increasing it when the positive component is in front of the negative component, and decreasing it when the negative component is in front of the positive component, as illustrated in Figure 4-59. With the camera lens focused on infinity and the afocal attachment added, the focus can be adjusted for different object distances by changing the distance between the positive and negative elements. Changing the ratio of the focal lengths of the positive and negative elements alters the effect of the attachment on the focal length of the combination and, therefore, image size. The afocal attachment has no effect on the f-number of the camera lens.

4.32 Convertible Lenses

Some lenses, generally referred to as convertible lenses, are designed so that one or more elements can be removed to change the focal length. Removing a positive element or group of elements increases the focal length. Removing the part of a compound lens that is in front of or behind the diaphragm introduces other complications. Since the focal length and the lens-to-film distance are both increased with the removal of a positive component, the f-numbers will be affected and a separate set of markings must be provided. This differs from the addition of an afocal attachment, where the focal length is altered but the camera lens-to-film distance and therefore the f-numbers are unaffected.

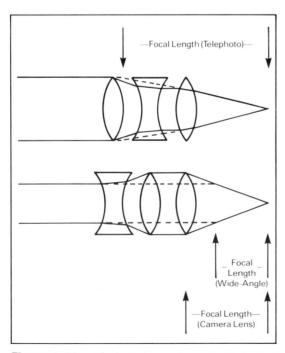

Figure 4–59 Afocal attachments change the effective focal length of camera lenses without changing the lens-to-film distance or the f-number. A two-element telephoto attachment is shown in front of a camera lens, at the top; a wide-angle attachment is shown at the bottom.

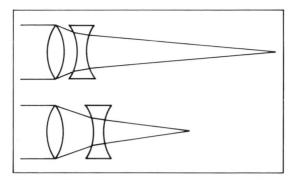

Figure 4–60 Changing the distance between the positive and negative elements of a telephoto lens changes the focal length.

Although multiple elements can be used in both components of a convertible lens to minimize aberrations, the photographer should not expect the same image quality when part of the lens is removed. If a component is removed from a convertible lens to obtain a longer focal length for the purpose of making portraits, for example, the loss of image sharpness at large diaphragm openings may be flattering rather than detrimental, and stopping the lens down will reduce any loss of sharpness. Disrupting the symmetry of the lens on both sides of the diaphragm by the removal of one component without introducing barrel or pincushion distortion presents the lens designer with a difficult problem.

A more recent variation of the convertible lens is the substitution of a different component. This procedure makes it possible to maintain a higher degree of aberration correction and to offer a greater variety of longer and shorter focal lengths at a lower price than for completely separate lenses with different focal lengths.

4.33 Zoom Lenses

From the photographer's point of view, the ideal solution to the problem of having the right lens available for every picturemaking situation is to have one versatile variable-focal length lens. Lens designers have made excellent progress toward the goal of a universal lens with the zoom design, but there is still far to go. With a zoom lens, the focal length can be altered continuously between limits, with the image remaining in focus. The basic principle involved in changing the focal length of a lens can be illustrated with a simple telephoto lens where the distance between the positive and negative elements is varied, as illustrated in Figure 4-60. This change in position of the negative element would change the focal length (and image size and angle of view), but the image would not remain in focus. Other basic problems include aberration correction and keeping the relative aperture constant at all focal length settings. It should not be surprising that one of the early zoom lenses contained more than 20 elements, was large and expensive, and was not very successful in solving all of the basic problems. Better zoom lenses are now being mass produced with relatively few elements, due to design improvements.

Two methods have been used for the movement of elements in zoom lenses. One is to link the elements to be moved so that they move the same distance. This is called optical compensation because the mechanical movement is simple but the optical design is complex and requires more elements. The other method is called mechanical compensation and involves moving different elements by different amounts, requiring a complex mechanical design. For the problem of maintaining a constant f-number as the focal length is changed, an optical solution is to incorporate the concept of the afocal attachment at or near the front of the lens so that the aperture diameter and the distance between the diaphragm and the film can remain fixed. An alternative mechanical solution is to use a cam that adjusts the size of the diaphragm opening as the focal length is changed.

Similarly, there are mechanical and optical methods of keeping the image in focus. The mechanical method consists of changing the lens-to-film distance, as with conventional lenses. The optical method involves using a positive element in front of the afocal component that is used to keep the relative aperture constant. The range of maximum

Figure 4–61 Photographs of a small object made with a normal-type camera lens (top) and a macro lens (bottom), both at the maximum aperture.

4.34 Macro-Zoom Lenses

to minimum focal length varies with different zoom lenses from less than 3:1 to more than 20:1, with the larger ranges found only on lenses for motion-picture and television cameras.

4.34 Macro-Zoom Lenses

Zoom lenses generally were not made to focus on short object distances. In 1967 the first of a series of macro-zoom lenses was introduced. Macro-zoom lenses are designed to photograph small objects near the camera either by extending the conventional focusing range or by making a separate adjustment in the position of certain components for the so-called macro capability. Use of the term *macro* in this context is misleading, as most lenses of this type produce a maximum scale of reproduction no larger than 1:2. To date, none yield a scale larger than 1:1, which is considered the lower limit for the specialized area of photography called photomacrography.

4.35 Macro and Process Lenses

Lenses of normal design that produce images of excellent quality with objects at moderate to large distances may not perform well when used at small object distances. At scales of reproduction larger than 1:1, where the image distance is greater than the object distance, such lenses tend to produce sharper images when they are turned around so that the front of the lens faces the film. Macro lenses are small-format camera lenses especially designed to be used at small object distances. The important optical characteristic of macro lenses is the excellent image definition they produce under these conditions compared with normal-type lenses (see Figure 4-61). The lens designer's task of optimizing aberration correction for small object distances is made easier by removing the additional requirement to make the lens fast. Thus most macro lenses are two or three stops slower than comparable normal-type lenses. The implication that macro lenses are not suitable for photographing objects at larger distances is not entirely valid, however. Because of the slower maximum speed, the aberration corrections are not as sensitive to changes in object distance, and some photographers prefer to use a macro lens for general-purpose photography when a faster lens is not needed.

Beyond the optical characteristics, some macro lenses have convenience features such as the ability to focus at smaller object distances without adding extension tubes or bellows, markings to indicate the scale of reproduction and required exposure compensation for the increased image distance, and automatic exposure compensation with behind-the-lens camera meters. Some manufacturers provide macro lenses with longer than normal focal lengths so that the camera and lens can be kept at a larger distance from the subject for a given scale of reproduction, making it easier to control the illumination on the subject.

Process lenses were originally designed for graphic-arts process cameras used to make line and halftone negatives for photomechanical reproduction, but they have since also been used by photographers on large-format cameras, including view cameras and copy cameras. Process lenses are well corrected for aberrations at the moderately small object distances usually used for copying. Lens speed is sacrificed for image quality, so the maximum aperture may have an f-number as large as f/8 or larger. It has been the practice to use fairly long focal lengths in relation to the film diagonal since the longer focal length lenses provide more uniform illumination over the image area. Some process lenses are especially well corrected for chromatic aberrations and are identified as apochromatic process lenses.

4.36 Soft-Focus Lenses

Photographers have for the most part demanded lenses that produce sharp images, but for some purposes a certain amount of unsharpness is considered more appropriate. Soft-focus lenses are sometimes labeled portrait lenses because they have been used so widely for studio portraits, but they have also been used extensively by other photographers, including pictorialists and even photographers doing advertising illustration, when certain mood effects are desired.

The soft-focus effect is generally achieved by undercorrecting for spherical aberration in designing the lens. Since spherical aberration is reduced as the lens is stopped down, the photographer can control the degree of unsharpness by the choice of l-number. To the discerning viewer, the effect produced with a soft focus lens on the camera is not at all similar to that produced by defocusing the enlarger or diffusing the image while exposing the print with a sharp negative. Rays of light near the axis of a soft-focus lens form a sharp image on the film, which is surrounded by an unsharp image formed by the marginal rays of light so that highlight areas in the photograph appear to be surrounded by halos (see Figure 4–62). If the same lens were used on an enlarger, the shadows in prints would be surrounded by dark out-of-focus images, except when making reversal prints from transparencies.

4.37 Anamorphic Lenses

An anamorphic lens produces images having different scales of reproduction in each of two perpendicular directions, usually the vertical and horizontal directions. It is common practice to think of one of the two dimensions of the image as being normal and the other as being either stretched or squeezed. Even before photography some artists were experimenting with anamorphic drawings where, for ex-

Figure 4–62 Photographs made with a normal-type camera lens (left) and a single-element lens that was uncorrected for spherical aberration (right).

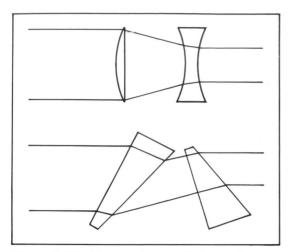

Figure 4-63 Two types of anamorphic lens attachments, one using cylindrically shaped elements (top) and the other using prisms (bottom). Oriented as shown, the vertical dimension of the image would be compressed.

Figure 4-64 The water-filled parts of the glasses function as anamorphic lenses to stretch the images horizontally. Two stretched images of the penny on the left were rotated 90° and placed on the glass on the right where the bottom one was stretched back to a circular shape by the water. With widescreen cinematic photography, the anamorphic camera lens squeezes a wide angle of the scene onto normal-width film, and the anamorphic projector lens stretches or unsqueezes the image to fit a wide projection screen.

ample, it was necessary to view the image at an extreme angle for it to appear normal. Lens designers have long been familiar with the concept of anamorphic lenses but there was little demand for such lenses before the introduction of wide-screen motion pictures.

Motion-picture cameras equipped with anamorphic lenses have a wider-than-normal horizontal angle of view, but the extra width is squeezed by the lens to fit the conventional film format, which typically has an aspect ratio of 1.33:1. The projector, in turn, is equipped with an anamorphic lens that will stretch or unsqueeze the horizontal dimension to produce a picture with a higher aspect ratio (1.8:1, for example) and images that appear normal.

In the absence of anamorphic lenses for still cameras, advertising and other photographers have resorted to more complex procedures to produce images with altered height-to-width proportions when such special effects were desired. One procedure is to make a two-generation copy, tilting the original photograph in one direction and the first-generation copy in the opposite direction to reduce the height without affecting parallelism of the vertical lines.

Two different techniques have been used by lens designers to produce anamorphic lenses and anamorphic attachments for camera and projector lenses-one using prisms and the other cylindrically shaped lens elements. The selective change of image dimension in one direction with the two types of anamorphic attachments is illustrated in Figure 4-63. The schematic drawings do not include the additional elements that would be needed to correct for dispersion of the light. The effect of a cylindrical lens on image shape can be demonstrated easily by attaching two pennies to the back of a clear drinking glass with transparent tape, one above the center and one below. When the glass is half filled with water the top penny appears about normal in shape but the bottom penny appears elongated horizontally, as shown in Figure 4-64. Anamorphic lenses have also been used in the graphicarts field to alter the height-to-width proportions of type letters. Electronic scanners now being used to make color separations for photomechanical reproduction offer a convenient and versatile method of altering the proportions of illustrations either for the purpose of fitting an available space or to create a desired visual effect.

4.38 Enlarger Lenses

The requirements for enlarger lenses are similar to those for a camera lens intended for copying, with aberrations minimized for small object distances; and in practice the degree of correction can be expected to vary with the price for a given focal length. In the past, most enlarging lenses were designed for normal covering power with the expectation that the photographer would select a focal length about equal to the diagonal of the film format. Recent years have seen the increasing use of shorter focal length lenses with larger angles of coverage to increase the range of scales of reproduction, and the range of image sizes that can be obtained with a given enlarger at the upper and lower limits of elevation.

The introduction of variable focal length enlarger lenses followed years behind widespread use of variable focal length lenses for motion-picture cameras, television cameras, small-format still cameras, and slide projectors.

4.39 Projector Lenses

Like enlarger lenses, projector lenses project a film image onto a flat surface, but there are important differences. High screen luminance is generally desirable, so there is no need to incorporate an adjustable diaphragm in projector lenses. Enlarger lenses are often stopped down to increase depth of field and reduce residual aberrations, a control not provided with projector lenses. However, most viewers are less critical of reduced definition in projected images, especially motion pictures, than in photographic prints.

Nevertheless, the shallow depth of field does create problems, especially with slide projectors and slides in cardboard mounts where the transparencies do not lie flat and tend to pop to a different position when subjected to heat from the projector lamp. Since the former practice of binding slides between cover glasses has been largely rejected as being too time consuming and expensive, other solutions are needed. One is to equip the projector with a focusing servomechanism to compensate for changes in slide position, and the other is in their maniform houses for the project on the rather than the traditional flat surface.

4.40 Lens Shortcomings

The geometrical drawings used to illustrate image formation in preceding sections imply that the lenses form perfect images. Such is not the case, of course. Actually, there is no need for such perfect images in the field of pictorial photography, where photographs tend to be viewed from a distance about equal to the diagonal, and, as noted earlier, circles of confusion up to a certain maximum size are perceived as points. This tolerant attitude does not apply to photographs viewed through magnifiers or microscopes to extract as much information as possible, or even pictorial photographs that are enlarged and cropped in printing.

Although the responsibility for improving photographic lenses by reducing or eliminating shortcomings is in the hands of lens designers, photographers who have a basic understanding of the major types of shortcomings or aberrations are in a position to obtain better optical images by being able to select the most appropriate lenses for various picture-making situations, and by being able to control the conditions of use in order to optimize the lenses' image-forming capabilities.

Lens shortcomings can be subdivided into four categories: those that affect image definition, image shape, image illuminance and image color. With respect to definition, a perfect lens would render every point in the plane focused on in object space as a point in the film plane. With respect to shape, the perfect lens would form images in which the sizes and shapes of the parts of the scene being photographed were represented faithfully according to the principles of perspective, including the rendering of straight lines in the scene as straight lines. With respect to illuminance, the perfect lens would form images in which the illuminances of the various parts of the images were in exactly the same relationships as the luminances of the corresponding parts of the scenes. With respect to color, the perfect lens would form images that faithfully matched the color attributes of the subject.

4.41 Diffraction

Diffraction is the only lens aberration that affects the definition of images formed with a pinhole. According to the principles of geometrical optics, which ignore the wave nature of light, image definition will increase indefinitely as a pinhole is made smaller. In practice there is an optimum size, and image definition decreases due to diffraction as the pinhole is made smaller. The narrow beam of light passing through the pinhole from an object point spreads out in somewhat the same manner as water coming out of a nozzle on a hose, and the smaller the pinhole the more apparent the effect.

Similarly, the definition of an image formed by an otherwise perfect lens would be limited by diffraction. Some lenses are referred to as diffraction-limited because under the specified conditions they are that good. Using resolution as a measure of image definition, the diffraction-limited resolving power can be approximated with the formula R = 1,800/N where R is the resolving power in lines per millimeter, 1,800 is a constant for an average wavelength of light of 550 nm, and N is the f-number. Thus a lens having minimum and maximum f-numbers of f/2 and f/22 would have corresponding diffraction-limited resolving powers of 900 and 82 lines/mm. If the resolution is to be based on points rather than lines, the formula is changed to R = 1,500/N (see Table 4–2).

4.42 Spherical Aberration

Spherical aberration is characterized by marginal rays of light from an object point coming to a focus a shorter distance behind the

Table 4–2 Diffraction-limited resolving power vs. f-numbers. The underlined rows identify the f-numbers that would produce the same diffraction-limited resolving power of 14 lines/mm on 8×10 -inch prints made from five different size negatives.

f-number	l/mm	<i>E</i> :1	Adjusted for 8 \times
j-number	l/mm	Film	10print
$R = -\frac{1800}{1800}$			
F-Number			
f/1	1800		
f/1.4	1286		
f/2	900		
f/2.8	643		
f/4	450		
f/5.6	321		
f/8	225		
f/11	160		
f/16	112	$1 \times 1\frac{1}{2}$	112/8 = 14
f/22	80		
f/32	56	21/4	56/4 = 14
f/45	40		
f/64	28	4×5	28/2 = 14
f/90	20		
f/128	14	8×10	14/1 = 14
f/180	10		
f/256	7	16×20	7/0.5 = 14
f/360	5		

Note: 1500 used for points, 1800 for lines.

 $R = \frac{10^6}{\lambda \times \text{f-number}} \text{ where } \lambda = 550 \text{ nm}$

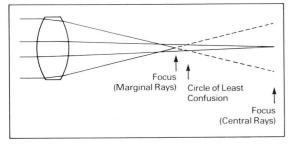

Figure 4–65 With spherical aberration, marginal rays of light from an object point come to a focus closer behind the lens than central rays.

Figure 4-66 Coma is a comet-shaped image of an object point.

Figure 4–67 A lens having curvature of field focused at the center of the field (left), at the edges (center), and at an intermediate position (right). The depth of focus required to obtain an acceptably sharp image is indicated with broken lines.

lens than central (paraxial) rays, as illustrated in Figure 4–65. The circle of confusion of the image will be relatively large, regardless of where the film is positioned, but will be smallest at about one quarter the distance from the marginal focus to the paraxial focus. As the name implies, this defect is linked to the spherical shape of lens and mirror surfaces. Nonspherical (aspherical) shapes have been used to prevent or reduce spherical aberration, but such lenses are more costly to manufacture, and the optimum shape varies somewhat with object distance. Lens designers have other options. Even with a single-element lens, spherical aberration can be reduced considerably for a given object distance by the proper choice of the radii of curvature and the orientation of the two spherical surfaces. Positive and negative elements that exhibit spherical aberration in opposite directions are commonly combined in more complex photographic lenses.

Photographers have considerable control over spherical aberration by stopping down the diaphragm, whether the lens is a softfocus lens in which the spherical aberration was purposely undercorrected, or a supposedly sharp-focus lens in which the manufacturer was not successful in removing this defect. Users of soft-focus lenses are advised to focus at the aperture that will be used to expose the film, as stopping down after focusing moves the point of sharpest focus in object space farther away, as from the eyes to the ears in a portrait. The distance between the focal points for the marginal and the paraxial rays is called the longitudinal spherical aberration, and this distance varies inversely with the f-number squared. The diameter of the smallest circle of confusion at the position of best focus can also serve as a measure of spherical aberration, and this varies inversely with the fnumber cubed.

4.43 Coma

Whereas spherical aberration affects the entire picture area, coma is a closely related defect that increases with the off-axis angle. It is caused when oblique rays of light from an object point pass through different zones of the lens and come to a focus at different distances behind the lens, thereby forming a comet-shaped image at the film plane, as shown in Figure 4–66. Coma, like spherical aberration, can be reduced by stopping down the lens, and the linear size of the image of an object point varies inversely with the f-number squared.

4.44 Curvature of Field

Lenses exhibiting curvature of field form the in-focus image of a subject plane on a curved rather than flat surface. Thus, if a camera or enlarger equipped with a lens having this defect is focused in the center of the ground glass or easel, the corners will be out of focus, and vice versa (see Figure 4–67). With positive lens elements the offaxis curvature is toward the lens; with negative elements the curvature is in the opposite direction. Lens designers, therefore, can combine positive and negative elements to reduce curvature of field. Although stopping down a lens does not change the shape of the curved focus surface, it does reduce the size of the circles of confusion for the outof-focus images at the film or paper plane.

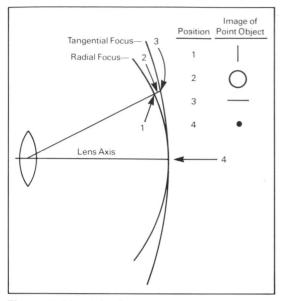

Figure 4–68 A lens having astigmatism can produce a satisfactory image of an object point on the lens axis but images an off-axis object point as a radial line or a tangential line.

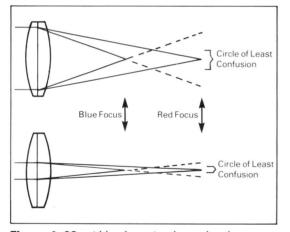

Figure 4-69 Although stopping down a lens does not change the positions at which blue and red light come to a focus with longitudinal chromatic aberration, it does reduce the sizes of the circles of confusion so that the defect is less noticeable.

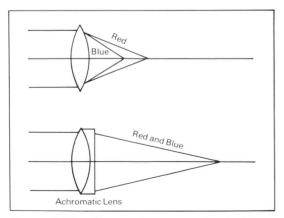

Figure 4–70 Chromatic aberrations can be reduced by combining positive and negative elements made from appropriate types of glass.

4.45 Astigmatism

Astigmatism causes an off-axis object point to be imaged as two perpendicular lines—identified as radial and tangential lines—at different distances behind the lens. As the distance between the lens and the ground glass is increased, the image of the point will first appear, for example, as a sharp vertical line, then an unsharp circle, then a sharp horizontal line. In effect, the lens has different focal lengths for the radial and tangential rays of light, as shown in Figure 4–68.

The sharpest image of the object point can be obtained by placing the ground glass or film in an intermediate position between the two line images and stopping down the lens. Stopping down does not change the positions of focus of the radial and tangential lines, but, as with curvature of field, it reduces the size of the circle of confusion. Astigmatism also becomes apparent when photographing lines that are perpendicular to each other and positioned so that one is a radial line with respect to the lens axis and the other is tangential; the lens can be focused on one object line or the other but not both simultaneously.

4.46 Chromatic Aberrations

Longitudinal chromatic aberration is a defect whereby the lens has different focal lengths for different wavelengths of light, forming red, green, and blue images at different distances behind the lens with a white object point. Stopping down the lens does not change the focus position of the different color images, but again reduces the size of the circle of confusion at the film plane (see Figure 4-69).

Lateral chromatic aberration also results from the lens having different focal lengths for different wavelengths of light, but the image nodal planes are in different positions for the different colors. The various color images all come to a focus on the same image plane, but they differ in size. The image of an off-axis white object point is a radial line with a spectrum of colors. Stopping down does not affect lateral chromatic aberration. Whereas the longitudinal aberration affects the entire photograph, the lateral aberration does not affect the on-axis image but it increases progressively with the off-axis angle. Lens designers can reduce both chromatic aberrations by combining positive and negative elements made of different types of glass (see Figure 4– 70). Achromatic lenses are corrected for two colors, apochromatic lenses are corrected for three colors, and superapochromats are even more highly corrected.

4.47 Distortion

All the lens aberrations discussed above prevent the formation of a faithful image of an object point. Distortion appears not as a loss of definition but rather as a displacement of the position of the image point, thereby causing straight subject lines to be imaged as curved lines. The underlying cause of distortion is a difference in magnification on and off axis at the film plane. Increasing magnification as the off-axis angle increases produces pincushion distortion, and decreasing magnification produces barrel distortion (see Figure 4-71).

Stopping down a lens has no effect on distortion. The only effective control the photographer has with a given lens is to move the camera farther away from the object being photographed to produce a

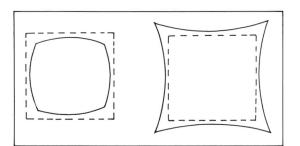

Figure 4–71 Barrel distortion (left) and pincushion distortion (right). The broken lines represent true image shape.

Figure 4–72 An example of barrel distortion produced by a 7.5 mm fisheye lens with a 180° angle of view. Note that the distortion does not affect radial subject lines—straight subject lines that intersect the lens axis—such as the horizon line.

smaller image, which can be enlarged and cropped in printing to obtain the desired image size and angle of view.

With single-element lenses, distortion tends to increase with the thickness of the lens. Placing the diaphragm in front of singleelement positive lenses tends to produce barrel distortion; placing the diaphragm behind tends to produce pincushion distortion. The most obvious solution is to design symmetrical lenses with the diaphragm in the center. Many lenses are more or less symmetrical, but some types of lenses, such as telephoto and reversed telephoto, cannot be made symmetrical. Since the diaphragm in a simple telephoto lens is behind the positive element and in front of the negative element, such lenses tend to have pincushion distortion. As the angle of coverage and the angle of view are increased with wide-angle lenses, a limit is reached beyond which it is impossible to prevent barrel distortion from affecting the image (see Figure 4-72).

4.48 Image Illuminance

Unlime of a here or highlight reads in the herepy the hereby nance relationships of the parts of the scene can be due to (a) a decrease in illumination from the center to the corners of the film; (b) superimpositon of uniform flare light on the optical image; and (c) superimposition of localized patterns of illumination referred to as ghost images, flare spots, or diffraction streaks on the optical image.

Illumination falls off with a pinhole according to the fourth power of the cosine of the off-axis angle, and this relationship is known as the cosine to the fourth power law. The illumination tends to decrease in a similar manner with lenses of uncomplicated design. In addition, some of the marginal off-axis rays of light are blocked by the lens barrel—an effect known as vignetting. Eventually, as the off-axis angle increases, all light will be blocked, and the edge of the circle of illumination is established at the film plane. Stopping down a lens reduces

Figure 4-73 Out-of-focus images of bright lights and reflections in the background produce more or less in-focus images of the diaphragm opening.

Figure 4-74 Star pattern and halo formed around a bright light by two wire screens rotated at 45° to each other in front of the camera lens.

falloff due to vignetting, but it has no effect on falloff due to other factors.

With a lens-film combination having an angle of view of 53° , the illumination at the corners will be approximately 60% of the on-axis illumination due to the cosine effect alone. With an angle of view of 90° , the corresponding value is 25%. In recent years lens designers have made much progress in reducing the falloff of illumination with wide-angle lenses. The negative front element in reversed-telephoto wide-angle lenses is especially useful in increasing uniformity of illumination at the film plane.

Some of the light entering a lens eventually reaches the film as more or less uniform non-image-forming light after being reflected from various parts of the lens mount and the camera interior. A typical outdoor scene has a luminance range of about 160:1. One unit of flare light equal to the image shadow illuminance will reduce the image ratio to approximately 80:1. The flare factor is 160/80 = 2. Flare factors are commonly as high as 3 or 4. An efficient lens shade can help prevent excessive flare light from degrading the image.

Ghost images and flare spots result from light that is reflected back and forth between lens-element surfaces before it reaches the film. Such light represents grossly out-of-focus images of the light source but a more or less in-focus image of the diaphragm opening. These effects occur most commonly when the sun or other light source is included in the picture and they cannot be completely eliminated, although efficient lens coatings reduce the amount of light reflected from the lens surfaces (see Figure 4-73).

Diffraction streaks can occur with most lenses under the proper conditions. They frequently appear around the images of small, intense light sources in night photographs, causing the light sources to appear like stars with radiating streaks. The effect is caused by diffraction of light at the edges of the diaphragm blades, producing a pair of opposite streaks for each blade. Star images are sometimes desired as a special effect in photographs, and they can be produced by using wire screens and diffraction gratings in front of the lens (see Figure 4–74). With diffraction gratings the streaks include a spectrum of colors, which can be recorded on color film.

4.49 Lens Testing

Photographers who inquire about testing a lens are commonly advised to do so by making photographs of the same type that they expect to be making with the lens in the future, and to leave the more analytical testing to lens designers, manufacturers, and others who have the training and the sophisticated equipment necessary for the job. It makes sense that a photographer should not worry about shortcomings in the imaging capabilities of a lens if the effects are not apparent in photographs made with the lens. On the other hand, many photographers use their normal lens in a variety of picture-making situations, and certain lens shortcomings may appear in one photograph and not in another. Thus the subject matter and the conditions for even a practical test of this type must be carefully controlled.

To test for image definition, the following are required:

- 1. The subject must conform to a flat surface that is perpendicular to the lens axis and parallel to the film plane.
- 2. The subject must exhibit good detail with local contrast as high

as is likely to be encountered, not of a single hue such as red bricks or green grass.

- **3.** The subject must be large enough to cover the angle of view of the camera-lens combination at an average object distance.
- **4.** The subject must also be photographed at the closest object distance likely to be used in the future.
- **5.** Photographs must be made at the maximum, minimum, and at least one intermediate diaphragm opening.
- 6. Care must be taken to be certain that the optimum image focus is at the film plane, which may require bracketing the focus.
- **7.** Care must be taken to avoid camera movement, noting that mirror action in single-lens reflex cameras can cause blurring of the image, especially with small object distances or long focal length lenses. Outdoors, wind can cause camera movement.

If the same subject is to be used to test for image shape, it must have straight parallel lines that will be imaged near the edges of the film to reveal pincushion or barrel distortion. If it is also to be uted to test for uniformity of illumination or the film plane, it must contain areas of uniform luminance from center to edge. Tests for flare and ghost images require other subject attributes. We can conclude that a practical test cannot be overly simple if it is to provide much information about the lens. In any event, evaluation of the results is easier and more meaningful if a parallel test is done on a lens of known quality for comparison.

Practical tests such as these are not really lens tests, but rather they are systems tests, which include subject, lens, camera, film, exposure, development, the enlarger and various printing factors. The advantage that such tests have of being realistic must be weighed against the disadvantage that tests of a system reduce the effect of variations of one component, such as the lens, even if all the other factors remain exactly the same. For example, if two lenses having resolving powers of 200 and 100 lines/mm are used with a film having a resolving power of 100 lines/mm, the resolving powers of the lens-film combinations would be 67 and 50, using the formula $1/R = 1/R_{\rm L} + 1/R_{\rm F}$. Thus, only dramatic differences between lenses will be detected easily in the photographs.

The influence of other factors in the system can be eliminated by examining the optical image directly, either on a finely textured ground glass or by removing the ground glass and examining the aerial image. A good-quality magnifier or low-power microscope should be used. An artificial star, made by placing a light bulb behind a small hole in thin, opaque material, is commonly used to check image definition by noting how the image deviates from an ideal point image. Since the ideal is seldom approximated closely, it is better to evaluate a lens by comparison with a lens of known quality than by judging it alone. By placing the artificial star at an appropriate distance on the lens axis, the effect of stopping down on spherical and longitudinal chromatic aberrations can be seen. The chromatic aberration can be removed by placing a green filter behind the hole to study spherical aberration alone. Moving the star laterally so that the image appears near a corner will reveal off-axis defects, including coma and lateral chromatic aberration.

Resolving power has been a widely used but controversial method of checking image definition. The testing procedure is simple. The lens is focused on a row of resolution targets that contain alternating

Figure 4-75 Resolving-power target.

light and dark stripes and that are placed at a specified distance from the lens (see Figure 4–75). The separate targets are arranged so that the images fall on a diagonal line on the ground glass or film plane with the center target on the lens axis, and oriented so that the mutually perpendicular sets of stripes constitute radial and tangential lines. The aerial images are examined through a magnifier or microscope of appropriate power, and the smallest set of stripes that can be seen as separate "lines" is noted for each target. Resolving power is the maximum number of light-dark line pairs per millimeter that can be resolved.

Critics of resolving power note that different observers may not agree on which is the smallest set of stripes that can be resolved, and that in comparing two lenses, photographs made with the lens having the higher resolving power sometimes appear to be less sharp. In defense of resolving power, it has been found that observers can be quite consistent even if they don't agree with other observers. Consistency makes their judgments valid on a comparative basis such as between on-axis and off-axis images, images at two different f-numbers, and images formed with two different lenses. It is appropriate to make comparisons between lenses on the basis of resolving power as long as it is understood that resolving power relates to the ability of the lens to image fine detail rather than the overall quality of the image.

Electronic methods have largely replaced visual methods of testing lenses in industry. The equipment required is complex and expensive but it is capable of providing comprehensive and objective data quickly. The results are commonly presented in the form of modulation transfer function curves in which the input spatial frequency is plotted as cycles per millimeter on the horizontal axis against output contrast as percent modulation on the vertical axis. Representative curves for three different lenses, two having imaging shortcomings, are shown in Figure 4–76, where lens B has higher contrast in the highfrequency (fine detail) areas but lower contrast in the low-frequency (coarse detail) areas than lens C. The accompanying pictures illustrate that a photograph in which fine detail is better resolved may appear less sharp because of the lower contrast in the larger image areas.

4.50 Testing Flare

Optical images formed with lenses are always less contrasty than the scenes being photographed due to the effects of flare light. Antireflection lens coatings are effective in reducing the proportion of light reflected from lens surfaces and increasing the proportion of light transmitted, but they reduce flare light rather than eliminate it. In practice, the flare light that falls on the film in a camera is a combination of lens flare and camera flare, and the amount of flare light can vary greatly with a given lens, depending upon the distribution of light and dark tones in the scene, the lighting, the interior design of the camera, and whether or not a lens shade is used. Thus, flare tests can be conducted with the lens in a laboratory where a standard test target is used and the effects of the camera are eliminated, or they can be conducted with the lens on a camera with a representative scene or a variety of scenes.

Flare light can be specified in various ways: as a flare factor, as a percentage of the maximum image illuminance, and graphically as a flare curve. The flare factor is defined as the scene luminance ratio divided by the image illuminance ratio. The flare factor can most easily be determined with a large-format camera and an in-camera meter of

В

10

8 9

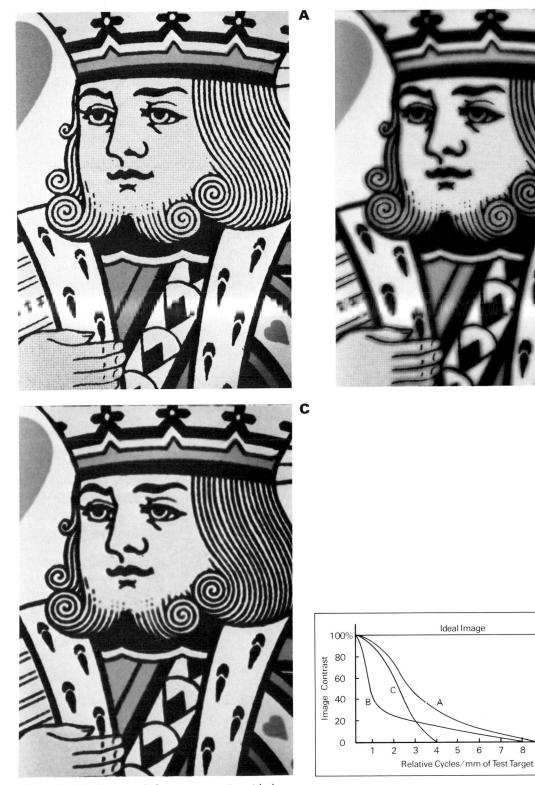

Figure 4-76 Prints made from a copy negative with three different lenses and representative modulation transfer function curves. Lens A was a high-quality enlarging lens. The lens B image shows a large loss of contrast in the intermediate frequencies, while the lens C image shows the largest loss in the high frequencies. Lens B would score higher on a resolvingpower test even though photographs made with lens C tend to appear sharper due to the higher contrast of the intermediatesize tonal areas.

Figure 4–77 A black hole in a neutral test card surrounded by a gray scale, used to determine the flare factor in a given situation.

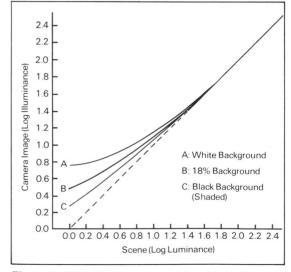

Figure 4–78 Flare curves prepared by taking meter readings at the film plane of the image of a gray scale with white, gray, and black backgrounds. The straight broken line represents the complete absence of flare light.

the type where a probe can be positioned to take readings in selected small areas such as a highlight and a shadow. If the image illuminance ratio is 80:1 with a scene having a luminance ratio of 160:1, the flare factor is 160/80 = 2. Flare factors are typically between 2 and 3, but they can be much higher.

An opaque black card placed in front of a large transparency illuminator in an otherwise darkened room can be used to determine the percentage of flare light by dividing an illuminance reading of the image of the black card by an illuminance reading of the image of the transparency illuminator. A white surface and a black hole can be placed in any scene and used in the same way, where the black hole is a small opening in an otherwise light-tight enclosure painted black on the inside (see Figure 4–77). Standard test targets and simple procedures are available for the routine determination of the percentage of flare with process cameras in the graphic arts field where flare levels above 1.5% are considered excessive. With a normal scene having a luminance ratio of 160:1, a flare level of 1.5% corresponds to a flare factor of 2.4.

Flare curves can be prepared in various ways. One method is to place a step tablet or gray scale, with an appropriate surround, in front of a large-format camera, measure the relative illuminance of each step of the image with an in-camera meter, and plot log relative illuminance on the vertical axis vs. log relative luminance (i.e., 1/density) of the original on the horizontal axis (see Figure 4–78).

References

Adams, The Camera.

- ANSI, Apertures and Related Quantities Pertaining to Photographic Objectives and Projection Lenses, Methods of Designating and Measuring (PH3.29-1979).
 - —, Color Contribution of Photographic Lenses, Determining and Specifying (PH3.607-1981).
- ——, Distribution of Illuminance over the Field of a Photographic Objective, Method of Determining (PH3.22-1958, R1979).
 - -----, Focal Length Marking of Lenses (PH3.601-1981).
- ——, Focal Lengths and Focal Distances of Photographic Lenses, Methods of Designating and Measuring (PH3.35-1977).
- —, Focusing Camera Lenses, Distance Scales for (PH3.20-1975).
- —, Optical Elements and Assemblies, Definitions, Methods of Testing, and Specifications for Appearance Imperfections (ANSI 3.617-1980).
- -----, Photographic Resolving Power of Photographic Lenses, Method for Determining (PH3.63-1974).
- ——, Resolution Test Target for Photographic Optics, Dimensions for (PH3.609-1980).
- ——, Photographic Contact Printers, Contact Uniformity Test for (PH3.45-1971, R1976).

——, Photographic Enlargers, Methods for Testing (PH3.31-1974). Blaker, Field Photography.

- —, Photography: Art and Technique.
- Born and Wolf, Principles of Optics.
- Brown, Modern Optics.
- Cox, Photographic Optics.
- Davis, Photography.
- Eastman Kodak, Bibliography on Underwater Photography and Photogrammetry (P-124).

References

_____, Characteristics of Rear-Projection Screen Materials (S-73).

———, Electron Microscopy and Photography (P-236).

——, Kodak AV Equipment Memo: Choosing Between Curved-Field and Flat-Field Projection Lenses (S-80-8).

_____, Kodak Image Test Chart (P-301).

——, Kodak Projection Calculator and Seating Guide (S-16).

, Optical Formulas and Their Applications (AA-26).

_____, Photography Through the Microscope (P-2).

_____, Photography with Large-Format Cameras (O-18).

——, Projection Distance Tables and Lamp Data for Kodak Slide and Motion Picture Projectors (S-49).

——, Reflection Characteristics of Front-Projection Screen Materials (S-18).

_____, Schlieren Photography (P-11).

_____, Small Lens Openings Destroy Image Sharpness (Q-104).

———, Techniques of Microphotography (P-52).

—, Viewing a Print in True Perspective (M-15).

_____, A Visual Flare-Testing Method for Process Cameras (Q-107A).

Local Lineae, Havar Hunga hymritic of Planaviantes.

Hecht and Zajac, Uptics.

Jacobson and Manneheim. Enlarging: The Technique of the Positive.

Jacobson et al., The Manual of Photography.

Klein, Optics.

Langford, Advanced Photography.

——, Basic Photography.

Levi, Applied Optics.

Meyer-Arendt, Introduction to Classical and Modern Optics.

Morgan, Vestal, and Broecker, Leica Manual.

Neblette and Murray, Photographic Lenses.

Palmer, Optics, Experiments and Demonstrations.

Ray, The Photographic Lens.

_____, The Lens and All Its Jobs.

_____, Lens in Action.

Reynolds, Lenses.

Spencer, The Focal Dictionary of Photographic Technologies.

Stroebel, View Camera Technique.

Stroebel and Todd, Dictionary of Contemporary Photography.

Stroke, An Introduction to Coherent Optics and Holography.

Upton and Upton, Photography.

Young, Fundamentals of Optics and Modern Physics.

Light and Photometry

5.1 The Nature of Light

Light is fundamental to photography. The function of photographic materials is to record patterns of light. The function of photographic equipment used for taking pictures is to produce light (lamps), to measure light (exposure meters and color-temperature meters), and to control light (lenses, shutters, apertures, filters). It is therefore desirable for the photographer to possess some understanding of the nature of light.

Light is defined as the form of radiant energy that our eyes are sensitive to and depend upon for the sensation of vision. The obvious importance of light has resulted in it being the object of an enormous amount of experimentation and study over many centuries. One of the first persons to make significant headway in understanding the nature of light was Isaac Newton. In the seventeenth century he performed a series of experiments, and proposed that light is emitted from a source in straight lines as a stream of particles. This theory was called the "corpuscular theory".

However, the fact that light bends when it passes from one machine to another, and that infinit proving through a way small anatoms tends to spread out, are not easily explained by the corpuscular theory. As a result, Christian Huygens proposed another theory called the "wave theory". This theory holds that light and similar forms of electromagnetic radiation are transmitted as a waveform in some medium. (This theory was elaborated on considerably by Thomas Young in the nineteenth century as a result of a number of experiments performed by him.) The wave theory satisfactorily explained many of the phenomena associated with light that the corpuscular theory did not, but it still did not explain all of them.

One of the more notable of these unexplained effects was the behavior of "blackbody radiation". (Blackbody radiation is radiation produced by a body that absorbs all the radiation that strikes it, and emits radiation by incandescence, depending on its temperature.) In 1900, Max Planck suggested the hypotheses of the "quantization of energy" to explain the behavior of blackbody radiation. This theory states that the only possible energies that can be possessed by a ray of light are integral multiples of a quantum of energy. These suggestions, along with others, gradually developed into what is known today as "Quantum Theory" or "Quantum Electrodynamics". This theory combines aspects of the corpuscular and wve theories, and satisfactorily explains all of the known behavior of light. Unfortunately, this theory is difficult to conceptualize, and can be rigorously explained only by the use of sophisticated mathematics. As a result, the corpuscular and wave theories are still used to some extent where simple explanations of the behavior of light are required.

5.2 Light Waves

If the idea that light moves as a wave function is accepted, it becomes necessary to determine the nature of its waves and the relationship of light to other forms of radiation. Actually, light is but a fractional part of a wide range of radiant energy that exists in the universe, all of which can be thought of as traveling in waves. These forms of energy travel at the same tremendous speed of approximately 186,000 miles (3×10^8 meters) per second, differing only in wavelength and frequency of vibration. These waves have been shown to vibrate at right angles to their path of travel. The distance from the

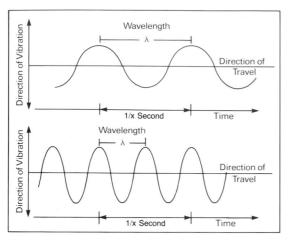

Figure 5–1 A simple form of a light wave, illustrated in a longitudinal cross section. In reality, the wave is vibrating in all possible right angles to the direction of travel. The second wave has a wavelength one half that of the first and, therefore, a frequency twice as great.

Table 5–1 Units of length	Tabl	e	5-1	Units	of	length
-----------------------------------	------	---	-----	-------	----	--------

Unit	Symbol	Length		
Meter	m	3.218 ft. (38.6 in.)		
Centimeter	cm	$0.01 \text{m} (10^{-2} \text{m})$		
Millimeter	mm	$0.001 \text{m} (10^{-3} \text{m})$		
Micrometer	μ (mu)	$0.00001 \text{m} (10^{-6} \text{m})$		
Micron	"	"		
Nanometer	nm	$0.00000001 \text{m} (10^{-9} \text{m})$		
Millimicron	mμ	"		
Angstrom	mµ Å	0.000000001m (10 ⁻¹⁰ m)		

 Table 5-2
 The electromagnetic spectrum

Frequency		
Hertz	Wavelength	
(cycles per second)	nm	Type of Radiation
	1015	
10^{4}	1014	Maritime radio
	1013	communications
10^{6}	10 ¹² 1 km	AM radio
	1011	
10^{8}	1010	
	10 ⁹ 1 m	FM radio
1010	10^{8}	Radar
	10 ⁷ 1 cm	TV
1012	10^{6}	Microwave
	105	
10^{14}	10^{4}	Infrared
	10 ³	Light 700 nm Red
		400 nm Blue
1016	10 ²	
	10^{1}	Ultraviolet
1018	10^{0}	
	lnm	
10.22	10 ⁻¹ 1 Å	
10 ²⁰ 1	0-2	X-rays
	10^{-3}	
1022	10^{-4}	
	10 ⁻⁵	
	10-6	Gamma rays

crest of one wave to the crest of the next is termed the wavelength, with the Greek letter λ (lambda) used as the symbol. Figure 5–1 illustrates this concept. The number of waves passing a given point in a second is called the frequency of vibration; the symbol f is used to specify it. The wavelength multiplied by the frequency of vibration equals the speed or velocity (symbol v) of the radiation. Thus, $\lambda \times f = v$.

Since the wavelength of radiant energy can be determined with far greater accuracy than the frequency, it has become common practice to specify a particular type of radiation by its wavelength. Because of the extreme shortness of the wavelengths encountered with light sources, the most frequently employed unit of measure is the nanometer (nm) which is equal to one-billionth of a meter. A somewhat less commonly used measure is the Angstrom (Å), which is equal in distance to 1/10 of a nanometer (e.g., 400 nm equals 4,000 Å). Table 5-1 summarizes these measurement concepts.

5.3 The Electromagnetic Spectrum

When the various forms of radiant energy are placed along a scale of the shortest to the longest wavelength, the resulting continuum is called the *electromagnetic spectrum*. Although each form of radiant energy differs from its neighbors by an extremely small amount, it is useful to divide this spectrum into the generalized categories shown in Table 5–2. All radiations are believed to be the result of electromagnetic oscillations. In the case of *radio waves*, the wavelengths are extremely long, being on the order of 10^{10} nm, and are the result of long electrical oscillations. The fact that such energy permeates our environment can easily be substantiated by turning on a radio or television receiver in any part of the civilized world. This form of radiant energy is not believed to have any direct effect upon the human body. Radio waves are customarily characterized by their frequency, expressed in hertz (cycles per second).

The portion of the electromagnetic spectrum that is sensed as heat is called the *infrared* region. The origin of this form of radiant energy, which is shorter in wavelength than radio waves, is believed to be the excitation of electrons by thermal disturbance. When these electrons absorb energy from without, they are placed in an elevated state of activity. When they suddenly return to their normal state, electromagnetic radiation is given off. It has been shown that all objects at a temperature of greater than -273° C give off this type of radiation. The temperature of -273° C is referred to as absolute zero or 0° Kelvin (K), after Lord Kelvin, who first proposed such a scale. Thus, all the objects we come into contact with give off some infrared energy. In general, the hotter an object, the more total energy it produces and the shorter the peak wavelength.

If the object is heated to a high enough temperature, the wavelength of the energy emitted will become short enough to stimulate the retina of the human eye and cause the sensation of vision. It is this region of the electromagnetic spectrum that is termed *light*. Notice that it occupies only the narrow section between approximately 380 nm and 720 nm. Because the sensitivity of the human visual system is so low at these limits, 400 and 700 nm are generally considered to be more realistic values. Objects with very high temperatures produce *ultraviolet* energy, which is shorter than 400 nm in wavelength.

To produce radiant energy shorter in wavelength than about 10 nm requires that an object be bombarded by fast-moving electrons. When these rapidly moving electrons strike the object, the sudden stopping produces extremely short wave energy called X-radiation, or more commonly, X-rays. Still shorter wavelengths can be produced if the electron bombardment intensifies, as occurs in a cyclotron. In addition, when radioactive material decomposes, it emits energy shorter in wavelength than X-rays. In these two cases the energy is referred to as gamma rays, which are usually 0.000001 nm (10⁻⁶ nm) in wavelength and shorter. These forms of electromagnetic energy are the most energetic, penetrating radiation known.

Thus it can be seen that the wave theory of radiant energy provides a most useful system for classifying all the known forms of radiation.

5.4 The Visible Spectrum

Located near the middle of the electromygnetic spectrum are the wavelengths of energy referred to as light. It is important to note that the location of this region is solely dictated by the response characteristics of the human eye. In fact, the international standard definition states: "Light is the aspect of radiant energy of which a human observer is aware through the visual sensations which arrive from the stimulation of the retina of the eye." Stated more simply, light is that energy which permits us to see. By definition, all light is visible, and for this reason the word *visible* is an unnecessary (and perhaps confusing) adjective in the common expression visible light. This definition also may be interpreted to mean that energy which is not visible cannot (or should not) be called light. Thus it is proper to speak of ultraviolet radiation and infrared radiation, but not ultraviolet light and infrared light. The popular use of such phrases as black light and invisible light to describe such radiation make it impossible to determine what type of energy is being described, and they should be avoided.

To understand more about light, it is necessary to become familiar with the way in which the human eye responds to it. The graph in Figure 5-2 represents the results of testing 100 observers with normal color vision for the perception of brightness in respect to different wavelengths of energy. The plot comes from the average of all observers and shows the sensitivity of the eye to different wavelengths (or colors) of light. In this case, sensitivity is similar to a film speed. These data indicate that the sensitivity of the eye drops to near zero at 400 nm and at 700 nm, thus specifying the limits within which radiant energy may be referred to as light. It also shows that the response of the eye is by no means uniform throughout the visible spectrum. In fact, if equal physical amounts of different colors of light are presented to an observer, the curve shows that the middle (green) portion of the spectrum would appear the brightest, and the extreme (blue and red) parts would look very dim. It is for this reason that a green "safelight" is used when processing panchromatic film. Since the eye is more sensitive to green light, it takes less of it to illuminate the darkroom than any other color of light.

The plot shown in Figure 5-2 has been accepted as an international standard response function for the measurement of light. Therefore, any meter intended for the measurement of light must possess

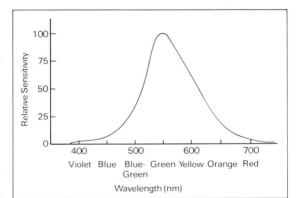

Figure 5–2 The sensitivity curve of the human eye. The plot indicates the relative brightness of the energy at each wavelength. Note that the curve is asymmetrical.

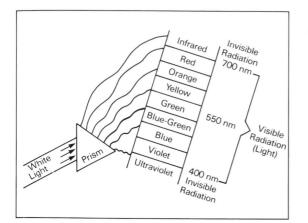

Figure 5-3 The dispersion of white light into the visible spectrum.

a sensitivity function identical to it. Most photoelectric meters used in photography have response functions significantly different from the standard (see Section 3.21) and are not properly called light meters, although the international standard curve can be approximated by the use of appropriate filters with some meters. (It should be noted that the determination of the proper f-number and shutter speed for a given photographic situation does not require a meter with this response function.)

When all of the wavelengths between 400 nm and 700 nm are presented to the eye in nearly equal amounts, the light is perceived as white. There can be no absolute standard for white light because the human visual system easily adapts to changing conditions in order to obtain the perception of whiteness. For example, the amounts of red, green, and blue light in daylight are significantly different from those of tungsten light; however, both can be perceived as white (due to physiological adaptation and the psychological phenomenon known as color constancy). Thus our eyes readily adapt to any reasonably uniform amount of red, green, and blue light in the prevailing illumination. This means that our eyes are not to be relied upon when judging the color quality of the prevailing illumination for the purposes of color photography.

If a beam of white light is allowed to pass through a glass prism as illustrated in Figure 5–3, the light is dispersed into a series of colors termed the visible spectrum. This separation of the colors occurs as a result of the light of various wavelengths being bent by varying amounts. The shorter-wavelength blue light is bent to a greater extent than the longer-wavelength green and red light. The result is a rainbow of colors that range from a deep violet to a deep red. Experiments indicate that human observers can distinguish nearly 100 different spectrum colors. However, the visible spectrum is often arbitrarily divided into the seven colors listed in Figure 5–3. For the purpose of describing the properties of color photographic systems in simple terms, the spectrum is divided into just three regions: red, green, and blue. The color of the light may be specified at a given wavelength, thereby defining a spectral color. Such colors are the purest possible because they are unaffected by mixture with light of other wavelengths. It is also possible to specify a certain region or color of the spectrum by the bandwidth of the wavelengths. For example, the red portion of the spectrum could be specified as the region from 600 nm to 700 nm.

5.5 Solid-Object Sources and the Heat-Light Relationship

Light is a form of energy that can only be produced from some other form of energy. The simplest and perhaps most common method is from heat energy, a process called *incandescence*. Whether the source is a filament in a tungsten lamp, a candle flame, or anything that has been heated until it glows, incandescence is always associated with heat. In fact, the amount and color of light produced by an incandescent source is directly related to the temperature to which it is heated. Consider, for example, an iron poker; one end of which is placed in a fire. Initially the poker feels somewhat cold; but as it is left in the fire, its temperature rises and it begins to feel warm. By increasing the temperature of the poker, we can become aware of a change in its radiating properties through our sense of touch, although

Figure 5-4 Cross-section of a simple blackbody radiator consisting of an enclosure surrounded by boiling or molten

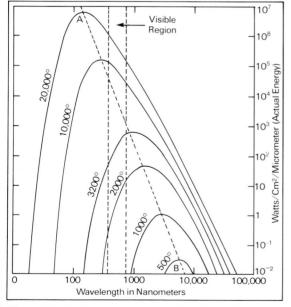

Figure 5–5 Spectral-energy curves for a blackbody heated to various temperatures.

it looks the same. Soon the poker will become too hot to touch and we will be able to sense its radiation as heat at a short distance. As the temperature is raised even higher, the poker reaches its point of incandescence and begins to emit a deep red glow. If the poker is allowed to get hotter still, the color of the light it produces will become more yellowish, and the light will become brighter. At extremely high temperatures, the end of the poker will look white, and ultimately blue, in addition to becoming still brighter. All of this illustrates the fact that a solid object, when heated to its point of incandescence and higher, produces light that varies in color as a function of its temperature. When describing the temperature of such sources, it is common practice to employ the absolute or Kelvin scale for reasons discussed earlier.

The best solid-object radiator is an absolutely black body, as it absorbs all the energy that strikes it. All light sources are radiators, some of which are more efficient than others. Thus, since a perfectly black object would only emit energy and not reflect it when heated, it would be the most efficient source. A blackbody source is achieved in practice by the design shown in Figure 5–4. An enclosure surrounded hy a hulling manened but on the concave, any light that enters will be absorbed, either immediately or after one or more reflections. Consequently the hole will appear perfectly black. As the walls of the oven are heated, they will emit radiant energy in all directions; that which escapes through the hole is called blackbody radiation. When such an experiment is performed and the blackbody is heated to a variety of temperatures, the characteristics of the radiant energy it produces change systematically, as shown in Figure 5–5.

As discussed previously, every object emits energy from its surface in the form of a spectrum of differing wavelengths and intensities when heated to temperatures greater than -273° C (absolute zero). The exact spectrum emitted by the object is dependent upon its absolute temperature and its *emissivity* (the flow of radiation leaving a small area divided by the area). Since the blackbody has perfect emissivity, the temperature in degrees Kelvin becomes the only important factor. It can be seen in Figure 5–5 that as the temperature increases, the curves are everywhere higher, indicating that the amount of energy at each wavelength increases. Additionally, as the temperature increases, the wavelength at which the peak output occurs becomes shorter. The peak position shifts from the long-wavelength end of the infrared region toward the short-wavelength end of the ultraviolet region as the temperature increases. The portion of emitted energy that would be perceived as light is contained within the narrow broken lines.

Some observations are now in order. First, since all of the objects with which we come into contact are at temperatures greater than -273° C, they are emitting some form of radiant energy, principally in the long-wavelength infrared region. For example, the human body at a temperature of 98.6 F (40 C, 313 K) emits infrared energy from 4000 nm to 20,000 nm, with the peak output at approximately 9600 nm. Second, most objects must be heated to a temperature of greater than 1000 K (727 C, 1340 F) in order to give off energy short enough in wavelength to be sensed by the human eye. For example, iron begins to glow red when it is heated to a temperature of about 1200 K, and a typical household tungsten lamp operates at a filament temperature of nearly 3000 K. Both sources will emit large amounts of infrared energy in addition to the visible energy. Third, in order for

5.6 Vapor Sources and the Effect of Electrical Discharge

Figure 5-6 Spectral energy distribution of a low-pressure sodium-vapor source. Such sources appear yellow.

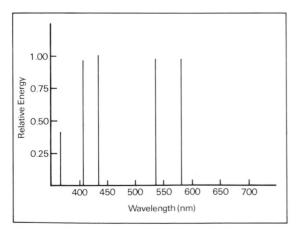

Figure 5-7 Spectral-energy distribution of a low-pressure mercury-vapor source. This source would appear violet.

it to emit ultraviolet energy, a solid-object source must be heated to extremely high temperatures. Since tungsten steel melts at 3650 K, incandescent sources are not typically used when large amounts of ultraviolet energy are needed.

5.6 Vapor Sources and the Effect of Electrical Discharge

A fundamentally different method for producing light makes use of radiation emitted from gases when an electrical current is passed through it. Such sources are called discharge lamps and generally consist of a glass tube containing an inert gas, with an electrode at each end. An electrical current is passed through the gas to produce light and ultraviolet energy. This energy may be used directly or to excite phosphors coated on the inside of the glass tube, as in a fluorescent lamp.

The basic process involved in the production of light is the same for all vapor lamps. The light emission from the vapor is caused by the transition of electrons from one energy state to another. When the electrical current is applied to the lamp, a free electron leaves one of the electrodes at high speed and collides with one of the valence electrons of the vapor atom. The electron from the vapor atom is bumped from its normal energy level to a higher one and exists for a short time in an excited state. After the collision, the free electron is deflected and moves in a new direction at reduced speed. However, it will excite several more electrons before it completes its path through the lamp. The excited electron eventually drops back to its former energy level and, while doing so, emits some electromagnetic radiation.

The radiation emitted may be at any of several wavelengths, depending primarily upon the properties of the vapor in the tube. Each type of vapor atom, when excited, gives off energy at wavelengths determined by its structure. Some gases emit radiation only at a few wavelengths, while others emit energy at many different wavelengths. These sources are said to show a discontinuous or line spectrum. For example, the spectrum of sodium vapor shows a bright yellow line near 600 nm, as shown in Figure 5–6, while mercury vapor produces energy at many different wavelengths, both in the ultraviolet region and in the visible region, as illustrated in Figure 5–7.

The pressure under which the vapor is dispersed in the tube has a significant effect upon the amount of energy that will be emitted. The terms low pressure and high pressure are often used to describe such lamps; low pressure indicates some small fraction of atmospheric pressure, while high pressure is applied to sources working above atmospheric pressure. High-pressure sodium-vapor lamps are often used for illuminating streets at night. Low-pressure sodium-vapor lamps are often used as safelights in photographic darkrooms when working with orthochromatic materials because they produce light in regions of the spectrum where the emulsion shows low sensitivity. High-pressure mercury-vapor sources are often used when making blueprints, while low-pressure mercury-vapor sources are used in greenhouses as plant lights because the ultraviolet energy they emit is beneficial to plant growth. It is important to note that the spectral characteristics of the radiation emitted by these sources is dependent primarily upon the properties of the vapor in the tube.

Perhaps the most commonly encountered vapor source is the fluorescent lamp. These are typically low-pressure mercury-vapor tubes

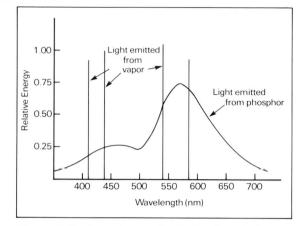

Figure 5–8 Spectral energy distribution of a cool white fluorescent lamp.

that have phosphors coated on the inside of the glass envelope. When bombarded by the large amount of ultraviolet radiation emitted by the mercury vapor, these phosphors begin to glow and give off visible energy at all wavelengths in the visible spectrum. Thus, the light emitted by a fluorescent lamp is the result of both the discontinuous energy emitted by the vapor and the continuous energy emitted by the fluorescing phosphors.

There are many classes of phosphors that can be used for this purpose, with each phosphor emitting its own color of light. Figure 5-8 illustrates the spectral energy distribution for a typical cool white fluorescent lamp. The light that corresponds to the discontinuous line spectrum produced by the mercury vapor may not be apparent to a human observer because of the ability of the visual system to adapt to variations in the color balance of "white" light. Photographic films do not have this capability. Therefore, color transparencies made on daylight type color film with "daylight" flourescent illumination tend to have a greenish cast unless an appropriate filter is used.

5.7 Luminescence

Luminescence can be described as the emission of light due to causes other than incandescence. It is generally caused by the emission of photons from atoms by exciting them with energy of relatively short wavelengths. As the electrons return to a lower energy level, energy of longer wavelengths is released. The rate at which this occurs can be affected by the presence of an *activator*, which is made up of ionized atoms that trap, then release the electrons slowly for recombination. The exciting energy is usually in the ultraviolet region, but can be caused by energy in the visible and infrared regions. There are many forms of luminescence. Bioluminescence is the result of biochemical reactions, and is typically seen in fireflies and glowworms. Chemiluminescence occurs as the result of some chemical reactions. Galvanoluminescence occurs as the result of galvanic action (the result of the flow of an electrical current) and, in the days when vacuum-tube rectifiers were common, could be seen as a "glow" when they were operating. Triboluminescence occurs when a material is ground; an example would be the grinding of sugar with a mortar and pestle. Solid substances that luminesce are called *phosphors*. Photographers are most concerned with the luminescence that occurs as a result of excitation with ultraviolet energy and light.

Fluorescence is luminescent emission of electromagnetic radiation in the visible region that occurs during the time of excitation. Thus, phosphors that are radiated with ultraviolet energy fluoresce. When the excitation is stopped, the fluorescence ceases within about 10^{-8} seconds; but it sometimes continues for as long as 10^{-1} seconds, depending on the activator.

Phosphorescence is the emission occurring after the excitation has been stopped, and which continues for somewhat more than 10^{-8} seconds up to several hours. The duration is strongly dependent on temperature. Phosphorescence is similar to fluorescence, but has a slower rate of decay.

Some dyes fluoresce, including fluorescein, eosin, rhodamine, and a series of dyes (and other materials) that are used as brighteners in substances such as paper and cloth. Photographic papers may contain brighteners to give them "cleaner" and more brilliant "whites." Most modern papers are treated with brighteners, a distinguishing characteristic when comparing modern prints to those made 30 or 40 years ago, without brighteners. The occurrence of brighteners in fabrics and similar materials can present problems in color photography when the ultraviolet component of electronic flash energy (or other light sources) causes them to fluoresce, most often in the blue region of the spectrum. This has a strong effect on the reproduced color of the material, often rendering it "blue" or "cyan" when the other materials in the scene have been reproduced satisfactorily in the photograph. The effect is minimized or eliminated by the use of an ultraviolet-absorbing filter over the electronic flash, or other source, to prevent it from exciting the fluorescing dyes or pigments in the material. An ultraviolet filter over the camera lens in this case would not correct for the fluorescence.

Fluorescent lamps excite gas molecules within the tube by means of electrons, to produce energy of discrete wavelengths, or lines, largely in the blue and ultraviolet regions (but dependent to a great extent on the gas elements in the tube). Some of this energy is absorbed by phosphors coated on the inside of the tube and is converted to longer-wavelength (visible) radiation. The color of the fluorescent emission is highly dependent on the phosphor material, and the activators incorporated in it.

Fluorescing screens are extensively used in radiography. In this application, they are called *intensifying screens*. They fluoresce when activated by the X-rays used for exposure, and the visible radiation from the screens is considerably more effective in exposing photographic emulsions than the X-rays themselves. The screens are placed in contact with both sides of the film, in the film holder, during exposure.

5.8 The Use of Color Temperature

As discussed previously, the amount and color of radiation emitted by a solid-object source is very much temperature dependent. In fact, the color of light being emitted from such a source can be completely specified by the Kelvin temperature (K) at which it is operating. Such a rating is referred to as the color temperature of the source. A color temperature may be assigned to any light source by matching it visually to a blackbody radiator. The temperature of the blackbody radiator is raised until the color of its light visually matches that from the lamp, and the Kelvin temperature of the blackbody is then assigned as the color temperature of the lamp. Thus, the use of color-temperature ratings in photography presumes that the lamp being described adheres to the same heat-to-light relationship as does the blackbody radiator. For incandescent lamps, this presumption is correct. However, the color of light emitted by some sources, such as fluorescent lamps, has no relationship whatever to the operating temperature. In these cases, the term correlated color temperature is used to indicate that the color of light emitted by a blackbody radiator of that temperature produces the closest visual match that can be made with the source in question. It is important to note here that a visual match of two sources does not ensure a photographic match. In fact, in most cases, the photographic results will be different.

The color temperatures of a variety of light sources are given in Table 5-3. It is apparent that photographers are faced with a tre-

 Table 5-3
 The color temperatures of some common light sources.

	Color
	Temperature
Source	(°K)
Candle	1800
60-watt tungsten lamp	2800
100-watt tungsten lamp	2900
250-watt photographic lamp	3200
250-watt studio flood lamp	3400
Flashbulb (uncoated)	4000
Direct sunlight	4500
Photographic daylight	5500
(sunlight plus sky light)	
Electronic flash	6000
Sky light (overcast sky)	8000
North sky light	15,000
	(approximately)

mendous range of color temperatures, from the yellowish color of a candle at about 1800 K to the bluish appearance of north sky light, rated at 15,000 K. Notice that as the color temperature increases, the color of light emitted from the source shifts from red to white to blue in appearance. In order for photographers to produce excellent photographs under widely varying illuminant conditions, color films are designed for use with three different color temperatures. Type A color films are designed to produce images having optimum color balance with light rated at 3400 K, while Type B films are intended for a source rated at 3200 K. Daylight-balanced color films are designed to be used with 5500 K light, which is often referred to as photographic davlight. The actual color temperature encountered from a lamp in practice can vary significantly as a result of reflector and diffusor characteristics, changes in the power supply and the age of the bulb. Consequently, it is often necessary to measure the color temperature of the source with a color-temperature meter when using color films. Most color-temperature meters employ photoelectric cells used in conjunction with color filters to sample specific regions of the spectrum being produced There incomments measure the life the property property of the test red energy output and give a reading directly in color-temperature values, or indirectly through the use of calibration charts. Such meters can be successfully used in both daylight and tungsten lighting conditions, where the source is producing a continuous spectrum. However, when used with vapor sources that produce a discontinuous spectrum, the results may be very misleading because of significant differences in this response compared to the visual response (see Section 3.32).

When the color temperature of the light from a solid-object source does not match the response of the film, light-balancing filters must be used over the camera lens. If the color temperature is too high, a yellow filter over the camera lens will lower the color temperature of the light that the film receives. If the color temperature of the light is too low, a blue filter can be used to raise it. If the filters are desaturated in color, then the changes to color temperature will be relatively small, while saturated filters will give large changes in color temperature (see Section 14.4).

The filters necessary to properly correct the color of light from vapor sources, such as fluorescent lamps, must either be determined from manufacturer's literature or from tests performed with the color film itself.

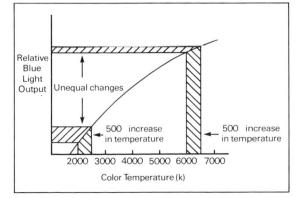

Figure 5–9 The relationship between color temperature and the relative amount of blue light being given off by a solidobject source.

5.9 The Mired Scale

Although color temperature provides a useful scale for classifying the light from continuous-spectrum sources, it does have some limitations. For example, a 500 K change at the 3000 K level does not produce the same visual or photographic effect as a 500 K change at the 7000 K level. This is because there is a nonlinear relationship between changes in a source's color temperature and the changes in the color of light it produces, which is illustrated in Figure 5–9.

This awkwardness in the numbers can be eliminated if the reciprocal of the color temperature is used, because of the more nearly linear relationship existing between this value and the effect. Since this number would be quite small, it is commonly multiplied by 1 million to obtain a number of appropriate size. The resulting value is called the *mired* and is an acronym for the term "micro-reciprocal-degrees."

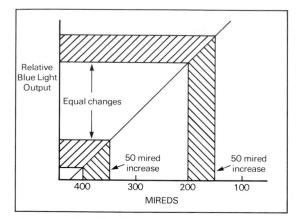

Figure 5–10 The relationship between mireds and the relative amount of blue light given off by a solid-object source.

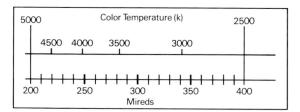

Figure 5–11 Comparison of color temperature and mired scales.

Therefore, to convert color temperatures to the mired scale, the following formula is used:

Mired Value =
$$\frac{1}{\text{Color temperature}} \times 10^6$$
.

Some publications also refer to this value as "reciprocal megakelvins."

Figure 5–10 illustrates the relationship between changes on the mired scale and changes in the resulting effect. It shows that equal changes in the mired scale produce equal changes in the effect. The relationship between color temperature and mireds is illustrated in Figure 5–11, which indicates that the higher the color temperature, the lower the mired value. Consequently, bluish sources with very high color temperatures will have very low mired values, while reddishappearing sources with low color temperatures will have high mired values.

The mired scale is most frequently used for color-compensating filters that are intended to correct the color of light from a source to match the response of the color film. For example, if it is desired to expose a daylight color film balanced for 5500 K to a tungsten lamp operating at 3000 K, a color correction filter will be necessary to obtain the proper color balance. The color temperatures are converted to mired values, as shown below.

Mired value of film = $\frac{1}{5500} \times 10^6 = 182$

Mired value of source
$$=\frac{1}{3000} \times 10^6 = 333.$$

The mired value of the source, 333, is subtracted from the mired value of the light for which the film is balanced, 182; the resulting mired shift is -151. Thus, to correct this light source, a filter providing a mired shift of -151 would have to be used over the camera lens. The filter manufacturer's data sheet will provide the information necessary to determine the appropriate filter for this mired shift value. Negative mired values require bluish filters to increase the color temperature, while positive mired values require yellowish filters to decrease the color temperature. A major benefit of using the mired scale for designating filters is that a given mired change will have the same effect on the color of the light from solid-object sources at any color temperature. The color-temperature meters discussed previously often read out directly in mired values, and the mired shift can be calculated from that.

5.10 Color-Rendering Index

Correlated color-temperature specifications are quite adequate for describing the visual appearance of vapor and fluorescent sources. However, when considering the way object colors are represented, such data are often misleading. The color-rendering ability of a light source is a measure of the degree to which the perceived color of objects illuminated by the source will match the perceived colors of the same objects when illuminated by a standard light source of high color-rendering ability, under specified viewing conditions. Thus, the

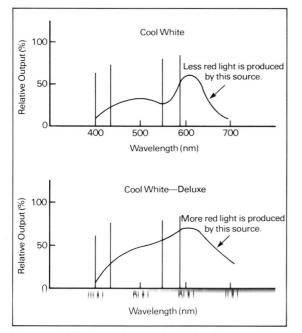

Figure 5–12 Spectral-energy distributions for two fluorescent lamps with same correlated color temperature (4200 K).

Table 5–4	The correlated color temperatures and color
rendering inde:	xes for a variety of fluorescent lamps.

Lamp Name	Correlated Color Temperature	Color-Rendering Index
Warm white	3000 K	R = 53
Warm white-deluxe	2900 K	R = 75
White	3500 K	R = 60
Cool white	4200 K	R = 66
Cool white—deluxe	4200 K	R = 90
Daylight	7000 K	R = 80

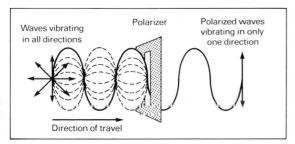

Figure 5-13 The polarization of light.

color-rendering properties of a light source relate to color perception of the objects it illuminates.

Since fluorescent lamps do not follow the energy-emission properties of a blackbody radiator, correlated colors temperature do not indicate the amount of energy being produced at each wavelength. For example, the spectral-energy distributions for two fluorescent lamps of equal correlated color temperature (4200 K) are shown in Figure 5– 12. Note that the lamp labeled Cool White—Deluxe is producing more red light than the lamp labeled Cool White, which would result in widely different color rendering for some objects. For example, if a person's face were illuminated by these sources, the Cool White— Deluxe lamp would provide more red light, resulting in a healthier, more natural skin-complexion appearance than that given by the Cool White lamp.

In an effort to address this problem, the concept of a colorrendering index (R) was established by the CIE (Commission International de l'Eclairage or International Commission on Illumination). Determining the color rendering index, R, for any given light source requires that the spectral energy distribution and the correlated color temperature are known, so that an appropriate reference source can be selected. In this method, eight arbitrary Munsell color samples are used, and the CIE chromaticities under the given source are calculated. A similar set of calculations under the selected reference source will give eight different CIE chromaticities. The differences between the two sets of data indicate the color shift of the given light source in relation to the reference source. The eight differences are then averaged to arrive at the color-rendering index, R. The R value is based upon an arbitrary scale that places a specific warm white fluorescent lamp with a correlated color temperature of 3000 K at R = 50 and the reference source at R = 100. The reference source always has an R equal to 100. Thus, the higher the R value for a given source, the more closely object colors will appear to their counterparts under the reference source, and, therefore, the better the color rendition. The color rendering indexes for a variety of fluorescent lamps are given in Table 5-4.

Some limitations to this concept should be noted. First, since the calculated R value is obtained in relation to a reference source, two given sources can only be compared to each other if their reference sources are similar (within approximately 200 K). Second, since the Rvalue is an average taken from eight different colors, it does not specify the performance of the source on a specific color. Third, the R value is based upon the visual appearance of the object colors and not their photographic appearance. Thus, a source can have a high R value (90 or greater) and not give desirable color reproduction in a color photograph.

5.11 The Polarization of Light

As discussed previously, light, like other forms of radiation in the electromagnetic spectrum, is believed to move in a wave motion. The vibrations of these waves occur in all directions at right angles to the path of travel, as illustrated by the light beam to the left of the filter in Figure 5–13. This is described as an unpolarized light beam. However, the wave can be made to vibrate in one direction only, and when this occurs, the light is said to be polarized. The light beam on

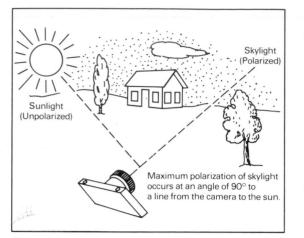

Figure 5-14 The polarization of sky light.

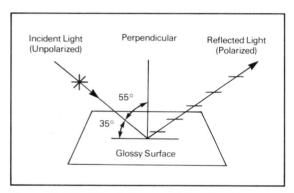

Figure 5–15 The polarization of light reflected from a glossy surface.

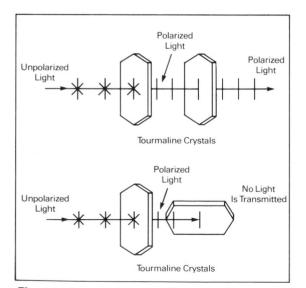

Figure 5-16 The polarizing effect of tourmaline crystals.

the right of the filter in Figure 5-13 illustrates this condition. Such polarization of light occurs naturally in a number of ways described below.

- Light emitted from a portion of clear blue sky, at right angles to a line connecting the viewer (or camera) and the sun, is highly polarized. This is caused by the scattering of the light rays by very small particles in the atmosphere such as dust and molecules of water vapor and other gases. As the angle decreases, the effect also decreases, as illustrated in Figure 5-14. Thus, a portion of the blue sky light encountered in typical outdoor scenes is polarized.
 Light becomes polarized when it is reflected from a flat, glossy, non-metallic surface, such as glass, water, and shiny plastics. However, this effect only occurs at an angle whose tangent is equal to the refractive index of the reflecting material; this is known as the Brewster angle. For common surfaces, such as glass and water, this angle is approximately 55° from the perpendicular (35° from the surface) and is illustrated in Figure 5-15.
- 3. Light becomes polarized when it is transmitted through certain natural crystals or commercially manufactured polarizing filters. Among the substances having the ability to polarize light are the dichroic crystals, particularly the mineral tourmaline. When a beam of unpolarized light passes through a thin slab of tourmaline, it becomes polarized. This property can be demonstrated by rotating a second slab of tourmaline across the direction of polarization, as illustrated in Figure 5–16. When the second slab is rotated to a position of 90° from that of the first, no light will be transmitted through the second filter. Commercially available polarizing filters are made from dicrylic substances whose chemical composition calls for the grouping of parallel molecular chains within the filter. This is the nature of the filter illustrated in Figure 5–13.

Polarized light will become depolarized when it strikes a scattering medium. This most frequently occurs when the light is reflected from a mat surface, such as a sheet of white blotting paper. It can also be depolarized upon transmission through a translucent material, such as a sheet of mat acetate.

The phenomenon of polarized light provides the photographer with a very useful tool for controlling light. For example, a polarizing filter will absorb light that is in one plane of polarization. If the plane of polarization of the filter and the plane of polarization of the light are the same, the maximum amount of light will be transmitted. However, if they are at right angles to each other, no light will pass, as shown in Figure 5–17. At angles between these two, varying amounts of light will be transmitted, allowing for the useful control of light. Thus, polarizing filters can be thought of as variableneutral density filters. (Also see Section 14.8.)

5.12 Practical Sources of Light and Their Properties

Thus far, the discussion of light has centered on the methods of production, its properties and measurement. At this point it is appropriate to consider some practical sources of light commonly encountered by the photographer.

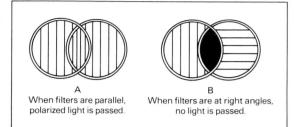

Figure 5-17 The use of polarizing filters to control light.

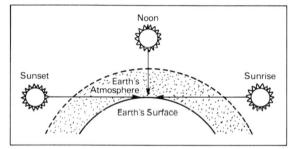

Figure 5–18 The relationship between position of the sun and the length of the sunlight's path of travel through the earth's atmosphere.

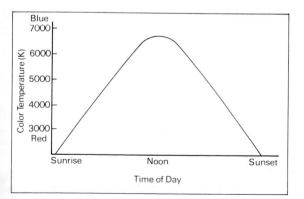

Figure 5–19 The variation in color temperature of light with time of day at the surface of the earth (no cloud cover).

5.12.1 Daylight

Although there are many different types of artificial lamps available to the photographer, most photographs are still made in daylight. Daylight is usually composed of at least two different sources of light: (a) direct sunlight, which is modulated by the earth's atmosphere; and (b) blue sky light, which is the light reflected from the atmosphere. Additional light may also reach the subject by reflection from objects on the earth's surface. The nature of daylight at any given time is dependent upon the geographical location, the time of day, the season of the year, and the prevailing weather conditions, which is an important factor. When the sky is clear, the amount of direct sunlight is at a maximum, which is about 88% of the total light on the ground, with the remaining 12% principally the result of sky light. This produces a natural lighting ratio of approximately 8:1. On very overcast days this ratio is lowered considerably as a result of diffusion. Thus the ratio of sunlight to skylight is directly related to the atmospheric conditions.

Sunlight is produced by the high temperature of the sun, and its energy distribution outside the cardi's atmosphere closely approximates that of a blackbody source at 6500 K. However, in passing through the earth's atmosphere, a considerable amount of this light is lost, particularly in the blue region of the spectrum, and when the light strikes the earth's surface, it can no longer be represented by a true blackbody radiation curve. As a result of the loss of light in the blue region, the color temperature of sunlight alone on the ground varies between 5000 and 5800 K. However, the use of color temperature to describe the appearance of daylight is of limited photographic value, since the energy-output characteristics of daylight only approximate those of a blackbody radiator.

The distance that sunlight must travel through the atmosphere varies with latitude, season, and time of day. The longer the distance, the greater the amount of scattering, and consequently the lower the color temperature becomes. Figure 5–18 illustrates the change in the path of sunlight during a day from sunrise to sunset. Notice that at both sunrise and sunset the light has a much greater distance to travel through the atmosphere than at noontime. Since it is primarily short-wavelength blue light that is scattered, the light reaching the earth's surface at both sunrise and sunset is very reddish. The variation in color temperature on the earth's surface between sunrise and sunset is illustrated in Figure 5–19.

Sky light is blue because the small particles of the atmosphere selectively scatter the short wavelengths of light away from the direct sunlight. The sky is bluish because these short wavelengths are redirected toward our eyes. This effect is known as Rayleigh scattering, and varies inversely with the fourth power of the wavelength. Thus, the scattering at 400 nm is 9.4 times that at 700 nm. Therefore, since sky light is much richer in blue light, its color temperature ranges between 10,000 and 20,000 K. The sky appears at its bluest on clear days because the atmospheric particles are very small, being comparable to the wavelength of light. As the cloud cover increases, the size of the particles present increases and, consequently, there is less differentiation of scattering of long and short wavelengths, resulting in the grayer and less transparent appearance of the sky.

As indicated previously, daylight consists of the relatively low color temperature of the direct sunlight, and the relatively high color temperature of sky light. The result is a mixture of light on the

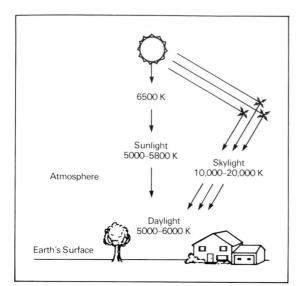

Figure 5-20 Daylight results from a mixture of sunlight and sky light.

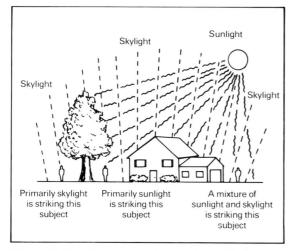

Figure 5–21 Variations in the composition of daylight (sunlight plus sky light) for an outdoor subject.

ground, which for typical sunlight-clear sky conditions provides a color temperature between 5000 and 6000 K on the ground. This is illustrated in Figure 5-20. Thus, since sunlight and skylight reach the earth's surface from different directions, the color temperature of light striking a particular area depends upon its orientation. The daylight color films are balanced for a color temperature of 5500 K, since this is believed to be the most commonly encountered mixture of sunlight and sky light. Consequently, when making color photographs outdoors, it is important to consider the type of light that is striking the subject. For example, in Figure 5–21, a subject standing between the tree and the house is illuminated primarily by direct sunlight and so will appear slightly yellowish. A subject standing to the left of the tree is being illuminated only by sky light and thus would appear quite bluish. The subject standing to the right of the house is being illuminated both by sunlight and by sky light. In this last case, if the color of daylight is incorrect, there is little that can be done, since there are actually two sources of light striking the subject. The selection of the appropriate color-compensating filters to be used over the camera in such cases invariably involves a compromise in color reproduction.

5.12.2 Tungsten-Filament Lamps

Aside from daylight itself, one of the more common sources of light is the incandescent electric light bulb. Incandescent lamps give off light because of the high temperature reached by the tungsten filament wire. This high temperature results from the resistance to the passage of electricity through the wire, and represents a conversion of electrical energy into heat energy, which, in turn, is converted to light. Tungsten is employed for the filament because its melting point is higher than that of any other metallic filament. This allows for a higher operating temperature, which results in a greater light output, in addition to a higher color temperature of the light. The upper temperature limit for the operation of these sources is approximately 3650 K, since this is the temperature at which tungsten melts. As the filament temperature is increased, atoms of tungsten evaporate or are boiled off, resulting in a deposit of black tungsten on the inside of the bulb. As a result, the total amount of light emitted will be reduced and its color temperature altered. The use of color temperature to describe both the visual and photographic color characteristics of the light is appropriate, since such sources produce light that is completely temperature dependent.

The glass envelope itself may be clear or have a frosting on the inside that is the result of chemical etching or coating with a white powder. The visual and photographic effects of these two different types of envelopes are significant. The lamp equipped with a clear bulb will produce light with high luminance and produce sharp shadows, while the frosted lamp will produce lower luminance and more diffuse shadows. In photography, clear tungsten lamps are used when point sources are required, and frosted lamps are used when more uniform lighting is required, as in a contact printer or an enlarger. Measurements indicate that the internal frosting of a glass bulb absorbs practically no light.

Tungsten lamps are manufactured in a variety of forms, the most common being the typical household light bulb. These lamps are available in a wide range from 15 watts to over 1,000 watts and are available with either clear or frosted envelopes. The color temperatures of these lamps range from approximately 2700 K for the smaller-wattage lamps to nearly 3000 K for the larger lamps. The typical 60-watt

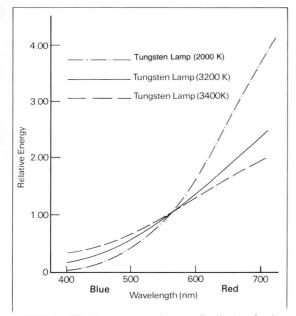

Figure 6-22 Relative spectral energy distributions for three incandescent sources.

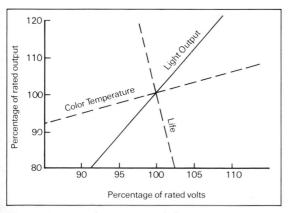

Figure 5 23 The constantion in light output, color temperature, and life of a tungsten lamp at different voltages.

tungsten lamp has a color temperature of approximately 2800 K, with an average life of 1,000 hours. The term *photographic lamp* is applied to a variety of lamps that are manufactured expressly for photographic purposes. The color temperature of these lamps is maintained at 3200 K, which significantly shortens their life to approximately 100 hours. Such lamps are useful in the studio because their higher temperature of operation allows for a greater light output at all wavelengths, which will result in shorter exposure times.

Additionally, as the color temperature of the source is raised, the percentage of blue light also increases. Since the silver halide emulsion is most sensitive to blue light, this effect will also lead to shortened exposure times. To this end, a category of photographic lights called *photoflood lamps* has been manufactured. These lamps are designed to operate at 3400 K, and they produce more light per unit of electrical energy, making them more efficient. However, at this elevated temperature, which is approaching the melting point of the filament, the effective life of these lamps seldom exceeds 10 hours.

Figure 5-22 illustrates the changes in spectral-energy distribution for a tungsten-filament lamp operated at a variety of color competitutes. Such a plot is property range a relative spectral energy distribution, indicating that the data have been normalized at a wavelength of 550 nm. Setting the energy output for all of these sources to be equal at the middle of the spectrum allows for easy comparison of the relative amounts of blue light and red light being emitted by the source. The data for these curves are actually obtained from the curves in Figure 5-5, by determining the output values at different wavelengths. These output values are originally logs and must be converted back to conventional numbers (antilogs). The antilogs arc normalized by dividing by the antilog for the output at 550 nm. For example, using the 3200 K curve and three wavelengths only, at 400 nm, the log output value is nearly 1.6; at 550 nm, the log output is approximately 2.3; at 700 nm, the log output is nearly 2.7. The antilogs are: 40 at 400 nm; 200 at 550 nm; 500 at 700 nm. These values are now divided by the value (200) for 550 nm, and are converted to proportions; $0.20 \times$ at 400 nm; $1.00 \times$ at 550 nm; $2.50 \times$ at 700 nm.

It is these relative proportions that are plotted in Figure 5–22. Most data about photographic light sources will come in this form. The curves need to be interpreted with care. For example, if the 2000 K curve represents a candle flame and the 3400 K curve represents a photoflood lamp, it should not be concluded from the curves that the candle produces more red light than the photoflood lamp. That the curve for the candle is much higher in long wavelengths means that of the little light it gives, most is reddish. But if a photographer wishes to obtain a large amount of red light, he would do well to choose a photoflood lamp.

Lamp life depends primarily upon the rate at which tungsten evaporates from the filament, which is determined principally by filament temperature. As the filament temperature increases, its life decreases. Each type of tungsten lamp is designed to operate at a given voltage level. Variations in the voltage of the electrical current will affect both the total amount of light produced and the color temperature of the radiation emitted, as illustrated in Figure 5–23. Here, the variables of light output, color temperature and life are illustrated as a function of the percentage of rated units applied to the lamp. Variations in voltage relate directly to variations in filament temperature; as the volts are increased, the filament temperature increases. The

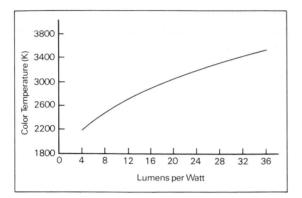

Figure 5–24 The average relationship between luminous efficiency and color temperature of tungsten filament lamps.

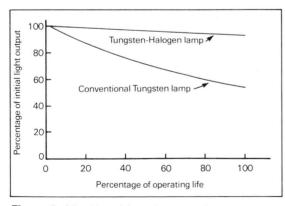

Figure 5–25 Typical lamp depreciation for a conventional tungsten lamp and a tungsten-halogen lamp.

variations in total light output can affect exposure, but in black-andwhite photography the differences are usually within the exposure latitude of the film. The variation in color temperature can be sufficient to affect the color reproduction of color films. If variations greater than $\pm 5\%$ of the rated voltage of the lamp occur, correction filters will be necessary to obtain proper color reproduction. This problem can be avoided if voltage regulators are used with the light sources as is sometimes done in studios and color-printing darkrooms.

Since incandescent lamps convert electrical power (watts) into light (lumens), the luminous efficiency of such sources can be expressed in lumens per watt (lm/W). The light output (in lumens) of a tungsten lamp depends primarily on two factors; the filament temperature and wattage. However, lamp efficiency (lm/W) is almost exclusively governed by filament temperature. Lumens per watt is related to the color temperature of the filament as illustrated in Figure 5–24. This plot, which is the result of averaging a variety of tungsten lamps, illustrates that luminous efficiency increases with color temperature. Typical household tungsten lamps (25 watts to 150 watts) vary in luminous efficiency from 6 to 20 lm/W. A 500-watt studio photoflood at 3400 K has a luminous efficiency of approximately 35 lm/W.

Since the luminous efficiency is based upon the visual effect of the emitted energy, such data are of limited value in determining its photographic usefulness. A related concept, called actinic efficiency, is used to describe the photographic effect of light sources. This value is typically determined by testing the source in question with a specific film type. The reciprocal of the exposure (lux-seconds) to produce a density of 1.0 is often employed as a measure of actinic efficiency.

5.12.3 Tungsten-Halogen Lamps

Sometimes referred to as quartz iodine lamps, tungstenhalogen lamps are essentially the same as conventional incandescent lamps since they both have tungsten filaments. In conventional incandescent lamps, the tungsten evaporates from the filament as it is heated and leaves a black deposit on the bulb wall. This blackening of the envelope leads to a loss of light output and a change in the lamp's color temperature. If iodine is added to the normal gas fill, it will chemically combine with the evaporated tungsten, provided the internal lamp temperatures are sufficient to begin this reaction. The resulting tungsten-iodine gas migrates back to the filament, where the extremely high temperature decomposes it into tungsten and iodine. The tungsten is deposited on the filament and the iodine is free to begin this cycle again. It is this cycle that keeps the tungsten from depositing on the inside wall of the bulb and, therefore, keeps it clean. Figure 5-25illustrates the loss in total light output for both the conventional tungsten lamp and the tungsten-halogen lamp over their operating lives.

Other halogens (chemical elements related to iodine), particularly bromine, have been substituted for iodine with beneficial effects. Because extremely high temperatures are required to sustair the chemical cycle of the tungsten-halogen lamp, the lamp envelope is made from quartz or other high temperature glass. These lamps are finding greater use in photographic applications because of their increased light output, the higher color temperatures of which they are capable, and the longer lamp life. Tungsten-halogen lamps are routinely used in enlargers and projectors, and to a lesser extent in studio lighting equipment.

5.12 Practical Sources of Light and Their Properties

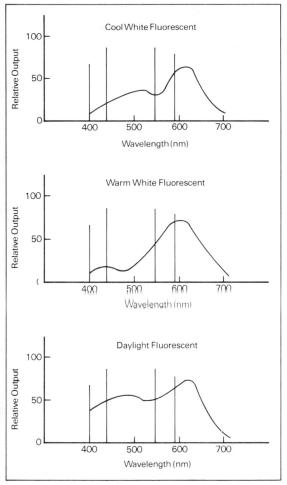

Figure 5–26 Spectral-energy distributions of three different fluorescent lamps.

5.12.4 Fluorescent Lamps

Fluorescent lamps produce light by establishing an arc between two electrodes in an atmosphere of very low-pressure mercury vapor contained in a glass tube. This low-pressure discharge produces ultraviolet radiation at specific wavelengths that excite crystals of phosphors lining the wall of the tube. Phosphors such as calcium tungstate have the ability to absorb ultraviolet energy and to reradiate this energy as light. The color of light emitted by a fluorescent tube depends largely on the mixture of fluorescent materials used in the phosphor coating.

The light that reaches the eye (and the camera) from such a lamp, therefore, consists of the light given off by these fluorescent compounds plus such part of the light from the mercury vapor that gets through them without being absorbed. The result is a continuous spectrum produced by the fluorescent material, superimposed upon the line spectrum of energy produced through the electrical discharge of the mercury vapor. The spectral-energy distributions for three of the more commonly encountered fluorescent lamps are illustrated in Figure 5-26.

Notice that the discontinuous line spectrum occurs at the same wavelengths for all three sources, indicating that the same vapor is present for all three. The differences in the continuous portion of the distributions are the result of different phosphors coating the inside of the tubes. The lamp labeled "cool white fluorescent" produces more blue light, while the lamp labeled "warm white fluorescent" produces more red light. However, it must be remembered that the color of the light being produced by these sources has no relationship whatever to the operating temperature of the source. Therefore, the terms cool and warm relate only to the visual appearance of the light and do not describe either the temperature of the source or the photographic effect of the light. The source labeled "daylight fluorescent" produces light approximately the same visual color as daylight, has a correlated color temperature of 7000 K. It should be noted that the spectral energy curve for this lamp bears little relation to the energy distribution of actual daylight. The correlated color temperatures of these sources will give information about their appearance, but are of little use in determining their photographic effect.

Fluorescent lamps with a correlated color temperature of 5000 K (such as the General Electric Chroma 50[®]) are believed to give a better match to daylight and are now specified in ANSI standards for transparency illuminators and viewers. Fluorescent lamps find wide-spread use because they generate very little heat and are less expensive to operate (i.e., have higher luminous efficiency) than tungsten lamps. Additionally, they are low luminance sources, because they possess larger surface areas than do tungsten lamps. The result is that these lamps have less glare and produce softer illumination. Fluorescent lamps are nearly always used for commercial lighting and, consequently, photographers working under such light conditions should be familiar with their characteristics.

Circular fluorescent tubes are sometimes employed as light sources in enlargers and are often referred to as "cold" light sources. The benefits obtained are related both to the diffused nature of the light, which softens the contrast of the image, and an improvement in the evenness of illumination at the negative. Also, since these sources produce very little heat, they do not cause negatives to buckle in the negative carrier.

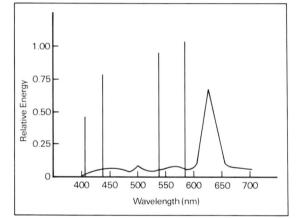

Figure 5–27 Spectral-energy distribution of a highintensity mercury discharge source with the name DeLuxe White.

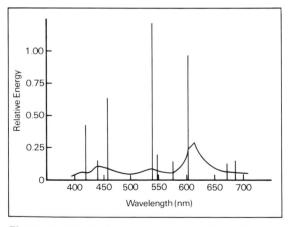

Figure 5–28 Spectral-energy distribution of a highintensity metal halide discharge source, the General Electric Multi-Vapor[®] lamp.

5.12 Practical Sources of Light and Their Properties

The luminous efficiency of fluorescent lamps is generally higher than that of tungsten sources, ranging between 40 and 60 lm/W, making them more economical to operate. Additionally, the average life of a fluorescent lamp is approximately 5,000 hours, which is nearly five times as long as that of a conventional tungsten lamp.

5.12.5 High-Intensity Discharge Lamps

Similar in operation to fluorescent lamps, high-intensity discharge lamps produce light by passing an arc between two electrodes that are only a few inches apart. The electrodes are located in opposite ends of a small sealed transparent or translucent tube. Also contained within the tube is a chemical atmosphere of sodium and/or mercury. The arc of electricity spanning the gap between the electrodes generates heat and pressure much greater than in fluorescent lamps, and for this reason these lamps are also referred to as high pressure discharge sources. The heat and pressure thus generated are great enough to vaporize the atoms of the various metallic elements contained in the tube. This vaporization causes the atoms to emit electromagnetic energy in the visible region. Since the physical size of the tube is small, it allows for the construction of optical sources that have excellent beam control. Such sources are frequently employed for nighttime illumination of sports stadiums, highways, exteriors of buildings and the interiors of large industrial facilities.

As in the operation of low-pressure discharge sources (i.e., fluorescent lamps), high-intensity discharge lamps produce spikes of energy at specific wavelengths. These peaks are the result of specific jumps of the electrons within the atomic structure of the metallic elements. Energy is emitted in peaks located in different positions of the visible spectrum for each element. Thus these lamps do not have a true color temperature, since they are not temperature dependent for the color of light emitted. The three most commonly encountered highintensity discharge sources are:

- 1. Mercury. For clear mercury lamps, the spectral peaks occur at 365, 405, 436, 546, and 578 nm, as illustrated in the spectral-energy distribution shown in Figure 5-7. In practice, the lamp's outer bulb absorbs most of the ultraviolet energy. Clear mercury lamps are seldom used today because of their poor color-rendering ability. Since they emit virtually no red light, they appear very blue and are almost impossible to filter for acceptable color photography. The more frequently encountered mercury lamp is the phosphorcoated type labeled DeLuxe White. The phosphor coatings applied to the lamp's interior are excited by the ultraviolet energy and, in turn, emit visible energy with continuous characteristics, thus improving the color-rendering properties of the mercury lamp. The relative spectral output for such a lamp is illustrated in Figure 5-27. The light produced appears bluish-white and tends to desaturate the appearance of reds. An improved version of this lamp, labeled DeLuxe Warm White, tends to improve the appearance of reds, as a result of employing a phosphor material that emits more red light.
- 2. Metal halide. These are primarily mercury-vapor sources with small amounts of sodium, indium and thallium iodides added. The resulting spectral-energy distribution is shown in Figure 5–28. The line spectrum of the mercury is suppressed, and the majority of the light is produced at 410, 451, 535, and 590 nm, which is characteristic of the metal iodide additives. The result is more

5.12 Practical Sources of Light and Their Properties

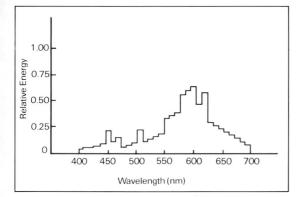

Figure 5–29 Spectral-energy distribution of a highintensity sodium-vapor discharge source, the General Electric Lucalox[®].

equal spacing of the peaks, and the relative energy at each peak yields whiter light and provides improved color rendering.

3. Sodium. As discussed earlier, low-pressure sodium discharge lamps emit energy only at the wavelength of 589 nm. However, under the temperature and pressure present in a high-intensity discharge lamp, the sodium vapor emits a relatively continuous spectral energy distribution as shown in Figure 5–29. Trace amounts of mercury are also contained in the tube, producing small light output at the mercury lines. The visual result is a yellowish-white light. The most frequently encountered such lamp is the General Electric Lucalox[®].

Since their introduction in the 1950s, high-intensity discharge sources have steadily increased in use. Mercury vapor lamps were the first lamps of this type available. Although their efficiency was high (17 to 46 lm/W) compared to tungsten, their color-rendering ability was poor. Today, the metal halide (54 to 92 lm/W) and sodium lamps (59 to 106 lm/W) are preferred for both efficiency and improved color rendering. However, these sources pose the same problems photographically as do fluorescent lamps. The use of color temperature and the mired scale is entirely inappropriate for those sources. The results of testing specific sources with specific color films to obtain acceptable color balance are summarized in Table 5–5. The filtration conditions

 Table 5-5
 Guides for initial tests when exposing color films with fluorescent and high intensity discharge lamps.

		KODAK Color Film Type				
Type of Lamp	Group 1ª Daylight Balance	Group 2ª Daylight Balance	Group 3 ^a Tungsten Balance	Group 4 ^a Tungsten Balance		
Fluorescent						
Daylight	40M + 40Y	50M + 50Y	$85B^{b} + 40M + 30Y$	$85^{d} + 40M + 40Y$		
	+ 1 stop	$+1\frac{1}{3}$ stops	$+ 1^{2/3}$ stops	$+ 1^{2/3}$ stops		
White	20C + 30M	40 M	60M + 50Y	40M + 30Y		
	+1 stop	$+\frac{2}{3}$ stop	$+ 1^{2/3}$ stops	+1 stop		
Warm white	40C + 40M	20C + 40M	50M + 40Y	30M + 20Y		
	$+1\frac{1}{3}$ stops	+1 stop	+1 stop	+1 stop		
Warm white deluxe	60C + 30M	60C + 30M	10M + 10Y	No Filter		
	+2 stops	+2 stops	+ ² / ₃ stop	None		
Cool white	30 M	40M + 10Y	10R + 50M + 50Y	50M + 50Y		
	$+\frac{2}{3}$ stop	+1 stop	$+ 1^{2/3}$ stops	$+1\frac{1}{3}$ stops		
Cool white deluxe	20C + 10M	20C + 10M	20M + 40Y	10M + 30Y		
	$+\frac{2}{3}$ stop	$+\frac{2}{3}$ stop	+ ² / ₃ stop	$+\frac{2}{3}$ stop		
Average fluorescent ^c	10B + 10M	30 M	50R	40R		
	$+ \frac{2}{3}$ stop	+ 2/3 stop	+1 stop	+ 2/3 stop		
High-Intensity Discharge Lamps						
General Electric Lucalox ^{®d}	70B + 50C	80B + 20C	50M + 20C	55M + 50C		
	+3 stops	$+2\frac{1}{3}$ stops	+1 stop	+2 stops		
General Electric Multi-Vapor®	30M + 10Y	40M + 20Y	60R + 20Y	50R + 10Y		
-	+ 1 stop	+1 stop	$+ 1^{2/3}$ stops	$+1\frac{1}{3}$ stops		
Deluxe white mercury	40M + 20Y	60M + 30Y	70R + 10Y	50R + 10Y		
	+ 1 stop	$+1\frac{1}{3}$ stops	$+ 1^{2/3}$ stops	$+1\frac{1}{3}$ stops		
Clear mercury	50R + 30M + 30Y	$50R + 20M + 20Y^{e}$	90R + 40Y	90R + 40Y		
	$+ 1^{2/3}$ stops	$+1\frac{1}{3}$ stops	+2 stops	+2 stops		
Sodium vapor	NR	NR	NR	NR		

Note: Red or blue filters have been included to limit the number of filters to three.

^aGroup 1 includes KODAK EKTACHROME 200; KODACHROME 25; KODAK VERICOLOR II, Type S; KODACOLOR II and KODACOLOR 400 Films.

Group 2 includes KODACHROME 64, KODAK EKTACHROME 64, and KODAK EKTACHROME 400 Films.

Group 3 includes KODAK EKTACHROME 50; KODAK EKTACHROME 160; and VERICOLOR II, Type L Films.

Group 4 includes KODACHROME 40 Film.

^bKODAK WRATTEN Gelatin Filter No. 85B. ‡KODAK WRATTEN Gelatin Filter No. 85.

^cUse of these filters will yield results of less than optimum correction. They are intended for emergency use only, when it is impossible to determine the type of fluorescent lamp in use.

^dThis is a high-pressure sodium vapor lamp; however, the *Guides for Initial Tests When Exposing Color Films with Fluorescent and High Intensity-Discharge Lamps* may not apply to other makes of high-pressure sodium vapor lamps due to differences in spectral characteristics.

"For KODAK EKTACHROME 400 Film, use 25M + 40Y and increase the exposure 1 stop.

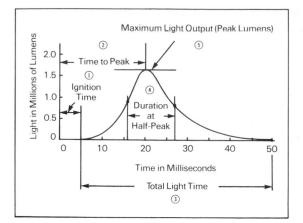

Figure 5-30 Light-output curve of a flashlamp.

only represent starting points for individual tests, since lamps and films are affected by problems of variability. Additionally, alternating current causes fluorescent and high-intensity discharge lamps to flicker. This effect is typically not visible due to the persistence of vision (see Section 13.1), but it can lead to unevenness of exposure across the film plane at shutter speeds faster than 1/60 second with focal-plane shutters. The same phenomenon can lead to underexposure when using a betweenthe-lens shutter at higher speeds.

5.12.6 Flashlamps

A flashlamp consists of a glass bulb enclosing aluminum or zirconium, in the form of shredded foil or fine wire, in an atmosphere of oxygen, as well as a filament of tungsten. By applying an electrical current, the filament is heated to ignite a primer, which in turn ignites the foil. Since this foil is in the presence of oxygen, it is consumed rapidly, producing a brilliant flash of light for a very brief duration.

The characteristics of flashlamps are best illustrated through the use of a time-light curve in which flux in lumens is plotted against time in milliseconds (1 ms. = 1/1000 second), as illustrated in Figure 5-30. In this graph, flux (in millions of lumens) is found on the vertical axis, and the time in milliseconds of the flash operation is located on the horizontal axis. This graph indicates that the light output for a flashlamp changes dramatically over its duration of operation. The essential information about the time-light characteristics of flashlamps is derived from these curves in the following manner:

- **1.** The time from the application of the electrical current to the beginning of the curve is termed the ignition time.
- **2.** The time from the application of the electrical current to the maximum output is called the time to peak.
- **3.** The time from the beginning of the curve to its end is the total light time.
- **4.** The flash duration is the time in milliseconds over which the light output is at least one-half the peak value. This is sometimes referred to as duration at half-peak.
- **5.** The maximum light output occurs at the top of the curve and is referred to as peak lumens.
- The total light output is found by multiplying the flux by the 6. time and is typically expressed in lumen-seconds. Since for flashlamps the number of lumens varies with time, a straight multiplication will not do. It is the area contained under the flashlamp curve, which shows the total quantity of light. The resulting number only suggests the total light available from the flashbulb when used on open flash because it measures the light without regard to the direction. If a reflector were used with the flashlamp, a considerably different amount of light would be directed toward the subject. Additionally, this value includes even the very weak light at the beginning and end of the flash, which may not reach the film when the flashlamp is used with a synchronized shutter set at a high speed. It is conventional to start counting the effective time of flash from the moment the lamp curve gets up to half its maximum level, and to stop counting time after the lamp gets down to half peak again. This time interval is called duration at half peak.

Successful synchronization with flashlamps requires a delicate

dovetailing of the shutter operation and the flashlamp operation. The marked shutter speed for a between-the-lens shutter should be the effective time of operation, calculated from half open to half closed. The ideal relationship between the shutter and the lamp occurs when the peak output of the lamp comes substantially at the center of the open time for the shutter. As a result, flashlamps are usually divided into four classes. Those lamps designated as F (fast) are intended for use with shutters without a timing delay mechanism. M-type lamps (medium) are intended for use with synchronizing shutters having a delay mechanism. Class S lamps (slow) are designed for open flash at speeds of 1/25 second or longer. Lamps with the designation FP are intended for use with cameras equipped with focal-plane shutters. Delays between closing the circuit and peak light output are F = 5 ms, M = 14-20 ms, S = 30 ms. Because there are many ways of measuring the flashlamp light output, and many variables to be synchronized, it is invariably necessary to determine the proper conditions of use through a practical test of the bulb with the camera to be used.

The light emitted by flashlamps shows a continuous spectrum with a color temperature of nearly 3800 K. When these lamps are used with a color lillin having chlici Type. It in daylight sensitization, color-correcting filters must be used over the camera lens. Some types of flashlamps are available with a transparent blue coating over the bulb, which provides a mired shift suitable to convert the color temperature to 5500 K. Such lamps are intended for use with daylightbalanced color films, and are also suitable for black-and-white photography.

5.12.7 Electronic Flash

An electronic flash lamp consists of a glass or quartz tube that is filled with an inert gas such as xenon and has electrodes placed at either end. When a high-voltage current from the discharge of a capacitor passes between the electrodes, the gases glow, producing a brilliant flash of light. The total time of operation is exceedingly short, with the longest times being on the order of 1/500 second and the shortest times approaching 1/100,000 second. The time-light curve for a typical electronic flash unit is shown in Figure 5-31. The effective flash duration is typically measured between one-third peak power points, and the area contained under the curve between these limits represents nearly 90% of the total light produced. If this number is measured in lumen seconds, the light being emitted in all directions is considered. A more revealing measurement is the number of effective beam-candle-power seconds, which is a measurement of the light output at the beam position of the lamp.

Synchronization is a simple matter for between-the-lens shutters with these lamps since, in effect, open flash is being used in all shutter speeds, and all that is necessary in synchronization is to ensure that the shutter is fully open before the lamp is flashed. Synchronizing shutters with an "X" setting for electronic-flash lamps have contacts that make contact the moment the shutter blades are fully open. With a focal-plane shutter, synchronization requires the entire area of the film to be uncovered by the curtain at the moment of flash. On most 35 mm cameras this is possible only at exposure times no longer than 1/60 second, although some newer cameras permit the use of shorter times. Thus, the exposure time is dictated by the duration of the flash, which, being extremely short, accounts for the motion-stopping ability of these lamps.

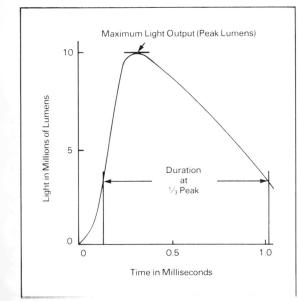

Figure 5-31 Light output curve of an electronic flash unit.

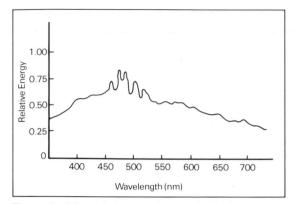

Figure 5–32 Relative spectral-energy distribution of a typical xenon-filled electronic flash unit.

The spectral-energy distribution of these sources shows a line spectrum, the exact nature of which is determined by the type of gas dispersed in the tube. Although the gas gives a line spectrum, there are so many lines and they are so well distributed throughout the visible spectrum that no serious error is involved in considering the spectrum to be continuous, as shown in Figure 5–32. The spectrum from the gas in these tubes approaches incandescence due to the high-current density at the time of discharge. The resulting light has a correlated color temperature of approximately 6000 K, which is conveniently close to the 5500 K level at which daylight color films are designed to operate. The small difference in color temperature is often compensated for by using a color-correction filter built into the lens of the flash unit. If no such filter exists in the source, a color-correction filter can be used over the camera lens to avoid a bluish cast in the color images.

The total light output for an electronic-flash unit depends upon the design of the flashlamp and reflector, the voltage, and the capacity of the capacitor. While there are special exposure meters available for use with electronic flash units, camera settings for these sources are usually derived from guide numbers or with automatic control systems (see Sections 3.30 and 3.31). The guide number for a given source is divided by the distance of the subject to obtain the f-number to be used for the exposure. For example, if the guide number is 110 and the subject is 10 feet from the flash unit, f/11 is the proper aperture to use. For an electronic flash, the guide number is a function of the reflection factor of the reflector, the film's ASA speed, the energy being supplied to the flash tube, and the efficiency in lumen-seconds per watt second.

For many on-camera electronic flash units the formula for the guide number reduces to the following:

Guide Number = $\sqrt{(s \times BCPS)} \times k$

where s is the ISO (ASA) speed of the film, BCPS is the beam-candlepower second output of the flash unit and k is a constant. If the guide number is expressed in feet, k is 0.25, while for the guide number in meters it is 0.075. For example, if an electronic flash unit with an output of 4100 BCPS is to be used with an ISO (ASA) 100 film, the resulting guide number in feet would be found as follows:

> G.N. = $\sqrt{100 \times 4100} \times 0.25$ = $\sqrt{41,000} \times 0.25$ = 640 × 0.25 = 160.

The resulting guide number of 160 means that at a distance of 10 feet, the correct aperture would be found by dividing 160 by 10, giving 16; therefore f/16 is the appropriate aperture. Guide-number ratings are routinely supplied by the manufacturers of electronic flash units. Whether obtained from manufacturer's data sheets or a practical test, the guide number must still be related to subject conditions. Indoor use of electronic flash in small rooms with white walls can increase the guide number by one third. For outdoor-flash photographs without reflected light from surroundings, the guide number can be reduced by the same one third.

Many electronic flash units have an automatic exposure con-

trol system that serves to regulate the flash duration. A small solidstate cell with a very fast response time is linked to an integrating circuit. The latter is arranged to trigger a quenching circuit when the photo cell has received a predetermined amount of light. The quenching circuit can divert the voltage from the flash tube to a second tube, which is not allowed to emit any light in the direction of the subject. Newer units contain circuitry for extinguishing the flash without wasting the remaining energy stored in the capacitor through the use of a solid-state switch, which is used to interrupt the discharge circuit when the sensor indicates that sufficient light has been obtained.

In summary, electronic flash units have proven to be a most useful source of light for photographers. Their consistency in color output, quantity of light output from flash to flash, and the extremely short duration of the flash are all reasons for the widespread use of these sources.

5.13 Lasers

The word *laser* is an acronym for "light amplification by stimulated emission of radiation." Othnulated emission is a process by which a photon of light stimulates an excited atom to emit a second photon that is at the same frequency and moves in the same direction as the initiating wave. This concept is sometimes referred to as optical pumping, which is the process whereby matter is raised from a lower to a higher energy state.

For example, the potential energy of water is raised when it is pumped from an underground well to a storage tank on top of a tower. There are many forms of matter that can be elevated or pumped, from one energy level to a higher one, by optical methods. It has been discovered that the atoms of some substances will absorb photons of light and when doing so increase their energy level. It has also been discovered that the excited atoms do not remain in the higher energy state but fall randomly and spontaneously to their lower or ground state. When this occurs, the stimulated atom emits a photon of light. Therefore, the laser medium is a substance such as a gas, liquid, or solid that amplifies the light waves by means of the stimulated emission process. Energy must be pumped into the laser medium to make it active. One way to supply this pumped energy is with light from an external source such as a flash tube.

Figure 5-33 illustrates the basic properties of a ruby laser. A ruby crystal rod has parallel polished ends and are mirrored surfaces. One end is only partially silvered and acts as a window for the light to escape. Energy is supplied to the ruby crystal by a powerful electronic flash tube, which serves to pump the atoms of the crystal to a higher energy state. They exist at this level for a few millionths of a second before dropping to their ground level, resulting in the emission of a photon of light as shown in Figure 5-33A. Although many of these photons will pass out of the crystal walls and be lost, eventually one photon will move directly along the rod and be reflected from the polished ends, passing back and forth along the rod until it encounters an atom in the excited elevated state, as shown in Figure 5-33B. As it strikes this excited mirrored atom, the atom radiates its photon in exact phase with the photon that struck it. This second photon will in turn stimulate another atom and, in this cascade process, continue to fill the rod with in phase radiation that is oscillating back and forth between the mirrored ends of the rod. A portion of this radiation is

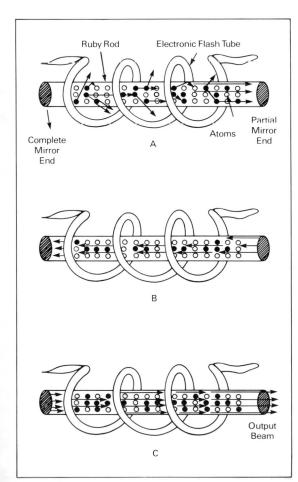

Figure 5–33 Dasic operation of a ruby laser (the principle of "optical pumping").

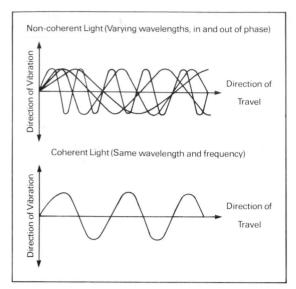

Figure 5-34 Noncoherent and coherent light waves.

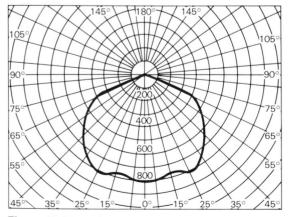

Figure 5–35 *Polar-coordinate plot of intensities for a lamp-reflector combination.*

emitted through the partially silvered end of the rod and becomes the laser beam (see Figure 5-33C).

The entire process occurs within a few thousandths of a second, and as the flash tube fires again, the process repeats itself. The result is an intense, monochromatic beam of light that can be focused to a tiny spot. Lasers emit light waves that are in phase with each other, and are described as being coherent. Conventional light sources radiate light of varying wavelengths in and out of phase with each other, which is described as noncoherent light. This concept is illustrated in Figure 5-34. It is this high degree of coherence that makes laser light different from that of all other sources.

5.14 The Language of Light

The intelligent selection and application of light sources requires a familiarity with the units of light measurement. Photometry is the branch of physics dealing with the measurement of the strength of light emitted by a source or the light falling on, transmitted by, or reflected from a surface. From the early 1900s, when the science of light measurement was first seriously undertaken, candles were used as the standard sources of light. Consequently, many of the definitions and units of measurement are based on the candle. However, since 1940 the international standard unit for light sources is based on the light emitted by one square centimeter of a blackbody radiator heated to the melting point of platinum, providing a standard that is more exactly reproducible. This standard unit of light is called the candela. The difference in light emitted by this new standard and the old standard candle is less than 2%.

5.15 The Measurement of Intensity

Intensity (sometimes called luminous intensity) is a measure of the rate at which the source emits light in a given direction. Initially, the intensity of a source was determined by comparison to the old standard candle, with the result expressed in terms of candlepower. Thus a 50-candlepower source was one that emitted light equivalent to that which would come from 50 of the standard candles. The correct unit now is the candela. One candela is defined as one sixtieth the light from one square centimeter blackbody heated to the freezing temperature of platinum. However, the term candlepower is still often used to describe intensity. Practical sources of light such as tungsten lamps and fluorescent tubes always vary in their intensity with direction, and therefore no single measurement of intensity can completely describe such sources. Perhaps the easiest way to understand the concept of intensity is to think of a ball-shaped lawn sprinkler with many holes through which the water can flow. The intensity of such a source would be similar to the rate at which water was being emitted through one of those holes in a specific direction. Such information would be of limited value since it would not describe the variation in intensities around the ball nor the total amount of water being emitted by the sprinkler.

Since the intensity of a real source changes with direction, it is desirable to learn about the distribution of intensities. Such information is usually provided by the lamp manufacturer in the form of a two-dimensional graph based on polar coordinates, an example of which is shown in Figure 5–35. In this graph, intensity is plotted against the angle on special paper, called polar-coordinate graph paper,

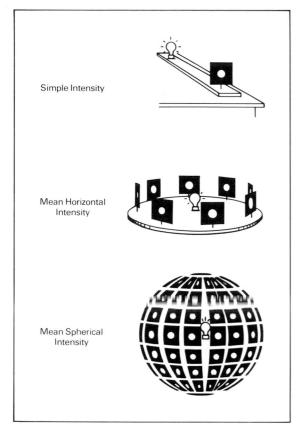

Figure 5-36 The measurement of intensity.

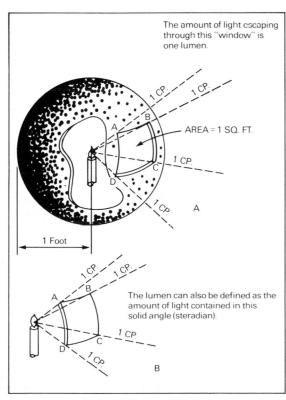

Figure 5–37 The relationship between candelas and lumens.

that is constructed like a protractor with the angles marked around the margins and each angle having a marked value in candelas. The zero angle is head-on to the lamp, with the intensity in this direction known as the beam intensity (candlepower). From such a graph the intensity at any desired angle can be found.

For the lamp-reflector combination illustrated in Figure 5–35, the beam intensity is approximately 800 candelas. This intensity is nearly uniform, within 25° either side of the beam position, indicating that this lamp-reflector combination provides nearly uniform illumination over a 50° angle of projection. At 65° off the beam position the intensity drops to nearly 400 candelas. The same lamp equipped with a more narrowly curved reflector would produce a distribution of intensities much narrower than what is shown in Figure 5–35. Therefore, such polar-coordinate plots give fundamental information about the nature of the light that will be emitted.

When the intensity of a source is reported as a single value, there are three ways in which this value can be obtained, as illustrated in Figure 5–36. In the simplest case, the intensity in only one direction to espected and the value reported as a single randels value. When a number of readings are taken at uniform intervals on a horizontal plane around the source and then averaged, the result is the mean horizontal intensity (candlepower) of the light source. Instead of taking a large number of individual readings, this result is obtained in ordinary practice by rotating the source rapidly upon its vertical axis while a single reading is made. The intensity of light in all directions can be determined by measuring intensities at uniform intervals around the light source. An average of these readings would give the mean spherical intensity (candlepower) of the illuminate. It should be noted that this value is related to the total light output of the lamp. In each of these cases, the intensity is determined through comparison to a standard lamp at a variety of distances.

5.16 The Measurement of Flux

Flux (sometimes called luminous flux) is the rate at which a source emits light in all directions. The flux of a source is usually calculated from measurements of intensity and is closely related to the measurement of mean spherical intensity previously discussed. The unit of measurement is the lumen. Since flux involves the output of light in all possible directions, the lumen therefore involves a three-dimensional concept.

The lumen may be defined as the amount of light falling on a surface one square foot in area, every point of which is one foot from a uniform source of one candela (candlepower). The relationship between the candela and the lumen is illustrated in Figure 5–37. If the opening indicated by A,B,C,D is one square foot of the surface area of a sphere of one-foot radius, the light escaping will be one lumen. If the area of this opening is doubled, the light escaping will be 2 lumens. Since the total surface area of a sphere with a one-foot radius is 12.57 square feet (i.e., $4\pi r$), a uniform one-candela source of light emits a total of 12.57 lumens. Thus a source of 10 mean spherical candelas emits 125.7 lumens. Since an area of one square foot on the surface of a sphere of one-foot radius subtends a unit solid angle (i.e., one steradian) at the center of the sphere, the lumen may also be defined as the amount of light emitted in a unit solid angle by a source having an average intensity of one candela throughout the solid angle. Therefore, when considering

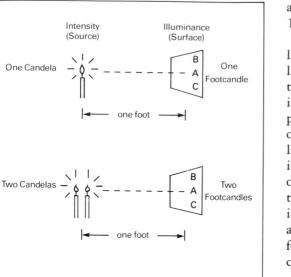

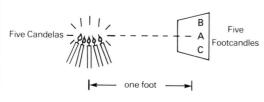

Figure 5–38 The relationship between intensity and illuminance for a constant distance of one foot.

a point source that emits light equally in all directions, there will be 12.57 (4π) lumens of flux for every candela of intensity.

However, real sources, such as tungsten lamps, do not emit light equally in all directions. For these sources the relationship between lumens and candelas is more nearly 10 lumens for every candela, due to the interception of light by the base of the lamp. The flux of a lamp is often multiplied by the average number of hours in its lifetime to produce a rating called lumen hours. These ratings are typically found on household tungsten lamps and provide a basis for comparing the lamps of different brands and of different wattages. A similar concept is used for flashbulbs, but the rating is given in lumen seconds because of the shorter lifetime of these lamps. In most photographic applications, just knowing the flux of a lamp is not worth much because it includes all of the light coming from the lamp regardless of its direction, as opposed to just the light traveling toward the subject. Therefore, for a given bulb, the reflector design will have a great effect on the quantity of photographically useful light.

5.17 The Measurement of Illuminance

Light sources may be termed the cause, and illumination the effect or result. Since candelas and lumens are both a measure of the cause, they apply only to the light source and not the effect obtained. Illuminance is defined as the light incident upon a surface. For the measurement of illumination, a unit known as the footcandle is often used.

A footcandle represents the illumination at a point on a surface that is one foot distant from, and perpendicular to, the light rays from a one candela source. For example, if the light source in Figure 5–38 has an intensity of one candela, the illuminance at point A, which is one foot distant from the source, will be equal to one footcandle. The illuminance at points B and C will be somewhat less because they will be at greater distances than one foot. Therefore, an illuminance reading applies only to the particular point where the measurement is made. By averaging the number of footcandles at a number of points, the average illumination of any surface can be obtained. This is often done when evaluating the evenness of illumination on an enlarger easel.

The footcandle is the unit of measure most closely associated with the everyday use of light. A working idea of this unit may be obtained by holding a lighted candle one foot from a newspaper in an otherwise darkened room. The result will be approximately one footcandle of illumination. A full moon on a clear night gives approximately 0.02 footcandle; a well-lighted street gives approximately 5 footcandles; a well-lighted classroom has nearly 50 footcandles of illumination; in daylight in open shade there are approximately 1,500 footcandles of illumination, and in direct sunlight approximately 12,000 footcandles.

Referring again to Figure 5–37, it is evident that the surface A,B,C,D fulfills the conditions for a surface illuminated to a level of one footcandle. Every point on this square foot of surface is perpendicular to the rays of a one-candela source that is one foot distant. This illustrates an important relationship between lumens and footcandles. A lumen is the light flux spread over one square foot of area that will illuminate that area to a level of one footcandle. Therefore, one footcandle is equal to one lumen per square foot. This relation forms the basis of a simplified method of lighting design known as the lumen

5.17 The Measurement of Illuminance

method. When the number of square feet to be lighted is known and the desired level of illumination determined, it is simple to determine the number of lumens that must be provided on the working plane.

For example, to illuminate 100 square feet to an average level of five footcandles, 500 lumens would have to be distributed uniformly over this area. This may be expressed in the following equation: Area (sq. ft.) \times Footcandles (Average) = Total Lumens.

Having defined the footcandle as a unit of illumination, the next point of interest is in seeing how the illuminance varies as the intensity of the source varies, and also as the distance of the plane from the source varies. Figure 5–38 shows that if instead of an intensity of one candela there is a source with an intensity of two candelas, the illumination at point A would be twice as great as before. If the intensity were increased to five candelas, illumination at point A would be five times as great. Thus, for a constant distance, the illuminance increases directly as a result of increases in the intensity of the source.

With a one-candela source, as shown in Figure 5-39, the level of illumination on point A, which is one foot distant, is one footcandle. However, if plane A is removed and the same beam of light to allowed to plane M, which is two boot any, this dome beam of light would now cover an area four times that of plane A. The average illumination on plane B would be one quarter as great as that on plane A, which would be equal to one-quarter of a footcandle. In the same fashion, if the beam of light is allowed to fall upon plane C, which is three feet away from the source, it will be spread over an area nine times as great as plane A, and so on.

Thus, illumination falls off (decreases) not in proportion to the distance but in proportion to the square of the distance. This relationship is known as the inverse-square law. It should be emphasized that this law is based on a point source of light from which the light rays diverge as shown in Figure 5–39. In practice, it applies with close approximation when the diameter of the light source is not greater than approximately one tenth the distance to the illuminated surface. The formula for the inverse square law is as follows:

$$E = \frac{l}{d^2}$$

where E is the illuminance in footcandles, I is the intensity of the source in candelas, and d is the distance of the surface from the source in feet. Likewise, illuminance measurements can be used to determine the intensity (expressed in candelas) of a source using the following relationship:

$$I = E \times d^2$$
.

An alternative unit commonly used in photography for expressing the measure of illuminance is the metercandle. The definition of a metercandle is similar to that of a footcandle, illustrated in Figure 5–38, except that the distance from the source to point A would be increased to one meter. Consequently, one metercandle is equal to the amount of light falling on a surface at a point one meter from a one candela source. Since the meter is a greater measure of distance than a foot, the inverse-square law governs the relationship between a metercandle and a footcandle. There are approximately 3.28 feet in one meter, and therefore one metercandle would be equal to 1 divided by 3.28^2 , which

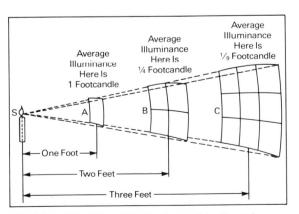

Figure 5-39 The relationship between intensity and illuminance for a constant intensity and varying source-to-surface distances (inverse-square law).

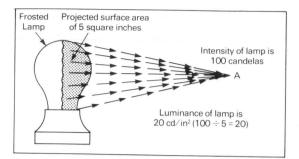

Figure 5-40 The concept of luminance.

equals 1/10.76, or 0.0929 footcandle. Therefore, 1 footcandle is equal to 10.76 metercandles. The term metercandle is becoming less frequently used; the preferred name is now *lux*. One lux is equal to one metercandle. In the photographic literature the lux (metercandle) measure of illuminance is more common than the footcandle.

When exhibiting reflection prints, the level of illumination can have a significant effect upon their appearance. Consequently, a number of standard conditions have been specified for viewing purposes and are summarized in Table 5–6. The variety of levels suggested is due in part to the differing visual tasks being performed. For example, the viewing of prints for comparison purposes requires a higher level of discrimination and, therefore, a higher illuminance level than does the viewing of a pictorial display. Further, since print judging and display involve subjective opinions, it should not be surprising that a variety of standards exist. Table 5–6 also contains the measured illuminance levels of some actual viewing conditions, indicating the range of illuminances that can be encountered when viewing reflection prints.

5.18 The Measurement of Luminance

Luminance can be defined as the rate at which the unit area of a source emits light in a specific direction. If a source is not a point source but has an appreciable size (as all real sources do), it is less useful to describe the intensity of such a source than to specify its luminance. Luminance is derived from intensity measurements, which are then related to the projected surface of the source.

Luminance is expressed in candelas per unit area (candelas per square foot, candelas per square inch, candelas per square centimeter, depending upon the size of the surface area being considered). For example, Figure 5-40 shows a frosted tungsten lamp with an intensity of 100 candelas in the direction of point A. This lamp has a projected area in that direction of 5 square inches. The luminance in that direction would then be 100 candelas divided by 5 square inches, equal to 20 candelas per square inch. Luminance is the photometric

Table 5–6 Standard illumination levels for viewing reflection prints and the measured

illuminances of actual areas.	
Standard Conditions	
ANSI PH2.41-1976, Comparison viewing	$2200 \pm 470 \text{lux}$
ANSI PH2.41-1976, Quality inspection	$1400 \pm 590 \text{lux}$
ANSI PH2.41-1976, Exhibition judging and display	$1400 \pm 590 \text{lux}$
PSA Uniform Practice No. 6	$753 \pm 215 \text{ lux}$
Transparency illuminator luminance	$1400 \pm 300 \text{ cd/m}^2$
Measured Illuminances of Actual Viewing Areas	
Photographic print darkroom with inspection light on only	5500 lux
Photographic print darkroom with tungsten room lights on only	175 lux
Photographic gallery A with tungsten and daylight (maximum)	5500 lux
Photographic gallery A with tungsten only (minimum)	2200 lux
Photographic gallery B with tungsten only (maximum)	5000 lux
Photographic gallery B with tungsten only (minimum)	500 lux
Photographic gallery C with tungsten and daylight (maximum)	1800 lux
Photographic gallery C with tungsten only (minimum)	440 lux
Photographic gallery D with tungsten only (maximum)	700 lux
Photographic gallery D with tungsten only (minimum)	440 lux
Typical college office with fluorescent and daylight	1400 lux
Typical college classroom with fluorescent only	1000 lux
Typical living room with tungsten and daylight (maximum)	100 lux
Typical living room with tungsten only (minimum)	75 lux

quantity that relates closely to the perceptual concept of brightness. The term *brightness* is used exclusively to describe the appearance of a source and, therefore, cannot be directly measured.

Generally, as the luminance of a source increases, so does the brightness of that source. If two 60-watt tungsten lamps are placed side by side, and one lamp is frosted while the other is clear, the clear lamp looks much brighter than the frosted lamp. Since they are both consuming the same amount of electrical energy and they both are using a tungsten filament, the intensities of the two lamps would be the same. However, the luminance of the clear bulb will be much greater since the projected area of the filament is much smaller than the projected area of the glass envelope on the frosted lamp. From this example it should be evident that knowledge only of the intensities of the sources would be very misleading, while knowledge of the luminance of the sources. Consequently, luminance data for real sources are always preferred over intensity data, when the visual appearance of the source is desired.

With photographic applications, high-luminance sources (such as clear tungsten lamps) will produce harsh lighting with sharply delineated shadows. The low-luminance sources, such as fluorescent tubes and floodlights with diffusing screens placed over them, will produce soft lighting with diffused shadows. It is important to note that the computation of luminance does not involve the total surface area of the lamp, but rather that portion of the surface area that is projecting the light in the direction of the subject.

The concept of luminance applies with equal validity to reflecting and transmitting surfaces as well as to light sources, since it makes no difference whether the surface being considered is originating the light or merely reflecting or transmitting the light. In this respect, if all of the light falling on a perfectly diffusing surface were reradiated by the surface, the luminance would be numerically equal to the illuminance. This does not happen, since real surfaces never reflect 100% of the light that strikes them. For this reason, it is necessary to determine the reflection factor of the surface, which is the ratio of the reflected light to the incident light. The following formula may be used:

Reflection factor $= \frac{\text{Reflected light}}{\text{Incident light}}$.

Thus, it can be seen that for perfectly diffusing surface, luminance equals illuminance multiplied by the reflection factor.

The most commonly used unit of luminance when considering reflecting surfaces is candelas per square foot, and the formula is:

$$L = \frac{K \times E}{\pi}$$

where L is the surface luminance in candelas per square foot, E is footcandles incident on the surface, and K is the reflection factor of the surface. As shown in Figure 5-41, the product of the reflectance and the illuminance must be divided by π (3.14), since the light is actually being emitted into a hemisphere of unit (one-foot) radius, and π is the ratio of the radius to the surface area of the hemisphere ($\pi = A/(2r)^2$).

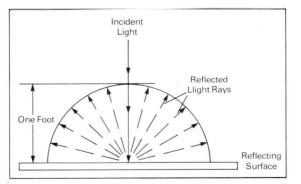

Figure 5–41 A perfectly diffusing surface; sometimes referred to as a lambertian surface.

For example, if a perfectly diffusing surface with 18% reflectance is being illuminated with 100 footcandles of light, the luminance of that surface is found by multiplying 0.18 by 100 divided by 3.14, which equals 5.73 candelas per square foot.

To avoid the necessity of dividing by π all the time, the concept of a footlambert was invented. The footlambert is defined as 1 divided by π candelas per square foot. Thus the above relationship reduces to:

$$L = K \times E$$

where L is now expressed in footlamberts. The footlambert is actually defined as the luminance of a 100%-reflecting surface illuminated by one footcandle of light. Therefore, the luminance of the graycard described previously would be found by multiplying 0.18×100 footcandles, which equals 18 footlamberts. Although the calculations are simpler for footlamberts, many modern photoelectric meters read the luminance directly in candelas per square foot, and therefore this is the more commonly used unit of measure in photography.

(These examples assume that the illuminated surfaces are perfectly diffusing (i.e., reflect equally in all directions), which is approximately true for mat surfaces. However, shiny surfaces give highly directional reflections and do not follow these formulas.)

The concept of luminance is particularly useful in photography since it provides a way of describing the light reflected from the surfaces of the subject being photographed. Whenever a reflected-light meter reading is made, it is a luminance measurement. Such data have the unique characteristic of being independent of the distance over which the measurement is made. For an example, if a hand-held meter with a 50° angle of view is used to measure the reflected light from a given surface, the luminance obtained will be identical to that which will be given by a spot-meter reading on the same area at the camera position. The reason for this independence is the fact that as the amount of light being measured from the original area decreases with increasing distance, the projected surface area included in the angle of view increases in direct proportion. Thus, the number of candelas per square foot will remain the same. This assumes, of course, a clear atmosphere exists between the meter and the surface area being measured, which is usually the case.

However, if the distance over which the measurements are made is very great, or if the atmosphere is unclear, as in a smoke-filled room, then significant differences will occur for such measurements. If the hand-held meter with a 50° angle of view is aimed at the subject from the camera position, a resulting luminance value will be the average amount of luminances in the field of view. If, however, the spot meter with a restricted angle of view of 1° or 2° is used from the camera position, selected areas of the subject can be measured and their individual luminances determined.

If such measurements are made in the darkest shadow and lightest highlight of the subject, the ratio of these luminances provides the basic measure of the subject contrast in the form of a luminance ratio. For example, if it is found that the darkest shadow has a luminance of 0.5 candelas per square foot, and the highlights have a luminance of 60 candelas per square foot, the luminance ratio is found by dividing 60 by 0.5 which gives a ratio of 120:1. This indicates that the highlights are reflecting 120 times as much light as the shadows in the direction of the camera lens. Such information is valuable in determining the nature of the contrast of the subject being photographed. The various conversions of illuminance data to luminance data are summarized in Table 5-7.

The photometric concepts discussed above are often employed to describe the properties and characteristics of all types of light sources. Table 5–8 summarizes the basic light terms and presents typical values for comparison purposes. It should be obvious from this table that light sources can be described in a wide variety of ways. Thus it is important to understand the differences in order to obtain appropriate information.

References

- American National Standards Institute, Activity or the Relative Photographic Effectiveness of Illuminats, Method for Determining (PH2.3-1972).
- ------, Camera Flash Sources, Determining and Specifying Spectral Distribution Index PH? 8 1081).
- _____, Exposure Guide Numbers (PH3.405-1984).
- ------, Flashlamp/Reflector Combinations, Method for Measurement of Light Output (PH3.407-1980).
- ——, Illuminants for Photographic Sensitometry: Simulated Daylight and Incandescent Tungsten (PH2.29-1982).
- ------, Photographic Electronic Flash Equipment (PH3.40-1977).
- —, Photographic Flash Lamps, Method for Testing (PH2.13-1965, R1971).
 - Photographic Still-Front-Projection Equipment, Illumination Tests (PH3.705-1980).

Table 5–7 Illuminance-luminance conversions. (Examples based on 18% reflectance neutral test card)

Illuminance to Luminance Luminance = illuminance × reflectance 1. Footlambert = footcandle × reflectance

- Luminance = 1.0 footcandle $\times 0.18 = 0.18$ footlambert 2. Apostilb = metercandle \times reflectance
 - Luminance = 1.0 metercandle $\times 0.18 = 0.18$ apostilb
- 3. Candela per square foot = footcandle \times reflectance/ π
- Luminance = 1.0 footcandle \times 0.18/3.1416 = 0.057 C/ft.²
- 4. Candela per square meter = metercandle \times reflectance/ π Luminance = 1.0 metercandle \times 0.18/3.1416 = 0.057 C/m²

Luminance to Illuminance

Illuminance = luminance/reflectance

- 1. Footcandle = footlambert/reflectance
- Illuminance = 1.0 footlambert/0.18 = 5.56 footcandles
- 2. Metercandle = apostilb/reflectance
- Illuminance = 1.0 apostilb/0.18 = 5.56 metercandles 3. Footcandle = candela per square foot $\times \pi$ /reflectance
 - Illuminance = $1.0 \text{ candela/ft.}^2 \times 3.1416/0.18 = 17.45 \text{ footcandles}$
- 4. Metercandle = candela per square meter $\times \pi$ /reflectance
- Illuminance = $1.0 \text{ candela/m}^2 \times 3.1416/0.18 = 17.45 \text{ metercandles}$

A perfect diffusely reflecting surface (100%) illuminated by 1 footcandle (1 lumen per square foot) will reflect 1 footlambert (1 lumen per square foot or $1/\pi$ candela per square foot).

Metric: A perfect diffusely reflecting surface (100%) illuminated by 1 metercandle (1 lumen per square meter or 1 lux) will reflect 1 apostilb (1 lumen per square meter or $1/\pi$ candela per square meter).

References

Popular Concept	Technical Term	Symbol	Unit	Abbreviation	Measurement (Practical)
1. Strength	Luminous intensity	Ι	Candela	с	Compute from illuminance and distribution
2. Strength	Luminous flux	F	Lumen	lm	1 (Mfr. data) or estimate: watt \times luminous efficiency
3. Strength/watt	Luminous efficiency	μ	Lumens/watt	lm/W	2 (Mfr. data)
4. Total light	Luminous energy	Q	Lumen-second	lm-sec	3 (Mfr. data) or integrate area under curve
5. Color	Wavelength	λ	Nanometer	nm	Spectrometer (electronic) Spectroscope (visual) Spectrograph (photographic)
6. Color balance	Color temperature	Т	Degree Kelvin	κ°K	4 (Mfr. data) or color-temperature meter
7. Source conversion	Mired shift		Mired	μrd	5 (Mfr. data) or compute: $\mu rd = \frac{10^6}{K_1} - \frac{10^6}{K_2}$
8. Brightness	Luminance	L	Candela/sq. foot	c/ft ²	Reflected-light meter
9. Illumination	Illuminance	E	Footcandle	ftc (fc)	Incident-light meter with flat
			Metercandle Lux	mc	surface
10. Exposure	Photographic exposure	Н	Footcandle-second	ftc-sec	Compute:
-			Metercandle-second	mc-sec	$H =$ illuminance \times time

Table 5-8 Ten basic light terms with typical examples of each.

Note: Concepts 1-8 apply to light sources. Concept 8, Luminance, also applies to reflected and transmitted light. Concepts 9-10, Illuminance and Photographic exposure, apply to light falling on a surface.

Typical Values:

		2—Luminous	
	1-Luminous Flux	Efficiency	3—Luminous Energy
40W tungsten lamp	472 lm	11.8 lm/W	AG-1 7,000 lm-sec
75W tungsten lamp	1,155 lm	15.4 lm/W	No. 22 70,000 lm-sec
100W tungsten lamp	1,750 lm	17.5 lm/W	4-Color Temperature
200W tungsten lamp	4,000 lm	20 lmW	
500W tungsten lamp (3200 K)	13,500 lm	27 lmW	Photographic lamp 3200 K
500W tungsten lamp (Photoflood)	17,000 lm	34 lmW	Photoflood lamp 3400 K
100W fluorescent	4,600 lm	46 lmW	Photographic daylight 5500 K
200W high pressure mercury	19,000 lm	45 lm/W	5-Mired Shift
200W high pressure mercury	22,000 lm	75 lm/W	85B Filter $+131 \mu rd$
			80A Filter $-131 \mu rd$

——, Safety Times of Photographic Darkroom Illumination, Methods for Determining (PH2.22-1978)

- ------, Screen Illumination of Front Projection Audiovisual Equipment, Method for Measuring (PH7.201-1983).
 - ——, Spectral Distribution Index of Camera Flash Sources, Method for Determining and Specifying (PH2.28-1981).
- Arnold, Rolls, and Stewart, Applied Photography.
- Burnham, Hanes, and Bartleson, Color: A Guide to Basic Facts and Concepts.
- Eastman Kodak, Applied Infrared Photography (M-28).
- ———, Color News and Documentary Photography with Fluorescent Lighting (H-9).
 - _____, Electronic Flash (Workshop Series).
- , Exposure with Portable Flash Units (AC-37).
- —, Kodak Infrared Films (N-17).
- ——, Medical Infrared Photography (N-1).
- —, Photographing Television Images (AC-10).
- , Ultraviolet and Fluorescence Photography (M-27).

Engel, Photography for the Scientist.

Evans, An Introduction to Color.

References

Hunt, The Reproduction of Colour in Photography, Printing and Television. Jacobson, et al., The Manual of Photography. Judd and Wyszecki, Color in Business, Science and Industry. Neblette, Fundamentals of Photography. Stimson, Photometry and Radiometry for Engineers. Thomas, SPSE Handbook of Photographic Science and Engineering. Todd and Zakia, Photographic Sensitometry.

Chemistry for Photographers

6.1 Silver Systems

From its inception up to the present, photography has depended mainly on the response of silver compounds to light. With some exceptions, the effect of light has been to produce a *latent image* on a light-sensitive surface that usually consists of an emulsion of one or more silver halides in gelatin. This image is made visible as the result of a chemical process known as *development*. After development, the image is made relatively permanent by fixing. That is, the silver halides that were not affected by the exposure in the camera are removed by converting the water-insoluble halides into a soluble complex that can be washed away, leaving only the silver image in the gelatin coating. This produces an image in which the areas that received the greatest exposure are darker than those areas that received less exposure. In other words, the photographic process is a *negative*-working process, in that the light tones in a scene are rendered dark, and the dark tones are rendered light.

8.2 Negative and Positive

In order to produce an image in which the areas of varying lightness correspond to the tones in the original object or scene, a positive print is usually made from the negative that was exposed in the camera. The dark areas in the negative allow little light to pass so that the tones in the positive appear light, as they did in the original scene. A positive can be a print or a transparency. In most cases the light-sensitive material on which the positive is made is also a silver halide emulsion, which is coated on a paper or film support and is developed and fixed in a way similar to that used for the negative.

Figure 6-1 The silver halide photographic process is a negative-working one. Exposure in the camera produces a negative image like that shown at the left. This negative is then printed on another negative working material, resulting in a positive image, such as that shown at the right.

6.3 Modification of Silver Images

Negative and positive silver images may be modified by other chemical reactions to enhance them in one way or another. In an overexposed or overdeveloped negative, for example, the dense silver image can be chemically reduced. Another process might be used to increase the density and contrast of the image if it has been underexposed or underdeveloped. These processes are known as *reduction* and *intensification*.

A positive print on paper owes some of its esthetic value to the color of the image. Image color is partly determined by the emulsion technique used in the manufacture of the paper, but chemical treatment of the silver image can also be resorted to after normal processing to modify the image color. This process is known as *toning*. The actual chemical makeup of the developer can also have an effect on the color of the "untoned" image, as well as on the final color of the image after treatment with one of the auxiliary toning processes.

6.4 Washing

In addition to the actual chemistry involved in the making of a photograph, other more physical parts of the process require consideration. These include the washing of the negative or print, after it has been fixed, to remove chemicals that could react with the image. If the processing chemicals are allowed to remain in the emulsion, they can be activated by later exposure to moisture, chemicals, gases in the atmosphere, or to energy such as light or heat, to alter the density or color of the image. If maximum permanence is required, it is essential that these excess chemicals be entirely removed, and washing becomes a very critical and important part of the process. In addition to thorough washing, the silver image is sometimes chemically modified to render it less susceptible to the effects of these deleterious agents. Archival processing procedures and equipment are used to achieve maximum permanence.

6.5 Drying

Improper drying after washing can harm the photographic image. Defects can be introduced into the negatives by physical distortions due to differential drying, such as when drops of water have been allowed to remain on the surface and thus take longer to dry than the remainder of the surface. Water spots and other defects are formed that will show in the print. A surface-active chemical, known as a *wetting agent*, is commonly used to reduce surface tension and therefore more evenly wet the surface, thus preventing the formation of spots.

6.6 Other Photographic Systems

There are other photographic systems that do not involve silver, and many of these have been in existence for almost as long as *silver photography*. They have been used mainly in printing from negatives to make positives. Research is continually being conducted to produce new non-silver systems, but products of this effort have had a low sensitivity to light, and have been too slow for practical exposures in the camera. Improvements are always being made, and some day the

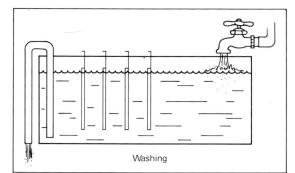

Figure 6-2 Section of a typical film washing arrangement. The films are submersed in a tank fed by running water. The drain is arranged to draw water from the bottom of the tank where the more dense hypo-laden water might tend to accumulate.

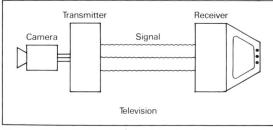

Figure 6-3 A signal generated by the television camera is sent to the transmitter from which it is broadcast to the home receiver, which converts the signal into a visual image, along with accompanying sound.

making of photographs without a silver halide emulsion may be a practical reality.

It is conceivable that one or more electronic methods of image making and recording could be substituted for the existing systems to produce photographs. Television is an electronic system for transmission of sound and images that has reached a high degree of refinement in a relatively short time.

A large part of the silver now being produced is consumed in photography, and as the metal becomes more scarce, it becomes necessary to recycle silver and to find another way to produce photographs economically. One such way is to use black-and-white film that uses silver for the initial image, which is later converted to a "blackand-white" dye image, allowing the silver to be reclaimed. In color photography, most of the silver can be recovered, as only a dye image remains on the film or paper.

Photographic chemical processes, like all processes, are subject to variability. The major factors affecting processing rate are time, temperature, agitation, and chemical makeup of the solutions.

6.7 Dusic Chamberry

In order to understand photographic chemistry, it is necessary to review the basic concepts of general chemistry. The universe is made up of a number of elements. Ninety two of these occur naturally, but elements heavier than uranium have been created by means of nuclear bombardment and radioactive decay. These elements have distinct characteristics and can be divided into two groups—metals and nonmetals. Each element is composed of atoms, which are the practical minimum particle that has the characteristic of an element. Scientists break the atom into smaller particles or subdivisions, but it is not necessary to go deeply into this to understand photographic chemistry.

6.8 The Periodic Table

In 1869 Mendeleyev arranged the then-known atoms into a table, according to their chemical and physical properties. At first there were 89 elements in the table. A few years ago this number had been extended to 103 (see Figure 6–4). More recently, it has been increased to 107, and more elements will likely be produced in the future. When recent information concerning the atomic structure became available, it gave further support to the arrangement of the table. The atomic number is equal to the positive charge of the nucleus in the atom, that is, the number of protons in the nucleus. The first column of the table contains the *alkalis*—lithium, sodium, potassium, rubidium, cesium and francium. Near the other side of the table can be found the *halogen* family, the *halides*—fluorine, chlorine, bromine, iodine and astatine. Other families of elements are similarly grouped in the table. The atoms marked with an asterisk (*) have significance in photography.

6.9 Atoms

The smallest atom is that of hydrogen, which consists of a single positive nucleus surrounded by one electron. All of the other atoms have a nucleus of higher positive charge, with corresponding electrons orbiting around the nucleus, and which have a total negative charge equal to the positive charge of the nucleus. Thus a stable atom

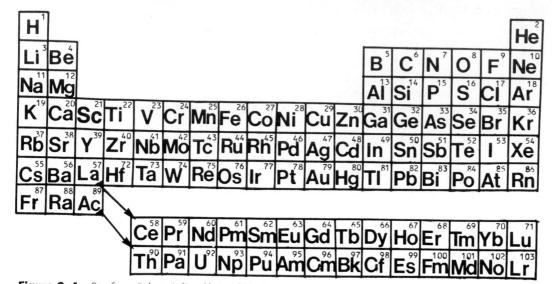

PERIODIC TABLE OF THE ELEMENTS

Figure 6-4 One form of the periodic table in which the atoms are arranged according to their chemical and physical properties. As the atomic numbers increase, so do the atomic weights.

Elements

Symbol		Atomic Number	Atomic Weight			Valence
Н	Hydrogen	1	1.0080	Lightest element. Almost never found free on earth.	*	1
He	Helium	2	4.0026	8% lighter than air. Used in balloons.		0
Li	Lithium	3	6.939	Lightest of solid elements.		1
Be	Beryllium	4	9.0122	Melts at 2345°F. Makes elastic alloys—in gears.		2
В	Boron	5	10.811	Nonmetal. In borax (sodium borate). Developer alkali.	*	3
С	Carbon	6	12.011	Diamond, charcoal, graphite. Many organic compounds.	*	2,4
N	Nitrogen	7	14.007	78% of air. Inert. Many compounds.	*	2,4
С	Oxygen	8	15.999	Most abundant element. Makes up half of all earth.	*	2
F	Fluorine	9	18.998	Most reactive of nonmetals. Corrosive.		2
Ne	Neon	10	20.183	Inert gas. Gives off orange-red light on electron bombardment.		-
Na	Sodium	11	22.990	Sixth most abundant element. Reacts violently with water. Developer alkali.	*	0 1
Mg	Magnesium	12	24.312	Eighth most abundant element. Burns with brilliant light.		2
A 1	Aluminum	13	26.982	Third most abundant element, most abundant metal.	*	3
Si	Silicon	14	28.086	Second most abundant element—1/4 earth's crust.		4
)	Phosphorus	15	30.974	Glows in dark. Used in detergents.	*	3,5
5	Sulfur	16	32.064	Readily combines with silver.	*	2,4
21	Chlorine	17	35.453	Almost as reactive as fluorine. Sodium chloride = salt.	*	1,3,5,7
١r	Argon	18	39.948	Most abundant of inert gases (noble). 0.934% of air.		0
<	Potassium	19	39.102	Seventh most abundant element. Developer alkali.	*	1
Ca	Calcium	20	40.08	Fifth most abundant element. Essential for bones and teeth.		2
Sc	Scandium	21	44.956	No practical use yet.		3
ſi	Titanium	22	47.90	Ninth most abundant element. White pigment in paper, etc.	*	3,4
7	Vanadium	23	50.942	Used to make tough steel.		3,5
Cr	Chromium	24	51.996	Used to make hard steel. Causes rubies to be red. Hardens gelatin.	*	2,3,6
A n	Manganese	25	54.938	Used to harden steel.	*	2,3,4,6,7
e	Iron	26	55.847	Fourth most abundant element, and cheapest.	*	
Co	Cobalt	27	58.933	Hardens steel. Colorant in ceramics. Medicine.		2,3 2,3
Ji	Nickel	28	58.71	Hard, durable. Used in plating other metals.		2,5
Cu	Copper	29	63.54	One of two colored metals.		1,2
ľn	Zinc	30	65.37	Used to galvanize metals. Bluish.		2
fa	Gallium	31	69.72	Low melting point, but boils at 3,600 F.		2,3
Ge	Germanium	32	72.59	Used for transistors. Resembles silicon.		4
As	Arsenic	33	74.922	Sublimes—vaporizes directly.		3,5

6.9 Atoms

Symbol		Atomic Number	Atomic Weight			Valence
Se	Selenium	34	78.96	Conductivity varies with light. Both metal and nonmetal.	*	2,4,6
Br	Bromine	35	79.909	Caustic, fuming liquid. Photographic emulsions, restrainer.	*	1,3,5,7
Kr	Krypton	36	83.80	Radioactive form is product of nuclear reactors.		0
Rb	Rubidium	37	85.47	Used in electric eye cells.		1
Sr	Strontium	38	87.62	Rare metal.		2
Y	Yttrium	39	88.905	A radioactive isotope used in medicine.		3
Zr	Zirconium	40	91.22	A metal unaffected by neutrons; hence inner lining for reactors.		4
Nb	Niobium	41	92.906	Used in steel, atomic reactors, etc. (Formerly columbium)		3,5
Mo	Molybdenum	42	95.94	Fifth highest melting metal. Used in boiler plate.		3,4,6
Tc	Technetium	43	(99)	First manmade element. First produced by atomic bombardment.		6,7
Ru	Ruthenium	44	101.07	Too hard and brittle to machine.		3,4,6,8
Rh	Rhodium	45	102.91	Makes lustrous hard coating for other metals.		3
Pd	Palladium	46	106.4	Corrosion resistant—used on electric contacts.		2,4
Ag	Silver	47	107.87	Best conductor of heat and electricity. Basic salt in photography.	*	1
Cd	Cadmium	48	112.40	Used to slow up atomic chain reactions.		2
In	Indium	49	114.82	Scarce, used in metal bearings, transistors, etc.		3
Sn	Tin	50	118.69	Resists rust and other corrosion; hence "tin" cans.		2,4
Sb	Antimony	51	121.75	Mixed with lead in batteries, and in type metal.		3 5
Те	Tellurium	57	127.60	One of section of section with the section of the s		2,4,8
Ι	Iodine	53	126.90	Formerly from seaweed, but now from oil-well brines. Photographic emulsions.	*	1,3,5,7
Xe	Xenon	54	131.30	Rarest gas in the atmosphere. Used in electronic flash.	*	0
Cs	Cesium	55	132.91	Softest metal—liquid at 83°F. Atomic clocks.		1
Ba	Barium	56	137.34	White sulfate used in "baryta coatings" on paper.	*	2
La	Lanthanum	57	138.91	Gives glass special refractive powers. Used in lenses.	*	3
Ce	Cerium	58	140.12	Most abundant of rare earths. Used in heat-resistant engines.		3,4
Pr	Praseodymium	59	140.91	Used with neodymium in special glasses.		3
Nd	Neodymium	60	144.24	Used to color glass purple, and to make UV transmitting glass.		3
Pm	Promethium	61	(147)	Only rare earth that has never been found in nature.		3
Sm	Samarium	62	150.35	CaC1 ₃ doped with samarium used to make lasers.		2,3
Eu	Europium	63	151.98	Most reactive rare earth. Can absorb more neutrons than any.		2,3
Gd	Gadolinium	64	157.25	Falls in middle of rare earth series.		3
Tb	Terbium	65	158.92	Very reactive; handled in vacuum or inert atmosphere.		3
Dy	Dysprosium	66	162.50	Used in reactors as a neutron-absorbing material.		3
Ho	Holmium	67	164.93	Absorbs neutrons. Used in reactors to control reaction.		3
Er	Erbium	68	167.26	Used in ceramics to produce a pink glaze.		3
	Thulium	69	168.93	When radiated produces an isotope giving X-rays for medicine.		3
Tm		70	173.04	Curiosity. Easily oxidized.		2,3
Yb	Ytterbium					2,5
Lu	Lutetium	71	174.97	Heaviest of rare earths. No practical value.		-
Hf	Hafnium	72	178.49	Great appetite for neutrons—used in reactor control rods.		4
Ta	Tantalum	73	180.95	Impervious to corrosion. Used in surgical repairs.	*	5 6
W	Tungsten	74	183.85	Highest melting metal (6170°F). Tungsten filaments.	*	0
Re	Rhenium	75	186.2	Ninth scarcest element. Second highest melting point.		2240
Os	Osmium	76	190.2	Pungent smell. Produces alloys of extreme hardness.		2,3,4,8
Ir	Iridium	77	192.2	Very hard. Hardens other metals.		3,4
Pt	Platinum	78	195.09	Used in weights and measures, jewelry, delicate instruments.	*	2,4
Au	Gold	79	196.97	Most malleable metal. Used for money, jewelry, dental.	*	1,3
Hg	Mercury	80	200.59	Used in thermometers, barometers, vapor lights.	*	1,2
Tl	Thallium	81	204.37	Used in rat poison.		1,3
Pb	Lead	82	207.19	Very durable—used in plumbing for centuries.		2,4
Bi	Bismuth	83	208.98	Forms low-melting-point alloys-fuses and sprinkler systems.		3,5
Po	Polonium	84	210	Scarcest natural element. Alpha particle source.		
At	Astatine	85	(210)	Radioactive and has maximum half-life of 8.3 hours.		1,3,5,7
Rn	Radon	86	222	Heaviest gaseous element. Radioactive. Treating cancer.		0
Fr	Francium	87	(223)	Product of the decay of actinium. Never actually seen.		1
Ra	Radium	88	226	Sixth rarest of elements. Luminous dials-radioactive.		2
Ac	Actinium	89	227	Second rarest of elements. Half-life of 22 years.		
Th	Thorium	90	232.04	Abundant. Can be used instead of uranium as a reactor fuel.		4
Pa	Protactinium	91	231	Third rarest of the elements.		
U	Uranium	92	238.03	Heaviest atom among the natural elements. Used in reactors.		4,6
Np	Neptunium	93	(237)	First synthetic element made from radium.		4,5,6

Figure 6-4 Elements

Symbol		Atomic Number	Atomic Weight		Valence
Pu	Plutonium	94	(242)	Used instead of uranium in the first atomic bombs.	3,4,5,6
Am	Americium	95	(243)	Produced by bombarding plutonium with neutrons.	3,4,5,6
Cm	Curium	96	(247)	Decay product of americium. Half-life = 19 years.	3
Bk	Berkelium	97	(249)	Only infinitesimal samples have been made.	3.4
Cf	Californium	98	(249)	Produced in very small amounts.	
Es	Einsteinium	99	(254)	First detected at time of Eniwetok H-bomb.	
Fm	Fermium	100	(253)	Discovered at Eniwetok explosion. Never enough to weigh.	
Md	Mendelevium	101	(256)	Only scant unweighable quantities ever produced.	
No	Nobelium	102	(254)	Claim of discovery disputed, but positively identified in 1958.	
Lr	Lawrencium	103	(257)	Latest artificial element. Made bombarding californium with	_
				boron nuclei.	

would be neutral. The *atomic number* is the number by which the charge on the hydrogen nucleus must be multiplied to equal the nuclear charge of the atom. These numbers determine the chemical behavior of the elements, and also support the arrangement of the atomic table (see Figure 6-5).

The various elements are designated by their symbols; that is, the symbol for hydrogen is H, He for helium, Na for sodium (for *natrium*, its Latin name), K for potassium (*kalium*), and so on. Strictly speaking, a single atom can be called a molecule—i.e., a "monatomic molecule"—or two or more atoms can be combined, such as O_2 and O_3 to become molecules of oxygen and ozone that are made up of more than one atom of oxygen; or molecules can be composed of different atoms. In the latter case they are called *chemical compounds*. Potassium bromide is a compound commonly used in photography.

Some compounds are made up of more than two elements, in which case two or more of each of the elements assume the charge characteristic of a single element. For example, ammonium chloride (NH_4Cl) in solution ionizes into NH_4^+ and Cl^- . The NH_4 is known as a *radical*.

Atoms ordinarily exist with a balance of charges; that is, the electrons orbiting the nucleus have an electron charge that balances the positive charge of the proton nucleus. Under certain conditions, a molecule can dissociate into separate atoms, each having a separate positive or negative electronic charge. Sodium chloride (NaCl), for example, when heated to make it molten, can exist with sodium atoms (Na⁺) and chlorine atoms (Cl⁻); or a solution of sodium chloride in water dissociates into atoms having $^+$ and $^-$ charges, which are identified as *ions*.

Chemical compounds have different physical characteristics than those of the atoms that are combined to make the compounds. Such attributes as melting points, solubility in water or other solvents, crystalline form and color, and specific gravity or density are some of the characteristics that differentiate various compounds. *Inorganic compounds* are those containing metals, and do not contain the element carbon, with the exception of the oxides of carbon—compounds containing the carbonate (CO₃) radical—carbon disulfide and a few other compounds. *Organic compounds* are those containing carbon—with the exceptions noted above—usually along with hydrogen, oxygen, sulfur, nitrogen, iodine, phosphorous, and other elements. Organic compounds are often not very soluble in water, and they are combined with sodium or similar alkali to form a salt that is more soluble, with the compound retaining most of its desirable photographic characteristics.

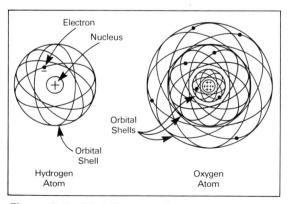

Figure 6-5 The bydrogen atom has one electron in orbit around a nucleus with a single positive charge. The oxygen atom has 8 electrons orbiting in shells around its nucleus, with an equal number of positive charges.

6.10 Valence

Depending on the free charges in their outer electron orbits, elements combine to form compounds in various whole-number proportions. Thus a sodium atom (ion) with a valence of one (Na⁺) and a chlorine atom (ion) with a valence of one (Cl⁻) combine to form NaCl, sodium chloride. Gold, with a valence of one or three, takes a valence of three (Au⁺⁺⁺) and each atom requires three chlorine atoms to form gold chloride (AuCl₃). Nitrogen can have a valence of three or five. Oxygen has a valence of two, so two atoms of nitrogen can unite with three atoms of oxygen to form N₂O₃ (nitrous anhydride). When nitrous anhydride combines with a molecule of water (H₂O), it forms two molecules of nitrous acid (2HNO₂).

6.11 Atomic Weight

The atomic weight is the relative weight of the atom—with that of oxygen taken as 16—or very near to the weight of the nucleus (protons + neutrons) of the atom. The malecular weight of a compound is the total of the weights of the atoms making up the molecule. To form a given quantity of a compound without any of the atomic or molecular components left over, the reaction is carried out with amounts that are proportional to their atomic or molecular weights. When 23 grams of sodium (atomic weight—23) are combined with 35.5 grams of chlorine (atomic weight—35.5), 58.5 grams of sodium chloride (molecular weight—58.5) are formed. A molar solution is one that has the same number of grams as the molecular weight dissolved in one liter of water. Such solutions would have equal numbers of molecules of chemicals dissolved in them, and equal numbers are then available for reaction. A molar solution of sodium chloride would contain 58.5 grams per liter.

6.12 Chemical Reactions

When two compounds in solution are mixed by adding separate solutions of the compounds together, a chemical reaction may take place. If the new compounds remain in solution, they assume an equilibrium of the ions, and the solution may take on some of the characteristics of either of the compounds in solution alone. If one of the products of the reaction is a gas, it is given off and removed from the reaction. If one of the products is a solid that is less soluble than either of the compounds entering into the reaction, a precipitate is formed, which is removed from the reaction. In either case, the reaction proceeds in the direction of the compound that is being removed, until the quantity that can remain in solution under the conditions is reached. If the reaction products (precipitate or gas) are removed, the reaction can continue as long as the unreacted chemicals are added.

For example, a solution of silver nitrate added to a solution of sodium chloride will form relatively insoluble silver chloride and soluble sodium nitrate. (Chemical reactions can be indicated by means of chemical equations.) Silver nitrate added to sodium chloride can be indicated by the following (see Figure 6-6):

$$\begin{array}{ccc} AgNO_3 + NaCI & \longrightarrow & AgCI + NaNO_3 \\ & \downarrow \\ (precipitate) \end{array}$$

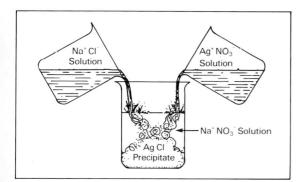

Figure 6-6 When clear, colorless solutions of sodium chloride and silver nitrate are added together a white insoluble previpitate of silver chloride is formed, along with a clear solution of sodium nitrate.

or more precisely,

$$Ag^+ NO_3^- + Na^+ CI^- \longrightarrow AgCI + Na^+ NO_3^-$$

The silver nitrate and sodium chloride in solution have dissociated into their ions or radicals. When the silver and chlorine ions combine, they no longer exist as ions, they are not dissociated, and are an insoluble *precipitate* that is removed from the reaction. Na⁺ and NO₃⁻ ions remain in the solution.

6.13 Oxidation/Reduction

Chemical reactions can take place without being in solution; that is, between solids, liquids and gases. When something burns, it means that oxygen has combined with it, giving off heat at the same time. This is referred to as *oxidation*. Whenever oxygen unites with any other material, oxidation takes place. Oxygen is called the *oxidizing agent*. The material with which the oxygen combines is referred to as the *reducing agent*. Thus, *reduction* also occurs when a material takes on oxygen—one is the reciprocal of the other.

The oxidation/reduction concept can be applied to elements other than oxygen. Any element that gains electrons more rapidly than another element is said to have higher oxidizing power. Conversely, any element that loses electrons more readily than another element is said to have higher reducing power. When silver metal is subjected to chlorine gas, the two elements combine to form silver chloride (see Figure 6–7). This is an oxidation/reduction reaction where the silver is oxidized (and the chlorine is reduced), even though no oxygen is involved.

When treated with a reducing agent, such as a solution of ferrous sulfate, the silver chloride will be converted to metallic silver to form ferric sulfate and ferric chloride (see Figure 6–8). The iron, in changing from the ferrous form with a valence of two (Fe⁺⁺) to the ferric form with a valence of three (Fe⁺⁺⁺), provides the electron that neutralizes the ⁺ of the silver:

$$3 \text{ Ag}^+ \text{ Cl}^- + 3 \text{ Fe}^{++} \text{ SO}_4^{--} \longrightarrow \text{ Fe}_2^{+++} (\text{SO}_4)_3^{---}$$

+ $3 \text{ Ag}^\circ + \text{ Fe}^{+++} \text{ Cl}_3^{---}$.

If the silver chloride occurs in a photographic emulsion, a mild reducing solution, the developer, will selectively reduce (by providing electrons) only that part of the silver chloride that has been exposed to light. The "latent image" is converted into a real, visible silver image. Oxidation/reduction concepts can become rather involved. (If it seems inappropriate for a reducing agent to *provide* electrons rather than *accept* them, it should be noted that the oxidation/reduction concept was formulated at a time when it was commonly thought that electrons had positive charges.)

6.14 Acid/Base

An *acid* is a compound containing hydrogen and another element or radical. Hydrochloric acid, for example, is a compound containing hydrogen and chlorine, HCl. This is a strong acid. HCl can

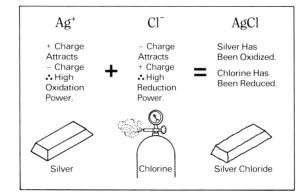

Figure 6-7 Oxidation occurs when a positively charged atom attracts a negatively charged atom, and reduction occurs when a negatively charged atom attracts a positively charged atom. In this reaction silver has been oxidized and chlorine has been reduced to form silver chloride.

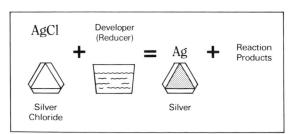

Figure 6–8 Silver chloride in a photographic emulsion is acted on by a reducer, the developer, to form metallic silver along with the other products of the reaction.

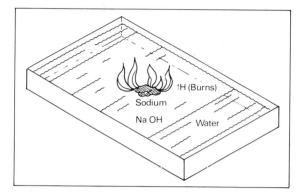

Figure 6-9 When the metal sodium is placed in water a violent reaction takes place in which one of the hydrogen atoms of water is released. The hydrogen burns while the remaining single atom each of oxygen and hydrogen combine with the sodium to form strongly alkaline sodium hydroxide.

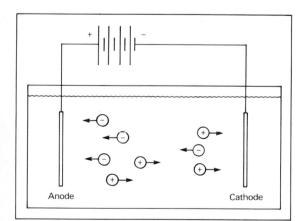

Figure 6-10 A solution of sodium chloride contains negatively charged chlorine ions and positively charged sodium ions. Electrodes placed in the solution and connected to a battery will cause the negatively charged ions to move to the anode where they lose their charge and become chlorine gas. The positively charged sodium ions will move to the cathode to form sodium metal, which reacts with the water to form sodium bydroxide and bydrogen gas.

exist as a gas, but as an acid it is a gas in a water solution. Sulfuric acid is made up of hydrogen and the SO4 radical (SO3 [gas] + H2O $[water] = H_2SO_4$ [sulfuric acid]). Like hydrochloric acid, this is also a strong acid, which means that it is highly ionized or dissociated in solution; that is, H⁺ SO₄⁻, and H⁺ Cl⁻. Acetic acid, an organic compound, CH₃COOH, is a relatively weak acid by comparison. Acids are formed when oxides of nonmetallic elements are dissolved in water, and bases are formed when oxides of the metallic elements are dissolved in water. Essentially, a base is a compound containing a hydroxyl (OH⁻) radical and another element or radical. Calcium oxide, CaO, when dissolved in water, yields calcium hydroxide, Ca(OH)2, a base. A base is also known as an alkali. Practically all developers are basic in composition. When placed in water, metallic sodium produces a violent reaction in which one of the hydrogen atoms of water is given off as a gas, which ignites from the heat of the reaction and burns, leaving a strong alkali, NaOH (Na⁺ + OH⁻), as shown in Figure 6-9. Ammonium hydroxide, NH4OH, is also a base, and has the characteristic "ammonia" odor. (Ammonia with moisture, ammonium hydroxide, is the developing agent for dlazo papers.)

Acids are sour to the taste (such as acetic acid, the chief component of vinegar). Bases are characterized by their "slippery" feeling—a weak solution of lye, NaOH, feels very slippery, as do most developer solutions that contain an alkali. When an acid solution is combined with a solution of a base, in equal molecular amounts, a *salt* is formed. For example, if hydrochloric acid is added to sodium hydroxide, sodium chloride, a salt, and water are formed. The water of formation is simply added to the water containing the acid and the base:

 $\begin{array}{rcl} HCI \ + \ NaOH & \longrightarrow & NaCI \ + \ H_2O \\ \\ H^+ \ CI^- \ + \ Na^+ \ OH^- & \longrightarrow & Na^+ \ CI^- \ + \ H_2^+ \ O^- \ . \end{array}$

6.15 Ionization

Pure water is made up of equal parts of H^+ (hydrogen) and OH⁻ (hydroxyl) radicals. When a salt is dissolved in water, it dissociates into the ions of the elements or radicals making up the salt. Sodium chloride, for example, ionizes into Na⁺ and Cl⁻ ions. The presence of these free ions permits the passage of an electrical current through the solution, and it becomes known as an *electrolyte* (see Figure 6–10). A solution of sugar, an organic compound that does not dissociate into ions, therefore does not carry an electric current.

6.16 pH

Pure water ionizes very little, but the extent to which it does can be stated by multiplying the molar concentrations of H⁺ and OH⁻ ions. This produces a *dissociation constant*, K, that is equal to $0.0000001 \times 0.0000001$ or 0.000000000000001. These molar concentrations can be expressed mathematically as 10^{-7} , and their product as 10^{-14} ; and the latter number is known as the dissociation constant of water. A salt produced by the reaction of a strong base and a strong acid dissolved in water has the same dissociation constant. In either of these two cases, the hydrogen ion concentration is equal to 10^{-7} , and

6.17 pH of "Normal" Solutions

the hydroxyl ion concentration is an equal amount. Pure water or the salt solutions are *neutral* solutions. (In actual practice most "tap" water has free chlorine and carbon dioxide, among other things, and would actually be found to be "acid" in nature.) If we have a solution of a strong acid, the hydrogen ion molar concentration will be relatively high—say 0.01—and the hydroxyl ion will be correspondingly low, but the product of the two will be equal to the constant, 10^{-14} . The hydrogen ion and hydroxyl ion concentrations in this case can be stated as 10^{-2} and 10^{-12} , respectively. A strong alkali, on the other hand, would have a high concentration of hydroxyl ions, and a correspondingly low concentration of hydroxyl ions. The values for a hypothetical case might be 10^{-1} for hydroxyl ions and 10^{-13} for hydrogen ions.

It is the custom for chemists to specify the hydrogen ion concentration in terms of pH. pH is the negative logarithm of the hydrogen ion concentration. A strong acid with a hydrogen ion concentration of 10^{-2} (i.e., 1/100) has a pH of 2, and a strong alkali with a hydrogen ion concentration of 10^{-12} (i.e., 1/1000000000000) has a pH of 12. Thus the pH of a neutral salt solution, or of pure water, becomes 7. The higher negative exponents, representing lower hydrogen ion concentrations, and thus higher hydroxyl concentrations, range from 7 through 14, and are the alkaline side of the scale. (D-72 developer for paper has sodium carbonate as the alkali, and a pH in the vicinity of 10.) Conversely, lower negative exponents, representing higher hydrogen ion concentrations, are on the acid side of the scale, and range from 1 through 7. (An acetic acid stop bath, for neutralizing the alkali of the developer after development, might have a pH in the vicinity of 3.5.) Or this can be restated as follows:

$$pH = \frac{1}{\log (H^+)}$$

or
$$= -\log (H^+)$$

or pH is the negative logarithm of the hydrogen ion concentration.

6.17 pH of "Normal" Solutions

A normal solution is one containing one gram molecular weight (grams \times molecular weight) in one liter of water. A 0.1 normal solution is one containing 0.1 gram molecular weight of the substance in one liter of water. A 0.1 normal concentration of hydrochloric acid has a pH of 1.1; a 0.1 normal solution of acetic acid has a pH of 2.9; a 0.1 normal solution of sodium hydroxide has a pH of 13.0, and a 0.1 normal solution of sodium bicarbonate has a pH of 8.4. In dilute solutions, the product of the dissociated ions divided by the undissociated part is equal to a constant. With acetic acid, for example, this becomes:

 $\frac{Concentration (H^{+}) \times Concentration (CH_{3}CO_{2}^{-})}{Concentration of undissociated CH_{3}CO_{2}H} = 0.0000185 .$

6.18 pH Meters

Since pH is an indication of hydrogen ion concentration, it is also related to electrical potential. That is, if suitable electrodes are placed in such an ionized solution, it acts as a battery or galvanic cell, and produces a voltage, E. The relationship between pH and the voltage (or electrical potential) is rather complex, and therefore several qualifications have to be made when using this potential to measure pH. Since we are interested in the potential—without the passage of current, which would have the effect of immediately lowering the voltage—the voltage is usually measured in comparison to a standard cell incorporated in the meter. Some modern meters, however, with very little internal resistance, are direct reading. The relationship between the measured potential and pH is as follows:

$$\mathsf{pH} = \frac{(E - E_{\rm o})}{0.0591}$$

where E_{o} is a constant.

pH meters are calibrated directly in pH values, and it is not necessary to read a voltage and then convert it to pH. The measurements are directly affected by temperature; this has to be taken into consideration and adjustments made if it is different from 25 C

Early pri meters used electrodes" assembled as follows: A platinum anode was immersed in the solution to be tested (the *anode* is the positively charged electrode of an electrolytic cell). A stream of hydrogen bubbles was directed against the anode. Also immersed in the solution was the exit of a tube filled with a strong solution of potassium chloride to form a "liquid junction" with the solution being tested. The other end of this tube terminated in a larger vessel also filled with potassium chloride over the cathode (the *cathode* is the negatively charged electrode in a cell), a layer of calomel (mercurous chloride, Hg_2Cl_2) over a pool of mercury. Wires connected the anode and the mercury to the meter. This apparatus was difficult to maintain, and required considerable skill to operate.

More recently, glass electrodes have been substituted for the platinum electrode and hydrogen gas (see Figure 6–11). It has been found that certain glasses will permit the proper voltages to be generated without the necessity for actual contact of the solutions. A typical glass electrode is one filled with hydrochloric acid, into which a platinum wire is immersed for electrical connection. The cathode side of the electrode remains essentially the same as that of the older cell. Modern electrodes for pH measurement are arranged to have both electrodes in a single unit that is immersed in the solution to be tested.

There are other electrode arrangements, with other solution junctures, for specialized applications of pH meters, but the basic principle is the same as that described above. Even with the improvements that have been made, it is important to follow directions covering the use and maintenance of pH meters. If they are neglected, the results are not only inaccurate, but these inaccuracies will lead to incorrect decisions that will adversely affect the performance of a chemical system. It is especially important to thoroughly remove chemicals from the electrodes by rinsing with distilled water before immersing them in the solution to be tested.

6.19 pH Indicators

Many dyes change their color under the influence of a particular pH condition. These are referred to as pH indicators. Papers that have been impregnated with the dyes are available for indicating in

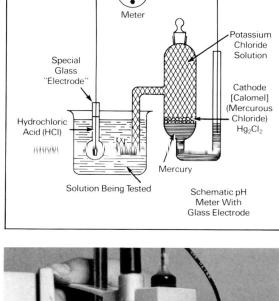

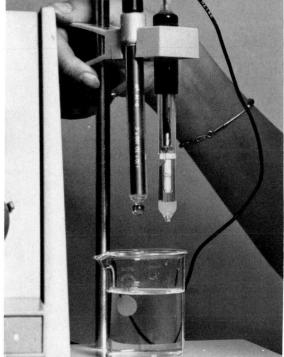

Figure 6-11 (A) The glass electrode containing the platinum anode immersed in hydrochloric acid is immersed in the solution being tested. This interfaces with the potassium chloride solution over the calomel cathode, and the circuit is completed through the meter via the mercury junction. The voltmeter is calibrated in terms of pH values. (B) The operator is preparing to lower the prepared electrodes for measuring pH into a solution to be tested. (Photograph by John Trauger.)

various pH ranges (see Figure 6-12). These are generally more broad in their measure than pH meters, and there is a limit to the number of useful indicators that are available. Also, some judgment may be required in the interpretation of the colors produced. However, they are useful under many circumstances.

The performance of various photographic chemical solutions is influenced to a great extent by pH, and the control of this factor in one way or another is important. For example, the rate of development tends to increase as the pH, or alkalinity, of the developer is increased. Bleaches and other solutions used in color photography require control of pH to make sure that the bleaching action is adequate while at the same time dyes formed by the process are not adversely affected. The acid strength of stop baths and fixers has to be maintained to ensure that their neutralizing effects are adequate without producing other problems. Rate of fixing, hardening, and stability of the fixing solution are influenced by pH.

6.20 Complexes

A complex compound is one that is made up of two or more compounds or compounds and ions. In the fixing process used in photography, for example, silver complexes are formed when the unexposed and undeveloped silver halide salt is treated with the fixing agent, sodium thiosulfate, $Na_2S_2O_3$. The fixing reactions pass through several complexes of varying solubility before one that is easily soluble is reached. The following represent several complexes that are thought to occur:

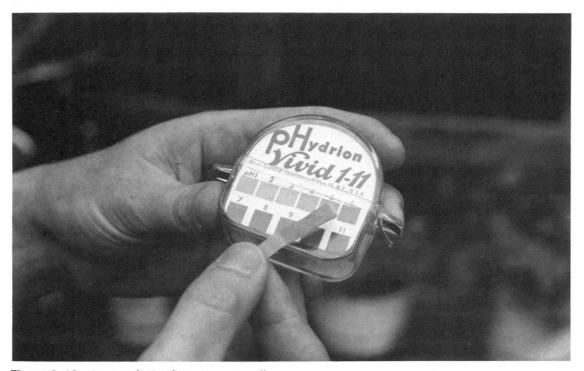

Figure 6-12 Dye-treated pH indicator paper. A small strip of the paper is taken from the package and dipped in the solution to be tested. The dye in the paper changes color according to the pH of the solution. The pH value is then assessed by comparing it with the color references on the package. (Photograph by Ira Current.)

1. 2 AgCl + $Na_2S_2O_3 \longrightarrow Ag_2S_2O_3 + NaCl$ (insoluble)
2. $Ag_2S_2O_3 + Na_2S_2O_3 \longrightarrow 2 NaAgS_2O_3$ (slightly soluble)
3. $4NaAgS_2O_3 + Na_2S_2O_3 \longrightarrow Na_6Ag_4(S_2O_3)_5$ (slightly soluble)
4. $Na_6Ag_4(S_2O_3)_5 + Na_2S_2O_3 \longrightarrow Na_5Ag_3(S_2O_3)_4$ (soluble)
5. $2Na_5Ag_3(S_2O_3)_4 + Na_2S_2O_3 \longrightarrow 3Na_4Ag_2(S_2O_3)_3$. (soluble)

When the silver halide has been converted to complexes 4 and 5, they can be washed out of the emulsion and/or paper to increase the image permanence. Complexes 1, 2 and 3, while they are transparent and give the film or paper the appearance of being fixed, are incluble in only slightly soluble, and thus are not removed by washing.

6.21 Solutions

Most of the chemical processing of photographs is accomplished with various solutions. A solution consists of the solvent-water in most photographic applications, with various chemical compounds dissolved in it. A chemical in solution is referred to as the solute. Various compounds have varying degrees of *solubility*; that is, capability of being dissolved in water, the solvent, until no more will dissolve. Such a solution is known as a saturated solution. The solubility of most chemicals varies with the temperature of the solution; a greater amount of the chemical can be dissolved in water at higher temperatures. When a solution has as much solute dissolved in it as is possible at a higher temperature, and the solution is cooled, the solute is thrown out of solution, usually in the form of crystals. A supersaturated solution is one that contains more solute dissolved in it than would normally be possible at that temperature. The addition of a small crystal of the solute, or some other disturbance, will cause the excess to be crystallized out rapidly. If a chemical compound in solution is mixed with another one also in solution, the product of the chemical reaction may be insoluble, and will be thrown out as a precipitate.

Other liquids can also be considered to be solvents, and indeed in chemistry there are many systems in which solvents other than water are used.

Rate of solution also depends on the size of the particles being dissolved, as shown in Figure 6–13. Small particles or crystals have a much higher ratio of surface to volume, hence the solvent can act over a larger area in a given time and thus the particles go into solution faster. (Extremely fine powders may provide excess surface and permit such factors as hydrolysis—reactions with water—to decrease solubility. The chemistry of solubility is complex and involves rates of diffusion, degree of dissociation, and many other factors.) Chemical compounds may either give off heat—exothermic—or absorb heat endothermic when they are dissolved. Anhydrous sodium thiosulfate (Na₂S₂O₃) gives off heat when it goes into solution; but the compound of crystallization with water (Na₂S₂O₃ · 5H₂O) absorbs heat when it

Figure 6-13 Volume of large cube (hence weight) is equal to that of all of the smaller cubes, but surface area of large cube is one third that of the smaller cubes.

goes into solution; that is, it is endothermic and the solution becomes cooler as the thiosulfate is dissolved. Monohydrated sodium carbonate (Na₂CO₃ \cdot H₂O) gives off heat when it is dissolved, and is thus exothermic; but sodium carbonate with 10 molecules of water of crystallization (Na₂CO₃ \cdot 10H₂O) absorbs heat, cools the solution, and is endothermic.

6.22 Specific Gravity

Specific gravity is the weight of a given volume of a substance, such as a solution, compared to that of an equal volume of water at a given temperature (which has to be taken into account for precise measurements). Specific gravity can be measured with a hydrometer, a graduated weighted tube that floats to a greater or lesser degree depending on the specific gravity of the solution in which it is floated. Specific gravity is read from a scale inside the tube.

6.23 Sequestering and Chelating Agents

A sequestering agent is an inorganic compound that forms a complex molecule with metal ions, thus preventing them from exhibiting their usual ionic characteristics. An early example of a sequestering agent is trisodium phosphate, $Na_4P_2O_7$, or "Quadrophos," which is very effective in developer formulas for sequestering calcium or magnesium salts found in hard water, thus preventing them from forming precipitates in the developer. Calgon[®] is a class of sodium polyphosphate and metaphosphate compounds (sometimes improperly referred to as hexametaphosphate) that also serve as sequestering agents.

A chelating agent is an organic compound that forms a complex compound with a metal ion, thus removing it from its ionic state. The word chela means a pincerlike claw, such as that of the lobster. A chelating agent is one that "grabs" or holds a metal ion from reacting and thus being precipitated from a solution, as shown in Figure 6-14. One of the most powerful of chelating agents is ethylinediaminetetraacetic acid (EDTA). This is used in developers to prevent the formation of sludges or precipitates resulting from the reaction of calcium or magnesium in hard waters with sulfite, borate, carbonate, etc., in the developer. It forms a complex that ties up these metal ions so that they are not able to react with the developer components. It is also incorporated in bleach formulas containing iron to prevent the iron ions from reacting to form insoluble compounds and thus be thrown out of solution. The iron is tied up in the complexing compound, to be released slowly in the presence of an "activator" chemical in order to perform its function.

Other than mentioned above, the presence of soluble natural compounds such as those of magnesium and calcium presents no problems in photographic processing. In some critical processes or chemical steps it may be suggested that distilled or deionized water be used. Distilled water is water that has been boiled and the vapor condensed, leaving all of the impurities behind. Deionized water is usually pure enough to be substituted for distilled water, and is produced by an ion exchange method. The soluble ions are exchanged by means of a "resin" for a different ion such as H⁺ or are retained in the resin. Water to be used for washing does not require either of these treatments but is satisfactory if solid material in it has been filtered out. It is important

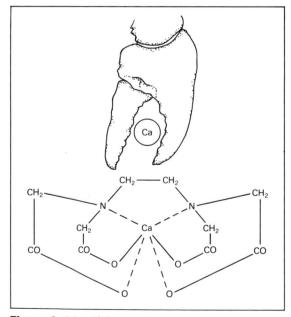

Figure 6-14 Chelate complex.

References

that particles containing iron or sulfides be removed, since these can react with the image to produce spots and stains.

References

Amphoto, The Encyclopedia of Practical Photography.

American National Standards Institute, pH of Photographic Processing Solutions, and Specifications for pH Meters Used to Measure pH of Photographic Processing Solutions, Method for the Determination (PH4.36-1978).

Carroll, Higgins, and James, Introduction to Photographic Theory. Eastman Kodak, Basic Chemistry of Photographic Processing. (A-23-ED) Eaton, Photographic Chemistry. Haist, Modern Photographic Processing. Mason, Photographic Processing Chemistry. Schaffert, Electrophotography. Sturge, Neblette's Handbook of Photography and Reprography.

Photographic Emulsions, Films, and Papers

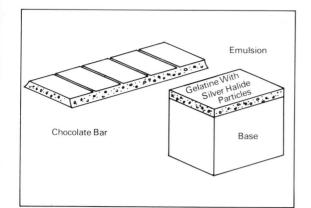

Figure 7-1 The photographic emulsion can be compared to the chocolate nut bar. The nuts are suspended and separated by the chocolate as the silver halide grains are in the emulsion.

7.1 Photographic Emulsions

A photographic emulsion consists of silver halide crystals suspended in gelatin. The emulsion is usually coated on a support that may be clear, as in the case of negative films, or opaque, as for photographic prints. The emulsion has the most significant controlling effect on the photographic and physical properties of the final product.

To visualize the emulsion, think of a chocolate candy bar with peanuts imbedded in it as shown in Figure 7–1. The peanuts are suspended in the chocolate medium. Similarly, the silver halide particles are suspended in gelatin. There are many different recipes for making photographic emulsions. Choice of gelatins and different combinations of salts (sodium, potassium, ammonium, or calcium and chloride, bromide, or iodide, for example), along with other chemical ingredients impart characteristics to the emulsion such as speed, spectral sensitivity, contrast, resolution, graininess, and physical properties. The emulsion is applied to the film or paper in a "liquid" state, and thickness of the emulsion layer is adjusted by controlling viscosity and speed of coating. The gelatin is then chilled (just as a gelatin desert is when placed in the refrigurem), and then showly the literation of the matrix

The silver halides respond to light to produce a latent image that is later developed to produce a visible silver image. The gelatin also acts as a "binder," serving to protect the silver halide from abrasion and other mechanical and chemical influences; in some cases the gelatin can even serve as the support for the image. Through "impurities" and other characteristics, the gelatin contributes to the photographic and chemical performance of the silver halides in the emulsion. Silver is used because its compounds are more sensitive to light than any other photochemical material.

7.2 Image-Support Systems

In most cases an additional support is needed for the photographic sensitized surface or image layer. In the beginning this support consisted of paper that was treated to make it more transparent so that the negative image could be photographically printed onto another emulsion-coated support to produce a positive image. The daguerreotype (1839) did not have a gelatin silver emulsion. A silver coating on a copper base was converted to silver iodide by subjecting it to iodine fumes to produce a light-sensitive layer. Development took place by subjecting the exposed plate to mercury fumes to produce an image on the silver surface. The unexposed silver halide was "fixed" by means of a solution of salt or of sodium hyposulfite (thiosulfate or "hypo") as shown in Figure 7–2. (We now know that mercury fumes are injurious to our health. The Mad Hatter of *Alice in Wonderland* is an example of the result of such exposure.)

With the arrival of the wet collodion process in 1851, the support for the photographic negative became a glass plate. With this process, one or more of the soluble halogen salts (sodium, potassium, ammonium, or calcium and chloride, bromide or iodide) dissolved in an ether-alcohol solution of cellulose nitrate (chemically similar to guncotton) was flowed onto a glass plate, the excess was drained off, and the coating was allowed to evaporate until it became tacky, as shown in Figure 7–3. The coated plate was then dipped in a silver nitrate solution for one to two minutes to produce a silver halide salt in the cellulose nitrate coating. At this stage the "wet plate" was sensitive to

7.2 Image-Support Systems

Figure 7-2 Daguerreotype process.

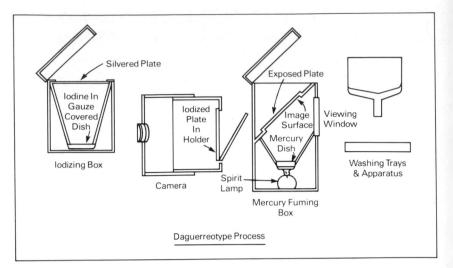

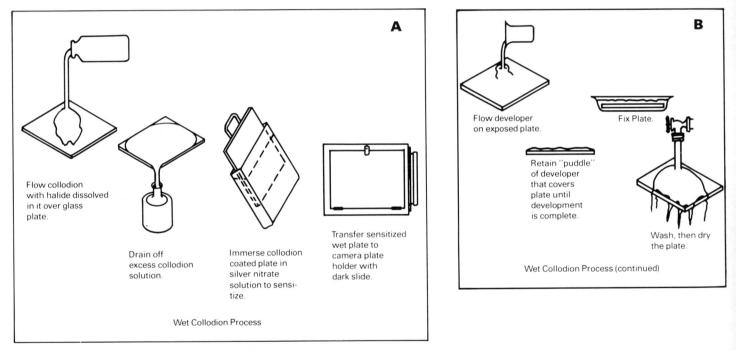

Figure 7-3 Wet collodion process. (A) Preparing the plate for exposure. (B) Developing the exposed plate.

light. It was then placed in the camera and the exposure was made while the plate was still wet.

Development was accomplished by flowing a weak reducing solution (developer), such as ferrous sulfate or pyrogallol, over the plate without allowing the solution to drain off. Since a limited amount of developer was used, the action was partially one of "physical development," where some of the excess silver in the solution actually plated out on the image being formed. When development was complete, the excess developer was drained off, and the plate was immersed in sodium thiosulfate (or sometimes sodium cyanide) to remove the unexposed, undeveloped silver halide, a step not too much unlike the fixing process used today.

Even after the introduction of emulsion-coated dry plates, glass continued as the support for many years. Glass plates were of

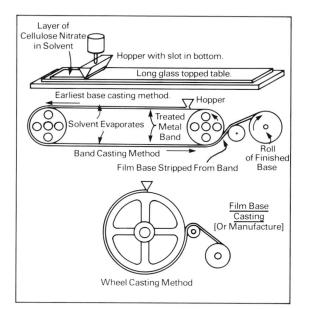

ENDINE FOR FOR THE COMPANY CONTRACTOR

course heavy, bulky, and were easily fractured and destroyed. They did possess one clear advantage, though: dimensional stability. (For this reason, glass plates are still in use today, especially for scientific and metric purposes.)

The use of wet collodion coatings on glass plates continued well into the twentieth century in some special applications such as photoengraving. These emulsions and plates were used for copying line and halftone engravings, and they could be stripped easily from the original glass support and transferred to a new support for making advertising and other layouts. They could be cemented down from either side, to permit lateral reversal of the images if necessary.

7.3 Film Supports

In the early 1900s flexible film supports were introduced. These early supports were essentially cellulose nitrate, and were produced in a manner not unlike the making of a wet collodion plate. In the beginning, a solution of the cellulose nitrate in solvents was flowed from a mapping on the maximum time, and mapping the maximum and provide a flexible support that could be coated with a gelatin silver halide emulsion similar to that used today.

As can be imagined, cellulose nitrate, which is also chemically similar to guncotton, an inflammable compound, was not the safest support for photographic films. It had reasonably good physical characteristics, but anywhere that large collections of negatives existed there was a pronounced danger of fire. In fact, there were many fires in motion picture theater booths where the film could be ignited accidentally by the carbon arc light, particularly if the film was delayed for some reason in the projector film gate. There were also some disastrous hospital fires where accumulations of X-ray film made with nitrate base became ignited. Nitrate bases can spontaneously ignite as the result of deterioration, and archives of this material have to be carefully watched. Considerable effort has gone into preserving early nitrate-based images by photographically transferring them to more stable modern bases.

7.4 Safety Base Films

The Eastman Kodak Company developed a nonflammable cellulose acetate safety film very early in the 1900s, but it was not accepted by the motion picture industry because of cost; and some of the other physical characteristics, such as wear on repeated showings, were not as good as those of the nitrate film. Since flammable films would not be suitable for use in even modest quantities by the amateur cinematographer in the home, the introduction of a nonflammable base was necessary, and its production in volume occurred with the introduction of the 16mm home-movie films in 1923. With more experience and further research and development, improved versions of "acetate" films were produced, and they are still the best support for commercial motion picture film.

Nitrate base of greater thickness was also used for early sheet films replacing glass plates. These nitrate films were supplanted by acetate bases when this type of material became available. While acetate bases had better dimensional stability during processing and storage

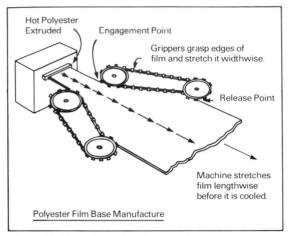

Figure 7-5 Polyester film base manufacture.

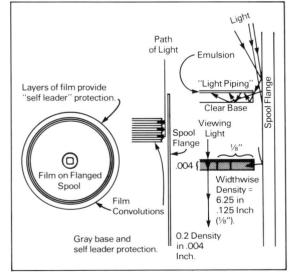

Figure 7-6 Daylight loading spools depend on the protection provided by several convolutions of film (4 to 7 feet in length). The necessary light stopping density is provided by the combination of emulsion, antihalation protection, and base density. Light entering between the film and the spool flange may be decreased by incorporating a pigment or dye in the base. The density in the viewing direction is relatively low, but adds up rapidly in the widthwise dimension.

than did nitrate bases, they were still far from ideal for some applications. They were less flexible, more brittle, and did not wear as well as the nitrate films.

All of these films of various thicknesses—roll film, motion picture film, and sheet film—were produced by flowing the cellulose nitrate or acetate, dissolved in acetone, ether, alcohol, etc., onto a polished surface, and evaporating the solvents, after which the base was stripped off. The casting of the mixture onto a glass table has long since been abandoned. One method of producing the base in continuous lengths is by flowing the solvent mixture, "dope," onto a large polished drum, but other manufacturers use a metal band running over two drums some distance apart. Even though the acetate or "safety" base is nonflammable, there is some hazard in the manufacture of the base if flammable solvents are used.

7.5 Polyester Film Bases

In recent years many of the products previously manufactured with acetate base have been produced on polyester bases, which are made in an entirely different manner. These are manufactured by extruding the heated polyester material through a slot, stretching it in a longitudinal direction at the same time that it is stretched by means of grippers in a widthwise direction while still heated and soft, as shown in Figure 7–5. This orients the molecules of plastic, yielding a base material that is free from stresses and strains, and that has very good dimensional stability and certain other characteristics.

One problem with this type of base is the need of a suitable subbing so that the emulsion will adhere properly during the life of the material. While the techniques of subbing for good adhesion have been worked out satisfactorily for the old solvent cast base materials, there have been some lingering problems with the newer polyester materials, leaving some doubt as to their suitability for "archival" storage of images. Another early problem with the polyester films for motion picture applications was that of splicing, but this has been solved by new heat and tape splicing techniques (in those applications where the stronger base might be required).

Such polyester films can act like fiber optics and pipe light in a transverse direction, thus not serving well as a self leader when the film itself is intended to protect the image-forming part of the film from ambient light when on a daylight loading spool. In many applications, light piping of films is eliminated by introducing dyes or pigments into the base itself, as shown in Figure 7–6. Some light is absorbed in the viewing direction, where the density of the base may be on the order of 0.1 to 0.2, and the thickness of the base may be around 0.002 to 0.004 inch. In the crosswise direction the density adds up very rapidly, and thus absorbs most of the light traveling in this direction.

Polyester films also have a greater tendency to generate static electricity—they are good insulators—and this makes them more susceptible to picking up dust and lint from the atmosphere. They are also more susceptible to scratching, and readily show scratches on viewing the photographic images if the base is not protected by a gelatin NC (non-curl) or antihalation coating. In the beginning, their very high tensile strength prevented them from breaking when trouble occurred in processing machines and similar equipment, and therefore

7.8 Thinner Emulsions

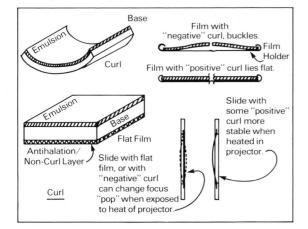

Figure 7–7 Curl.

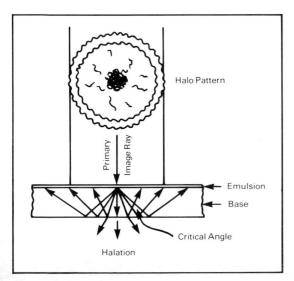

Figure 7–8 Halation.

the machinery was damaged rather than the film. The solvent cast acetate types of film are still largely used for commercial and amateur motion-picture applications, and for most roll films.

7.6 Film Structure

A photographic film can be very simple in structure—a coating of a gelatin-silver halide emulsion on a transparent base, such as positive film, used for printing black-and-white motion pictures. Negative films used for pictorial photography are generally more complex in their structure. In many films two or more coatings of emulsion are used to derive the sensitometric characteristics that yield good pictorial tone rendition. On top of this there is generally an overcoating or surface layer that controls many of the physical characteristics of the film.

7.7 Physical Properties of Films

Since the gelatin emulsion coating expands when wetted for processing and shrinks after drying, and also has a greater response to changes in atmospheric relative humidity than does the base support, it exerts considerable effect on the amount of curl in the film. In order to control or counteract this effect, films are coated with a noncurl (NC) gelatin coating on the side opposite from the emulsion coating, as shown in Figure 7–7. Since this gelatin back coating responds similarly to the emulsion coating, it tends to counteract the curl of the film.

The NC coating also usually contains dyes or other materials that absorb light that gets through the emulsion and would otherwise be reflected from the back side of the support to produce halation around images of the brighter objects in the scene, as shown in Figure 7–8. This halo around the image of bright objects such as lamps is a photographic phenomenon, but artists such as Georgia O'Keeffe have sometimes incorporated halos in their paintings. (This halo should not be confused with that sometimes seen when observing the rings around the moon or sun, often called "sun dogs." These are optical phenomena caused by frost particles suspended in the air. Colored discs can also sometimes be seen surrounding the moon or sun, and are due to refraction of light by ice crystals.) Some 35mm films have antihalation material in the base rather than in a noncurl backing layer (see Figure 7-6).

7.8 Thinner Emulsions

Earlier photographic emulsions were relatively thick, and thus had a more pronounced effect on the physical characteristics of the film, such as curl and brittleness, compared to the more modern emulsion coatings. Emulsions are now designed to have a low gelatin-tosilver ratio; that is, the amount of gelatin has been reduced without materially reducing the photographic *covering power* of the silver after development. Covering power is the ability of the silver layer to absorb light. The form of the silver image structure can have an effect on the amount of light absorbed even though the amount of silver in an area is unchanged. These thinner emulsions consequently have less curl and brittleness, and they also have the advantage of not retaining processing solutions and water to the extent of the older, thicker emulsions. Hence processing, including development and fixation, can be more efficient, and can be done in shorter times; the film can be washed faster and better, and requires less time to dry. There is also a tendency to have fewer water spots and other deformities in the thinner emulsions. Processing techniques depending on the retention of some solution in the emulsion for varying amounts of time may not perform the same with thinner emulsions as with the older thicker ones, so revision or abandonment of old techniques may be in order. Multiple emulsion coatings are also used to achieve certain sensitometric characteristics, which will be discussed later in this chapter.

7.9 Surface Coatings

The *surface coating* on the emulsion may serve a variety of purposes. A simple thin gelatin coating protects the emulsion itself from abrasions and pressure marks. Sliding a hard edge across an unprotected emulsion, and sometimes even just static pressure, will produce a latent image that will develop as though produced by exposure to light. (If the pressure of the scraping is great enough, of course, the surface can be physically damaged, and this can be seen in the print as a mark due to the optical characteristics of the deformation, in addition to the photographic effect.)

7.10 Retouching Capability

Films that require *retouching*, such as those used for portrait photography, may have finely divided starch, mineral, or other substances incorporated in the surface coating to provide a *tooth* that will take the retoucher's pencil, as shown in Figure 7–9. A similar treatment may be given to the NC coating on the back to permit retouching on

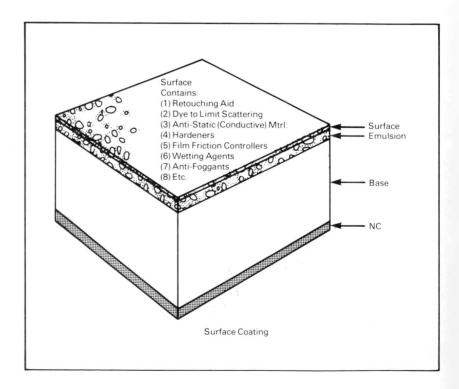

Figure 7-9 Surface coating.

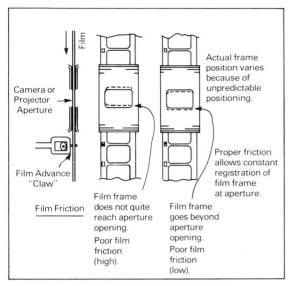

Figure 7–10 Film friction.

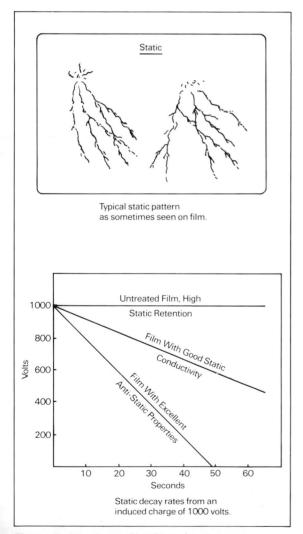

Figure 7–11 Static. (Top) Typical static pattern as sometimes seen on film. (Bottom) Static decay rates from an induced charge of 1,000 volts.

both sides of the film. Materials of this kind in reduced amounts may also be added to films intended for other purposes, in order to minimize *ferrotyping* of the emulsion against the base side of the film when it is wound in long rolls, producing glossy areas on the emulsion surface.

7.11 Film Friction

Motion picture films and films with some industrial and recording applications may require control of their *friction* characteristics. If the film friction is too high, it may be difficult to withdraw 35mm film from magazines used in hand cameras. (*Film friction* is the term used to define the combined effects of the coefficients of friction of both sides of the film.) In motion picture photography, high film friction may produce so much resistance to film movement in the camera or projector that the film is deformed by the sprocket or claw mechanism that advances and registers the film for exposure or projection, resulting in unsteadiness of the pictures when viewed. On the other hand, if the film friction in the line film map front of the individual frames, and a similar unsteadiness (see Figure 7–10). High-speed cameras using rotating prisms, or streak cameras, which do not have intermittent movements, may operate better with low film friction.

7.12 Static Discharges

Under dry conditions there is a tendency for static electricity to be generated and a charge to be built up when film is being transported through cameras or other equipment. The sudden discharge of this static electricity can produce light that exposes the film to produce a latent image that becomes apparent when the film is developed. "Static marks" sometimes have the appearance of a lightning discharge, as shown in Figure 7–11. In addition to this, films with a static charge have a tendency to pick up dirt and dust when the film is being dried, or after it has been dried. For these reasons, a conductive material, or something that retains moisture, may be introduced in the surface layer, or in the emulsion and NC layers as well, to render them conductive. This conductivity dissipates the static electricity before it has a chance to discharge or to pick up dust or other material from the atmosphere.

Other additives may be incorporated in the surface layer, such as antifoggants, hardeners, and preservatives. (In manufacture, chemicals can be incorporated in the surface layer to provide hardening of the emulsion some time after it has been coated, rather than the hardening taking place in the emulsion during the time it is being held while coating.) Wetting agents or surfactants may also be incorporated in the gelatin surface coating to permit more even spread of water and processing solutions, which gives more even development, and to minimize water spotting when the films are being dried. With color films, the surface coating might contain a corrective dye filter to adjust for sensitivity imbalance of the three emulsion layers.

7.13 Color Films

Subtractive color films, often referred to as integral tri-pack films, have a considerably more complex structure than black-and-white

films. Subtractive color films operate by subtracting red, green, and blue light from white viewing light by means of cyan, magenta, and yellow images to produce the composite color image. They have at least three emulsion layers, each designed to respond to red, green, or blue light, as shown in Figure 7–12. Some special films, such as those used for making internegatives, may have multiple layers to produce the desired tonal response for each of the three primary colors.

In addition to these emulsion layers, there is a yellow layer beneath the top, blue-sensitive emulsion layer to absorb any blue light that is not absorbed by the emulsion. The color of this layer is destroyed during processing to render it clear. The traditional material used for the yellow layer has been colloidal silver, which is bleached out with the silver images during processing. (Silver of very small particle size absorbs blue light and appears yellow. Similarly, very fine-grained film looks brownish.) Sometimes a yellow dye is used, which is rendered colorless during processing. Color films may also have a separating layer between the green-sensitive and red-sensitive layers. This layer may simply isolate these layers from one another, or it may be treated to contribute to the quality of the overall image. Interimage effects can give a result similar to that of masking for improved color rendition.

Color films may also have an antihalation layer beneath the bottom red-sensitive emulsion layer, an arrangement that gives better halation protection, as the light is absorbed before reaching the base, which tends to spread the halo. This antihalation layer can also be made of finely divided silver in gelatin that can be removed during processing, along with the image silver that is formed. Also, this antihalation material can be a dye that is destroyed during processing. Color films may also have the conventional antihalation layer on the back side of the film, and they might even utilize both types of antihalation treatment.

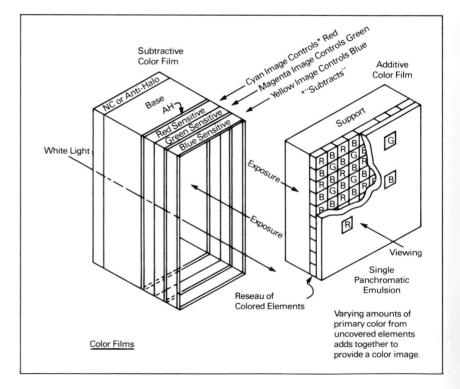

Figure 7-12 Color films.

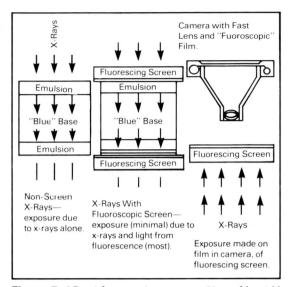

Figure 7-13 After processing, nonscreen X-ray film yields an image that is due to X-ray exposure alone. When X-ray film is sandwiched between fluorescent screens the major part of the immune memory in two modulity of $h_{\rm H}$ is an analytic memory of screens in response to X-ray stimulation. The film in the fluorescepic camera produces an image of the fluorescent screen that has been stimulated by X-rays.

7.14 X-Ray Films

X-ray films may be coated with one or more emulsions on both sides of the base. Such films intended for radiography in medicine, as well as for radiography of structures in industry, also make use of intensifying screens placed on both sides of the film in the manufacturing process. The X-rays cause these intensifying screens to fluoresce in the visible region, producing a much greater photographic effect on the photographic emulsion coatings than would result from the X-ray exposures alone (see Figure 7–13). Calcium tungstate is a fluorescing material often used in the manufacture of intensifying screens. The presence of two emulsions on X-ray films also increases the overall contrast of the image, and has the effect of keeping the films physically flat, without curl.

7.15 Other Coatings on Two Sides

There may be other reasons for coating emulsions on both sides of the film or paper base. Early two-color processes made use of filling in minich one color mange was produced on one side of the base, and the other color image on the opposite side. Film materials have been made with white opaque diffusing material incorporated in the base to produce a deluxe image for viewing by reflected light. A similar material with emulsions on both sides of the base is designed to be viewed by either reflected or transmitted light without loss of image density or contrast. Photographic materials viewed by reflected light make use of the image twice, so that only half the density needed for viewing by transmission is required. However, if this half-density image is viewed by transmitted light, it appears washed out and lacking in contrast. The presence of a similar image on the opposite side reinforces the corresponding image on the front side, and the contrast is then satisfactory. Such photographs are satisfactory when viewed by either reflected or transmitted light. If the image on the side away from the viewer is hand colored, then a display can be produced where the front side image is first viewed as black-and-white, and the image becomes colored when the light is changed to permit viewing by transmitted light.

7.16 Paper Bases

Most photographic prints are made on some form of paper base. Traditionally this type of base was manufactured with pulp made from old rags, but in more recent years practically all of it has been made from a high-quality wood pulp (alpha cellulose). These are referred to as *fiber-base* papers. Many photographs are made on paper that has been coated with a plastic or resin (such as polyethylene) on both sides. These are referred to as RC (resin-coated) papers. The resin surface coating of the stock protects it from the chemical solutions and water of processing, so that processing, washing, and drying times can be much shorter than with the fiber-base papers. Because of the problems of emulsion adhesion to polyethylene coatings, fiber-base papers are still preferred for producing photographs with archival permanence.

Fiber-base papers can be simple calendered stocks with relatively smooth surfaces that are coated directly with emulsion, after any necessary treatment to ensure that the emulsion will adhere through-

Figure 7–14 Calendering. Heavy rolls apply pressure to paper, and surfaces of some rolls travel at a different speed from paper web, thus polishing or "ironing" the surface.

out all of the processing steps. Calendering involves passing the paper web through a stack of heavy smooth rollers, sometimes with heat and with control of moisture, along with some differential in rate of travel at the roller surfaces, as shown in Figure 7–14. This pressure and sliding action produces a smooth surface on the paper. Many of the recording and document papers are in this category. A paper stock can be manufactured with a coarse "felt" on the paper-making machine that imparts a definite "felt" (canvas- or clothlike) structure to the surface of the paper. Some portrait papers, and some proof papers are manufactured with this type of base.

Several paper surfaces are produced by embossing the stock with an engraved roller under pressure to impart a distinctive textured surface pattern. These patterns can be irregular, but some are geometric in nature, for example, "silk" and "linen" surfaces. Any of the above can be coated with one or more layers of barium sulfate (baryta), and/ or other white pigments (sometimes before embossing) before coating with photographic emulsion. This imparts a better, brighter color to the base, and also limits the penetration of the emulsion into the base, which gives a more uniform coating and a more even image, with more uniform blacks. The nature of the baryta coating also affects the reflectivity of the coating's surface. The Baryta coating is omitted from photographic papers that may be folded in use, to prevent the emulsion layer from cracking.

7.17 Brighteners

It is common to incorporate optical brighteners in both nonbaryta-coated and baryta-coated paper surfaces, producing the effect of intensifying the paper's brightness. These are similar to laundry brighteners, and the effect is produced by using a dye or other substances that fluoresce on exposure to ultraviolet energy (available to some extent from most light sources) to convert the invisible ultraviolet radiation to visible light.

7.18 Glossy Papers

A smooth paper stock can also be coated with several layers of baryta, with calendering taking place between each coating and after the final coating has been applied, to produce a very smooth surface. When this is coated with emulsion, a paper with a "glossy" surface is produced. With the proper type of emulsion such a paper can have a fairly high gloss without ferrotyping, but the maximum gloss is achieved when the print is ferrotyped by the photographer. Ferrotyping is accomplished by rolling the washed, wet print into contact with a smooth, glossy surface such as that on a lacquered metal, or a chrome-plated metal plate, and allowed to dry. The surface of the plate is molded into the gelatin coating. In early days, a sheet of glass was used as the ferrotyping surface.

Ferrotyping and drying can be accomplished at room temperature, or drying can be accelerated by means of heat. Some heat dryers can be operated at quite high temperatures; this may have some effect on the photographic characteristics of the emulsion, as well as possibly introducing physical problems such as "oyster shelling." Resinor polyethylene-coated papers should not be ferrotyped, since the water of evaporation cannot escape through the barrier coatings. However,

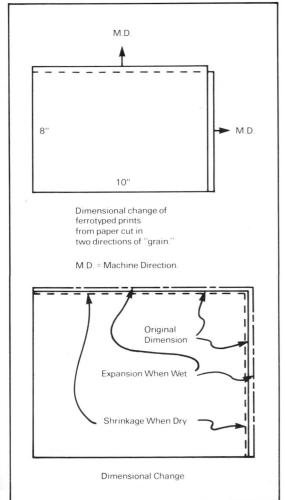

Figure 7–15 (Top) Difference in dimensions of 8×10 inch sheets of fiber-base paper that have been cut in the machine direction and in the cross-machine direction. The opposite corners of the sheets match. (Left) Dimensional change.

even without ferrotyping these papers can have a high-gloss surface after drying.

7.19 Expansion and Shrinkage

Ordinary fiber-base papers expand considerably when wet. After processing and drying they shrink, usually to a smaller size than they were when exposed. This change in dimension is usually greater in the lengthwise dimension of the paper web (as manufactured) than it is in the widthwise dimension. If the print is ferrotyped, the paper is prevented from shrinking—it is temporarily "glued" to the surface of the ferrotype plate—and the final dimensions are greater than at the time the paper was exposed (see Figure 7–15).

These dimensional changes are usually of little importance in ordinary pictorial photography; but they do become important in certain industrial applications, and in photogrammetry, where precise measurements are taken from aerial photographic images to produce maps. In such applications, paper must have minimal (or no) dimensional change from the time the image is exposed, and what change there is should be as uniform as possible in the lengthwise and widthwise dimensions. In addition, the dimensional change should be uniform throughout the area of the image, and not, for example be different when comparing the center parts of the photographs to the marginal areas. RC papers and other special stocks that do not absorb much water provide better dimensional stability than do most fiber-base pa-

7.20 Paper Weight and Thickness

pers. However, special fiber-base papers have been manufactured that have little dimensional change, with uniform change in all directions.

7.20 Paper Weight and Thickness

Photographic papers are manufactured in various "weights." These are referred to in such terms as single weight, document weight, light weight, medium weight, and double weight (see Figure 7–16). Paper stock is customarily manufactured, controlled, and sold in terms of weight, but photographers are more aware of the different thicknesses of photographic paper bases. Hence, international standards designate papers in terms of their thicknesses. American National Standard PH1.1-1974, *Thickness of Photographic Paper, Designation For,* lists nine groups of paper thicknesses, with ranges for each group both in English and in metric units, and gives common trade designations (in terms of weights) for each of the groups.

Other related American National Standards publications include Dimensions for Photographic Roll Paper, Dimensions for Photographic Sheet Paper for General Use, Requirements for Spooling Photographic Paper for Recording Instruments, and Methods for Determining the Dimensional Change Characteristics of Photographic Films and Papers.

7.21 The Gelatin Colloid

Gelatin is a *colloid*. A colloid is a particulate material that can be suspended in water or other solute without settling out. The sizes of the particles range from approximately 1 to 1,000 nm, or intermediate between visibly suspended particles and invisible molecules. (One nanometer is one billionth of a meter, or one millionth of a millimeter.) Other colloids have been used for photography, and

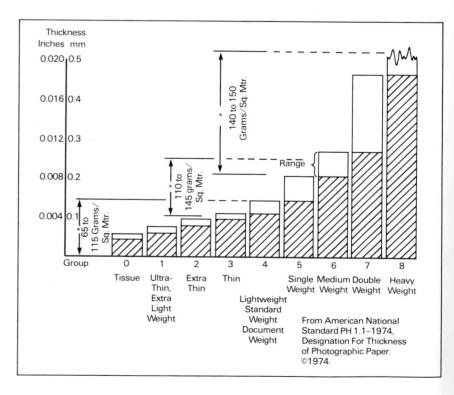

Figure 7-16 Paper thicknesses.

colloids that are a more similar substitute for gelatin have been tried, but gelatin has been, is, and will continue, for the near future at least, to be the best material for the preparation of photographic emulsions. (Albumen and collodion are examples of other colloids that have been important in photography.)

7.22 Properties of Gelatin

The gelatin colloid used to make photographic emulsions has several important properties:

- **1.** Gelatin disperses the light-sensitive silver halide crystals and prevents them from adhering to one another, or coagulating, and thus forming in effect larger crystals or "grains."
- **2.** When wet, gelatin can be changed to a "solid" gel or liquid reversibly by changing the temperature.
- **3.** When dry, gelatin is reasonably stable, and thus protects the silver halide grains
- 4. Gélátih serves as a receptor for halogen atoms in some aspects of latent image formation.
- **5.** Gelatin has no effect on the silver halide, other than the protective function, although impurities found in many gelatins contribute to the photographic result (sensitivity, fog, etc.), sometimes beneficially, at other times in a manner that degrades the image.
- **6.** Gelatin permits the processing solutions to penetrate and chemically react with the silver halide grains in development, fixing, etc.
- 7. Gelatin can be produced uniformly and inexpensively, and stored for long periods prior to use in manufacture.
- 8. Gelatin is transparent.

To help ensure uniformity, numerous batches of gelatin of a given type are blended so that when a new batch is added, it contributes only a relatively small amount to the overall characteristics of the blend. (American table wines are often blends of various batches of grapes for the same reason.)

7.23 Sources of Gelatin

Gelatin is derived from *collagen*, which is a more complex molecule, and in turn is obtained from the hides, hoofs and other parts of animals. (Early workers at the Eastman Kodak Company who processed gelatin from hides would, when asked where they worked at Kodak, reply: "Hyde Park.") The gelatin used for photography has to be more carefully selected than that used for food or in other applications, and is usually obtained from selected hides and ears. To process the hides, they are first carefully cleaned and sterilized with boiling water, then placed in a lime (alkaline) solution to soak for a period of about two months to remove fat, hair, albumen, and other undesirable materials. Following this, the hides are washed, and the lime is neutralized with an acid (a process called "deliming").

The collagen thus formed is further carefully treated with water at a controlled elevated temperature to hydrolize it to gelatin, which is then extracted. (Hydrolysis is a reaction in which water reacts with a substance to form other substances.) If the treatment is overdone, the gelatin breaks down too far, forming glue, and is not suitable for photography. After the gelatin has been extracted, the remainder of the soluble material is essentially glue. Glue is an adhesive—it sticks well to other materials—while gelatin is cohesive—it adheres well to itself. Gelatin can also be manufactured by treating hides with an acid solution, rather than lime, and when thus produced it has entirely different properties.

7.24 Chemical Nature of Gelatin

Gelatin is an organic compound, or, more precisely, a group of compounds (they are derived from "organic" materials—living animals—and can be burned) largely made up of carbon, hydrogen, oxygen and nitrogen atoms having a composition of approximately 50, 7, 25, and 18 parts of these atoms, respectively. It has a very complex molecular structure made up of various amino acids. The average molecular weight of gelatin is about 27,000 or some multiple of this. (Molecular-weight values determined in a variety of different ways have ranged from 768, corresponding to a formula $C_{32}H_{52}O_{12}N_{10}$, to 96,000.) Since the amino acid molecules contain both acid carboxyl groups and basic amino groups, they are *amphoteric;* that is, they can act either as an acid or a base. Since the acidic and basic characteristics are not strong, it acts as a buffer: Large additions of either an acid or a base do not have a large effect on the hydrogen ion concentration (pH).

7.25 Physical Properties of Gelatin

Dry gelatin contains about 10% water, and is a tough material with great mechanical strength. To prepare an emulsion, dry gelatin is soaked in water, which penetrates into the gelatin structure and causes it to swell many times its original dimension. When thus wet, it is soft and easily damaged. When the soaked gelatin is heated to about 40 C (100 F), it melts and can be further diluted with water indefinitely. If the concentration of gelatin in water is greater that 1%, it will "set" when cooled, just as dessert gelatin does, to become a gel that can be dried with dry air without remelting. Before drying, the set gelatin can be remelted by raising the temperature, and reset by cooling, repeatedly; but the setting and melting temperatures do not coincide (see Figure 7–17).

During the manufacture of film or paper, a warm gelatin emulsion in a melted condition with some appreciable viscosity and that contains silver halides is uniformly coated on the film or paper base either by extrusion through a slot orifice, or by one of several dip or applicator methods. It is then chilled to set the gelatin emulsion, followed by gradual drying. (*Viscosity* is a fluid's internal resistance to flow. It is measured in terms of the *poise*, or *centipoise*, which is 1/100 poise. This measurement can be made in several ways, but one method is to time the flow of the liquid through a narrow tube.)

The physical properties of gelatin are important to the photographer, who must be aware of its chemical and physical nature. Films and papers are continually subjected to alkaline and acid chemical solutions, prolonged washing, changes in temperature—especially heat to dry them after processing—mechanical stress, etc. The nature of gelatin is also of primary importance to the manufacturer and emulsion maker, whose problems are many in addition to those presented for photographers. These physical properties vary with the acidity or al-

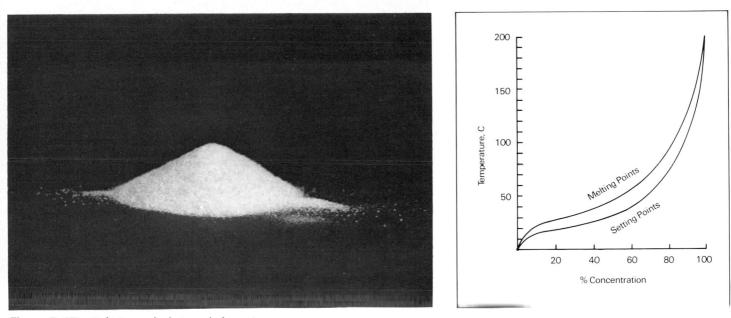

Figure 7–17 (Left) Processed gelatin ready for use in photographic emulsion. The flakes produced in the gelatin extraction process have been ground into a powder that has a pale amber color. (Right) Melting temperatures are higher and setting temperatures are lower for gelatin at different concentrations.

kalinity of the gelatin solution, with its optimum characteristics being at or near the solution's *isoelectric point*. The isoelectric point is that pH where the negative and positive electrical charges balance out. A neutral, lime-prepared gelatin acts as an alkali gelatin, so the pH at the isoelectric point must be less than 7.0. For such a lime-processed gelatin, this point turns out to be at a pH of about 4.7.

Many characteristics of gelatin are minimal at the isoelectric point. Some of these are the total swelling of the gelatin when wet (see Figure 7–19), the osmotic pressure generated within the gelatin, the conductivity, the viscosity of the gelatin in water (see Figure 7–18), and the hydrogen ion concentration. The physical characteristics of the

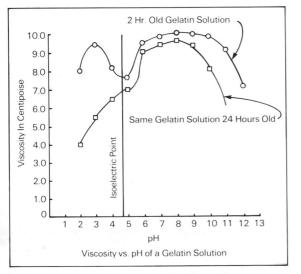

Figure 7–18 Viscosity vs. pH of a gelatin solution.

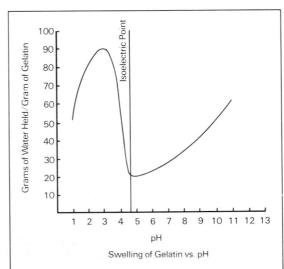

Figure 7–19 Swelling of gelatin vs. pH.

265

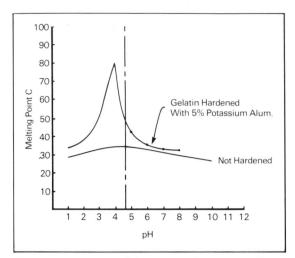

Figure 7–20 Many of the properties of gelatin are affected by its isoelectric point. These curves illustrate the effect of the isoelectric point on viscosity, swelling, and melting point of gelatin.

final coatings are also related to the isoelectric point (see Figure 7–20). Curl and brittleness of the film or paper tend to be lower when the gelatin used for the coatings is at or near the isoelectric point. Swelling of an emulsion coated on film or paper is greatest when placed in solutions that are highly alkaline, highly acid, or at a high temperature; and lowest when the solutions are near the isoelectric point. Photographic processing systems and recommendations for processing are designed to take advantage of these principles as far as is practicable, and the photographer can sometimes encounter difficulties when recommended procedures are not followed.

Photographic gelatin emulsions are required to withstand some fairly rigorous conditions. The gelatin component of the emulsion must be capable of surviving the rigors of the emulsion-making process—wetting, melting, washing, chilling, cooking, holding, etc. It must be capable of maintaining a uniform viscosity during coating, be coated uniformly on the base, and chill set and dry properly. It should retain good physical characteristics, not produce excessive curl, or have a tendency to be brittle; and it should not deteriorate physically or photographically up to the time of exposure in the camera. After exposure, it must withstand the alkaline developer, the acid stop bath, acid hardening fixer, wash, and drying without significant deformity. After processing, it should retain its physical nature throughout the life of the negative or print, which in some cases may be expected to extend to hundreds of years. Gelatin is unique in having all of the ideal characteristics for photographic emulsions.

In spite of its ideal characteristics, it can be abused, and fail in some measure. When developed, the gelatin film expands due to the solution intake by its structure. This would be quite excessive, but it is inhibited by the salt content (sodium sulfite, for example) of the developer. This expansion has to be mainly in the vertical direction since the coating is attached to the base, but stresses are induced in the horizontal plane. Following development, the rinse removes some of the salts, which momentarily at least allows more swelling to take place. A hardening fixer then applies a de-swelling effect, but there remains a strain on the coating. These stresses and strains can be quite severe, and when swelling and contraction are occurring at the same time, reticulation of the gelatin emulsion layer can result.

Stress and strain are aggravated by excessive changes in temperature from one solution to another, or in the wash water. An emulsion coating that has been excessively swollen can also be reticulated by drying it at too high a temperature after washing. Warm, dry air removes the water more rapidly, and sometimes can be counted on to produce a cooling effect due to evaporation, so that the reticulation point may not be reached; but water-laden warm air does not provide much cooling.

7.26 Emulsion Making

Throughout the history of photography, the theory of the emulsion-making process has been difficult to understand. The characteristics of the final emulsion are governed by many factors, including the choice of soluble halides and gelatin, the method of silver halide precipitation, the cooking or ripening processes, and the choice of chemical additives to the emulsion. Since many of these processes cannot be patented, photographic manufacturers take great pains to maintain

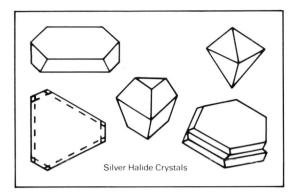

Figure 7–21 Silver halide crystals.

the secrecy of their emulsion-making techniques. The following basic considerations, however, are well known. The basic emulsion-making steps for a typical black-and-white film emulsion are: precipitation, ripening, washing, digestion, additions, and coating.

A photographic emulsion is formed by treating a soluble silver salt with a soluble halide or halides in the presence of gelatin in solution; for example,

 $AgNO_3 + KCI \longrightarrow AgCI + KNO_3$.

Silver nitrate plus potassium chloride yields silver chloride plus potassium nitrate.

The light-sensitive silver halide, in this example silver chloride, exists in the form of crystals or "grains" that are one micrometer (one thousandth of a millimeter) in diameter or less. Mixtures of halides (chloride, bromide, iodide) are commonly in the form of mixed crystals containing two or three halides in each crystal (see Figure 7–21). The gelatin acts as the protective colloid in that it prevents the crystals from confesting, and also concrols the size and distribution of the crystals to some extent. Silver halides are primarily sensitive to ultraviolet radiation and blue light. Small amounts of compounds that react with the silver halide to increase sensitivity may be present in the gelatin, or they may be added separately to inert gelatin. Dyes may also be added to extend sensitivity to other regions of the spectrum than the ultraviolet and blue. Other compounds may be added for various purposes, such as to stabilize the emulsion against effects of aging before exposure and processing, and to combine with the reaction products of development to form dye images.

7.27 Emulsion Composition

A typical emulsion for printing papers has about 30 parts of silver halide and 70 parts of gelatin. The chlorobromide content will range from 95 parts of silver chloride and 5 parts of silver bromide to 30 parts of silver chloride and 70 parts of silver bromide. The high chloride content is representative of the slow contact-printing papers, while the high bromide content represents the faster emulsions for enlarging. Emulsions for negative films might have 40 parts by weight of silver halide, predominantly silver bromide, and 60 parts of gelatin, with silver iodide ranging from 1% to 10%.

7.28 Emulsion Characteristics

The photographic properties of an emulsion depend on a number of factors including its silver halide composition; the shape, average size, and size distribution of the crystals, and the presence of substances that affect sensitivity. All of this is governed by the amount and kind of gelatin(s) in the original solution, choice of halide compounds, the way in which they are mixed together, the way they are treated following this "precipitation," what other substances are added, and the coating procedure. These factors control photographic properties such as the speed, characteristic-curve shape, spectral sensitivity, and exposure latitude of the emulsion; and image characteristics such as graininess, sharpness, and resolving power.

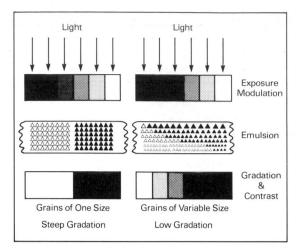

Figure 7–22 Emulsions having grains of nearly equal size will produce steep gradation, while those having a wide variety of grain sizes will produce low gradation.

7.29 Grain Size, Sensitivity, and Contrast

The grains of the emulsion can be considered as individual units as far as exposure and development are concerned. A latent image formed in one of the grains does not ordinarily spread to the other grains unless they are touching. For a given exposure there is a greater probability that a large grain will absorb a quantum of light than will a small grain. If the grains were uniform in size, and in a single layer (one grain thick), the probability that individual grains would be exposed and made developable would depend on the random distribution of photons reaching the grains. Since such grains are uniform in size, density after development will vary with the fraction absorbing at least the number of photons required to become developable. When several photons are required, most of the grains will receive enough at the same time; and thus the characteristic curve will have steep slope, indicating high contrast. The toe of the curve represents the region of exposure where only a small fraction of the grains receive enough photons to become developable.

If the grains are large, they provide a greater area for receiving photons, are thus more likely to be exposed, have a greater number of silver ions available for reduction, and after development they have a greater light-absorbing capability. This has the effect of giving the larger grains a greater amplification effect than smaller grains.

Intermediate-size grains would produce an amplification effect between those of the largest and smallest sizes (see Figure 7–22). Emulsions with a wide variety in grain sizes will have inherently lower contrast than emulsions having equal grain sizes, and will have greater sensitivity due to the availability of larger grains. The resulting characteristic curve will have a lower slope than in the case where the grains are all nearly the same size.

Since the grains are seldom side-by-side in a single layer, but rather they are in an emulsion that is considerably thicker than this (about 20 grains thick), other factors contribute to the curve shape. The top layer of grains will have a greater chance of being exposed, and by absorption of light will shield the grains below them from some of the exposure. The grains will also tend to scatter the light, and this increases the difference in illuminance and exposure at the top and bottom of the layer. All of these factors will have some additional effect on the shape of the characteristic curve. Larger grains will also contribute to increased graininess of the photographic image.

Covering power is the ratio of diffuse density to the mass of silver in the developed emulsion layer:

$$CP = \frac{D}{M}$$

Generally, if the image particles are small, the covering power is higher than if the image particles are large. In other words, covering power is inversely related to image particle size. A linear relationship exists between the diffuse density and the total surface area of the grains in the emulsion layer, with smaller grains having a greater total area than larger ones per unit of weight or volume. For this reason, some photographic materials that contain relatively low total silver mass per unit of area can have high optical density. This is true for both films and papers. In a diffusion transfer process, for example, the negative image can consist of relatively large particles, but the silver that diffuses and transfers to the receiver can be made up of relatively small particles. The latter would exhibit considerably higher density than the negative image, which can be fairly thin compared to conventional emulsions. Modern photographic papers can exhibit high maximum density compared to older "silver-rich" emulsions, even though the total amount of silver in the newer papers is lower than that of the older types of paper. The covering power can vary considerably, as well as the color of the image, with variations in the composition of the developer and the conditions of development, such as temperature and hardening.

7.30 Grain Composition

The composition of the silver halide grains plays an important part in the emulsion. The presence of iodide in small amounts enhances the sensitivity of silver bromide grains. The composition of the grains formed by precipitation of a silver salt and two or three halogen salts depends on the solubility characteristics of the precipitated halides. The three fight tensition and or help on photography are relatively insoluble compared to the salts from which they are formed. Of these, the iodide is the least soluble, the chloride the most soluble, with the bromide falling between the two. Therefore, if silver bromide is added to a solution of potassium iodide, the less soluble silver iodide tends to be formed, with the liberation of the more soluble bromide ions, until equilibrium is reached. These kinds of exchanges influence the final halide composition of the grains in an emulsion.

The soluble component of silver halide compounds is considered to be very low. However, in the presence of excess halogen ions (I^-, Cl^-, Br^-) , these insoluble-compounds become more soluble due to the formation of complexes, such as the following:

 $\begin{array}{rcl} AgBr + Br^{-} & \longrightarrow & AgBr_{2}^{-} \\ \\ AgBr_{2}^{-} + Br^{-} & \longrightarrow & AgBr_{3}^{--} \\ \\ AgBr_{3}^{--} + Br^{-} & \longrightarrow & AgBr_{4}^{---} \end{array}$

These complexes are used to a considerable extent to increase the solubility of silver bromide in emulsion making. If ammonia (NH_3) is added to the emulsion during ripening, grain growth is accelerated due to the positive charge of the ammonia complex $(Ag[NH_3]_2^+)$ with silver. Therefore, for the highest-speed emulsions, this type of ripening is often used to increase the grain size.

The overall solubility of the silver halides in emulsions is increased by virtue of the small size of the crystals, 1 micrometer or less, which increases the surface-to-weight ratio significantly. This difference in solubility according to grain size accounts for the increase in average grain size during ripening, in which the smallest grains become smaller and the dissolved silver halide comes out of solution as an addition to the larger grains.

7.31 Spectral Sensitivity

The fine division of halides in emulsions provides a greater amount of surface for adsorption of materials to the silver halide grains.

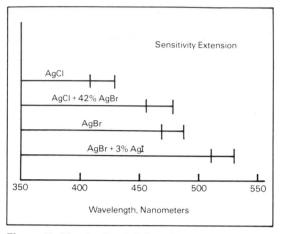

Figure 7-23 In silver halide emulsions, grains of silver chloride are sensitive to the shortest wavelengths of light, silver bromide to considerably longer wavelengths, and combinations of bromide and iodide to the longest wavelengths. (Chateau et al., The Theory of the Photographic Process, 1966, p. 6.)

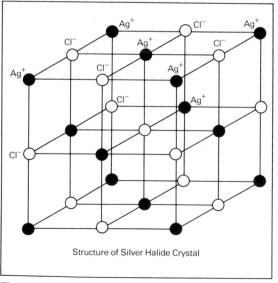

Figure 7-24 Structure of silver balide crystal.

Adsorption is the adherence of atoms, ions, or molecules to the surface of another substance. First, silver halide grains adsorb additional halide ions, with the greatest adsorption occurring with iodide and the least with chloride ions. In addition, the grains adsorb gelatin, sensitizing dyes, and other compounds. These all contribute to the overall sensitivity of the emulsion. The silver halide grains themselves have varying sensitivities to light of different wavelengths, depending on the halide. Silver chloride, which is colorless, is sensitive at the shortest wavelengths, mostly ultraviolet energy, extending to about 420 nm. Silver bromide, which is more yellowish in appearance, has sensitivity extending to about 500 nm. Additions of iodide, which has a strong vellow color, in amounts ranging from 0.1% to 1.0% of the chloride crystals, extends the sensitivity to 450-475 nm. A similar extension is achieved when about 40% bromide is added to chloride. Bromide with about 3% iodide extends the sensitivity to about 525 nm (see Figure 7–23). Even without further extensions of sensitization, such as with dyes, the safelight filter must not have any transmission below 550 nm.

7.32 Crystal Structure

Defects in the crystals of silver halides are an important aspect of light-sensitive emulsions. Silver halide crystals are usually composed of ions in a cubic lattice so that each halide ion is surrounded by six silver ions, and each silver ion is surrounded by six halide ions, as shown in Figure 7–24. This arrangement can exist within the interior of the crystal, but at the outer surface there has to be one of each with only five of the other surrounding it. Even in the cubic system, crystals can be formed that are octahedral in shape, or in the form of hexagonal plates (see Figure 7–21). Different photographic effects are produced by the surfaces presented by these different crystal shapes.

7.33 Defects

The defects in the crystal lattice can be divided into extended imperfections and point defects. Whereas the faces of the crystal have only five ions around each one of opposite charge, at the corners there can be only three, and at the edges only four. Adsorption is greater at these positions and reactions may begin here. These positions are supplemented by other dislocations that can occur in the crystal's formation, and all are important in the photoconductive and photochemical processes. The most important type of point defect is interstitial silver ions; a minute fraction of the silver ions escape from their positions in the crystal lattice and can move through the spaces in the lattice, as shown in Figure 7–25.

Defects in the crystal act as locations for the formation of sub-image centers during latent image formation. Silver and halogen ions are not free to move, except to adjacent positions in the lattice, but electrons are free to move throughout the crystal. These motions are manifest as electrolytic conductivity, which plays an important part in the photolytic process. One kind of defect arises from a vacancy in the crystal lattice, such as would occur if a silver ion were removed to an interstitial position. This would leave a silver-ion vacancy that would have a negative charge. The interstitial silver ion itself would have a positive charge. An extra electron would produce a negative charge,

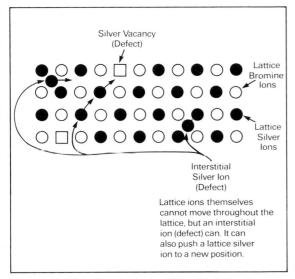

Figure 7-?5 The point defect of interstitial silver ions in a utility imported. I attice ions themselves cannot move throughout the lattice, but an interstitial ion (defect) can. If can also push a lattice silver ion to a new position.

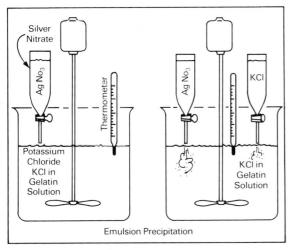

Figure 7–26 Emulsion precipitation.

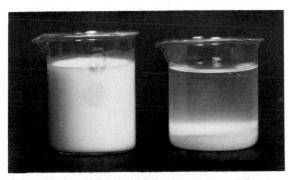

Figure 7-27 Silver bromide has been precipitated from silver nitrate and potassium bromide in the presence of gelatin in solution, in the beaker on the left. The silver bromide is kept in suspension, and the grains, "protected" by the gelatin, are essentially the same size as they were at the time of precipitation. In the beaker on the right, without gelatin, the precipitate has settled to the bottom, and the crystals have grown considerably larger in a relatively short time.

and a positive charge would occur when an electron is removed from the valence band of the crystal.

7.34 Emulsion Precipitation

A typical emulsion-making process starts with a relatively dilute solution of gelatin in water (about 1%). Soluble halide salts (one or more) are added to this solution (potassium, sodium, or ammonium chloride, bromide or iodide), as shown in Figure 7–26. Then, at a selected temperature, a soluble silver salt, such as silver nitrate, is added at a controlled rate and with controlled stirring. The silver halide or halides are precipitated out, and the crystals are first formed in a strong solution of soluble halide, in which the silver halide is much more soluble than in pure water. Under these conditions the crystals first formed grow rapidly and continue to grow throughout the precipitation.

As more of the soluble halide is combined with silver through the addition of more gilver rait solution, the solubility of the silver halide decreases. The grinns formed later grow more slowly and have less time to grow, so that at the end of the precipitation, the size variation of the crystals is quite large. A long precipitation results in an emulsion having relatively high sensitivity—since there is a high proportion of large crystals—and a relatively moderate gradation or gamma due to the wide variation in the sizes of the crystals. A shorter silver run time gives smaller grains with a narrow range of sizes, and thus less speed and higher contrast.

If the soluble halide solution and the silver salt solution are both added together at the same rate into the gelatin solution through a "double jet" technique, nucleation (dissolving and recombining) will stop in a short time, and all of the crystals will be of more nearly the same size. This emulsion would have high contrast and relatively low speed. Other modifications of the rate of adding the two soluble components can include unlimited combinations of the two methods to achieve the desired starting emulsion characteristics.

Even a relatively dilute gelatin solution provides protection to the silver halide crystals formed. If it were not for the gelatin, the particles of the precipitate would coalesce and rapidly fall to the bottom of the reacting vessel, as shown in Figure 7–27. The growth of crystals to grains of the desired size with good structure would be difficult.

7.35 Ripening

Following the initial emulsion precipitation, a more concentrated gelatin solution (up to 10%) may be added to the mix, which affords further protection. This new gelatin may have been selected to impart certain desired sensitivity or other characteristics. The mixture may then be heated, a process called ripening, to a temperature of about 50 C to 70 C with constant stirring. Speed is low at this point in iodobromide emulsions. This ripening process permits the larger grains to grow at the expense of the smaller ones because the smaller are slightly more soluble. It increases the range of grain sizes as well as the average size. (Ripening is also referred to as Ostwald ripening.) The ripening process is not carried to the extent that significant fog will be produced.

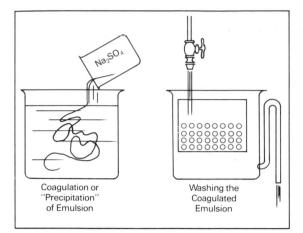

Figure 7–28 The gelatin emulsion is coagulated while at its isoelectric point by the addition of a salt solution such as sodium sulfate. It is then washed to remove the salts including those that were formed during the emulsion-making process. The washed grains can then be redispersed by raising the pH, along with the addition of more gelatin.

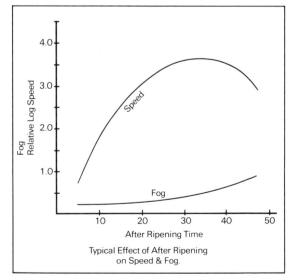

Figure 7–29 Typical effect of after-ripening on speed and fog.

7.36 POP Emulsions

Emulsions intended for coating proofing-type printing-out papers (POP) are started with the soluble silver salt dissolved in the gelatin solution, to which the soluble halide salt is added. This procedure maintains an excess of soluble silver ion for the entire precipitation time; and an excess of silver ions is allowed to remain in the emulsion to act as halogen acceptors and allow an image to form during exposure without development. The result is an emulsion in which the photolytic effect reduces the silver halide to metal directly during exposure, without any need for development. The sensitivity is many times less than that for development-type papers, and requires exposure to sunlight for several minutes when contact printing.

Naturally the images are not permanent, since further exposure to light darkens the nonimage areas of the emulsion, and if carried to an extreme the fogging effect will obscure the image. POP images can be rendered permanent by gold toning after exposure, then either subsequently or at the same time dissolving the unexposed silver halide followed by washing to remove all soluble silver salts. A visible image can be produced on conventional papers and films with long exposures, but the color and quality of the images are less satisfactory.

7.37 Washed Emulsions

If the emulsion is to be coated on a porous support such as a baryta-coated or otherwise uncoated paper base, the excess alkali nitrate (after the precipitation reaction) can be absorbed by the base. If the base or support is a film, or a paper base with a water-impermeable surface such as resin coated (RC), these excess salts have to be removed by washing to prevent them from crystallizing out on the surface (see Figure 7–28). It is also desirable in the emulsion-making process to remove excess salts to prevent further growth of the silver halide grain before continuing the process. This is accomplished by coagulating the gelatin, washing the emulsion, then redispersing (dissolving) the gelatin and halides. The gelatin at its isoelectric point can be coagulated by adding a salt such as a sulfate. There are other methods of accomplishing this coagulation.

Historically the emulsion, with added gelatin, was chilled and set in a manner similar to setting food dessert gelatin. This set emulsion was then extruded into noodles, or sometimes cut into cubes (the noodling procedure was established by F.C. Wratten—of Wratten Filters—around 1878), and washed with chilled water until conductivity or pH tests showed that enough of the soluble salts had been removed.

7.38 After-Ripening

After washing, another heating step called digestion or afterripening may be used to further increase speed and cause other changes in the emulsion's photographic characteristics (see Figure 7–29). This ripening has very little effect on grain-size distribution, because the soluble halides that increase solubility of the silver halide have been removed. After-ripening is usually accompanied by the addition of various sulfur or gold compounds, or reducing agents, which increase the sensitivity of the grains by up to one or two orders of magnitude. With these treatments, low-illuminance reciprocity failure is greatly reduced.

Silver sulfide apparently forms electron traps on the silver grains that tend to stop the motion of electrons and thus permit them to combine with mobile silver ions to form the silver of the latent image. Gold becomes part of the latent image, and acts as an improved nucleus for the deposition of silver at the start of development. Reduction sensitization forms nuclei that react to reduce the probability of an electron recombining with a positive hole.

When after-ripening has been completed, the emulsion is again chilled and stored under refrigeration until required for coating. Prior to coating, various chemicals may be added to the emulsion, which may include hardeners, surfactants, stabilizers, retouching mat and antistatic agents (these additions are sometimes incorporated in the surface coating). In many cases, the final emulsion coating is a "blend" made by mixing various emulsions that have been produced by two or more of the methods outlined above.

7.39 Multiple Coatings

Some black-and-white films owe their sensitivity and tonereproduction characteristics to the coating of two different emulsions, one on top of another. A slow, relatively short-scale, or high gamma emulsion is coated first, then a faster, coarse-grained, long-scale emulsion is coated on top of it to provide a characteristic curve with increasing slope in the upper midtone or lower highlight regions (see Figure 7– 30). This provides better speed and scale characteristics than would be achieved by blending the emulsions. Color films, of course, are made up of at least three emulsions, one for recording each of the primary colors. One or more of these three, in turn, may be made up of multiple coatings to provide required tonal response, such as required by internegative films and those for other special applications.

7.40 Effects of Development on Developers

The reaction products of development include soluble salts of the halides, along with modified developer components. The soluble halides act as restrainers, and thus curtail development. The kind and quantity of restrainer included in the developer formula is intended to minimize, as far as practicable, the effects of these reaction products of development. The proportions of the different halides used in making emulsions for tri-pack color films can affect the formation of byproducts. If one of the emulsions, for example, had a higher bromide/iodide content than the other, an allowance would have to be made in composing the replenisher solutions for development to take care of the proportions of reaction products from the two different emulsions.

If two different products utilizing the same processing line, such as one balanced for tungsten illumination and one balanced for daylight illumination, have different halide ratios, the replenisher for the two types of film may have to be modified if one of them is processed in excess, or to the exclusion, of the other. Recent Kodak films utilizing the E-6 process have been manufactured with the sophistication necessary to permit any quantity of the various reversal color products

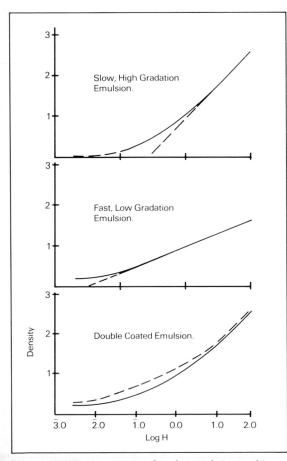

Figure 7-30 By coating a fast, low gradation emulsion over a slow, high gradation emulsion, the combination produces a sensitometric curve with increasing slope in the upper mid-tone and lower highlight regions.

(daylight-balanced camera film, tungsten-balanced film, duplicating film, etc.) without requiring modification of the replenishment.

7.41 Dye Sensitization

The basic silver halide emulsion is sensitive only to the blue and ultraviolet regions of the spectrum (about 180 nm to 520 nm) that it absorbs. The human visual response is highest in the green region, with a peak in the vicinity of 550 nm. Thus, photographs made with an unsensitized emulsion will have different black-and-white rendering of the brightnesses of colors than that perceived with the human visual system.

In 1873, the photographic scientist H.W. Vogel found that emulsions could be made to respond to wavelengths of light in the green region of the spectrum by adding a pink or red dye. The emulsion became sensitized to the color absorbed by the dye. When an emulsion sensitized to green by means of a red dye is used in the camera, with a yellow filter over the lens to absorb some of the blue light (to which the film remains sensitive), it gives a response in terms of black-andwhite rendering that is somewhat closer to that observed by the eye; and it is thus described as an *orthochromatic* or "correct" color rendering. The term *isochromatic* also has been used to identify this characteristic.

Later, a green or cyan dye that absorbs red light extended the emulsion's sensitivity. Thus the emulsion is sensitized to red light by the addition of a cyan (red-absorbing) dye. Combined with the added green sensitivity, the emulsion responds to all of the colors of the visible spectrum, which includes blue, green, and red, and it is termed *panchromatic* (see Figure 7–31). Spectral sensitization, while used in films mostly to provide appropriate tone reproduction of subject colors, also increases the film speed with white light, and some higher-speed films have a greater-than-normal sensitivity to red light.

In some cases, the sensitizing dye is added in emulsion making at the time of halide precipitation. It may be included in the salts used for precipitation, but most often it is added after digestion has been completed, and prior to coating of the emulsion on the support.

These sensitizing dyes are sometimes retained by the film after processing, especially if a rapid processing technique is used, giving black-and-white negatives a pink cast. Normal development, fixation and washing usually remove nearly all of the sensitizing and antihalation dyes from the negatives.

While most photographic papers are manufactured with emulsions that have been made to meet the sensitometric requirements without further modification, some papers require a final speed adjustment that can be achieved by addition of sensitizing dyes to the emulsion. This extends the sensitivity to some of the longer wavelengths of light. This technique can be satisfactory until a change in the color of the light sources used for printing or recording reveals a greaterthan-expected shift in speed from one emulsion coating to another. Some variable-contrast papers have mixed emulsions of different contrast with spectral sensitivities that can be used to control the contrast by changes in filtration. A typical variable-contrast enlarging paper produces high-contrast images when exposed with blue light (with a magenta filter), low-contrast images when exposed with green light (with a yellow filter), and medium-contrast images when exposed with white light.

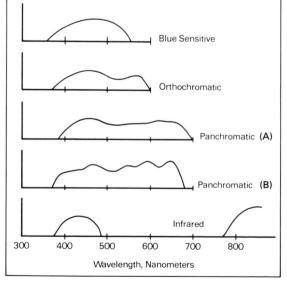

Figure 7-31 Traces from spectrograms for typical blue sensitive, orthochromatic, panchromatic and infrared films. Panchromatic (A) has extended red sensitivity to nearly 700 nanometers; Panchromatic (B) is more representative of that used for pictorial photography.

7.42 Coating Finals

Just prior to coating, chemical finals are added to the emulsion for various reasons. Included in these additives may be an alcohol to reduce froth or foam in the emulsion, and surfactants such as saponin (used since the beginning of dry-plate photography) to lower the surface tension so that an even coating is achieved. Sensitizing dyes may also be added at this stage. Free bromide or chloride is maintained in a small amount (except in POP), and organic compounds may be added to stabilize the emulsion against growth of fog and loss of sensitivity in storage. Salts such as potassium nitrate or potassium chloride may be added to film to increase conductivity, and reduce static electrical charges that may occur when handling the film. In some instances matting agents may be added to alter the nature of the surface, for example to lower the "gloss" in the case of some papers, or to provide some tooth for retouching, or to prevent "blocking" or sticking of the emulsion to adjacent convolutions of film in rolls, or to the back of sheet films when stacked.

These materials are more often included in a surface coaring introport the unique of the multiple of the content of the unique of the unique of the unique of the emulsion during storage and coating, and after manufacture. An important additive is a "hardening" agent to reduce the emulsion's swelling during processing. Chrome alum is a gelatin hardener with a long history, but formaldehyde has also been used for many years. Other more recent widely used hardening agents include other aldehydes, such as gluteraldehyde. Hardening occurs by introducing cross linkages among the gelatin molecule chains.

7.43 Subbing

Before coating the emulsion on the support or base, the latter has to be prepared to make the emulsion adhere—a process referred to as *subbing*. The subbing provides adhesion between the emulsion and the base. A typical subbing material is an acid solution containing alcohol and gelatin, sometimes with other solvents, depending upon the type of base being coated. It amounts to a thin coating of a solution formulated for the particular type of support, and which is usually applied in a separate coating operation and allowed to dry. Baryta-coated and other uncoated papers do not usually need an additional subbing. In some types of coatings, an electrostatic charge is applied to the base, providing suitable adhesion. The rolls of stock can be electrostatically charged and held for several days before coating, but sometimes the charging device is a part of the coating machine, and the charge is applied just prior to emulsion coating.

Polyester bases are difficult to sub, and this has been one of the problems with providing a final coating that meets archival requirements. The emulsion does not separate from the base, but the lack of firm adhesion manifests itself as "breaks" or lines in the material after aging, particularly if it has been subjected to cycling temperatures and relative humidities, such as seasonal or daily changes in storage conditions.

7.44 Coating

The most common coating technique is that of extruding the emulsion through a slot onto the support as it passes the coating

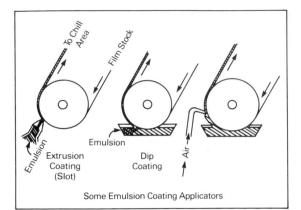

Figure 7-32 Some emulsion-coating applicators.

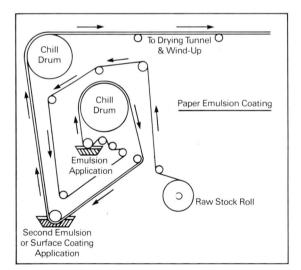

Figure 7-33 Paper emulsion coating.

point. With this technique, multiple coatings can be laid on top of one another with a single pass of the support through the coating machine, as shown in Figure 7-32. A common method in the past was to pass the stock over a roller positioned to allow the surface of the stock to touch the surface of the melted emulsion held in a pan, and maintained at such a depth as to not allow the emulsion to run to the back side of the stock. The emulsion (or gelatin if it is an NC coating) is picked up, and the thickness of the coating depends on the viscosity of the emulsion and speed at which the base material travels through the pan. Viscosity is a function of temperature, so the temperature must be carefully controlled. At a given viscosity, if the coating speed is increased, the emulsion thickness is decreased.

Other methods of emulsion application are quite numerous. They include the use of a pick-up roller or a cluster of rollers that transfer the emulsion from the pan to the stock. Another technique is to pick up the emulsion by one of these methods, then blow off the excess with an air knife. This allows higher machine speeds with fairly viscous emulsions, and may improve coating uniformity. (Coatings of nonsilver materials in aqueous solution have low viscosity, and can be coated at much higher speeds. In addition to the air knife, a simple doctor blade, which is rigid and at an angle, can be used to wipe off excess solution after enough has penetrated into the surface.) Coating machines can be quite elaborate and can be arranged to apply several emulsion and surface coatings with a single pass of stock, as shown in Figure 7-33.

After coating, the film or paper passes through a chill chamber, or over a drum filled with brine (a salt solution that can be cooled without freezing) in order to set the emulsion. It then passes into the coating machine's dryer section. Drying is best done at a relatively low temperature at the start, using dry air, with somewhat higher temperatures permitted as the drying process draws to a close. The coated master rolls are stored at low temperatures until quality-control tests have been completed, after which they are brought out for finishing; that is, slitting and cutting into sheets and rolls as required for packaging and sale.

7.45 Formation of the Latent Image

After the sensitized material is exposed in a camera, examination of the surface would not reveal an image. It is said to be a latent image. Some of the chemical characteristics of this image are as follows:

- **1.** It is weakened or destroyed by oxidizing agents such as chromic acid, which also oxidize metallic silver.
- 2. This oxidizing reaction does not destroy the sensitivity of the emulsion, which after washing and drying can be used to expose a new image, although spectral sensitivity and speed may be degraded.
- **3.** It is not soluble in silver halide solvents. (If the exposed image is bathed in sodium thiosulfate solution and the remaining silver and halide ions are removed by subsequent washing, physical devel opment can then be used to develop the latent image. Silver meta from silver ions in the developing solution plates out on imagareas where exposure occurred.)

4. The reduction of silver ions to silver metal by the developer is catalyzed by the presence of silver atoms. The latent image also increases the reduction of silver ions.

From the above it appears that the latent image and silver have the same reactions. This indicates that exposure sets into operation a mechanism within the crystal that in the end produces silver atoms which distinguish exposed silver halide grains from those that are unexposed.

Thus, when the crystal of silver halide, made up of silver and halogen ions, is exposed to light, it becomes capable of being reduced by a developer to metallic silver, which along with all the other exposed crystals forms the image of the photograph. Among several theories that have been proposed for the mechanism of latent image formation, the Gurney-Mott hypothesis is a prominent one. It consists of two distinct steps in an exact order, but concluded in a short time interval. Using silver bromide as an example, they are:

- 1. The radiation of the silver bromide crystal producer electrons (lime in a fulled to a higher run agy level accolated with the conductance band. The electrons move through the crystal by photoconductance until they are trapped by the sensitivity specks (see Sections 7.32 and 7.33). The specks, or traps, then possess a negative electrical potential. This concludes the primary process, and its final effect is to initiate the secondary process.
- 2. The secondary process involves the movement of the interstitial silver ions that are attracted to the negatively charged specks. The positive silver ions are neutralized by the negative charges, and the production of silver atoms is completed.

The hypothesis does not explain the fate of the halogen. It is possible that the halogen atoms may either recombine with an electron, may attack the silver atoms produced, or react with a halogen acceptor such as gelatin or sensitizers that reduce the atoms to halogen ions (see Figure 7-34).

Absorption of a quantum of light by the crystal excites an electron so that it is free to move through the lattice and may combine with an interstitial silver ion, thus yielding an atom of silver. This is most likely to occur at a nucleus produced by chemical sensitization, called a sensitivity center, which traps the electron and holds it until an interstitial silver ion arrives. There is a strong tendency for this atom of silver to give up an electron and thus return to the ionic state. It is also possible for the electron to recombine with the positively charged "hole" left when it was released from a halide ion. If exposure is sufficient, two silver atoms together form a sub-latent image that is not capable of development. However, a greater time will be required for the two atoms to give off electrons and return to the ionic state than is the case for a single atom. When sufficient exposure has been received to bring about four atoms of silver at the site, the grain may become developable. Further exposure of the grain to light adds to the number of silver atoms at the original site, and thus increases the developability of the grain. About 10-20% of the grains in a fast negative emulsion are rendered developable when four atoms of silver have been formed at the site, but the average number of atoms required for developability is considerably higher.

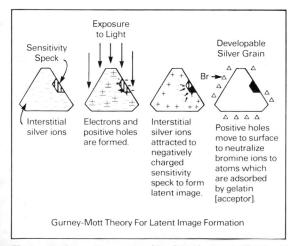

Figure 7-34 Gurnoy Mott hypothesis for latent-image formation.

The latent image is usually formed on the surface of the

crystal, but a latent image can also be formed in the crystal's interior on exposure to light. This internal image is usually protected from the developer, but it can be developed in a solution containing a silver halide solvent. In nearly all emulsions the contribution of the internal latent image to the developed image is negligible. A grain with an internal image usually has a surface image. For purposes of experimental research, the surface image can be destroyed to demonstrate the existence of the internal latent image.

The positive holes, formed by the loss of electrons to form silver atoms, move to the crystal surface to neutralize halogen ions to atoms that are adsorbed by the gelatin. The gelatin in this context is referred to as a halogen or bromine acceptor.

While most of the latent image in ordinary photographic materials is formed on the surface of the crystal, the interior latent image plays an important part in some photographic effects. In the Gurney-Mott hypothesis the electron "traps" are considered to be distributed throughout the crystal but are more effective on the crystal's surface.

The concept of surface and internal latent images is based on experiments in which silver halide crystals are given alternate treatment in a silver solvent (oxidizing agent) and a silver halide solvent in a developing solution. The silver solvent oxidizes the surface latent image. The developer will not develop the internal latent image until it is made physically available by removing the surrounding silver halide.

One interesting experiment shows the depth of the internal latent image. A large crystal was prepared on a glass plate, given a constant exposure through a longitudinal slit, and then placed slowly lengthwise in a silver halide solvent so that one end of the crystal was dissolved more than the other. Part of the crystal was not allowed to protrude into the solvent bath. The crystal was then processed. Figure 7-35 shows the technique of producing the graded etching and the results, as well as a schematic diagram of latent-image distribution. The experiment is helpful in showing that there is an internal latent image, and in giving a relative quantitative indication of its depth.

7.46 Photographic Effects

Eighteen photographic effects were discussed in Sections 2.23 to 2.40. The mechanism of latent-image formation is closely related to six of these photographic effects, which are examined in this section. These six are: Reciprocity, Intermittency, Herschel, Clayden, Solarization, and Sabattier.

7.46.1 Reciprocity Effects

Photographic exposure is the amount of light falling on the emulsion (Exposure = Illuminance \times Time). Reciprocal combination of illumination and time will give the same exposure, but not necessarily the same density. This decrease in density with certain combination of illuminance and time is called reciprocity law failure. When exposure are made at low light levels, the efficiency with which the sub-laten images are formed on the crystal is low because of the tendency of the silver atoms to give up an electron and return to the ionic state. Furthe exposure allows a greater number of silver atoms to accumulate around

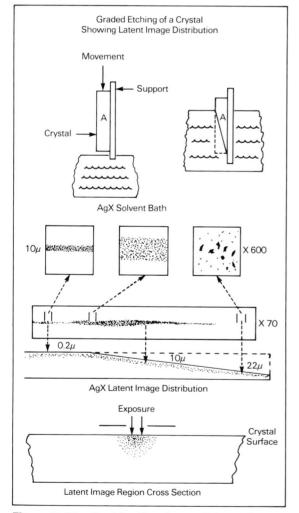

Figure 7–35 Graded etching of a crystal showing latent image distribution.

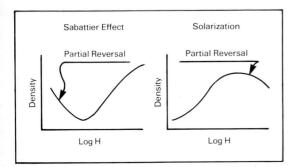

Figure 7–36 The Sabattier effect is the result of arrested development, wash, re-exposure, and further development. Solarization is the result of extended exposure and moderate development in a developer without silver halide solvents. Both effects produce a "reversal" image.

those few sub-images that survive, but these sub-images are relatively stable.

When exposures are made at high illuminance, with correspondingly short exposure times, the electrons are released so rapidly that the relatively slower-moving silver ions cannot neutralize them fast enough for the centers to grow to the predicted size. A greater number of sub-image centers are spread over the crystal surface, and sometimes into the crystal's interior. There is more competition for the additional silver atoms formed, and thus a smaller number of them grow large enough to become permanent developable latent-image centers (see Figure 7–36).

Reciprocity law failure is caused by the relatively low efficiency of the formation of sub-image centers at low intensities with long exposure times; and by the high efficiency of the formation of sub-image centers at high intensities, with corresponding wide distribution of competing sub-image centers. Emulsions for pictorial use are formulated so that the most efficient compromise between exposures made at low intensities and those made at high intensities generally occurs when the exposure times are in the vicinity of 1/10 to 1/100second. The reciprocity law failure of an emulsion is the same for all wavelengths of light when compared on the basis of equal densities and equal times.

The reciprocity law is valid for the production of electrons in the primary process of the Gurney-Mott hypothesis, but does not apply to the secondary and other processes that are necessary for the production of the final image.

The reciprocity failure of a photographic material is dependent on the temperature of the material during exposure. Tests show that the failure virtually disappears at temperatures of -186 C, with an accompanying loss of sensitivity. Temperature variation has different effects on low and high intensity reciprocity law failure.

Exposures made with X-rays and gamma rays show no reciprocity failure, due to the high velocity of the electrons first liberated, releasing large numbers of electrons on collision with ions in the grain. Print-out papers also do not show reciprocity failure. (Also see Sections 2.23–2.28.)

7.46.2 Intermittency Effect

The intermittency effect is closely associated with reciprocity failure. Intermittent exposure means exposures in discrete installments rather than in one continuous installment. If the intermittency rate is low, the intermittent exposure will produce the same photographic effect as a continuous exposure of equal total energy. As the frequency is increased at a given level of illumination, the photographic effect is decreased until with a further increase in frequency the loss in photographic effect becomes constant. The point at which this occurs is a critical value that varies with the illuminance level. If the intermittent exposure is made at a sufficiently high illuminance level, the photographic effect will be greater than that of a continuous exposure of equal energy. In relation to the U-shaped reciprocity-law-failure curve, the intermittency effect at the critical interruption frequency is equivalent to moving to the left on the curve. In the case of low illuminances on the left half of the curve, the move is upward, indicating that more exposure is required to produce a specified density. In the case of high illuminances on the right half of the curve, the move to the left is

7.46 Photographic Effects

indicating that *less* exposure is required to produce a specified density (See Figure 7-37.).

7.46.3 The Herschel Effect

The Herschel effect occurs when a colorblind emulsion is first exposed to blue light, then to a much greater quantity of longerwavelength radiation, such as red light. The first exposure produces a latent image, and the subsequent exposure to red bleaches or destroys the latent image. This is explained on the basis that the absorption of the second exposure of long-wavelength energy by the short-wavelength latent-image silver will cause the release of an electron from the silver atoms. This will cause a reduction in the latent image to a point where it no longer is sufficient to render the crystal developable.

7.46.4 The Clayden Effect

If the emulsion is exposed for a very short time at high intensity, and this is followed with a much longer exposure time under moderate illuminance, the combined exposures do not give an additive effect. The image produced by the first exposure may even be reversed. An early noted practical example of this is the "black lightning" effect. If the shutter of the camera, placed on a rigid mount, is opened to record a lightning flash, and then after a considerable time the shutter is closed, the lightning will print black. (See Figure 2–65.)

According to the Gurney-Mott hypothesis, the first highintensity exposure produces electrons at a greater rate than they can be neutralized by the interstitial silver ions at the traps. The electrons migrate to the interior of the crystal to form an internal latent subimage. The second exposure produces electrons that, in the exposed grains, may be attracted to the internal image and thus detract from the forming of a surface latent image. This would decrease the developability of these grains. The second exposure would expose the remaining crystals and render them developable in a normal manner.

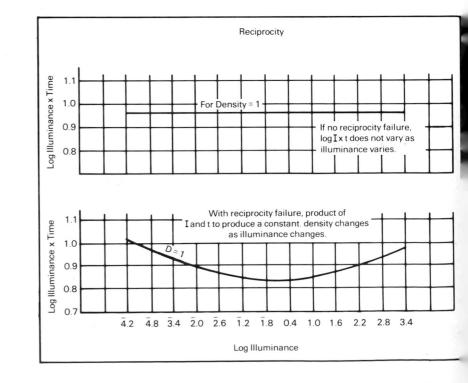

Figure 7–37 Reciprocity.

7.47 Latent-Image Stability

7.46.5 Solarization

When a sensitometric curve is considered, solarization is the reversal or decrease in density with additional exposure increase beyond that required to produce maximum density on the film (see Figures 8–1 and 2–69). The maximum solarization effect is produced with moderate developing times, while extended development reduces, or even eliminates, the effect. In addition, the presence of silver halide solvents, such as sodium thiosulfate and sodium sulfite, in the developer inhibits or removes the solarization. Developers that do not contain silver halide solvents usually produce the effect.

If halogen acceptors are present during exposure, solarization may be diminished or even eliminated. Thus, solarization is considered to be the result of rehalogenation of the photolytic silver formed at the sensitivity specks as the result of exposure. Normal exposure produces halogen at a rate that allows the halogen to react with acceptors such as gelatin. If the exposure is great, the production of the halogen proceeds at a rate beyond the capability of the acceptor, and thus may react with the latent-image silver to reform silver halide. This surface coating of silver halide, although it commins a latent linage beneath it, will shield the downlaper from the LINPF. This is sufficient to lower the number of developable crystals, and the result is a lower density. If the developer contains a silver halide solvent, it will remove the surface silver halide and thus expose the latent image for development.

7.46.6 Sabattier Effect

The Sabattier effect is produced by developing an exposed photographic emulsion for a short time, washing it, and then allowing the emulsion to be exposed a second time. This is followed by further development, fixing, and washing (see Figures 7–36 and 2–67). The effect is sometimes confused with solarization, in that the final result is a partially reversed image. It appears to be caused by two mechanisms: (1) the image produced by the first development screens or acts as a negative and thus allows the exposure of the remaining silver halide to be modulated to produce a positive image during the second development; and (2) the byproducts of the first development act as a restrainer in the developed areas. The migration of used and fresh developer across image boundaries may produce Mackie lines, a line of increased density just inside the denser area and a line of decreased density just inside the thinner area.

7.47 Latent-Image Stability

The fact that amateur photographers sometimes allow months and even years to elapse between the time the first exposure is made on a roll of film and the time the film is processed attests to the stability of the latent image. Preservation has been exceptional in cases where exposed film has been frozen in ice, such as in the Arctic region, but images have been obtained with exposed film that has been stored for as long as 25 years under household conditions.

These examples are not intended to suggest that the latent image is permanent and does not change with time. Since the latent image consists of a cluster of silver atoms, the loss of only a few atoms may render a silver halide grain undevelopable. An atom of silver can combine with an atom of bromine, for example, to form a molecule of silver bromide—reversing the effect of exposure. After long periods of time the image, when developed, may have less contrast and be less

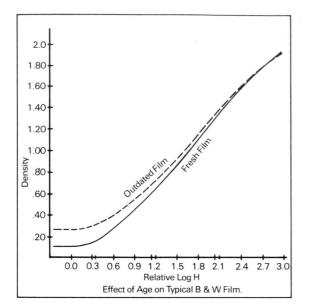

Figure 7–38 Effect of age on a typical black-and-white film.

distinct due to the spontaneous development of a larger number of unexposed silver halide grains. As this type of development fog increases, a point is reached where the developed latent image can no longer be detected. A small amount of development fog, however, can produce the effect of increasing the speed of the photographic emulsion and the density of the developed latent image in the same manner as latensification (see Figure 7–38).

For critical work, detectable changes in developed latent images sometimes occur in remarkably short times. Exposing a large number of black-and-white prints identically, and then developing part of the batch one day and the balance the following day, has been reported to produce a significant difference in density. Improvements in emulsion technology in recent years have reduced the decay rate of the latent image in black-and-white printing papers, however.

Changes in the latent image of color printing papers are more serious because they can affect the color balance of the print in addition to the density and contrast. For this reason, recommendations are made to store color paper for a fixed time after exposure prior to processing to make the latent image change relatively constant. If the exposed paper is to be held for more than the hour or two normally built into the schedule, recommendations are that it be stored at 0 F (-18 C) or below, and then for a period of no more than 72 hours. Film manufacturers recommend that color films be processed as quickly as possible after exposure or that they be stored at a low temperature, noting that storage in a closed automobile on a hot day for only a few hours can have a serious effect on the developed image. They also warn against allowing color films to come into contact with various fumes, including those of chemical solvents and mothballs.

7.48 Some Alternative Systems

The familiar black-and-white and color films and papers that use gelatin as a suspension vehicle for the light-sensitive silver salts are but one of many ways to make a light-sensitive photographic system. Most of the older processes, such as calotype, daguerreotype, cyanotype, albumen, wet collodion, ambrotype, carbon, carbro, gum bichromate, platinum and kallitype, use something other than silver salts and/or gelatin. None have the light-amplification ability of silver and therefore they all have very slow speeds. The required long exposure times or high light levels limit their use in a camera, so they are relegated to photographic printing or certain types of recording where high sensitivity is not required.

Many of these older processes are also being rediscovered by photographers who are exploring their delicate tones and esthetic qualities. Some processes utilize silver and/or gelatin only in an intermediate step. Many of the present-day color processes are examples of the latter where the final images consist of dyes. Newer processes such as electrophotography and television use electrical and magnetic fields for image recording and reproduction. Light-sensitive microchips containing many light-sensitive picture elements have sufficient sensitivity tc be used as discs in cameras (see Chapter 12).

The "heliographic drawings" produced by Niepce in the 1820s used bituminous varnish on paper, glass, or metal, which hardened on exposure to light, and was essentially the same in principle as the photoresists that are used today for the production of printed circuits, other microelectronic devices, and small metal parts. In 1826 Niepce was able to produce a photograph with a camera on a pewter plate coated with albumen. The exposure time in bright daylight was about eight hours; and the plate was processed by dissolving away the unexposed, unhardened areas with oil of lavender. Today's photoresists are organic resinous materials whose polymer structures are changed on exposure to light to render a differential in solubility of the resist. Processing is achieved by washing away the more soluble parts after exposure. They can be made to be either negative working or positive working.

7.49 Calotype Process

Another early process utilizing silver but not involving gelatin was the *calotype* process, invented by William Henry Fox Talbot, and patented in 1841. Talbot had obtained negative silver images on silver chloride paper as early as 1839, with what was later called the Talbotype process. The negative and positive images formed the basis of modern photography. Paper was sensitized with eiler indich alloci nitrate, and game and was developed in gallic acid; this paper was used for both the camera negative, and for printing a positive from the negative.

According to a modern version of the process, the paper is first iodized by coating it with an approximately 7% solution of silver nitrate in distilled water, as shown in Figure 7–39. After the paper is dried it is floated on a solution containing about 7% potassium iodide and 1% sodium chloride, and dried again. It is then sensitized by flowing onto the surface a solution containing about 10% silver nitrate, 7% acetic acid, and 1% gallic acid, producing light-sensitive silver halide. The sensitized paper is dried and kept in the dark until ready for camera exposure. The exposed paper is developed in a solution containing about 0.8% gallic acid and 2.5% silver nitrate, producing a silver image. The developed negative is fixed in a solution of about 30% sodium thiosulfate (hypo) solution, washed, and dried. Prints can be made by exposing this negative on a conventional modern printing paper, or on another sheet of calotype paper.

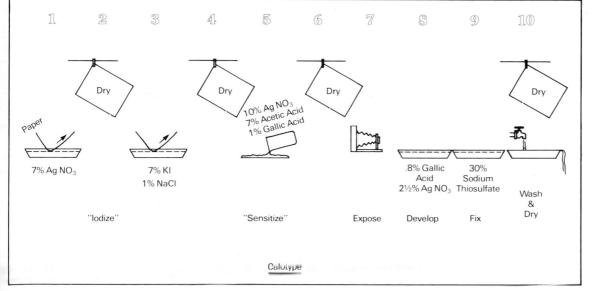

Figure 7-39 Calotype.

7.50 Daguerreotype

The process announced by Louis Jacques Mande Daguerre on August 19, 1839, introduced practical photography to the world. No gelatin was involved. A sheet of copper or brass was plated on one side with silver, which was buffed to a high mirrorlike polish (see Figure 7–2). It was then sensitized by placing it in a light-tight box containing iodine crystals, which gave off iodine vapor that reacted with the silver to form a coating of silver iodide. Exposures were made in a camera, and since the image was viewed on the surface of the plate and not through it, it was reversed from left to right, a condition that was corrected in practice by placing a mirror at 45° to the lens in front of the camera.

After exposure, the plate was placed in a box containing a dish of mercury that was heated to about 75 C (165 F). The mercury adhered only to the exposed parts of the plate, giving a whitish amalgam of silver and mercury. The plate was fixed in a solution of sodium thiosulfate (hypo), washed, and dried. When the daguerreotype was viewed so that the unexposed, undeveloped areas reflected the dark surroundings of a room, a positive image was seen. The speed of the plate was increased by adding bromine to the iodine vapor, and the image strength could be improved by toning with gold chloride after fixing. Since the silver image was readily tarnished or damaged by handling, it was protected by placing it in a decorative cutout frame and covered with glass.

7.51 Cyanotype

The cyanotype (or blueprinting) process, invented by Sir John Herschel in 1842, is a nonsilver, nongelatin process. The ferric iron salt used in coating the paper is reduced by light to the ferrous state, which is then precipitated to Prussian Blue (ferric ferrocyanide, $Fe_4[Fe(CN)_6]_3$), by the action of the potassium ferricyanide, the second component of the coating solution. The image is made up of varying densities of the Prussian Blue. A good grade of sized paper should be used; the paper is sensitized by coating (brushing, floating, swabbing) with a solution consisting of about 12.5% ferric ammonium citrate and 7.5% potassium ferricyanide (usually prepared by mixing separate solutions of these two compounds). Ferric ammonium oxalate can be substituted for the ferric ammonium citrate for increased speed, and about 1% of potassium dichromate can be added for increased contrast.

After exposure a pale image can be seen, and processing normally consists of washing the prints in plain water to remove the unexposed soluble ferric salt, followed by drying. Prussian Blue is a fairly stable compound but it is soluble in alkalis, and the image is affected by impurities in the atmosphere that sometimes cause the image to take on a "metallic" lustre in the denser areas. The cyanotype process can be used for printing continuous-tone photographs by contact from large negatives. It was also once used on a large scale for copying drawings from original tracings but has since been supplanted by the diazo process. (There are several other cyanotype formulas, but they all result in a Prussian Blue image).

Cyanotypes can be converted to purplish-black images by bathing in a 10% sodium carbonate solution, which bleaches the image then redeveloping in about 1% tannic acid solution. Cyanotype images can be inked over with waterproof ink, and the blue bleached out with about 5% oxalic acid, followed by washing and drying, to produce a pen-and-ink drawing. A modification of the process (*pellet process*) produces a faint image that can be developed to a reversal image (positive to positive) upon development with potassium ferrocyanide. Another version, the *pointevin process*, is a positive-to-positive one that produces purplish-black lines on a light background.

7.52 Albumen Paper

Albumen was used as the colloid for glass negatives for a short time before the introduction of the wet collodion process, which replaced it. *Albumen paper*, on the other hand, was used extensively as either a printing-out or developing-out paper from 1850 to 1890. The paper is first prepared by coating it with egg albumen containing about 2% ammonium chloride, and burnishing it by drying against a ferrotype tin. The paper is then floated on a solution containing about 22% silver nitrate, which has been ammoniated. (The ammoniated solution is made by dissolving about 60 mg of silver nitrate in 185 ml of water. About one third of this is separated out and ammonium hydroxide added to it until a precipitate is formed, which is then redissolved with further addition of the ammonium hydroxide. About 30 ml of grain alcohol [ethanol] and the remainder of the silver nitrate solution are then added to this.)

After drying, the albumen paper is ready for exposure. A dense, contrasty negative is required, and the image can be judged during exposure since it is printed out on exposure to sunlight, or to an ultraviolet lamp. The prints can be developed in a gallic acid solution, or it can be fixed out—in which case the image should be made somewhat darker with increased exposure. For better image color, the print can be washed and gold toned, followed by fixing and thorough washing.

7.53 Wet Collodion

The *wet collodion* process is a silver process, but it uses nitrocellulose as the binder for the halide crystals. It represents an important phase in the development of photography because it produces negative images on a transparent base, and was the principal method of making negatives from 1851, when it was introduced by Frederick Scott Archer, until the 1870s, when gelatin dry plates were introduced.

The cellulose nitrate is prepared by immersing cotton in a mixture of nitric and sulfuric acids, followed by washing in water. When dry, the nitrated cotton is dissolved in a mixture of ether and alcohol to produce collodion. (Prepared collodion can be obtained from chemical supply houses.) For photography, the collodion is prepared by adding a small amount of sodium or potassium iodide or bromide to the collodion and dissolving it. Some formulas have also made use of cadmium bromide and other halides. The prepared collodion is then flowed onto a clean glass plate until it is covered, and the excess collodion drained back into the bottle. The alcohol and ether evaporate and leave a tacky coating on the plate (see Figure 7–3). Flow characteristics, which vary with atmospheric conditions, are adjusted by altering the relative amounts of ether and alcohol in the collodion. The tacky plate is immersed in the dark in a tank containing silver nitrate, about 65 grams per liter, for about one minute. The plate is then loaded

into a special holder, while still wet, and inserted into the camera for exposure.

Following exposure the plate is developed before it has a chance to dry, by flowing a ferrous sulfate solution, or pyro solution, over the plate, and allowing the "puddle" to remain there during development. Some operators drain and replace the developer during development. However, it is thought that some physical development takes place, that is, some of the silver is plated back onto the image from the excess on the plate.

Two common formulas for developers are as follows. These developers, unlike most developers in use today, are acid rather than alkaline.

Formula No. 1	
Ferrous sulfate	36 g
Glacial acetic acid	50 ml
Alcohol	20 ml
Water to make	1 liter

Formula No. 2

Pyrogallol	4 g
Glacial acetic acid	40 ml
Alcohol	120 ml
Water to make	1 liter

After development, the plates are fixed in a solution of potassium cyanide, or sodium cyanide, about 65 grams per liter, or with a sodium thiosulfate (hypo) fixing bath. The collodion image could be stripped off the glass to provide a film negative and a reusable glass plate, but this was not done often in the field. The wet collodion process continued to be used in the graphic arts industry until well into the twentieth century. The images were routinely stripped off the glass support, and recemented onto another support, or "flat"—a number of images placed together on a single support. The term *stripping* is still applied to the removal and repositioning of images into a new layout.

7.54 Ambrotype

When a thin wet-collodion plate, bleached, or developed to have a light gray image, is bound up with a black background, it produces a positive when viewed by reflected light, and is called an *ambrotype* (see Figure 7–40). A further variation of wet collodion is the *tintype*, which consists of the wet collodion process coated on a black enameled metal plate. The whitish image on the black plate produces a positive image, not too much unlike the ambrotype. In later years manufacturers provided tintype materials coated with a dry emulsior for monobath (developer and fixer-combined) processing, eliminating the need for the photographer to coat the plates.

7.55 Carbon

The nonsilver *carbon* processes, like many printing processes require an original negative, which was usually made by a silver process It is a pigment printing process, and derives its name from the fac

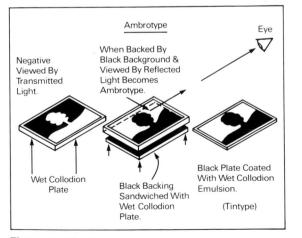

Figure 7-40 Ambrotype.

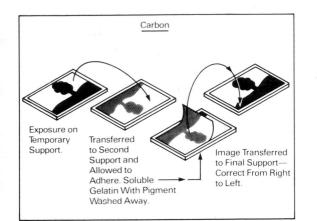

Figure 7-41 Carbon.

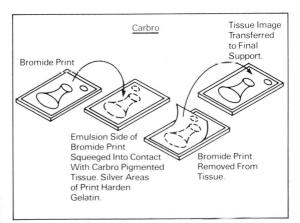

Figure 7-42 Carhro

that the pigment most often used in the beginning was carbon. Practical prints were made as early as 1864, but the process was perfected and came into fairly wide use 10 years later, in 1874. It is based on the fact that gelatin containing bichromate is hardened by exposure to light. The pigment in the gelatin acts as a screen that controls the depth of exposure, and thus the amount of hardened gelatin. The unhardened gelatin is washed away, leaving the image of pigment in the hardened gelatin (see Figure 7–41).

If a coating of this type, after exposure, were washed, the surface image would go along with it. Therefore, it is necessary to transfer the image from a temporary support used for exposure to another support; and, once it has adhered, remove the temporary support and wash the unhardened gelatin and pigment away. Since this is a laterally reversed image ("mirror image"), it is necessary to make a second transfer of the image onto a permanent support. If the negative used for printing is laterally reversed at the time of exposure, the second transfer step is unnecessary, and the second support becomes the permanent support. A wide variety of colored pigments can be used in the process.

7.56 Carbro

The *carbro* process also makes use of pigments, but is a variation of a process that was patented in 1899. The original procedure involved exposure of a paper coated with bichromated gelatin, followed by washing to remove the bichromate stain; then a pigment sheet was rolled into contact with it. The sandwich was immersed in a solution containing 4 ml of glacial acetic acid, 1 gram of hydroquinone, and 1 gram of copper sulfate in a liter of water. After one-half to one hour, the sheets were separated and the soluble gelatin was washed away in warm water. In 1905, Thomas Manley, the inventor of the process, introduced another modification, which utilized a bromide print (without a surface coating) instead of the bichromated gelatin image. With improvements in 1919, the process became known as the *carbro process*.

A bromide print is soaked and squeegeed into contact with a prepared pigmented tissue, as shown in Figure 7-42. After several minutes, the gelatin is hardened in those areas in contact with the silver image. With soaking the bromide print is separated, and can be used for making more tissue prints. The tissue is laid on a transfer paper for about 20 minutes, then the two are carefully separated under water, leaving the pigment image on the transfer paper. It is gently washed to remove the soluble pigmented gelatin, followed by treatment with 5% alum, washed in two or three changes of water and dried. In some cases, the original bromide print is not separated and becomes the base for the final print, the silver either being used to reinforce the pigment image or, being bleached away, leaving only the pigment image. By using colored pigment sheets, the process can become tricolor carbro. In this case, the transferred images are superimposed on one another in register-a cyan image to absorb red light, a magenta image to absorb green light, and a yellow image to absorb blue light.

7.57 Gum Bichromate

The gum hichromate process depends on the hardening effect produced by light on a bichromated colloid; in this case the colloid is gum arabic. Before the turn of the century the process enjoyed great popularity because of its adaptability to printing controls, and the wide choice of colored pigments that could be used. While it is considered obsolete today, it is enjoying revived popularity as a means of artistic expression. There are various formulas for preparing the sensitizer, depending on the tonal rendering desired, but a fairly standard formula consists of mixing equal parts of a 10% solution of potassium bichromate with a 30% solution of gum arabic. The potassium bichromate can be dissolved in hot water, but the gum arabic requires soaking overnight or longer at room temperature. A small amount of thymol or other preservative can be added to improve the keeping qualities of the gum solution. Ammonium bichromate is sometimes used in place of the potassium salt to produce increased sensitivity. Any of a wide variety of water-miscible colorants can be added to the mixture.

The mixture should be applied to paper or another support, which is temporarily attached to stiff cardboard, using a brush. Experience will result in a technique that will produce a uniform coating. The coated material is dried in a dark room. Sensitivity is low until the material is nearly dry. The speed is similar to that of POP (printingout-paper), but it is necessary to run an exposure test, as the speed depends on variations in the colorant.

The prints are made by contact, using sunlight, or some other source rich in actinic ultraviolet radiation, using a printing frame. A typical exposure is about five minutes. Development consists of dissolving the unhardened coating. The print is placed face-down in a tray of cold water for a time that may vary from 15 minutes to hours. The process can be speeded up with a gentle spray after the initial soaking. The image should not be touched until it is completely dry. During the drying stage, the print should be attached to a stiff support to prevent curling.

7.58 Platinum Process

Commercially coated paper for the *platinum process* was available until about 1937. It involves neither silver nor gelatin. There are several formulas that the photographer can use to prepare platinum paper. A common formula makes use of oxalic acid, ferric oxalate, potassium chlorate, and potassium chloroplatinate. It is prepared in three stock solutions, which can be mixed in various proportions to alter the contrast of the print. For very soft prints the potassium chlorate is eliminated, along with formula changes; and for very contrasty prints, the ferric oxalate is minimal. When the coated, dried paper is exposed to light, the ferric oxalate is converted to ferrous oxalate to form an iron image. The print is developed in a solution of potassium oxalate and monobasic potassium phosphate. This reduces the chloroplatinate to platinum in those areas where the ferrous oxalate was formed.

The paper is quite insensitive when wet, so coating can take place in subdued illumination, but it should be stored in the dark when dry. Speed is low, and sunlight or other high-ultraviolet-radiation source is required for printing. Following development, the print is cleared by rinsing it with a 1:60 hydrochloric acid solution. There are other developer formulations that produce warmer tones than with the formula described. The ferric oxalate has to be pure, and thus the photographer is advised to prepare it by precipitating the ferric hydroxide from ferric ammonium sulfate with ammonium hydroxide, then dissolving the hydroxide in oxalic acid.

7.59 Kallitype

A close cousin to the platinum process is the *kallitype* process, in which silver is substituted for the platinum. The light-sensitive compound is still ferric oxalate, which is reduced to ferrous oxalate on exposure to light. When the image is developed, in a solution containing borax and potassium sodium tartrate (Rochelle salts), the silver is reduced to metal in those areas where the ferrous oxalate has been formed. The print is cleared and fixed in a solution of hypo and ammonia. Like the platinum paper, this paper is slow, and requires daylight or a similar source for exposure. The sensitizer contains ferric oxalate, oxalic acid, and silver nitrate.

7.60 Electrophotography

There are many different electrophotographic processes (which use electricity to form images), some of which have not yet been fully developed. Electrostatic photography (xerography), which had its beminning with the human and there is the most advanced electrophotographic system in use today. The basic principle of image formation is that certain materials, such as selenium (early experiments were conducted with sulfur) and zinc oxide, will take on an electrical charge when passed near a source of high voltage, a corona charge. This is usually a positive charge in systems utilizing selenium, but the zinc oxide (in a resin binder) requires a negative charge. The action of light is to eliminate the charge, resulting in an image that can be made visible by dusting the plate with pigmented "toncr," which adheres to the charged (unexposed) areas. The toner also can be carried in a liquid.

With xerography (Xerography is a trade name, but *xerography* is now listed in dictionaries as a generic term), a drum plated or coated with selenium rotates first through an electric field (corona discharge) where it picks up a uniform positive electrical charge, as shown in planographic form in Figure 7–43. The image of the original is projected onto the charged

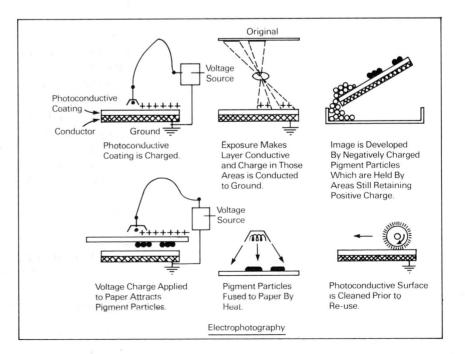

Figure 7–43 Electrophotography.

drum, leaving an image consisting of positive ions in those areas that were not exposed. The drum is dusted with the toner, which adheres to the charged image. The drum then picks up a sheet of paper and both are passed through an electrical field that causes the toner to transfer from the drum to the paper. The paper is passed through heat to fix the pigmented toner permanently to the paper. If the exposure is made while the drum is rotating, a scanning system is used to synchronize the image with the rotation of the drum, but an alternative system uses a stationary charged surface with electronic flash illumination.

A modified method of electrostatic photography, represented by Electrofax, does not utilize a drum coated with selenium or other material from which the image is transferred to "plain" paper, but instead uses a paper coated with zinc oxide in a resin binder. In this process, a negative charge is placed on the paper itself, after which it is exposed to form an image that is then "dusted" with pigment, or passed through a toner carried in a suitable liquid. The toner adheres to those areas that were not discharged through exposure to light. The transfer step and heating to set the image are not required. The special zinc oxide-coated paper is required; it is characterized by its heavy weight, due to the zinc oxide coating. A multipaged report will require considerably more postage than one made on "plain" paper. These processes are rapidly being displaced by xerographic electrostatic transfer processes.

Good line copies are readily made with these processes, but one problem in their development has been to produce good continuoustone reproductions. There have been efforts in this direction to devise methods that control the corona charging rates, among other things, which are meeting with continued success. Since the toner can be made in various colors, and since successive images can be made on the same sheet, it is possible to produce multicolored copies. Positive images are produced, since the toner adheres to the areas that are not exposed to light.

7.61 Thermography

Thermography is another nonsilver, nongelatin process. Images are formed by heat, usually by radiation from an infrared lamp that is modulated by the image on the original document. The denser areas absorb infrared radiation and become hotter than the surrounding less-dense areas. The heat is transferred to the heat-sensitive material, which is placed in contact with the original. The most common changes are a physical softening in the heated areas, or a chemical decomposition. Since printing and typing inks generally do not strongly absorb infrared, it is necessary first to make an electrostatic copy of such originals and then make a thermographic copy from that copy—not a practical procedure if a single copy is needed.

With the 3-M Thermofax process, a dark image can be obtained on a transparent base through chemical decomposition, for use on an overhead projector, or a heat-softened image can be transferred to a paper base. Spirit masters can be produced by the latter method when inexpensive multiple copies are needed. When the heat-sensitive material is the final copy, subsequent exposure to heat may fog the nonimage areas. When a softened image is transferred to another support, there is no such problem. The chemical process typically involves the combination of two substances to form a colored byproduct. The substances may be either dispersed in a single layer or coated in adjacent layers; one combination consists of an aromatic triazene and an azo coupler.

A third type of thermographic process—distillation—uses a thin layer of oil that transfers to a receiving sheet through evaporation in the heated areas. The oil image is made visible by dusting with dye particles. Subsequent heating makes the image permanent as with electrostatic processes.

7.62 Diazo

The *diazo* family of nonsilver, nongelatin processes is mainly divided into two categories: one producing dye images, and the other vesicular images. With the *dye image* process, ultraviolet radiation decomposes compounds known as diazonium salts. The remaining salts are converted to azo dyes with ammonia or heat. The ammonia may be applied either in solution form or as ammonia fumes. Since dye is formed in the areas protected from radiation a positive image in formul trom a positive original. No fixing is nonded because the antibility is destroyed in the nonimage areas by the action of the exposing radiation.

A diazo material that produces black images on a white background is widely used for copying drawings, and the resulting prints are called white prints to distinguish them from blueprints. Diazo materials are available with paper, film, and foil bases and a wide variety of image colors. Limitations of the process are low sensitivity and the need for an ultraviolet-rich source of radiation for exposure. The high-contrast characteristics of the sensitized materials make them unsuited for copying continuous-tone originals. However, they are capable of high resolution, and they were at one time considered favorable for reproduction of microfilm images and optical sound recordings.

With the *vesicular* process, crystalline and noncrystalline diazonium salts are randomly dispersed in a thermoplastic film (see Figure 7-44). Upon exposure to ultraviolet-rich radiation, the diazonium salt is decomposed and nitrogen gas is released into the thermoplastic film. Development consists of heating the film to change the dispersal pattern mainly due to the tiny bubbles that are formed as the gas expands. Upon cooling, these larger bubbles remain and produce an image by

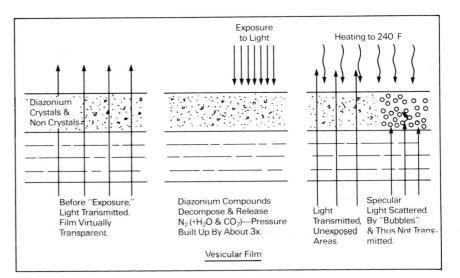

Figure 7-44 Vesicular film.

scattering light (as contrasted to silver and dye images, which produce visible images by absorbing light). Fixation consists of a uniform exposure to radiation without heat which decomposes the residual diazonium compounds and the released nitrogen gas is allowed to diffuse from the film.

Although vesicular images appear low in contrast when viewed by diffuse illumination, the contrast is satisfactory when viewed by specular illumination (Sections 2.4 and 2.15). Since bubbles are formed where exposure occurs, a negative image is formed, but the processing procedure can be modified to produce a positive image. Typical applications are the production of positive images from microfilm negatives, black-and-white negatives from 35 mm color slides, and quick projectuals in audio-visual work. Before the displacement of black-andwhite motion pictures with color, this process was a strong contender for making motion-picture release prints.

7.63 Television

Television is an electronic process that in its essential form does not produce a permanent image; but when tied to magnetic recording, the system does produce images that can be modified, edited, and recalled at any time. The vidicon tube contains an image-receiving area having a transparent electrically conductive coating upon which is deposited a photoconductive layer that is normally a good insulator (see Figure 7-45). When any area of the photoconductive layer is exposed

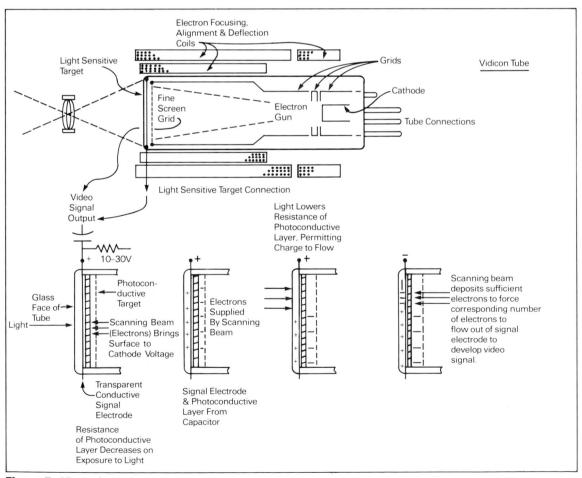

Figure 7-45 Vidicon tube.

to light, its resistance is decreased (it becomes conductive). When this is scanned with an electron beam, a signal is generated between the photoconductor and the transparent conductor in front of it, which depends on the scanned light pattern that was produced on it by the camera lens. This signal is then amplified and broadcast to the home receivers, where the signal is reconverted to an image on the TV screen. The signal can be recorded on a magnetic tape or disc to form a permanent image, or series of images. No silver or other materials such as colloids are involved in this type of process and electronic imagery is rapidly becoming an important medium.

7.64 Charged Coupled Devices

There are several ways in which images formed by light can be electronically processed, including Charge-Injection Devices (CID), Charge-Priming Devices (CPD), and Charged-Coupled Devices (CCD). An example of the latter is the system announced by Sony in 1981, in which an image is placed on an array of small photocondition dimension in the measurement processing as a signal to a TV receiver for presentation of the picture. The same record can also be used to reproduce the picture, one such device making use of dye tissues that are heated to release colored dyes. The amount of heat in a given area is modulated by the signal from the magnetic disc to evaporate the dyes in amounts relating to the original image. The dyes then migrate to a plain paper sheet receiver. Three colored tissues plus a "black" tissue are used to produce a colored image with good shadows.

7.65 Dye Transfer

The gelatin-silver emulsion provides an intermediate matrix from which the image is produced by transferring dye to a mordanted gelatin coated film or paper support. (A mordant is a substance that binds a dye to a given material—in this case, gelatin.) With the Technicolor motion picture process, now defunct in the United States, a set of matrices (one each dyed with cyan, magenta, and yellow to represent the red, green, and blue records of the scene) transferred the dyed images to a gelatin coated "imbibition blank" film, as shown in Figure 7–46. Beginning in the 1930s the images were transferred to a processed positive film carrying the silver sound track. For dye transfer prints on paper, see section 10.10.

7.66 Diffusion Transfer

With *diffusion transfer*, an exposed gelatin-silver negative emulsion on either a film or paper base is brought into contact with a receiver sheet, with a viscous activator solution containing a strong alkali and a silver halide solvent such as thiosulfate placed between them. The negative emulsion also contains a developing agent, and the receiver sheet, which is not light sensitive, contains nucleating particles such as silver sulfide, along with a developing agent. The activator causes development to take place in the negative, and the halide is reduced to silver to form a negative. At the same time, the undeveloped silver halide in the negative is dissolved by the thiosulfate, and diffuses to the receiving sheet. The silver sulfide particles serve as nuclei for

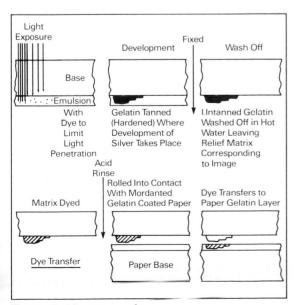

Figure 7–46 Dye transfer.

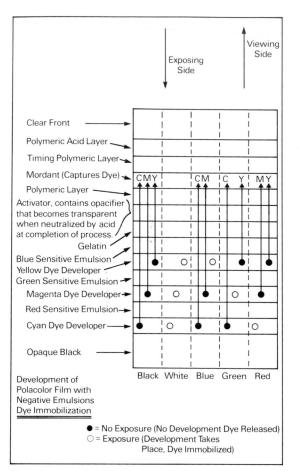

Figure 7–47 Development of Polacolor film with negative emulsions dye immobilization.

development of the halide that diffuses to the receiving sheet, and it is reduced by the developing agent, now activated, to metallic silver to form a positive image. When the two sheets are separated, the remaining viscous activator—developing/solvent solution—stays with the negative, leaving the clean positive image on the receiving sheet. No further fixing or washing is required. The process normally goes to completion, although varying the time and/or temperature can permit some variation in density or contrast.

This is essentially the type of process used in "instant" cameras for black-and-white photography, such as Polaroid. If the negative is on a paper base, it is discarded after the positive print has been formed; but if it is on a film base, the negative can be salvaged for normal printing by rinsing away the activator in a sodium sulfite solution. The Polavision[®] color motion picture process also utilized a variation of this type of process, but the negative is not removed from the positive since it is of relatively low density after processing. This is an additive screen process, in which the red, green, and blue filter elements are continuous fine lines, 4,500/inch.

The Polacolor[®] system of photography makes use of a multilayer film consisting of red-, green-, and blue-sensitive layers, interspersed with dye-developing layers containing developer molecules linked to cyan, magenta, and yellow dye molecules, as shown in Figure 7– 47. In those areas that have been exposed to light, development takes place after the developer has been activated by the viscous material from the pod that has been broken to start the process. Where development occurs the developer/dye molecules are immobilized, but where no development occurs the developer/dye molecules migrate through the emulsion layers to the receiving layer of the adjacent paper, and are fixed in position to produce the positive color image (see section 10.11). The Polacolor II system makes use of an opaque layer that protects the film during processing, and that permits the image to be visible after processing has taken place.

KODAK Instant Print Color Film, no longer being manufactured, incorporated high-speed direct-reversal emulsions that produced positive images on development without the need for conventional reversal processing steps, as shown in Figure 7–48. The processing chemicals from the pod supplied with the film packs operated by releasing dyes (not forming them) as the result of development. The release of the dyes from their "anchors" in the film was accomplished by the concerted action of the developer oxidation products and alkali on agents in the film called dye releasers. The released dyes then diffused to an image-receiving layer in the picture unit to form the color image (see section 10.12).

References

Amphoto, The Encyclopedia of Practical Photography.

- Daguerre, L. An Historical and Descriptive Account of the Various Processes of the Daguerreotype and the Diorama.
- American National Standards Institute, Curl of Photographic Film, Methods for Determining (PH1.29-1971).
 - ——, Photographic Roll Paper, Dimensions (PH1.11-1981).
 - ——, Photographic Sheet Paper for General Use, Dimensions (PH1.12-1981).

——, Thickness of Photographic Paper, Designation (PH1.1-1974).

Carroll, Higgins, and James, Introduction to Photographic Theory.

References

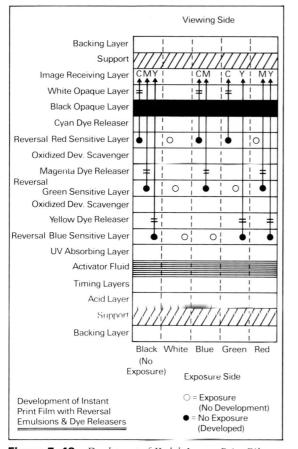

Figure 7-48 Development of Kodak Instant Print Film with reversal emulsions and dye releasers.

Eastman Kodak Company, Kodak Color Films (E-77). Eastman Kodak, Kodak Films—Color and Black-and-White (AF-1).

—, Kodak Professional Black-and-White Films (F-5).

—, Processing Chemicals and Formulas (J-1).

Ross, Television Film Engineering.

Schaffert, Electrophotography.

Sturge, Neblette's Handbook of Photography and Reprography. Wall and Jordan, Photographic Facts and Formulas.

Zworykin and Ramberg, Photoelectricity and Its Application.

Black-and-White Photographic Development

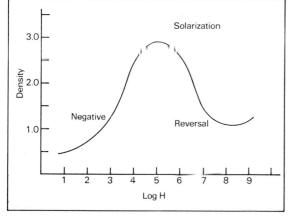

Figure 8-1 Solarization.

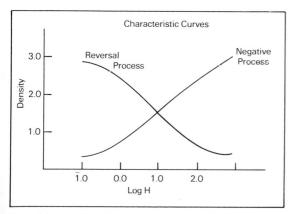

Figure 8–2 Densities increase as exposure increases in a negative process; while densition docrease with increased exposure in a reversal process.

8.1 Negative Development

When a silver halide emulsion on film or paper has been exposed to a light image, a *latent image* is formed in the emulsion; in most circumstances this image would not be visible because of the small amount of silver produced. The energy required to produce such a latent image is relatively small, permitting exposure times of 1/1,000 second or shorter under daylight illumination. The development process amplifies this image by a factor of up to 10^9 , producing the final silver image. Assuming that optical density is approximately proportional to the amount of silver per unit area of the image, it is possible to calculate the density of a latent image. For example, the maximum density that can be obtained in a reflection print is about 2.0. This density divided by 10^9 , the maximum development amplification factor, equals 0.00000002, the calculated density of the corresponding latent image. The smallest density difference that can be measured with conventional densitometers is 0.01.

The subsequent fixing step converts the unexposed, while veloped silver holide remaining in the film to soluble ail a complexes that are unabled away to leave only the silver image. The photographic process is a negative-working one, in that dark areas in the scene record as light areas on the film, and light areas record as dark on the film. In the case of the original camera exposure, a negative image is created that serves as a light modulator to produce a positive image on another piece of sensitized material for viewing.

8.2 Direct-Positive Images

A positive image can be produced on some types of emulsions by overexposing them to such an extent that the reversal region of the characteristic curve is reached (see Figure 8–1). X-ray film, for example, could be used as a contact-printing medium for reproduction of an original negative X-ray image as a negative image simply by grossly overexposing it, and processing in the usual way. Emulsions have been produced that give positive images with normal development for copying and duplicating negatives. High-speed emulsions of this type, for example, were incorporated in KODAK Instant Color Film where dyes were released in the areas where development took place; these dyes diffused to the receiver to form the colored images (see Section 10.12).

8.3 Reversal Processing

The basic negative-working silver halide cmulsion system can be used to produce positive images by means of reversal processing (see Figure 8–2). Some emulsions are more suited to this type of processing than are others. Reversal processing begins with a negative image, as in normal development. The silver image is then removed in a bleach, such as potassium dichromate-sulfuric acid, which reacts with the metallic silver to form soluble silver sulfate that is washed away, leaving the undeveloped silver halide in the emulsion. The remaining silver halide is then exposed to a strong light source, and developed again to produce a "reversed" or positive image. The regions that do not receive much original image exposure have very little density after the first development, but a great deal of halide is available to the second developer to produce a high density. Similarly, where there was high exposure in the beginning, there is little silver halide re-

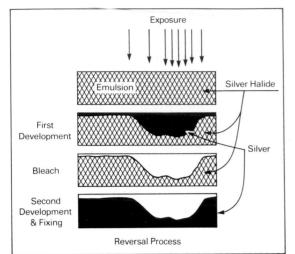

Figure 8-3 Reversal process.

maining for the second exposure and development, and low density is produced, as shown in Figure 8-3.

More recently, fogging developers have been used for the second or reversal development, which eliminates the need for second exposure. Stannous salts or borine compounds are used as a pre-bath or are added to a typical formula to make it into one that will fog without exposing the halide. The positive image can also be developed in a solution of sodium sulfide to produce a sepia image without second exposure. With tri-pack subtractive color reversal films, first development produces three negative silver images that remain in the film when the subsequent color development takes place, forming dyes in the three layers in proportion to the silver formed by development. Then all of the silver from both (negative and positive) images is bleached and removed, leaving only the positive dye images (see section 10.4).

8.4 Mechanism of Development

Latent images can be divided into surface latent images and internal latent images. Most of the development takes place with the surface latent image, and the internal latent image normally contributes little to the total image. The latent image is formed when a certain number of quanta have produced a nucleus of silver atoms in or on the surface of a silver halide grain. Four atoms of silver are considered to be the minimum number that constitutes a latent image.

Development is the selective reduction to silver of additional silver halide molecules around the site of the silver latent image nuclei, with no appreciable reduction in those areas that have not been exposed to light. As development continues, the amount of metallic silver grows, and if carried far enough the entire silver halide grain is converted to metallic silver. There are basically two types of development: chemical development and physical development. In physical development, the silver is provided by a silver salt in the developing solution, whereas in chemical development the silver comes from the reduction of silver halide grains in the emulsion. In most instances, some physical development takes place along with chemical development as a result of the solvent action of sodium sulfite on silver halide grains, and the amount varies with the type of developer. Physical development can be accomplished after fixing the exposed but undeveloped image, in which case the silver nuclei not removed by fixing serve as the focal points for accumulation of silver from the developer, which contains a soluble silver compound. The acid in conventional fixing baths will destroy the latent image, however.

8.5 Constitution of Typical Developers

The most important ingredient in a chemical developer is the developing agent or chemical reducer that converts the exposed silver halide to metallic silver. Most developing agents require a pH higher than 7 to function, and for this reason the developer also contains an alkali, sometimes referred to as the accelerator. In order to minimize oxidation of the developing agent by oxygen in the air, the solution also usually contains a preservative, most often a sulfite. A restrainer, usually a bromide, is also part of most developers. The restrainer has the effect of slowing the rate of development, but this effect is greater in the unexposed areas than in the exposed areas of the emulsion, thereby limiting spontaneous development, or chemical fog. The presence of a restrainer in the developer formula also tends to minimize variations

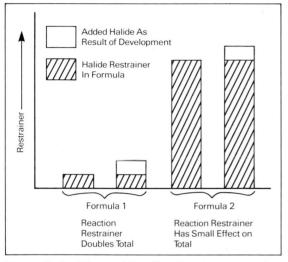

Figure 8-4 The restraining effect of reaction products of development is much greater when the developer formula contains a low amount of restrainer. A longen many of contribute the end about planmum maker the downloper many volcame of increases in restrainer due to the byproducts of development.

Figure 8-5 Developing agents.

due to the release of halide ions during development, which would themselves act as restrainers (see Figure 8–4). Bromides or other halides are also sometimes referred to as anti-foggants, but this term is usually applied to a number of organic compounds that are used at much lower concentrations than bromide. A developer formula may also include other compounds that accelerate development, provide more even development, prevent the formation of insoluble compounds, etc.

8.6 Developing Agents

Common developers today make use of organic developing agents, although in the past inorganic metallic agents such as ferrous sulfate have been used. Development takes place as a result of the transfer of an electron to the silver halide. With ferrous sulfate the iron of the developing agent goes to a higher valence, in the presence of an organic ion such as oxalate. (The loss of an electron to Ag^+ converts Fe^{++} to Fe^{+++} .)

More recently, renewed interest has been shown in this and other metallic ions such as titanium and vanadium. The ferrous sulfate developers were most commonly acid with a pH range of 4 to 6, but they can operate in an alkaline solution.

Most organic developing agents are related to benzene, which usually forms a part of their chemical structure. One of the oldest of these is pyrogallol, or pyro (1,2,3 benzenetriol), which is a benzene ring with three of the hydrogen atoms replaced by OH groups, or "hydroxyl" groups, as shown in Figure 8–5. Hydroquinone (1,4 ben-

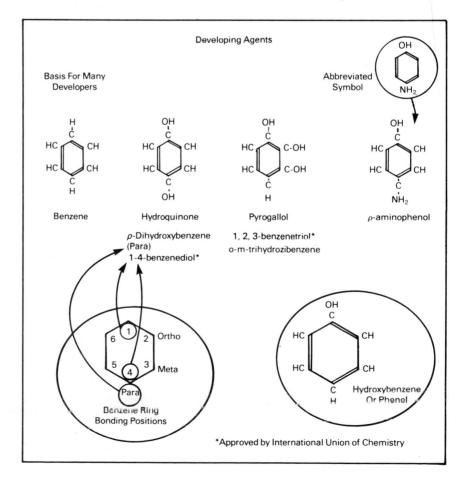

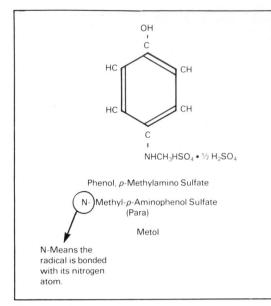

Figure 8-6 Metol.

Figure 8–7 Simplified development reaction (actual hydroquinone to benzoquinone is a complex change).

zenediol, or para-dihydroxybenzene) is another developing agent of long standing, with two opposing OH groups on the benzene ring. These compounds are also related to phenol, which is a benzene ring with one OH group substituted for one of the hydrogen atoms. Another class of common developing agents is represented by Metol (N-methylp-aminophenol sulfate), and more recently by Phenidone (1-phenyl-3pyrazolidone) (see Figure 8–6). Manufacturers sometimes substitute trade names for the generic names. In a representative development reaction, which actually involves several steps, the developing agent, hydroquinone for example, is oxidized to benzoquinone at the same time as the silver halide is reduced to metallic silver, as shown in Figure 8-7.

8.7 Hydroquinone

The majority of silver developers utilize hydroquinone and Metol as their developing agents. Hydroquinone, discovered in 1881 by Abney, is used probably more than any other developing agent although usually in combination with another developing agent. It requires strongly alkaline solutions, since it has relatively low energy. Hydroquinone is slow to take effect but, once it has started, proceeds to develop rapidly and produces high contrast. It is quite sensitive to changes in temperature, and is practically inactive at temperatures below 15 C (59 F). In strongly alkaline solutions it is a good developer for high contrast and line copy work. Developers made with hydroquinone tend to produce stain and fog unless sufficient sulfite and bromide are included in the formula. Both hydroquinone and pyrogallol tan the gelatin of an emulsion adjacent to those areas where development takes place; and either of these developing agents, or a combination of both (sometimes with other agents), is used in tanning developers. Tanning developers are used to produce matrices that can be dyed, with the dye being transferred to a mordanted paper or film as in the dye transfer (or, previously, the Technicolor motion-picture film) processes (see section 10.10).

8.8 Metol

Metol, introduced by Hauff about 10 years after the discovery of hydroquinone, is another popular developing agent. It is packaged,

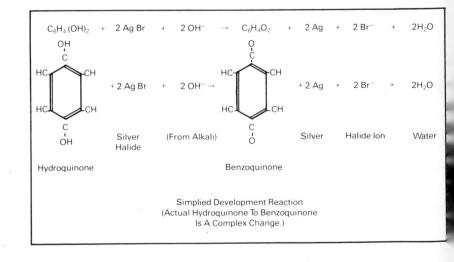

Figure 8–8 *Typical developing agents of the p-phenylenediamine type.*

Figure 8-9 Color development.

sometimes with a modification of the acid radical, under a variety of proprietary names other than Metol—such as Elon, Pictol, and Photol. Metol is unlike hydroquinone in its developing action. It is a softworking developer, development is initiated almost from the start of the developing time, it retains much detail in the images produced, it is not very sensitive to restrainers such as bromide, it has good shelf life, and it is capable of developing relatively large quantities of photographic emulsion before becoming exhausted.

8.9 MQ Developers

Developer formulas made with both Metol and hydroquinone (MQ) produce an effect superior to either one used alone or the sum of the two used separately. This superadditive effect seems to have the advantage of an earlier induction period, allowing the hydroquinone to come into play sooner than it otherwise would. The superadditivity, however, exists not only during the induction period, but also at any degree of development. One explanation is that Metol is the primary developing agent and its oxidation product is reduced back to Metol hy the hydroquinnin at Ming as any hydroquinone exists in the developer solution. Several other developer combinations also produce an improved working characteristic, but Metol and hydroquinone are the best known. Phenidone and hydroquinone used together produce a similar superadditivity effect.

8.10 Color Developers

For color development, a para-phenylenediamine type of developing agent (in which the hydrogens of one amino group are replaced by organic groups) is used (see Figure 8–8). Another name for para-phenylenediamine is 1,4-benzenediamine. As development takes place, the reaction product unites with another compound (a color former) present either in the emulsion or in the developer, to produce a colored dye in proportion to the amount of silver formed, as shown in Figure 8–9. The color of the dye depends on the radicals used to form part

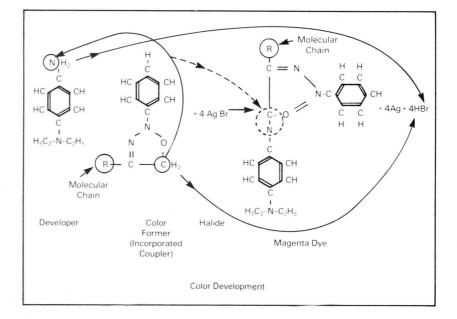

8.11 Accelerators

of the color-forming compound. The actual coupling reactions are quite complex, going through several stages almost simultaneously.

8.11 Accelerators

In order for the developing agent to function properly, the pH of the solution must be maintained at some value, usually above 7 with organic developing agents. This is accomplished by adding an alkali compound, or a mixture of compounds designed to maintain the pH at the desired level over the life of the developer, or at least during the development time of a given film. Sodium hydroxide is a strong alkali that is used for some types of developers, but the amount required to produce the required pH for most developers would be small, and the hydrogen ions liberated during development would rapidly change the pH. If the required pH is above 12 or 13, however, the quantity would be sufficient to maintain the pH even after the hydrogen has neutralized a substantial proportion of the hydroxyl OH^- ions to H_2O .

Most developers require that the alkali be *buffered* so as to maintain the availability of OH^- ions over a period of use. The buffering compound is usually a salt of a weak acid, such as sodium phosphate, sodium metaborate, sodium sulfite, or sodium bicarbonate. Several factors, including other chemicals in the formula, affect the pH of the developer, but the choice of alkali is the most significant one. The pH, then, is an indicator of the relative activity of the developer; the higher the pH, the higher the activity. Some types of developing agents require a strong activator to make them function, whereas others can function with relatively weak activators, and a few with none at all. The following typical accelerators are arranged in order of decreasing alkalinity:

Sodium hydroxide, pH \longrightarrow	12 +	
Sodium carbonate, pH \longrightarrow	11.5	
Sodium metaborate (Kodalk), pH	>	10.8
Borax, pH \longrightarrow 9.6		

Sodium sulfite \longrightarrow (weak alkali).

8.12 Preservatives

Being a reducing agent, the developer will also react with oxygen in the air and thus lose its capability to develop a silver image A preservative is added to the solution to prevent aerial oxidation Sodium sulfite is the most commonly used preservative for developer utilizing organic developing agents. In the case of Metol-hydroquinondevelopers, the sulfite also serves the purpose of removing the reaction products of regeneration of the Metol by hydroquinone, so that the process can go on without slowing down. Sulfite also acts as a weal silver halide solvent, forming complexes that provide for a degree c physical development—the effect being influenced by other ingredient in the formula such as bromide, certain developing agents, etc. A smal amount of physical development contributes to "fine-grain" develop ment. In color developers, where the formation of dyes requires furthe

8.15 Other Development Accelerators

reactions with oxidation products, the amount of sulfite must be kept to a minimum to prevent removal of the intermediate reaction products.

8.13 Restrainers

A simple developer formula (developing agent, activator, and preservative) may not differentiate adequately between the exposed and unexposed grains of silver halide in the emulsion. That is, in addition to developing the image grain, it may also tend to develop the nonimage grains to produce silver or fog. (Restrainers sometimes cause some reduction in emulsion speed, especially if used in larger amounts.) A soluble halide, usually bromide, is added to the solution to act as a restrainer. It has the effect of controlling the reduction process so that there is a better differentiation between exposed and unexposed grains. In addition, since one of the reactions of development is the release of bromide or other halogen ions into the solution, these ions will act as a restrainer. As more and more film is processed in the developer, additional halide will be added to the solution, thus increasing the restraining effect. A quantity of bromide in the developer formula minimizes the mariability producted by the addition of relatively much smaller quantities of halide resulting from development (see Figure 8-4).

In the processing of multilayer color films where at least three emulsions have to be quite precisely controlled relative to one another, the maintenance of the halogen ions in the developer may have to be closely monitored. The restraining action of various halides is considerably different—iodide, for example, requiring one-thousandth the quantity of bromide required to produce a given restraining action. On the other hand, the amount of chloride required is so high that it is not useful as a restraining agent.

8.14 Anti-Foggants

Since halides such as potassium bromide restrain the development of fog in nonimage areas, they are often referred to as antifoggants. However, the term is usually reserved for another class of developer additives that minimize fog, usually with less effect on the overall speed of the emulsion. The term is applied to a group of organic compounds sometimes used in the preparation of emulsions, as well as developers, although the specific compounds are not necessarily interchangeable in the two applications. Some high-energy developers that require a high pH, for example, must of necessity incorporate an antifoggant of this type to keep the fog at an acceptable level. Since the organic anti-foggants usually require lower concentrations than does bromide, they may be used where high concentrations of bromide are out of the question because of its effect on the other characteristics of the emulsion. Typical anti-foggants used in developers include 6-nitrobenzimidazole and benzotriazole.

8.15 Other Development Accelerators

There are numerous compounds that increase the rate of development when added to developer formulas due to other than the effect of the pH increase produced by the developer accelerator. These compounds work in a variety of ways. Some wetting agents, for example, have a positive charge (cationic), and decrease the induction period by canceling out the negative charge on the silver grain. Some sensitizing dyes with positive charges can have a similar effect. Certain neutral salts such as potassium nitrate and sodium sulfate also have an accelerating effect, which is thought to be due to the improved diffusion of the developer ions through the gelatin of the emulsion. Another class of compounds that are weak silver solvents also act as development accelerators through the extra density provided by physical development (thiocyanates, thiosulfates, cyanides). Wetting agents are sometimes added also for the purpose of smoothing out the flow of development.

Other substances, manufactured under proprietary names, are often added to developer formulas to increase shelf life, lower the freezing temperature of liquid developers, improve mixing and solution capabilities, etc. Thus a packaged formula may be considerably different from a mixed formula used for the same purpose, or sometimes even having the same name. These proprietary formulations often provide competitive advantages in handling, and they are not disclosed to the general public.

8.16 Concentration of Developer

The components of a developer interact in a variety of ways. The development rate is influenced by the developing-agent concentration, the alkali and resulting pH, the restrainers, and the sulfite or preservative concentration. The interaction of all these components is not constant, and adds further to the complexity. For example, it is often difficult to predict the results of dilution of many developer formulas. Some of them are designed to minimize these interrelating effects, and carry recommendations for diluting to various strengths to meet specific photographic requirements. In general, these developers are such that the product of dilution and development time to provide a given degree of development is not always constant, and each dilution should be tested with the type of film being used. Many developer formulas are such that a concentrated stock solution is prepared, which is diluted to various strengths as required.

Other factors affecting the degree of development are time, temperature, and agitation. These are interrelated so that a change in one can, to a considerable degree, be compensated for by a change ir the other. Thus, different developing times are recommended for tray development of film with constant agitation and tank development with intermittent agitation. Agitation should be selected to produce uniform development over the picture area, not to control the degree of development. Most photographic processes, however, are designed to function best at a prescribed combination of time, temperature, and agitation. This is particularly important for color processes, where the relationship of reproduction characteristics between the red, green and blue records has to be precisely maintained.

8.17 Development Time

The chemical effects of development are not constan throughout the total time of the process. In the beginning there ar no reaction products, and the developer has to penetrate the emulsion

to gain access to the silver halide grains. As soon as the development process starts, reaction products begin to form and a restraining action comes into play, which is controlled to some extent by the removal of these products and their replacement with fresh developer by means of agitation. In the beginning there is also a relatively low concentration of silver ions present as the result of the solvent action of the developer, and it is some time before any physical development begins to take place. Rapid-acting developers, therefore, have a minimum of physical development component, whereas developers requiring extended times tend to have a greater physical development component. Most finegrain developers require relatively long developing times. The composition of the developer, the proportions of the developing agents, etc., have significant effects on the development characteristics with time. Most developer formulas in common use have been optimized for performance throughout the range of times that produce the desired contrast indexes for films.

8.18 Developer Temperature

DUVelopment time is also a function of developer temperature. But again, there is no hard and fast rule for quantifying the relationship that would apply to all developer formulas. In practical situations with well-designed developers, and within the range encountered in normal practice, the rate of development approximately doubles for every 10 C (18 F) increase in temperature. The *temperature coefficient* is the ratio of increase in development time that occurs when the temperature is decreased by 10 C (18F). It can be determined by observing the times for first appearance of the image in the developer at two different temperatures and applying the following formula:

Log temperature coefficient =
$$\frac{(\text{Log } T_1 - \text{Log } T_2) \times 10}{t_1 - t_2}$$

where T_1 and T_2 are the times of appearance of the two images, and t_1 and t_2 are the Celsius temperatures used.

When the developer contains two developing agents, the coefficient is useful over only a limited range. Some typical coefficients are:

If the time to achieve a constant gamma at two temperatures is plotted on a graph in which the time scale is logarithmic, a chart is produced that will show the time of development for any temperature required to produce the gamma, as shown in Figure 8-10.

Developers with hydroquinone as a developing agent have a relatively high response to changes in temperature, whereas those with Metol or Phenidone have a lower response. With the combination of Metol and hydroquinone this is evened out to some extent, but at lower temperatures there is less developing effect of the hydroquinone than Metol, and at higher temperatures the reverse is true. The concentration of bromide in the developer affects its response to temperature varia-

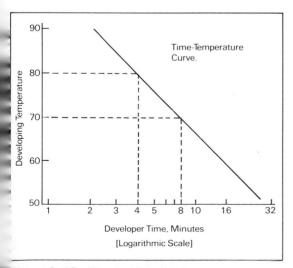

Figure 8-10 Time-temperature curve

8.19 Developer Agitation

tions, as does pH. A higher pH value or a lower bromide concentration makes the developer less responsive to temperture variation (it has a lower temperature coefficient).

8.19 Developer Agitation

Agitation affects both the degree and the uniformity of development. When development starts, the solution penetrates into the emulsion to react with the silver halide grains. As this proceeds, the developer is used up, and has to be replaced with fresh developer. The presence of the gelatin retards the diffusion, but in time the partially exhausted developer diffuses to the surface of the emulsion. If development is stagnant, this exhausted developer accumulates at the surface and slows down development. Agitation of the developer removes the exhausted developer and replaces it with fresh solution that diffuses into the emulsion to continue the development process. Agitation rate should be geared to obtain maximum uniformity of development. With high-acutance developers, where the image enhancement is achieved by the accumulation of exhausted developer and of fresh developer, at the edges of high densities and low densities, respectively, little or no agitation is recommended (see the Eberhard effect, section 2.36). With short developing times agitation has a greater effect on degree of development and overall density than it does with long developing times.

To ensure uniformity of development, the manner of agitation is important. There should be a nonlinear flow of the developer over the film, otherwise large areas of density differing from the surrounding area will allow exhausted (or relatively fresh) developer to be swept across adjacent areas of differing exposure. A motion-picture film, for example, that is carried through the process in a linear fashion will show "drag," areas of light density trailing dark areas on the film. The effect would be more prominent with short developing times. Likewise, intermittent agitation in trays can produce standing waves that will cause patterns on the developed film. Constant gas-burst agitation will tend to produce linear patterns, but if the bursts are intermittent, the combination of the bubbles' sweeping action followed by a period of stagnation will produce a more uniform result on the developed film With drag processing constant agitation is recommended, but the tray or the materials in it should be moved in a random way (the tray i. rocked, first one corner down, then the second) so as to minimize standing waves or directional effects.

The type of processing apparatus used has a strong influence on the degree of agitation (see Figure 8–11). Deep tanks in which the film is manipulated by hand can produce minimum agitation, as wel as can stagnant tray development. Shallow tanks, spiral reels, and tray offer an intermediate degree of agitation and require well defined ag itation techniques to minimize nonuniformity problems. Processing drums, on which the film or paper is held in close proximity to th rotating drum surface with the developer carried between the drun surface and the emulsion surface, produces close to maximum agita tion—the developer is exchanged at a very high rate. The roller trans port processor produces a similar high degree of agitation. Tubes tha carry the sensitized material inside, with the developer and other so lutions flowing over the emulsion as the result of rotating or tiltin the tube, also produce a high degree of agitation. Processing machine for long lengths like motion picture films, with spiral configuration **Figure 8–11** Some film and paper processing configurations.

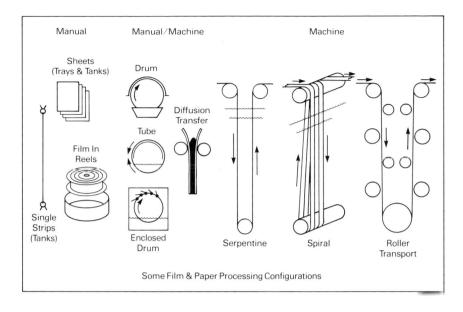

also provide good agitation, but these can lead to unevennesses due to the linear passage of the film through the solution. Here extra agitation of the solution by means of circulating pumps and jets can be made to sweep the film to minimize these problems.

8.20 Replenishment

When processing small volumes of photographic materials, it is best to use the developer once, then discard it. In this way uniform fresh developer is always used, and the resulting degree of development is more uniform from one time to the next.

When larger quantities of materials are being processed, it is not economical to discard the relatively large volumes of solutions required, and so replenishment can maintain the constant activity of the developer (or other solutions used in the photographic process). In determining the makeup of the replenisher formula, and the rate of addition, several factors have to be considered. These include: (1) the loss of developer resulting from carry-out by the film or paper as it is removed from the solution; (2) loss in developer activity due to accumulation of reaction products of development in the solution, mainly soluble bromide, and to some extent other halides; (3) loss of activity due to exhaustion of developing agent and sulfite consumed in the developing process; (4) increase in developer concentration due to evaporation; and sometimes (5) carry-in of water or other chemicals if a prebath or pre-rinse is used prior to development. (Other steps in a process will also have to take into account the carry-over of the previous solution or rinse.)

The replenishment formula is calculated to accommodate these changes due to processing, and to maintain the activity of the developer at a constant level. Such a formula is established by measuring the changes in the developer's chemical composition as measured quantities of film or paper are processed; calculating the amount of each chemical required to maintain the developer at its original strength, and adjusting this formula by actual performance tests. Since there are differences in the variables, it is often necessary to adjust the replenishment rate and/or formulation, especially if the process is to be maintained over a long period of time. Some moderate volume replenishment systems are designed to be replenished over a period that would require the addition of an amount of replenisher equal to the volume of the original developer solution. Then the developer is discarded, and a new developer, along with an equal volume of replenisher, is prepared for use with additional films. This generally avoids or minimizes the problems that can arise when attempting to maintain the process over a long period without remixing. With some systems, only a replenisher chemistry set is sold, and a starter solution is provided that adjusts the replenisher to make it similar to a "seasoned" developer by adding bromide and reducing pH with an acid, and without processing any film to"condition" the developer. This becomes the properly compounded developer, and the replenisher itself is used for replenishment as intended.

Replenisher formulas generally supply additional sulfite and developing agent that are consumed in the process, provide additional alkali to make up for loss, but reduce the amount of or omit bromide to compensate for that added to the developer as the result of the development reaction. In general, long-running processes can be maintained by suitable control of the chemistry through sensitometric monitoring and analysis of the constituents of the developer in use. In many instances, the carryover of solution from the tank is sufficient to accommodate the replenisher solution introduced into the tank; but in some instances control is achieved by having the formulas adjusted so that some additional developer has to be withdrawn to permit the introduction of a greater amount of replenisher. This makes it possible to adjust the withdrawal rate as another means of controlling the developer's chemical composition. In some cases it may be necessary to remove more than is carried over by the film to compensate for excessive buildup of halides beyond that required in the original formula.

Large-scale operations with continuous processing require constant chemical and sensitometric monitoring, as well as careful adjustments in the replenisher formula and rate in order to maintain the result within narrow limits. Since the rate of replenishment is dependent upon the type of film being processed, and the type of images on the film (high density vs. low density, etc.) these factors must be considered in maintaining uniformity, particularly in the case of color processes.

8.21 Paper Processing

The developers used for papers generally follow the same principles as those for films, with additional problems due to the physical differences (which govern carryover, among other things). Alkalinity and other aspects of the developer may have an effect on the sizing, curl, and/or brittleness of the paper. The content of the devel oper—restrainers and reaction products—can have a significant effec on the tone of the image produced, and this can become more apparen if the prints are subsequently toned (see Sections 9–20 to 9–28).

8.22 Analysis of Developers

The best control of processing operations involves the use o both sensitometric tests and chemical analysis of the processing solu tions, techniques of process control (see Chapter 1). However, the analysis of most photographic chemistries involves rather complicated procedures and requires a well-equipped laboratory operated by a trained chemist. In addition, some methods are subject to error due to the presence of other chemicals in the solution. It is best to continually make reference to a properly mixed operating solution that has not been used, to make sure the calibrations of the analyses are accurate. Simple procedures include the measurement and control of pH, measurement of specific gravity, and notation or measurement of the color of the solutions. These can be plotted and serve as an indication of change that may call for further study or more advanced analysis. And, of course, since all chemical processes are a function of time, temperature, and, in the case of photography, agitation, careful monitoring of these aspects are probably the most important controls that can be exercised.

The importance of good darkroom habits cannot be overstressed. Most failures of photographic processes can be attributed to accidents involving contamination of the processing solutions, even in trace amounts.

8.33 Epssific Black-and-white Processes

Processing of black-and-white films, papers, and plates normally involves development, followed by a rinse in an acid stop bath, fixing in an acid thiosulfate solution, washing to remove the soluble silver complexes and processing chemicals, and then drying. The wide choice of developer formulas depends on the photographic objectives, economic considerations (time, overhead), quality advantages (real or imagined), safety, coological considerations, etc. If the film negative requiries a lower contrast index and fine grain, a Metol type of developer may be the choice; whereas if high contrast is required for negatives, positives, or microfilms, a hydroquinone type of developer may be required. Where the application requires an ultrahigh contrast, as in many graphic-arts applications, a special "lith"-type hydroquinone formula is used. For "batch" or "one-shot" processing, a low-cost formula may be used and discarded. For large-volume continuous processing of sheets of long rolls, a stable formula with good life, freedom from sludging and other effects, and good replenishment capabilities are required.

Paper processing formulas are designed to produce pleasing image colors and densities, both before and after chemical toning; to have good tray or machine tank life, and freedom from unwanted stain or fog in the whites of the print. Color formulas have to be capable of forming appropriate dyes of good density. In some applications, film speed is the primary criterion, and the formula may be chosen to maximize this characteristic, even at the sacrifice of some aspects of image quality. In most cases there has to be a "trade-off" between desired attributes and those that are required to meet some condition. Table 8–1 compares some typical developer formulas.

8.24 KODAK Developer DK-50 for Films

KODAK Developer DK-50, a Metol-hydroquinone, metaborate developer, is a general-purpose developer suitable for use with practically all pictorial negative films, regardless of their manufacture. (The photographer can modify the amount of sodium metaborate in the formula to increase or decrease the time required to produce a given

	DK-5 0	DK-50R	D-76	D-76R	D-76d	A-17	D-25	DK-20	DK-20R	D-72	D-85
Water (liters)	.750	.750	.750	.750	.750	.750	.750	.750	.750	.750	.500
Metol	2.5 g	5.0 g	2.0 g	3.0 g	2.0 g	1.5 g	7.5 g	5.0 g	7.5 g	3.1 g	
Sodium sulfite	30.0 g	30.0 g	100.0 g	100.0g	100.0g	80.0 g	100.0 g	100.0g	100.0 g	45.0 g	30.0 g
Hydroquinone	2.5 g	10.0 g	5.0 g	7.5 g	5.0 g	3.0 g	0	U	0	12.0 g	22.5 g
Sodium metaborate ^a	10.0 g	40.0 g				U		2.0 g	20.0 g	0	0
Borax			2.0 g	20.0 g	8.0 g	3.0 g		U	0		
Sodium carbonate ^b			-			U				80.0 g	
Boric acid					8.0 g					0	7.5 g
Sodium bisulfite					0		15.0 g				2.2 g
Paraformaldehyde							0				7.5 g
Sodium thiocyanate								1.0 g	5.0 g		0
Potassium bromide	0.5 g					0.5 g		0.5 g	1.0 g	2.0 g	1.6 g
Water to make	1 liter	1 liter	1 liter	1 liter	1 liter	1 liter	1 liter	1 liter	1 liter	1 liter	1 liter

Table 8–1 Some developer formulas compa

^aKodalk

^bMonohydrated

degree of development; an increase lowers developing time, a decreased amount increases developing time. Excluding other considerations, length of developing time has an effect on the variability of the degree of development, with longer times providing less variation. An average developing time in the unmodified developer using tray processing is in the vicinity of $4\frac{1}{2}$ minutes. When diluted 1:1 with water, the developer serves as a tank-processing solution with a processing time of about 8 minutes (depending on the type of film being processed). Remember, variations in degree of agitation will influence the degree of development, also.

Replenisher DK-50 R can be used to maintain the strength of the developer over a period during which the replenisher is consumed. The developer bath should then be discarded and a new one mixed. The replenishment rate is 28 ml for each 80 square inches (8×10 -inch sheet, or four 4×5 -inch sheets) of film developed. Hence a liter of developer, plus a liter of replenisher, is capable of processing about 36 8×10 -inch sheets or $144 \ 4 \times 5$ -inch sheets. (If the diluted developer is used, then the replenisher should also be diluted, after measuring out 28 ml before being added to the developer to maintain the proper chemical-to-film ratio.)

8.25 KODAK Developer D-76 for Fine Grain

This is a medium-contrast, general-purpose film developer for tray or tank use, generally recommended for use without dilution, although in some instances it is diluted 1:1 with water. The formula provides maximum effective speed with good shadow detail. It has relatively high sulfite content compared to the DK-50 formula, which provides greater silver solvent action and greater degree of physical development, thus contributing to a silver morphology having minimum graininess. Development times are somewhat longer than those for DK-50 and range from 9 to 17 minutes with most films. The D-76 formula does not contain bromide because bromide lowers the film speed.

The alkalinity of the developer tends to rise as the result of aeration, which makes performance somewhat inconsistent. To overcome this, a modified formula, D-76d, containing higher borax and incorporating some boric acid, is thus buffered to maintain the pH at a more constant level. The modified formula has been used extensively in machine processing of films such as those used for motion-picture photography. Manufacturers other than Kodak have provided similar formulas. For example, Ansco A-17 is a variation that includes some bromide. Developing time is about 20% longer than for D-76. The D-76 replenishment rate is 30 ml for each 80 square inches (8×10 inch sheets) of film developed, discarding some of the used developer if necessary. This replenishment is expected to extend the life of the D-76 mix by at least five times its original volume.

8.26 KODAK Developer DK-20 for Fine Grain

The KODAK Developer DK-20 formula produces graininess comparable to that obtained with paraphenyline-diamine developers, but without their toxicity. It is also claimed to produce less film-speed loss compared to DK-50 and D-76 developers. Developing times range from about 15 minutes to 20 minutes, the multing time time type at the bring processed. The formula contains sodium thiocyanate—a silver solvent—along with high sulfite content, and some potassium bromide as a restrainer; it has no hydroquinone, and it utilizes sodium metaborate as an accelerator. Replenishment is approximately 28 ml for 80 square inches of film processed, and can be continued for the life of a mix of replenisher equal in volume to that of the original mix. D-25 is a formula somewhat similar to DK-20, but depends on the sulfite for alkalinity. It has no restrainer.

8.27 KODAK Developer D-72 for Paper

A common formula for developing photographic papers is KODAK Developer D-72; it can also be used for rapid processing of some films and plates. It has high hydroquinone content compared to DK-50 and D-76, and utilizes sodium carbonate as the accelerator. It also contains a fair amount of potassium bromide restrainer. The formula given in Table 8–1 consists of a stock solution that is diluted 1:2 with water for normal development, or 1:1 with water for greater contrast or more rapid development. A proprietary packaged formula, KODAK DEKTOL Developer, serves a similar purpose, but the formula has been modified to provide better mixing charactersitics, shelf life, and developing capacity. Other manufacturers publish formulas with different numbers that are essentially the same as D-72.

8.28 KODAK Developer D-85 for High Contrast

This type of developer is designed to process line and halftone negatives of extreme contrast that have been exposed on one of the "lith" (for lithographic) types of graphic arts films. The developer tends to promote "infectious development," which occurs when development spreads among emulsion grains that are near or in physical contact with one another. When development proceeds, the oxidized hydroquinone in the partially used developer in the vicinity of the developing grains has a momentarily higher activity than fresh developer. This enhances development at the edges of the image. By the time this enhanced developer has migrated from the area of development, it is exhausted. The presence of some sodium sulfite inhibits this developing effect and serves to control the speed of the developing action and limit its spread away from the area of development. Too much sulfite, however, would eliminate the effect altogether. To maintain the small amount of sulfite at the desired concentration, a formaldehyde/bisulfite combination is included in the formula. This acts as a buffer that maintains the sulfite at the desired level. Proprietary formulas are provided as concentrates in two separate solutions, one containing the hydroquinone and a formaldehyde/bisulfite complex; the other containing the alkali.

References

Amphoto, The Encyclopedia of Practical Photography.

- American National Standards Institute, Black-and-White Photographic Papers, Evaluating the Processing with Respect to the Stability of the Resultant Image (PH4.32-1980).
- ------, Determination of Silver in Photographic Films, Papers, Fixing Baths, Sludges, or Residues, Method for (PH4.33-1975).
 - —, Effluents, Identification and Analytical Methods (PH4.37-1983).
 - ——, Manual Processing of Black-and-White Photographic Films, Plates, and Papers, Method for (PH4.29-1975).
- ———, Methylene Blue Method for Measuring Thiosulfate and Silver Densitometric Method for Measuring Residual Chemicals in Films, Plates, and Papers (PH4.8-1978).
- ——, pH of Photographic Processing Solutions, and Specifications for pH Meters Used to Measure pH of Photographic Processing Solutions, Method for Determination (PH4.36-1978).
- ——, Photographic Inertness of Construction Materials Used in Photographic Processing, Specification for Testing (PH4.31-1962, R1975).
- ------, Pictorial Black-and-White Films and Plates, Method for Evaluation of Developers with Respect to Graininess (PH4.14-1979).
 - ——, Resistance of Photographic Films to Abrasion During Processing, Methods for Determining (PH4.35-1972).
- Carroll, Higgins, and James, Introduction to Photographic Theory.
- Eastman Kodak. Basic Chemistry of Photographic Processing (A-23-ED).
 - , Disposal of Photographic Effluents and Solutions (J-28).
- —, Processing Chemicals and Formulas (J-1).
 - ——, Recovering Silver from Photographic Materials (J-10).
 - —, Safe Handling of Photographic Chemicals (J-4).
- Eaton, Photographic Chemistry.
- Haist, Modern Photographic Processing.
- Mason, Photographic Processing Chemistry.
- Sturge, Neblette's Handbook of Photography and Reprography.

Post-Developmental and Archival Considerations

9.1 Stop Baths

A stop bath consists of a mild acid, with a pH of 3 to 5, that neutralizes the alkali of the developer and stops development. An acid fixer also provides stopping action; but after a quantity of developer has been carried over to the fixer, the acid is neutralized, the aluminum of the hardener will precipitate out as a sludge, and the stopping action is no longer precise. A water rinse before either the stop bath or the acid fixer will remove some of the developer, and prolong the life of either, but then the stopping action is drawn out and imprecise. A stop bath may also contain some hardening agent, and thus becomes an acid hardening stop bath. The most commonly used stop baths consist of 1.4%-4.5% solutions of acetic acid, although a solution of sodium or potassium bisulfite is sometimes used. Some contain other additions.

9.2 Indicator Stop Baths

Indicator and limits community a dot that thanges color after a substantial increase in pH as the acid is neutralized, and the stop bath can then be renewed before trouble occurs. It is important to select a dye that changes to a color that can be distinguished under the red, orange or amber color of a safelamp. An alkaline solution of bromocresol purple dye can be used to test the effectiveness of an acetic acid stop bath. When a few drops of such a solution made up as KODAK Stop Bath Test Solution SBT-1 is added to a sample of about 30 ml of the stop bath, it will have a yellow color if satisfactory, and a purple color if the acid has been neutralized. Some photographic chemical manufacturers sell a proprietary indicator stop bath that has the indicator dye incorporated in the bath. The dye is not strong enough to have any effect on the appearance of prints or films processed through the bath.

KODAK Stop Bath Test Solution, SBT-1

Water (distilled), 26.5 C (80 F)	750 ml
Sodium hydroxide	6.0 g

With stirring, add:

Bromocresol purple (Eastman Organic Chemical No. 745) 4.0 g

Mix for 15 to 20 minutes, then add:

Phosphoric acid, 86%	3.0 ml
Add water to make	1.0 liter

Caution: The Stop Bath Test Solution contains chemicals that can be hazardous. Sodium hydroxide is caustic and can cause severe burns in all tissues. Special care should be taken to prevent contact with skin or eyes. A face shield or goggles should be used when handling the solid compound. Phosphoric acid is a strong, nonvolatile inorganic acid. It is corrosive to tissue and can cause severe skin or eye burns. Impervious gloves and goggles should be worn when handling the concentrated solution. In case of contact with either of these chemicals, immediately flush the involved areas with plenty of water; for eyes, get prompt medical attention.

9.3 Dichroic Fog

A fixer whose acid strength is at or near exhaustion will no longer effectively stop the developing action. As a result, some development will proceed at the same time as some silver halide is being dissolved by fixation; and dichroic stain, which is mostly silver in the colloidal or near-colloidal state, will be produced. *Dichroic* means that it has two different colors, one by reflected light and the other by transmitted light.

9.4 Timing Layers

Another system of stopping development was used in instant photography systems, such as KODAK Instant Color film or KO-DAMATIC Instant Color film. One of the many layers in the film consisted of a "timing" layer that dissolved through a membrane in a definite time and neutralized the activator component of the system to stop development.

9.5 Fixing Baths

A fixing bath converts the relatively insoluble silver halide in the film or paper into a soluble complex of silver that can be washed out of the emulsion layer, baryta layer, or paper fibers, to make the negative or print stable. Otherwise, the undeveloped silver halide would not only reduce the contrast of a negative, but it would darken in time and destroy the image. Sodium, ammonium, or (sometimes) potassium thiosulfate are the compounds most commonly used in fixing baths; although sodium thiocyanate, and sodium cyanide have been used. (The latter is a hazardous compound and therefore is not recommended for use in photography.)

When a fixing bath is used to fix films or prints, silver ions accumulate in the solution, which exert a force in the opposite direction and thus slow down the rate of fixation. If this is carried far enough, a point is reached where the soluble complex is not completely formed in the time allotted to fixation. If the fixing time is increased, the insoluble complex is adsorbed to the gelatin of the emulsion, the baryta coating if there is one, and the fibers of the paper base. The insoluble complexes are thus not removed by washing, and the silver can later be reduced by environmental factors to produce unwanted color and/ or density. The presence of this reduced silver can affect the metallic silver image and cause it to become sulfided, thus changing color and losing density. Therefore, to ensure stable photographic images, it is important that the fixing solution not be worked beyond its capacity. The use of a two-solution fixing technique, whereby the prints are first bathed for a time in a fixing solution, then transferred to a second, fresher fixing solution, assures that the silver halide is converted to a soluble complex. After some time, the first fixer is discarded (or consigned to silver recovery), the second fixer becomes the first fixer, and a fresh fixing bath is added.

9.6 Fixing

After development, the films or prints are rinsed in water for a minute or so—or transferred to an acid stop bath—to terminate development, and then transferred to a fixing bath containing a thiosulfate that reacts with the undeveloped silver halide to form a soluble complex that can be washed away in running water. The reaction process passes through intermediate complex formations that are insoluble, even though they may be colorless when observed. For this reason it is important not to overwork the fixing bath, and to allow sufficient time for the reaction to proceed to the soluble complex.

Most fixing baths make use of the sodium salt of thiosulfate and are formulated to be acid in nature, in order to neutralize any remaining alkali from the developer, and because most hardeners require an acid condition. Potassium alum is commonly used as a hardening agent. Boric acid serves as a buffer to maintain the acidity of the bath as it is used. Sulfite reacts with any free sulfur that is formed in the process, converting it to thiosulfate. A typical acid hardening fixing bath is the following:

KODAK Fixing Baut r-b

Water, about 52 C (125 F)	600 ml
Sodium thiosulfate (pentahydrated)	240.0 g
Sodium sulfite (anhydrous)	15.0 g
Acetic acid (28%)	48.0 ml
Boric acid crystals	7.5 g
Potassium alum, fine granular	
(dodecahydrated)	15.0 g
Cold water to make	1.0 liter

Films should be fixed for not less than double the clearing time, usually 5 to 10 minutes. The recommended fixing time for prints is also 5 to 10 minutes. Excessive fixing times will promote adsorption or retention of the fixer complexes in gelatin, or more particularly on the fibers of paper base, and should be avoided. In addition, excessive fixing can bleach silver images, especially those on paper prints. Where the photographic application requires a nonhardening fixer, the formula contains only sodium thiosulfate, sodium sulfite, and sodium bisulfite to produce an acid condition.

If a fixing bath is made with ammonium thiosulfate, or with ammonium chloride added to sodium thiosulfate, the fixing action is much more rapid. The following formula is more rapid-working than the F-5 formula, and is capable of fixing about 50% more film, or paper. Over-fixation should be avoided, especially of prints and finegrained films, to prevent bleaching.

KODAK Rapid Fixing Bath F-7

Water, about 52 C	
(125 F)	600 ml
Sodium thiosulfate	
(pentahydrated)	360 g

Ammonium chloride	50.0 g
Sodium sulfite (anhydrous)	15.0 g
Acetic acid (28%)	48.0 ml
Boric acid crystals	7.5 g
Potassium alum, fine granular	
(dodecahydrated)	15.0 g
Cold water to make	1.0 liter

Caution: With rapid fixing baths, do not prolong the fixing time for fine-grained film or plate emulsions or for *any* paper prints; with prolonged fixing, the image may have a tendency to bleach, especially at temperatures higher than 20 C (68 F). This caution applies particularly to warm-toned papers.

9.7 Cost Factors

The cost of film-processing chemicals can range from about 5 to 10 cents per 8×10 -inch sheet (in 1982 dollars) using the DK-50 formula with replenishment, mixed from bulk chemicals; it can range close to one-third or one-half the cost of the film with some color processes. Added to this is the value of the time spent mixing the solutions, plus the overhead for space, equipment, transportation, etc. Other factors also have to be considered, such as the time required to carry out the process; that is, formulas with long developing times can be more expensive to use than those requiring shorter times, and therefore the shorter processes are used when it can be demonstrated that the final performance is equal. Since the film expense plus all other costs involved in making the photograph (lighting, travel, model fees, time, overhead) may be many times the cost of the chemicals and processing, it is more important to ensure that the development or processing can be depended upon. It is unwise to achieve savings that will jeopardize a much larger investment in time and money. On the other hand, a large-volume photographer or processor can achieve substantial savings by control of waste and by other good management techniques.

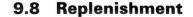

There are several approaches that can be taken in management of chemistry. One of these is to utilize a "one-shot" technique, in which a minimum volume of chemistry is used that will ensure complete processing of the sensitized material, and then is discarded (see Figure 9–1). This has the advantage that each process is accomplished with fresh solution (provided it has not exceeded its shelf life); and with careful control of quantities, agitation, time, temperature, and cleanliness it can produce uniform, dependable results. This may be the best way to go when processing small rolls of film (35 mm, for example), small batches of sheet film (as in tube processors), and sheets of color printing materials (in tubes).

A second technique is to replenish the solution. A common procedure is to use replenisher solution of starting volume equal to that of the primary solution, according to the area of film processed, until

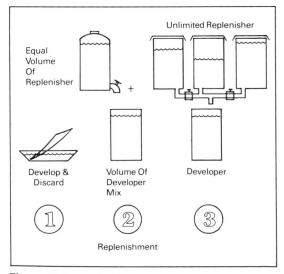

Figure 9-1 Replenishment.

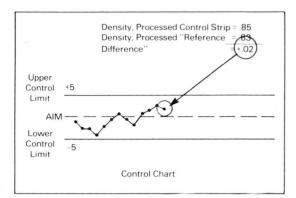

Figure 9-2 Control chart.

the replenisher is consumed; then discard the developer and start over again. This is a reliable procedure when normal care is exercised (control of replenishment volume, temperature, time, agitation, and prevention of contamination), and quality control can be relatively simple, since the solution is usually discarded before serious problems occur. Should problems occur, the procedure of remixing and starting over again offers a quick, simple solution.

The third, more elaborate technique consists of starting with a fresh or "conditioned" batch of developer (or other chemistries), and replenishing with no planned limit to the life of the solutions. This approach requires careful monitoring, quality-control procedures, filtering the solutions, and reliable film and solution manipulation. It may involve the availability of a laboratory staffed by a trained chemist, if the size of the operation is large enough to warrant it. However, many processing "lines" can be operated by control and analysis based on sensitometric observations in comparison to a "reference" consisting of the same material that has been certified to be representative of the process when in good control. Control charts can be based on the deviation of the processed sensitometric control strip from the values obtained from the reference strip (IIII Figure $\beta=2$). Problems can be solved by consulting a table of causes for various observed anomalies.

Replenishers are designed to maintain the strength and chemical balance of a developer or other solution throughout its life. With some processes that run continuously with replenishment, the makeup of the replenisher itself may have to be modified or supplemented to ensure the proper balance of chemistry. With a simple blackand-white film, as development takes place, halogen ions-say bromide-are released into the solution at the same time as metallic silver is formed. A quantity of the halogen ions then acts as a restrainer on subsequent film being developed. The replenisher formula will have less restrainer in its formulation, but it will be supplemented by the released halogen to keep the restrainer level relatively constant. When processing some color products, the reaction products may vary from one variety of film to another, such as tungsten-balanced film vs. daylight-balanced film. The daylight-balanced film has a greater response to red light; i.e., its red-sensitive layer is made with a faster emulsion. This can lead to a greater amount of iodide being released in comparison to bromide; and the iodide reaction product will increase at a greater rate than would be the case with the tungsten film. Thus there will be an effect on the color balance of all the films being processed in the system. The proper balance can be reestablished through replenisher modification. More recent color film systems, such as the KODAK EKTACHROME Films developed using process E-6, have solved this problem with a design that allows the release of consistent iodide from all the films making up the family (tungsten, daylight, duplicating, etc.).

There are other ways in which some solutions can be maintained or rejuvenated. The bleach in process E-6, for example, makes use of ferric iron (Fe^{+++}) in the reaction that converts metallic silver to silver bromide, which in turn can be fixed out:

 $Br^- + Fe^{+++} + Ag^{\circ} \longrightarrow Fe^{++} + AgBr$.

The bleach is rejuvenated by bubbling air through the solution, which converts the Fe⁺⁺ to Fe⁺⁺⁺:

$$Fe^{++} + O_2 \longrightarrow Fe^{+++}$$
.

9.9 Rejuvenation and Maintenance of Fixing Baths

Since the bromide ion is consumed, it has to be made up by replenishment, along with proper maintenance of the strength of the other solution components.

9.9 Rejuvenation and Maintenance of Fixing Baths

Fixing baths cannot be replenished, since the problem is not exhaustion of the chemicals, but the accumulation of silver ions in the solution. More thiosulfate could be added, but this would not overcome the excess silver. Electrolytic silver recovery, however, can remove silver from the solution, and the other components of the fixer (hardener, sulfite, etc.) can be made up by replenishment to prolong the useful life of the bath from which silver has been removed.

9.10 Washing

After fixing, photographic materials have to be washed to remove any of the fixing chemicals remaining as well as the silver compounds that have been formed during the fixing reaction. The problem is not a simple one. The chemical reactions leading to a soluble silver complex pass through steps in which insoluble complexes are formed, and these have to be fully converted to the soluble compounds. In addition, these complexes have a pronounced tendency to adhere to or be adsorbed by the fibers and baryta coatings of ordinary papers (see Figure 9–3). Films and polyethylene- or resin-coated (RC) papers do not generally present this problem except to the small extent that it may occur in gelatin coatings. For these reasons the fixing step should be for the minimum time that will ensure that the reaction goes to completion to prevent any appreciable adsorption of the chemicals.

As the fixing process continues, and more silver complexes accumulate in the fixing bath, the tendency increases for the reaction to be forced in the reverse direction. In general, the fixing bath will perform well when the total amount of silver (in the form of ions from residual silver thiosulphates) in the bath is below 2.0 grams/liter. Films and resin-coated papers are readily washed, as they do not have fibers or baryta coatings exposed to the solutions for adsorption to take place. Fiber-base papers may not be completely washed even after 60 minutes

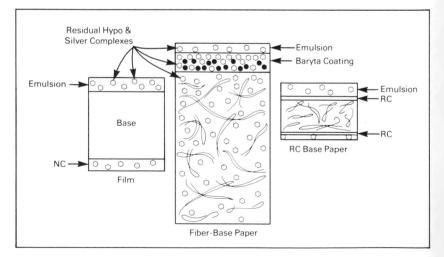

Figure 9–3 Baryta-coated fiber-base paper favors retention of residual hypo and silver complexes; whereas film and RC-base paper do not have the fiber areas or baryta for retention of these compounds.

of washing under ideal conditions, whereas films are usually washed in 20 to 30 minutes under similar conditions and resin-coated papers in 4 minutes, provided the wash-water flow rate is sufficient to give the required number of changes. The specific gravity of a typical fixer is in the vicinity of 1.18. However, with a reasonable flow of water the fixer does not have a chance to settle to the bottom of the wash tank.

9.11 Hypo Eliminators and Washing Aids

Hypo removal by washing can be facilitated by the use of *washing aids*, and residual hypo and thionates can be eliminated with *hypo eliminators*. The hypo-clearing agents consist of salts that act on the relatively small amount of thiosulfate or complexes remaining after a short washing, replacing them with a radical that is more easily removed by further washing. A 2% sodium sulfite solution has been found to be one of the best for this purpose, but other salts such as sodium sulfate can be used.

The suffice replaces the thiosulface and thionates, and is itself readily washed out. The following would be a typical procedure in practice: The fixed materials are rinsed for a short time in water to remove excess fixer solution; then they are soaked for about 2 minutes for films and 3 minutes for papers in a 2% solution of sodium sulfite, followed by a longer wash—10 minutes for single-weight papers, 20 minutes for double-weight papers.

Hypo eliminators work on a different principle, that of oxidizing the residual thiosulfate to sulfate, which is more readily removed by washing. This should be carried out only after most of the hypo or thionates have been removed by washing, possibly with the aid of a hypo-clearing agent.

9.12 **Preparation for Drying**

After films or papers are washed for the time necessary to remove residual thiosulfate or thiosulfate-silver complexes, they should be carefully dried. This aspect of the photographic process is often neglected to the extent that it subtracts substantially from the quality and acceptability of the final product. Fiber-base papers absorb considerable water during washing, and this has to be removed in the drying process. RC (resin-coated) papers, on the other hand, absorb very little water, and this is restricted to the thin emulsion and NC (non-curl) coatings. These materials dry very rapidly—in a matter of a few minutes.

After washing and prior to drying there are several important techniques to note. The wash water sometimes contains sediment that has been allowed to pass into the water lines from water-treatment plants. At certain times this may be more of a problem than at others. For example, changes in water demand cause disturbances in settled particles. When municipal filter beds are flushed, fine sand or other sediment may be noticed in the tap water. If this sediment is allowed to remain on a processed negative, it may become attached to the emulsion or NC surface and produce small white spots on the final print. For this reason it may be required to rinse the negatives in a separate bath of filtered water. If this is a persistent problem, the water line leading to a laboratory should be fitted with a filter. Excess water droplets and sediment in small amounts can be removed with a clean moist sponge or chamois by carefully wiping the surfaces. This has the disadvantage of sometimes putting more contamination on the negative than it removes.

Films washed in clean water can be hung up to dry without wiping. However, if the excess surface water is not removed from the negative, and if it is in the form of droplets, drying marks or deformities in the image will form, ruining the negatives. In large laboratories where the film is processed in a serpentine fashion in continuous lengths, excess moisture is blown off by an air jet or squeegee. Water spots on sheet films and individual rolls can be avoided by using a wettingagent bath before drying, which spreads the surface layer of water so that no droplets are formed. A commercial wetting agent, Photo-Flo, is one sold for this purpose. This bath, if made with filtered or otherwise clean water, can also serve as a rinse to remove some sediment. Gently rubbing the film surfaces as they are removed from the wash water can dislodge particles that may tend to cling to them.

9.13 Drying

It is best to dry films at room temperature; but this procedure may require an inconveniently long time in some situations so that heat is often applied, along with air circulation, to hasten the drying process. At the start of drying, relatively warm air can be used, as evaporation of the moisture in the film has a cooling effect. As drying progresses, high temperatures should be avoided. If the temperature is too high, drying will become excessive, and the film will become brittle and have a tendency to excess curl. Other damage to the film may occur. The air should be filtered to prevent the accumulation of dust on the film surfaces. A large volume of relatively pure air can carry a substantial number of particles that could be attracted to the tacky film. This attraction can be accentuated by the electrostatic charge built up in the film by the air flowing over its surfaces.

9.14 Drying Prints

Similar precautions apply to the removal of excess water from the surfaces of prints that are to be dried. Print-drying machines usually have squeegee rollers at their entrances that remove excess surface water. RC or "plastic"-coated papers carry relatively little water and can be dried quite rapidly, within a few minutes without heat, after the excess water has been removed. Fiber-base papers, on the other hand, can carry a relatively great load of water, which has to be removed. Air drying the prints at room temperature on clean cheesecloth or racks is probably the least destructive to the image and the physical quality of the prints. However, if the relative humidity is high, this kind of drying process is apt to be excessively long. For this reason, most photographic installations make use of heat dryers of one form or another (see Figure 9-4).

9.15 Print-Drying Problems

Control of heat in the drying process is necessary to prevent excessive drying and undesirable changes in the nature of the prints. Physical problems include curl, brittleness and buckling—nonuniform

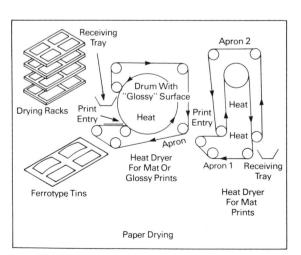

Figure 9-4 Paper drying.

dimensional change. In addition, ordinary fiber-base papers expand when wet and shrink on drving to a final dimension that is usually smaller than that existing at the time of exposure. These dimensional changes are not uniform for the machine and cross-machine directions (referring to the original paper-making-machine web). In ordinary photography such changes are insignificant, but they can be a factor where the print's dimensional characteristics are important, as in photogrammetry. However, if the prints are dried by ferrotyping or on a dryer that utilizes a similar principle, they retain their expanded dimension when dry, and this dimensional change is considerably greater than the result of drying without restraint. This change also is of no consequence, unless a collection of prints is made with the grain of the paper in two directions. Then the differential between the expansion in one direction and that in the other will make images that appear to be considerably different in size—up to 3/16 inch on an 8×10 -inch print. (In ferrotyping the wet print is squeegeed onto a smooth metal or laquered metal surface for drying. The gelatin on the print's surface is molded by the glossy surface of the ferrotype plate, producing a high gloss. The ferrotyping surfaces are usually treated with a polich that must must the schule firm that to the plant when dry.)

9.16 Color Changes

A further potential problem in print drying is the color change that sometimes occurs in the image. Some prints dried on heat dryers will change from a good black image tone, particularly in the maximum densities, to a bluish tone of less density. This effect is called plumming. Sepia-toned prints often change color on heat drying, and this is more noticeable with selenium-toned prints than with sulfidetoned prints. In either case, if the print is not entirely dry at the time it is dry-mounted with heat, the difference in color within a given print can be as much as to make it totally unacceptable.

Prints dried without heat also change tone and apparent density, compared to their visual appearance when wet. The effect depends to some extent on the type of emulsion, but mostly on the nature of the print surface and appears to be greatest on mat-surface prints. The photographer or darkroom printer has to take this into account when judging the exposure and development of prints as observed under the darkroom illumination. The amount of adjustment is governed by experience with the particular type of paper being used. One guide is to observe the just-perceptible difference between a nonspecular white highlight in the print and the nonimage area (margins).

The amount of moisture removed by drying photographic materials has to be considered in the design and layout of photographic finishing establishments. If the drying process saturates the air, the removal of water is impeded. This can lead to attempts to correct the problem with increases in drying temperature, which can have a destructive effect on the final product.

9.17 Preservation of Photographs

The chief factor in the preservation of silver photographic images is the total removal of silver complexes and hypo from the print by washing, before drying. After that it is important that the print not be exposed to any contaminant that would react with the silver image. The choice of adhesives for mounting, if the print is mounted at all, is important. Some kinds of glues and pastes, especially those that might contain sulfur, should never be used. Hygroscopic materials (substances that absorb water from the air) should not be used. Drymounting tissues especially designed and marketed for mounting photographs are generally acceptable. But even this type of mounting may eventually deter from the value of the photograph if it becomes a collector's item. The best recommendation seems to be that of using "archival" materials (mounting and matting boards, and cloth tape) to suspend the print under a mat, then in a frame under glass for display. If the mat has to be replaced after some handling, it is a simple matter to remove the print and remat it.

Sometimes the photographic print is only an intermediate image for use in preparation of plates for printing in catalogs, magazines, or newspapers, and once these plates have been prepared, the photograph is no longer needed. In the motion-picture industry, the release prints need only last as long as the physical capability of the film to sustain screenings—about 500 to 1,000 projections—after which it is destroyed. However, if the images are expected to have some value in later years, other precautions have to be taken. The photographer will need to make sure the print is made to have archival permanence, and the motion-picture companies will have to have their prints made on film with dyes that will hold up under long-term storage, or have separations made on black-and-white film that can be stored and then brought out for regeneration of the color films at a later date.

Storage containers, mat boards, and mounting boards are potential sources of agents that are deleterious to photographs. For this reason, if photographs are to be stored for any time, they should be packed in properly designed containers made of inert materials. Old film and paper boxes should not be used, neither should wooden and cardboard cases. Metal cases coated with paints that do not give off any fumes, or cases made of inert or "acid-free" board, should be used. Mount and mat boards should be inert and acid free; that is, buffered to a slightly higher than neutral pH for black-and-white photographs. However, there may be some question in using this type of material for color photographs, since most of these dyes may survive best under slightly acid or nearly neutral conditions.

It is important that the storage area's atmosphere be maintained with moderate or lower temperatures, and low relative humidity (below 50%). The cyclic effect of day and night conditions—wet then dry, winter then summer—contributes more to rapid deterioration than when these conditions are maintained at a desirable low humidity and temperature with small cyclic variations.

9.18 Archival Considerations

Since resin-coated papers have not existed long enough to establish their long-term keeping characteristics, prints intended for archival storage or for permanence are usually made on fiber-base papers, which have a longer history for forecasting the permanence of their images. However, since these papers will retain some small amounts of residual silver complexes even with prolonged washing, additional consideration has to be given to their fixing, washing and aftertreatment.

9.18 Archival Considerations

There are several ways to process for permanence, proposed by photographic materials manufacturers and by the American National Standards Institute. The recommendation of the Eastman Kodak Company is to follow the procedure given in the following table after the prints are developed:

Steps After Development				
Step	Time	Comments		
Rinse	30 sec.	Fresh acid stop bath.		
First fix	3-5 min.	Use two fixing baths with		
Second fix	3-5 min.	frequent agitation.		
Rinse	30 sec.	Running water.		
Hypo clear	2-3 min.	KODAK Hypo Clearing Agent.		
Hypo eliminator	6 min.	HE-1 formula with occasional agitation.		
Wash	10 min.	Running water flowing rapidly enough to replac water at least every 5 minutes.		
Gold protective solution	10 min	OT = 1 IUIImula with III I.IIIIonal agriculuii. *		
Wash	10 min.	Same as first wash.		
Dry	As required	In clean, dust-free space.		

*A selenium toner or a sulfide toner can also be used at this stage. Toners are considered to be more effective than the gold protection.

KODAK Hypo Eliminator HE-1

Water	500 ml
3% hydrogen peroxide	125 ml
10% ammonia solution ¹	100 ml
Water to make	1 liter
water to make	1 IIIC

Prepare the eliminator solution immediately before use, and do not store in a stoppered bottle, since the gas that develops may break the bottle.

KODAK Gold Protective Solution GP-1

Water	750 ml
1% gold chloride solution	10 ml
Sodium thiocyanate solution ²	15.2 ml
Water to make	1 liter

Add the gold chloride stock solution to the volume of water indicated. Dissolve the sodium thiocyanate separately in 125 milliliters of water. Then add the thiocyanate solution slowly to the gold chloride solution, stirring rapidly.

The American National Standard Method for Evaluating the Processing of Black-and-White Photographic Papers with Respect to the Stability of the Resultant Image, PH4.32-1980, gives a somewhat different treat-

¹Prepared by adding 1 part 28% ammonia (concentrated) to 9 parts water.

²1 ml of thiocyanate solution is equal to 0.66 grams of powdered sodium thiocyanate.

9.19 Alternative Methods

ment method. The hypo eliminator precedes a 1% sodium sulfite clearing bath, and the eliminator formula contains four times as much hydrogen peroxide, and one gram of potassium bromide/liter to stabilize the tone of the print, which is sometimes modified by the HE-1 formula.

9.19 Alternative Methods

Various other methods of archival processing are suggested. One of these is the Ilford Ilfobrom Archival Chemistry and Processing Sequence (from the Ilfobrom Galerie brochure), which places emphasis on a short fixing time. The rate of fixing is substantially faster than the rate of build-up of thiosulfate complexes in the fibers of the paper, and the time is not sufficient to permit thiosulfate complexes to attach themselves to the fibers of the base. The recommended Ilfobrom Archival Chemistry is as follows:

Step	Material	Time
1. Development	Ilfobrom Developer $(1 + 9)^*$	2 min.
2. Stop bath	Ilfobrom Stop Bath $(1 + 9)$	5-10 sec.
3. Fixation	Ilfobrom Fix $(1 + 4)$	30 sec.
4. First wash	Good supply of fresh running water	5 min.
5. Wash aid	Ilfobrom Archival Wash Aid $(1 + 4)$	10 min.
6. Final wash	Good supply of fresh running water	5 min.

*One part of concentrate added to 9 parts of water. All processing times are at 68 F (20 C). This sequence totals less than 23 minutes.

9.20 Toning

Toning is the chemical modification of the silver image to give it a different color. The term *tone* is sometimes applied to the lightness of an image or area, and to the color of the silver image prior to chemical modification, which may be affected by modifications of development (see Figure 9–5).³ The most common toning technique is to form a silver sulfide or silver selenide image by one of several methods. Less common is to convert the silver image to a metallic salt that is other than silver, or that is in combination with the silver. Some combination toning processes involve sulfide or selenide and a metallic toner.

The sulfide- or selenium-toned images are quite stable—in fact, usually more stable than the silver image alone—since the sulfide compound is one of the most common results of deterioration when residual thiosulfate is present or when sulfur compounds in the air have attacked the silver image. These compounds are resistant to further oxidation. The non-noble metallic compounds (iron, copper, uranium, etc.—those whose salts are more soluble than those of the noble metals such as silver, gold, platinum, etc.—form images less stable than the original silver images. This is particularly true of the iron compounds, which are easily attacked by impurities in the air and by alkalis in the water during washing. Gold- and platinum-toned images are, along with selenium and sulfur, the most stable of photographic images.

³Current, I., 1950, pp. 684-7.

Figure 9-5 Spectrophotometric curves for paper tones.

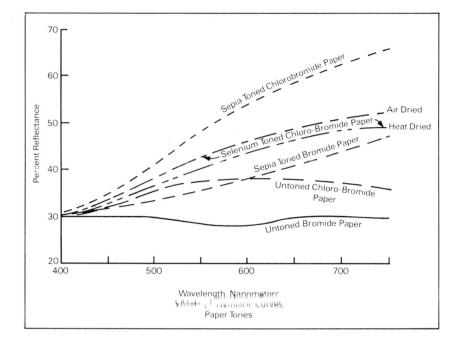

9.21 Sepia Tones

The sepia tones produced by selenium and sulfur are less popular than they were some years ago. This may be partially due to the extra processing steps involved, the difficulty of maintaining and reproducing a given tone, the public association of sepia tones with antiquity; and to less emphasis on permanence along with the improved knowledge of proper processing of silver images for greater permanence. There was a time when photographers emphasized sepia-toned images in their marketing efforts, and sometimes adopted a proprietary tone of their own for sales promotion.

9.22 Developer Modification and Tone

Regardless of the toning method used, the final color depends to a great extent on the nature of the silver image produced before the toning operation. Not only do the various contact- and enlarging-paper emulsions have a pronounced effect on the final toned image, but so does the processing. Short development or other underdevelopment of the silver image will tend to produce warmer sepia images when toned by one of the sulfur or selenium methods; while extended developing times, or extended developing times with a developer containing a high amount of bromide restrainer, tend to produce colder images when toned. The latter effect is more noticeable with selenium-toned prints than with sulfur-toned prints.

The effect of bromide on image tone is one of the causes for tone variation between prints, especially when the developer is overworked and accumulates excessive restrainer as one of the reaction products, more so if the developer is an energetic one. Another cause for tonal variations is the drying method. Heat drying will sometimes produce a noticeable change in tone, compared to drying at ambient temperatures. This can be a problem when dry-mounting a print with

9.23 Bleach and Redevelopment Toning

heat, when the print is not completely dry. The moist center of the print will be changed by heat, while the dry outer areas of the picture will not, thus producing nonuniformity of tone within a single print.

9.23 Bleach and Redevelopment Toning

Sulfur toning processes can be divided into two categories: 1. bleaching of the silver image to form a halide, which is then "redeveloped" or toned with a sulfide solution; and 2. direct toning by reacting the silver image with a sulfide or polysulfide solution or suspension. Bleach and redevelopment toners can be used with cold-tone printing papers that do not respond well to direct toning.

Bleach (Solution 1)

10% potassium ferricyanide solution	.500 liter
10% potassium bromide solution	.100 liter
10% sodium carbonate	
solution	.200 liter
Water to make	1.0 liter

The prints are treated in this bleach until the image almost disappears, then they are washed in running water for about 5 minutes, and redeveloped in the following:

Sulfide Stock Solution

Sodium sulfide	90 g
Water	1.0 liter

For use, 1 part of this stock solution is diluted with 8 parts of water. This toner tends to soften the print's emulsion layer, and a hardener may be required following the toning operation, before washing and drying. A suitable hardening bath is made up as follows:

Print Hardening Bath

Hot water (about 52 C,	
125 F)	.500 liter
Sodium sulfite	
(anhydrous)	50 g
28% acetic acid	150 ml
Potassium alum	50 g

Allow the hardening solution to cool before use.

With bleach and redevelop toning processes, the photographer should be careful to use plastic, stainless steel, or enamel trays that have not been chipped, since the exposed iron from chipped enamel trays causes blue stains and spots on the prints.

9.24 Hypo Alum Toner

The hypo alum toner is a typical one in category 2. The bath is used as a single-solution toner that produces more reddishbrown tones on many papers, compared to the tones that would have been produced with the bleach and redevelop toners. Since it is made by sulfurizing a solution of hypo (sodium thiosulfate), it does not require that the prints be washed after fixing and before toning. It does require heating for more rapid toning, and since the chemical makeup of the suspension varies with use, there are sometimes problems in getting uniformity of tones.

9.25 Gold Toner for Blue Tones

Warm-tone chloride or chlorobromide papers can be toned to a deep blue color by using a gold toner such as the following:

Blue Gold Toner

Hot water	.750 liter
Ammonium thiocyanate	105 g
1% gold chloride	
solution	60 ml
Water to make	1 liter

Toning requires about 10 minutes. The prints should then be washed for about 1 hour and dried. If a print is first toned to a sepia with one of the sulfide methods, and then toned in the blue and gold toner, a vivid red tone will be the result.

9.26 Iron Blue Toner

An iron toning formula can be used to produce a brilliant blue tone on most papers, with the exception of bromide papers. Iron tones are not considered to be archivally permanent, and the color is easily washed out in water that is even slightly alkaline. If protected, the prints can last for several years.

Iron Blue Toner

Hot water	.500 liter
Ferric ammonium	
citrate	8 g
Potassium ferricyanide	8 g
28% acetic acid	265 ml
Cold water to make	1 liter

Prints to be toned in this solution should be thoroughly washed in water that is not alkaline. After toning is complete, washing in nonalkaline water should be sufficient to remove any traces of the yellow color of the ferricyanide. This can be accomplished, without destruction of the image, by making the wash water slightly acid with acetic acid. Under artificial light it may not be easy to see the yellow color. The prints should be toned to completion—that is, all of the silver ferrocyanide first formed should be converted to ferric ferrocyanide. Any of the silver compound remaining is easily affected by sulfides in the air or from other sources, forming metallic silver in some areas.

Other metallic compounds used for coning include those of copper, uranium, mercury, platinum, and palladium.

9.27 Other Toning Methods

Other methods of toning include that of converting the image to a mordant, and then dyeing it. This method lends itself more to transparencies and motion-picture films than to paper prints, since the latter have a tendency for the dye to adhere to the paper fibers or baryta coatings. Toning can also be accomplished by dye development using a developer formula containing a color coupler that produces dye by uniting with the reaction products of development, in proportion to the amount of silver developed. The image is then either left with the silver and dye together, or the silver is bleached and removed by fixing, leaving only the dye image. Toners of this type are supplied as proprietary prepared chemicals that need only to be diluted with or dissolved in water by the user to prepare a toning bath.

A developer formula for dye toning consists of the following:

p-amino diethylaniline	
monohydrochloride	3 g
Sodium sulfite	5 g
Sodium carbonate	
(monohydrated)	35 g
Distilled water to make	1 liter
Dye color former	
solution	(see below)

The color-forming dye solution is made by dissolving 10 grams of color former in 1 liter of methyl alcohol. For use, one part of this solution is mixed with 10 parts of the developer solution. Suitable color formers include: ortho-phenyl phenol for blue-green color; para-nitro phenylacetonitrile for magenta color; and acetoacetanilide for yellow color. The developing agent and solution are irritants, therefore avoid contact with the skin. If contact does occur, wash well with soap and water.

9.28 Selective Area Toning

By blocking out an area of a print with a resist such as diluted rubber cement, applied in two or three thin coatings, or with an adhesive plastic material such as Maskoid, the unprotected area can be toned without toning the protected area. After toning, washing and drying the print, another area can be similarly protected, and another toner used to produce a different color. Or an area previously toned can be retoned with another toner, such as the gold toner/sepia toner combination referred to above. The rubber cement, if used for protection, is rubbed away after the print is dried. The Maskoid material can be removed using sticky tape after the prints have been dried.

9.29 Reduction and Intensification

Modification of a negative to improve its printing characteristics may involve reduction or intensification in one form or another. This is less likely to be required in the present day than it was in the

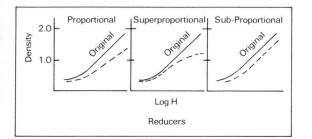

Figure 9–6 Reducers.

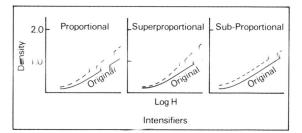

Figure 9-7 Intensifiers.

past, before modern film, exposure meters, and more precise processing methods were used. These procedures are useful at times to salvage a negative that has been incorrectly exposed or processed, where reshooting is not possible. Some reducers and intensifiers may be used in modified form to make corrections or improvements in prints, but formulas and techniques have to preclude staining. Reduction consists of lowering the densities and contrast of the negative. Intensification involves increasing the negative's densities and contrast. Some toners lighten or darken print images.

Reducers can be classified according to the effect they have on the negative densities. *Proportional* reducers are those that lower densities by a given percentage of the original densities, thereby removing more density from the dense areas and lowering contrast (see Figure 9–6). *Sub-proportional* reducers are those designed to remove equal amounts of silver from all densities, producing a less-dense negative with no change in contrast. With *super-proportional* reducers, the percentage of reduction is greater in the higher densities than in the lower densities, resulting in considerably less contrast with little change in shadow densities.

Intensifiers penerally produce proportional intensification of the negative's densities; that is, they add density in proportion to the amount of silver already present, thereby increasing contrast (see Figure 9–7). Intensifiers that add proportionately more density to highlights than to shadows are called *super-proportional*, and are used where extreme high contrast is desired. Those that increase densities in the shadow region (toe of the curve) by a larger percentage (but not by a larger amount) than in the highlight region are called *sub-proportional* intensifiers.

Other procedures have been used successfully to retrieve information from negatives that have been badly underexposed. One of these is to soak the developed negative in a fluorescing dye, such as Rhodomine B, that is absorbed more strongly in areas where silver is present even in minute quantities. The dyed negative is subjected to ultraviolet radiation to produce a fluorescent image, which is then rephotographed. Figure 9–8 shows prints made from negatives that were underexposed by four stops and six stops without and with fluorescent image enhancement.

9.30 Reducers

Chemically, reduction usually involves the oxidation of the metallic silver image to a water-soluble salt that can be washed away, or to a compound that is soluble in the reducing solution itself. When carrying out any of the chemical modification procedures, such as reduction or intensification, care must be taken to make sure the negative has been thoroughly fixed and washed. An exception to this is Farmer's reducer, which includes hypo in its formula, making complete washing unnecessary. The negative should be free of finger marks, scum, stains, or the presence of other materials that might interfere with uniform action of the chemical bath. Most of the procedures should be tested first with a similar, unimportant negative in order to be able to stop the action at the desired stage.

A typical sub-proportional (sometimes also referred to as subtractive or cutting) reducer for negatives is the following:

Figure 9-8 Prints from underexposed negatives without and with fluorescent image enhancement. (Top left) Print from negative four stops underexposed. (Top right) Print from the same negative with fluorescent image enhancement. (Bottom left) Print from negative six stops underexposed. (Bottom right) Print from the same negative with fluorescent image enhancement. (Photographs by Carl Franz.)

KODAK	Reducer	R-2 ((Permanganate)
-------	---------	-------	----------------

Stock Solution A:	
Water	1 liter
Potassium	
permanganate	52.5 g
Stock Solution B:	
Water	1 liter
Concentrated sulfuric	
acid*	32.0 ml

To make the working solution, mix 1 part of Solution A and 2 parts of Solution B with 64 parts of water. The stock solution keeps fairly well, but the life of the mixed working solution is short so it should be mixed just prior to use. Place the negative to be treated in the solution and remove it when the desired degree of reduction has taken place. Then place the negative in a fresh fixing bath for about 3 minutes. Wash the negative thoroughly and dry.

*Caution: Always remember to add acid to water with stirring; never add water to acid!

This reducer oxidizes the silver to silver sulfate, which is soluble in water. The fixing bath removes yellow stains that are formed.

With Farmer's reducer, the silver is oxidized to silver ferrocyanide, which forms a soluble complex with sodium thiosulfate that is washed away. The formula was introduced by Howard Farmer in 1884. There have been several modifications, but the original formula is essentially as follows:

Solution A:

Potassium ferricyanide	37.5 g
Water to	500 ml
Solution B:	
Sodium thiosulfate	480 g
Water to make	2 liters

For use, 30 ml of solution A and 120 ml of solution B are diluted with water to make 1 liter of reducing solution. The negative is immersed in this working solution until the desired reduction has been muched. The mixed solution does not keep well, and if the doined induction has not been unabled within 5 minutes, the negative should be transferred to a fresh mix of working solution for further treatment.

A typical proportional reducer for negatives is the following:

KODAK Reducer R-5

Solution A:	
Water	1 liter
Potassium	
permanganate	0.3 g
10% sulfuric acid	16.0 ml
Solution B:	
Water	3 liters
Ammonium persulfate	90.0 g

To use, add 1 part of solution A to 3 parts of solution B. Place the negative in this solution, and when sufficient reduction has taken place, clear the negative in a 1% solution of sodium bisulfite. Wash the negative thoroughly and dry.

The ammonium persulfate/sulfuric acid combination apparently forms an unstable silver persulfate that decomposes to silver peroxide prior to forming silver sulfate. The reducer is the result of the combined effect of the sub-proportional permanganate combined with the super-proportional persulfate/sulfuric acid.

The following is an example of a super-proportional reducer:

KODAK Reducer R-15

Stock Solution A:	
Water	1 liter
Potassium persulfate	30.0 g
Stock Solution B:	
Water	250 ml
10% sulfuric acid	15.0 ml
Add water to make	500 ml

To use, take 2 parts of solution A and 1 part of solution B. Be sure to use only plastic, glass, hard rubber, or unchipped enamelware vessels. Then immerse the negative in the reducer solution and agitate constantly. When the desired degree of reduction has *almost* been reached, remove the negative and immerse it in an acid fixing bath for a few minutes. Wash thoroughly and dry. If your test example of a negative made on the type of film you are reducing is excessively softened, the negative can be treated in the following hardener bath for 3 minutes and washed thoroughly before beginning the reduction procedure.

KODAK Hardener SH-1

Water	500 ml
37% formaldehyde	10 ml
Sodium carbonate	
(monohydrated)	6.0 g
Add water to make	1 liter

9.31 Intensifiers

Intensification involves the addition of silver, copper, chromium, mercury, or sulfur to the silver deposit already existing in the negative. In some cases, intensification is achieved by bleaching and redeveloping the negative in a nonstaining developer or a staining developer, or redeveloping it in a sulfide toner, either of the latter two producing a yellowish image that is more effective in absorbing ultraviolet or blue light in the region to which the printing paper or other material is sensitive. Most all of the intensifiers other than silver change the color of the image in one way or another.

A typical proportional intensifier utilizing a nonstaining developer is the following chromium solution. The actual chemical process is not certain, but it is generally thought that the acid-dichromate converts part of the silver image to a silver-chromium compound, while the remaining silver is converted to silver chloride. On redevelopment in the presence of light, the silver chloride is reconverted to silver which along with the silver-chromium compound makes up the stronge image. The process can be repeated utilizing the silver part of the image, but since only about one half of the silver is involved, the degree of intensification diminishes each time. The practical number of rep etitions is limited to about three.

KODAK Intensifier In-4

Stock solution:

Potassium dichromate	
(anhydrous)	90.0 g
Hydrochloric acid	
(concentrated)	64.0 ml
Water to make	1 liter

To use, take 1 part of stock solution and 10 parts of water. Since th bleaching solution is strongly acid, it may be necessary to harden th negative in the SH-1 hardener. Then it is bleached thoroughly in th dichromate-hydrochloric acid solution (18-21 C, 65-70 F), and the washed thoroughly. The bleached negative is then redeveloped in fast-acting nonstaining developer such as KODAK Developer D-7

under artificial light or daylight (not sunlight). It is then rinsed, fixed for 5 minutes, washed thoroughly, and allowed to dry.

A typical silver sulfide intensifier is similar to bleach and redevelopment toning. A potassium ferricyanide/potassium bromide bleach converts the image to silver bromide; then redevelopment in a 0.1% solution of sodium sulfide converts the silver halide to silver sulfide, which owes much of its intensification to the greater absorption by the silver sulfide in the short-wavelength part of the spectrum.

9.32 Print Modification

Reduction and intensification techniques can be applied to paper prints or film transparencies as well as to negatives, but it is usually not worthwhile to resort to these treatments for overall changes in density or contrast (although Ansel Adams used selenium toner for blacker blacks and increased contrast). Instead, the methods lend themselves to local treatment to enhance the tonal makeup. The formulas for reducers and intensifiers for this purpose are usually different, and the concentrations are lawar. It is important that no residual traces of the the mital treatment the tonal print or regenerate later.

9.33 Nonchemical Treatment

A nonchemical method of modifying a negative is to make a positive transparency by printing, and from this make a new negative with exposure and development in both steps adjusted to produce the desired negative characteristics. Contrast and other printing characteristics can also be altered by producing simple masks that are bound in register with the negative for printing.

9.34 Masking to Reduce Contrast

In lieu of chemical reduction to reduce contrast, an unsharp mask can be made to serve a similar purpose and at the same time enhance fine details in the picture (see Figure 9–9). The low-density positive mask is made by exposure onto a sheet of KODAK Pan Masking Film or if this is not available, any camera negative film such as KODAK Plus-X Film. In order to make the mask unsharp, a glass spacer is used between the negative and the film to be exposed for the mask. Above this, and with the diffuse side facing the negative to be masked, is placed a sheet of diffusion sheeting. Exposure can be made using the enlarger as a light source, and is adjusted so that with reduced development (about 30% less than normal) a mask having a total density of something under 0.3 is produced. This mask is then bound in register with the base side of the original negative for making the print exposure. The unsharp character of the mask has the effect of enhancing fine detail, and also makes it easier to register the mask with the negative.

9.35 Masking to Increase Contrast

If a good diapositive is first made from the negative, and then a thin negative mask printed from the diapositive, the mask can be bound in register with the original negative to increase contrast in the final print. In this case, both the interpositive and the negative

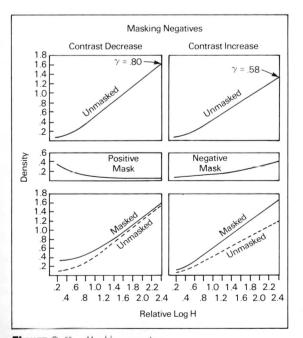

Figure 9-9 Masking negatives.

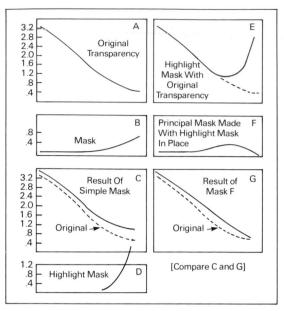

Figure 9–10 The highlight mask (D) shields the highlights when bound in register with the original (E) to expose principal mask (F). Thus the masking effect does not exist in the highlights when the final copy or separation is made.

mask have to be made as sharp as possible—without diffusion—since unsharpness in either step would lead to deterioration of image quality.

9.36 Highlight Masks

Negative masks for contrast modification as well as for color correction can be used when duplicating color transparencies or making separation negatives from them. Since the mask would tend to lower contrast in the highlight areas—thus "graying" them over—a highlight mask can be made to hold back exposure in the highlights when exposing the principal mask (see Figure 9–10). The highlight mask is then discarded, and the principal mask is bound in register with the transparency when making the duplicate or separation negatives. It has the effect of reducing overall contrast without lowering contrast in the highlights.

References

Amphoto, The Encyclopedia of Practical Photography.

- American National Standards Institute, Ammonia Processed Diazo Photographic Film, Stability (PH1.60-1979).
 - ——, Black-and-White Photographic Films, Evaluating the Processing with Respect to the Stability of the Resultant Image (PH4.32-1980).
 - ——, Comparing the Color Stabilities of Photographs, Method (PH1.42-1969, R1975).
 - ——, Dimensional Change Characteristics of Photographic Films and Papers, Method for Determining (PH1.32-1973).
 - ——, Methylene Blue Method for Measuring Thiosulfate and Silver Densitometric Method for Measuring Residual Chemicals in Films, Plates, and Papers (PH4.8-1978).
- ——, Photographic Film, for Archival Records, Silver-Gelatin Type, on Cellulose Ester Base (PH1.28-1984).
- ------, Photographic Film for Archival Records, Silver-Gelatin Type, on Polyester Base (PH1.41-1984).
- ------, Processed Films, Plates, and Papers, Filing Enclosures and Containers for Storage (ASC PH1.53-1984).
 - —, Scratch Resistance of Processed Photographic Film, Methods for Determining (PH1.37-1977).
- , Storage of Processed Safety Film (PH1.43-1983).
- Current, "Some Factors Affecting Sepia Tone." PSA Journal 1950 Annual, pp. 684-87.
- Eastman Kodak, Preservation of Photographs (F-30)
 - ——, Processing Chemicals & Formulas (J-1).
- ——, Quality Enlarging with Kodak B/W Papers (G-1).
- Eaton, Photographic Chemistry.

Haist, Modern Photographic Processing.

Ilford, Ilfobrom Galerie.

- Mason, Photographic Processing Chemistry.
- Sturge, Neblette's Handbook of Photography and Reprography.
- Henney and Dudley, Handbook of Photography.
- Wall and Jordan, Photographic Facts and Formulas.

Color Processes

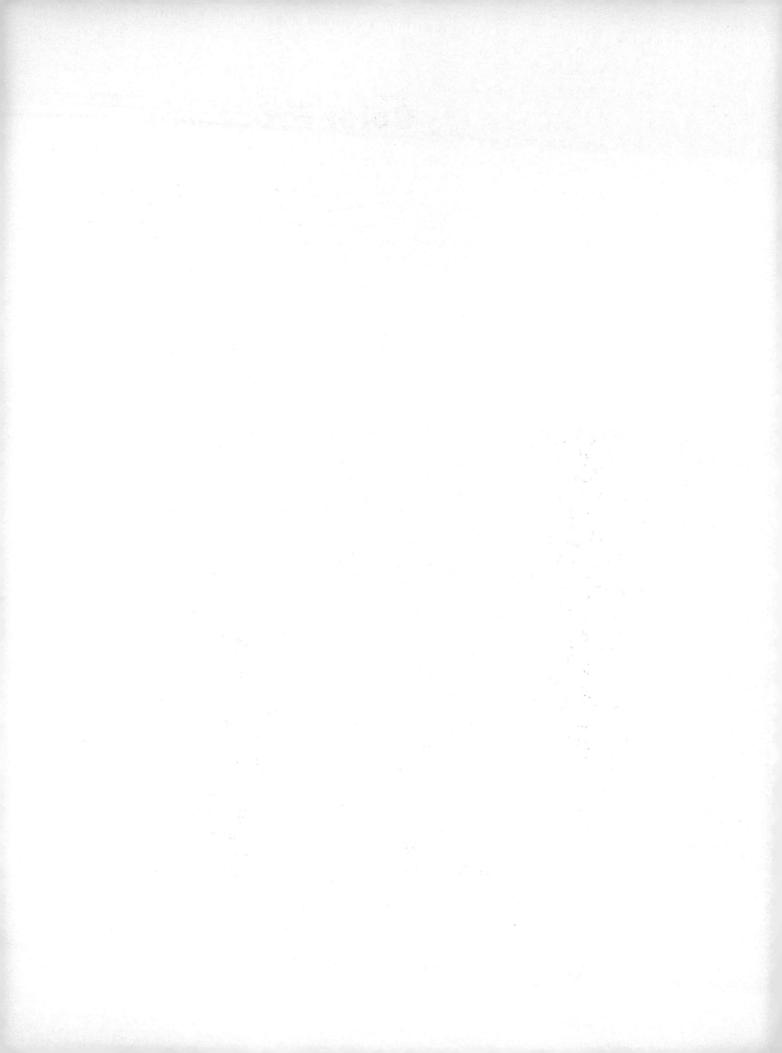

10.1 Tricolor Photography

Color photography depends on the principle that almost any color can be reproduced by mixing various amounts of red, green, and blue light. Hence photographic systems are designed to record the colors in a scene by making three records: one each for the scene's red, green, and blue components. This can be done by making exposures through red, green, and blue filters on panchromatic film. Three positive images can be made from these negatives and projected (with three projectors) through the same red, green, and blue filters. Superimposing the three images on a screen produces a photographic representation of the original scene. This is an *additive system* of color photography. Television is an example of an additive system as the red, green, and blue phosphors on the surface of the receiving tube reconstitute the colors in the original scene. Alternatively, a cyan positive dye image can be made from the red filter negative, a magenta positive from the green filter negative, and a yellow positive from the blue filter negative. When these dye images are superimposed, or assembled, they produce a subtractive color photograph; each image absorbs one of the red, green and blue colors from the white winning light (see Figure 10-1). Dye transfer is an example of this type of assembly printing process.

To summarize, there are two ways to form color images after the scene has been analyzed in terms of the three color components (*tricolor analysis*). Additive systems reconstitute the original scene (approximately) by adding the red, green, and blue "records" for presentation to the viewer.

Subtractive systems reconstitute the scene (approximately) by subtracting red, green, and blue light from the white light used to illuminate the color image. With both systems there are various ways of accomplishing the analysis of the scene and the synthesis of the color image.

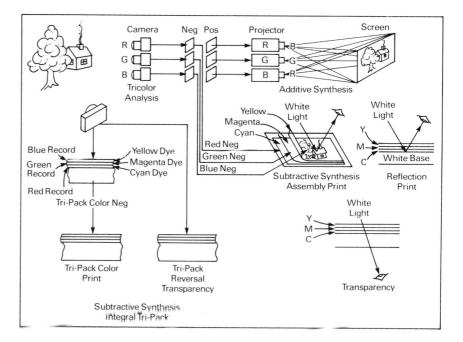

Figure 10-1 Tricolor analysis can be accomplished with separate exposures through red, green, and blue filters, or with a single exposure on an integral tripack of three emulsions sensitive to blue, green, and red. Additive synthesis recombines the images obtained with the three filters by projecting through similar colors to those used for the original exposure. In subtractive synthesis, complementary colored images control the amounts of red, green, and blue light reaching the visual system.

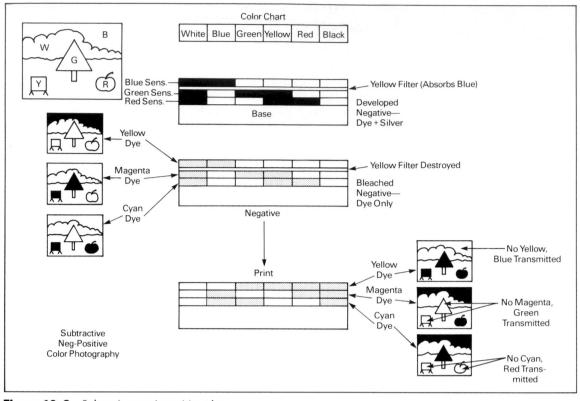

Figure 10–2 Subtractive negative-positive color photography.

10.2 Chromogenic Processes

Chromogenic refers to "a substance or process that produces color."¹ Today most color photography is accomplished with subtractive systems using a tripack of three emulsion layers in a single camera film—one sensitive to blue light, one sensitive to green light, and one sensitive to red light. Processing produces images that are colored yellow, magenta, and cyan, respectively. A yellow filter layer is placed between the blue-sensitive and green-sensitive layers to absorb blue light that would also record in the green-sensitive and red-sensitive layers (see Figure 10-2). This filter layer is destroyed when the film is processed.

10.3 Negative Color Films

Positive color images can be produced either by forming a negative color image in the film exposed in the camera and then making a positive print from the negative, or by using reversal processing to obtain a positive image on the camera film. Cyan, magenta, and yellow negative images are formed in negative camera films in the red-, greenand blue-sensitive layers of the film. To produce a color print or transparency, this negative composite is printed on a positive material that also has three emulsion layers sensitive to the same red, green, and blue primary colors, in order to produce a subtractive color print.

The three emulsion layers of a chromogenic integral tripack film incorporate "color couplers" consisting of molecules of compound

¹Stroebel, L. and Todd, H., 1974, p. 37.

that will unite with the reaction products of silver development to form dyes. Thus dye is formed in relation to the silver developed. The molecules in the blue-sensitive layer form yellow dye; those in the green-sensitive layer, magenta dye; and those in the red-sensitive layer, cyan dye, as shown in Figure 10-3.

Dye masks (integral dye masks) are incorporated in modern color films to compensate for the unwanted absorptions of light by the cyan and magenta image dyes. The overall orange mask color can be compensated for in printing to produce a balanced color image. To produce the masks, the films are manufactured with colored color formers in the green- and red-sensitive emulsion layers, which combine with the reaction products of development (with a color-forming developer) to form the magenta and cyan dyes with development (in proportion to the amount of silver formed) (see Figure 10-4). The coupler in the green-sensitive layer is yellow (to absorb blue light), and it forms magenta dye along with the silver image. The yellow coupler is consumed in proportion to the amount of magenta dye formed so it produces a positive yellow mask that makes up for the unminical blue absorption of the magantu dye negative image. The counter in the redsensitive lower in rul, 111.4 it forms evan dye along with the silver image. The red coupler is consumed in proportion to the amount of cyan dye formed, so it produces a positive mask that makes up for the unwanted green and blue absorptions of the cyan dye. The two masks, yellow and red, give negative films their characteristic orange color. The coupler in the blue-sensitive layer is colorless, but on development vellow dye is formed along with the silver image. In most cases the yellow image dye does not have serious unwanted absorptions of green and red light; therefore no mask is needed.

Following development, the negative color film is treated with a bleach that converts the silver to a silver halide, and this along with the undeveloped halide is removed by fixing. The bleach and fix can be combined in a single bath. The film is then washed and dried. The dye images, including the color masks, remain in the film.

10.4 Reversal Color Films

Reversal films for producing positive transparencies also have three layers—one sensitive to blue, one to green, and one to red light,

Figure 10–3 Incorporated couplers, color negative film.

10.5 Films with Incorporated Couplers

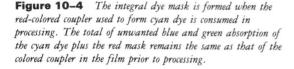

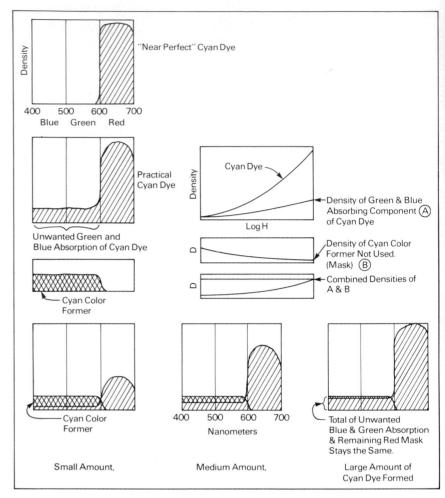

along with a yellow filter layer between the top blue-sensitive layer and the middle green-sensitive layer, as in negative films. With reversal processing, however, the film is first developed in a developer that does not form any dye-a black-and-white developer that produces a negative silver image in each layer. The remaining unexposed silver halide grains that constitute positive images are then made developable by a chemical fogging agent (sometimes referred to as a reversal bath), or by a fogging exposure to light. The film is then developed again but this time with a developer whose reaction products combine with the color couplers, which are either in the film itself or in the developer, to form dye in proportion to the amount of silver developed. A bleach converts all of the silver (negative and positive images) to silver halide, which, as with negative films, is removed by fixing and washing, leaving only the dye images. Reversal films do not have masking dyes because their color in the finished print or transparency would not be acceptable. (Neutral-color silver masks can be superimposed on the transparency to make high quality color prints, however.)

10.5 Films with Incorporated Couplers

Chromogenic color films, both negative and reversal, can be manufactured with incorporated color couplers in the emulsion layers, in contrast to putting the color couplers in the developers. One type of reversal film is manufactured with the colorless color components Figure 10–5 Incorporated couplers, reversal color film.

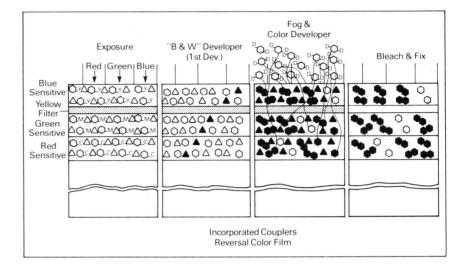

(color couplers) incorporated in the three emulsion layers—one that forms yellow dye with color development in the hlue-sensitive layer, interment maganeted dye in the green-sensitive layer, and one that forms cyan dye in the red-sensitive layer, as shown in Figure 10–5. Thus, using the reversal procedure described above, yellow, magenta, and cyan positive images are formed.

10.6 Films without Incorporated Couplers

Another type of reversal film does not have the color-forming components incorporated in the three emulsion layers. An example of this is KODACHROME Film. Here the three emulsion layers are, in effect, simple black-and-white emulsions of the proper color sensitivity, speed, and contrast, as shown in Figure 10–6. After washing to remove the antihalation backing, the film is developed in a non-color-forming

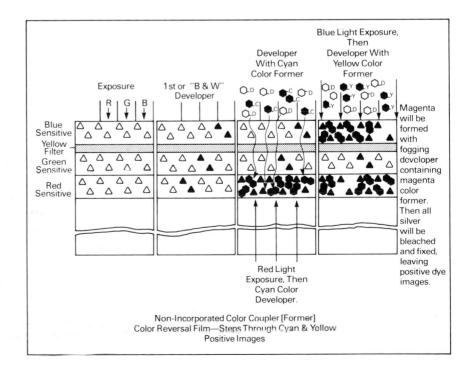

Figure 10-6 Nonincorporated color-coupler (former) color reversal film—steps through cyan and yellow positive images.

developer to produce negative silver images. Then, after a rinse, the film is exposed from the base side with red light, which exposes only the red-sensitive layer (which has retained its red sensitivity), and it is developed with a cyan color developer that forms a positive cyan dye image in this layer at the same time as a positive silver image is formed. The color-forming component is part of the developer formula. Next the film is exposed from the top with blue light, which affects only the top blue-sensitive layer. It is then developed in a yellow colorforming developer. Finally, the film is developed in a fogging developer that forms magenta dye, along with silver, in the remaining greensensitive layer. All of the silver (the negative and positive images plus the yellow filter layer) is then bleached in a formula that converts it to a complex that can be removed by fixing. After fixing, the film is washed and dried. The process, with all of its secondary steps, is a complex one that requires elaborate processing equipment, and careful attention to many chemical and processing details.

10.7 Color Paper for Prints from Negatives

Color paper for making prints from color negatives is manufactured with three layers, each sensitive to one of the red, green, and blue additive primary colors, and in which the appropriate cyan, magenta, and yellow subtractive primary colors are formed with processing. Unlike camera films, which have layer arrangements in the order (from the exposure side) of blue, green and red sensitivity, the printing papers may have different layer arrangements to meet the various other requirements, including image stability, minimizing color-balance change on fading, etc. A typical paper, for example, might have the red-sensitive layer on top, and the blue-sensitive layer on the bottom. The separation of the exposures is achieved by high conferred sensitivities in the red region for the red-sensitive layer, and in the green region for the green-sensitive layer (see Figure 10-7). Since the dye densities, and thus the emulsion thicknesses, of reflection paper prints need only be about half that of transparency films because they are viewed by reflection from the white surface, processing steps can be shorter. In general, the processing steps to make positive prints from a negative are otherwise similar to those for a color negative or color print film.

10.8 Reversal Color Paper

A typical color paper for making prints from color transparencies also has three layers responding to red, green, and blue, and in which cyan, magenta, and yellow subtractive primary colored image dyes are formed as the result of a modified reversal process with steps somewhat similar to those used for reversal color films. Papers designed for printing from negatives have relatively high contrast in order to produce prints having desired contrast and tone reproduction from the relatively low-contrast color negatives. The contrast of paper for printing from positive originals is necessarily lower, and is designed to be optimum for reproducing the reversal transparency.

10.9 Dye Bleach

Another system for making prints from color transparencies is that of dye bleach. The final dyes that are to appear in the print are

10.9 Dye Bleach

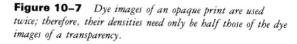

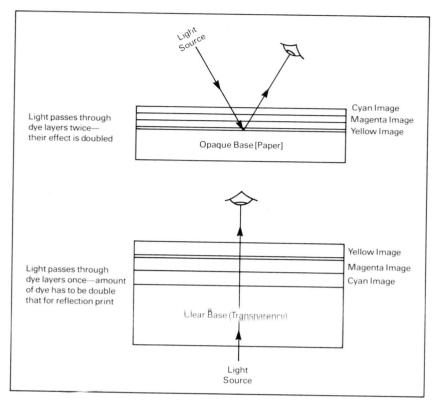

incorporated in the three emulsion layers: yellow dye in the bluesensitive, magenta dye in the green-sensitive, and cyan dye in the redsensitive layer, as shown in Figure 10–8. Following exposure to a transparency, a silver image is formed in each emulsion layer with development. This is followed by bleaching with a formula that destroys the dyes adjacent to the silver in proportion to the silver that is bleached. The bleach contains a strong acid such as hydrochloric acid, thiourea, and a catalyst. The film is again bleached with a non-dye-destroying formula to convert any remaining silver to silver halide, followed by fixing and washing. Cibachrome[®] printing is an example of this type of process.

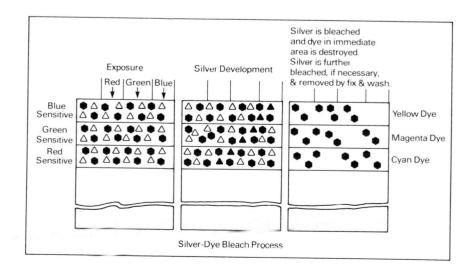

Figure 10-8 Silver-dye bleach process.

10.10 Dye Transfer

The dye-transfer process is an assembly print process. Prints can be made from tripack color negatives or internegatives, from direct separations, or from color transparencies via separation negatives. It utilizes a matrix film that has either a non-color-sensitized emulsion (KODAK Matrix Film), or a panchromatic-sensitized emulsion (KO-DAK Pan Matrix Film) (see Figure 10-9). The latter can be used to make the separations directly on the matrix film from a color negative by exposing separate pieces through red, green, and blue filters. The matrix film is not pre-punched for registration, but the pan matrix film is pre-punched with holes that can be used in conjunction with a register board equipped with pins to maintain registration of the three separation exposures. The regular matrix film is used to expose matrices from separation negatives that have been made from either an original subject or a color transparency. In most cases with the latter procedure, masks need to be made to correct for unwanted absorptions in the magenta and cyan dyes in the system. The film contains screening dye to prevent excessive light spread, and to control penetration of the light into the emulsion when it is exposed to image light. (The screening dye in the matrix film is yellow and is removed during processing, whereas that in the pan matrix film appears blue-black and is retained after processing.)

The films are exposed through the base: otherwise the final image would not be attached to the base and would flow away in the hot water wash (see Figure 10–10). After exposure, the film is processed in a developer containing pyrogallol and/or other developing agents, which tan (or harden) the gelatin in the areas where development takes place. The unexposed, and thus undeveloped, emulsion is washed off with water at a temperature of about 49 C (120 F) (sometimes referred to as etching), leaving the hardened image on the film. The image is then dyed in a dye bath and the film is rinsed; it is rolled into contact

Figure 10-9 Dye-transfer printing systems.

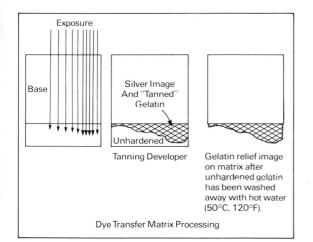

Figure 10–10 Dye-transfer matrix processing.

with a mordanted sheet of gelatin-coated paper or film, and left there until the dye migrates from the film to the paper or film receiver.

Before transfer, the three matrices can be visually registered and punched with holes that match a register board to which the paper is squeegeed. With the prepunched pan matrix film, this visual registration is not required if care has been taken not to move the register board at the time of exposure. When the three dye images (cyan, magenta, and yellow) have been superimposed on the paper or film, the result is a subtractive color print.

10.11 Polaroid Instant Photography

Instant color photography systems utilize the same red, green, and blue records as do conventional color photography systems, but their "processing" is entirely different. With the Polacolor[®] system, the red-, green-, and blue-sensitive layers are interleaved with dye developer layers containing developer molecules linked to dye mole cules. The blue-sensitive layer, for cample, has an adjoining the veloper laver that has the developer molecules linked to yellow dye molecules. In those areas where exposure to blue light has occurred, development takes place after the developer has been activated by chemistry from a "pod" that has been broken and distributed over the film to start the process. Where development occurs, the molecules are immobilized; but where no development occurs, the developer/dye molecules migrate through the emulsion and other layers to the receiving layer of the adjacent paper, and are fixed in position to produce part of the positive color image. (In this case, since the dye was immobilized at the place where blue light exposure was received, no yellow dye reaches the receiver; therefore, blue light is allowed to be reflected on viewing.) A similar development/immobilization mechanism works for the other two layers. The receiver sheet with the final color image can be peeled away to provide a correct-reading photograph (not a mirror image).

The Polacolor II[®] system makes use of an opaque layer that protects the film from light during processing, and that permits the image to be visible after processing has taken place. The unit with all layers and spent chemistry is the photograph—it is not peeled apart (see Figure 7–47). If this newer material were to be used in a conventional camera, the image would be reversed from left to right, a mirror image, and thus Polaroid cameras using this material require a mirror in their design to produce a correct-reading image.

10.12 KODAK Instant Color Film/ KODAMATIC Instant Color Film

These films utilized a dye-release chemistry. Instead of negative emulsions, high-speed direct-reversal emulsions were used that produced positive images on direct development. The processing chemistry operated by releasing dyes (not forming them) as the result of development. The release of the dyes from their "anchors" in the film unit was accomplished by concerted action of the developer oxidation product and alkali on agents called dye releasers. The released dyes in the area where no exposure occurred diffused to an image-receiving layer at the top of the picture unit to form the color image. Where exposure occurred (remember, this is a reversal system), no development took place, and the dyes were not released. Thus if the blue-sensitive layer received exposure, no development would take place, the yellow dye would not migrate to the receiver, and blue light could then be reflected from the white base for viewing. The activator also eats its way through a timing layer to liberate an acidic layer that reacts with the activator and neutralizes it, thus controlling the development time. If the film were exposed to red light, no development would take place in the red-sensitive layer in the region of the image, and no cyan dye would be released. Since no exposure was received to green and blue light, development would take place in the green- and blue-sensitive layers, releasing magenta and yellow dye which would absorb green and blue, allowing only the red light to be reflected from the white base to produce the red part of the image.

With the KODAK films, the activator was a black fluid that contained a strong alkali, a developing agent, an antifoggant, sodium sulfite, carbon, water, and a thickener. The carbon rendered the activator black and sealed off the silver halide emulsion from light from the exposure side and back of the pack. Oxidizing scavenger layers were provided to prevent dye release in the wrong layers. The migrating dyes eventually passed through a black opaque layer of carbon and a white opaque layer of reflective titanium dioxide to form the image for viewing.

10.13 Photo Color Transfer Process

The photo color transfer process (PCT) makes use of a film sensitized material that, after exposure with the enlarger or printer, is soaked in a highly alkaline activator solution for about 20 seconds, and is then rolled into contact with a receiving sheet for 6 to 15 minutes (depending on temperature). During this time the color image migrates to the receiver, KODAK EKTAFLEX PCT Paper, and the moist finished product is peeled away from the film. The KODAK EKTAFLEX Process was the first commercially successful process of this type. Two types of film are provided, KODAK EKTAFLEX PCT Negative Film for use when printing color negatives, and KODAK EKTAFLEX PCT Reversal Film for use when printing color reversal transparencies.

10.14 Color Television

A brief mention of the electronic process should be made, since the use of electronic recording, transmission and presentation is increasing. Color television operates on the tricolor principle, and the camera incorporates red, green, and blue beam splitters directed to three image tubes. (There are other camera configurations. One camera utilizes only two tubes, one receiving luminance information, the other chrominance through a striped dichroic filter over the tube.) One may think of a beam-splitting system as not too much unlike the Ives photochromoscope in reverse, breaking the image into three parts red, green and blue. (The photochromoscope was a device for recombining the three positive images from early color separations so that they were combined and presented to the viewer's eye as a single colorec image.)

Electronic processing produces picture signals that are transmitted over a frequency band about equal to that originally allotted to black-and-white television. The picture information is encoded by mean of phase, time-delay and frequency band width selection, including side bands. After encoding and transmission, one of the three parts o

the signal carries high-resolution luminance information composed of a mixture of parts of the red, green and blue signals. Another part of the signal carries the low-resolution delineation of red-yellow and greenyellow; and the third delineation of green from purple.

After these signals have been received, an electronic system decodes the information and reconverts it into signals that control three electron guns in the receiver tube, one of each directed to scan and excite red, green and blue phosphors on the tube's surface. (There are other arrangements for projecting the three electron beams—for example, with a single gun where the electron beam is magnetically deflected in sequence by 120° , directing it toward the specific colored phosphors.) A shadow mask with holes in it is placed behind the phosphor grid in the tube. The holes line up between the electron gun and the clusters of red, green, and blue phosphors, which are elements in forming an additive presentation of the original scene.

Some color and luminance control is exercised by the broadcaster, who tries to operate at a gamma equal to 1.0. This may have to be modified at the receiver to a gamma between 1.2 and 1.5, depending on the viewing conditions surrounding the television screen, Those are an lines of information in the vertical interval (VIT) between plining interval, part of which can be used by the broadcaster to transmit a signal that can be used to identify and control differences in color balance and contrast between different cameras or other points of origin. Standards for performance have to be set somewhere between "true" color, which is impossible to achieve, and "preferred" color, which is of a subjective nature.

References

Amphoto, The Encyclopedia of Practical Photography

American National Standards Institute, Photographic Inertness of Construction Materials Used in Photographic Processing, Specification for Testing (PH4.31-1962, R1975).

Eastman Kodak, Kodak Color Films (E-77).

- ——, Kodak Dye Transfer Process (E-80).
- _____, Kodak Films–Color and Black-and-White (AF-1).
- ——, Kodak Filters for Scientific and Technical Uses (B-3).

------, Printing Color Negatives (E-66).

- ——, Printing Color Slides and Larger Transparencies (E-96).
- ——, Techniques for Making Professional Prints on Kodak Ektachrome Papers. (E-87).

Eynard, Color: Theory and Imaging Systems.

Friedman, History of Color Photography.

Ilford, Cibachrome A-II Manual.

Mason, Photographic Processing Chemistry.

Sturge, Neblette's Handbook of Photography and Reprography.

Stroebel and Todd, Dictionary of Contemporary Photography.

COLLEGE LIBRARY COLLEGE OF TECHNOLOGY CARNARVON ROAD SOUTHEND ON-SEA, ESSEX

Tone Reproduction

11.1 Purposes of Tone Reproduction

Modern photographic systems are used in nearly all areas of human endeavor. The proper materials and processes are in large part dictated by the purpose of the photograph. In technical and scientific applications the typical goal is to produce a photograph that correctly communicates information about the original subject. The goal of pictorial photography involves a similar desire for subject information, with the additional wish for a visually pleasing photograph. In most cases, except where the photographer is creating a photograph that bears no resemblance to an original subject, it is important to study the relationship between the tones in the original scene and the corresponding tones in the reproduction. Thus, by studying the factors influencing the reproduction of tone, the photographer can learn how to control the process to give the desired results.

Chapter 2 showed how the tone-recording properties of films and papers can be described through the use of the characteristic curve. If the conditions of measurement used to obtain the data timulate the tranditions of use, the characteristic curve provides an uncellent description of the tone-rendering properties of the film or paper emulsion. However, the result of the photographic process is a reproduction that will be observed by a person, which therefore involves the characteristics of the human visual system. In this respect, perceptual phenomena, including brightness adaptation, appear to play a significant role. Thus the determination of the objective tone-reproduction properties required in a photograph of excellent quality is related to the perceptual conditions at work when the image is viewed.

11.2 Objective and Subjective Tone Reproduction

When determining the tone-reproduction properties of the photographic system, there are objective and subjective aspects to be considered. In the objective phase, measurements of light reflected from the subject are compared to measurements of light reflected or transmitted by the photographic reproduction. These reflected-light readings from the subject are called luminances (see section 5.18) and can be measured accurately with a photoelectric meter having a relative spectral response equivalent to that of the "average" human eye. The logarithms of these luminances are then plotted against the corresponding reflection or transmission densities in the photographic reproduction, and the resulting plot is identified as the objective tone-reproduction curve.

The perception of the lightness of a subject or image area corresponds roughly to its luminance; but unlike luminance, lightness is not directly measurable. Because the perception of lightness involves physiological as well as psychological factors, an area of constant luminance can appear to change in lightness for various reasons, including whether the viewer had previously been adapted to a high or a low light level. Psychological scaling procedures have been devised to determine the effect of viewing conditions on the perception of lightness and contrast. It has been established, for example, that a photograph appears lighter when viewed against a dark background than when viewed against a light background; and that the contrast of a photograph appears lower when viewed with a dark surround than when viewed with a light surround (see Section 13.4). A graph showing the relationship between the perceived lightnesses of various areas of a scene or photograph and the measured luminances of the corresponding areas would be called a subjective tonereproduction curve. It is because the perception of a photograph's tonal qualities can vary with the viewing conditions that the American National Standards Institute and other organizations have prepared standards for the viewing conditions in which photographs are produced, judged, and displayed. The influence of viewing conditions should not be underestimated when considering the specifications for optimum tone reproduction (see Section 5.17).

11.3 Objective Tone-Reproduction/ Preferred Photographs

Most photographers realize that tone-reproduction characteristics required for satisfactory photographs depend to a great extent upon the lighting conditions under which the photographs are viewed. Unfortunately, reflection-type prints are commonly viewed under illumination levels ranging from less than 100 lux to more than 5,000 lux. (The Photographic Society of America currently recommends an illuminance of 800 lux for judging and displaying reflection prints [PSA Uniform Practice No. 1, 1981].) Large transparencies are often viewed by back illumination, with a recommended luminance of approximately 1,200 candelas per square meter.

However, since these transparencies are viewed under the same general room illumination as reflection-type prints, the eye is in a similar state of adaptation. Slides and motion-picture films projected onto a screen and observed in a darkened room are viewed with the eye in a considerably different state of adaptation. Since there are three widely varying viewing conditions, different objective tone-reproduction curves are required if the photographs are to meet the subjective standards of excellence in each case.

In order to determine the objective tone-reproduction curve that gives the best subjective tone reproduction for black-and-white reflection prints, an experiment was performed under the conditions typically encountered by photographers. Various outdoor scenes were photographed at different exposure levels. The exposed films were processed to different contrasts, and from the resulting negatives blackand-white prints were produced. The prints varied in contrast, density, and tone-reproduction properties. Numerous observers were asked to view these prints and judge them for their subjective quality. The objective tone-reproduction curves for all of the first-choice prints were averaged, and the resulting curve is illustrated in Figure 11–1, where the reflection densities of the print are plotted against the log luminances of the scene.

The 45° reference line is arbitrarily located so that its lowest point corresponds to a diffuse white object in the scene and the minimum density of the photographic print material. If the luminances in the scene were reproduced exactly in the print, the resulting tonereproduction curve would have a slope of 1.00, matching that of the reference line. In fact, the average curve for first-choice prints is located 0.2 to 0.3 density units below the 45° line except in the highlight region, where the curve cannot go below the minimum density of the paper. The curve shows low slope in both the highlight and shadow

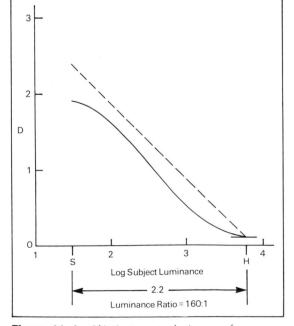

Figure 11–1 Objective tone-reproduction curve for a preferred reflection print of an average outdoor scene.

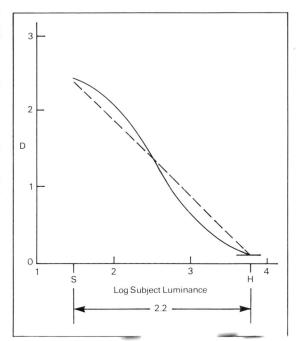

Figure 11-2 Objective tone-reproduction curve for a transparency of preferred quality, viewed on a bright illuminator under average room light.

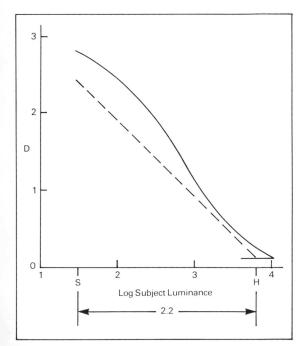

Figure 11–3 Objective tone-reproduction curve for motion pictures (and slides) of preferred quality, projected on a screen in a darkened room.

regions, but has a gradient of 1.1 to 1.2 in the midtone area. This indicates that the print's highlights and shadow regions are compressed compared to the original scene, while the midtones have been slightly expanded in contrast. The experiments that lead to this tone-reproduction curve involved scenes of low and high contrast, as well as interior and exterior subject matter. The results in all cases were remarkably similar to that shown in Figure 11–1. Whenever the departure from the desired slopes was greater than 0.05, the observers invariably judged the prints as being unacceptable in contrast, indicating very narrow tolerance levels. Consequently, it appears that the desired objective tone-reproduction properties in a black-and-white reflection print are essentially independent of the characteristics of the original subject.

Similar studies have been performed with large transparencies viewed under room-light conditions on a back illuminator. The objective tone-reproduction curve that gave the best objective tone reproduction for this condition is illustrated in Figure 11–2, where the diffuse transmission density of the image is plotted against the log luminance of the scene. The desired abjective tone-reproduction curve is very nearly the same at the 15° interaction but with a midtone slope still greater than 1.0.

The differences in curve shape between the transparency and the reflection print are due primarily to the increased density range of which the transparency film is capable, since the eye is in a similar state of adaptation. As the brightness of the illuminator used to view the transparency increases, the desired tone-reproduction curve moves slightly above and to the right of the one illustrated in Figure 11-2.

The preferred objective tone-reproduction curve for a transparency or a motion-picture projected onto a screen and viewed in a darkened room is illustrated in Figure 11–3, where the effective screen viewing densities (measurements made with a spot photometer of the projected image on the screen) are plotted against the log luminances of the scene. This curve shows a slope considerably greater than that of the previous two and is principally the result of the dark-adaptation, lateral-adaptation, and visual-flare characteristics of the eye. Psychophysical experiments of the human eye's response indicate that the perceived brightness (lightness) contrast is lower when the eye is dark adapted than when it is light adapted.

Since it is desirable to obtain a lightness contrast in the projected image on the screen similar to that which would occur in a reflection print, the objective tone-reproduction curve necessary for dark-adapted conditons must have a greater slope. If a higher-intensity lamp is used in the projector, the tone-reproduction curve shifts slightly to the right and above that which is shown in Figure 11-3. Therefore, the preferred density level and optimum exposure for a transparency film are related to the amount of light supplied by the projector and screen used when viewing the images. This means that the effective film speed for a reversal film is in part related to the conditons under which the images will be viewed.

The three conditions illustrated represent those most commonly encountered in photographic reproductions and pertain only to pictorial representations. In each case, the curve represents optimum subjective tone reproduction, and thus an aim for the system. It is the task of the photographer to select the appropriate materials and processes to achieve these aims.

11.4 Objective Tone-Reproduction Analysis

Figure 11-4 Flow diagram of the photographic process.

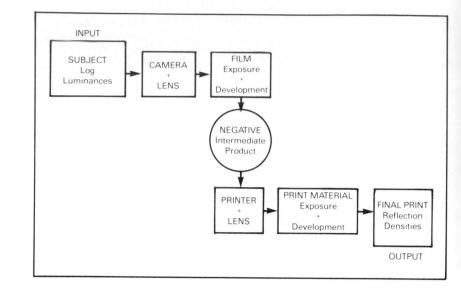

11.4 Objective Tone-Reproduction Analysis

The flow diagram in Figure 11–4 isolates some of the more important factors to be considered in a study of the photographic reproduction of tones. Since the subject represents input in terms of log luminance values and the print represents output in terms of densities, it is the stages in between that must concern us. It should be noted that a study of tone-reproduction characteristics excludes many important properties of the photographic system. For example, no attention is paid to the reproduction of small detail nor to the reproduction of various colors in the scene. Thus, when considering the various stages of the process, only those factors that influence the largescale tonal relationship should be considered.

To simplify this task it is necessary to consider only three principal stages in the process, as illustrated in Figure 11–5. Each of these stages will be represented by a graph illustrating its influence on the tonal relationships. Each graph has a set of input values and a set of output values. The output from the first stage becomes the input to the second, and so on through the system, thus forming a chain of input/output relationships. In this fashion, the major stages of the process can be studied for their effects upon the end result. The important phases of the photographic process can be synthesized by means of this tone-reproduction study. For such an approach to work, data must be obtained about these phases. Methods for obtaining data about the subject, film, and photographic papers were discussed in Chapter 2 and so will not be repeated here. However, the problem of optical flare was only briefly mentioned in Chapter 3, and so a discussion of it follows.

11.5 Optical Flare

When a camera is aimed at a subject, the subject luminances and therefore the physical values of light reaching the lens represent the initial input data for the process. If the luminance of the lightest diffuse highlight is divided by the luminance of the darkest shadow with detail, the resulting value is termed the *luminance ratio* and the

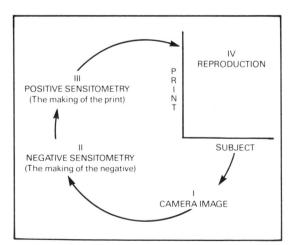

Figure 11-5 Simplified tone-reproduction system.

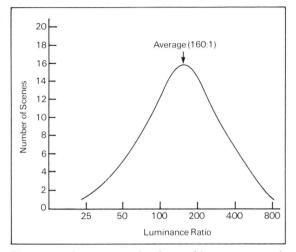

Figure 11–6 Frequency distribution of luminance ratios of outdoor scenes.

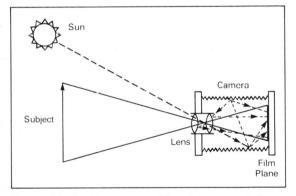

Figure 11–7 The occurrence of flare in a camera. Solid lines in camera represent image-forming light, while dashed lines in camera represent non-image-forming (flare) light.

log of that ratio is termed the *log luminance range*. In an important experiment conducted by Jones and Condit of the Eastman Kodak Research Laboratory, the luminance ratios of more than 100 outdoor scenes were measured. The frequency distribution of the luminance ratios is shown in Figure 11–6. The smallest ratio encountered was 27:1 and the largest was 760:1, with an average ratio of 160:1. The frequency distribution in Figure 11–6 indicates that luminance ratios of less than 100:1 and greater than 300:1 are encountered much less often.

Much less information exists about the luminance ratios of interior scenes, but some experiments indicate that the average luminance ratio of an interior scene is not greatly different from 160:1. The average scene ratio of 160:1 has special significance since most manufacturers optimize exposure and development conditions for their products based on this value. A set of luminance readings from a typical outdoor scene is shown in Table 11–1. Nine different areas of the scene were measured with a spot meter to obtain the data. The luminance ratio of the scene is 160:1.

When the current is pollited at such a scene, the lenging light the light from each area and focuses it on the film plane at the back of the camera. Thus, in this first stage of tone reproduction, the subject luminances are transformed to image illuminances at the film plane. In an ideal situation there would be a direct proportion between the subject luminances and the image illuminances; the tonal relationships would be maintained at the back of the camera. However, at any point in the image plane of a camera, the illuminance is the result of two different sources: (a) the illumination focused by the lens and projected to the film plane, which constitutes the image-forming light; and (b) light that is the result of single and multiple reflections from the lens surfaces, diaphragm, shutter blades, and additional interior surfaces of the camera, providing an approximately uniform illuminance over the whole image area.

This second source of light is referred to as flare light, or simply flare, and provides non-image-forming light, since it is not directly focused by the lens. Figure 11-7 illustrates how flare occurs in a simple camera. Since the light is reflected off any interior surface, flare light is present on any projected image, whether it is formed by the lens or a pinhole.

Since flare is non-image-forming light and occurs in the image plane as a uniform veil, it increases the illuminance of every point on the camera image and thus results in a loss of image contrast.

Table 11–1 Luminance values of an outdoor so	able 11-1	Luminance	values	of an	outdoor	scene
---	-----------	-----------	--------	-------	---------	-------

		Luminance		
Area No.	Description of Area	Candela/Square Foot	Footlambert	
1	White cloud	1,114	3,500	
2	Clear sky	637	2,000	
3	Grass in sunlight	350	1,100	
4	Side of house in sunlight	200	630	
5	Front of house	115	360	
6	Car in open shade	67	210	
7	Tree trunk	38	120	
8	Grass in shade	22	70	
9	Base of use in heavy shade	7	22	
	Luminance ratio of	subject = 160:1		

The effect is similar to viewing a projected transparency on a screen in a darkened room and then viewing the same image with the room lights on. The loss of image contrast on the screen is due to the additional illuminance produced by the room lights on the screen surface.

To illustrate the effect in the camera, assume that the camera is being pointed at an average subject with a 160:1 luminance ratio. If there were no flare-light in the camera, the range of image illuminances at the back of the camera would also be 160:1. However, if in addition to that image-forming light there was one unit of flare light uniformly distributed over the film plane (i.e., the corners are receiving one unit, the edges are receiving one unit, the center is receiving one unit), the ratio would now be 161:2, which reduces to approximately 80:1. Thus the 160:1 luminance ratio in front of the camera has been reduced to an illuminance ratio of 80:1 at the back of the camera.

It is perhaps obvious that the reduction in contrast is the result of different percentage increases at the opposite ends of the scale. For example, the additional unit of flare light in the shadows provides a doubling of the light in that region, while the additional unit of light in the highlights represents only a very small percentage of increase in that region. The result is that the ratio of illuminances at the back of the camera is always less than the ratio of luminances in the subject. Flare can be expressed as a flare factor, which is derived by dividing the luminance ratio in front of the camera by the illuminance ratio at the back of the camera:

$\label{eq:Flare factor} \mathsf{Flare factor} \, = \, \frac{\mathsf{Subject luminance ratio}}{\mathsf{Image illuminance ratio}} \, .$

The flare factor will be 1.0 when there is no flare light, which would occur only in a contact-printing situation. The results of many experiments indicate that most modern lenses and cameras have an average flare factor of nearly 2.5 under typical conditions. Under some conditions the flare factor may be as high as 4 or 8, or as low as 1.5.

Some of the more important factors that influence the amount of flare are:

- 1. *Subject characteristics*. Subjects with high luminance ratios or subjects with large areas of high luminance tend to produce large amounts of flare. Snow scenes, beach scenes, and high-key scenes (white on white) are all examples of subject matter that would give large amounts of flare.
- **2.** Lighting conditions. Subjects that are back lit (with the light source in the field of view) give greater amounts of flare than subjects that are front lit.
- **3.** Lens design. By designing a lens to contain the smallest number of elements possible, and coating the elements with antireflection materials, its flare characteristics can be greatly minimized. However, lens design and coatings cannot decrease the flare factor to 1.00 (zero flare), since considerable stray light still reaches the image plane by reflection from the lens mount and other inner areas of the camera, and even the surface of the film itself.
- **4.** *Camera design.* If the camera's interior is black and the surfaces are mat, stray light reflections will be minimized. Any light leaks in the camera body will also act as flare and further reduce the image contrast.

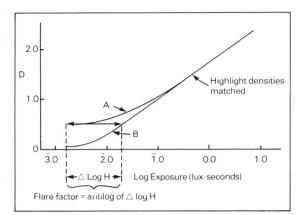

Figure 11–8 The effects of flare on the characteristic curve of a black-and-white negative material. Curve A was generated by photographing a reflection gray scale with a camera, while curve B came from a sensitometer (contact printed to a step tablet).

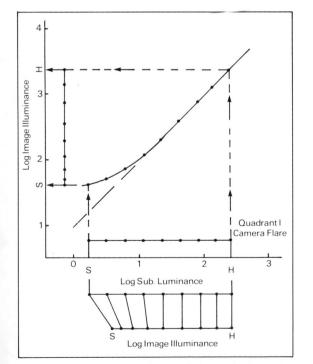

Figure 11–9 The effect of optical flare (or other stray light) on the image illuminances at the back of the camera.

5. *Dust and dirt.* By keeping the lens surfaces clean and minimizing dust particles in the camera body, the number of surface areas on which light reflections may occur can be minimized and the flare reduced.

Of all the factors listed, the two with the greatest influence on flare are the subject characteristics and the lighting conditions. A number of studies suggest that approximately 80% of the flare encountered in typical photographic situations is governed by these two factors. Consequently, even when high-quality lenses and cameras are used and kept in good condition, the photographer cannot avoid the loss of image contrast that results from flare. Thus it is important for the photographer to obtain an estimate of the amount of flare, in the form of a flare factor, that is affecting his system.

The direct method for measuring flare involves the use of a gray scale and a small spot meter. The camera is focused on the gray scale and the small spot meter is used to measure the corresponding image areas at the back of the camera. The ratio of luminances on the original gray scale can then be compared to the ratio of illuminances at the back of the camera, and the flare factor can be computed. Although this method is direct, it is a difficult procedure to follow, and in small-format cameras it is a practical impossibility.

An alternative method is to work backwards using a photographic film as the measuring device. First, a negative of the gray scale is made with the camera. A second piece of film is exposed in a sensitometer, which is a flare-free instrument since it involves a contact print. Both pieces of film are processed together to ensure identical development and the resulting characteristic curves are drawn. The highlight densities of the curves are matched, and any difference in the rest of the curves can be attributed to flare. The actual amount of flare can be found by measuring the horizontal displacements between the two curves, at the bottom of the top curve. The antilog of the difference in log exposures is the flare factor.

Such a set of curves is illustrated in Figure 11-8, which shows that the effect of flare on the characteristic curve is to increase the length of the toe, add curvature to the lower part of the straight line, and reduce the shadow contrast (slope) in the negative. The greater the amount of flare in the system, the greater the differences will be between these two curves.

The purpose for obtaining the flare factor is to estimate the range of illuminances that will occur at the back of the camera, and thus the range of tones to which the film will be exposed. For example, if a scene with a luminance ratio of 200:1 is photographed with a lens-camera combination with a flare factor of 4, the film will actually receive a ratio of illuminances of 200 divided by 4, which equals 50:1. In this fashion the exposure ratio (or, more usefully, the log exposure range) for the film, and ultimately the development time necessary to produce a normal-contrast negative, can be determined.

In order to more thoroughly study the influence of flare in the tone-reproduction cycle, consider the graph in Figure 11-9. The data for such a graph are derived from the flare-measurement method first described. A small spot photometer was used to meter the illuminances provided by the gray scale at the back of a camera, and the relationships between subject luminance and image illuminance were plotted Since logarithms are commonly used to describe the input and output properties of photographic materials, the scales are log lumi-

11.6 The Making of the Negative

nance and log illuminance on the graph. If there were no flare in the system, the relationship between subject log luminance and image log illuminance would be a 45° straight line, indicating a direct proportion.

However, as discussed earlier, the low-illuminance shadow regions at the back of the camera suffer a greater percentage increase than do the highlight illuminances. Since the highlights are relatively unaffected, the relationship is at a slope of $1.0 (45^\circ)$ in that area. As the image illuminances decrease (the shadows become darker), the percentage increase becomes greater and thus reduces the slope of the curve considerably, resulting in a loss of contrast in the shadow area. This indicates that flare reduces shadow contrast in addition to reducing the overall ratio of tones at the film plane.

In Figure 11-9, the nine dots on the log luminance axis represent the nine luminances of a typical outdoor scene listed in Table 11-1. By extending straight lines directly up from these nine points until they intersect the flare curve, and then extending them to the left until they intersect the log illuminance axis, the nine dots on that axis can be generated.

A diagram at the bottom of Figure 11–9 compares the log subject luminances in front of the camera to the log image illuminances at the back of the camera for a normal amount of camera flare. The log image illuminance range is shorter, indicating an overall loss of contrast, and the relationship between the darker tones has been compressed, indicating a loss primarily of shadow contrast.

The graph in Figure 11–9 is important because it represents the first stage of the objective tone-reproduction process and illustrates the effect on tonal relationships occurring at that stage. Ultimately, the log image illuminances will be fixed in position when the camera shutter is tripped, converting them to log exposures, which become the input to the film. In this example, the two dashed lines on the graph indicate the location of the darkest shadow with detail and the lightest diffuse highlight. These two tones will be followed through the four-quadrant objective tone-reproduction cycle.

11.6 The Making of the Negative

The next stage of the process involves the making of the negative and is represented by the characteristic curve of the filmdevelopment combination used. Since the output of stage I (the optical flare quadrant) becomes the input of stage II (the making of the negative), it is necessary to rotate the characteristic curve of the film 90° counter-clockwise so that the log illuminance axis of quadrant I matches the log exposure axis for quadrant II, as illustrated in Figure 11–10. Here the broken line indicating the shadow detail area (S) has been located at the log exposure for the film that results in a minimum useful density of 0.10 above film base plus fog. This is reasonable as this density level is considered to be the minimum density for maintaining minimum shadow detail.

Since this is the ISO/ASA speed point for pictorial films, the shadow detail of the scene should be exposed in a way that produces this density. If less camera exposure is given, the dashed shadow detail line from quadrant I would intersect the negative curve at a much lower density (quadrant II would be shifted upward). If more camera exposure were given, the dashed shadow line would fall at a higher density on the characteristic curve (quadrant II would be shifted downward).

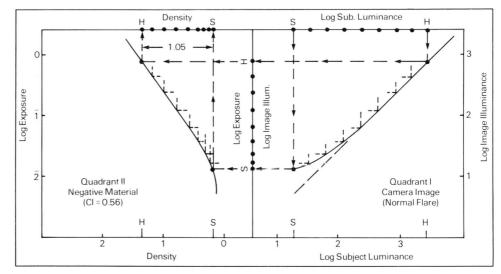

Figure 11–10 The combined effect of the transfer of camera flare onto the negative's characteristic curve.

The shape of the characteristic curve shown in quadrant II indicates that it was developed to a contrast index of 0.56, resulting in a highlight density of 1.15 above base plus fog, as indicated by the dashed diffuse highlight line (H). The film was developed to this contrast index because it was desired to produce a negative with a density range of approximately 1.05, since it is known that such a negative will easily print on a grade 2 paper in a diffusion enlarger. If a condenser enlarger were to be used, the necessary range would be less, as discussed in Chapter 2. The nine dots on the density axis of the negative are generated by continuing the lines from quadrant I into quadrant II until they strike the characteristic curve, and then reflecting them upward until they intersect the density scale.

The relationship between the log exposures on the film and the resulting densities can be illustrated in a fashion similar to that of quadrant I, as shown in Figure 11–11. This diagram indicates that compression of tone is occurring at all levels in the image, with the greatest amount of compression occurring again with the shadow areas. This is typically the case for pictorial negative films, since they are invariably processed to contrast indexes less than 1.0. Thus, significant compression of tones occurs at the negative making stage, with the darker shadow tones suffering the greatest amount of compression.

At this stage of the process the photographer has many image controls available. Among the more important are:

- 1. Film type. To a great extent, the properties of the emulsion determine the shape of the characteristic curve. For example, lithographic (or lith) emulsions generally will produce curves with slopes greater than 1.0 under most development conditions, while pictorial films will produce slopes less than 1.0 under most development conditions. Therefore, if the input log exposure range is very short, the photographer would do well to select a lith-type emulsion. If, however, the log exposure range is long (1.3 or greater), a pictorial film would be a better choice. Specialized emulsions have been designed to handle log exposure ranges of excessive lengths (1,000,000: 1 and greater)
- 2. Development. As discussed in Chapter 2, the length of development tlme provides a useful control for obtaining a variety of curve shapes

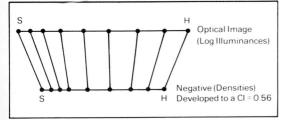

Figure 11-11 The relationship between the optical image at the film plane and the densities in the negative.

11.7 The Making of the Positive

(slopes) in the film. For pictorial applications, the concept of contrast index provides the most useful guide for estimating the required slope. The recommended development times found in most manufacturers' literature are those which will produce a contrast index of approximately 0.56, since this is the slope that will convert an average outdoor scene into a normal-contrast negative for diffusion enlargers. Flatter scenes will provide a shorter input range to the film and require a steeper slope to maintain a constant density range (contrast) in the negative. Contrasty subjects will provide the film with a longer range of log exposures and consequently require a lower slope to maintain the density range at the normal level. Thus, development provides the photographer with a powerful tool for contrast control in tone reproduction.

3. *Exposure.* The task here is to select the appropriate f-number and shutter speed to place the shadow-detail area of the subject at an exposure that will produce the minimum useful density for shadow detail in the negative. If less exposure is given, less shadow detail will result. If more exposure is given, greater shadow detail will result. Thus the f-number and shutter speed selected will have the greatest influence upon reproduction of the shadow tones. It is important to note that underexposure by more than one-half stop introduces a compression of shadow tones that cannot be adequately compensated for in later stages of the process. On the other hand, with typical pictorial subjects and films, overexposure by as much as four stops can be compensated for in the later stages but with the result of increased print exposure and grainier prints.

11.7 The Making of the Positive

The third major stage of this system is the making of the positive. For the example that follows, the reproduction will be in the form of a reflection print. When printing a negative, the negative's densities control the exposures that the paper will receive. The thinner shadow areas of the negative will allow more light to strike the paper than will the denser highlight areas. Consequently, the output of the negative in the form of transmission densities can be related to the input of the photographic paper in the form of log exposures; this explains the positioning of quadrant III in Figure 11–12. Quadrant III represents the characteristic curve of a normal grade of black-and-white photographic paper.

The curve shape selected for this quadrant is based upon the relationship between the density range of the negative and the usefu log exposure range of the paper. In Chapter 2 it was shown that pictoria negatives generally are best printed on a paper where the negative density range is equivalent to the paper's useful log exposure range. If this example, the negative has a density range of 1.05 and therefore requires a paper curve having a useful log exposure range of 1.05, a does the curve in quadrant III of Figure 11-12.

The f-number and printing time of the negative determine the location of the characteristic curve in quadrant III relative to thleft and right position. The best reproduction is generally obtained when the useful shadow density of the negative produces a density is the print equal to 90% of the maximum density of which the prin material is capable; this is the basis for the location of the paper curv in quadrant III.

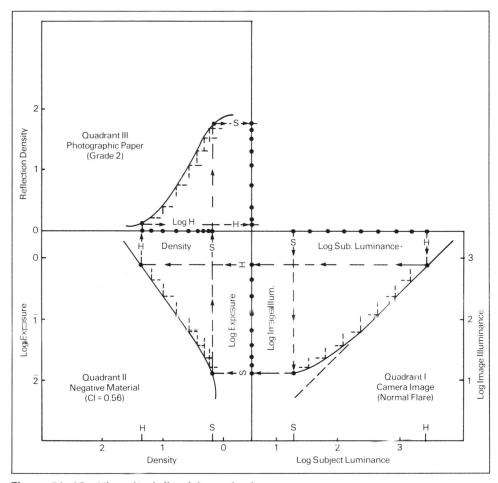

Figure 11–12 The combined effect of the transfer of camera flare through the negative characteristics and onto the print characteristics.

If the relationship between the negative and the paper is correct, the diffuse highlights of the negative should generate a density in the print that is approximately 0.04 greater than the base density of the print. The broken shadow-detail line is extended upward from quadrant II, where it is reflected from the negative curve until it intersects with the print curve at its density of 90% of the maximum density.

Likewise, the dashed diffuse-highlight line is extended upward until it strikes the paper curve at the density equivalent to 0.04 above the base plus fog of the paper. Both lines are then reflected to the right, which is the way in which all of the dots on the print density line were generated. Figure 11-13 illustrates the relationship of the nine input tones to the paper (from the negative densities) and the nine output tones from the paper in the form of reflection densities. The midtones of the negative are expanded in the print, while the shadows and the highlights of the negative are compressed.

11.8 Generation of the Tone-Reproduction Curve

In the last phase of the system the tones generated in the print are compared to the tones that existed in the original scene. As

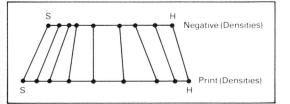

Figure 11–13 The relationship between the negative densities and print densities.

illustrated in Figure 11-14, this is achieved by extending the print tone lines from the photographic paper quadrant to the right into the fourth quadrant titled Reproduction, and noting where they intersect the corresponding lines projected upward from the appropriate subject log luminances.

For example, in Figure 11-14 the line representing the diffuse highlight on the photographic paper curve has been extended into the fourth quadrant until it intersects the line extended upward from the diffuse highlight of the subject. The intersection of these highlight lines in quadrant IV determines the highlight point on the objective tone-reproduction curve. Likewise, the line representing the detailed shadow tone in the print is extended into the fourth quadrant until it intersects the line extended upward from the same tone in the subject, generating the shadow detail point of the tone-reproduction curve.

This procedure is repeated for each of the intermediate points to obtain the complete objective tone-reproduction curve in Figure 11– 14 in the fourth quadrant. The shape of this curve can provide insight into the nature of the tone reproduction occurring in the photograph.

Alert readers will have noticed that a flare curve has not been included for the printing stage of the tone-reproduction process. All optical systems have flare, which, as we have seen with camera flare, can have a significant effect on image contrast. In this discussion

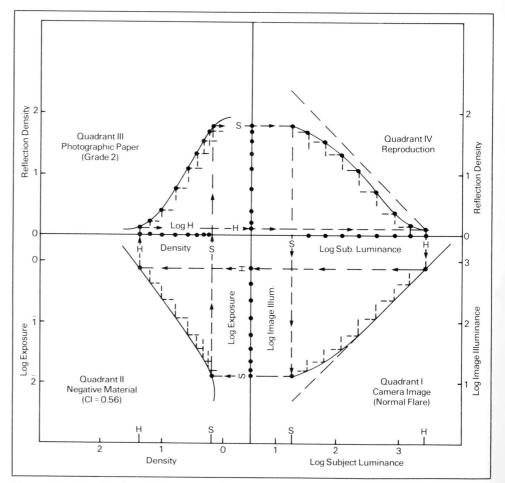

Figure 11–14 Complete objective tone-reproduction diagram for a pictorial system.

of tone reproduction it is assumed that contact prints are being made so that flare is not a factor at the printing stage. If prints are to be made with an enlarger, two additional factors must be considered flare and the Callier effect. Enlarger flare reduces contrast and the Callier effect increases contrast, but since the net effect of these two factors is different for diffusion and condenser enlargers, different data must be used for the two types of enlargers. The easiest way to incorporate this information into the four-quadrant tone reproduction system is to make the D-log H paper curves by projection-printing a step tablet with the type of enlarger that is to be used for future printing, being careful to mask the negative carrier down to the edges of the step tablet.¹

In this idealized case, since correct exposure and development of the negative were achieved and the negative was correctly printed, the resulting tone-reproduction curve closely resembles that of the desired tone-reproduction curve for black-and-white reflections prints, illustrated in Figure 11–1. The 45° dashed line representing facsimile reproduction has been included in quadrant IV for comparison purposes only. Examination of the curve in quadrant IV reveals that the shadow region of the curve has a slope less then 1 0 (45°), indicating that the subject tones in the hrint have been compressed relative to those in the sciene. This is also the case with the highlight region of the curve. In the midtone region the slope is slightly greater than 1.0 (45°), indicating a slight expansion of midtone contrast in the print compared to the original scene.

Thus, in preferred tone reproduction for black-and-white reflection prints, there is often compression of shadow and highlight detail with an accompanying slight increase in midtone contrast. This relationship between tones in the photographic print and the tones in the original scene can also be illustrated as shown in Figure 11-15. In this representation, the nine different subject tones are equally spaced, indicating equal tonal differences. However, in the bar representing the print tones, the highlight and shadow tones have been significantly compressed while the midtones have been slightly expanded. Again, this is typical of the negative-positive process when a reflection print is the final product.

At this point it is useful to review the properties of the fourquadrant tone-reproduction diagram illustrated in Figure 11–14. This system represents a graphical model of the actual photographic process with respect to the reproduction of tone. The major limitations and strengths of the photographic system can be determined by such a diagram. For example, quadrant I represents the camera image as primarily affected by optical flare. Optical flare is an inescapable part of any photographic system that incorporates the projected image. Thus the photographer must live with the compression of tone (loss of detail and contrast) that results from this problem. Little control can be exerted on the process at this stage except to use a lens shade and keep the lens clean.

Quadrant II represents the results of exposing and processing the film, and thus the production of the negative. It is at this point that the photographer can exert the greatest amount of control through the selection of the film type and the corresponding exposure and development conditions.

Quadrant III represents the making of the print and, con-

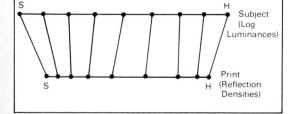

Figure 11-15 The relationship between the subject tones and the print tones.

¹Stroebel, March 1982, pp. 39-42.

11.8 Generation of the Tone-Reproduction Curve

sequently, is the last step in controlling print tones. Since the choice of paper grade is primarily dictated by the nature of the negative, and since development variation does not have any significant effect upon paper contrast, the photographer has only limited control of the outcome at this stage of the process. Additionally, if a reflection print is being made, the photographer must accept the fact that the print's tonal range will be less than that of the original subject.

The use of the four-quadrant tone-reproduction diagram also allows the photographer to see the expansion and compression of tones resulting at each stage of the process. For example, there is an inevitable loss of shadow contrast in the camera image caused by optical flare. Shadow contrast is further decreased when the shadow exposures are placed in the toe of the film's characteristic curve, which is typically the case. A third reduction in shadow contrast occurs when the negative is printed and the shadow tones of the negative are placed on the shoulder of the paper's characteristic curve. This explains the lowered contrast in the shadows of the final black-and-white reflection print.

The subject's midtones are relatively unaffected by the camera's flare characteristics and are typically exposed onto the straightline section of the film's characteristic curve. Although the midtone slope of the negative curve is usually less than 1.0 (0.5 to 0.6), the midtones of the negative are printed onto the mid-section of the paper's characteristic curve where the slopes are considerably greater than 1.0 (1.5-3.0). The result is a midtone contrast in the print that is only slightly greater than that of the original subject.

The highlights are also unaffected by optical flare at the camera stage and, when the film is exposed, are placed on the upper straight-line section of the characteristic curve. Thus the only distortion introduced into the highlights when the negative is made is associated with the lowered slope in the negative's characteristic curve. However, when the negative is printed, the highlight tones are placed in the too section of the characteristic curve for the photographic paper and, as a result, suffer their greatest compression. This is the cause of the lowered slope and lessening of highlight detail in the tone-reproduction curve in quadrant IV.

It should be evident that all four quadrants can be described in terms of the slopes in the various areas (shadows, midtones, high lights) in each quadrant. Slope can be considered to be the rate of output for a given input, and the cumulative effect can be predicted by multiplying the slope of the curve in quadrant I by the slope of quadrant II, by the slope in quadrant III, to predict the slope that would result in quadrant IV. If the concept of the average gradient (\overline{G} is substituted for slope, the relationship may be expressed by the following formula:

$$\overline{G}_{I} \times \overline{G}_{II} \times \overline{G}_{III} = \overline{G}_{IV}$$

The average gradient in each quadrant represents the averag slope between the diffuse highlight point and the shadow detail point For example, in Figure 11–14 the average gradient for quadrant I i 0.82, for quadrant II it is 0.56, and for quadrant III it is approximatel 1.78. Substituting these values in the above formula gives the followin result:

$$0.82 \times 0.56 \times 1.78 = 0.82$$
.

11.9 The Effect of Changes in Various Stages of the System

The calculations indicate that the average gradient for quadrant IV will be approximately 0.82, which is the case when the average gradient in quadrant IV is measured. A similar study may be done individually for the shadows, midtones, and highlights to assess the effect of each stage of the process on these areas. Often, this relationship between gradients can be used to work backwards in the system to predict the necessary gradient in any quadrant. For example, if it is desired to obtain an average gradient of 0.82 in quadrant IV (the reproduction quadrant), and it is known that a photographic paper with an average gradient of 2.0 will be used when making the print, and it is further known that the average gradient in the flare quadrant will be 0.82, the values can be substituted in the formula and the average gradient necessary in quadrant II can be predicted as follows:

$$0.82 \times \overline{G_{\parallel}} \times 2.0 = 0.82$$
$$\overline{G_{\parallel}} = 0.50.$$

In this fashion the photographer can predict the necessity contrast index for the production of an ormalism print under these Ghditions D, knowing the relationship between contrast index and development time, the photographer can actually determine the proper length of development time for any set of conditions. The concept of relating the various stages of the photographic process through the gradient at each stage often serves as the basis for some very useful nomographs that assist the photographer in predicting such things as the correct development time for the negative and the proper printing conditions of the resulting negative. An elementary example of a nomograph is illustrated in Chapter 2 (Sensitometry) Figure 2–28. A more complex nomograph involving these concepts is presented in Chapter 3, Figure 3–57.

It should be evident that these nomographs represent abstractions or simplifications of the objective tone-reproduction diagrams discussed in this chapter and, as such, are more useful to the photographer. However, it is important to have an understanding of the inputoutput relationships at the various stages of the process and the rates affecting those stages; that understanding is most directly obtained through an understanding of the four-quadrant tone-reproduction diagram.

11.9 The Effect of Changes in Various Stages of the System

The four-quadrant tone-reproduction diagram can be used to graphically study the effects of changes in each stage of the process. For example, Figure 11–16 illustrates the effect of a system with an unusually large amount of optical flare, as indicated by the flare curve in quadrant I. It reduces the range of log exposures that the film will receive at the back of the camera. If the film is given normal exposure (the shadow-detail position is located at 0.10 above base plus fog on the film's characteristic curve) and normal development, as seen in quadrant II, the resulting density range will be less than that of a normal negative. As a result, in quadrant III it is necessary to use a higher grade of paper to compensate for the lower negative contrast.

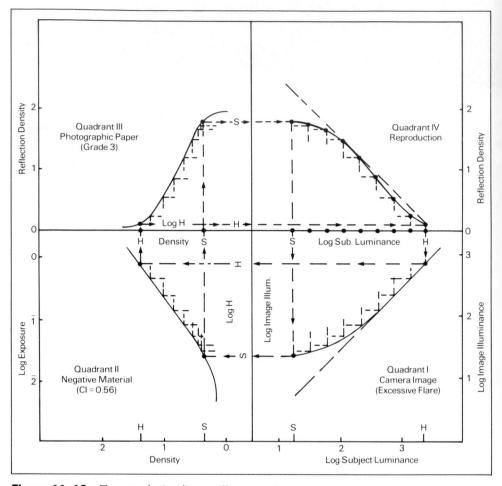

Figure 11–16 Tone-reproduction diagram illustrating the loss of shadow contrast as a result of excessive flare.

The tone-reproduction curve for the print resulting from this combination of effects is seen in quadrant IV. This resulting curve could then be compared to the aim curve to determine any departure from preferred tone reproduction. This curve appears to be quite similar in shape to that of the preferred curve, and thus indicates an acceptable reproduction. If the photographer desired to use the same grade of paper in this situation as would have been required under normal conditions, the development of the negative would have to be increased to compensate for the loss of contrast due to the increased flare.

Figure 11–17 illustrates the effect of reducing the camera exposure by two stops, which is what occurs when the ISO (ASA) film speed is overrated by a factor of four. The shadow detail tone is positioned on the film's characteristic curve at a point that is 0.6 in logs in the direction of less exposure from the minimal useful point on the curve, as illustrated in quadrant II. Likewise, all of the other subject tones will be shifted 0.6 log units in the same direction on the curve in quadrant II. Quadrant III contains the characteristic curve of the grade of paper that is best suited to the negative that has been produced.

The tone-reproduction curve in quadrant IV is the result of the conditions indicated in the previous three quadrants. The shape of the resulting tone-reproduction curve is significantly different from that of the aim curve for black-and-white reflection prints. The principal

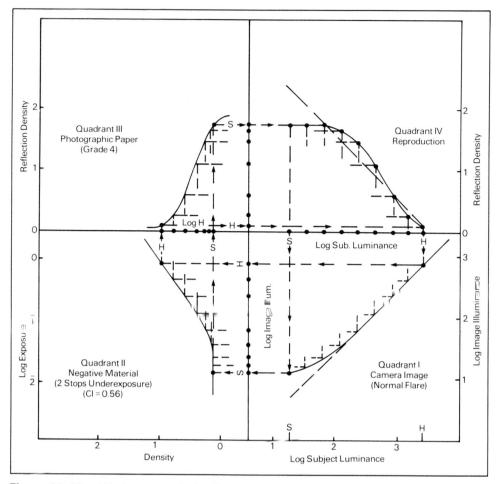

Figure 11-17 Objective tone-reproduction diagram illustrating the effects of underexposing by two stops with normal development of the negative.

difference is in the shadow region, where this reproduction shows a slope of near zero, indicating a significant loss of shadow detail. Such a result is typical of negatives that have been underexposed. In an attempt to compensate for this, some photographers give the negative more than normal development, either by extending the development time or by substituting a more active developer formula.

The result of this approach is illustrated in Figure 11–18. The characteristic curve in quadrant II, representing extended development, shows a steeper slope than does the curve from normal development. As indicated by the broken lines representing the diffuse highlight and the detailed shadow, the density range of the resulting negative has been increased and now requires a lower grade of paper as indicated in quadrant III. The tone-reproduction curve resulting from this combination of effects can be seen in quadrant IV. It should be obvious that the tone-reproduction curve resulting from extended development of an underexposed negative is significantly different from the preferred tone-reproduction curve. Not only are the shadows of negatives represented by the curve lacking in detail, but the midtones show excessive contrast as illustrated by the very steep slope in the middle region of the curve. Thus, underexposure and overdevelopment

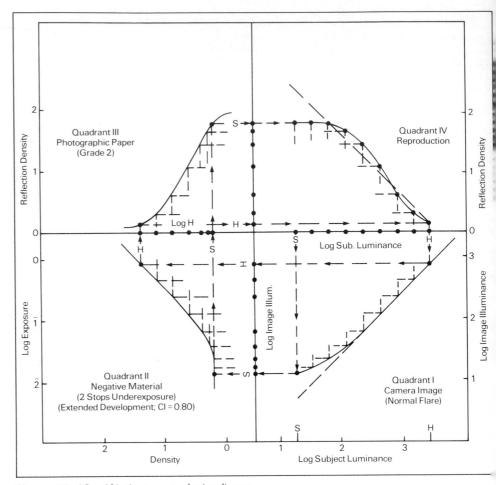

Figure 11–18 Objective tone-reproduction diagram illustrating the effects of underexposing by two stops with greater-than-normal development of the negative (CI = 0.80).

of the negative do not combine to provide acceptable print quality for pictorial subject matter.

Figure 11–19 illustrates the result of printing the san negative on three different grades of paper. The negative represente in quadrant II is best suited for a grade 2 paper, which is represente by the dotted characteristic curve in quadrant III. The tone-reprodu tion curve for this paper grade is represented by the dotted curve quadrant IV. If the same exposure time were utilized for a grade 0 at then a grade 4 paper on this negative, the tone-reproduction curv represented by the solid lines in quadrant IV would result.

The tone-reproduction curves for the grade 0 and grade papers depart considerably from the preferred tone-reproduction curv The curve for the grade 4 paper indicates a loss of detail in both t shadow and highlight regions of the print, and excessive midtone co trast. The curve for the grade 0 paper indicates that the shadows ha enough detail but not enough density, and consequently would not dark enough. On the other hand, the highlights would be too dark be acceptable. The slope of the midtone part of the curve for the gra 0 paper indicates that a loss of contrast has occurred and that the priwould appear too flat in the midtone region.

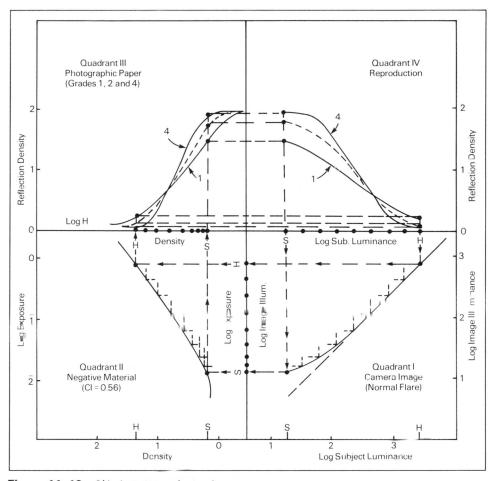

Figure 11–19 Objective tone-reproduction diagram illustrating the effects of printing a normally exposed and developed negative on three different grades of paper.

The benefits of printing a negative onto a film positive material are illustrated in Figure 11–20. Quadrant I indicates the normal flare condition in the camera, and quadrant II illustrates the effect of normal exposure and normal development on the negative. If this negative were printed onto a high-contrast film material represented by the curve shown in quadrant III, the tone-reproduction curve in quadrant IV would result. This curve of the resulting transparency is nearly identical to the aim curve for a transparency viewed on a back illuminator shown in Figure 11–2. Notice that the use of the positive transparency film provides a higher gradient than the reflection print throughout the entire range of subject tones. Because of the higher densities, the transparency photograph must be viewed on a light source that provides an illuminance several times greater than the general room illuminance.

11.10 Applications of the Tone-Reproduction System

Variations of the four-quadrant tone-reproduction diagram can be used to illustrate the reproduction characteristics of any pho-

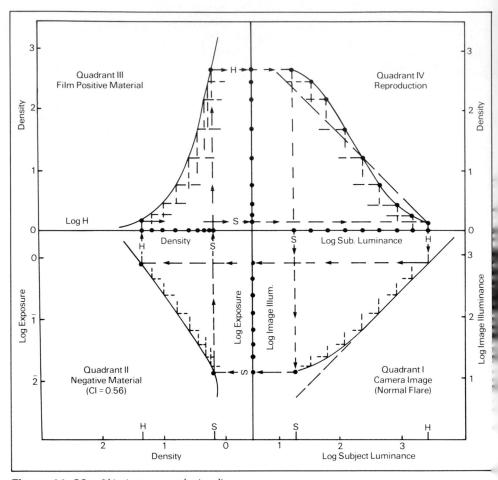

Figure 11–20 Objective tone-reproduction diagram illustrating the effects of printing a normal negative on a film positive material.

tographic system. For example, Figure 11-21 shows the tone-reproduction diagram for a color-reversal film image viewed by projection in a darkened room. Quadrant I represents the camera image flarcharacteristics as previously discussed. Quadrant II now becomes simpl a 45° transfer line, since there is no separate negative in the reversa process. Quadrant III contains the characteristic curve of the reversa film, and by extending the lines representing the diffuse highlight and the detailed shadow (and intermediate points) through these three quadrants, the tone-reproduction curve in quadrant IV can be generated The resulting curve is nearly the same as that in quadrant IV of Figur 11-20, which also represented a transparency image viewed on a bac illuminator. If the transparency image is to be viewed by projection i a darkened room, it would be necessary to consider the effects of flar light from the projector and the small amount of unwanted room ligh that inevitably reaches the screen, superimposed upon the projecte image. This could be achieved by adding an additional quadrant i lustrating the effect of projection flare and ambient room light upo the tone-reproduction curve.

The use of tone-reproduction diagrams can also be applie to the characteristics of photographic systems used for copying an duplication. The copying of reflection photographic prints is a fair common operation, but it must be carried out with care if high-qualit results are to be obtained. The general procedure is to illuminate th

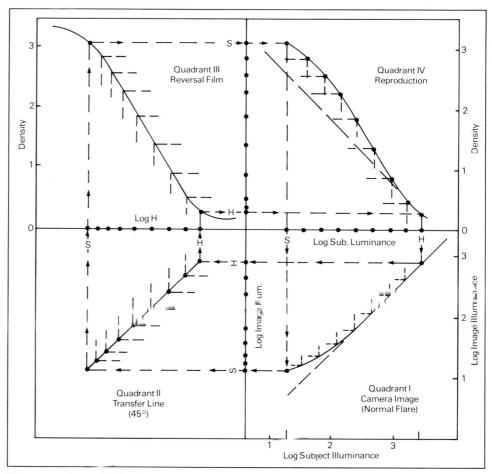

Figure 11–21 Objective tone-reproduction diagram illustrating the effects of using a reversal film in the camera.

original print evenly and then to make a copy negative using a camera. This copy negative is printed on the grade of photographic paper best suited to its density range. If the goal is to make a copy print identical to the original, then the desired tone-reproduction curve would be represented by the straight line at 45° . For this to occur, special attention must be paid to the original print's tonal values and to the nature of the film being used to make the copy print.

An understanding of the tonal relationships in the original print is provided by Figure 11–15, which illustrates the compression and expansion of tones in a print compared to the original subject. The highlight and shadow tonal values are compressed to a much greater extent than they are in an original scene. The midtones have been extended in contrast compared to the original scene. Thus special care must be taken to preserve these delicate shadow and highlight tonal relationships in both the copy negative and the copy print.

This is achieved primarily with a film emulsion giving a characteristic curve that will record and maintain these delicate density differences in the original print. Figure 11-22 is a tone-reproduction diagram that describes such a copy system. Quadrant I represents the optical flare present in the copy camera. The input to this quadrant is the light reflected from the various tones of the original photograph; that input axis is labeled "density of the original print." The output values are in the form of log image illuminances occurring at the back of the copy camera. Notice that flare reduces the tonal differences

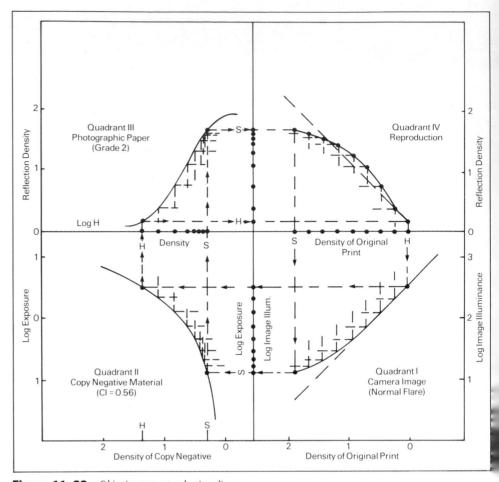

Figure 11–22 Objective tone-reproduction diagram illustrating the effects of copying a black-and-white print with a copy film.

(contrast) of the shadows in the original print, where the tonal differences were small to begin with. This is a major reason why copy prints often show less shadow detail than the original print. The midtones and highlights of the original print are nearly unaffected by the flarc properties in the copy camera. In Figure 11-22, the diffuse highlight and the shadow-detail tone of the original print have been identified the lines projected into quadrant I come from these tones.

Quadrant II shows the characteristic curve of the copy film developed to an average gradient producing a density range that wil allow the negative to be printed on a grade 2 paper. The film exposure was adjusted to place the shadow-detail line at a density of 0.20 abov the film's base plus fog to maintain as much shadow detail as possiblin the copy negative.

Notice that the shape of this characteristic curve is consid erably different from that of a conventional camera speed pictorial film. The difference is primarily in the upper or highlight region of th curve, where the copy film's slope is much steeper than that of th pictorial film. The increased slope in the copy film's highlight regio allows for the recording and maintaining of highlight detail.

The use of a conventional pictorial film as a copy film will lead to compression of highlight detail because the highlight ton differences in the original print were small to begin with. The cop negative must maintain adequate highlight contrast, since these high light tones will be placed in the toe of the printing paper's characteristic curve, causing further compression of tone. Quadrant III illustrates this concept. The copy negative produced is best suited to a grade 2 paper, which is represented by the characteristic curve. The diffuse highlight and shadow detail lines have been extended up to the paper curve to indicate where these tones have been placed. By extending these lines to the right into the fourth quadrant and matching them to the corresponding lines from the density of the original print axis, the tone reproduction curve describing the copy print is generated. This curve illustrates that the copy print has less detail in the shadows than does the original print, while the midtones and highlights have been reproduced at nearly the same contrast level.

In some cases it is desirable to use a copy system to generate a duplicate negative. If the original negative is extremely valuable, or if it is necessary to produce a number of negatives for distribution purposes, or to obtain a negative of better quality from a very flat or contrasty original negative, it is preferable to produce duplicate negatives. In this case, the original subject becomes the negative itself and is represented by the densities of the original negative. If the Original negative is contact printed and the copy film to contact a master positive, and if the matter positive is contact printed again to produce the duplicate negative, there will be no camera-flare problems to consider. If the desire is to produce a negative with the same density range and intermediate contrast as that of the original negative, the desired tone-reproduction curve would be the straight line at a 45° angle.

The tone-reproduction diagram in Figure 11-23 represents a system for the generation of duplicate negatives. Since the original negative will be contact printed, quadrant I is simply a 45° transfer line. The diffuse highlight and detailed shadow have been indicated on this axis, and the lines extending downward into quadrant I come from these tones. In this system the use of the gradient formula is quite straightforward. For example, the desired gradient in quadrant IV is 1.0, since the duplicate is to have the same contrast as the original. The gradient in quadrant I is 1.0, since there is no flare and it is simply a 45° line transfer quadrant. Therefore, using the following gradient formula:

$$\overline{G_{IV}} = \overline{G_{I}} \times \overline{G_{II}} \times \overline{G_{III}}$$

the gradients for quadrant I and IV can be substituted, giving the following formula:

$$1.0 = 1.0 \times \overline{G_{\parallel}} \times \overline{G_{\parallel}}$$

where it is evident that the gradients in quadrants II and III, when multiplied together, must equal a gradient of 1.0. In other words, if a gradient of 1.0 were used in quadrant II and in quadrant III, the resulting reproduction gradient would be the desired 1.0 slope (i.e., $1.0 = 1.0 \times 1.0 \times 1.0$).

The characteristic curve in quadrant II is for a typical copy film processed to an average gradient of 1.0. The film exposure has been adjusted so that the minimum density produced is approximately 0.20 above base plus fog. This results in a master film positive with the same density range as the original negative, as illustrated by the distances between the diffuse highlight and detailed shadow lines in the diagram. If the master positive is again contact printed onto the

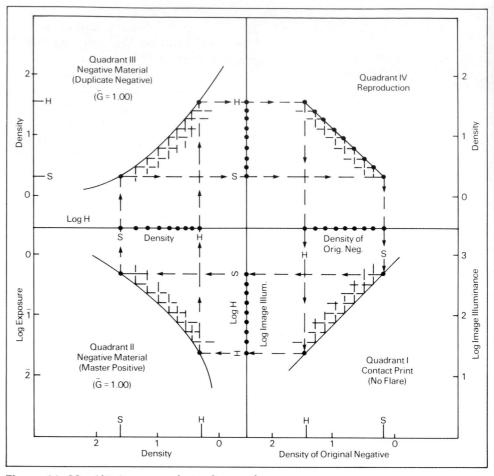

Figure 11–23 Objective tone-reproduction diagram of a process for making duplicate negatives.

same emulsion type and processed to a slope of 1.0, the characteristic curve in quadrant III would illustrate this condition. As before, the film exposure is such that the minimum density produced in the duplicate negative is at least 0.2 above base plus fog, indicating that the density range of the duplicate negative is the same as that for the master positive and the original.

By extending the lines into the fourth quadrant and noting where they intersect the corresponding lines from the density of the original negative, the resulting tone-reproduction curve is plotted. The fact that the curve is a straight 45° line indicates that the objective of producing a duplicate negative with identical contrast to the original has been achieved.

This example illustrates a tone-reproduction concept called the mirror image rule. The gradient formula given previously makes evident that in order to obtain a reproduction gradient of 1.0, the gradients of the negative and positive curves must be reciprocally related. In other words, the gradient of the negative should be the reciprocal of the gradient of the positive. Thus, point-for-point, the two curves must have reciprocally related slopes, which will make them mirror images of each other.

The film curves shown in quadrants II and III of Figure 11–23 meet this requirement. Where the slope is low in quadrant II, the corresponding slope in quadrant III is high, and vice versa. Therefore, not only does the duplicate negative have the same density range as

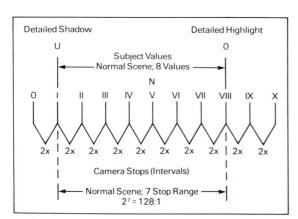

Figure 11-24 The relationship between subject zones and camera stops (intervals) in the Zone System.

the original, but the intermediate contrasts are also equal. Occasionally this approach results in a duplicate negative with a greater overall density level, which causes longer printing times and a degradation of the small-scale image characteristics (see Sections 12.3 and 12.11).

If the original negative had a density range too narrow to yield a good print on a grade 2 paper, this deficiency could be corrected in the duplicate negative. For example, if the original negative had a density range of only 0.90 and a duplicate with a density range of 1.10 was desired, the desired gradient in the tone-reproduction quadrant could be predicted with the following formula:

Desired gradient $(\overline{G_{iv}}) = \frac{\text{Duplicate negative density range desired}}{\text{Original negative density range}}$

Substituting the proper values gives the following relationship:

$$\frac{1.10}{0.90} = 1.22$$

indicating that the desired tone-reproduction slope is 1.22. Utilizing the formula of gradients given previously and substituting the proper values gives the following relationship:

$$\overline{G}_{I} \times \overline{G}_{II} \times \overline{G}_{III} = \overline{G}_{IV}$$

$$1.0 \times \overline{G}_{II} \times \overline{G}_{III} = 1.22$$

$$\overline{G}_{II} \times \overline{G}_{III} = 1.22$$

where it can be seen that the slope of the master positive multiplied by the slope in the duplicate negative stage must equal the slope of 1.22. Thus, any two numbers that give a product of 1.22 when multiplied can be used to define the slopes necessary in these two quadrants (for example, $1.00 \times 1.22 = 1.22$; $1.10 \times 1.10 = 1.21$). A similar approach could be used to compensate for an original negative with a density range too great for a number 2 grade paper, requiring a decrease in the contrast of the duplicate negative. For such a system to work requires that a family of curves be generated for the film that will be used in the making of both the master positive and the duplicate negative. From this information the development times necessary to produce the required gradients can be determined. As is the case with all photographic systems, care must be taken in the exposure and processing stages if the predicted results are to be obtained.

11.11 Tone Reproduction and the Zone System

The concepts of tone reproduction and the accompanying tone-reproduction diagrams are intended to provide the photographer with a basis for understanding the nature of the photographic process. Experience has shown that photographers who have a firm understanding of the materials and how to control them are those most likely to consistently produce high-quality images. However, it is recognized

that the tone-reproduction diagrams presented in this chapter do not provide a convenient way for photographers to exert control over the process at the time images are being made.

During the past several decades, there have been countless procedures proposed for the control of image quality through the manipulation of the various stages of the photographic process. For example, the early Weston exposure meter dial had U and O positions marked to represent shadow and highlight positions for a normal scene. A third position labeled N represented the average midtone position, and therefore the normal exposure. The U position was located four stops below the normal arrow, the O position three stops above the normal arrow. The difference between the U and O locations corresponded to a seven-stop range or a luminance ratio of 128:1 (or 160:1 rounded to the nearest whole stop).

Perhaps the most comprehensive system—certainly the best known—is the Zone System, which was proposed by Ansel Adams and further refined by Minor White and others. In its most elementary state, the Zone System provides the photographer with a vocabulary for describing the various stages of the photographic process from the original scene through the completion of the final print. In its more advanced form the Zone System will lead the photographer to proper exposure, development, and printing conditions in order to reproduce the scene in a given fashion. Thus the basic premise of the Zone System is that the photographer must visualize the final print from the appearance of the original subject before taking the photograph. Through knowledge of the capabilities and limitations of the photographic system, the photographer can then manipulate its various components to achieve this visualized result.

In tone-reproduction studies of pictorial systems, the subject properties are expressed in terms of luminances (candelas per square foot) and log luminances. In the Zone System, the subject is described in terms of subject values, which relate to different subject luminances that are labeled by Roman numerals for easy identification. The values are related to each other by factors of two (one camera stop); Value II reflects twice as much light as Value I, Value III reflects twice as much light as Value II and four times as much light as Value I, and so on.

Table 11–2 contains the 10 subject values commonly used in the Zone System and their definitions. Using these definitions, the contrast of the original subject can be described in terms of the number of values it contains. For example, the scene-luminance measurements by Jones and Condit that led to the average luminance ratio of 160:1 were made on the darkest and lightest areas of the scene. These areas most nearly correspond to Values I and VIII in the Zone System. This means that the typical outdoor scene contains eight values: I, II, III IV, V, VI, VII, and VIII. Furthermore, since each value is related to the next by a factor of two (one camera stop), such a scene contains : seven-value range (VIII – I = VII); and the ratio of the extreme value can be found by multiplying 2 times itself seven times (2⁷), as shown in Figure 11–24. The resulting ratio of 128:1 compares closely with the results of the Jones and Condit study.

Thus, in Zone System terminology, the typical outdoor scen contains eight values and is said to cover a seven-stop range. If a scen contains fewer than eight values, it is a flatter-than-normal scene, whil a scene with more than eight values would be described as a contrast scene. It is important to note that many references describe the averag outdoor scene as containing five (or some other number) values rangin

value in the Lone Sys	stem.
Subject Value	Description
0	Absolute darkest part of scene. Example: when photographing the side of a cliff containing a cave.
Ι	A very dark portion of the scene where the surface of an object can be detected. Examples: dark cloth in shade; surface is visible with slight texture.
Ш	A dark area of the scene showing strong surface texture; perceptible detail. Examples: surface of building in heavy shade; shadow of tree cast on grass in sunlight.
III	Darkest part of scene where tonal separation can be seen; texture and shape of objects are evident. Example: tree trunk in shade where texture of bark and roundness of trunk with shading are evident.
IV	The darker midtones of a scene; objects in open shade. Examples: landscape detail in open shade; dark foliage; Caucasian skin in shadow.
V	The middle gray tone of the scene; 18% reflectance. Examples: dark skin; gray stone (slate); clear north sky.
VI	The lighter midtones of a scene. Examples: average Caucasian skin in direct light; shadows on snow in sunlit scene.
VII	A very light area of the scene containing tour mutual detail. Examples: light objects with sidelighting.
V111	The diffuse highlights (nonspecular) of the scene; white surfaces show- ing texture. Examples: white shirt in direct light; snow in open shade; highlights on Caucasian skin.
IX	The specular (glare) highlights of the scene; surface is visible but no texture. Examples: glare reflections from water, glass, and polished metal; fresh snow in direct sunlight.
Х	The absolute brightest part of the scene. Example: a light source (sun, tungsten bulb, flash lamp, etc.) included in the field of view.

Table 11–2 The relationship between various parts of a scene and the corresponding subject value in the Zone System.

typically between value III and Value VIII. The discrepancy is due to at least two factors. The first is associated with defining exactly what is meant by the terms *detailed shadow* and *textured highlight*. Obviously, the opinions of photographers will differ as a result of esthetic judgments. The second reason (and perhaps a more fundamental one) is related to the definition of a value. Some references define a value as an interval—a difference between two tones—while others state that it is a specific tone or subject luminance. This problem will cause a one-value discrepancy, since the number of intervals between tones will always be one less than the number of tones. In all discussions of the Zone System in this text, a value is defined as a specific tone and the difference between tones as a value range. The difference between tones is also expressed as a stop range, log luminance range, and luminance ratio.

The value range of a subject can be converted to a log luminance range by simply multiplying the number of camera stops (factors of two) it contains by 0.30, the log value of one stop. Thus the average outdoor scene containing eight values covers a seven-stop range, which will give a log luminance range of $2.1 (7 \times 0.3 = 2.1)$ and a luminance ratio of 128:1. A flat scene containing only five values covers a four-stop range and gives a log subject luminance range of $1.2 (4 \times 0.3 = 1.2)$ or a ratio of 16:1. A contrasty scene containing nine values will cover an eight-stop range and give a log range of $2.4 (8 \times 0.3 = 2.4)$ or a ratio of 256:1. Therefore, in its initial application the Zone System provides the photographer with a method of describing and quantifying the tonal values of the original scene. In the more uechnical tone-reproduction system, this correlates with the determi-

nation of the subject luminance ratio and ultimately the log subject luminance range as the principal description of the subject contrast.

In its second phase, the Zone System provides a way to determine the proper exposure and film development to obtain a normalcontrast negative. However, as with all systems of image control, it is necessary to test the film extensively to determine its characteristics. In the Zone System this invariably involves determining the camera exposure necessary to obtain the details desired in a particular shadow value, and the development necessary to correctly reproduce a given highlight value. Typically, the photographer would arrive at a personal working film speed and would determine the relationship between development time and contrast in the negative.

In this context, the subject values are translated into exposure zones, which are described by a similar set of Roman numerals. Although subject values can be measured in candelas per square foot (c/ ft²), they are typically determined through visual (subjective) evaluation of the scene. Exposure zones (or, more simply, zones) are used to describe the input exposure scale of the film and are more technical. Thus a given subject value may be placed in any exposure zone, with the other values falling on the exposure scale where they may. Typically, an area of important shadow detail is placed in a lower exposure zone (Zone II or III), with the higher values (highlights) falling in higher zones, depending upon their lightness.

In Zone System terminology, the development time necessary to make a typical outdoor scene (eight values) result in a negative of normal contrast (density range equal to 1.10 for printing with a diffusion enlarger) is identified as "N" development. The development time necessary to make a nine-value subject result in a normal-contrast negative (density range of 1.10) is defined as "N minus one zone," or simply, "N minus 1." Similarly, a subject containing only six values would require N plus 2 development to yield a normal-contrast negative.

The concept of zone development is related to the use of a normal contrast index for film development. "N minus" development is associated with lower-than-normal contrast-index values, while "N plus" development is associated with higher-than-normal contrast indexes. In the Zone System, "N plus" development is often referred to as expansion, while "N minus" development is referred to as compaction.

Therefore, the function of the Zone System at this stage is to assist the photographer in placing the important shadow value at some minimum useful position (Exposure Zone II or III) in the toe of the characteristic curve, and to provide the proper development that will result in a normal-contrast negative, regardless of the original scene contrast. This phase of the Zone System is often summarized by the following statement: "Expose the film for the shadows and develop the negative for the highlights." If the photographer has provided correct exposure and development, the density values produced in the negative will just fill the reproduction capacity (useful log exposure range) of a normal grade of photographic paper.

The third phase of the Zone System involves the printing of the negative and, therefore, the production of print values. At this stage the concept of zones can, again, be used to describe the appearance of the tones of gray in the print; however, the term *print value* is used instead of *zone* to differentiate it from the exposure scale of the negative Since reflection prints are limited in the range of tones that can be produced, and since there is distortion present in the photographic process, the values of the print have different definitions. These are listed in Table 11–3. The goal is to produce a print in which the values of the original subject are reproduced as the desired values in the finished print. This phase of the Zone System is analogous to the third quadrant of the tone-reproduction diagram, in which the characteristic curve of the photographic paper is inserted and the output expressed in terms of reflection densities.

At this point the Zone System comes full cycle; the photographer views the final print and determines the closeness with which it matches the visualized print. The results of this evaluation provide the basis for future refinements and improvements of the system. At this stage photographers rely upon their subjective opinion regarding the quality of the final image. However, the Zone System provides photographers with a vocabulary and a set of measurement concepts that can provide a clear understanding of the factors influencing the final result. In the objective tone-reproduction system, this relates closely to the fourth quadrant, which contains the tone-reproduction curve resulting from the combination of matchals and processor would to make the photograph, In the tone reproduction system the quality of the final print can be assessed in terms of how closely it matches the aim curve for that particular system. In the Zone System, the quality of the reproduction is assessed relative to what the photographer visualized in the subject.

The similarities between the tone-reproduction system and the Zone System are not the result of chance. The Zone System actually

d print values.	
Value	Description
0	Maximum density of paper; principally determined by surface char- acteristics of print; absolutely no tonal separation.
Ι	In theory, a just-noticeable difference from the maximum density. Sensitometric tests indicate that this value is located at 90% of the maximum density. At print densities higher than this, texture is suppressed.
II	Darkest area of the print where strong surface texture is still main- tained. Approximately equal to a density that is 85% of the max- imum density.
III	Darkest area of the print where detail can be seen; in the shoulder of the curve where there is sufficient slope for tonal separation.
IV	The darker midtones of the print. The upper midsection of the curve is used, giving obvious tonal separation.
V	The middle gray tone of the print; 18% reflectance; reflection density of 0.70. Occurs in the middle of the curve, producing maximum tonal separation.
VI	The lighter midtones of the print. The lower midsection of the curve is used where the slope is still quite high, yielding good tonal separation.
VII	A very light area of the print containing texture and detail. The toe section of the curve is employed where the slopes and densities are low, causing tonal compression.
VIII	The diffuse (nonspecular) highlights of the print. The just-noticeable density difference above the paper's base-plus-fog density. A re- flection density of approximately 0.04 above base plus fog.
IX	The specular highlights of the print. This is the base-plus-fog density of the paper and is the absolute whitest tone obtainable in the print.
х	Base plus fog density of the paper; maximum white (same tone as print zone IX).

Table 11-3	The relationship	between	the various	reflection	densities	of the	photographic pa	ıper
and brint values								

represents a practical simplification of the concepts of tone reproduction. It is not surprising then, that many photographers have trouble understanding and implementing the Zone System without understanding the tone-reproduction system. The relationship between the two systems can be illustrated in a variety of ways. First, consider Figure 11– 25, which represents an adaptation of Zone System terminology to the conventional four-quadrant tone-reproduction diagram. This figure reveals the distortions encountered by the original subject zones in their travels through the photographic process. Notice for example, that the shadow values are compressed first because of the camera's flare characteristics, second because they are placed in the toe section of the film curve, and third because they are placed in the shoulder section of the paper curve.

As a result, the print's shadow values are considerably compressed compared to the shadow values in the subject. Although the highlight values in the subject are unaffected by camera flare, they are somewhat compressed by the minimum slope in the upper portion of the film curve, and greatly compressed as a result of being exposed onto the toe section of the paper curve. Thus the print's highlight values are greatly compressed compared to the highlight values of the original subject.

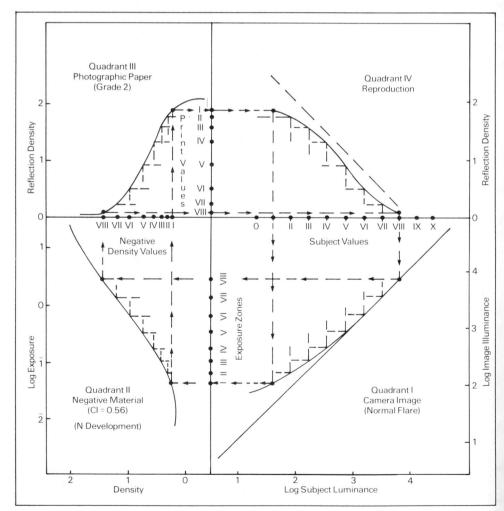

Figure 11–25 Objective tone-reproduction diagram illustrating the Zone System concept.

References

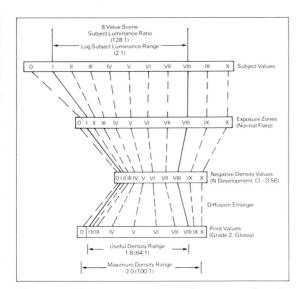

Figure 11–26 Distortion of zones that occurs at the major stages of the photographic process. (Adapted from Eastman Kodak Publication F-5.)

The midtone subject values are relatively unaffected by camera flare; they are somewhat reduced in contrast because of the medium slope (less than 1.0) in the mid-section of the film curve; and they are greatly expanded in contrast because they are placed in the steep midsection of the paper curve. As a result of these conditions, the midtone values in the print are slightly expanded compared to the midtone values in the subject. Thus there is not a simple one-to-one relationship between the values of the subject and the values in the final print.

The effects of various stages of the photographic process on the subject values can also be illustrated through the use of a bar diagram as shown in Figure 11-26. The horizontal bar designated Subject Values has been divided into 10 equal values, with the appropriate Roman numerals. Value I and Value VIII have been marked to indicate that they cover the range nearly equivalent to that of a typical outdoor subject. The Exposure Zones bar illustrates the effect of camera flare on the optical image at the back of the camera. Here only the lower (shadow) zones are being compressed.

A third bar represents the density values in the negative of the it has been given "N" dowelepincin (Contrast index equal to 0.90). Notice that the challon Lulies liave been further compressed and now the midtone and highlight zones are compressed. The fourth bar illustrates the relationship of the print values for a glossy paper, assuming the negative was printed in a diffusion enlarger. The shadow and the highlight values are considerably compressed compared to the corresponding zones in the original subject. The midtone values show a slight expansion, indicating they have a slightly higher contrast than the corresponding subject zones. Figures 11-25 and 11 26 are presented with the belief that an understanding of tone-reproduction principles will facilitate an understanding of the Zone System. In no way can such diagrams be substituted for the actual testing of the photographic system and for the creative use of the results. The four-quadrant tone-reproduction system, however, can be correlated with the Zone System provided the exposure meter and shutter are known to be accurate (or the errors are known and compensated for); and the flare, film, and paper curves are appropriate for the materials and equipment.

References

Adams, The Camera.

- —, The Negative.
- ____, The Print.

American National Standards Institute, Direct Viewing of Photographic Color Transparencies (PH2.31-1969, R1976).

——, Distribution of Illuminance Over the Field of a Photographic Objective, Method of Determining (PH3.22-1979).

—, Photographic Color Prints, Viewing Conditions (PH2.41-1976).

------, Small Transparencies with Reproductions, Projection Viewing Conditions for Comparing (PH2.45-1979).

Carroll, Higgins, and James. Introduction to Photographic Theory.

Clerc, Photographic Theory and Practice.

Davis, Beyond the Zone System.

Dowdell and Zakia, Zone Systemizer.

James, The Theory of the Photographic Process.

References

Stroebel, "Print Contrast as Affected by Flare and Scattered Light." PSA Journal, 48:3 (March 1982).

Sturge, Neblette's Handbook of Photography and Reprography.

Todd, Sensitometry: A Self-Teaching Text.

Todd and Zakia, Photographic Sensitometry.

Wakefield, Practical Sensitometry.

White, Zakia, and Lorenz, The New Zone System Manual.

Micro-Image Evaluation

12.1 Image Characteristics

In addition to the important esthetic and compositional considerations in critiquing photographs, perceptual and technical matters are of concern. Chapter 11 examined the importance of the tonal rendering of a scene and outlined the control of contrast when pictorial information is transferred from the original scene to the negative, and finally to the print. The relationship between the input tonal values (log luminances) in the scene and the output tonal values (reflection densities) in the print can be compared graphically, numerically and perceptually. So can certain micro-characteristics important in achieving optimum photographic quality.

The small-scale image characteristics of graininess, sharpness, and detail (collectively called definition) strongly influence picture quality. One can produce a print that has good tone-reproduction qualities but suffers in overall quality because of excessive graininess, lack of sharpness, or insufficient detail. For this reason it is important to understand small-scale image characteristics and how they relate to the choice of photographic materials, equipment, and processes. The micro-image attributes of characteristic, equipment, and processes. The micro-image attributes of characteristic imposed on lightsensitive film or paper. Graininess, however, is a characteristic imposed on the image by the recording material.

12.2 Graininess/Granularity

Photographic emulsions consist of a dispersion of light-sensitive silver halides in a transparent medium such as gelatin. Figure 12–1 represents a small area of unexposed photographic film magnified 2,500 times. Figure 12–1A shows the emulsion in its pristine state, before exposure and development. The crystals vary in shape and size, and crystals with similar shapes can be oriented in any direction within

Figure 12–1 Silver balide crystals. (Left) Grains of silver balide are randomly distributed in the emulsion when it is made. (Right) Silver is developed at the sites occupied by the exposed silver halide.

the thickness of the emulsion. The spacing between the crystals varies, with some crystals touching and others overlapping. Although the crystal size typically varies widely within a given emulsion, the average size is generally larger in fast films than in slow films. It should be noted, however, that the size of the silver halide crystals is not the sole determinant of film speed.

The exposed silver halide crystals are transformed during development into grains of silver that are more or less opaque, depending upon their size and structure (see Figure 12–1B). The developed silver grains seldom conform exactly to the shapes of the silver halide crystals; the size and shape of each silver grain depends upon the combination of exposure, developer type, and degree of development in addition to the size and shape of the original silver halide crystal. As the silver grains increase in size, the spaces between the grains through which light can pass freely become smaller. The overlap in depth of the individual silver grains results in a rather haphazard arrangement of silver grain clusters. This nonhomogeneity of the negative image usually can be detected in prints made at high magnifications

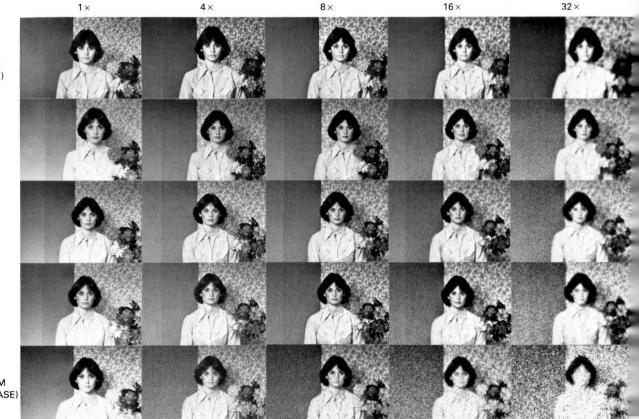

TECHNICAL PAN (ESTAR-AH BASE)

PANATOMIC-X

PLUS-X PAN

TRI-X PAN

RECORDING FILM 2475 (ESTAR-AH BASE)

Figure 12-2 The effect of film graininess on detail. (© Eastman Kodak Company.) (A) Comparison prints from five different 35 mm black-and-white negatives at various magnifications. (A 32X magnification represents a 30×45 inch print.) (B) Comparison of four different 35 mm color transparency films at various magnifications (1X, 4X, 8X, 16X, and 32X). (C) Comparison prints from four different 35 mm color negatives at various magnifications (1X, 4X, 8X, 16X, and 32X).

A

as an irregular pattern of tonal variation superimposed on the picture image. Figure 12-2A compares enlarged prints and transparencies made from different 35 mm films. Notice the loss of fine detail as graininess increases.

Graininess is an important variable since it sets an esthetic limit on the degree of enlargement, as well as a limit on the amount of information or detail that can be recorded in a given area of the film. Graininess can be thought of as noise or unwanted output that competes with the desired signal (the image). All recording mediums have some

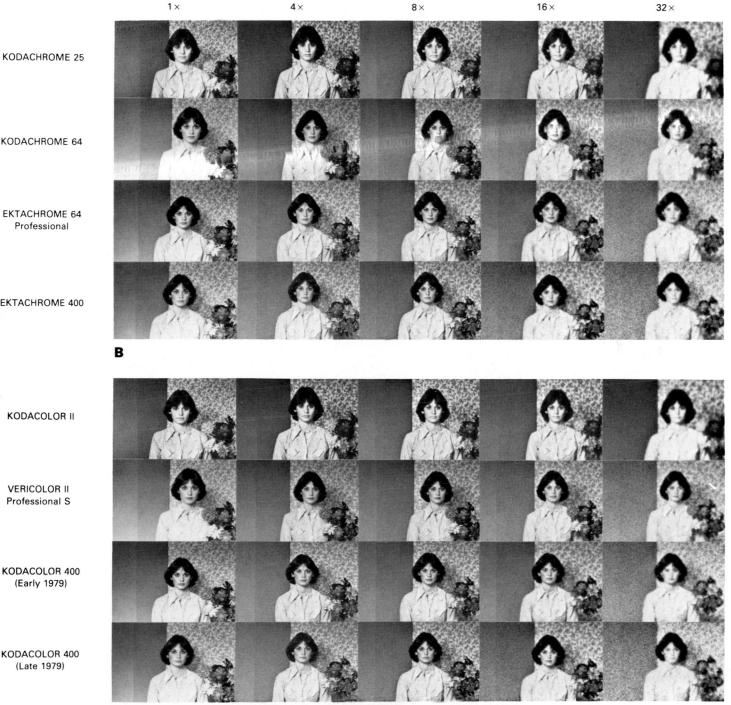

 $4 \times$

KODACHROME 25

KODACHROME 64

Professional

EKTACHROME 400

VERICOLOR II

KODACOLOR 400 (Early 1979)

KODACOLOR 400 (Late 1979)

С

Table 12–1 Comparison of speed and graininess for several panchromatic films intended for pictorial use. (Manufacturer's graininess classifications must be compared with caution since the methods of measurement and specification are not standardized.)

Film Name	ISO (ASA) Speed	Graininess
Panatomic-X	32	Extremely Fine
Plus-X Pan	125	Extremely Fine
Super-XX	200	Fine
Tri-X Pan	400	Fine
Royal Pan	400	Fine
Royal-X Pan	1250	Medium

type of noise that limits the faithfulness of the desired signals, including television, photomechanical reproduction, and video and audio tapes and discs. Graininess, which can be esthetically pleasing, adversely affects sharpness and resolution. Even though graininess, sharpness, and resolution are defined as three distinctly different image characteristics, in practice they are not entirely separate and independent.

Since graininess is generally considered to be an undesirable characteristic, why not make all photographic film fine-grained? Finegrained film represents a trade-off in which some film speed has been sacrificed. There tends to be a high correlation between graininess and film speed, as shown in Table 12–1. It should be noted, however, that significant advances have been made in emulsion technology so that the fast films of today are much less grainy than they were some years ago. Since the measurement and specification of graininess have not been standardized internationally, caution needs to be exercised when comparing data from different manufacturers.

12.3 Measuring Graininess

It is relatively simple to look at an enlarged print and determine whether or not graininess can be detected. The extent of the graininess, however, is more difficult to assess. It is tempting to make greatly enlarged prints from two negatives and compare them side-byside for graininess. Although such a method is commonly used in studies of graininess described in photographic magazines and is appropriate for some purposes, it does not actually measure graininess. It is a subjective qualitative method that enables one to say print A looks grainier than print B, but not to indicate the magnitude of the difference. Even when making such simple comparisons it is difficult to make the prints so that there are no other differences to confuse the issue, such as subject, density, contrast, and sharpness.

Various methods have been used in an effort to obtain a reliable and valid measure of graininess. The most widely used method of measuring graininess directly is a procedure called *blending magnification*. Under a set of rigidly specified conditions, a negative that has been uniformly exposed to produce a uniform density is projected onto a screen at increasing levels of magnification, beginning at a level where graininess is not visible. A viewer, seated in a specified position with controlled room-light conditions, is asked to determine when graininess first appears. A numerical value is then obtained by taking the reciprocal of the blending magnification and multiplying it by 1,000. For example, if the blending magnification were 8, then $\frac{1}{8} \times 1,000 = 125$. The number 125 represents the graininess of that negative under the conditions specified, and as the conditions are repeatable, other negatives could be so measured.

A practical alternative to the blending magnification method is to keep the magnification constant but to vary the viewing distance. One can move toward a print until it begins to look grainy. The minimum distance at which graininess is not evident is the *blending distance*, and the number is a measure of graininess. Such blending distance measurements, although practical, are subject to variability.

When judging whether a print is excessively grainy one must keep in mind its use. One does not normally view a 16×20 -inch print at a reading distance of 10 inches, nor an 8×10 -inch print at a distance of 10 feet. How the final print will be viewed or reproduced

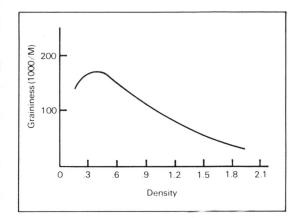

Figure 12–3 Negative graininess is highest at a density of 0.3 to 0.6 and then decreases rapidly as density increases. (The illuminance on the sample is constant.)

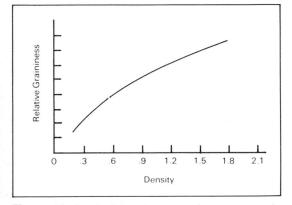

Figure 12–4 Graininess increases as density increases if the light reaching the eye is adjusted so that it is the same regardless of the density of the negative.

is important. Photographs reproduced in newspapers using a 60 lines/ inch screen will look grainier than those reproduced in a quality magazine using a 150 lines/inch screen. Motion pictures present an interesting situation, since each frame is in the projector gate for only 1/ 24 second. When one views a motion picture at a large magnification, as from the front row in a theater, graininess is commonly experienced as a boiling or crawling effect, especially in areas of uniform tone. This is a result of the frame-to-frame change of grain orientation.

It is essential that the density level be specified when making graininess measurements. As shown in Figure 12–3, graininess is highly dependent upon the density level. With negatives, maximum graininess occurs at a density between 0.3 and 0.6, depending to some extent upon the luminance level of the test field. A density of 0.3 corresponds to a transmittance of one half, which represents equal clear and opaque areas. One would expect little graininess at very low and very high density levels, but for different reasons. At very low densities there is little grain structure. As the density of the negative increases, the amount of light transmitted decreases. Since the ability to see detail and tonal differences decreases at low light levels, the percention of graininess decreases rapidly as the density limitation.

In a way hilgh density, graininess is not perceptible even though the silver in the negative has a very grainy structure. This can be demonstrated by selecting a negative having a uniform density of about 1.5 and increasing the intensity of the viewing light source 16 times. The appearance of graininess will jump considerably, for in effect the density of 1.5 behaves as though it were a density of only 0.3 with respect to viewing luminance. In fact, if the light level is adjusted so that the transmitted light remains constant regardless of the density level, the result will be the curve shown in Figure 12–4, which indicates that the graininess increases gradually with increasing density.

There is another method of demonstrating that graininess increases with negative density when compensation is made for the lower transmittance; it involves making a series of photographs of a gray card with one-stop variations of exposure, from four stops below normal to four stops over. Developing the film normally will produce negatives having nine different density levels ranging from about 0.2 to about 1.5. Each negative is printed at a fixed high magnification with the necessary adjustment in the printing exposure time to produce the same medium gray density on all of the prints. The prints should be viewed side-by-side under uniform illumination and at the same distance to observe differences in graininess.

Considerable variation in the density level at which graininess is most apparent has been found among different types of images such as film negatives, prints, projected black-and-white transparencies, projected color transparencies, black-and white television, and color television. The density level is higher for color images than for black-and-white, for transparencies as well as television, as shown in Figure 12–5. This is partly due to the scattering of light by silver particles, known as the Callier effect. The Callier coefficient, a measure of this effect, is the ratio of the density with specular illumination to the density with diffuse illumination. Since color dyes scatter the light very little, the Callier coefficient is approximately 1.0 with color images. In black-and-white images, the scattering of light and the Callier coefficient increase with density and the size of the silver grains, producing values higher than 1.0. (See Sections 2.4 and 15,5)

Recent measurement of graininess for black-and-white and

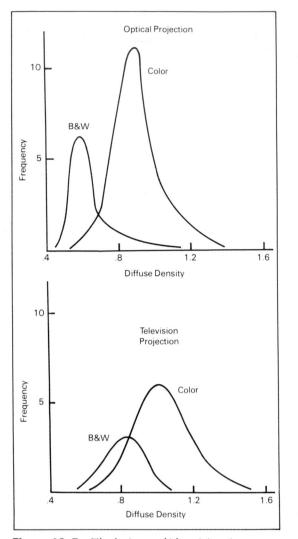

Figure 12-5 The density at which graininess is most objectionable is different for black-and-white and for color films, and for different systems of projection. (The difference between black-and-white and color is due mostly to the Callier Q factor; silver images scatter more light.) (Redrawn from Zwick, D., 1972, p. 345.)

12.4 Grain Size and Image Color

color *prints* reveals that the black-and-white prints exhibit peak graininess at a density of about 0.65 and color prints at an average density of about 0.93, with some prints peaking at a low density of 0.80 and others at a high density of 1.05. Further, it was found that varying the level of illumination on prints had little effect on the density at which peak graininess was observed. "An increase in illumination level by a factor of $6.5 \times$ increases the critical density by about 0.07. The shift in critical density that would occur between viewing a print in sunlight and in indoor home lighting would be less than 0.2 density."¹ (The illumination level does of course have a pronounced effect on the perceived tone reproduction of a print as discussed in Section 11.2.)

There is a practical consequence of knowing at what density level a photographic print exhibits the perception of maximum graininess. In arranging to photograph a scene, one can selectively minimize the graininess of an object by planning to have that object reproduce in the print at a density level higher or lower than the print density that corresponds to peak graininess. For example, to minimize the potential graininess of a uniform background in a studio setup, plan to have it reproduce as a black-and-white print density higher or lower than 0.65. Conversely, to maximize the perception of graininess, aim to have the background reproduce as a print density of 0.65. The smaller the negative format and the larger the print magnification, the more pronounced the results.

12.4 Grain Size and Image Color

Although we think of the silver image as being black, as the term *black-and-white* implies, the color can vary considerably between images depending upon the size and structure of the silver particles. Large silver particles absorb light almost uniformly throughout the visible spectrum, producing neutral color images that appear black where the density is high. Smaller silver grains absorb relatively more light in the blue region than in the green and red regions, causing the images to appear more brownish. By making the silver particles sufficiently small, it is possible to obtain a saturated yellow color, as exemplified by the yellow filter layer between the top two emulsion layers in some color films.

When the smallest dimension of small particles approximates the size of the wavelength of light, they scatter light selectively by wavelength, an effect known as Rayleigh scattering. Since the scattering varies inversely with wavelength to the fourth power, blue light is scattered most, and the transmitted light appears reddish. Fine-grained negatives that have a brownish color can have different printing characteristics than would be predicted by visual inspection, because of the lower Callier coefficient when printing with a condenser enlarger, and because of the different response of some printing materials to light of different colors—for example, variable-contrast papers.

12.5 Granularity

Granularity is the objective measure of density nonuniformity that corresponds to the subjective concept of graininess. Granularity determination begins with density measurements made with a microdensitometer—a densitometer that has a very small aperture—across

¹ Zwick, D., 1982, p.73

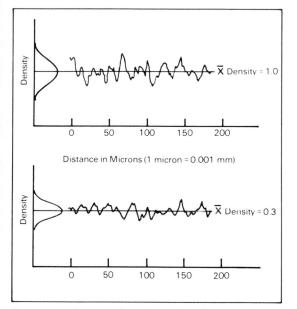

Figure 12-6 Microdensitometer traces of a negative material at a high density, and at a low density. The fluctuation of density over micro-areas on the negative density the granularity of the mag view. The higher density of 111 New greater fluctuation multiplemistic higher granularity.

Table 12–2 Some typical Kodak films and plates and their rms granularities. The data represent a very specific set of conditions of testing. Any comparison of rms granularity for other films must be made under the same set of conditions.

Film or Plate	RMS Granularity
High-resolution plate	0.0025
Kodachrome 64 (daylight)	0.010
Plus-X Aerecon Type 8401	0.034
Tri-X Aerecon Type 8403	0.048

an area of a negative that has been uniformly exposed and developed. The data are automatically recorded and mathematically transformed into statistical parameters that can be used to describe the fluctuations of density due to the distribution of the silver grains in the negative, and therefore to determine the granularity.

The process can be described graphically as illustrated in Figure 12–6. The fluctuations are greater at a density of 1.0 than they are at a density of 0.3. If all of the many points indicating the variation from an assumed average density are collapsed as shown on the left of the illustrations, a near-normal distribution is generated. Such a curve allows the specification of granularity in statistical terms that may be generalized. For any mean or average density (D), the variability of density around that mean is specified by the standard deviation σ (D) (read sigma D). Because σ (D) is the root mean square (rms) of the deviations, such granularity measurements are called *rms granularity*. (RMS is the standard deviation of micro-density variations at a particular average density level.)

Granularity values for Kodak negative films, and reversal and direct duplicating films are made at a density of 1.00 Microdensitometer traces are made with a circular aberture lawing a diameter of 48 micrometers (1).040.000

Since there is a good correlation between granularity measurements and graininess, rms granularity numbers are used to establish the graininess classifications found in some data sheets and data books: microfine, extremely fine, vcry fine, fine, medium, moderately coarse, coarse, and very coarse grain. In addition to providing a good objective correlate for graininess, rms granularity is analogous to the way noise is specified in electronic systems. This provides an important linkage for photographic-electronic communication channels and systems. Some typical values of rms granularity for several Kodak films and plates are shown in Table 12–2. They were made with a microdensitometer having a scanning aperture of 48 micrometers, corresponding to a magnification of 12, on a sample having a diffuse density of 1.0.

12.6 Minimizing Graininess

Much has been written and claimed about developers for reducing graininess. The same could be said for such claims as was said years ago by Mark Twain when he read his obituary in a newspaper: "Claims. . . are highly exaggerated." Two major problems with claims of reduced graininess are the questionable authenticity of the testing procedures, and the failure to completely report difficulties and losses associated with such reduction. Validity of graininess comparison tests requires negatives that have been exposed and developed to produce the same density and contrast, and printed to produce the same tone reproduction. This is a difficult task, and processing the film for the manufacturer's recommended time and temperature seldom produces negatives that meet these requirements. The fact of the matter is that little can be done to improve graininess through development unless one is willing to sacrifice one or more other attributes such as film speed, image sharpness, and tone-reproduction quality. Depending upon the requirements for specific photographic situations, such trade-offs may be warranted, but there is no substitute for beginning with a finegrained film.

Fine-grain development always results in a loss of film speed. (See Sections 7.29, 8.25, and 8.26.) In situations where minimum

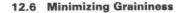

Figure 12–7 Kodak Technical Pan Film 2415 developed at 20 C in POTA developer to different contrast indexes for pictorial photography.

graininess and maximum film speed are both important, the photographer is presented with a choice of using a high-speed film and a finegrain developer or a slower film that has finer inherent grain with normal development. The control over graininess by the choice of developer tends to be small compared to the control by the choice of film. Films that are especially designed for microfilming, where high contrast is appropriate and slow speed is tolerable, have a low level of graininess that is truly remarkable. Such films have even been used for pictorial photography by developing them in low-contrast developers in situations where the lack of graininess is a more important consideration than the slow speed.

One such film is Kodak Technical Pan Film 2415, which is used for scientific and technical photography such as astrophotography, photomicrography, photomacrography, laser recording and black-andwhite slides. It is a high-contrast film having extremely fine grain (rms granularity of 8), extremely high resolving power of 320 to 400 lines/ mm and extended sensitivity to red light.² With special low-contrast developers, however, such as the POTA developer formulated by Marilyn Levy in 1967, normal-contrast negatives for pictorial-type photography are attainable (Figure 12-7). Since the film is not intended for pictorial use it does not have an ISO (ASA) number, but it does have an exposure index rating of 100. For film used in pictorial photography an Exposure Index of 25 is recommended (that is, use an exposure meter film-speed setting of 25). This film speed is appropriate since the film has effectively about the same speed as Panatomic-X and with about twice the resolving power. The extended red sensitivity might create a problem, however, when photographing people, since it will produce a skin tone in the print that is lighter than normal.

To prepare POTA developer, dissolve a pinch of sodium sulfite in 1 liter of water (preferably distilled or deionized), 1.5 grams of developing agent phenidone (or Kodak BD-84, or 1-phenyl—3pyrazolidinone) and 30 grams of sodium sulfite. Developing the film for 15 minutes at 20 C will provide a contrast index of about 0.56, which is normal for pictorial-type negatives exposed to an average scene.

POTA developer is especially subject to aerial oxidation and should therefore be mixed just prior to use and discarded after it has been used once. Prepackaged developers such as the Kodak Technidol LC developer, H&W Control developer and Neofin Doku developer are also recommended.

Even after a negative has been made, several factors can affect the appearance of graininess on the print. For a given degree of enlargement, diffusion enlargers tend to produce less graininess on the print than condenser enlargers, although the difference becomes smaller when an adjustment is made for the difference in contrast produced by the two enlargers. Since image contrast does affect the appearance o graininess, the choice of contrast grade of printing paper is a factor with the graininess increasing with the contrast. Anything that reduce the sharpness of the image in the print will also reduce graininess including focusing errors, inferior enlarger optics, and intentional dif fusion of the image. The higher maximum density of glossy printing papers results in higher-contrast images with more graininess that images made on mat surface papers of the same contrast grade. *I*

² Further information on Kodak Technical Pan Film 2415 and 6415 may be obtained b writing to Photo Information, Photographic Products Group, Eastman Kodak Co., Roch ester, NY 14650.

Table 12–3 Graininess can be reduced by using a largerformat film having the same graininess or granularity rating to make the same-size enlarged print. Graininess can be kept constant and a higher film speed used in a similar exchange; i.e., by using a larger-format film with a higher speed.

Film Format	Print Size	Enlargement	
35mm	16×20	16X	
21/4	16×20	7X	
4×5	16×20	4X	
8×10	16×20	2X	

considerable amount of graininess can be camouflaged by using printing paper with a rough, textured surface. Patterned texture screens placed in contact with the printing paper or the negative during exposure have a similar effect on graininess.

An obvious method of decreasing graininess is to use a larger film size that requires less magnification in printing. Since graininess increases in proportion to magnification, a comparison of the magnifications required to produce 16×20 -inch prints with different film formats is meaningful: the magnification is 2 for an 8×10 -inch negative, 4 for a 4×5 -inch negative, approximately 7 for a $2 \frac{1}{4} \times 3 \frac{1}{4}$ -inch negative, and 16 for a 35mm negative (Table 12–3).

12.7 Graininess of Color Films

Color films exhibit graininess patterns having both similarities and differences, compared with the graininess patterns in blackand-white films. With dye-coupling development, dye is formed in the immediate area where a silver image is being developed so that the dye image closely resembles the grain built of the silver image, and the dye pattern in minimum different silver image is removed by bleaching. The image structure is more complex with color film due to the three emulsion layers, each containing a different color dye image. Graininess and granularity are measured and specified in the same manner with color films as with black-and-white. The perception of graininess with color films results from the luminosity (brightness) contribution of the three dye images rather than from the hue and saturation attributes, although the appearance of graininess is not equal for the three colors. The relative contribution of each of the dye layers to granularity is as follows:

Green record	(Magenta dye	
	layer)	60%
Red record	(Cyan dye layer)	30%
Blue record	(Yellow dye layer)	10%

These percentages will vary depending upon the dyes used, but the magenta layer will always be the major contributor to the perception of graininess, mainly because our eyes are most sensitive to green light, which the magenta dye layer controls. Figure 12–2B compares four different 35 mm color-transparency films at various magnifications while Figure 12–2C compares prints made from four different 35 mm color negatives at various magnifications $(1 \times, 4 \times, 8 \times, 16 \times, \text{ and } 32 \times)$.

12.8 Sharpness/Acutance

In art the terms *hard-edged* and *soft-edged* are sometimes used to describe the quality of an edge in an image. In photography the term *sharpness* describes the corresponding abruptness of an edge. Sharpness is a subjective concept, and images are often judged to be either sharp or unsharp, but sharpness can be measured. If one photograph is judged to be sharper than another, the sharpness is being measured on a two-point ordinal scale. If a large number of photographs are arranged in order of increasing sharpness, the sharpness is being measured on a continuum on an ordinal scale.

The sharpness of a photographic image in a print is influenced

and limited by the sharpness characteristics of various components in the process, including the camera optics, the film, the enlarger optics, and to a lesser extent the printing material. Sharpness and contrast are closely related, so any factor that increases image contrast tends to make the image appear sharper. Similarly, anything that decreases image sharpness, such as imprecise focusing of the enlarger, tends to make the image appear less contrasty.

Although it is not possible to obtain a sharp print from an unsharp negative simply by focusing the image with an enlarger as some wags suggest, there are various procedures available for increasing the sharpness of photographic images. Some film developers, for example, produce higher local contrast at the boundaries between areas of different density, which causes the image to appear sharper. The anomaly on the denser side of the boundary is called a *border effect*, the anomaly on the thinner side is called a *fringe effect*, and the two together are referred to as *edge effects*. (See adjacency effects, Section 2.36.) There are also electronic and photographic techniques for either making an image edge more abrupt or increasing the local contrast at the edge.

Developing factors that alter edge effects, and therefore image sharpness, include developer strength, developing time, and agitation. Diluting the developer and developing for a longer time with little or no agitation enhances edge contrast and sharpness. Unfortunately, this procedure can also cause uneven development with some film-developer combinations even though it is used routinely with highcontrast photolithographic materials. One developer specifically formulated to enhance image sharpness with normal-contrast films is the Beutler High Acutance Developer, named after the man who pioneered developers of this type. The formula is:

Sodium sulfite (Na ₂ SO ₃)	5.0g
Metol	0.5g
Sodium carbonate	
(Na_2CO_3)	5.0g
Water	1 liter

12.9 Acutance

Acutance is a physical measurement of the quality of an edge that correlates well with the subjective judgment of sharpness. It is measured in a laboratory by placing an opaque knife edge in contact with the photographic material being tested and exposing the material with a beam of parallel (collimated) light. This produces, after development, a distinct edge between the dense and clear areas, but because of light scatter in the emulsion the edge has a measurable width. The edge, which is less than 1 mm (1,000 microns) wide, is then tracec with a microdensitometer. The result is a change in density with distance. A typical density-distance curve is shown in Figure 12–8. The rate at which density changes as a function of the microdistance of thedge is a graphical description of acutance (sharpness).

Since the rate of change of density can be expressed in term of slope or gradient, the average gradient of the curve between two specified points becomes a numerical expression of acutance, as shown in Figure 12–9. Cutoff points A and B establish the part of the curv over which the geometric average gradient will be determined. The gradient $\Delta D/\Delta x$ is found for each of the intervals between A and B

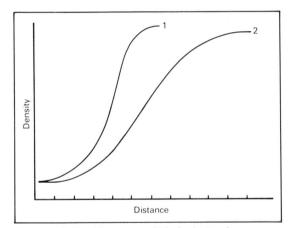

Figure 12-8 The rate at which the density changes across the very edge of an image is described by the slope of the curve. The film represented by curve 1 has a higher slope or gradient and therefore has higher acutance and sharpness.

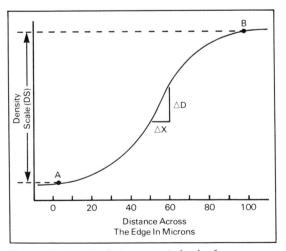

Figure 12–9 To obtain a numerical value for acutance, the average gradient of the curve is calculated and then divided by the density scale (DS).

The gradients are then squared, and the squared gradients are added together and divided by the number of intervals to determine the average square gradient. The formula for these calculations is:

$$\overline{G^2} = \frac{\Sigma (\Delta D / \Delta x)^2}{n}$$

Acutance is calculated by dividing the average square gradient by the density scale (DS) between points A and B on the vertical scale: Acutance $= \overline{G}^2 \div DS$.

12.10 Resolving Power

Resolving power is the ability of the components of an imageformation process (camera lens, film, projector lens, enlarging lens, printing material, etc.) individually or in combination to reproduce closely spaced lines or other elements as separable. Resolving power is the correlate of the image quality referred to as detail, so that a lens having high resolving power is capable of reproducing time datail Targets used to measure reactivity power typically have alternating light and dark elements either in the form of parallel bars as in the United States Air Force (USAF) and American National Standards Institute (ANSI) Resolution Targets, or in the form of angular letters and numbers as in the Rochester Institute of Technology (RIT) Alphanumeric Resolution Test Objects (see Figure 12–10). Since subject contrast influences resolving power, such test targets are commonly supplied in high-contrast (black-and-white) and lower-contrast forms.

To test the resolving power of a lens, a target is placed on the lens axis at the specified distance (for example, 21 times the focal length) to produce an image at a specified scale of reproduction (for example, 1/20). The aerial image is examined with a microscope at a power about equal to the expected resolving power, and the finest set of lines or elements that can be seen separately is selected. A conversion table translates this information into lines-per-millimeter resolving power, usually in terms of dark-light pairs of lines. Alternative methods of expressing resolving power are in lines per unit distance in object space rather than in the image, and as angular resolving power.

Variations can be made in the above procedure to obtain additional information. A row of targets can be used so that the images fall on a diagonal line at the film plane to determine the resolving power for various off-axis angles as well as on-axis (see Figure 12–11). The test can be repeated with the lens set at different f-numbers to determine the setting that provides the best compromise between reducing lens aberrations and introducing excessive diffraction. The effect of filters on the optical image can be determined by measuring the resolving power with and without the filter, also with and without compensation for focus shift with the filter.

The relationship between the resolving power of the components of a system and the resolving power of the entire system is commonly expressed with the formula $1/R = 1/r_1 + 1/r_2 + 1/r_3 \dots$ where R is the resolving power of the system and each r_n is the resolving power of a component. This formula reveals that the resolving power of the system cannot be higher than the lowest resolving power component. In fact, the resolving power of the system is always lower than the lowest component. If, for example, a lens with a resolving power of 200 lines/mm is used with a film having a resolving power of 50

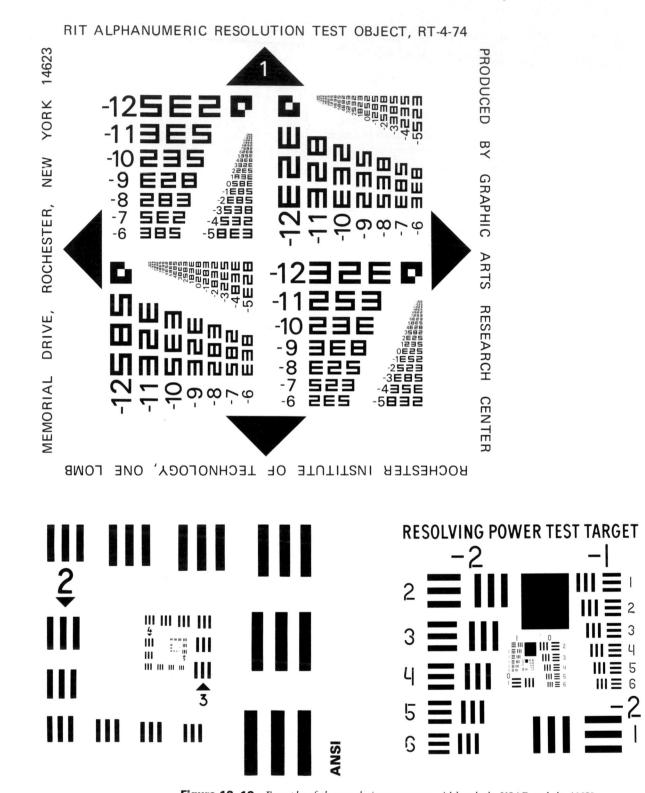

Figure 12–10 Examples of three resolution test targets. Although the USAF and the ANSI targets look different, they are quite similar. Both take the shape of a spiral made up of three black bars that have a square format and decrease in size (increase in line frequency). The USAF target has both vertical and horizontal bars, which allows a check for astigmatism. The ANSI target would have to be rotated 90° and photographed twice to accomplish the same thing. The RIT target is unique in that it is alphanumeric. Since the evaluator must correctly identify the letters and numbers in the smallest set of characters judged to be resolved, there is less variability when different evaluators examine the same images than with conventional test targets.

USAF

12.11 Resolving-Power Variables

Figure 12–11 Resolution test targets arranged to measure resolving power on and off axis.

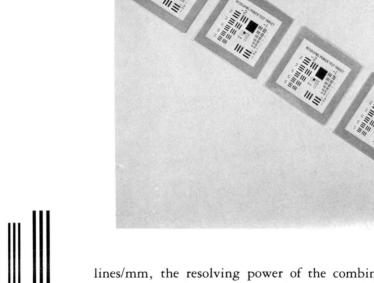

lines/mm, the resolving power of the combination is 40 lines/mm. Thus it would be a mistake to believe that the quality of the camera lens is unimportant for photographs made for reproduction in newspapers and on television, where the maximum resolving power is relatively low. The only question is whether differences in resolving power of two lenses would produce a noticeable difference in the reproduction.

Since it is not possible to measure the resolving power of photographic film directly, it is common practice to use the film with a high-quality lens of known resolving power, determine the resolving power of the system, and then calculate the film's resolving power. The resolving power of the lens-film combination is referred to as photographic resolving power to distinguish it from film resolving power and lens resolving power.

12.11 Resolving-Power Variables

There are a number of factors that can enter into the testing procedure to produce variable resolving-power values, including the following:

Test target contrast. The higher the contrast of the test target, the higher the measured resolving power will be. Black-and-white reflection targets have a luminance ratio contrast of approximately 100:1. The ratio for low-contrast targets may be as low as 2:1 or even less. The transmittance ratio for transparency test targets is generally about 1,000:1. High- and low-contrast test targets are illustrated in Figure 12-12, and comparison data for the two types are presented in Table 12-4.

Focus. Focusing inaccuracies can be caused by human error or mechanical deficiencies. With lenses having residual curvature of field, the position of optimum focus will not be the same for on-axis and off-axis images. Other common problems are a difference between the position of the focusing screen and the position of the film plane, and film buckle. Bracketing the focusing position is sometimes advisable.

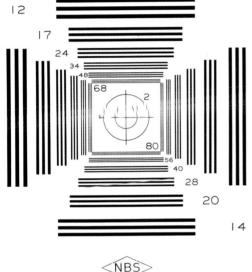

RESOLUTION TEST CHART 1952

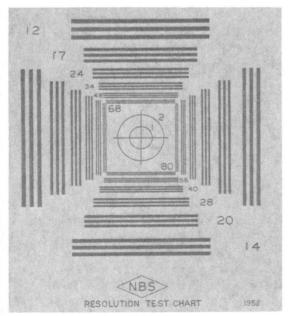

Figure 12–12 High-contrast and low-contrast resolvingpower test targets. The target on the top has a contrast ratio of 100:1, while the one on the bottom is 2:1.

12.11 Resolving-Power Variables

		Resolution			
Kodak Film	ISO (ASA) Speed	Low Contrast	High Contrast	Resolution Word Category for H.C.	
Panatomic X	32	80	200	Very high	
Plus-X	125	50	125	High	
Super-XX	200	40	100	High	
Tri-X Pan	400	50	100	High	
Royal Pan	400	40	80	Medium	
Royal X Pan	1250	40	100	High	

Table 12-4 Resolution, word and numerical data for several Kodak films. In general, as the speed of the film increases, resolution decreases. Resolution measured with a high-contrast target is two or more times that measured with a low-contrast target. (Special films such as spectroscopic plates have resolution values up to 2,000 lines/mm but speed values of about 1.0 or less.)

Camera movement. Any movement of the camera during exposure will have an adverse effect on resolving power, including the jarring caused by mirror movement in single-lens reflex cameras.

Exposure level. There is an optimum exposure level, with a given film, to obtain maximum resolving power. This level does not necessarily correspond to the published film speed.

Development. The degree of development affects negative density, contrast, and granularity, all of which can influence resolving power.

Light source. Exposures made with white light and with narrow-wavelength bands of light, ultraviolet radiation, or infrared radiation can produce different resolving-power values for a variety of reasons including chromatic aberration, diffraction, and scattering in the emulsion.

Human judgment. Different viewers may disagree on which is the smallest set of target lines that can be resolved in a given situation. With experience, a person can become quite consistent in making repeated interpretations of the same images. For this reason, resolving power is more useful for comparison tests made by one person than in comparison tests of resolving-power values to published values. Table 12–5 shows the variations in resolving power when six different laboratories tested the same film using high-contrast, medium-contrast and low-contrast targets. The values represent an average of three test: for each condition. The upper table shows the results before the number: were rounded off to fit the established ANSI categories. Much of the variation can be attributed to the difficulty viewers have in judging which set of lines is just resolvable.

"The resolving power of a photographic material is not mea surable apart from the other components of the photographic process

Table 12–5 Resolution values from six outstanding photographic organizations testing the same film under the same specified conditions. The upper values represent raw data while the lowe values are rounded off to fit categories specified by ANSI.

A 120	В	С	D	E	
120			ν	E	F
130	100	140	112	125	126
105	89	100	100	93	126
53	35	45	36	43	40
125	100	125	100	125	125
100	80	100	100	100	125
50	32	50	40	40	40
	105 53 125 100	105 89 53 35 125 100 100 80	$\begin{array}{cccccccccccccccccccccccccccccccccccc$	$\begin{array}{cccccccccccccccccccccccccccccccccccc$	$\begin{array}{cccccccccccccccccccccccccccccccccccc$

What we invariably estimate is the resolution of a *system*, including the target, the illumination method, the optical system, the photographic material and its treatment, and the readout method."³ The same can be said in testing resolution for any system—the resolution of paper copies made on machines such as the Ektaprint, Xerox, and IBM machines; the resolution of video systems; the resolution of printing plates used in graphic arts printing; the resolution of the human eye; and so on.

12.12 Resolving-Power Categories

Since resolving-power numbers mean little to those who are inexperienced in working with them, words are sometimes used to describe resolving-power categories. Eastman Kodak Company has set up the following relationship between words and numbers for films:

Ultra high	630 lines/mm and highu
Extremel, high	250, 320, 400, 500 lines/mm
Very high	160, 200 lines/mm
High	100, 125 lines/mm
Medium	63, 80 lines/ mm
Low	50 lines/mm and below

12.13 Resolving Power and Graininess

The effect of graininess on resolution can be seen in Figure 12-13. The sequence of prints are of a person and a resolution target photographed simultaneously at three increasing distances between subject and camera. All three photographs were made on the same 35 mm film and processed at one time. To obtain the same image size, different amounts of enlargement were required. The first print can be considered normal. Notice that there is detail and texture in the woman's coat and that many of the pine needles are easily distinguishable. Similarly, fine detail is maintained in the resolution target as seen in the small distinguishable lines in the center array. In the second and third prints the fine detail in both pictures has been increasingly obscured by the increase in graininess. The fine detail in the woman's coat, her facial features, the pine needles, and the small bars in the resolution target are no longer distinguishable. The coarser areas of the photograph, however, are still distinguishable as seen by the large array of threebars and the solid black square in the resolution target, and the vertical black area of the woman's coat. Graininess, which is the major contributor to visual noise in a photographic system, takes over and the signal (information) is diminished or completely lost.

³ Todd, H., and Zakia, R., 1974, p. 273.

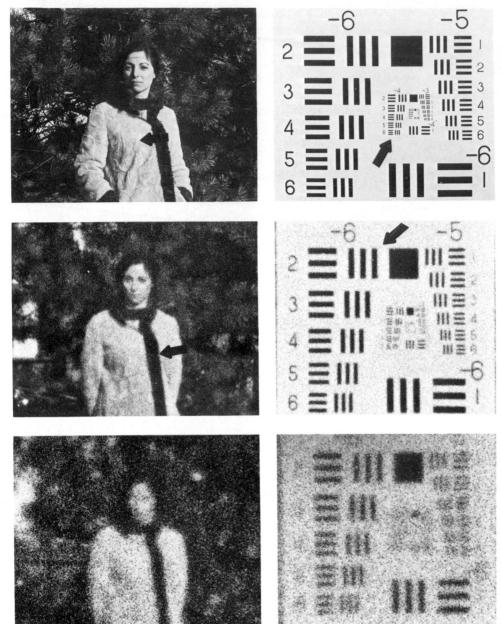

12.14 Resolving Power and Acutance

Figure 12–13 The effect of graininess on resolving power. (Photographs by Carl Franz.) $4 \times$ Magnification. $16 \times$ Magnification. $32 \times$ Magnification.

12.14 Resolving Power and Acutance

Although image detail and sharpness are commonly pe ceived as similar, and the corresponding measurements of resolvir power and acutance often correlate well, they can vary in opposi directions. That is, one film or lens can have higher resolving pow but lower acutance than another film or lens. There was some dissa isfaction with the heavy reliance on resolving power used as a measu of image quality in the past because occasionally a photograph th tested higher in resolving power than another photograph was judg by viewers to be inferior in small image quality. A small loss of fi detail, which corresponds to a reduction of resolving power, may Figure 12-14 Enlargements of small images of a test object made on the same film. The left image was made on the optical axis of the lens where acutance was high but resolving power was low. The right image was made 15° to the right of the optical axis where the acutance was low but resolving power was high.

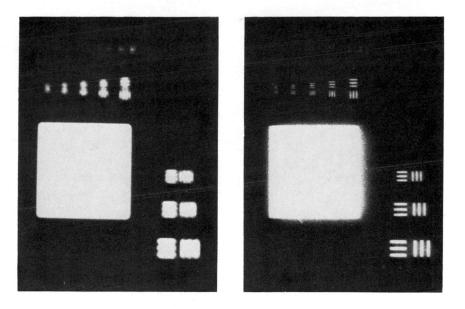

less objectionality could be a loss in sharpness or contrast (see Figure 12-14).

When trying to obtain a reliable and valid measure of image quality, it is tempting to search for a single number that will describe that characteristic. As early as 1958, two research scientists, George C. Higgins and Fred H. Perrin, cautioned: "No single number can be attached to any system to describe completely its capability of reproducing detail clearly."⁴

12.15 Modulation Transfer Function (MTF)

The modulation transfer function is a graphical representation of image quality that eliminates the need for decision making by the observer. The MTF system differs from resolving-power measurement in two other important ways. First, the test object generates a sine wave pattern rather than the square wave pattern generated by a resolving-power target; second, the percent response at each frequency is obtained. Resolving-power values are threshold values, which give only the maximum number of lines resolved; i.e., the highest frequency. Figure 12–15 shows a sine wave test target, a photographic image of the target, and a microdensitometer trace of the image. Note that the test target increases in frequency from left to right and that the "bars" do not have a hard edge but rather a soft gradient as one would expect from a sine wave.

The modulation transfer function is a graph that represents the image contrast relative to the object contrast on the vertical axis over a range of spatial frequencies on the horizontal axis, where high frequency in the test target corresponds to small detail in an object. If it were possible to produce a facsimile image, the contrast of the image would be the same as the contrast of the test target at all frequencies, and the MTF would be a straight horizontal line at a level of 1.0. In practice, the lines always slope downward to the right, since image

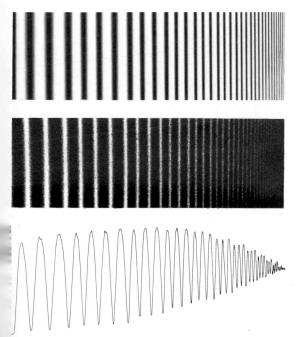

Figure 12–15 To measure modulation transfer functions a sinusoidal test target is photographed and then a microdensitometer trace made of the photographic image. (© Eastman Kodak Company.) (Top) Sine wave test target. (Middle) Photographic image of test target. (Bottom) Microdensitometer trace of the photographic image of the test target.

⁴Higgins, G., and Perrin, F., August 1958, p. 66.

contrast decreases as the spatial frequency increases. Eventually the lines reach the baseline, representing zero contrast, when the image-forming system is no longer able to detect the luminance variations in the test target. As with resolving power, an MTF can be determined for each component in an image-forming system or for combinations of components. The MTF for a system can be calculated by multiplying the modulation factors of the components at each spatial frequency.

There are three basic steps in the preparation of a modulation transfer function:

1. Determine the modulation of the test target and the modulation of the image at each frequency with the formulas:

and

$$M_{\text{image}} = rac{E_{\text{max}} - E_{\text{min}}}{E_{\text{max}} + E_{\text{min}}}$$

 $M_{
m target} = rac{E_{
m max} - E_{
m min}}{E_{
m max} + E_{
m min}}$

where M is modulation and E is luminance or an equivalent of the target for the target modulation and of the image for the image modulation. The modulation of a given test target remains constant for the entire range of spatial frequencies.

2. Determine the modulation factor at each frequency by dividing the image modulation by the target modulation:

Modulation factor
$$= \frac{M_{image}}{M_{object}}$$
.

3. Prepare the modulation transfer function by plotting modulation factors on the vertical axis against spatial frequencies on the horizontal axis (see Figure 12–16).

In practice the process may be more complex. For example, when the image is recorded on film, the luminance values for it must be calculated in terms of the resulting densities, and the nonlinear response of the film as represented by the S-shaped D-log H curve must be taken into account.

The advantage of modulation transfer functions is that they provide information about image quality over a range of frequencies rather than just at the limiting frequency as does resolving power; but there are also limitations and disadvantages. For example, photographers cannot prepare their own modulation transfer functions, and the curves are more difficult to interpret than a single resolving-power number. MTFs are most useful for comparison purposes. Figure 12-17 shows published curves for two pictorial-type films having speed of 32 and 1250. Although both films have the same response up te about 5 cycles/mm, the response falls off more rapidly for the faste film as the frequency increases, indicating that the slower film will hold fine detail better. It should be noted also that modulation transfe functions for lenses do not provide the desired information about off axis aberrations such as coma and lateral chromatic aberration. When this information is needed, it is necessary to go through an additiona procedure to produce an optical transfer function.

The following is an example of how a system MTF can b determined by multiplying the modulation factors of the components

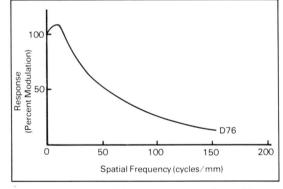

Figure 12–16 Modulation-transfer curve for Kodak Plus-X film developed in D-76.

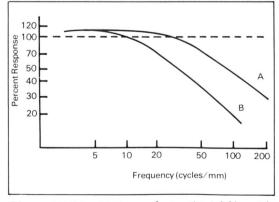

Figure 12–17 MTF curves for two pictorial films with quite different film speeds. Film A is a slow film (ISO 32) and B is a fast film (ISO 1250). One could expect intermediate speeds to fall between A and B. (Output values greater than 100% are the result of adjacency effects in the film.)

If the modulation factors at 50 cycles/mm are .90 for the camera lens, .50 for the film, .80 for the enlarger lens, and .65 for the printing paper, the product of these numbers, and therefore the modulation factor for the system, is .23.

12.16 Photographic Definition

Photographic scientists and engineers stress the fact that no single number satisfactorily describes the ability of a photographic system to reproduce the small-scale attributes of the subject. The term definition, however, is used to describe the composite image quality as determined by the specific characteristics of sharpness, detail, and graininess (or the objective correlates acutance, resolution, and granularity). Definition is applied to optical images as well as images recorded on photographic materials, although the term photographic definition is preferred for the latter. Since the measured resolving power of a photographic lens, material, or system did not always correlate well with perceived image definition, the modulation transfer function when in troduced as a more comprehensive upit I INH measure of image quality. Difaine it in difficult to translate modulation transfer function curves into small-scale image quality, photographers have still felt the need for a simple but meaningful measure of definition. One film manufacturer has attempted to satisfy this need by rating its films on the basis of the degree of enlargement allowed, which takes into account the combined characteristics of graininess, sharpness, and detail.

It should be noted that photographic definition is not determined entirely by the quality of the photographic lens and the photographic materials, but also by factors such as focusing accuracy, camera and enlarger steadiness, subject and image contrast, exposure level, and use of filters. It is not realistic to demand the same level of definition for all types and uses of photographs, including exhibition photographs, motion-picture films, portraits, catalog photographs, and photographs to be reproduced in magazines, newspapers, and on television. Many publications refused to accept black-and-white or color photographs made with small-format cameras long after it had been demonstrated that such cameras were capable of making photographs with much better definition than the photomechanical processes were capable of reproducing.

12.17 Point Spread Function

As a light ray travels through any more-or-less transparent medium, such as air or glass, some of the light deviates from the original direction. Even with a theoretically perfect lens, the image of an object point is never a point but rather is a spot surrounded by rings of increasing size and decreasing illuminance known as an *Airy disk*. This image-degrading effect is referred to as *diffraction*, and the diameter of the Airy disk varies with the limiting aperture of the lens.

The first quantitative study of the scattering of light by small particles was made by Rayleigh in 1871, and such scattering is often called *Rayleigh scattering*. The amount of scattering is found to be inversely proportional to the wavelength of light raised to the fourth power. This means that blue light will be scattered much more than red light. As an example, red light at 720 nm has a wavelength 1.8 times as great as blue light at 400 nm. The number 1.8 raised to the fourth power is 10, which means that the blue light will be scattered

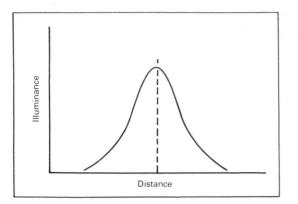

Figure 12–18 Emulsion point spread function. A point of light entering a photographic emulsion spreads in such a way as to form a normal (Gaussian) distribution of illuminance.

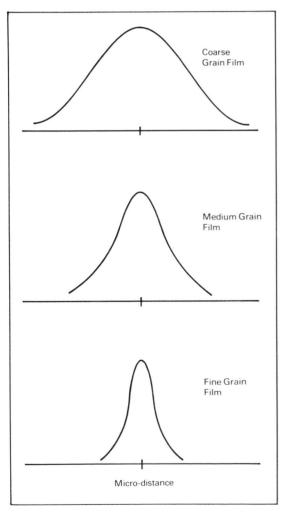

Figure 12–19 Emulsion point spread functions for three different classifications of graininess; coarse, medium, and fine grained. The general shape of the spread functions remains the same but spreads out as graininess increases. Fine-grained film bas a spread of about 10 microns, medium-grained about 20 microns and coarse-grained film about 40 microns (1,000 microns equal 1 millimeter).

10 times as much as the red light. This is true, however, only if the linear dimension of the scattering particles is considerably smaller than the wavelength of light.

Rayleigh scattering does not occur in photographic emulsions, as the particles are larger than the wavelength of light. In fact, because of emulsions' selective absorption of different colors of light, the absorption of blue light is hundreds of times greater than the absorption of red light. Therefore, there is less spreading of ultraviolet radiation and blue light than of red light within emulsions, and the emulsion spread function decreases as the wavelength of the exposing radiation decreases.

If the illuminance of the image of a single ray of light falling on a photographic emulsion could be measured with a microphotometer, the result could be plotted as shown in Figure 12–18. The distribution of illuminance across the image would resemble a normal distribution curve as discussed in Section 1.4. The curve is known as the *emulsion point spread function*, and it is related to the ability of the emulsion to record detail. The narrower the emulsion point spread function, the more resolvable object points are. The width of the spread function can be expressed as a single number by measuring the width of the curve at a specified height such as one quarter the maximum height.

Figure 12-19 shows emulsion point spread functions for three classifications of emulsions with respect to graininess, while Figure 12-20 compares the point spread function of a medium-speed photographic film to that of an electronic television image produced with an image orthicon. The detail-producing superiority of the film image over the video image is apparent, as is the direct relationship between film graininess and point spread function.

For any object area larger than a point, the image can be considered to be made up of a summation of the emulsion point spread functions. The two diagrams in Figure 12–21 illustrate what happens when objects consisting of two adjacent points are brought closer to gether; the point spread functions begin to overlap and merge and ther become one. The emulsion point spread function limits how closely two object points can be located and still be distinguishable.

12.18 Line Spread Function

Most photographic materials are isotropic; they consist c randomly oriented elements with no regular pattern, whereas in tele vision receivers the imaging characteristics are different in the vertica and horizontal directions. Emulsion spread functions are therefore sym metrical, allowing the substitution of line test objects, which are easie to work with for point test objects. If a line is thought of as a assemblage of points in one direction, a line spread function is simpl an assemblage of point spread functions as shown in Figure 12–22.

Just as the point spread function limits the ability to distinguish adjacent object points, the line spread function limits the ability to distinguish adjacent lines in the object. Thus there is relationship between line spread function and resolution, and betweeline spread function and modulation transfer function.

12.19 Edge Spread Function

Whereas a line spread function can be thought of as a assemblage of point spread functions, half of a line spread function ca

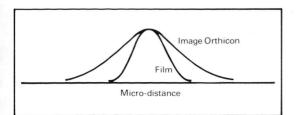

Figure 12–20 Comparison of a point spread function for a medium-speed film with that of an image orthicon video tube. The spread for the film is about 20 microns, while the image orthicon's is about 200 microns.

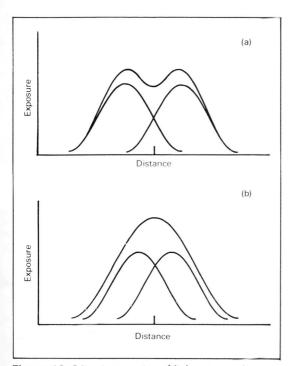

Figure 12–21 As two points of light (a) move closer together (b), the images will begin to merge and overlap and eventually become one as shown in the upper curves. The points are no longer separate or distinguishable.

Figure 12–22 A line spread function is an assemblage of contiguous point spread functions.

be thought of as an edge spread function. In practice it is easier to image the edge of a razor blade than a line on photographic material. There is a relationship between edge spread function and the subjective attribute of sharpness, or the corresponding objective attribute of acutance.

12.20 Chemical Spread Function

All of the emulsion spread functions discussed above refer to light images within emulsions. When the light images are converted to photographic images by processing the exposed material, the shapes of the spread functions are altered for two reasons. First, density does not increase in a straight-line relationship with exposure, or even with log exposure. Second, there is a separate spread function associated with development called chemical spread function, which varies with developer, time, temperature, and agitation. Thus, for a photograph exposed in a camera, a spread function would be a composite of the lens spread function, the emulsion spread function, and the chemical spread function.

12.21 Pixels

In electronic photography a light-sensitive, electrically charged microchip serves as the equivalent of film in a camera. Silicon is generally used as a light-sensitive surface, and the chip is designed as a mosaic containing hundreds of thousands of discrete minute areas that act as photoreceptors. Each area is capable of registering picture information and is called a *pixel* (picture element). (A microchip is also analogous to the retina of the eye, which contains a mosaic of minute light-sensitive receptors called rods and cones, or simply photoreceptors.) Figure 12-23 illustrates a light-sensitive silicon chip. For re-

Figure 12–23 A representation of a silicon chargedcoupled device (CCD) with 400 squares or pixels. The camera's lens focuses the image of an object or scene on the many light-sensitive discrete surfaces (pixels) of a charge-coupled device. The CCD converts the image into an array of electrical charges that are proportional to the intensity of the light falling on each pixel (light sensitive square).

Figure 12–24 The 120 million rods and 7 million cones in the retina of the human eye can be thought of as a total of 127 million pixels.

production purposes only 400 receptors or pixels are shown, whereas in reality they contain as many as half a million pixels within an area of one-half-inch square. As light falls on the chip, each pixel generates electrical signals that are proportional to the illuminance. The signals from each pixel are transmitted to a magnetic recording disc. The disc magnetic image can then be converted to a positive or negative visible image on a television screen, or it can be recorded on paper to form "hard copy."

To specify and compare the image-quality capabilities of a light-sensitive chip such as a charged-coupled device (CCD), a chargeinjection device (CID), or a charge-priming device (CPD), the term *pixel* has come into use. The greater the number of separate or discrete pixels possible per unit area of a chip, the higher the potential image quality. Put differently, the smaller the pixels, the more pixels per unit area, and the better the image quality. One way to compare the image-quality potential of a CCD, CID, or CPD system to a photographic system or other system of picture recording, such as television and graphic-arts printing, is in terms of point spread functions, described earlier. The smaller the point spread function of a pixel, the more information that can be packed per unit area.

With this in mind, imagine the 400-pixel chip in Figure 12–23 as having 1,000 pixels within each of the 400 small squares shown. Further imagine the overall square being reduced to an area of one-half square inch. This would provide a microchip having 400,000 pixels. Each pixel would be about 0.0008 inch in diameter (about half the diameter of a human hair). In 1983 a one-half-inch-square chip $(12.7 \times 12.7 \text{ mm})$ —about the size of a fingernail—had a total of about 280,000 pixels. By comparison, Kodacolor film of about the same size used in the 1982 disk camera had a total of about 3 million pixels, each pixel being about 0.0003 inch in diameter. With photographic emulsions the number of pixels possible per unit area is determined by the granularity and acutance of the emulsion. Projections for light-sensitive electrically charged chips estimate 1 to 10 million pixels by 1988. As a comparison, the human eye contains abut 127 million pixels consisting of 120 million rods and 7 million cones all contained in an area about two inches square (see Figure 12-24). The cones are much smaller than the rods, the smallest cone receptor being about 0.00008 inch (two micrometers) in diameter.

The concept of pixels lends itself to the retina, but it also has been applied to early color screen photographic processes, which were based on an additive system of color and had minute red, green and blue filters. Television, with its red, green, and blue phosphors is based on a similar principle. In 1869 Louis Ducos du Hauron published the book *Les Couleurs en Photographie*, in which he suggested : method for producing color photographs by using a photographic plathaving a mosaic of minute red, green, and blue color filters smal enough to defy resolution by the eye. In 1895, Professor Joly of Dublis successfully prepared such a mosaic by ruling adjacent fine lines of red green, and blue dyes, about 200 to the inch.

Other products based on the same principle followed. I 1907 the Lumière brothers provided the Autochrome process, consistin, of dyed red, green, and blue starch grains that were minute and nearl uniform in size and shape. The Agfacolor plate followed in 1914, an in 1928 Kodacolor 16 mm cine film based on a lenticular screen proces was introduced. Dufaycolor appeared in 1934, having pixels in th form of fine adjacent diagonal lines packed to about 200 lines per inch

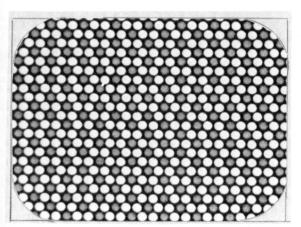

Figure 12–25 Television phosphors as pixels (enlarged view).

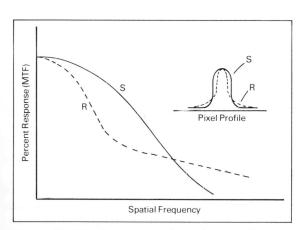

Figure 12–26 Response curves for two hypothetical television tubes. The information displayed by tube S will appear sharper but will have less resolution than that of tube R.

Figure 12–27 This illustration simulates the letter quality obtained by low-, medium-, and high-resolution computer slide-generating systems. (Illustration courtesy of Professor Deane K. Dayton, Audio-Visual Center, Indiana University.)

and later to about 500 lines per inch. (In graphic arts a fine line screen has about 300 lines per inch.)

Common to all systems of picture recording is the breaking up of a larger continuous optical image into small discrete elements. In photography the discrete picture elements are played back optically, whereas with silicon microchips (CCD, CID, CPD devices) the information is played back electronically. Since the pixels are discrete photoreceptors, they provide a digital system of recording and playback of pictorial information as well as text information.

In new micrographic technology, laser beams focused to about one-half micron are used to imprint information on a lightsensitive optical disk as tiny pits or holes. These pixels can be packed closely enough to record the images of 10,000 letter-size documents on a 12-inch-diameter disk.

On a television screen the individual areas of the phosphors can be thought of as pixels. In the United States a conventional 525line television screen consists of 49,152 pixels, 256 in the horizontal direction and 192 vertically (see Figure 12–25). (In Europe a 625-line screen is common. High-resolution screens have about 1,000 limes This provides the level of mining funding such on broadcast television. A much better picture is available, however, with a TV monitor, which consists of 128,000 pixels (640 \times 200), or with higher-resolution monitors such as those with 262,144 pixels (512 \times 512). In general, the more pixels per unit area of screen, the better the picture quality (Figure 12-26). There is presently (1985) no generally agreed-upon terminology for specifying the resolution of computer-generated images in terms of the number of discrete pixels. However, a qualitative grouping, as shown in Table 12-6, can be helpful. An illustration of the letter A on a low-, medium-, and high-resolution computer slidegenerating system is shown in Figure 12-27.

Unfortunately, when high-resolution TV monitors are used to display computer-generated information, they require a rather large computer memory and more computer time to display the information. Also, the more information each pixel has to display, the larger the memory required. For instance, a pixel that displays only two levels of gray (white and black) uses less memory than one that has to display 16 levels of gray. With a 128,000-pixel screen, 128K by two-bit memory is required. This would provide line graphic display only. To display 16 levels of gray would require 128K by four-bit memory,

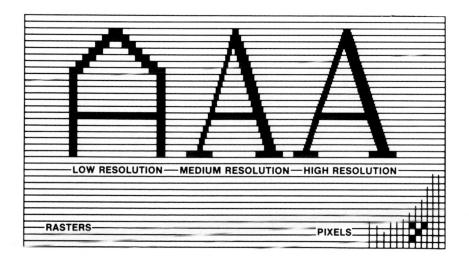

Table 12-6	Arbitrary	grouping	of pixels	in	terms	of
resolution.						

Computer-generated Images Resolution					
Pixels	Total Pixels	Resolution Category			
250×250^{a}	62,500	Low			
500 × 500	250,000	Medium			
$2,000 \times 2,000$	4,000,000	High			
$4,000 \times 4,000^{b}$	16,000,000	Very high			

^aOn a 19-inch diagonal TV screen, each pixel would have a diameter of about 1/16 inch.

^bKodak Ektachrome films can resolve about 3,000 \times 4,500 pixels in 35 mm format (1 inch \times 1½ inches) for a total of 13,500,000 pixels. Each resolved pixel would have a diameter of about 0.000,001 (one millionth of an inch).

while a display of three colors (red, green, and blue) with 16 shades for each color would require 384K by four-bit memory. This would provide a color gamut (palette) of 16,000 colors. Such memory requirements are beyond the 256K capabilities of personal microcomputers, unless special refresh boards are added.

12.22 T-Grain Emulsions

Major advancements in the field of emulsion chemistry have led to films with significantly increased film speed and no loss of sharpness or increase in graininess. In 1982 the Eastman Kodak company announced a major breakthrough in emulsion technology with their new T-grain emulsion. Figure 12–28 compares a conventionalgrain emulsion with the T-grain emulsion at a magnification of $6,000 \times$. (An electron microscope was used, as optical microscopes are limited to magnification of about $850 \times$.) Notice that the conventional grains are pebble-shaped whereas the T-grains are flat and present a larger surface per unit volume, which maximizes absorption of incoming incident light. The result is a much faster film with about the same amount of silver and no loss in image quality.

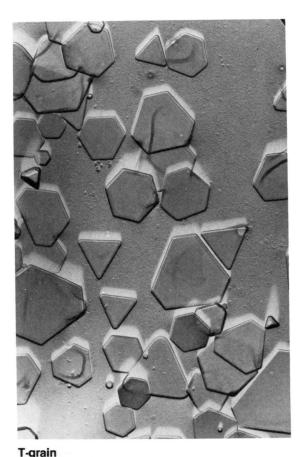

Figure 12–28 Silver halide grains at 6,000X magnification. The T-grains appear flat and absorb light more efficiently than the conventional pebblelike grains to the right.

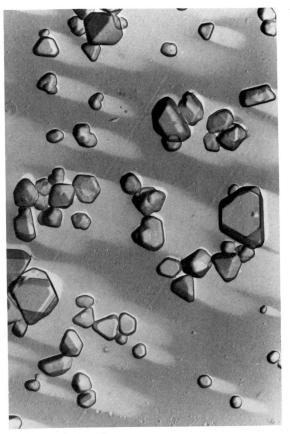

conventional grain

References

References

American National Standards Institute, Determination of ISO Resolving Power (ISO 6328-1982, PH2.33-1983).

——, Photographic Modulation Transfer Function of Continuous-Tone, Black-and-White Photographic Films, Method of Measuring (PH2.39-1977).

— Pictorial Black-and-White Films and Plates, Method for Evaluation of Developers with Respect to Graininess (PH4.14-1979).

Baines and Bomback, The Science of Photography, pp. 199-219, 245-50.

Berg, Exposure: Theory and Practice, pp. 216-59.

Carroll, Higgins, and James, Introduction to Photographic Theory, pp. 306-45.

Eastman Kodak Company, Kodak Plates and Films for Scientific Photography (P-135).

—, Understanding Graininess and Granularity (F-20).

Higgins and Perrin, *Photographic Science and Engineering* (August 1958):pp. 66-76.

Jacobson and Jacobson, Donnluping. The Leubnique of the Nagatin, pp. 52-69

Perrin, "Methods of Appraising Photographic Systems." Society of Motion Picture and Television Engineers Journal 69 (March 1960):151-56 and (April 1960):pp. 239-49.

Stroebel, Todd, and Zakia, Visual Concepts for Photographers, pp. 136-37, 140-41, 214-21, 250-51.

Thomas, SPSE Handbook of Photographic Science and Engineering, pp. 925–80.

Todd, H. and Zakia, R. Photographic Sensitometry, pp. 258-78.

Zwick, D. "Film Graininess and Density—A Critical Relationship." Photographic Science and Engineering 16:5 (1972):pp. 345-48.

, "Critical Densities for Graininess of Reflection Prints," Journal of Applied Photographic Engineering 8:2(1982):pp. 71-76.

Visual Perception

13.1 Post-Stimulus Perception

Some of the light now reaching the earth from distant stars and galaxies originated millions and even billions of years ago, thus events being observed through powerful telescopes are not happening now but actually occurred long ago. Our visual system does not operate on real time even for events viewed at small distances. The delay between when light falls on the retina in the eye and the perception, although measurable, is extremely short and is of little importance. Perceptions that occur after the light stops falling on the retina, however, are of considerable importance. Post-stimulus perceptions can be divided into categories including persistent images, afterimages, aftereffects, eidetic images, visual memory, and imagination imagery.

Laboratory studies indicate that *persistent images* last an average of approximately one-quarter second after the stimulus has been removed. If a slide of the letter A, for example, is projected on a screen in a darkened room and the presentation time is controlled with a shutter, the time cannot be made so short that the image cannot be seen, provided the luminance is increased proportionally so that the same total amount of light is available to the viewer Blach's law bredicts that the visual effect will be the same for difficunt combinations of luminance and time is long as the product remains the same. Like the photographic reciprocity law, it is not valid for high and low light values. Perception occurs with short exposure times because the persistent image keeps the image available to the viewer for somewhat longer than the actual presentation time.

Persistent images are essential to the perception of realistic motion-picture and television pictures. When motion-picture films are projected, it is necessary to darken the screen with a rotating shutter when the film is being moved from one frame to the next. The persistent image prevents the viewer from seeing the dark intervals, which would appear as flicker. Early motion pictures were sometimes referred to as "flicks" because they were shown at 16 frames per second and flicker was obvious. Even at the current 24-frames-per-second sound motionpicture speed, flicker would be objectionable without the use of a chopper blade, which produces three flashes of light for each frame, or 72 flashes of light per second.

Anyone who has photographed a picture on a television receiver at a high shutter speed realizes that there is never a complete picture on the screen. Since the image is constructed sequentially with a scanning electron beam, the persistent image is necessary for the viewer to see a complete picture. Duration of the persistent image can vary depending upon several factors, including the image luminance level and whether removal of the image is followed by darkness or by another image.

It would be reasonable to speculate that increasing image luminance would produce a stronger effect on the visual system, which would increase the duration of the persistent image, but the effect is actually the reverse. The *increase* in persistent image duration with *decreasing* luminance can be explained by comparing the visual effect with exposure of film in a camera at low light levels. If the film does not receive sufficient exposure at a selected shutter speed and the lens is wide open, the exposure time must be increased in order to obtain a satisfactory image. The visual system in effect compensates for the lower image luminance by sacrificing temporal resolution and increasing the duration of the persistent image, which is the equivalent of increasing the exposure time.

Figure 13-1 Afterimage. Stare at the isolated white X for about one minute. Then shift your gaze to the middle square and win the game of tick-tack-toe.

13.1 Post-Stimulus Perception

We can illustrate this effect with motion-picture film being projected on a screen. If flicker of the intermittent image is just noticeable at a certain luminance level, reducing the luminance will increase the duration of the persistent image to include the time the screen is dark between flashes, and the flicker will disappear. In this example, it would not make any difference if the decrease in luminance were achieved by substituting a smaller projector bulb, increasing the projector-to-screen distance, substituting a gray screen for the white screen, or viewing the screen through a neutral-density filter.

Whereas a persistent image cannot be distinguished from the image seen while the stimulus is still present, *afterimages* are recognized by the viewer as a visual anomaly. Afterimages are most evident when the eye is exposed to an intense flash of light. Looking directly at a flashbulb or flashtube when it is fired usually causes the viewer to see a vivid afterimage spot for some time. An afterimage can be formed with a stimulus having lower luminance, such as a white circle on a black background, by staring at it for a long time and then looking at a uniform surface (see Figure 13–1). One should not look at the sun, arc lights, UV sources, lasers, or other sources of radiation that can damage the retina.

Afterimages can be either negative or positive; but after looking at a bright stimulus such as a light bulb, the afterimage is typically dark (negative) if one looks at a white surface, and light (positive) if one looks at a black surface or closes and covers the eyes. Negative afterimages can be attributed to local bleaching of the visual pigments in the retina's receptors, positive afterimages to a continuation of the firing of the visual nerve cells. Negative afterimages of colored stimuli tend to be approximately complementary in color; for example, a yellow light bulb or other stimulus would tend to produce a bluish afterimage. Colored afterimages can also be seen after looking at a white light source. If the red, green, and blue visual pigments in the cones are not bleached and regenerated at the same rate, a sequence of different colors may result, usually in the order of blue, green, and red.

In contrast to persistent images, which contribute to the effectiveness of motion pictures by eliminating flicker, afterimages tend to interfere with subsequent perceptions. For example, an attempt to read immediately after looking directly at a flashbulb when it is fired can be frustrated by the afterimage. When a visual perception is altered by a preceding visual experience, the alteration is referred to as an aftereffect. Whereas the afterimage of a yellow light bulb tends to appear blue when the gaze is shifted to a gray surface, it tends to appear magenta when the gaze is shifted to a red surface. The perceptual result of mixing a blue afterimage with a red stimulus is similar to that produced by physically mixing blue and red light. If such an experiment were conducted to demonstrate an aftereffect, the viewer would be aware of the altered perception, but viewers are not commonly aware of aftereffects that occur in everyday life. Brightness adaptation to daylight alters the subsequent perception of the light level in a dimly lit interior, and it is only when the interior begins to lighten as the visual system adapts to the lower light level that the viewer is aware of the aftereffect.

Aftereffects can alter the perception of other subject attributes besides color and lightness. Watching continuous motion in one direction, such as a waterfall, can cause stationary objects to appear to move in the opposite direction due to the aftereffect. Similarly, a rotating spiral design that appears to be expanding will appear to shrink when the rotation is stopped after prolonged viewing. *Figural aftereffects*

Figure 13-2 Figural aftereffect. After looking steadily at the X above the curved lines for a minute or so and then shifting the gaze to the X above the straight lines, the straight lines tend to appear curved in the opposite direction.

are changes in the size, shape, or orientation of a perception as the result of a preceding visual experience. Fixating a set of curved lines for a minute or so will tend to make straight lines appear to be curved in the opposite direction. The reader can experience a figural aftereffect with the drawing in Figure 13–2. After looking steadily at the X above the curved lines for a minute or so and then shifting the gaze to the X above the straight lines, the straight lines tend to appear to be curved in the opposite direction.

Eidetic imagery, which is sometimes referred to as photographic memory, is an ability to retain a visual image for half a minute or longer after a stimulus has been removed from view. A 1968 study by Haber and Haber indicated that approximately 16 of 200 elementary school children experienced eidetic imagery. Since eidetic imagery is rare in mature adults, it is believed to decrease with increasing age. Eidetic imagery enables the viewer to read a printed page word for word and to see details in a complex picture for some time after removal of the printed page or picture. Whereas afterimages move with the eye, eidetic images remain stationary so that they can be scanned. Some persons who do see eidetic images are not aware of this capability limited the experience server normal in them and they assume that everyone has the same experience.

Visual memory shares many characteristics with other types of memory, but it consists of an ability to retain or to recall a visual image that is distinct from persistent images, afterimages, aftereffects, and eidetic images. Visual memories are usually divided into two categories—short term and long term. Just as a new telephone number can be remembered long enough to dial it by repeating it and keeping it in the conscious mind, so can a visual image be remembered for a short time by keeping it in the conscious mind. Experiments indicate that most people cannot retain more than five to nine independent pieces of information, such as numbers in random order, in short-term memory.

One should not expect to remember even for a short time all of the details in a complex picture. Instead, a person tends to remember the details that attract the most attention or hold the most interest. Short-term visual memory is used even as one scans a picture and fixates different parts of the image, and this enables the viewer to create a composite perception of the total picture.

Once the attention is allowed to go on to other things, longterm memory is required to revive an earlier visual image. If people are asked to indicate how many windows are in their home or apartment, they will use visual memory to form an image of the interior and then mentally move around it and count the windows. Some visual memories can be recalled easily, but those stored in the subconscious mind are more elusive and may require the use of special techniques such as hypnosis or association. Various procedures for testing visual memory include the use of recognition, where the subject selects the one picture of several that most closely resembles the original stimulus. Another procedure, known as the recall method, is to ask the person to describe the original scene from memory or to draw a picture of it. Visual memory can be improved by several methods, such as using attention to produce a more vivid perception, keeping short-term memories in consciousness longer through rehearsal, and practicing making sketches from memory.

Except for simple stimuli such as a circle or a square, visualmemory images generally are not facsimile representations of the orig-

Figure 13-3 Previsualizing a finished photograph, such as this one, before making it involves imagination imagery. (Photograph by Les Stroebel.)

inal scene, but rather they usually contain just the more important details. *Imagination imagery*, on the other hand, may bear no resemblance to any single earlier visual experience. Just as a writer can write a fictional story, so can a person create a fictional visual image that is as vivid as a visual memory of an actual object, scene, or event. Artists use imagination imagery when they draw or paint pictures of something that does not exist: a pocket watch flowing over the edge of a table in a surrealistic Salvador Dali painting is a dramatic example.

Photographers also use imagination imagery when they previsualize a finished picture, possibly even including a subject, props, background, arrangement, lighting effect, and colors (see Figure 13– 3). Imagining impossible images has been recommended as an exercise for developing creative imagination, such as visualizing a large building jumping around like a bird, the water in Niagara Falls moving up rather than down, or a full moon shrinking in size and then disappearing.

13.2 Perception of Stimulus Attributes

If one were required to describe precisely to another person the appearance of an object, using only words, it would be necessary to analyze the object's appearance in terms of attributes such as shape, color, and size. Different authorities on visual perception often disagree about the critical stimulus attributes for visual perception, the relative importance of each, and even the definitions of the terms. For example, the word *form* generally implies different object qualities to artists and photographers. Six attributes considered especially important to photographers will be discussed here: color, shape, depth, size, sharpness, and motion.

13.3 Color Hue

To accurately describe or identify a color, three different qualities of the color must be considered: hue, lightness, and saturation. Hue is the quality associated with color names such as red, green, blue, cyan, magenta, and yellow. White, gray, and black are also colors, but they are all neutral—without hue. Neutral colors are sometimes referred to as achromatic colors.

Since color hues are commonly associated with names, problems in communicating specific information about colors will millin unless everyone uses the same names for the million colors. Unfortunately, many children have lemmal that the names of the primary colors of million colors used for painting are blue, red, and yellow, rather than the correct names of cyan, magenta, and yellow. Advertisers have not helped matters by using exotic-sounding or unusual names for colors rather than more common and descriptive names. Color notation systems such as the Munsell system (see Section 15.5) have done much to bring order to the identification of colors. The Munsell system uses five basic hues: red, yellow, green, blue, and purple. The complete Munsell hue circle, which includes subtle transitions between adjacent hues, has 100 hues—which is about the maximum that persons with normal color vision can distinguish in side-by-side comparisons.

Much of the discussion about color as it relates to color photography can be accomplished with combinations of the three additive primary colors: red, green, and blue. Combinations of pairs of these colors of light produce cyan, magenta, and yellow, which are called additive secondary colors or subtractive primary colors. The relationship of these six hues is often represented in the Maxwell triangle, shown in Figure 13-4.

Red, green, and blue are considered additive primary colors because by combining red, green, and blue *light* in different proportions it is possible to produce almost any color, including neutral colors. Cyan, magenta, and yellow are considered subtractive primary colors because dyes and other *colorants* in these hues absorb red, green, and blue *light*, respectively, from the white viewing light. Perceptually, however, primary colors are defined as those hues that appear to be pure rather than a mixture of other hues. In this sense, red, green, blue, and yellow are primary colors, and they are identified as *psychological* primary colors. Including the neutral pure colors of black and white increases the number of perceptual primary colors to six.

Persons having normal color vision are identified as *normal trichromats*, based on the three types of cones in the retina, which are sensitive to red, green, and blue light. Not all normal trichromats, however, respond to colors in exactly the same way. For this reason, scientific studies of color vision make use of the average response of a number of persons having normal color vision.

Red

Figure 13-4 The Maxwell color triangle.

There are a number of types of defective color vision. A

person who is missing one of the three types of cone pigments is known as a *dichromat*. *Monochromats* are missing two of the three cone pigments (or possibly have rhodopsin, the rod photopigment, in the cones). Dichromats have difficulty distinguishing between red and green, or more rarely between blue and yellow. There are very few monochromats, but their vision is the equivalent of black-and-white photography.

The red, green, and blue cone sensitivities suggest a simple trichromatic theory of color vision, but much of the experimental evidence supports the opponents' theory of color vision, whereby information from the red-, green-, and blue-sensitive cones is thought to be transmitted in combinations—specifically red-green, blue-yellow, and black-white—through three separate channels.

Other than missing one or two of the three types of cone photopigments, defective color vision can also be associated with reduced sensitivity of one or two of the three cone types, or with a shift in sensitivity along the spectrum for one or more of the cone types. People who have all three types of cone photopigments but who do not have normal color vision for either of the reasons cited are referred to as anomalous trichromats—as distinct from normal trichromats, dichromats, and monochromats.

A person with normal color vision may have inaccurate perception of stimulus colors under certain conditions. Some of these conditions are (a) when the image is formed near the periphery of the retina; (b) when the light level is very low or very high; (c) when the stimulus is very small in area; (d) when the stimulus is presented for a very short time; (e) when the stimulus is illuminated with other than white light; and (f) when the viewer is adapted to a different color. Accurate color identification requires normal color vision, standard viewing conditions, and the opportunity to make side-by-side comparisons with standard colors.

Heredity is responsible for most cases of defective color vision, although it can result from other causes such as the use of certain drugs, excessive use of alcohol, and brain damage. About 8% of Caucasian males and 0.4 percent of females of all races have some form of defective color vision. There is no cure for congenital defective color vision. Some people whose occupations require discrimination between certain colors have been helped by using filters of different colors over the left and right eyes. Photographers with defective color vision are able to make color prints that are acceptable to themselves, but the prints often do not appear correct to people with normal color vision.

Defective color vision can be detected with various types of tests. One pseudoisochromatic test contains simple geometric designs made up of colored circles against a background of gray circles (see Figure 13–5). People with defective color vision are unable to see some of the designs, which are visible to persons with normal color vision. Another type of test requires the subject to arrange color samples that vary in hue in the correct order to provide a consistent transition. This test can also determine how well people with normal color vision car make small discriminations between colors. With this test, defective color vision is revealed by large errors with certain hues, whereas low discrimination is revealed by randomly distributed errors with all hues.

13.4 Color Lightness

Luminance ratios as low as 100:1 in a photographic print can create the perception of a range of tones from white to black. This

Figure 13–5 A pseudoisochromatic color vision test plate containing geometric designs of colored circles surrounded by gray circles. A person with normal color vision will be able to see the designs (left), whereas a person with defective color vision will not be able to see them (right).

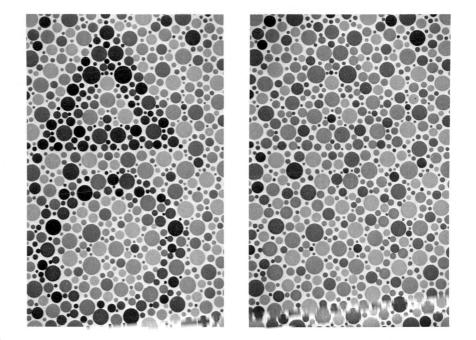

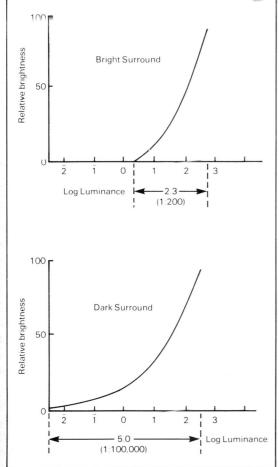

Figure 13-6 Curves representing the perception of brightness in relation to subject luminance with a bright surround (top) and dark surround (bottom). The difference in the log luminance ranges indicates that more contrasty photographic images are required for projection viewing in an otherwise darkened room than for viewing with normal room illumination.

fact is misleading with respect to the ability of the visual system to detect differences in lightness (reflected light) or brightness (light sources) over a wide range.

Viewing transparencies or projected slides in a darkened room requires a somewhat greater luminance ratio to produce the perception of a range of tones from white to black—approximately 500:1 (see Figure 13-6). Since reversal color films typically produce a maximum density of over 3, it is possible to obtain a luminance ratio of 1,000:1 in the image, compared to a maximum density of approximately 2 in typical photographic papers. Placing one gray scale in direct sunlight and a second gray scale in the shade on a clear day when the lighting ratio is about 8:1 produces a luminance ratio of approximately 800:1 between the light end of the gray scale in sunlight and the dark end of the gray scale in the shade. A person may be able to see the separation between all steps on both gray scales due to *local adaptation*, whereby sensitivity of the visual system is increased in darker areas and decreased in lighter areas.

When general adaptation is taken into account, the ratio of luminances over which the visual system responds is truly amazing. A white object in sunlight has a luminance of approximately 100 million times that of a white object in starlight, and yet both can be seen quite easily when a person is fully adapted to each light level. Under optimum laboratory conditions a person can detect a flash of light having a luminance of only 1/100 that of white paper in starlight, and when adapted to bright light a person can detect luminance differences up to 1,000 times that of white paper in sunlight, which is approaching luminances that can be damaging to the retina. Thus the total response range of the visual system is approximately 10 trillion:1, or a log luminance difference of 13.

It is important to make a distinction between *luminance*, which is psychophysical and measurable with a light meter, and the perception of brightness (or lightness), which is influenced by physiological and psychological factors and is not directly measurable. The eye is not a dependable instrument for measuring luminance values.

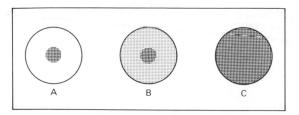

Figure 13-7 Field of view in a visual densitometer. (A) Dark small circle is the unknown density of the sample. The larger circle is the matching field set at 0 density. (B) The density of the matching field is increased but insufficient to match the density of the sample. (C) More density is added to the matching field and it now matches the density of the unknown sample. The known density of the matching field now becomes the density of the sample.

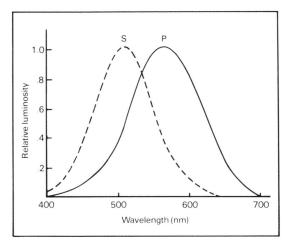

Figure 13-8 Photopic (P) and scotopic (S) response curves for the human eye.

For example, it is difficult for a person to judge whether a black surface in direct sunlight is reflecting more or less light than a white surface illuminated with lower-level incandescent light indoors, because of two variables: reflectance of the two surfaces and the amount of light falling on them. The adaptation level of the visual system can affect perception in that a surface with a fixed luminance will appear lighter when the eye is dark adapted than when it is light adapted. Also, a gray tone appears lighter in front of a black background than in front of a white background, an effect known as lateral adaptation or simultaneous contrast.

The eye, however, is very good as a null instrument where very small luminance differences can be detected in side-by-side comparisons. Thus, visual densitometers can be quite accurate where the sample being measured is seen in a circle surrounded by a ring that can be adjusted to match the inner circle in brightness (see Figure 13-7).

It is more difficult to match the brightness or lightness of two areas if they differ in hue. If, for example, the inner circle in a visual densitometer is red and the outer ring is blue, the operator will have more trouble judging when the two match in brightness. When it is important to match the brightness of samples having different hues, a device called a flicker photometer can be used to present the two fields to the viewer alternately in rapid succession. When the two do not match closely in brightness, a flicker is seen. It is important for photographers to develop some skill in judging the lightness of subject colors so that they can anticipate whether there will be tonal separation in black-and-white photographs, such as in a photograph of a red object in front of a blue background made on panchromatic film. Viewing filters are used by some photographers in an effort to deemphasize hues and thereby make lighting effects easier to see.

Equal amounts of light of different wavelengths do not generally appear equally bright. With light levels high enough for the retinal cones to function—*photopic* vision—the greatest sensitivity is at a wavelength of approximately 555 nm, which is usually identified as green yellow (see Figure 13–8). Since there is some variation among persons with normal vision, the luminosity function curve, or the American Standard Observer, is based on the average of a number of observers with normal color vision. With low light levels where only the rods function—*scotopic* vision—peak sensitivity shifts to a wavelength of about 507 nm. This change is known as the Purkinje shift, and can cause two colors, such as blue and red, that match in lightness when viewed in bright light to appear different in lightness when viewed in dim light, with the blue appearing lighter.

It is convenient to think of the limits of the visual system's response to electromagnetic radiation as being 400 nm and 700 nm. Although responses beyond these values are somewhat limited, 380 nm and 770 nm are more accurate limits, and responses have been detected as low as 300 nm and as high as 1,050 nm. The cutoff on the low end tends to increase with age as the transparent material in the eye become more yellow and absorbs more ultraviolet and blue radiation.

Numerous attempts have been made to find a mathematica relationship between stimulus luminances and perceived brightnesses but three laws—Weber's law, Fechner's law, and Stevens' power law are especially important. According to Weber's law, if the luminance of a certain stimulus must be increased 2% to produce a detectable change in brightness, the same percentage increase (but larger or smalle

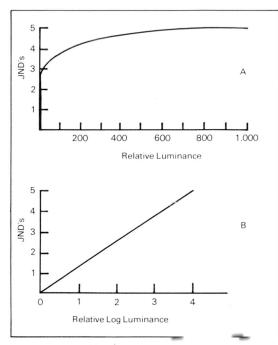

(A) and Fechner's law (B) for the mathematical relationship between stimulus luminance and perceived brightness.

Figure 13–10 Contrast between adjacent patches appears to decrease near the dark end.

amounts) will be required at different luminance levels. When plotted as a graph with luminance on the horizontal axis and luminance increase required to produce a detectable change on the vertical axis, an asymptotic curve is produced, which reveals the constantly changing relationship between the input and output variables (see Figure 13–9A).

Fechner's law in effect supports the relationship expressed by Weber's law, but by substituting log luminance for luminance on the horizontal axis, a straight-line relationship is produced (see Figure 13–9B). Since log luminance varies inversely with density, the Fechner straight-line graph indicates that a gray scale or step tablet having uniform density increments between adjacent patches will also appear to have uniform decrements in lightness or brightness. Examination of such a gray scale or step tablet reveals that the contrast between adjacent patches appears to decrease near the dark end, which contributes to the difficulty of retaining good shadow contrast in photographs. Other experiments reveal that the straight-line relationship between brightness and log luminance breaks down in the low-brightness region as illustrated in Figure 13–10. This decrease in perceived contrast in the darker areas bears some resemblance to the decrease in alluminimit tances in camera optical inner (10) tamera flare.

Stevens' power law is based on perceived brightnesses and the corresponding luminances raised to some power. A power of 0.33 is commonly used for perception of brightness, although changes in the apparent area of the stimulus require changes in the power value such as 0.50 for a point source. None of the laws, however, is universally accepted as adequate in establishing the relationship between stimulus luminances and perceived lightnesses or brightnesses.

It is not difficult to compare predictions of perceived brightness/lightness according to Fechner's law (based on log luminance) and Stevens' law (based on raising the luminance to a power of 0.33). The value scale in the Munsell system of color notation consists of a series of neutral tones that vary from black to white, as in a photographic

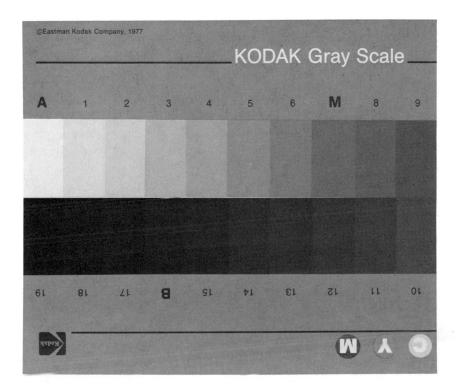

gray scale, but selected so that the lightness increments between adjacent patches appear to be uniform. Although the choices of the gray tones that represent equal differences in lightness were subjective, the average of a large number of trials was used to minimize variability of judgment of individual viewers.

Objective measurements can be taken from the Munsell value scale patches with a reflection densitometer. Since density is a logarithm, the density differences should be the same between all adjacent patches according to Fechner's law. The density readings in the third column of Table 13–1 reveal that the density differences actually ranged from a low of .117 at the light end of the value scale to a high of .41 at the dark end.

Objective relative luminance values or reflection factors can be obtained for the same Munsell value scale patches by taking the reciprocal of the antilog of the densities. When the relative luminances are raised to a power of 0.33, the differences between adjacent patches are quite uniform, ranging from a low of 0.35 to a high of 0.39, as shown in the last column of Table 13–1. Thus, while the Munsell patches were selected to provide equal lightness increments between adjacent patches, Fechner's law predicts that the perceived lightness difference between the two darkest steps will be about 3.5 times that of the two lightest steps. Stevens' power law, on the other hand, predicts that there will be only a 1:1.1 ratio between the smallest lightness difference and the largest lightness difference of adjacent steps. Furthermore, the power numbers in the last column reveal that the small variations in the predicted lightness differences are random rather than in increasing or decreasing order.

Table 13–1 A comparison of predicted perceived lightness differences between adjacent patches in the Munsell value scale according to Fechner's law (third column) and Stevens' power law (last column).

Munsell Value	Density	Density Difference	Relative Luminance	L ^{0.33}	L ^{0.33} Difference
10	0.000		85.11	4.334	
10	0.117	.117	65.01	3.965	> .369
9	0.240	.123	48.97		> .354
8		> .140		3.611	> .364
7	0.380	> .150	35.48	3.247	.350
6	0.530		25.21	2.897	
	0.717	. 187	16.33	2.514	.383
5	0.930	.213	10.00	2.138	> .376
4		.260			> .383
3	1.190	> .330	5.495	1.755	> .390
2	1.520	.410	2.570	1.365	.365
1	1.930 -		1.000	1.000 -	
1		^a (Fechner)			^b (Stevens)

^aFechner: $X = K \log L + A$, where K is a constant, L is luminance, and A is absolute threshold for luminance.

^bStevens: $X = K L^n$, where K is a constant, L is luminance, and n is a power value—0.33 for brightness.

13.5 Color Saturation

Saturation is the third dimension of color. It is defined as the extent to which a color departs from neutral. Thus grays have no saturation, and spectral colors have high saturation. The saturation of pure blue light can be reduced by adding either white light or yellow (the complementary color of blue) light, and the saturation of a blue dye or other colorant can be reduced by adding a gray or yellow colorant.

It is difficult for a person to judge the saturation of a color seen in isolation except in general terms such as low, moderate, and high saturation. In side-by-side comparisons, where the eye functions as a null instrument, it is easy to detect small differences in saturation provided the two samples match in the other two attributes—hue and brightness/lightness. The smallest difference that can be detected in saturation, or any attribute, is called a just-noticeable difference (JND).

Whereas there are upper and lower limits to the ability of the eye to detect changes in brightness, and limits at both ends of the visible spectrum with respect to seeing different wavelengths of electromagnetic radiation or hues, there are no limitation of the visual system at the lower and higher under of the range of saturations of stimulus theore, in the been a problem over the years to obtain primary-color dyes, inks, and other colorants with sufficient saturation to reproduce subject colors satisfactorily in photographic, photomechanical, and other images. Color masks in negative color films and black ink images in four-color photomechanical reproductions are compensations for the limited saturation of the dyes and the inks. The most saturated color of a specific hue and lightness that can be reproduced with a given system is called a *gamut color. Gamut* is also used to identify the full range of colors that can be produced with different combinations of the primary colors with a given system.

The perceived saturation of a given color sample can vary depending upon a number of factors. A blue sample will appear more saturated when viewed in front of a yellow background than in front of a gray background, and it will appear less saturated when viewed in front of a blue background of higher saturation. Whereas large juxtaposed areas of yellow and blue enhance one another's perceived saturation-an effect known as simultaneous contrast-the opposite effect can result when small areas of the same two colors are closely spaced in a picture or design. In this configuration, the colors tend to neutralize each other, an effect known as assimilation. Viewing large areas of complementary colors, such as blue and yellow, in sequence rather than simultaneously will also increase the perceived saturations, an effect known as successive contrast. Prolonged viewing of a color sample will decrease the retina's sensitivity to that color and cause it to appear less saturated, an effect known as chromatic adaptation. Shifting the gaze to a neutral surface will tend to produce an afterimage that is approximately complementary in hue.

Color-temperature variations in viewing lights can produce either an increase or a decrease in the perceived saturation of colors. A decrease in the illumination level can produce a decrease in the appearance of saturation, and in dim light where only the rods function, even saturated colors tend to appear neutral. For the same reason, colors appear most saturated when viewed directly so that the images fall on the fovea of the retina, where the concentration of cones is highest.

It is also possible to induce the perception of hues with low to high saturation in neutral subjects. The color afterimage produced with prolonged viewing is one example; chromatic sensations can also be produced when black-and-white images are presented to a viewer intermittently at frequencies of about five per second; when certain black-and-white designs are rotated at appropriate speeds; and even with certain stationary black-and-white designs that are viewed continuously, where the involuntary small-scale nystagmus movements of the eyes produce the necessary interactions in the visual response mechanism. These perceptions of colors in neutral stimuli are known as *subjective colors* or *Fechner's colors*.

13.6 Shape

The word *shape*, as applied to an object, refers to its outline. Silhouettes emphasize shape and eliminate or deemphasize other attributes such as color, form, and texture. We depend heavily upon the attribute of shape for the identification of many objects, and often that is the only attribute needed for a viewer to be able to recognize the object in a drawing or photograph.

Three-dimensional objects actually have many shapes because each can be viewed from many different angles. The choice of viewpoint selected by a photographer to provide the best shape for an object being photographed is important even when the object is lighted to provide detail, but it becomes critical in a silhouette. Silhouettes of people are commonly recognizable only in a full left or right profile view; thu profile views are normally used for the images of famous people or coins. Figure 13–11 shows an early American print in which George

Figure 13-11 The profile of George Washington, even though camouflaged, is easily recognized in this picture by Henry Inman. (Courtesy of the Metropolitan Museum of Art, New York City, New York.)

Figure 13-17 MUDD's figures an ambiguous picture where the center area can be seen either as a vase or as a background for two profiles.

Washington is memorialized with an embedded profile between two trees.

Photographers can control the emphasis on object shapes by controlling the separation or contrast between object and background. The term *figure-ground* is commonly used to refer to the subject of a picture and the surrounding area. Figure-ground is an important concept in Gestalt psychology, where the emphasis is on the perception of the whole rather than an analysis of the parts. Experienced photographers have little difficulty separating an object from the background (figure from ground) in a photograph by means of choice of background, lighting, depth of field, etc. In military camouflage the objective is to conceal the shapes of objects so that they appear to be part of the background and therefore escape detection. In pictorial photography it is often just as important to de-emphasize shape in certain areas of a photograph as it is to emphasize it in other areas, and the principle of camouflage can be used for this purpose.

Although it is sometimes difficult to see the shape of an object clearly when it is not well separated from the background, we are seldom confused as to which is the object and which in the background when we can see both, either with actual objects or in photographs of object. It is not difficult, however, to make simple drawings in which a given area can be seen alternately as figure and as ground. In a famous Rubin ambiguous picture, for example, the center area can be seen either as a vase (figure) or as a background for two profiles (see Figure 13–12).

It is usually unnecessary to see the entire outline shape of a familiar object in order to be able to identify it and to visualize its entire shape. Most people, for example, perceive the moon as being round, not only when there is a full moon but also when there is a half-moon or quarter-moon and the shadow side cannot be separated from the background (see Figure 13–13). One can conduct a simple

Figure 13–13 Viewers have little difficulty visualizing Saturn as being a complete sphere, due to the principle of closure, even though there is no detail on the shadow side here. (This photograph was taken by Voyager 1 from a distance of 3.3 million miles on November 16, 1980.) (Courtesy of NASA.)

Figure 13-14 Illusory figures. The long straight lines tend to appear curved due to the influence of the diagonal lines.

Figure 13-15 Which is the perfect square?

experiment by looking at objects outdoors through Venetian blinds, starting with the slats in the full open position and then gradually closing them to determine how small the openings can become before encountering difficulty in identifying the objects. A small number of dots arranged in a circular pattern can easily be seen as representing a circle. In Gestalt psychology this effect is known as the principle of *closure*, where the viewer mentally fills in the spaces between the picture elements. A distinction should be made, however, between closure, and *fusion*, where the optical-retinal system in the eye cannot resolve the small discrete elements as in a halftone reproduction of a photographic image at a small to moderate magnification.

Reading provides an excellent example of how the mind fills in spaces between fixation points. The area of sharpest vision represented by the fovea of the retina is very small, so that when a person fixates one letter in a line of type, only a few letters on each side can be seen clearly. The reason it is possible to read rapidly with only two or three fixations per line is that the reader recognizes groups of letters as familiar words without examining each letter, and can understand the meaning of a sentence without examining each word. Printed material that contains unfamiliar words and a high concentration of factual information requires more fixations per line. Eye-motion studies have provided valuable information concerning reading, and how we look at photographs and other pictures. Viewers of pictures rarely scan them as thoroughly as one would a printed page, but rather fixate a few points in the picture and let the mind fill in the shapes and details between the fixation points.

The accuracy with which we perceive shapes is important in the study of visual perception, but it is not considered as critical in our daily lives as normal color vision and good acuity—which are usually tested before one can obtain a driver's license or be permitted to perform certain occupational tasks. It has been demonstrated that it is easy to deceive a viewer about shape under certain conditions; for example, a straight line can be made to appear curved, as shown in Figure 13– 14. Under normal conditions, however, we are best able to detect changes in images having simple geometrical shapes such as straight lines, squares, circles, and triangles (see Figure 13–15). We are also better at making comparisons with superimposed or side-by-side images than with images that are separated in time or space, where memory becomes involved.

The perception of shapes is complicated by the fact that image shape changes with the angle and distance of the object relative to the eye or the camera lens. Parallel subject lines are imaged as converging lines except when viewed or photographed perpendicularly, and tilted circles are imaged as ellipses. Through experience we have learned that the parallel lines and circles do not change shape with a change in viewing angle, so we mentally compensate for linear perspective effects. *Shape constancy* refers to this stability of the perceivec shape of objects as the viewing or camera angle changes.

Shape generalization is the tendency to perceive an irregula shape as a simpler shape—obtuse and acute angles seen in perspective may be perceived as right angles, and an ellipse seen in perspective may be perceived as a circle (see Figures 13-16 and 13-17). Memorie of perceived shapes can also change with time. The simplification c irregular shapes due to memory is called *leveling*; and the exaggeration of a distinctive feature, such as a small gap in an otherwise continuou line, is called *sharpening*.

Figure 13–16 Due to the principle of shape generalization, the ellipses in this image are generally perceived as perspective views of circles.

Figure 13-17 When the sheet of film in the top photograph is viewed obliquely, it is perceived as being rectangular, due to shape generalization, even though the perpendicular view in the bottom photograph reveals that the film has only one 90° corner.

13.7 Depth

The perception of depth is important to photographers in two different contexts: how depth is perceived when viewing the threedimensional world, and how depth is perceived when viewing photographs and other two-dimensional representations of the real world. Binocular vision, whereby objects are viewed from slightly different positions with the left and right eyes, is commonly given much of the credit for the perception of depth in everyday life. The fact that a threedimensional scene does not suddenly appear two-dimensional when we close one eye is evidence that there are other depth cues besides those provided by binocular vision.

When an object in a three-dimensional scene is fixated with both eyes, the images formed in the two eyes are for the most part identical. To the extent that they are identical, the mind can fuse them into a single image. The inability to fuse the two images in certain areas, because of differences in viewpoint of the two eyes, is referred to as *disparity*, and the disparity provides the mind with important depth information (see Figure 13-18).

Disparity can be demonstrated very easily by looking at a fairly close object, then covering the left and right eyes alternately and noting how objects in the background seem to change position. If the background jumps when the right eye is covered but not when the left eye is covered, the indication is that the right eye is the dominant eye.

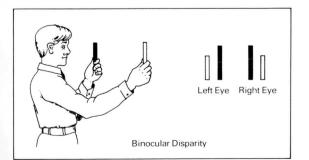

Figure 13-18 Binocular disparity.

Photographers usually feel more comfortable when they use the dominant eye for operations that can be done with only one eye, such as using a camera viewfinder or a focusing magnifier.

Disparity becomes so slight with objects at distances greater than approximately 450 feet that binocular vision contributes little to depth perception. Since the pupils in the eyes are separated, on the average, by 2.5 inches, at a distance of 450 feet the ratio of distance to separation is approximately 2,000:1. Conversely, at very close distances the disparity increases, and it is even possible to see opposite sides of one's hand when it is placed in a thumbing-the-nose position. When completely different images are presented to the two eyes with an optical device, so that no fusion is possible, the mind tends to reject one image or the other, sometimes both on an alternating basis.

There is no disparity when one looks at a photograph or other two-dimensional image with both eyes. Thus the perception of depth in photographs must be due to cues other than binocular vision. On the other hand, the absence of disparity in two-dimensional pictures may remove a minor source of tension that makes some realistic pictures more satisfying to look at than the original scenes they represent.

Stereopsis, the perception of depth due to binocular vision, can be created in photographs. By taking two photographs of the same scene from slightly different positions, separated horizontally by about 2.5 inches, and presenting them so that each eye sees only the photograph taken from the corresponding position, the same disparities are produced as when looking at the original scene. Various methods have been used to present the two images to the appropriate eyes. With the stereoscope, the pictures are placed side by side and the lenses make it possible for each eye to view the corresponding image. The need for stereoscope lenses can be eliminated by viewing specially colored superimposed images with glasses that have different-color filters or polarizing filters that are rotated at right angles to each other. The two images can also be presented as alternating narrow strips covered with transparent lenticular embossings that present each set of strips to the appropriate eye. With holography, there is a single photographic image but different interference patterns are presented to the two eyes so that the reconstructions constitute different images.

Convergence of the two eyes is stronger when viewing : closeup object than a distant object, which provides the mind with additional binocular information about depth (see Figure 13–19). Also the focus of the eyes changes with object distance, although this is no a binocular function and the viewer is usually aware of the effect only when the object distance approaches the near point—the shortest dis tance the eye can focus on without strain. The near point varies amony individuals, and increases with age from a minimum of approximatel 3 inches to a maximum of approximately 84 inches.

Although the eyes have a limited depth of field like photographic lenses, the depth of field of the eyes tends to be relativel large because of the short focal length (17mm). In addition, since th focus changes automatically as we look at different parts of a three dimensional scene, and the angle of critical vision is very narrow, dept of field plays a much smaller role in the perception of depth in the rea world than it does in photographs.

Other cues that contribute to the perception of depth i viewing both the real world and two-dimensional photographs include (1) aerial perspective, where distant objects appear lighter and les contrasty than nearby objects; (b) overlap, where closer subjects obscur

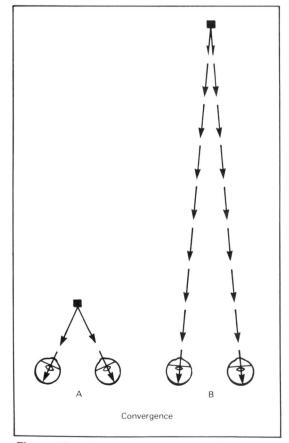

Figure 13-19 Convergence.

Aerial Porspective (Photograph by Kerry S. Coppin)

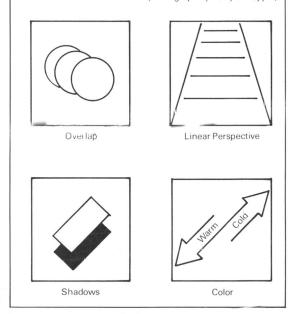

Figure 13-20 Some depth cues.

parts of more distant objects or the background; (c) linear perspective, where parallel subject lines converge in the image with increasing distance, and the images of objects of uniform size decrease with increasing distance; (d) lighting, where, for example, shadows provide a type of yardstick for measuring distances; and (e) color, where warm colors are known as advancing colors because they tend to appear closer than cool, receding colors (see Figure 13-20).

So far, the emphasis in the discussion of depth has been on the perception of distance, but the term *depth* properly includes two other important categories: form and texture. Form refers to the threedimensional quality of objects, as distinct from the two-dimensional outline shape (see Figure 13–21). Form is the quality that can be determined through the sense of touch with the eyes closed, such as the spherical form of a baseball or the cubical form of a pair of dice. Effective representation of form in two-dimensional photographs depends largely upon the choice of an appropriate viewpoint and the use of light to reveal the different planes and curved surfaces with highlights, shadows, and appropriate gradations of tone.

Texture refers to the small-scale dopth characteristics of a type that might be felt with the fingertips, such as the roughness of a wood file or the smoothness of window glass. Effective representation of texture in two-dimensional photographs depends largely upon using an appropriate scale of reproduction, as well as lighting that produces shadows in the recessed areas and highlights in the raised areas. Photographs made through optical and electron microscopes reveal that many surfaces thought of as being smooth, such as writing paper, appear to have a rough texture or even form and distance when magnified sufficiently. Conversely, the mountains on the moon appear to have a finger-touching type of texture when photographed from a distance with a small scale of reproduction.

13.8 Size

The perceived size of an object has little relationship to the size of the image on the retina (or the size of the image in a photograph of the object). An automobile, for example, is judged to be about the same size when viewed over a wide range of distances—an effect known as size constancy. Experiments have demonstrated that the accuracy of judging the size of an abstract shape, such as a circle, depends greatly upon being able to estimate the distance. As distance cues are systematically eliminated, the accuracy decreases (see Figure 13–22).

When the precise size of an object must be known, a ruler or other measuring instrument is used for a direct side-by-side comparison. As with the perception of other object attributes, the eye is most precise when used as a null instrument in making comparisons between adjacent stimuli. It is sometimes necessary to include a ruler beside an object in a photograph when it is important to be able to determine the size of the object, as in some forensic photographs. In pictorial photographs, it is usually sufficient to include an object of known size with the unfamiliar object, and to provide good distance cues.

It is not difficult to deceive a viewer about the size of objects represented in photographs. Use of a short focal length camera lens tends to make foreground objects appear larger than normal and background objects appear smaller than normal when the photograph is

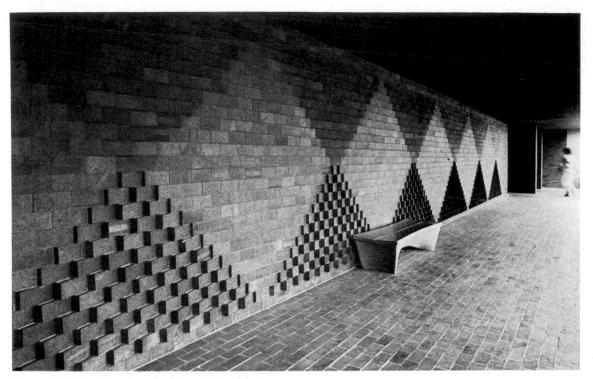

Figure 13-21 Three-dimensional form in the original scene is represented by the different planes of the ceiling, wall, and floor; the bench; and even the protruding bricks that make up the triangular designs in the wall. The pattern of the protruding bricks is reduced in size sufficiently so that the viewer can visualize feeling the roughness of the pattern with the fingertips, a characteristic of texture.

viewed at a comfortable distance; and long focal length camera lense have the reverse effect. Line drawings can also cause viewers to misjudge the relative length of lines or size of images. The Muller-Lyer arrow illusion and the Ponzo railway lines illusion both contain lines of equa length that are perceived as being unequal. In nature, the moon i commonly perceived as being larger when it is near the horizon that when it is overhead. Various explanations of this illusion have bees offered, but the most acceptable one is that the moon is thought of a being farther away when it is near the horizon, as an airplane would be, so that when the retinal image remains the same size as the moor moves toward the horizon from overhead it is perceived as being a large object farther away. Emmert's law—that the size of an afterimag increases in proportion to the distance to the surface onto which th image is projected—supports this explanation.

13.9 Sharpness

As an object of moderate or small size is moved farther awa from a viewer and the retinal image decreases in size, a point is reache where the viewer is no longer able to see the object. Visual acuity is measure of the ability of a person to see detail. Visual acuity tasks at commonly classified as *detection*, *localization*, *recognition*, and *resolutior* with different types of test targets used for each task. A black dot c a black line on a light background can be used to measure detectior It is usual to measure the visual angle subtended by the appropriat dimension of the test target, rather than specify both the target d

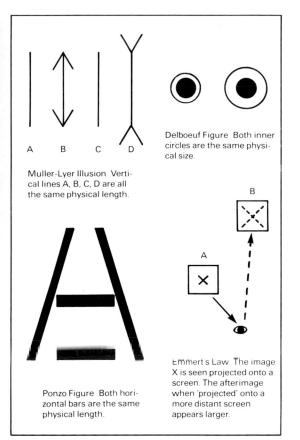

Figure 13–22 Sizeldistance constancy. For familiar objects, size and distance are inseparable. For an object to be the same actual size at a farther distance it has to be larger, and therefore it appears to be larger. (The moon illusion is yet another example of this phenomenon.)

mension and the distance. A person with normal vision may be able to detect a black line having a width that represents a visual angle of only 1/120 of a minute. Visual acuity is the reciprocal of this angle in minutes, or 120. This value corresponds to a 1/4-inch black line, the thickness of a lead pencil, at a distance of 4/5 of a mile.

Localization is the ability to see where the opening in a Landolt C or the vernier displacement between two straight lines is located. Maximum acuity for the vernier lines is about 30, or about one fourth the acuity for the detection of a black line.

Snellen eye charts containing letters of the alphabet of varying size are commonly used for eye examinations to test vision. Maximum acuity for this visual task is about 2.

Resolution can be tested with a target having parallel black bars separated by spaces equal to the width of the bars, similar to targets used for measuring the resolution of photographic systems or components. The maximum acuity for this task is also about 2.

Visual acuity can be affected by other factors such as the illumination level, where acuity increases steadily with the illumination level over a wide range. Pupil size also affects acuity, with the maximum being obtained at an opening of approximately f/4. At the maximum opening of f/? all trathout to more, and at the smallest opening of f/8 diffraction lowers the acuity.

13.10 Motion

Motion refers to a change in position of an object, and the rate of motion is identified as speed. The speed of a moving object may be either too fast to be detected (a speeding bullet) or too slow (the moon, from moonrise to moonset). Slow movement can be detected more easily when the movement takes place in front of stationary objects. One experiment revealed that when a reference grid was removed, the rate of movement of a spot had to be increased 10 times to be detectable. In fact, a stationary spot of light in an otherwise darkened room is commonly perceived as moving-an effect known as the wandering-light phenomenon. Although the speed of a moving object can be measured in units such as miles per hour, viewers in general are not very accurate in estimating the rate of movement. Such ability improves with experience when subjective judgments can be compared to objective measurements; an experienced batter in a baseball game, for example, can detect the difference between an 80 mph pitch and a 90 mph pitch.

The human visual system is designed to detect motion over the entire area of the retina, so that moving objects in the periphery of the field of view, up to 90° to the side, can be detected. If identification of the moving object is important, a semireflexive movement of the cyes enables the viewer to position the image of the object on the fovea of the retina, where visual acuity is highest. Once the object is fixated, the visual system is very good in tracking the movement unless the speed is very high and the direction of movement is erratic. Strangely, it is almost impossible to pan the eyes smoothly except when tracking a moving object. Instead, the eyes tend to move in quick jumps, called saccades. By closing the eyes, one may be able to pan the eyes smoothly by visualizing tracking a moving object. Skill in tracking rapidly moving objects is important for both motion-picture and still photographers, as well as for participants (and spectators) in many sports and other recreational and occupational activities.

Figure 13–23 Blurring the image is one of several methods of representing motion in a still photograph. (Photograph by Robert Mulkern.)

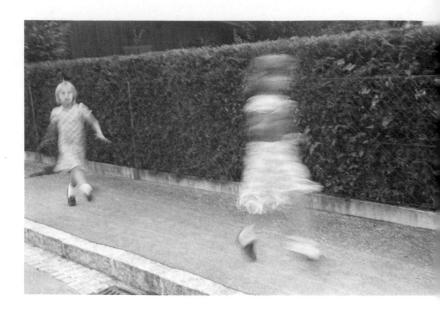

With present technology, it is impossible to accurately recreate motion photographically. In a single still photograph it is necessary to rely upon implied motion. A blurred image of a racing car i generally perceived as representing a rapidly moving object (see Figur 13-23). Similarly, a sharp image of a racing car with a blurred back ground implies motion. Motion can also be implied without blur, suc as a sharp image of a skier going down a steep slope or suspended i air. With two or more still photographs viewed side by side, a chang in position of an object is perceived as representing movement. A serie of such still photographs viewed sequentially in the same positio produces a more realistic perception of motion; and if the amount e change in position of the images and the rate of presentation of th still photographs is appropriate, the viewer accepts the images as representing smooth and continuous movement, as with contemporarmotion pictures.

This perception of motion—when the image of an obje appears in different positions in a sequence of still pictures presente in rapid succession—is known as the *phi phenomenon*. The phi phenon enon can be demonstrated in a darkened room with as few as two flash of light, provided the separation in time and space are appropriate. I sound motion pictures, a projection rate of 24 frames per second pre duces generally acceptable results, although rapid panning of the mtion-picture camera can produce an unrealistic jumpy effect. Early mm motion pictures used a projection rate of 16 frames per seconwhich was increased to 18 frames per second for super-8 motion pitures.

The phi phenomenon can be demonstrated effectively t illuminating a moving object with a variable-speed stroboscopic ligh where the flash frequency can be altered from approximately one flas per second to a frequency that produces the perception of a continuolight source (see Figure 13–24). A black circle with a white radial life rotated on a motor will appear to be standing still when the light flash once per revolution. Slowing down the frequency of the stroboscoplight so that the disk makes a little more than one complete revolution between flashes will make it appear to be rotating in the correct d rection. Speeding up the frequency so that the disc does not qui complete a full revolution between flashes will make it appear to be

Figure 13–24 A variable-speed stroboscopic light source was used to record 24 images of a dancer in a single photograph to produce a perception of implied motion. In a sound motion picture 24 still photographs are projected in rapid sequence to produce a perception of realistic motion due to the phi phenomenon. (Photograph by Andrew Davidhazy.)

rotating in the reverse direction. This explains why wagon wheels

Motion-picture photography offers the advantage over direct vision of being able to speed up or slow down motion by altering the rate at which the individual pictures are exposed in the camera. In time-lapse photography, a flower can change from a bud to full bloom in seconds by exposing the film at a rate of about one frame per hour. Conversely, motion that is too rapid to be seen with the eye can be slowed down by using a high-speed motion-picture camera that can expose film at rates up to approximately 10,000 frames per second. If a film exposed at 10,000 frames per second is projected at a rate of 24 frames per second, the rate of movement is reduced to approximately 1/400 the original speed.

A distinction must be made between the number of frames per second used in the projection of motion pictures to produce a perception of smooth motion (the phi phenomenon) and the number of flashes of light per second required so that the persistent image will eliminate flicker. Although a projection rate of 24 frames per second is sufficient to create a perception of realistic motion with most subjects, it is necessary to interrupt the light twice while each picture frame is in the projector gate to obtain 72 flashes of light in order to reduce flicker to an acceptable level.

References

American National Standards Institute, Calculation and Preparation of Projected-Image Size and Projection Distance Tables for Audiovisual Projectors, Method for (PH7.6-1975).

- _____, Determination of ISO Resolving Power (ISO 6328-1982, PH2.33-1983).
- ———, Direct Viewing of Photographic Color Transparencies (PH2.31-1969, R1976).
- ------, Photographic Color Prints, Viewing Conditions (PH2.41-1976).
 - ——, Small Transparencies with Reproductions, Projection Viewing Conditions for Comparing (PH2.45-1981).

References

Billmeyer and Saltzman, Principles of Color Technology.

Birren, Ostwald: The Color Primer.

, Munsell: A Grammar of Color.

Bloomer, Principles of Visual Perception.

Bower, The Perceptual World of a Child.

Burnham, Hanes, and Bartleson, Color: A Guide to Basic Facts and Concepts.

Carterette and Friedman, Handbook of Perception: Perceptual Processing.

Clark, Special Effects in Motion Pictures.

Clulow, Color: Its Principles and Their Applications.

Consulting Psychologist Press, Embedded Figure Test Manual.

Cornsweet, Visual Perception.

Davidoff, Differences in Visual Perception.

Dixon, Subliminal Perception: The Nature of a Controversy.

Eastman Kodak Company, Kodak Color Print Viewing Filter Kit (R-25).

—, Kodak Projection Calculator and Seating Guide (S-16).

------, Photointerpretation and Its Uses (M-42).

------, Reflection Characteristics of Front-Projection Screen Materials (S-18).

, A Visual Flare-Testing Method for Process Cameras (Q-107A).

—, Viewing a Print in True Perspective.

—, What Is B/W Quality? (G-4).

Evans, Eye, Film and Camera in Color Photography.

-----, The Perception of Color.

Festinger, Conflict, Decision and Dissonance.

Fielding, The Technique of Special-Effects Cinematography.

Forgus, Perception.

Frostig, Maslow, Lefever, and Whittlesley. The Marianne Frostig Developmental Test of Visual Perception.

Gibson, The Senses Considered as Perceptual Systems.

Gombrich, Art and Illusion.

Graham, Vision and Visual Perception.

Gregory, Eye and Brain.

Gregory and Gombrich, Illusion in Nature and Art.

Haber, Contemporary Theory and Research in Visual Perception.

Haber and Hershenson, The Psychology of Visual Perception.

Hebb, Textbook of Psychology.

Held, Image, Object and Illusion.

Hochberg, Perception.

Hurvich, Color Vision.

Judd and Wyszecki, Color in Business, Science and Industry.

Kaufman, Sight and Mind: An Introduction to Visual Perception.

Kelly and Judd, Color: Universal Language and Dictionary of Names.

Kling and Riggs, Woodworth and Schlossberg's Experimental Psychology. Koffka, Principles of Gestalt Psychology.

Kohler, The Task of Gestalt Psychology.

Lanners, Illusions.

L' I INT

Lindsay and Norman, Human Information Processing.

Luckiesh, Visual Illusions.

Manning and Rosenstock, Classical Psychophysics and Scaling.

McKim, Experiences in Visual Thinking.

Motokawa, Physiology of Color and Pattern Vision.

Munsell, A Color Notation.

Murch, Visual and Auditory Perception.

Neisser, Cognitive Psychology.

References

Ratliff, Mach Bands.
Richardson, Mental Imagery.
Rock, An Introduction to Perception.
Sheppard, Human Color Perception.
Stroebel, Todd, and Zakia, Visual Concepts for Photographers.
Teevan and Birney, Color Vision.
Vernon, Perception Through Experience.
Wasserman, Color Vision.
Weber, Vision, Composition and Photography.
Wright, The Measurement of Colour.
Yule, Principles of Color Reproduction.
Zakia, Perception and Photography.
Zakia and Todd, Color Primer I and II.
Zettle, Sight—Sound—Motion.
Zusne, Visual Perception of Form.

Filters 14

Figure 14–1 Light falling on a surface can be reflected (A), absorbed (B), or transmitted (C).

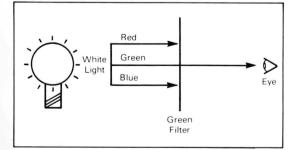

Figure 14–2 A green filter appears green to the eye because the filter absorbs the red and blue components of white light and transmits the green.

14.1 Filters

Light that falls on a surface can be reflected, absorbed, or transmitted. As a mnemonic device, these terms are commonly abbreviated as RAT (see Figure 14-1). The perception of the color of objects depends upon the spectral quality of the reflected or transmitted light. When illuminated with white light, an opaque white object appears white because the surface reflects a high proportion of the incident light, and a black object appears black because it reflects a small proportion of the incident light, nonselectively. In contrast, a red object appears red when illuminated with white light because it selectively absorbs most of the blue and green parts of the white light and reflects most of the red part. Although it will be necessary to consider what happens to the incident light wavelength by wavelength, for now it is sufficient to think in terms of the additive primary colors of light red, green, and blue—and the additive secondary colors (or the subtractive primary colors)—cyan, magenta, and yellow.

Photographic filters function by removing part of the incident radiation by absorption or reflection, so that the transmitted radiation is of the desired spectral quality. Filters, of course, cannot add anything to the incident radiation—a red filter cannot transmit red light if there is no red light in the radiation falling on the filter there income ways of classifying filters, but with respect to the effect they have on the incident radiation, they remove some of the radiation (a) selectively by wavelength, as with color filters; (b) nonselectively by wavelength, as with neutral-density filters; or (c) selectively by angle of polarization, as with polarizing filters.

14.2 Color Filters

Color filters are commonly identified by the perceived color of the transmitted light, viewed by white incident light (see Figure 14-2). Thus a red filter transmits red light and absorbs green and blue light. Color filters differ with respect to (a) which part of the visible spectrum is transmitted freely (identified by color hue or peak transmittance wavelength); (b) the width of the region transmitted and the sharpness of the cutoff (identified by a general description such as narrow, sharp-cutting passband or specific passband data); and (c) the degree of absorption of the unwanted colors (identified by general terms such as light yellow and dark yellow, or specific transmittance and density data).

Contrast filters are deep or saturated color filters that almost completely absorb the unwanted colors of light, and are commonly used in black-and-white photography to lighten or darken selected subject colors. Photographers need to be able to predict the effect that such filters will have on subject colors. One method is to look at the subject through the filter and note which colors are lightened and which are darkened. Accuracy of this process depends upon the film and the eye responding similarly to subject colors. Although panchromatic film and the eye do not respond identically, the responses are sufficiently close to make this a valid procedure. In Figure 14–3, steps of a gray scale were selected as the closest lightness matches with the adjacent subject color (identified with markers) without and with a filter before making the corresponding photographs on panchromatic film.

The Maxwell triangle (containing the three additive primary colors—red, green, and blue; and the three additive secondary colors—

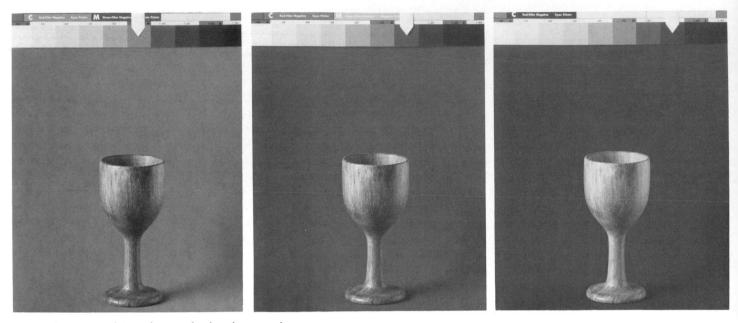

Figure 14–3 A white marker was placed on the gray-scale steps that most closely matched the lightness of the green background before the photographs were made with no filter (middle), a green filter (left) and a red filter (right). The closest visual matches were also the closest photographic matches.

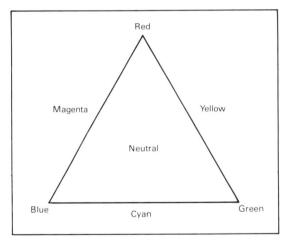

Figure 14-4 The Maxwell triangle can be used to predict the effect of contrast color filters on black-and-white photographs.

cyan, magenta, and yellow) can be used to predict the effect of contrast filters on black-and-white photographs without looking through the filters (see Figure 14–4). The general rule is that a filter will lighten subject colors that are the same color as the filter or are adjacent to that color in the triangle. Thus a red filter will lighten red, magenta, and yellow subject colors in the print, and will darken the opposite color, cyan, and its adjacent colors, blue and green. Note that to lighten yellow and darken red simultaneously, it would be necessary to use a green filter (which is adjacent to yellow but is not adjacent to red in the triangle).

Since filters absorb light, the images of neutral-colored objects would be thinner in negatives if the same camera exposure settings were used with a filter as without (see Figure 14–5). The filter factor is a multiplying number that specifies the change in exposure necessary to obtain the same density in a neutral subject area with the filter a without. Since color filters commonly change the slope of the characteristic curve and the contrast of images, a filter factor cannot produce the same density for all steps in a gray scale exposed through a filter unless the development of the film is adjusted. It has been commor practice when making color-separation negatives through red, green and blue contrast filters to adjust developing times to match curve slopes. This practice is less common when using contrast filters for pictorial black-and-white photography.

The dependence of filter factors on the degree of developmen is one reason manufacturers commonly indicate that published filte factors should be modified by the photographer if they do not produc satisfactory results. Two other aspects of the photographic process tha must be taken into account in determining filter factors are the colo quality of the illumination and the color sensitivity of the photographi material. Red filters, for example, have larger factors with dayligh illumination than with tungsten illumination because they absorb larger proportion of the bluer daylight illumination. Conversely, blu filters have smaller factors with daylight. Although red filters are no

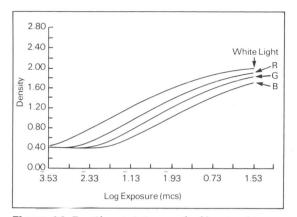

Figure 14-5 Characteristic curves for film exposed in a sensitometer with white light and with red, green, and blue filters. Since no adjustment was made in the exposure, the filter negatives are thinner than the no-filter negative. Filter factors for this light source can be determined by finding the antilogarithm of the horizontal displacement of each filter curve from the no-filter curve at a specified density. Any effect the filter may have on image contrast of neutral subject tones can be determined by calculating the contrast index.

recommended for use with orthochromatic films, which have very low sensitivity to red light, an attempt to use this combination would require a very large filter factor compared to that required for the same filter with panchromatic film.

If the filter factor is applied to the exposure time, the exposure time without the filter is simply multiplied by the filter factor. For example, an initial exposure time of 1/60 second modified for a filter having a factor of 2 becomes $1/60 \ge 2$, or 1/30 second. If the factor is applied to the diaphragm opening, it is necessary to remember that opening the diaphragm doubles the exposure for each whole stop, so that a lens would have to be opened up by four stops for a filter having a factor of 16 (2-4-8-16). For factors that do not correspond to whole stops, the equivalent number of stops can be computed by dividing the logarithm of the filter factor by 0.3 (the logarithm of 2). Thus, a filter factor of 12 corresponds to 1.08/0.3, or 3.6 stops.

An advantage claimed by manufacturers of some cameras having behind-the-lens exposure meters is that the meter automatically compensates for the decrease in the amount of light that reaches the film when a filter is added. These claims are valid to the extent that the spectral response of the meter corresponds to the spectral conditient, of the time being used. Some difficulty has here experienced in producing meters that have high overall sensitivity as well as the desired spectral response characteristics. A meter with high red sensitivity, for example, will give a false high reading, leading to underexposure when a red filter is used, and a false low reading, leading to overexposure when a blue filter is used.

A simple experiment can be conducted to determine the accuracy of a camera meter with filters. A neutral test card is metered with and without the filters, and the indicated changes in exposure are compared to the published filter factors. Or a gray scale is photographed with and without the filters as the camera meter indicates, and the densities of the resulting images are compared (see Figure 14-6).

Having noted that the objective of filter factors is to record neutral colors with the same density when a filter is used as without the filter, it is easier to explain why a filter lightens its own color and adjacent colors in the Maxwell triangle and darkens the opposite color and its adjacent colors (see Figure 14–7). If we think of white light as being composed of equal proportions of red, green, and blue light, a filter will lighten a subject color (on the print) when the filter transmits a larger proportion of that color of light than of white light from a gray scale or a neutral color object. In simple terms, a red contrast filter can be thought of as transmitting one-third of the white (R+G+B)light, all of the light from a red object, and one-half of the light from the adjacent yellow (R+G) and magenta (R+B) objects (see Figure 14–8). The red filter, therefore, will lighten its own color and the adjacent yellow and magenta colors (see Figure 14–9).

Similarly, cyan, magenta and yellow contrast filters can be thought of as transmitting two-thirds of the white light but all of their own color and *all* of the adjacent colors (see Figure 14–10). A yellow contrast filter, for example, will transmit its own color and the adjacent colors red and green freely (lightening these colors on the print), will absorb all of the complementary color blue (darkening it considerably), and will transmit one-half (less than two thirds) of the colors adjacent to blue—cyan and magenta (darkening these colors slightly) (see Figure 14–11).

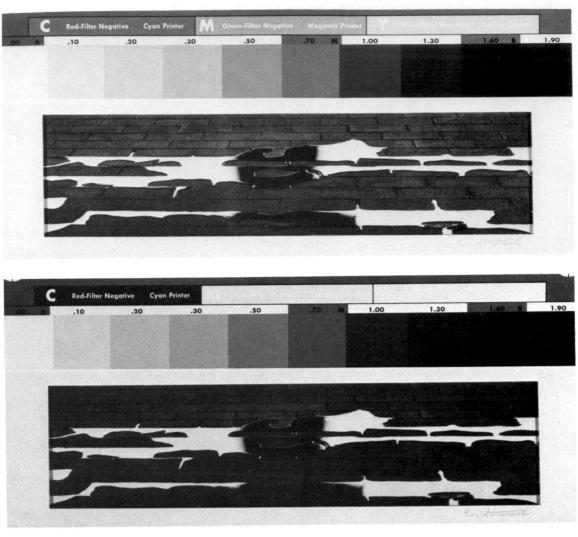

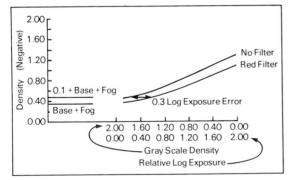

Figure 14-6 Copy photographs of a gray scale and a black-and-white print without a filter (top) and with a red filter (middle). Camera exposures were determined with behindthe-lens meter readings and the two negatives were printed exactly the same way. The difference in print density represents the meter error in reading through the red filter, due to high red sensitivity of the meter cell. (bottom) Characteristic curves based on the negative gray-scale densities. The two curves would be superimposed if the spectral response of the exposure meter matched the spectral sensitivity of the film. The 0.3 log exposure displacement represents an exposure error of one stop.

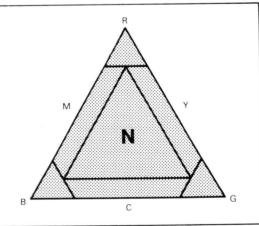

Figure 14–7 A triangular color chart containing the six basic colors—red, green, blue, cyan, magenta, and yellow—is used here to illustrate the effect of filters in lightening and darkening subject colors in black-and-white photographs. The lightness of the colors is such that without a filter they are all recorded with the same density as the neutral gray in the center.

14.2 Color Filters

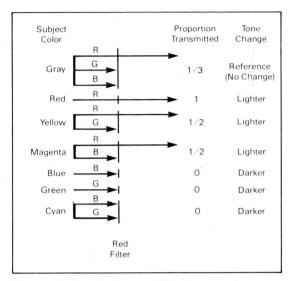

Figure 14-8 A red contrast filter is represented as transmitting one third of white light. The filter will lighten subject colors (in the print) when it transmits more than onethird of the light from the subject, and darken subject colors when it transmits how mean one obtail of the light. The visual effect is shown in Figure 14.0.

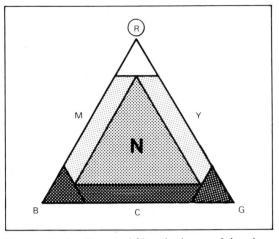

Figure 14-9 Since a red filter absorbs none of the red light, the red subject area will be dense in the negative and light in the print. The adjacent colors, magenta and yellow, will be lightened because the red filter absorbs less light from these areas (one-half) than from the neutral gray (two-thirds). The three remaining colors are darkened because the red filter absorbs essentially all guan hlue and genom light

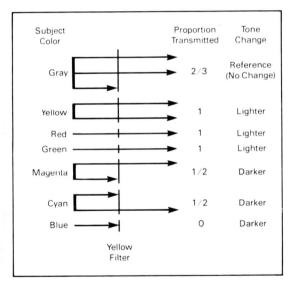

Figure 14–10 A yellow filter is represented as transmitting two-thirds of white light. The filter will lighten subject colors (in the print) when it transmits more than twothirds of the light from the subject and darken subject colors when it transmits less than two-thirds of the light. The visual effect is shown in Figure 14–11.

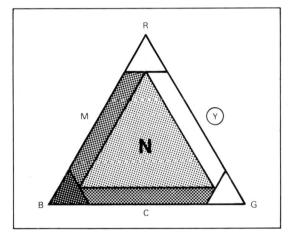

Figure 14-11 A yellow filter will lighten its own color and the adjacent red and green colors because it transmits these colors freely. The blue area will be darkened because the yellow filter absorbs blue light. Magenta and cyan will be darkened some because each of these areas is composed of one-balf blue, which is a larger proportion than the one-third blue in the neutral gray.

Even with contrast filters, the lightening and darkening effects in black-and-white photographs often are not as dramatic as photographers would like. The reason for this is that subject colors are seldom limited to such a narrow range of wavelengths that the light reflected from the subject is either completely absorbed or completely transmitted by contrast filters. Less saturated color filters are produced, however, for situations where more subtle tone changes are desired. For example, a red contrast filter will considerably darken blue sky on a clear day in a black-and-white photograph. A yellow contrast filter will not have as great an effect because the "blue" sky actually contains some green, which is not absorbed by the yellow filter. More subtle darkening can be obtained by switching from a contrast or deep yellow filter to a medium yellow or a light yellow filter.

Panchromatic films used without a filter tend to record blue sky as a little lighter than it appears to the eye due to the ultraviolet radiation in blue sky light, to which films are sensitive, and the slightly high blue sensitivity of panchromatic films with daylight illumination. Panchromatic films, therefore, produce a more realistic reproduction of the lightness of subject colors when used with a light yellow filter than when used without a filter. The recommended yellow filter is classified as a *correction* filter. With tungsten illumination, panchromatic films tend to record reds and blues too light, so a light green filter is used as a correction filter.

14.3 Ultraviolet and Infrared Filters

The silver halides in photographic films are inherently sensitive to ultraviolet radiation and they can be made sensitive to infrared radiation through the use of sensitizing dyes. When the objective is to make a photograph solely with ultraviolet or infrared radiation, a filter is needed that transmits the desired radiation but does not transmit unwanted radiation such as white light. Some UV and IR filters are therefore visually opaque, or nearly so. IR filters are usually used in front of the camera lens so that the film is exposed solely with IR radiation (see Figures 14-12 and 14-13). If the objective is to make surreptitious photographs at night, however, the filter can be used over the flash or other source of infrared radiation so that little or no light is transmitted.

In distant outdoor scenes, ultraviolet radiation often has a deleterious effect on photographs because short-wavelength radiation is scattered much more by the atmosphere than longer-wavelength radiation, creating the appearance of haze, which obscures detail. This

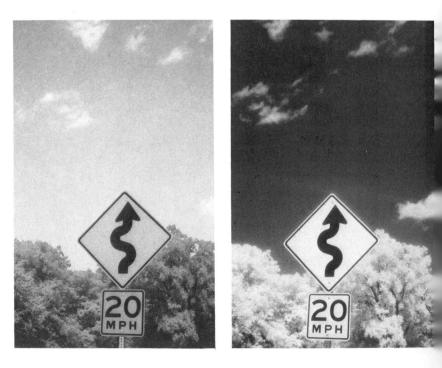

Figure 14-12 Both photographs were made on black-andwhite infrared film. The photograph on the right was exposed through a red filter, which transmits red light and infrared radiation but absorbs blue light and green light, to which the film is also sensitive. The photograph on the left was made without a filter.

Figure 14–13 (Top left) Photograph of an oil painting, was made with panchromatic film. (Top right) Photograph made with black-and-white infrared film and an 87C filter over the camera lens, reveals a somewhat different original painting. The sketch on the right shows the visible image with dotted lines and the differences revealed by the infrared film with solid lines. (Photographs by Andrew Davidhazy.)

> Rayleigh scattering, as it is called, is inversely proportional to the fourth power of the wavelength of the radiation. To reduce the appearance of haze, a filter should be used that absorbs UV radiation, as well as blue and green light. Thus a red filter is effective in reducing

Figure 14–14 A step tablet was printed on a photographic paper containing a fluorescent brightener and on a non-brightener paper. Under tungsten illumination, which contains little ultraviolet radiation, the two prints appear similar (top). With ultraviolet radiation there is a dramatic difference in the appearance of the two prints (bottom).

14.4 Filters for Color Photography

the appearance of haze with panchromatic films, and the effect is even more dramatic when the photograph is made with IR film and IR radiation.

Ultraviolet radiation causes certain substances to fluoresce, whereby invisible UV radiation is converted to longer-wavelength visible radiation, revealing useful information about the material (see Figures 14–14 and 14–15). The fluorescent effect may be obscured, however, if the object is also being illuminated with white light from another source. It is common practice, therefore, in fluorescence photography to use two UV filters, one that transmits only UV radiation (known as an exciter filter) over the radiation source, and another that transmits light but absorbs UV radiation (known as a barrier filter) over the camera lens so that the film records only the visible fluorescence.

14.4 Filters for Color Photography

Red, green, and blue contrast filters can be used for color photography as well as for black-and-white photography, for example, to make separation negatives from an original scene with a camera or from a color transparency with an enlarger, and to do tricolor printing with color printing paper. More widely used, however, are less-saturated filters to alter the color temperature of the illumination and to alter the color balance of transparencies and prints. If one wants to use a tungsten-type color film (which is designed to be used with illumination having a color temperature of 3200 K) with daylight illumination having a color temperature of 5500 K, it is necessary to use an orange filter that will lower the color temperature of the light from 5500 K to 3200 K. Conversely, to use a daylight-type color film indoors with studio lights having a color temperature of 3200 K, it is necessary to use a bluish filter that will raise the color temperature of the light from 3200 K to 5500 K. Such filters are identified as conversion or lightbalancing filters.

Calibration of conversion and light-balancing filters presents a problem because the orange filter noted above that lowers the color temperature from 5500 K to 3200 K, a decrease of 2300 K, will not lower the color temperature by the same amount if used with illumination having a different color temperature. For this reason, such filters are usually calibrated in terms of *mired shift value*. As noted in Chapter 5, the mired value is found by dividing a constant—1,000,000—by the color temperature. The mired shift value is the difference between the two mired values. Thus the mired value for 5500 K is 182 and the mired value of 130 (312 - 182) is required to use tungstentype film with daylight illumination (see Figure 14–16). This filter will produce the same mired shift with other light sources having either higher or lower color temperatures.

Color-compensating filters are designed to absorb any of the six additive and subtractive primary colors—red, green, blue, cyan, magenta, and yellow. Thus a red color-compensating (CC) filter will absorb green and blue light, whereas the complementary color cyar filter will absorb only red light. Color-compensating filters are usec on cameras and enlargers to control the color balance of color photographs, for the purpose of compensating for variability in any part o the process including the photographic material, the illumination, and

14.4 Filters for Color Photography

Figure 14–15 Ultraviolet and infrared radiation can sometimes reveal information that cannot be seen or photographed with white light. The water-damaged letter on the left was not legible under normal viewing conditions. The faded ink, however, fluoresced in the infrared region when illuminated with white light, producing a legible copy when photographed on infrared film with a filter. (Photographs by Andrew Davidhazy.)

the processing; or to create mood or other special effects. CC filters are produced in a range of saturations in each of the six hues, with the saturations calibrated in terms of peak density. Thus a CC30M filter is a magenta color-compensating filter with a density of .30 (the decimal is omitted in the designation). Filters are available in densities ranging from .025 to .50.

The density of CC filters is based on the maximum absorption, not the proportion of white light that is absorbed. For this reason, exposure corrections are not derived directly from the density but instead are obtained by trial and error, from the manufacturer's data sheet, or by measuring the transmitted light with a meter having appropriate response characteristics. A manufacturer's data sheet, for example, suggests two-thirds-stop exposure increase for CC30 filters in all hues except yellow, which is one-third stop.

Even though contrast filters are never sandwiched, because theoretically no light would be transmitted through most combinations, such as red and green, CC filters can be combined to obtain almost unlimited control over the color quality of the image-forming light. When two or more CC filters of the *same* hue are combined, the densities are additive. The combined density of a CC20M filter and a CC30M filter is the same as the density of one CC50M filter, although it is necessary to increase the exposure by approximately 10% for each additional filter to compensate for light lost due to surface reflection.

The situation is different when filters of different hues are combined. Sandwiching any two of the three subtractive primary hues cyan, magenta, and yellow—produces the same effect as a single filter of the resulting additive primary huc and the same density. Thus,

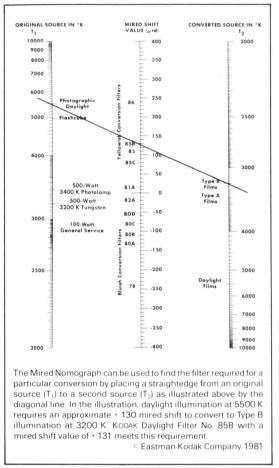

Figure 14–16 Mired nomograph for light source conversion. The mired nomograph can be used to find the filter required for a particular conversion by placing a straightedge from an original source (T_1) to a second source (T_2) as illustrated above by the diagonal line. In the illustration, daylight illumination at 5500 K requires an approximate + 130 mired shift to convert to Type B illumination at 3200 K. Kodak Daylight Filter No. 85B with a mired shift value of + 131 meets this requirement. (© Eastman Kodak Company 1981.) CC20M plus CC20Y filters are equivalent to one CC20R filter. Combining equal densities of all three of the subtractive primary hues results in neutral density. Thus, CC20M plus CC20Y plus CC20C is equivalent to a neutral-density filter with a density of 0.20. Combining complementary hues produces the same result; for example, CC20Y plus CC20B is equivalent to a neutral-density filter with a density of 0.20. When three or more CC filters are combined, as in color printing, it is usually better to eliminate any neutral-density combinations unless the resulting shorter exposure time would be inconveniently short.

It should be noted that combining two of the *additive* primary hues is not exactly equivalent to using one filter of the corresponding subtractive primary hue. For example, combining equal densities of red and green results in a greater absorption of blue, as with a single yellow filter, but there is also a neutral-density effect because the red filter absorbs blue and green, and the green filter absorbs blue and red.

14.5 Spectrophotometric Absorption Curves

The general type of filter data discussed above is usually sufficient to meet the needs of most photographers. However, when more specific information is required for technical and scientific applications, spectrophotometric curves that show the absorption characteristics of filters throughout the spectrum are useful. In the spectrophotometer, white light is dispersed to form a spectrum. A narrow slit permits the measurement of the transmittance of a filter to a narrow band of wavelengths as the spectrum is scanned from the short-wavelength ultraviolet radiation through the visible region to the long-wavelength infrared radiation. Since the transmittance is based on a comparison of the transmitted beam to an unfiltered reference beam, the specific response characteristics of the sensor are unimportant as long as it responds to the full range of wavelengths of interest.

Spectrophotometric curves typically represent wavelengths on the horizontal axis and transmittance and density values on the vertical axis, with the baseline representing 100% transmittance, or a density of 0. As illustrated in Figure 14–17, the transmittance scale on the vertical axis is a *ratio* scale, which makes it difficult to estimate values between the marked values. In contrast, the density scale is an *interval* scale, which provides uniform values for the smaller divisions.

Curves for red, green, and blue tricolor contrast filters are shown in Figure 14–17. The maximum transmittance (minimum density) is in the wavelength region that identifies the hue of the filter. It can also be seen that the curves do not neatly divide the visible spectrum into thirds, (it is impossible to obtain colorants that have perfectly sharp cutting characteristics at the desired wavelengths) and that all of the filters transmit infrared radiation freely. Infrared radiation transmittance is of little consequence with respect to tone reproduction if the photographic material is not sensitive to infrared radiation.

Furthermore, the curves reveal that some filters do not transmit their own colors freely. The red filter comes the closest to the ideal with a maximum transmittance of more than 90% in the red region beyond 630 nm. The blue filter has a maximum transmittance of approximately 50% to blue light, and the green filter has a maximum transmittance of only 40% to green light. It is difficult to obtain colorants with all of the desired characteristics for use in filters and in

14.6 Neutral-Density Filters

Figure 14-17 Spectrophotometric curves for blue, green, and red (top to bottom) tricolor contrast filters.

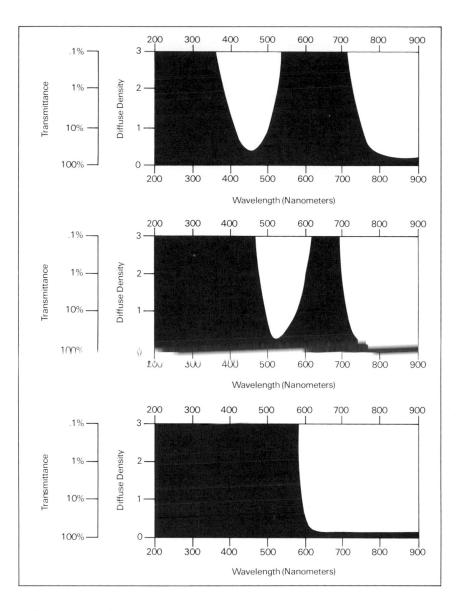

color films. Color masking, which is used in negative color films and in some color printing processes, is necessitated by the unwanted absorption of certain colors of light by the cyan and magenta imageforming dyes.

Color-compensating filter curves for the set of yellow filters from CC025Y to CC50Y are shown in Figure 14–18. All of the curves peak in the blue region of the spectrum, and all of the filters are quite transparent to green and red light.

14.6 Neutral-Density Filters

Neutral-density (ND) filters are used to reduce the illuminance by a known factor in cameras and other optical systems. The intent is to have the same transmittance for all wavelengths of radiation within specified limits. ND filters are usually calibrated in terms of white-light density. A filter with a neutral density of 0.3 has an opacity and filter factor of 2 (the antilog of 0.3) and a transmittance of 1/2(the reciprocal of the opacity). Some ND filters have been calibrated

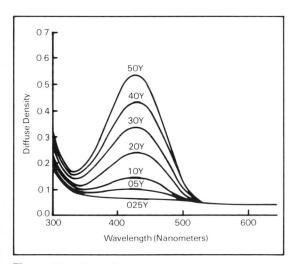

Figure 14–18 Yellow color-compensating filter spectrophotometric curves.

in terms of stops, where each 0.3 in density corresponds to one stop. ND filters offer an alternative method of controlling exposure when the conventional aperture and shutter controls are inadequate. With highly sensitive photographic materials, a combination of the smallest diaphragm opening and the highest shutter speed may result in over-exposure at high illumination levels. There are also situations in which the diaphragm opening is selected to produce a certain depth of field and the shutter speed is selected for a certain action-stopping capability rather than for exposure considerations. With some motion-picture cameras, the shutter setting is not a useful exposure control.

ND filters provide a convenient method of obtaining accurate small decreases in exposure. A 0.1 ND filter reduces the illuminance by the equivalent of one-third stop, 0.15 corresponds to one-half stop, and 0.2 corresponds to two-thirds stop.

In black-and-white photography an ND filter need not be entirely neutral with respect to the absorption of the different colors over the visible part of the spectrum. The relatively low-priced gelatin ND filters, which use carbon and dyes as light-absorbing materials, absorb somewhat more in the blue region (see Figure 14–19).

A more dramatic deviation from neutrality is noted in the ultraviolet region below 400 nm, where the transmittance decreases, and in the infrared region above 700 nm, where the transmittance increases. Clear gelatin and glass absorb considerable ultraviolet radiation. Thus the gelatin in the ND filter and in the photographic emulsion, and the glass lens in the camera or enlarger, absorb some (but not all) UV radiation. When photographs are to be made entirely with UV radiation, special precautions must be taken to minimize this absorption in the optical system, such as by substituting a quartz lens and avoiding use of gelatin and glass filters.

On the other hand, when UV radiation interferes with obtaining the desired effect, as in color printing, a special filter may be required to completely absorb the unwanted UV radiation. The excess IR radiation transmitted through ND filters will have no effect on

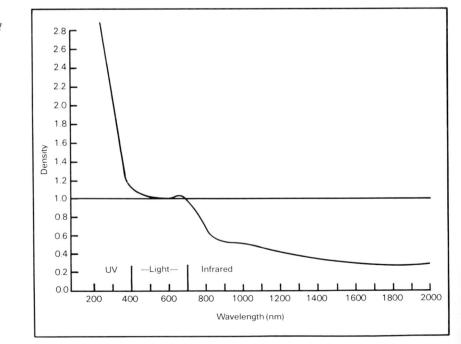

Figure 14–19 Gelatin neutral-density filters containing dyes and finely divided carbon absorb too much blue light and ultraviolet radiation and too little infrared radiation.

photographic emulsions that are not sensitive to these wavelengths, but it can introduce exposure errors if the exposure is based on meter readings made with a meter that is sensitive to IR radiation.

Some of the absorbing materials other than dyes that are used in ND filters include carbon, finely divided particles of photographic silver, and thin layers of metallic alloys deposited on a transparent base by evaporation in a vacuum. Colloidal carbon used in gelatin ND filters is somewhat yellowish, requiring the addition of dyes to reduce the deviation from neutrality. Larger carbon particles are more nearly neutral but they scatter the light more, so these filters are not suitable for use in imaging systems.

Spectrophotometric curves for typical examples of photographic silver, M-type carbon, and thin-film metallic alloy ND filters are shown in Figure 14–20. Note that the photographic silver has low transmittance to IR, the carbon has somewhat higher transmittance to IR than to light, and the metallic alloy is relatively neutral in the IR region. Transmittance in the UV region with all of these absorbing materials is highly dependent upon the type of support used, which includes gelatin, acetate, glass, quartz, and fused silica.

The color of finely divided particles of silver depende upon their size. Most black-and-white negatives appear quite neutral in color, but negatives made on fine-grained film developed in a fine-grain developer appear somewhat warmer in color. Even smaller particles of colloidal silver function as an efficient yellow filter in the Carey-Lea filter layer, used in color films to prevent blue light from reaching the green-blue and red-blue sensitive layers.

14.7 Interference Filters

Traditionally, photographic filters have consisted of colorants that absorb the unwanted part of the incident radiation and transmit the desired part suspended in transparent materials. Interference filters typically consist of thin layers of metallic alloys separated by thin layers

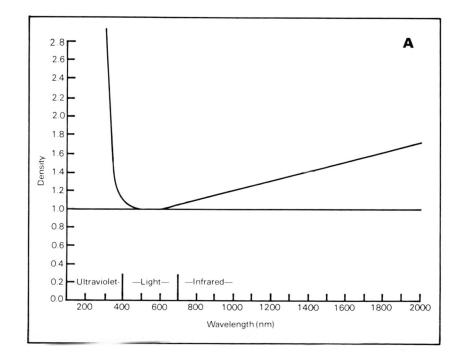

Figure 14–20 Spectrophotometric curves for photographic silver (A), M-type carbon (B), and thin-film metallic alloy neutral-density (C) filters.

14.7 Interference Filters

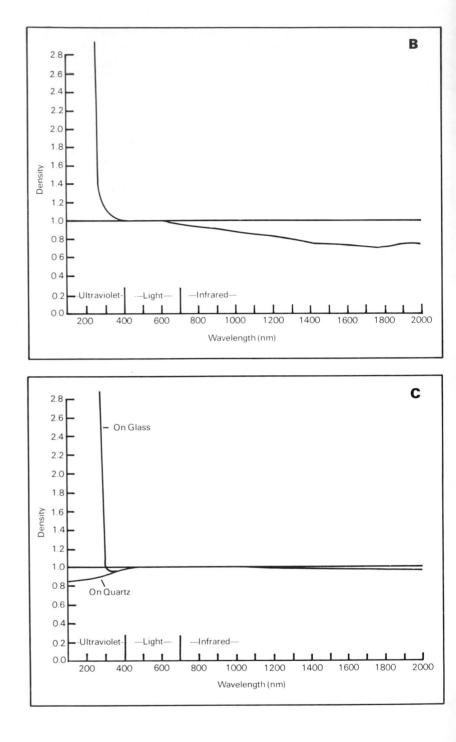

of transparent dielectric materials. In these layers the refractive indexes and thicknesses are controlled so that constructive and destructive interference separate the wanted and unwanted components of the incident radiation by means of reflection and transmission (see Figure 14–21).

Newton rings, sometimes seen when a negative is placed ir a glass negative carrier, are interference patterns caused by rays of light that are reflected from the shiny base side of the negative onto the lower surface of the top piece of glass, where it is reflected again to join the nonreflected ray of light either in phase, to produce a bright ring, or out of phase, to produce a dark ring (see Figure 14–22). Since

Figure 14–21 A dichroic filter (left) and a gelatin filter (right) were placed on a translucent grid on an illuminator. With the room lights on and the illuminator off, the dichroic filter looks like an opaque mirror (top left). With the room lights off and the illuminator on, the transparency of both filters is evident (bottom).

the two surfaces are not perfectly parallel, the two effects alternate to produce a series of lines or rings in the projected image.

Antireflection lens coatings also function on the basis of light interference. A thin layer of suitable material with a refraction index lower than that of the glass decreases the reflectance and increases the

Figure 14-22 Newton rings formed between the shiny base side of 35 mm film and the cover glass in an enlarger negative carrier, photographed by reflected light. Interference produces a pattern of lines that alternate in lightness and hue.

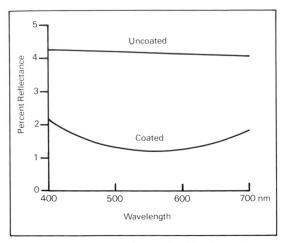

Figure 14–23 Curves showing the effect of a single antireflection coating on the reflection of light from a glass surface.

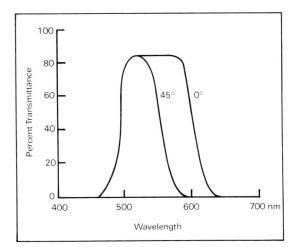

Figure 14–24 The effect of changing the angle of incidence on the spectral quality of the light transmitted by an interference filter.

transmittance for a band of wavelengths of light (see Figure 14–23). With a single coating, the thickness is usually adjusted to maximize the effect for green light, causing the light reflected from the surface to appear magenta. The increase in the green content of the transmitted light is less apparent than the change in the reflected light's color because it constitutes a small proportion of the total amount of image-forming light; however, it is sufficient to produce a noticeable change in the color balance of slides. Lens manufacturers now attempt to match this characteristic for their different lenses; and there are published national and international standards that describe a method for determining and specifying the contribution of camera lenses to the color of a photograph. Multiple coatings on camera lenses reduce the reflectance and increase the transmittance of other wavelengths.

Through the choice of materials, and the thickness and number of layers, interference filters can be made highly selective in transmitting and reflecting wavelengths. Since the filters separate the two components of the incident radiation on the basis of reflection rather than absorption, at least one filter surface has a mirrorlike appearance. The term *dichroic* (two colors) is commonly applied to interference filters, due to the difference in the colors of light reflected and transmitted. Narrow-band interference filters can be made to eliminate all but a few nanometers of a full spectrum of radiation, but interference filters can also be made nonselective over a wide range for use as neutral-density filters.

Interference filters are especially suitable for enlarger use in color printing due to their selectivity and resistance to fading. All dyes fade with prolonged exposure to light, although different dyes vary considerably in their stability. At least one manufacturer rates the stability of its dye filters, using a scale of A to D, where A represents less than one half the manufacturing variability change with exposure to daylight through a window for two weeks, and D represents a change of more than twice the manufacturing variability. A typical manufacturing tolerance is $\pm 5\%$ in total transmittance.

Since the quality of the transmitted radiation with interference filters does vary with the angle of incidence, they function best in collimated optical systems where the incident radiation is perpendicular to the surface (see Figure 14–24). For this reason, interference filters are less suitable for use on cameras where the angle of view includes light entering the camera over a range of angles up to approximately 27° to the lens axis for a normal focal length lens.

Interference filters are also useful in preventing heat damage to film in projectors. The filters can be made either to reflect infrared radiation and transmit light (called a hot mirror) or to transmit infrared radiation and reflect light (called a cold mirror) (see Figure 14–25). Hot mirrors are used between the light source and the film in an inline system where the light source is located on the lens axis. Colc mirrors are used either behind the light source or at a 45° angle to reflect the light along the lens axis when the light source is off to one side.

14.8 Polarizing Filters

A ray of ordinary light can be visualized as consisting o waves that undulate in all directions perpendicular to the line of travel Under certain conditions the light can become plane polarized so tha there is only one set of waves, and the undulation is restricted to

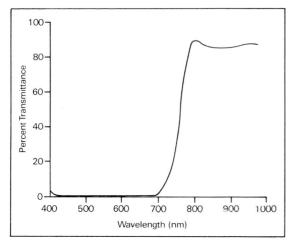

Figure 14–25 Left: Transmittance of a heat-transmitting or cold mirror. Right: Transmittance of a heat-reflecting or hot mirror.

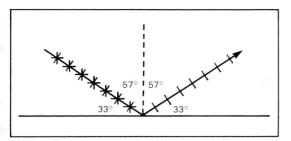

Figure 14–26 Maximum polarization of light reflected from nonmetallic surfaces occurs when the angle of incidence and the angle of reflection are approximately 57°.

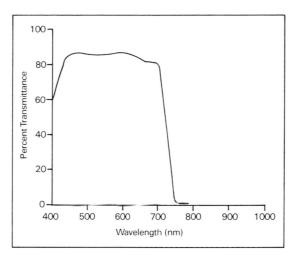

single plane—like that produced in a rope when one end is snapped up and down. Polarization occurs, for example, when light is reflected as glare at an appropriate angle from more manifesting ourlaces. The might at which the polarization is at a maximum varies somewhat with the reflecting material. For precision work, this angle—called Brewster's angle or the polarizing angle—can be determined from Brewster's law, which states that the tangent of the angle equals the index of refraction of the reflecting material. For example, if the glass in a window has an index of refraction of 1.5, the tangent of the polarizing angle equals 1.5, and the angle equals the inverse tangent of 1.5 or 57° .

In optics, angles of incidence and reflection are measured to the normal, a line perpendicular to the surface. When eliminating reflections in practical picture-making situations, it may be more convenient to measure the angle of reflection to the surface, which in this example would be $90^{\circ} - 57^{\circ} = 33^{\circ}$ (see Figure 14–26). Since the polarizing angle does not vary greatly with the different reflecting materials ordinarily encountered, and the polarizing effect decreases gradually with deviations from the polarizing angle, an angle of 35° to the surface is commonly used.

An artificial method of polarizing light is to pass ordinary light through a polarizing filter, which contains very small crystals all oriented in the same direction. The crystals transmit light waves oriented in the same direction and absorb light waves oriented at right angles; thus the transmitted light is plane polarized. Placing a polarizing filter in front of the eye or camera lens and rotating it to the proper position will absorb the polarized light of glare reflections from nonmetallic surfaces at an angle of approximately 35° to the surface. Therefore, the detail that had been obscured by the reflection can be seen and photographed (see Figure 14–27).

If the filter absorbed only the polarized light from the glare reflection, no increase in camera exposure would be required. Theoretically, the polarizing filter also absorbs half of the ordinary (unpolarized) light from the scene. In practice, a little more than half of the light is absorbed, and a filter factor of approximately 2.5 is generally recommended. The fact that the ordinary light from the scene becomes polarized by the filter is of no consequence as far as the quality of the image is concerned, as long as the exposure adjustment is made.

14.8 Polarizing Filters

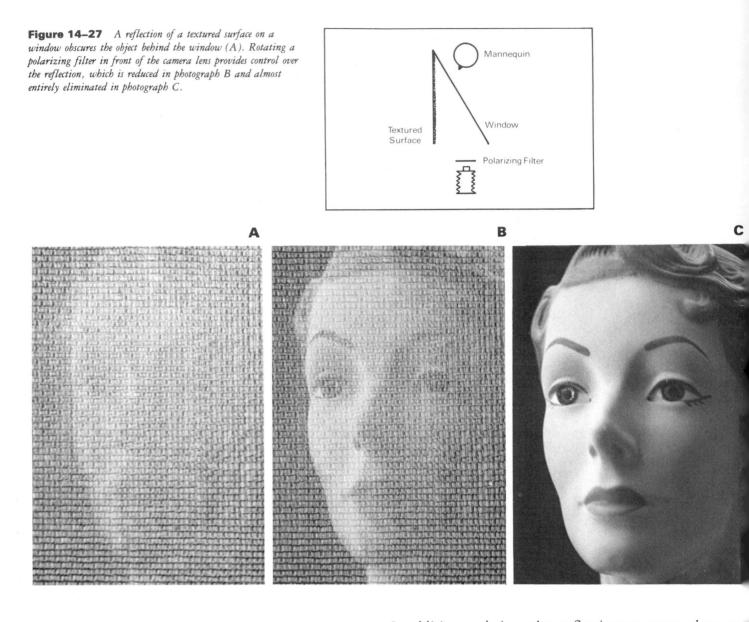

In addition to obvious glare reflections on water, glass, an other shiny surfaces, there are often more subtle veiling reflections o plant leaves and other surfaces that may be removed or reduced with a polarizing filter, producing the appearance of more saturated subjec colors. Whereas polarizing filters are supposedly neutral in color, is practice some filters deviate sufficiently from neutrality to produce noticeable shift in the color balance of color slides and transparencies Polarizing filters can also be used with color films to darken blue sky which contains considerable polarized light. The maximum effect obtained at a right angle to a line connecting the camera and the sur

Under controlled lighting conditions indoors, glare reflections can be removed from both metallic and nonmetallic surfaces wit the camera at any angle to the surface, provided the subject is illuminated with polarized light (by placing a polarizing filter in front of the light source) in addition to using a polarizing filter on the camer (see Figure 14–28). With polarizing filters over the light source surface glare reflections consist entirely of polarized light and thus cabe removed with the camera filter; the polarized light that penetrat the surface, however, becomes depolarized and thus can be used

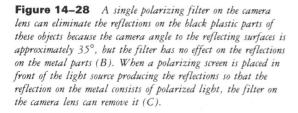

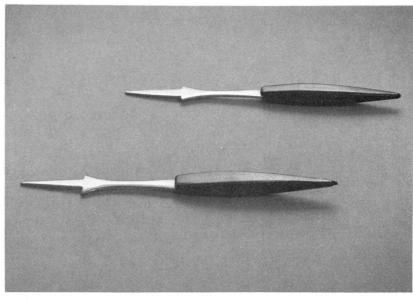

Α

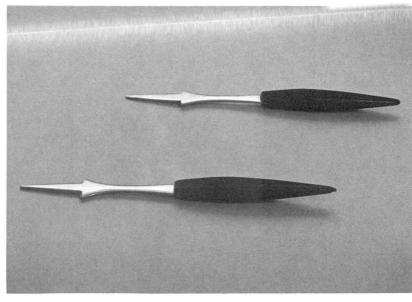

record the detail under the reflections. Polarized light is commonly used in copying textured surfaces, such as oil paintings. The filter on the camera must be rotated at a right angle to the direction of rotation of the filters in front of the light sources.

Crossed polarizing filters can be used to revcal stress patterns in transparent plastic items by placing them between the two filters, using transillumination. The stress patterns are revealed as areas of varying colors and densities (see Figure 14–29). A similar technique is used in photomicroscopy to reveal the structures of crystalline materials.

14.9 Safelight Filters

Whereas camera and enlarger filters are used mostly to control tone-reproduction characteristics-including density, contrast, and color balance-of photographic images, safelight filters are used to permit the photographer to see in an otherwise darkened room without altering the images. Generally, safelight filters are intended to absorb the colors of light to which the photographic film or paper is sensitive. A yellow filter, for example, absorbs blue light, so it is recommended for use with printing papers that are sensitive only to blue light. Prolonged exposure of photographic materials to safelight illumination however, even with the recommended safelight filter, will generally produce fog. This means either that the safelight does not absorb al of the light it is intended to absorb or that the photographic materia has some sensitivity to colors to which it was assumed to be insensitive Thus it is important not only to use the recommended filter for a given photographic material, but also to observe the recommendations con cerning bulb wattage, minimum working distance, and maximum time of exposure.

Safelight filters are susceptible to fading, so tests should be conducted periodically to make sure that safelights are not producing objectionable fog (see Figure 14–30). Care should be taken in testin, a safelight to make the safelight illumination test strip on a piece c photographic material that has received a normal exposure to an imag rather than a piece of unexposed material. This is because less energ

Figure 14–29 A transparent ruler was placed on a large polarizing filter on an illuminator. A second polarizing filter was rotated 90° and placed on top of the ruler, leaving the right end uncovered. Stress patterns in the ruler are revealed as areas of varying colors and densities.

Figure 14–30 A comparison of a faded safelight filter with a sample of the same roll of material that had been protected from light on a transparency illuminator with a neutral step tablet. The difference in density in the first photograph (A) made on black-and-white panchromatic film becomes more obvious when the two filters are hhotographed through a green camera filter (B). The low absorption of green light by the used safelight filter produced fogging with variable-contrast papers, which are sensitive to the blue and green regions of the spectrum.

Figure 14–31 A safelight fog test. A uniform picture exposure was made in complete darkness. The paper was then exposed to safelight illumination for zero, one, three, and seven minutes. Fog is evident in the picture area with the one-minute safelight exposure but is not evident in the border until the paper has received seven minutes of safelight exposure.

Α

В

is required to produce an increase in density in an area that has already received enough exposure to overcome merria than in a completely unexposed area (see Figure 14-31). A recommended procedure for conducting a safelight test is specified in the American National Standard *Methods of Determining Safety Times of Darkroom Illumination*, ANSI PH2.22-1978.

The fact that panchromatic films are sensitive to all colors of light suggests that they should not be used with any safelight illumination. Actually, it is possible to use a safelight provided it is not turned on until at least halfway through the normal developing time (to determine if the developing time should be shortened or extended) and provided the illumination level is sufficiently low. Also, a desensitizing bath can be used to reduce the risk of fog. The recommended safelight filter color for use with panchromatic films is green, not so much because the film has low sensitivity to green with tungsten illumination as that the eye has high sensitivity to this part of the spectrum. An amber safelight filter can be used with color-printing papers, which are sensitive to all colors, but only with a low-wattage bulb and for a short time.

14.10 Densitometer Filters

The use of white light for the measurement of density is satisfactory for most black-and-white photographic work, but density readings with red, green, and blue light are required for tone-reproduction analysis with color materials. Spectrophotometric curves of color images provide even more detailed information, showing the absorption of light, wavelength by wavelength, throughout the spectrum. Such curves are especially useful for research in color reproduction, but density measurements in the red, green, and blue parts of the spectrum are easier to make and to interpret, and are normally adequate for quality-control work. The types of red, green, and blue filters used in the densitometer can affect both the actual density readings and the relative density readings for the three colors of light. Thus, **R**, **G**, and **B** density readings of the image of a gray scale in a color transparency may produce entirely different sets of D log H curves when measurements are made with different densitometers.

Figure 14–32 Spectral response curves for the same light meter equipped with two different filters. The filter used for the curve on the left produces a relatively flat spectral response from 450 nm to 950 nm for radiometric applications. The filter used for the curve on the right produces a spectral response (broken line) that approximates that of the human visual system (solid line).

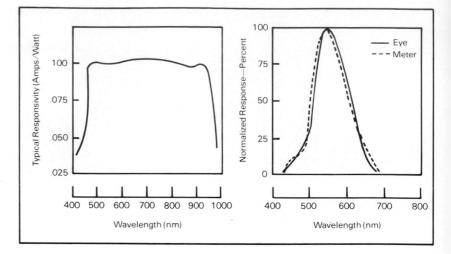

To minimize this type of variability, attempts have been made to standardize mainly on two basic types of filters, referred to as Status A and Status M filters. Status M filters are recommended for use with color-negative films, and Status A filters are recommended for use with most other color materials including reversal color films, color print films, and color printing papers.¹ Other less-expensive tricolor filters may produce satisfactory results provided the aim densities or aim D-log H curves are derived experimentally from a color image judged to be satisfactory in density and color balance when viewed under normal viewing conditions rather than using curves published by photographic manufacturers.

14.11 Light-Meter Filters

As noted in the section on exposure meters in Chapter 3, filters have been built into some exposure meters in an effort to bring the spectral response of the meter into closer agreement with typical spectral sensitivities of panchromatic and color films. To date, however, the agreement is not sufficiently close to permit photographers to depend upon meter readings made through filters on camera lenses.

Some light meters designed for technical and scientific work are provided with sets of interchangeable filters to modify the spectral response to resemble that of various sensing systems, including human vision (see Figure 14-32).

14.12 Viewing Filters

Various types of viewing filters have been used on a limited basis over the years. One type is intended to bring the spectral response of the eye into closer agreement with that of the film being used. Thus, with blue-sensitive film, a blue viewing filter reveals that blue subject colors would be recorded lighter than they appear to the unfiltered eye, and greens and reds would be recorded darker. A cyan filter provides the same type of information for orthochromatic film, which is sensitive mostly to blue and green light. Since the eye has high sensitivity to

¹ANSI PH2.18.

References

the middle green-yellow part of the spectrum, a magenta viewing filter reveals the tonal reproduction of subject colors with panchromatic films.

This would be an alternative to using a *correction* filter on the camera to bring the response of the film into closer agreement with that of the eye. A panchromatic viewing filter, of course, does not compensate for the difference in sensitivity to ultraviolet radiation between panchromatic film and the eye. Any color filter or polarizing filter that is going to be used on a camera can be considered to be a viewing filter for predicting the tone-reproduction effect.

Another use for viewing filters is to enable the photographer to judge the lighting effect more accurately. Objects that appear to be clearly separated from the background due to hue differences sometimes blend with the background when recorded in black-and-white photographs. Dense filters, including neutral-density filters, that reduce the light falling on the retina to the level where vision depends upon the rods (scotopic vision) will reduce or eliminate the hue differences and enable the viewer to judge better how the subject colors will be recorded in monochromatic photographs. Furthermore, such filters reduce the eye's ability to adapt locally to brightness differences. Local brightness adaptation generally allows a person to see more detail in dark areas of a unit than will be monded in a photograph, so the use of anoth a viewing filter provides the person with a more realistic impression of the contrast of the scene in terms of the photographic reproduction.

References

Adams, The Camera.

American National Standards	Institute, Color Contribution of Photographic
Lenses, Determining a	and Specifying (PH3.607-1981).

- —, Density Measurements, Spectral Conditions (ASC PH2.18-1984).
- ———, Illuminants for Photographic Sensitometry: Simulated Daylight and Incandescent Tungsten (PH2.29-1982).
- ------, Photographic Lenses, Method of Testing Spectral Transmittance (PH3.614-1983).
- ------, Safety Times of Photographic Darkroom Illumination, Methods for Determining (PH2.22-1978).
- ———, Spectral Distribution Index of Camera Flash Sources, Method for Determining and Specifying (PH2.28-1981).
- Blaker, Field Photography.
 - —, Photography: Art and Technique, pp. 181–203.
- Eastman Kodak Company, Applied Infrared Photography (M-28).
- ———, Color News and Documentary Photography with Fluorescent Lighting (H-9).
- —, Encyclopedia of Practical Photography (ZA-C).
- ——, Filters and Lens Attachments for Black-and-White and color Pictures (M-28).
- ——, How Safe is Your Safelight? (K-4).
- —, Kodak Color Dataguide (R-19).
- , Kodak Color Print Viewing Filter Kit (R-25).
- —, Kodak Ektacolor Filter Finder Kit (R-30).
- , Kodak Filters for Scientific and Technical Uses (B-3).
- ——, Kodak Filter Selector (Q-44).
- ——, Kodak Master Photoguide (AR-21).
- ------, Kodak Neutral Density Attenuators (P-114).
- ------, Kudak Polycontrast Filter Computer (G-11).

References

, Kodak Professional Photoguide (R-28).

, Practical Densitometry (E-59).

, Printing Color Negatives (E-66).

, Ultraviolet and Fluorescence Photography (M-27).

Focal Press, Focal Encyclopedia of Photography.

Jacobson et al. The Manual of Photography, pp. 198-221.

Langford, Advanced Photography.

——, Basic Photography.

Morgan, Vestal, and Broecker, Leica Manual, pp. 189-202.

Spencer, Colour Photography in Practice.

Stroebel, Photographic Filters.

Stroebel, View Camera Technique.

Stroebel and Todd, Dictionary of Contemporary Photography.

Todd and Zakia, Photographic Sensitometry, pp. 241-57.

Upton and Upton, *Photography*, pp. 110–17, 287–95, 318–19. Yule, *Principles of Color Reproduction*.

Color and Colorimetry

15.1 Introduction

The visual experience of perceiving color does not depend upon language or numbers, but the communication of information about the experience does. It is important that we use an agreed-upon and established vocabulary to talk about color. In the past, various disciplines including photography, art, and graphic arts have had difficulty communicating with each other due to the absence of an agreedupon common color language. The Munsell Color System and the Standard CIE System of Color Specification have emerged as two of the more successful attempts to organize the variables of color into a universally accepted system. In addition, the Inter-Society Color Council has brought together representatives of the various disciplines in an effort to lower the barriers to communication. The stated aims and purpose of the organization are "to stimulate and coordinate the work being done by various societies and associations leading to the standardization, description and specification of color and to promote the practical application of these results to the color problems arising in science, art and industry."

Before examining color systems, however, it is necessary to openalish a definition of take. Anthough specification, color refers to physiological and psychological responses to light in much the same way that taste, smell, touch and sound are responses to other physical stimuli. In everyday language, color is associated with words such as *red, green, blue,* and *yellow.* Actually, these words refer to only one of three attributes of color—namely hue. The other two attributes are brightness (or lightness) and saturation.

Clarity of language is achieved when we distinguish between using color terms to refer to the visual perception of an object and the physical characteristics of the object. For example, it can be argued that we should not refer to a "red" apple as being red. We see it as red because the surface of the apple has physical properties that reflect certain wavelengths and absorb other wavelengths of the white light that illuminates it (see Figure 15–1). If a "red" object is illuminated with "blue" light, most of the light will be absorbed and the object will be perceived as being red, we mean that it will generally be perceived as being red by persons with normal color vision when it is illuminated with white light and viewed under normal viewing conditions.

Colorant is a general name for colored substances, including pigments and dyes used to alter the color of objects or other materials. The colors we see in color photographs are a result of mixtures of three colorants in the photographs: cyan, magenta, and yellow dyes. The purpose of the three dyes, which are present in different proportions in various areas of the photographs, usually is to create the same perception of color as when the original scene is viewed directly—even though a wavelength-by-wavelength comparison of the light entering the eye from the scene and from the photographic reproduction might reveal entirely different compositions. In other words, the photograph is intended to create the illusion that it has faithfully reproduced the reflection characteristics of the original scene, without actually doing so.

In a sense we live in two different worlds, the physical world and the psychological world. The physical world lends itself rather

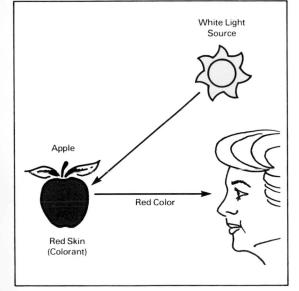

Figure 15–1 A "red" apple is seen as red because the surface of the apple acts as a filter absorbing the green and blue components of white light and reflecting the red component.

easily to measurement. We use instruments such as thermometers, clocks and rulers to measure temperature, time, and distance.

15.2 Spectrophotometers

The most fundamental physical instrument for measuring color is a spectrophotometer. It is a specialized photometer (light meter), as the name suggests; *spectro* refers to the fact that the instrument is capable of measuring light of different colors or wavelengths in the color spectrum from blue to red (measurements can also be made of radiation in the infrared and ultraviolet parts of the electromagnetic spectrum with some spectrophotometers). One can think of a color densitometer that measures red, green, and blue densities as a limited spectrophotometer capable of measuring only three broad parts of the color spectrum according to the particular type of red, green and blue filters used.

A spectrophotometer is a much more sophisticated instrument capable of measuring the density (or transmittance or reflectance) of a given sample at very precise and narrow intervals of color (wavelengths). The intervals are specified in terms of bandwidth. Light, for example, covers a bandwidth of about 300 nm (400 nm to 700 nm). Red, green, and blue light can each be thought of as covering a bandwidth of roughly 100 nm. A spectrophotometer has a dispersing element (prism or diffraction grating) that can separate white light into a full color spectrum. Then, through the arrangement of an optical network of lenses and slits, narrow bandwidths of color 10 nm or less can be isolated, and measured after they pass through or are reflected from a sample (see Figure 15–2). This is done at 10 nm intervals over the entire spectrum of colors to be measured.

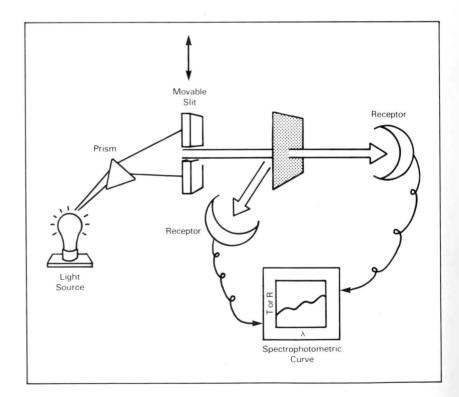

Figure 15–2 A simplified illustration of a spectrophotometer in transmission and reflection modes.

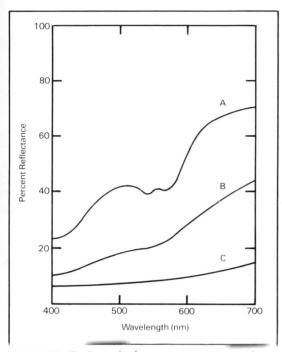

(A) light skin; (B) dark skin; (C) very dark skin. (Evans, R., 1948, p. 88.)

Figure 15–4 A simplified illustration of a color densitometer in transmission and reflection modes.

15.3 Spectrophotometric Curves

Spectrophotometric curves, such as those shown in Figure 15-3, can then be plotted from the data, or plotted directly by some instruments. The curves provide a contour or envelope that describes the reflection or transmission characteristics of a sample, such as an image area in a color print or color transparency. It is important to understand that such curves describe the physical characteristics of the colored samples, not the colors that would be perceived by a person viewing the samples. The curves for skin colors in Figure 15-3, for example, show that human skin has the highest reflection in the red region of the spectrum and the least in the blue region. Light skin has the highest reflection at all wavelengths, as one would expect, and the curve is bumpier. The reflectance for any specific wavelength is easily obtained from the curves. At 700 nm, for example, light skin has a reflectance of 70%, dark skin 45%, and very dark skin 15%. There are many different skin colors. Each would have its own curve shape but, in general, would be similar to those shown in Figure 15-3. Depending upon how the spectral response is specified, spectrophotometric curves can be referred to as spectral transmittance, spectral reflectance, or epochial density curves.

15.4 Color Densitometers

An essential difference between a color densitometer and a spectrophotometer is in the bandwidth of light being used to measure the reflectance or transmittance of a color sample. Whereas a spectrophotometer uses a prism or diffraction grating to spread the light and a slit to isolate narrow spectral bands of light ranging between 1 nm and 10 nm, a densitometer uses red, green, and blue filters to isolate broad bands of light of about 50 nm (see Figure 15–4). The result is not a curve showing the spectral transmittance or reflectance of a color sample at each wavelength, such as in Figure 15–3, but simply three numbers, expressed as density (the log of the reciprocal of the trans-

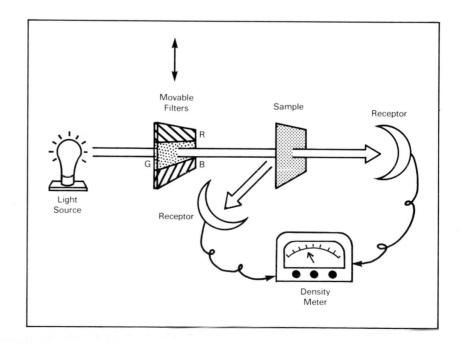

mittance or reflectance). The recommended red, green, and blue filters for use in measuring most color transparencies and prints are the Wratten 92, 93, and 94 filters, with bandwidths of approximately 60 nm, 30 nm, and 35 nm, as shown in Figure 15–5.

Color densitometers can be classified as either visual, if the human eye serves as the receiver, or physical, if some other lightsensitive device such as a photodiode is used. Densitometers can be further classified as direct reading, if the receiver output indicates the density, or null type, if the receiver indicates when two beams of light are balanced or equal. Visual densitometers are always of the null type based on the equality of light passing through the sample being measured and light passing through an area of known density.

15.5 Color Densities

Color densitometers measure the density of a colored layer to broad spectral bands of light as determined by the choice of filters. In photography, color densitometers are used to measure the density of cyan, magenta, and yellow dye layers to red, green, and blue light. Ideally, cyan dye would absorb only red light and transmit blue and green light freely. In practice, cyan dyes absorb some blue and green light. Therefore, the combined density of the three dye layers in a color transparency would be different if the layers were peeled apart and measured than when they are measured in the normal superimposed position. If all three layers are measured as one unit, the results are called *integral* color densities. When each layer is measured separately, the results are called *analytical* color densities.

Integral density measurements are typically used for the control of photographic color processes and to determine the printing times required for color negatives. Analytical densities are used primarily for research and development to improve existing color products and to develop new products. Figure 15–6 shows a spectrophotometric curve (expressed as spectral density) for a typical color film. The three lower curves represent the spectral analytical densities for each layer separately, while the upper curve represents the spectral integral densities of the cyan, magenta, and yellow layers combined to form a neutral.

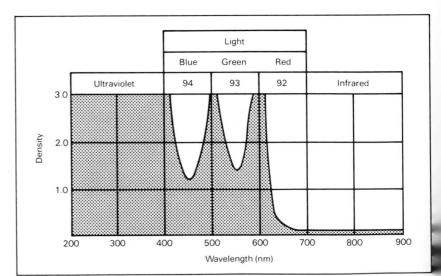

Figure 15-5 Wratten 92, 93, and 94 filters are recommended for color density measurements of photographic color transparencies and prints. (All gelatin filters absorb UV but transmit IR.)

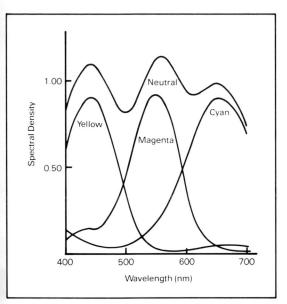

Figure 15–6 Spectrophotometric curves for a visually neutral sample of color reversal film.

three separate values: density to red light (D_r) , density to green light (D_g) , and density to blue light (D_b) . If the bandwidth of the three filters in the densitometer coincided with the three peaks of the upper curve in Figure 15–6, one could speculate that D_r would be a little less than 1.0, while D_g and D_b would be higher. The difference between the peak analytical densities and the integral densities at the same wavelengths represents unwanted absorption of blue and green light by the cyan dye, unwanted absorption of red and blue light by the magenta dye, and unwanted absorption of red and green light by the yellow dye.

Color density measurements are highly dependent upon the choice of red, green, and blue filters used to make the measurements and the spectral sensitivity of the phototube. Even when the same filters and phototubes are used, one should not be surprised to discover differences. And since filters and phototubes age and change, it is good practice to maintain control charts for color densitometers.

15.6 Physical, Psychophysical, and Psychological Measurements

Spectrophotometric curves describe the physical reflection or transmission characteristics of colored substances. We use our own perceptual systems, however, to make psychological measurements of hue, saturation, and brightness. Since psychological measurements are personal and subject to great variability, specialized instruments have been developed that provide, under rigidly specified conditions, physical measurements that correlate well with psychological visual perceptions. Such measurements are called psychophysical since they combine both worlds.

Figure 15-7 provides a comparative listing of terms to describe the attributes of light when the measurements made are physical, psychophysical, or psychological. Thoughtful description of these attributes will distinguish the intended meaning and facilitate clarity. For example, a spectrophotometer will measure the spectral distribution of light reflected from an object or transmitted by an object. This is strictly a physical measurement. An instrument called a colorimeter (to be discussed later) has a response characteristic similar to the human eye and specifies the chromaticity of the spectral distribution. This is a psychophysical measure that describes the quality of color relative to a neutral color in terms of dominant wavelength (hue) and purity (saturation), and allows it to be positioned on a color map (CIE diagram to be discussed later). How that particular chromaticity is sensed by a human observer falls into the realm of psychological measurement and is called chromaticness (or chrominance). Chromaticity and chromaticness represent only two of the three attributes of color; the other is luminance (brightness/lightness).

Color, like time and space, is a distinctive property of our daily experiences. Different individuals' concern with color will depend to a large extent upon their chosen professions. A chemist may be concerned with the molecular dye structure of the colorants; a colorimetrist with precise psychophysical measurements and specification; a psychologist with repeatable and predictable psychological measurement; a painter with the esthetics; and a photographer with the esthetics, accuracy of reproduction, archival qualities, and communication of color. Figure 15-7 Adapted from the system of nomenclature as given by the Committee on Colorimetry of the Optical Society of America 1943. (Sheppard, J., 1958, p. 11)

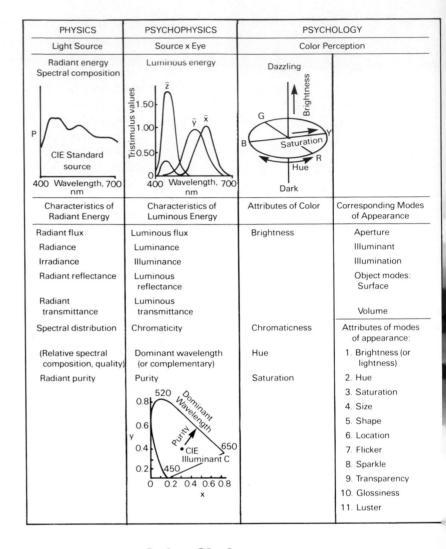

15.7 Color Chain

The perception or measurement of color follows a chain o events as shown in Figure 15–8. There are four major links in the chain. The characteristics and interactions of the first three—ligh source, color stimulus, and receiver—determine the response, which can be described in psychological, physical, or psychophysical terms Some of the terms used to describe the characteristics of the variou links are:

- 1. Light source: illuminant, color temperature, correlated color tem perature, spectral energy distribution, tungsten, sunlight, day light.
- 2. Color stimulus: colorant, dye, ink, pigment, color object, spectra reflectance or transmittance.
- 3. Receiver: human eye, photocell, photographic film.
- 4. Response: Munsell system (psychological), spectrograph (physical) CIE system (psychophysical).

15.8 Color Mode

The characteristics of the color stimuli can be further espanded to include the particular mode of appearance or context in whic

15.8 Color Mode

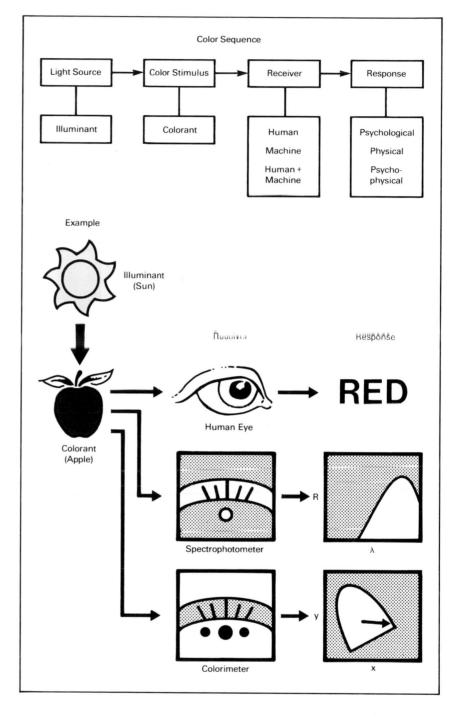

colors are experienced. There are five such modes generally recognized, which influence the response to the color stimuli: *surface, volume, aperture, illumination,* and *illuminant*. When photographing color it is helpful to recognize and distinguish between these various modes (see Figure 15–9).

The most common is the surface mode or surface color, which refers to light reflected from and modified by a surface. It is seen as belonging to a surface. Examples are painted walls, color photographs, fruits, vegetables, human skin, and all such objects that present reflecting surfaces.

Volume color refers to color perceived when one looks into or through a uniformly transparent substance such as a liquid. Examples

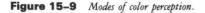

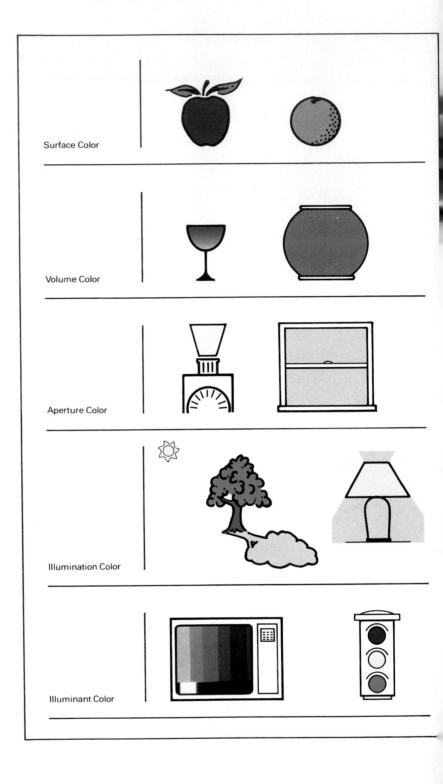

would be the bluish color of water in a swimming pool, yellowish cole of cooking oil in a bottle, pinkish color of a rosé wine, and the lik. A liquid filter used to change color temperature is yet another exampl The strength of the volume color is determined by the concentratic of the liquid and the thickness or depth (see Beer's and Bouguer's lay section 16.6).

Aperture color refers to color perceived in space and necognizable as an object. Examples include the bluish color of the sl

and the reddish color of a sunset or sunrise, which seems to fill the "emptiness" above us. Light seen in an opening, such as the color lights projected into an aperture of a colorimeter for color matching, is a prime example of an aperture color mode. A more practical example would be a virtual image that one could see at the film plane of a view camera when the ground glass is removed. (Aperture color is sometimes referred to as film color, which can be confusing to a photographer.)

Illumination color refers to the perceived color of light falling on an object. A familiar example in color photography occurs when we are taking photographs outdoors under sunlight conditions and we find that the shadows in the white snow (or on light sand or concrete) tend to have a bluish cast. This is a result of fill light from the blue sky, which casts a diffuse blue light over the entire landscape. Such bluish shadows are recorded objectively by the film as illumination color, but rarely by the eyes, which tend to compensate.

We may not perceive them as such but the colors we see reflected from a movie screen can be thought of as illumination colors. A projector has a white light source that is modified by the color film in the projector. The various colors of light passing through the film fall on a white screen surface and are reflected. We could, but generally do not, and them as illumination colors. In a studio setting we usually use white lights to obtain surface colors. If we used a warm (reddish) light to represent light from a fireplace, however, the colors would be modified. We would then attribute the altered appearance of the color objects to illumination color.

Illuminant color is distinguished from illumination color in that it is the color of the light source viewed directly. Instead of looking at the illumination color on the movie screen, we could turn around and look directly at the projector and the colors of light passing through the lens. More common experiences of illuminant colors are red, green, and yellow traffic lights, Christmas tree lights and neon lights. Another example of illuminant color is the viewing of a television picture or television display from a microcomputer or word-processing machine. The television screen (cathode ray tube) consists of thousands of dots of red, green, and blue phosphors that emit light as they are energized. When we view color pictures or color graphics on a television screen, we are looking directly at the light source. This system of color reproduction is uniquely different from a photographic system. (When working with video color systems it is important to realize that there is a decided difference between displaying pictures of three-dimensional objects on a television screen and using a computer to generate pictures and graphics on a television screen. Important to our perception of color are texture and line, which are usually absent with computergenerated graphics.)

15.9 Primary Colors

Surprisingly enough, the minimum number of colors needed to form most other colors, by mixing, is three. They must be independent of each other; i.e., two of the three colors when mixed must not form the third color. For subtractive systems of color, such as photography and printing, the primaries are called cyan (blue-green), magenta (blue-red), and yellow (red-green) *colorants* (inks, pigments, dyes). In additive systems of color, the primaries are red, green, and blue (Figure 15–10). Television is an additive system, which uses small dots of red, green, and blue phosphors that are too small to resolve as separate dots, although they can be seen with a magnifier. (Avoid doing this for any length of time since television tubes emit some potentially harmful radiation.) An early example of an additive system used to produce photographic color transparencies is Dufaycolor, which used a mosaic of minute red, green, and blue filters and was introduced in 1934.

Since the subtractive color primaries—cyan, magenta, and yellow—are complementary to the additive color primaries—red, green and blue—they are sometimes referred to as minus-red, minus-green, minus-blue. In color printing it is especially helpful to think of cyan, magenta and yellow filters in this way. It is also helpful to remember that a neutral can be formed by combining complementary colors (see Figure 15–11).

Although the selection of the three primary colors for the subtractive as well as additive systems is somewhat arbitrary, the choice is usually based on a number of factors: ability to produce the colorants, ability of the colorants to reproduce the greatest number of secondary colors, stability, availability, cost, and convenience.

15.10 Color Attributes

When we describe the colors we experience, we use such familiar words as *red*, *green*, *yellow*, *orange*, *blue*. Further, we might distinguish one red from another by saying it is darker or lighter, stronger or weaker. This is because colors have three distinct attributes hue, saturation, and brightness (or lightness). When we say lipstick is red we refer to hue. Saturation describes how strong or intense the rec hue is, and brightness or lightness how light or dark the red hue i

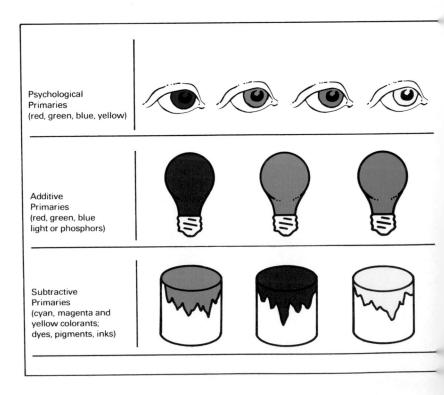

Figure 15-10 The four psychological primaries are distinct from any other color. The three additive primaries are colors of light that can be mixed to form other colors. The three subtractive primaries are colorants that can be superimposed to form most other colors.

Figure 15–11 When mixed in proper proportions, complementary colors form neutrals or near neutrals.

(see Figure 15–12). We shall see later that the specific terms used to describe these attributes distinguish the different systems for specifying color.

15.11 Neutrals

When mixed in the proper proportions, complementary colors produce neutral colors. Colors such as cyan and red, magenta and green, yellow and blue will, when mixed, form neutrals having various levels of lightness or brightness (see Figure 15–11). Neutrals are distinguished from other colors in that they have no hue or saturation, so they are sometimes referred to as achromatic colors. A scale of such neutrals ranges from black to white and is called a gray scale. It is wrong, as many of us have been taught in early schooling, to think of black or grays as the absence of color. Grays appear neutral because they do not alter the color balance of the incident white light illumination. They appear dark or black when little light reaches the eye, and they appear light or white when much light reaches the eye.

One of the most critical tests of a photographic color material is its ability to reproduce a scale of neutral colors. Small variations in color balance can be detected more easily with neutral colors than with saturated colors. To the eye, a neutral color is either neutral or not, whereas a color such as red can be modified considerably by the addition of blue (magenta-red) or yellow (orange-red) and still be accepted as red.

15.12 Color-Vision Theory

Figure 15–12 The three attributes of color: hue, saturation (chroma), and brightness (lightness or value).

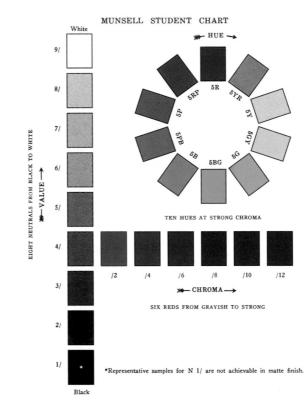

In testing the ability of a color film or paper to reproduce neutrals it should be noted that the results are often more dependent upon the user than the manufacturer. Regardless of how good the product is, if it is improperly stored, exposed to the wrong color temperature light or to mixed lighting, improperly processed, or viewed under poor lighting conditions, one cannot expect quality results.

15.12 Color-Vision Theory

As early as 1666, a 23-year-old instructor at Cambridge University demonstrated that white sunlight is made up of all colors of light. He did this by passing sunlight through a prism to create a spectrum of colors. This demonstration gave visual evidence of how light can be separated into different colors. It was not until 1704, however, that Sir Isaac Newton put forth a hypothesis to explain the process by which we see colors. He speculated that the retina contains innumerable light receptors, each of which responds to a specific color stimulus. This was rejected by Thomas Young nearly a hundred years later, in 1801. In a terse 300-word statement, Young hypothesized that there are only three different kinds of light receptors in the retina, each responding to one color of light—red, green, or blue. His theory was in turn rejected and ignored by his contemporaries. Some 50 years later, in 1850, Young's theory was rediscovered by Maxwell and Helmholtz.

Although there are many theories that attempt to explain our response to color, there remain many unanswered questions. Some theories, however, are more useful than others. The oldest, most efficient, and most persistent theory of color vision is the Young-Helmholtz three-component theory. This theory postulates that there are three kinds of receptors in the retina that react selectively. One can think of these as red, green, and blue receptors that somehow combine in our visual system and produce the perception of other colors.

Some unanswerable questions have been raised regarding this three-color theory for human vision. For example, the eye will distinguish not three but four fundamental or primary colors—colors that are distinct and have no trace of other colors. The colors are red, yellow, green, and blue and are called the psychological primaries. The Hering theory of color vision taken this interactional

A sumewhat more complex theory is the Hering opponent-colors theory. Whereas the Young-Helmholtz theory is based on three color stimuli, the Hering theory is based on the response to pairs of color stimuli. It assumes that there are six basic independent colors (red, yellow, green, blue, white, and black). Rather than postulating special and separate receptors for the six colors, Hering proposed that the light absorbed by the red, green, and blue sensitive receptors in the retina starts a flow of activity in the visual system. Somehow this flow is channeled into three pairs of processes with the two components of each opposing one another (opponents). The opposing pairs are blue-yellow, green-red, white-black. For example, a color may look bluish or yellowish but never both at the same time. Blue would oppose and cancel yellow, and vice versa.

A variation on the Hering theory that provides for quantification is the *Hurvich-Jameson quantitative opponent-colors theory*. This theory assumes a two-stage process. The first stage is the excitation stage, located in the cones of the retina and consisting of four lightreceiving cells that contain combinations of three photo chemicals. The second stage is an associated response stage located beyond the retina in the visual nerve center. It has three paired-opponent processes: blueyellow, green-red, and white-black. This opponent-response theory represents differences in the neural response to the stimulation that originated when the cones in the retina were excited. A single nerve transmits two different messages by one of the pairs of opponent colors raising the neural firing rate above the normal rate (excitation) and the other lowering the firing rate below the normal rate (inhibition).

15.13 Object-Color Specification Systems

Five different modes of perceiving color were mentioned earlier. The most common mode is object color or surface color, since it is the light reflected from the surfaces of objects that we normally see; a red tomato, green grass, blue shirt, brown pants, skin color, and so on. Systems for color specification of object colors consist of a large variety of colored chips from which a person can choose. The choice provides information on *matching colors* or *mixing colorants*. To determine which colorants need to be mixed to produce a certain color, a color chip is chosen. This provides information on the percentages of different inks, pigments, or paints needed to produce that chip color. Matching a color sample to a particular color chip provides a color-standard color name and notation for the sample. Color-matching and color-mixing information provide an agreed-upon means of communication. There are three different ways in which object-color specification systems can be designed.

The first is called *colorant mixtures;* a limited number of colorants such as dyes and pigments are used to generate a range of colors on some surface. This is done by systematically varying the proportions of colorants. One such system was developed from eight basic paints, including black and white. These were mixed in measured

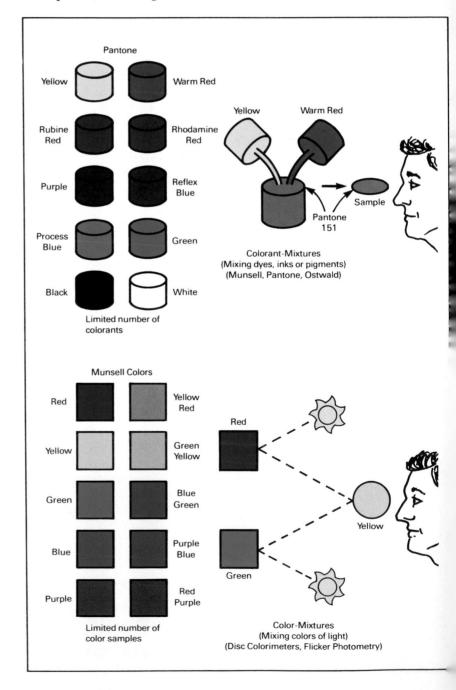

Figure 15–13 A comparison of two systems for producing a gamut of object-color samples.

proportions and put on 1,000 different cards. This system is useful in preparing specific colors of paints or inks by known mixtures of other basic paints or inks.

The second system for object-color specification, *color-mixtures*, is similar to the colorant-mixture system in that a limited number of colorants are used to produce a range of colors. It is different in that it is an *optical mixture* of colorants. The colors of light reflected from specially prepared surface colorants are blended in systematically varied proportions to generate a range of colors (see Figure 15–13).

Optical mixtures can be obtained by spatial integration or by temporal integration. An example of spatial integration is an integrating sphere as used in a colorimeter. An example of temporal integration is a mixture of colors of light that result from a rapidly revolving sector wheel having different colorants. This was the basis for producing the colors for the Ostwald system. Object-color samples obtained by color mixtures more closely approximate the way object colors are seen in our daily experiences. A photographic example of spatial integration is the measurement of the color balance and illuminance of the integrated light transmitted by an enlarger lens to determine the filtration and exposure time when printing color negatives and transparencies. The human eve also integrates colors when it cannot recolve the individual colors in an object or reproduction composed of fine detail, as when viewing dots of colors in photomechanical halftone reproductions of color photographs. Even the original color photographs are made up of minute clumps of colors that conform to the grain structure of the emulsion.

The third system for object-color specification is the *appear-ance* system, in which the color chips or samples are spaced so that they appear to have uniform intervals of hue, saturation, and lightness. This requires judgment by a standard observer under a standard set of viewing conditions. One of the most complete examples of the appearance system is the *Munsell Color System*, which consists of hundreds of object-color samples in a *Munsell Book of Color*. The book contains more than 1,200 individually removable chips having either a mat or glossy surface. The Munsell Color System is very useful to practicing photographers, artists, and designers.

Object colors can be analyzed in terms of primary colors or in terms of wavelengths. In a colorimeter, a color sample is matched with a mixture of red, green, and blue primaries. The proportions of red, green, and blue light necessary to make a match specifies the color sample being analyzed. A spectrophotometer provides a wavelengthby-wavelength analysis of a color sample in terms of spectral reflectance or transmittance. A densitometer analyzes a color sample in terms of densities measured with red, green, and blue light.

15.14 Munsell System: Brief History

Albert H. Munsell (1858–1918) was an artist and a teacher very much concerned about the lack of structure in the specification of colors. He clearly called attention to the fact that "words are incomplete expressions for color" and that color scales analogous to musical scales were needed to visually estimate and specify colors. A contemporary who was quite influential in the development of the Munsell system was Ogden N. Rood (1831–1902), who was also a teacher and an artist In 1863 Rood held the chair in physics at Columbia University and did much experimenting with light and color. In 1874 he began lecturing on optics, color, and painting, and in 1879 he wrote a book on color called *Modern Chromatics*, which became a classic in its field. He was a great influence on neoimpressionist painter Paul Signac.

In 1891 Rood read the paper "On a Color System" before the National Academy of Sciences; it was published in the American Journal of Science in 1892. He devised a double pyramid system, placed base to base, painting them white on top and black on the bottom. Spectral colors were arranged in a band around the perimeter of the pyramids. Munsell was familiar with Rood's approach to color specification and corresponded with him. On July 26th, 1899, he wrote that he would "look forward with pleasure to have the talk you suggested on this matter of a color globe—some time when it will be convenient for you. I think to pass the summer near Land's End and return to my teaching in Boston about October first."¹

Munsell had read Rood's book on *Modern Chromatics*, in which he wrote of preparing hundreds of carefully graded colors on paper discs and mixing the colors by spinning them on color wheels. He also devised mathematical notations in an attempt to specify colors. Rood admitted to Munsell in a letter that "with all desire in the world I have so far been unable to make a scientifically accurate color-system." Munsell was also familiar with the work and writings of another color pioneer, M. E. Chevreul.

15.15 Munsell System of Color Specification

In 1905 Munsell published his first edition of A Color Notation. He observed that a child's first "color sensations are sufficiently described by the simple terms of red, yellow, green, blue, purple. But soon he sees that some are light, while others dark, and later comes to perceive that each hue has many grayer degrees. Thus he recognizes three ways in which colors differ."² Recent researchers have confirmed this and discovered that infants as young as 2 or 3 months old see many if not all of the colors adults see. Further, infants tend to categorize colors into red, yellow, green, and blue and are more attracted to these colors than to blends of them.³ Researchers have also found that infants worldwide are born with a capacity to see different colors and to categorize them, but that once they learn their native languages children begin to describe their common color experiences quite differently.

One of the Munsell system's strengths is that it provides a common international notation for color in which a person first identifies a color visually (nonverbally) and then uses language to describe it and communicate it. In order to accomplish this, Munsell had to first prepare a large variety (gamut) of painted color chips. Imagine hundreds of such chips having different *bues*, which Munsell described as the "name of the color"; different *values*, which he described as "the lightness of color . . . that quality by which we distinguish a light color from a dark one"; and *chroma*, which is "the strength of a color . . . that quality by which we distinguish a strong color from a weak one; the degree of departure of a color sensation from that of a white or gray; the intensity of a distinctive hue; color intensity." In sorting out the gamut of color chips, one would first group them according to hue

¹Rood, O., 1973 (1879), p. 15.

²Munsell, A.H., 1967, p. 14.

³Bornstein, M., and Marks, L., January, 1982, pp. 64-73.

(red, yellow, green, blue, and the in-between hues). Then for each grouping of hue they would be arranged according to their values of lightness or darkness. A red hue grouping, for example, could be arranged so that all the red chips increased in lightness from dark to light. The final arrangement, more difficult, would be to group all of the chips having the same hue and lightness according to their color intensity or chroma. On one end would be red chips that are near neutral, on the opposite end would be a red chip that one might call an intense or vibrant red—one that was a highly saturated red.

This type of ordering is essentially what Munsell did with some refinement—the most important refinement being that he ordered the colored chips so that the interval between adjoining chips would be visually equal in hue, value and chroma, quite a monumental task. Once this visual structuring was completed, he had to communicate it to others so they could also visualize the arrangement and use a common language to describe the colors. Since color has three attributes (hue, value, chroma), it occupies a three-dimensional space or volume. Munsell described this concretely in terms of a color tree. "The Munsell color tree has a vertical trunk which represents a scale of values, branches which represent different *bues*, and leaves extending along the branches which represent different *bues*, and leaves extending along the branches which represent different bues, and leaves extending along the branches as one moves out along the branches (see Figure 15-14).⁴

A more abstract representation of this color system is shown in Figure 15-15. The trunk of the tree, representing values from black

⁴Stroebel, L., Todd, H., Zakia, R., 1980. p. 91.

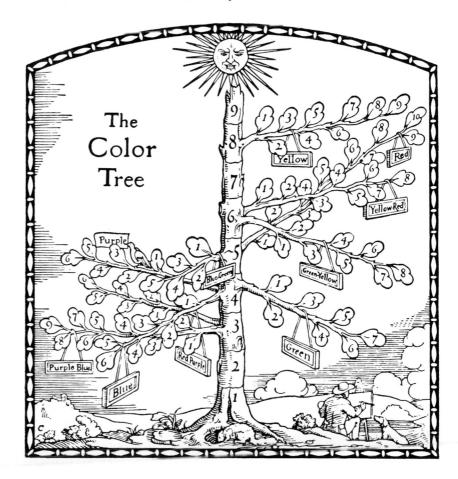

Figure 15-14 The Munsell color tree. (From Munsell, A Grammar of Color, edited by Faber Birren, © 1969 by Litton Educational Publishing, Inc. Reprinted by permission of Van Nostrand-Reinhold Co.)

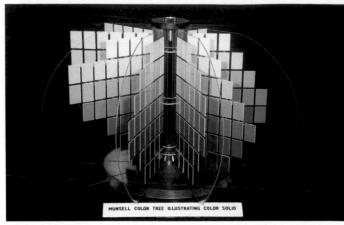

Figure 15–15 This Munsell color tree contains 10 constant hue charts on clear plastic leaves. (It may be purchased from Macbeth, Munsell Color, 2441 N. Calvert St., Baltimore, MD 21218.)

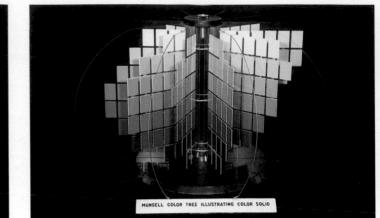

to white, is now the center post of a color sphere; the branches representing hues are now vertical sheets of plastic attached to the center post; and the leaves across the branches now become chips of color extending from the center post outward in all directions. The changes as one circles the Munsell color sphere: value changes vertically; and for a specific hue and value, chroma increases from the center post outward.

The three attributes of color (hue, value, and chroma) are visually represented in the Munsell tree as a color *space* or volume. The overall shape of the color space is not symmetrical. This is because the range of chromas is not the same for all hues. In the extreme it is possible to have a yellow hue of high value and high chroma but not one of low value and high chroma. Similarily, a blue hue of high value and high chroma is not attainable. The three-dimensional asymmetrical color solid represents colorants now available, not including fluorescent colors.

Of the 100 hues that can be represented in the Munsell system a select sample of 10 are actually shown. The others would fall in between, and all 100 hues would be equally spaced in terms of visual differences as illustrated in Figure 15–16. The left diagram represents

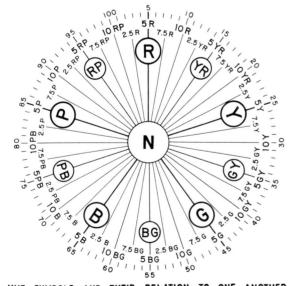

HUE SYMBOLS AND THEIR RELATION TO ONE ANOTHER Figure 15–16 The right diagram shows the 10 major hues of the Munsell system. The left diagram displays the names of these hues as letters in 100 divisions representing 100 different hues.

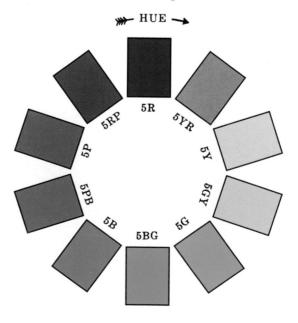

15.15 Munsell System of Color Specification

6	1				_																
	Red R	d		ellov Red Y-R		Yellov Y	N	Greer Yellov G-Y	~	Gree G	n	Blue Gree B-G		Blue B		Purple Blue P-B	e-	Purpl P		Red- Purple R-P	
1	5	1	0	5	10	5	10	5	10	5	10	5	10	5	10	5	10	5	10	5	10
1	5	1	0	15	20	25	30	35	40	45	50	55	60	65	70	75	80	85	90	95	100

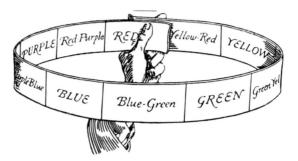

Figure 15-17 The hue circle chemican we would consumate waper of the figure 15 16, in store channels and a series of the store consecutive numbers from 1 to 100 simplify the numerical coding of colors for computer processing. (From Munsell, A Grammar of Color, edited by Faber Birren. © 1969 by Litton Educational Publishing, Inc. Reprinted by permission of Van Nostrand Reinhold Co.)

a schematic top view of the Munsell tree. The left diagram illustrates the arrangement of the 100 hues as numerical designations from 1 to 100, and as alphanumeric designations for 10 major hues from red to red-purple (see Figures 15-17 and 15-18). The names of these select or major hues are given below and are divided into principal and intermediate hues.

Principal Hues Red	Intermediate Hues Yellow-Red (YR)
Yellow	Green-Yellow (GY)
Green	Blue-Green (BG)
Blue	Purple-Blue (PB)
Purple	Red-Purple (RP)

Figure 15-16 (left) shows how the 10 major hue names can be used for qualitative notation. The 100 numbers in the outer circle provide more precise notation. The numbers make it easy to use the Munsell system for statistical work, cataloging and computer programming. The combination of numerals with hue initials is considered the most descriptive form of designation. This combination is shown in the inner circle; 5R, 75R, 10R, 2.5YR, 7.5YR, 10YR, etc. *The Munsell Book of Color* shows the actual colors of these 40 constant hues.

5	RED-PURPLE	95
6	RP	96
7	RP	97
8	RP	98
9	RP	99
10	RP	100
1	R	1
2	R	2
٦	11	ប
4	R	4
5	RED	5
6	R	6
7	R	7
8	R	8
9	R	9
10	R	10
1	YR	11
2	YR	12
3	YR	13
4	YR	14
5	YELLOW- RED	15
6	YR	16
7	YR	17
8	YR	18
9	YR	19
10	YR	20
1	Y	21
2	Y	23
3	. Y	23
4	Y	24
5	YELLOW	25

Figure 15–18 An expanded section of some of the bues in Figure 15–17 to show the division of bues into units of 10.

15.15 Munsell System of Color Specification

For a particular hue, say one of the 10 major hues represented in the Munsell tree, there are a number of different values and chromas, and therefore different colors, of that hue. Imagine the 5 Red hue segment removed from the tree and displayed as shown in Figures 15-17 and 15-18. The 5R notation designates that this hue is midway between a 5RP and a 5YR on the hue circle. The 5R by itself designates only the particular hue, not the color. As indicated in Figure 15-19, the 5R hue can be further specified in terms of value and chroma numbers or described in terms agreed upon by Inter-Society Color Council and the National Bureau of Standards (the ISCC-NBS).

In the Munsell system, color is specified in the alphanumeric sequence Hue Value/Chroma (H V/C). For example, a 5R hue with a value of 8 and a chroma of 4 would be called a Light Pink and designated 5R 8/4 or simply R 8/4 (for hues having positions other than 5 on the hue circle the position must be indicated-for example, 3R 8/4). R 5/12 translates to a Strong Red having a value of 5 and a chroma of 12. At the extreme left of the diagrams (center of the Munsell tree) the colors are neutral and are so represented. The notation for a neutral (achromatic) color is written NV/; for a middle gray (18% gray) the notation is N5/. Since the chroma is zero, it is usually omitted but could be included (N 5/0). (For those interested in Zone System notation a black. Zone 0, would be about N1/; a Zone V gray, N 5/; and a Zone IX white, N 9/.)

STRONG

YELLOWISH

PINK

DEEP

PINK

MODERATE

RED

DEEP

RED

10

VERY DEEP

RED

8

DAR

PINK

DARK RED

6

CHROMA

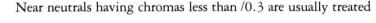

VIVID

YELLOWISH

PINK

DEEP

YELLOWISH

PINK

RED

STRONG

VIVID

RED

12 14

Figure 15-19 Method for converting Munsell notations to color names using The ISCC-NBS (Inter-Society Color Council and National Bureau of Standards) Method of Designating Colors, and a Dictionary of Color Names. (Available as circular 553 from the Superintendent of Documents, U.S. Government Printing Office, Washington, D.C. 20402.)

0

1

2

4

Figure 15–20 The Macbeth ColorChecker Color Rendition Chart contains an array of representative colors and a gray scale.

as neutrals. If more precision is needed, the form N V/(H,C) is used (H would be represented by one of the 10 select hues). For example, a light gray that is slightly yellowish might be noted as N 8/Y,0.2 or, using the regular H V/C form; Y 8/0.2. The form N V/0 can be reserved for absolute neutrals.

15.16 Munsell Color Materials

The Macbeth Division of the Kollmorgan Corporation (2441 N. Calvert St., Baltimore, MD 21218) has available a variety of colored items for use in education, testing, measuring, and quality control.

- 1. Munsell Book of Color is available in either a glossy finish or a mat finish. The book displays 1,490 removable color chips.
- 2. Macbeth ColorChecker is a 9×13 -inch target with an array of 24 colored squares (see Figure 15–20). Each color is specified in terms of Munsell notation and CIE values, and the colors closely match the spectral response of such things as blue sky, green foliage and skin tones. Also included is a scale of grays from black to while,
- 3. Munsell Color Tree or channelli Pipitre 15 14, compatible nearly 300 Plassy colored i High for 10 inajor hues.
- **4.** Student Sets consist of a number of chips representing major hues and varying in value and chroma. The chips are loose and scrambled, and the student learns Munsell color notation by organizing the chips according to hue, value, and chroma (H V/C).
- **5.** A Color Notation is a reprint of the original book on color written by A.E.O. Munsell in the early 1900s.
- 6. Farnsworth-Munsell 100 Hue Test is used for testing color-vision anomalies and color aptitude.
- 7. A number of other items, as well as custom services such as color measurements, are also available.

In 1984, the Munsell Color Science Laboratory was established at the Rochester Institute of Technology for the purpose of conducting research and development in the areas of color measurement, color appearance, color standardization, and color education. (Information can be obtained by contacting the Richard S. Hunter Professor, School of Photographic Arts and Sciences, RIT, 1 Lomb Drive, Rochester, NY 14623.)

15.17 Ostwald System of Color Specification

The Ostwald color system was prescribed by the German chemist Wilhelm Ostwald (1853–1932). It is an object-color system like the Munsell system, but it is based on the amounts of white or black added to a spinning disk having a color of maximum chroma. Ostwald arranged his system as shown in Figure 15–21. Hues of maximum purity form around an equatorial circle with complementary colors opposite. Like the Munsell tree trunk, the central axis contains neutral colors from black to white. The Ostwald system has a scale of only 8 neutrals from black to white and 30 color triangles of different hues. The color samples are sometimes hexagonal and are identified by the proportions of white and black mixed with a particular hue of maximum purity. For example, a blue with a notation of color (C) =

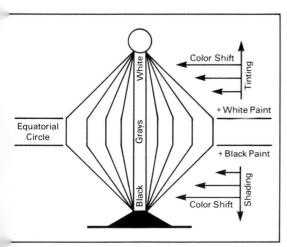

igure 15–21 Stylized illustration of an Ostwald color ee.

34, white (W) = 20, and black (B) = 46 designates a particular blue color. The three numbers total 100%.

The Ostwald system is sometimes preferred by artist-painters, as it provides them with information on how much white and black paint to mix with a particular hue to obtain a desired color. By adding white the color becomes progressively lighter (called a "tint") and less saturated, while adding black causes the color to become darker (called a "shade") and less saturated. Maximum saturation or purity is along the equatorial axis.

15.18 Pantone[®] System of Color Specification

The Pantone Matching System is an object-color system widely used in the graphic arts industry. (Pantone® is Pantone, Inc.'s check-standard trademark for color reproduction and color reproduction material.) It differs from the Munsell system in that it is not based on equal visual differences in color, and in that the colorants used are inks common to graphic-arts printing. Using colorants similar to those used for printing provides a closer match between the colors selected and specified by the client and the colors produced by the printer. The system comprises more than 500 standard Pantone® colors by blending various proportions of eight basic chromatic colors, plus black and transparent white. To produce a Pantone[®] 292 color similar to a Munsell 5PB 5/10, for example, would require 2 parts Pantone[®] Reflex Blue, 2 parts Pantone® Process Blue, and 12 parts transparent white. The reproduction of a gray card can be specified by matching it first to a Pantone® color such as Pantone® 424 and then giving that information to the printer. The printer knows that the gray-card color can be reproduced with an ink mixture of 3 parts Pantone® Black, 1 part Pantone[®] Reflex Blue, and 12 parts transparent white.

The colors used in Figure 15-13 were chosen by the authors from the Pantone[®] Color Formula Guide (see Figure 15-22). The Pantone numerical designation for each color specified was communicated to the book's graphic designer, who in turn used the same notation to communicate the desired colors to the printer. In this way, author, designer and printer shared a common color language, which facilitated communication and reduced error. Any standard system of color notation provides this. In communicating colors to others, however, it is essential to know which system they are using. (For more information on Pantone[®] Matching System write to Pantone, Inc., 55 Knickerbocker Road, Moonachie, NJ 07074.)

15.19 Color Matching

Color is a chameleon; it changes depending upon the environment in which it is located and observed. A red apple against a brown wall will appear different from the same red apple against a green wall. The background wall is what can be called a *simple visua*. *field* as compared to a more *complex visual field*, such as the natura environment in which the apple grew and was picked. An apple photographed in a contrived studio setup with a simple background wil appear quite different from an apple on a supermarket shelf among

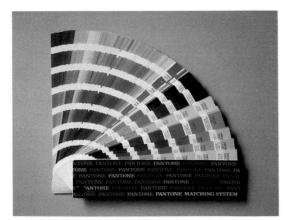

Figure 15-22 Pantone Matching System.

other red apples, yellow lemons, green pears, and oranges, illuminated by diffuse fluorescent light from above and a variable quality of daylight from the large store window. Color perception is an unpredictable variable that depends not only on the colorant but on many other factors, including the background or field conditions, type of lighting, color mode, and mood of the observer. There are far too many variables to attempt to measure and specify color as it will be perceived directly under uncontrollable field conditions. The alternative is to measure color under contrived and controllable conditions as we do for any standard system of measurement. In color measurement we can limit the perceptual variance by utilizing the fact that the most practical invariance of color is equality or identity. Two colors that appear to be the same under controlled and specified viewing conditions are said to have a *color match*. The "eye" or equivalent serves as a null instrument in establishing this equality.

What is specified are the *conditions* for color matching, not the color itself. The matching does not specify the color appearance but rather the physical conditions that provide the color match. Such a system of color specification is limited (as are all standardized methods of measurement) but is widely used in science, business, and induction. The term *colorimetry* is used to the utility that method of color identity the nucchility. Again, colorimetric measurements do not specify the color appearance of a sample but only that two samples with the same numerical specification have the same appearance. This equality or color match is valid only for identical viewing conditions—same size samples, same simple field conditions, same quality of illumination, and so on. (Metameric colors are those that match under one quality of light but not under a different one.)

15.20 Color Mixtures

Colorimetric measurements are based on the laws of color mixture decribed in 1853 by Professor H. Grassmann, based on his own experiments and others such as those by Abney, Young, and Helmholtz. They are often referred to as Grassmann's laws, since he was the first to elucidate them. Color mixtures can be made by mixing lights of different colors or colorants that reflect or transmit different colors of light. Only three colors are required to mix and produce most other colors. Mixing red, green, and blue light is called additive synthesis or additive mixtures. Mixing cyan, magenta, and yellow colorants is called subtractive synthesis or subtractive mixtures. There are two methods for additive synthesis. One is called a spatial additive mixture, in which three colored lights are combined into a homogeneous mix before the new color reaches the eye. The other is called *temporal* additive synthesis, in which sectors of different colors on a disk blend into a homogeneous mixture of one color. This is accomplished by rotating the disk at a rapid rate of over 50 HZ. The colors from the different sectors will reach the retina of the eye at too rapid a rate to be resolved and distinguished.

Grassmann's laws of color mixtures are based on additive synthesis. These laws provide the basis for color matching, colorimetry, and the CIE system for color specifications. (A listing and discussion of Grassmann's laws for additive mixtures can be found in Burnham, Hanes, and Bartleson.)

15.21 CIE System of Color Specification

Color specification with the CIE system differs from that of the Munsell in that a mixture of red, green, and blue light is used to match a given sample rather than the selection of a color chip. The Munsell system is based on appearance, whereas the CIE system is based on *stimulus-synthesis* (the additive mixture of three color primaries). Both systems have advantages, and specifying a color sample with one system allows conversion and notation to the other. The obvious advantage of the Munsell system is its simplicity and its directness. The selection of one of 1,490 color chips provides a color and color notation directly in terms of hue, value, and chroma (H V/C). It is a physical match easily made and easily understood. The CIE system is somewhat abstract and is based on mathematical conventions. It requires instrumentation but has the advantage that any color can be matched, numerically specified, and positioned on a CIE diagram or map. The CIE system provides psychophysical measurements of color, while the Munsell system, based on color appearance, provides psychological or perceptual measures.

15.22 CIE History and Standards

The letters CIE stand for Commission International de l'Eclairage (The International Commission on Illumination). In 1931 the CIE system of color specification became an international standard for colorimetry. Standardization requires strict agreement on the major variables involved in a particular measurement. Color measurement requires a standard light source, a standard observer, and standard viewing conditions.

Several standard light sources have been defined by the Commission. One is a tungsten-filament lamp operating at a color temperature of 2854 K and is designated CIE Source A. By the use of proper filtration, the 2854 K source is converted into a color temperature of 4870 K, which approximates noon sunlight. This is designated CIE Source B. Conversion of 2854 K to 6770 provides CIE Source C, which approximates average daylight conditions. (According to Wyszecki and Stiles, the CIE Source A was assigned a temperature of 2856K in 1971 by the Commission.) It should be noted that daylight type color films are balanced for a color temperature of 5500 K, which is identified as *photographic daylight*.

With the increased use of fluorescent whitening agents in colorants, it became necessary to introduce illuminants whose spectral power distribution in the UV region of the spectrum more nearly represented that of natural daylight. (The word *illuminant* describes a quality of light numerically defined by a spectral power distribution, which may not be physically attainable as a source, such as a tungsten lamp.) In 1964 the CIE recommended other illuminants to complement sources A, B and C. These would represent average daylight over a spectral range of 300 nm to 830 nm and have correlated color temperatures between 4000 K and 25,000 K. The most popular of these is designated D_{65} , which has a correlated color temperature of 6500 K. Others are D_{55} and D_{50} . (In 1971 the CIE indicated that illuminants B and C would be dropped. In practice they have fallen into disuse. Illuminant D_{65} is now widely used as representative of average daylight conditions. See Figure 15–23.)

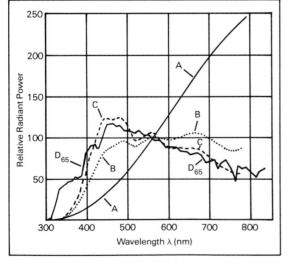

Figure 15–23 CIE Standard Illuminants. (A) Tungsten 2856 K. (B) Sunlight 4870 K. (C) Daylight 6770 K. (D₆₅) Daylight 6500 K. (From Wyszecki and Stiles, p. 144.)

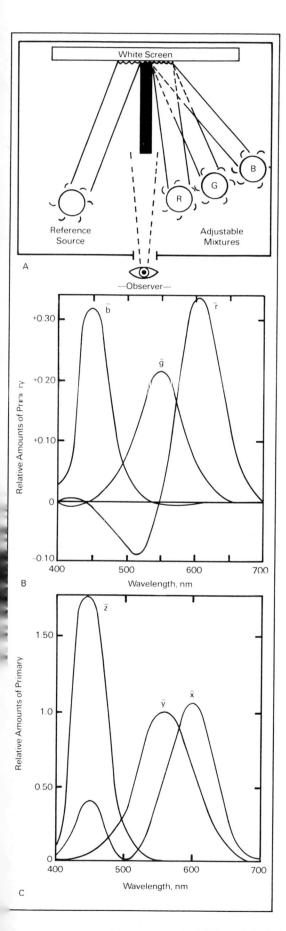

15.23 Tristimulus Distribution Functions

The 1931 CIE standard observer was chosen to have color vision representative of the average population having normal color vision. The red, green, and blue curves that describe the color matching functions of the standard observer are shown in Figure 15-24 and were arrived at by experimentation. Figure 15-24 illustrates the experiment in which three distinctly different lights (red, green, and blue) are used as *primaries* and adjusted to match the color of the reference source. Once the match is made, the amounts of red, green, and blue light used can be specified.

Imagine a similar situation in which the test lamp is filtered so that only narrow bands of color light from 400 nm to 700 nm are presented on the white screen for matching. If the red, green, and blue primaries are selected so that the red is at 700 nm, the green at 546 nm, and the blue at 436 nm, and they are adjusted to match the spectrum colors presented by the filtered reference source, then the standard curves shown in Figure 15–24B are obtained. Notice that the tristimulus (three stimuli: red, green, and blue) values \bar{r} , \bar{g} , \bar{b} contain some negative values. To match a bluish-green quantum unit unit = unit = 1000nm require about the same amount of b and \bar{g} primaries but a negative amount of \bar{r} primary because the spectral color is more saturated than a mixture of the two primaries \bar{b} and \bar{g} . This addition of a negative amount of red is accomplished experimentally by adding some of the red light primary to the opposite side of the matching arrangement in Figure 15–24A.

Negative values were considered inconvenient; and since the CIE system is abstract and mathematical, the data were mathematically transformed in 1931 so that all of the values were positive, as shown in Figure 15–24C. The new primaries are unreal or imaginary primaries because they cannot be produced by any real physical light source. These transformed primaries are designated \bar{x} , \bar{y} , \bar{z} and called *CIE Color-Matching Functions*.

The viewing conditions for the 1931 CIE standard observer were carried out using a dark surround and only foveal vision, which covers about a 2° angle. In 1964, color matching curves based on a 10° angle of vision were generated in order to provide a more accurate correlation with visual perception for large samples. The CIE standard observer represents an average of a small sample of about 20 people

Figure 15–24 CIE tristimulus distribution functions. (A) The mixtures of red, green, and blue primaries that are adjusted to match a reference. (B) Experimentally derived tristimulus values; the amount of red, green, and blue tristimulus primaries $(\bar{r}, \bar{g}, \bar{b})$ required by a CIE standard observer to match each of the colors in the spectrum. (C) A mathematical transformation of the curves in B. The tristimulus values are now labeled $\bar{x}, \bar{y}, \bar{z}$ and are called CIE tristimulus distribution functions. As in B they represent the relative amounts of CIE primaries required at each wavelength to produce a color match to spectral energy at the same wavelength. (Note that \bar{g} curve in B and \bar{y} curve in C match the luminosity function. All luminance characteristics are related to the "green" curve \bar{g} .)

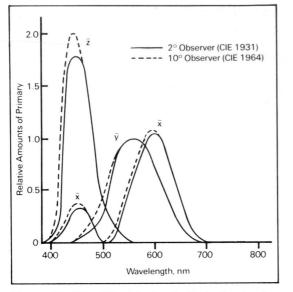

Figure 15–25 CIE tristimulus distribution functions for a 10° observer compared to the 1931 2° observer.

with normal color vision. Figure 15–25 compares the color matching functions for a 2° and 10° observer. Although the overall shapes of the curves are similar, there is a slight shift for all three curves to the shorter wavelengths for the 10° observer. There is better agreement between visual assessments of color carried out in practice and measurements using data from a 10° visual field than that provided by a 2° field.

15.24 CIE System: Colorimeters

A colorimeter is a specialized instrument for measuring color. This is accomplished by mixing colored light—typically red, green, and blue—of known quantity to match a sample in appearance. One of the simplest methods for accomplishing this is to use a spinning disk that has two or more different sectors of color. When the speed of the rotating disk exceeds the flicker frequency of the eye, the colors on the disk blend into one color that can be matched to the sample being measured. Colorimeters can be divided into two general classes: visual and photoelectric. Colors from different samples can be combined either temporally (as with a spinning disk) or spatially (as with an integrating sphere).

15.25 Visual Colorimeters

W. David Wright, one of the early researchers in colorimetry, wrote that

colorimetry is about color matching and we can only understand what a CIE specification really means if we do some basic experiments with a visual colorimeter. Therefore, I want you to imagine that we are engaged in a workshop with my colorimeter at Imperial College.

The instrument uses a prism system to produce two spectra, one spectrum providing the red, green, and blue instrument primaries, and the other the monochromatic test color to be matched. The red-green-blue mixture illuminates one half of a 2° field of view and the observer has three knobs to turn to vary the amounts of the primaries in the mixture. The test color, which can be taken from any wavelength in the spectrum, is seen in the other half of the field, and a small amount of one or other of the primaries can be added to the test color as required.⁵

To use a visual colorimeter, the operator looks into a split field, half of which contains the sample to be measured and the other half the mixture of red, green, and blue light primaries adjusted to match the sample. The amount of each of the primary colors required to obtain a match specifies the color of the sample in terms of tristimulus values (X, Y, Z). A simplified schematic of a visual colorimeter is shown in Figure 15–26.

15.26 Photoelectric Colorimeters

In a photoelectric colorimeter the eye is replaced by a set o photodetectors that have the same color-matching function as a CII standard observer. Photoelectric colorimeters are easy to use, can be operated rapidly, and are sufficiently accurate for most applications

⁵Wright, W. D., 1982, p. 67.

15.27 CIE System: Calculations

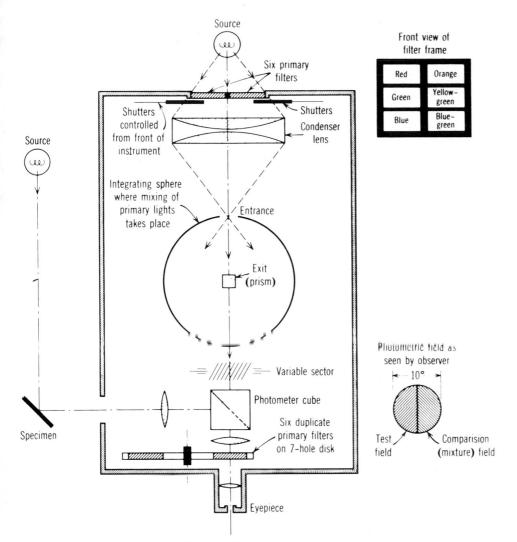

Figure 15–26 Optical diagram of the Donaldson Visual Colorimeter (Judd, 1963) (Courtesy of John Wiley and Sons, Inc.)

Their accuracy is highly dependent on the closeness with which their spectral responses match those of the standard observer. When mixtures of red, green, and blue light are matched to the color of the sample, tristimulus values (X, Y, Z) are given automatically.

15.27 CIE System: Calculations

All color measurements require information about three variables: light source, color sample, and receiver (eye or photocell). These three variables can be described in terms of curves and given symbols for graphical and mathematical expression and calculations as shown in Figure 15–27.

1. Light source (S). The light source is represented by the amount of spectral energy available for each wavelength and is represented by the symbol S. For precise measurements the wavelength region from 360 nm to 830 nm, which includes ultraviolet and infrared radiation, is recommended for the spectral energy distribution of the source. (The 1983 recommendation is for a wavelength region from 380 nm to 780 nm.)

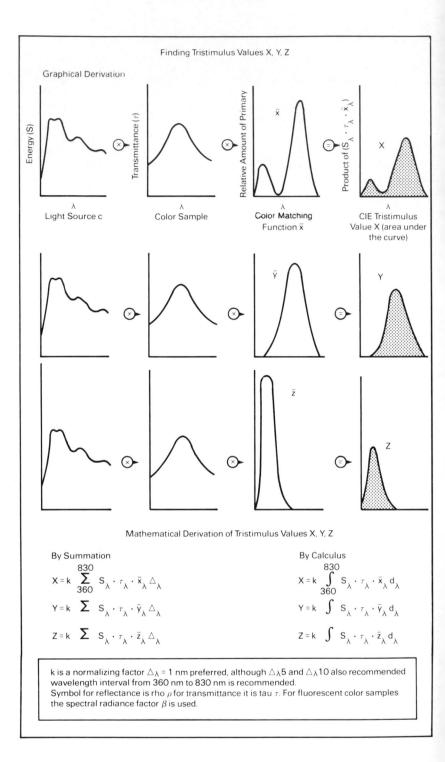

- **2.** Color sample (ρ, τ, β) . The color sample is represented by the amount of spectral energy reflected or transmitted by the sample over a region of 360 nm to 830 nm. The Greek letter rho (ρ) is used for reflectance, and tau (τ) for transmittance. If the color sample fluoresces, as some do, then the color sample is expressed in terms of the spectral radiance factor β (Greek letter beta).
- **3.** Receiver (color matching functions \overline{x} , \overline{y} , \overline{z}). In the CIE system the receiver is represented by three color-matching functions, \overline{x} , \overline{y} , \overline{z} . They describe the relative amounts of red, green and blue primaries

required at each wavelength to produce a color match to spectral energy of the same wavelength. For example, to match a spectral color represented by 500 nm requires about the same amount of \overline{y} and \overline{z} primaries but no \overline{x} primary.

15.28 Determining Tristimulus Values, X, Y, Z

By knowing the spectral energy distribution of the light source, the spectral energy reflectance or transmittance of the color sample and the color-matching function, $(\bar{x}, \bar{y}, \bar{z})$, it is possible to determine the sample's *tristimulus values* (X, Y, Z). Figure 15–27 shows how this can be accomplished graphically or mathematically. The graphical method is similar to the techniques used in tone-reproduction studies where the result is the product of multiplying the values of each component, increment (wavelength) by increment. The graphical products of the light source, color sample and color-matching functions are represented by the shaded curves to the far right. The shading reminds one that the X, Y and Z tristimulus values represent the *area* under the product curves, which specifies the relative amount of CIE primaries needed to match the color sample.

The same X, Y, and Z values can be reached mathematically by multiplying each of the three components from 360 nm to 830 nm using increments of 5 nm or less and then summing all the products. If the curve shapes for each component could be expressed by a mathematical function, then one could use integral calculus to arrive at the tristimulus values X, Y, Z. In practice the values are derived quite simply and directly through the use of computers.

For the green color sample being measured using CIE Daylight Source C the tristimulus values are: X = 54; Y = 67; and Z = 51.

15.29 Chromaticity Coordinates

It would be convenient to plot these numbers on a graph that would allow comparison to a neutral color and to other colors. For convenience in graphical representation the three numbers are reduced to two positions on a graph (x and y). This is accomplished by dividing each of the tristimulus values by the sum of the three values:

$$x = \frac{X}{X + Y + Z} = \frac{0.54}{1.72} = 0.31$$
$$y = \frac{Y}{X + Y + Z} = \frac{0.67}{1.72} = 0.39$$
$$z = \frac{Z}{X + Y + Z} = \frac{0.51}{1.72} = 0.30$$

Since x + y + z = 1.00, the third value z need not be calculated since it is implied by the other two; z = 1 - (x + y).

To specify a particular color in the CIE system, therefore, only the x and y chromaticity coordinates and the tristmulus value Y which in this case is 67—are needed. The chromaticity coordinates are plotted on a CIE Chromaticity Diagram. Chromaticity refers to a quality

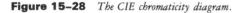

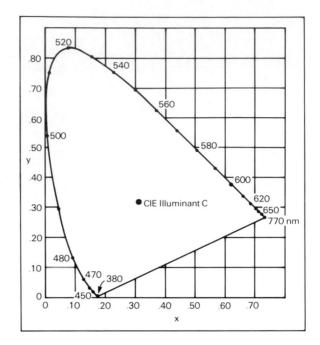

of color that includes hue and saturation (chroma), but not lightness (brightness or value).

15.30 CIE Chromaticity Diagram

"For the same reason that it is impossible to learn geography without the use of maps, it is difficult to understand the subject of color without some form of graphical representation of the relationship of the various colors one to another. To represent the tristimulus values graphically would require a three-dimensional coordinate system which is obviously impracticable. The chromaticity can be conveniently represented, however, merely by plotting the trichromatic coefficients, xand y on a two-dimensional diagram."⁶

The derived x and y chromaticity coordinates x = 0.31 and y = 0.39 provide a graphical method of showing where, in a twodimensional color space, the green color sample is positioned. By identifying a specific location on the graph, the values x and y also serve to identify the color attributes hue and chroma. The third attribute brightness, lightness—is given by the *luminosity function* Y in the CIE system, and is specified by a number, not a location on the graph.

The CIE chromaticity diagram for mapping colors is shown in Figure 15–28. The grid is familiar and conventional, having a horizontal x axis and a vertical y axis. Superimposed on the grid is a horseshoe shape within which all the colors measured by the CIE system would plot. Along the boundary of the horseshoe shape are positioned the wavelengths of color from 380 nm to 770 nm. All the spectrum colors having maximum saturation would fall on the horseshoe-shaped boundary or locus. Thus, for a spectrum color represented by a wavelength of 600 nm, the chromaticity coordinates are x = 0.63 and y= 0.37. Within the boundary, near low-center, is the location of the CIE standard illuminant used to make the measurements.

⁶Hardy, A., 1936, p. 10.

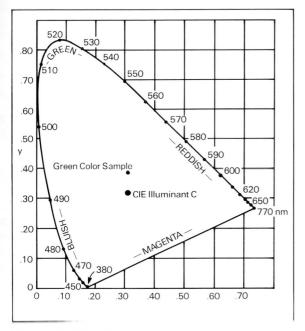

Figure 15–29 Chromaticity plot for a Wratten CC40 Green filter relative to a daylight source (CIE illuminant C).

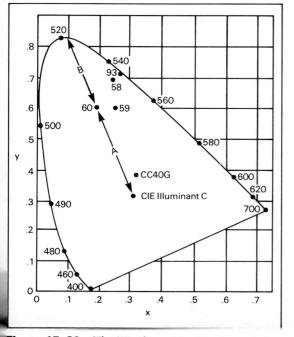

Figure 15–30 The CIE Chromaticity Diagram with the x and y coordinates plotted for several green filters.

All the colors plotted are relative to the illuminant used and, as one would expect, the CIE values of *dominant wavelength*, *purity*, and *luminosity* (to be described later) are dependent upon the color temperature of the light source used in making the measurements. Shown in Figure 15–28 is the position for CIE illuminant C (daylight). The x, y chromaticity values for locating illuminant C are 0.31 (0.3101) and 0.32 (0.3163), respectively.

15.31 Plotting x and y Values

The x = .31 and y = .39 values are plotted on a CIE Chromaticity Diagram as shown in Figure 15–29. Such a plot shows the position of the green color sample relative to the neutral position of the CIE illuminant and the highly saturated spectral colors, which are represented by the boundary of the CIE color map and the wavelength values from 400 blue to 700 red. The position of the green color sample can now be evaluated relative to a neutral and other colors.

If another green sample is measured and it is found to occurv the mine i, j problem, number have the same match. This does not necessarily mean that they are always seen as the same color. All it means is that the two colored samples would match each other under CIE illuminant C. They may not match under a different illuminant, if they are metameric colors.

15.32 CIE Dominant Wavelength and Purity

In the CIE system the term *dominant wavelength* relates to hue, and the word *purity* to chroma or saturation. By plotting the x and y chromaticity coordinates for a color sample, such as the Wratten 60 green filter, one can calculate the values for dominant wavelength and purity. Using illuminant C, the green filter has x and y values of 0.19 and 0.63. These are plotted on the CIE chromaticity diagram in Figure 15–30. The dominant wavelength for the WR 60 green filter is found by extending a straight line from the CIE illuminant C through the plotted point for the green filter to the spectrum locus. The dominant wavelength is between 520 nm and 530 nm, and is actually 526 nm. Purity relates to the color saturation of the green filter. If a plotted point lies on the spectrum locus, the color is 100% pure; if it falls at the position for illuminant C then it has zero purity—completely desaturated—therefore, neutral.

Purity is found by taking the distance from the illuminant point to the sample point (distance A) and dividing it by the distance from the illuminant point to the spectrum locus (distance A plus B). By simple observation we see that the position for the WR 60 green filter is more than 50% of the distance between the illuminant point and the spectrum locus point. By measurement it has a purity of 62%.

Comparison of the other green filters positioned on the CIE chromaticity diagram in Figure 15-30 provide for some interesting comparisons and further understanding of the usefulness of the CIE diagram. Table 15-1 will facilitate comparisons.

A visual inspection of the map shows that the dominant wavelengths are between 520 nm and 560 nm (the green to yellowishgreen region of the spec rum) and that the Wratten 93 filter has the

	Chromaticity	Coordinates	Dominant		Luminous	
Green Filter	x	у	Wavelength (Hue)	Purity (Saturation)	Transmittance M (Brightness)	
58	.24	.69	540	86%	24	
59	.25	.60	538	64%	39	
60	. 19	.63	526	62%	26	
93	.27	.72	545	98%	2	
CC40G	.32	.39	554	21%	68	

Table 15-1 CIE data for various Wratten green filters using CIE illuminant C (6750 K).

highest purity, being nearest the spectrum locus, and the CC40 green filter has the least purity. Table 15-1 quantitatively confirms this. Note in particular the large difference in purity between the WR 93 filter at 98% (a highly saturated, nearly spectrum green of 545 nm) and the low green saturation of a CC40G filter at 21% purity. A visual inspection of these two filters under a daylight source of about 6750 K would confirm this. Even under a tungsten source these differences in purity would be seen (being 96% and 21% for CIE illuminant A).

15.33 The Third CIE Dimension, Luminance Y

The third attribute of color for the CIE system is *luminanc*. (Y) which is shown in Figure 15–31A and which relates to the attribute of brightness (lightness), or value in the Munsell system. It can be imagined as extending vertically from the illuminant position on the CIE chromaticity diagram. Colors of highest *purity* appear when the luminance is zero, and this is the way the CIE diagram is usually shown. (This may appear to be in conflict with the observed colors in the Munsell system. It is not. Keep in mind that the CIE system i not predicated on perceptual space but rather mathematical space; purity [CIE] and chroma [Munsell] are quite different concepts. Further, spec tral colors located on the CIE locus represent pure isolated, singlwavelengths of light.) The Y value for luminance is usually given as number but not plotted.

Figure 15–31B, however, shows how a plot of a CC40C filter having a luminance value of 68 positions itself in space and how the shape of the horseshoe CIE diagram shrinks and becomes much more asymmetrical as the luminance increases. Compare this to the plot of WR 93 filter having a very low luminance value of 2. The topographical mapping in Figure 15–31C shows the progressive shrink age of saturated colors as luminance increases from 0 to 100. Notic that the shrinkage and distortion of the horseshoe-shaped CIE diagram is not linear and that the purity of the yellow colors is least affecte by increasing luminance values.

15.34 Color Names

Although the CIE system does not specify color appearan as does the Munsell system, it is useful to know approximately when specific colors would lie on the CIE chromaticity diagram. Figure 15 32 shows the sectioning of the chromaticity diagram in terms of ho the colors might be seen by a standard observer under daylight illumination. Keep in mind that what is represented is approximate ar that color is three-dimensional, as shown back in Figure 15–31. F

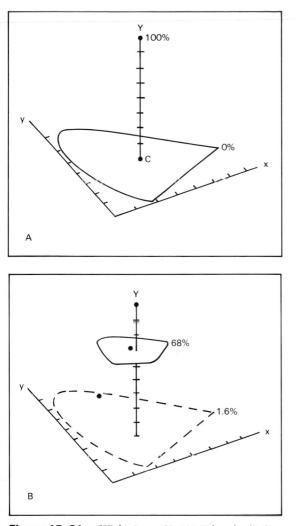

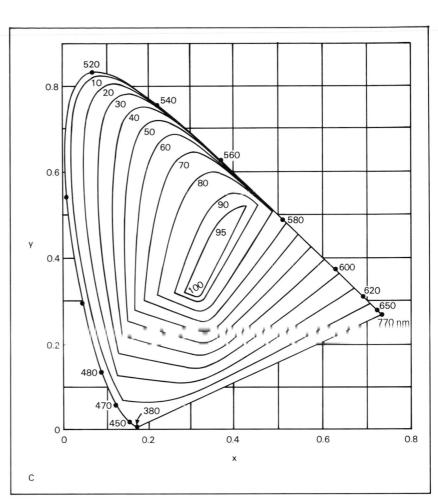

Figure 15–31 CIE luminance Y. (A) When the third dimension of color, the luminance value y, is added to the CIE chromaticity diagram it is seen as a vertical axis rising up from the neutral position of the illuminant. (B) A comparison plot for a Wratten 93 green filter having a luminance value of 1.6% and a CC40G filter having a luminance value of 68%. (C) A topographic map of the CIE chromaticity diagram showing how the horseshoe shape changes with increasing luminance. (MacAdam, 1935.)

the luminance value (Y) increases, the size of the chromaticity diagram shrinks in a skewed manner. For example, one would not expect to find saturated blues and purples at high levels of luminance.

By looking at Figure 15-32 we can now assign standard color names to the various green filters as shown in Table 15–2. Although four of the filters have the same yellowish-green hue, they have different luminance values; and one can infer that the WR 93 filter would be a dark and highly saturated green while the CC40G would be a light desaturated green. Further, the dominant wavelengths of the yellowish-green filters more precisely distinguish their hue difference.

Table 15–2 Color names for colored filters plotted on a chromaticity diagram.

			Luminous Transmittance	
Green Filter	Dominant Wavelength	Purity	(Y)	Color
58	540	86%	24	Yellowish-green
59	538	64%	39	Yellowish-green
60	526	62%	26	Green
93	545	98%	2	Yollowish green
CC40G	555	21%	68	Yellowish-green

Figure 15–32 The CIE chromaticity diagram sectioned in terms of color names (Judd, 1952). The colors are approximately correct when viewed under daylight illuminant C.

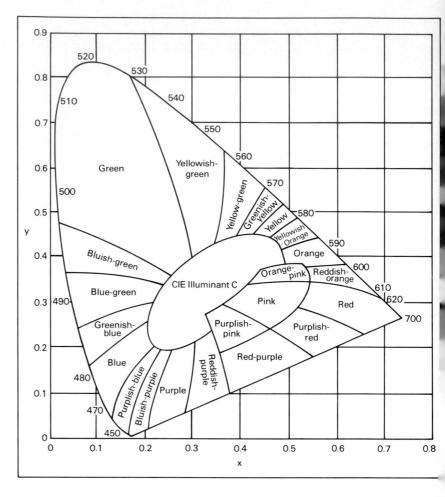

Both the Munsell and CIE systems specify color in threedimensional space but must of necessity represent it on paper as varying in only two dimensions (with the third dimension held constant). A basic difference between the two systems in such a representation can be readily seen if one considers an apple as representing color space. The Munsell system slices the apple vertically and describes the slice of color in terms of changing value and chroma. The slice represents a constant hue (blue, for example). The CIE system slices the apple horizontally and describes the slice in terms of changing dominanwavelength (hue) and purity (chroma, saturation). The slice represents a constant level of luminance (Y = 18, for example). Names for variou: hues in the Munsell system (Figures 15–16 through 15–19) provide (much larger list of color names than does the CIE system (Figure 15-32). The color names given to the nearly 1,500 Munsell colors are derived from the ISCC-NBS Dictionary of Color Names. These color name: were obtained from the Universal Color Language (UCL), developed by Kenneth Kelly and Deane Judd.⁷ The Dictionary provides a listing of 7,500 color names indexed to the ISCC-NBSC system.

Arbitrarily assigned color names present a problem in the precise specification of colors. Names can only establish broad categorie, of color that are imprecise, while numbers provide precise and un ambiguous identification. Unfortunately, numbers have no associationa

⁷Kelly, K. and Judd, D., 1976.

 Table 15–3
 Munsell alphanumeric color notations for a

 5R hue and the corresponding Universal Color Names.

Munsell Notation	Universal Color Name
5R 8/4	Light Pink
5R 7/4	Moderate Pink
5R 6/4	Dark Pink
5R 6/8	Deep Pink
5R 5/4	Grayish Red
5R 5/8	Moderate Red
5R 5/10	Strong Red
5R 5/12	Vivid Red
5R 3/4	Dark Red
5R 3/8	Deep Red
5R 2/4	Very Dark Red

Table 15–4	Emotionally	descriptive	red a	and	pink	hues	used
to describe and se							

Reds	Pinks
Almost Red	Alluringly Pink
Bamboo Red	Blazer Pink
British Red Coat	Carnation Pink
China Glaze Red	Coral Pink
Clear-Clear Red	Darling Pink
Dreamy Red	Dreamy Pink
Flame Red	Desert Frost Pink
Little Red-Red	Exciting Pink
Love That Red	French Pink
Magnet Red	Honeybee Pink
Primitive Red	Impulsive Pink
Racy Red	Jelly Roll Pink
Redhot Red	Passionate Pink
Tartan Red	Queenly Pink
True Red	Spicy Pink

Table	15-5	Names of	of lipstick	having ora	connotations.
Iabio	10-0	I THINKS U	y upsick	balling oral	connorarions.

Apricot Honey	Blackberry Cordial
Bermuda Melon	Cherry Brandy
Candy Apple	French Cognac
Cotton Candi	Iced Wine
Chocolate Cherry	Lilac Champagne
Frosted Nutmeg	Rare Brandy
Ginger Peachy	Red Rum
Mango Frost	Red Hot Toddy
Persimmon	Rose Crush
Pure Cranberry	Strawberry Cordial
Russian Cavier	Spicy Vermouth
Strawberry	Wild Wine
Tapestry Plum	Wine With Everything
Wineberry	Whispering Wine

meaning with respect to previous color experience. The color designation Munsell 5R 6/8 does not suggest as much as the words *deep pink* do to the layman (although a person who has had considerable experience with the Munsell system can visualize with some accuracy the lightness and the saturation of this red color).

A comparison of Munsell alphanumeric color designations and the related Universal Color Names is shown in Table 15-3. Such words are helpful in establishing a general category of color. Unfortunately, words can also be meaningless in terms of identifying colors. Words such as those used to sell cosmetic products are based primarily on emotional appeal rather than color identification. Lipstick, for example, which is often of a red or pink hue, is usually described as red or pink preceded by an appropriately appealing adjective such as *luscious*. which tells nothing about value or chroma of the color (Table 15-4). Many color names are based on familiar object colors such as cherry, carnation, rose, orange, gold, lemon, melon, mint, evergreen, lilac, plum, birch, and blacktop. There is good reason for this: "Most people pay so little attention to colors unattached to familiar objects that their affective responses are weak or indifferent."8 Then there are color names that suggest the newness and excitement of foreign travel (Lisbon Red. Tokyo Rose, Monaco Mauve and Paris Pink). Table 15-5 provides color names of lipstick for those more interested in such oral pleasures as eating and drinking.

To stir the emotions, kindle fantasy, and sell cosmetics as well as other products, words that have a synesthetic reference are often used. Such words trigger smell (fragrant rose, scented lemon), taste (blueberry frappe, sweet red, mint green), touch (delicate pink, textured green), and sound (rhythmic red, whispering blue). To communicate such colors requires a referential match to a standardized color specification system such as the Munsell or CIE system, or indirectly through the use of the ICSS-NBS *Dictionary of Color Names* (Table 15–6).

15.35 Nonspectral Colors

It was stated earlier that the boundary of the horseshoeshaped chromaticity diagram represents the color spectrum locus, and that no colors exist beyond the boundary or locus. This must now be modified somewhat. There are colors such as purple and magenta, that are not part of the color spectrum but that fall in the triangular area shown in Figure 15-33. Such colors are called nonspectral and are plotted and notated in the same manner as spectral colors. For example, a CC50 magenta filter has a chromaticity coordinate value of x = 0.31and y = 0.23 as shown in Figure 15-33. To find its dominant wavelength, a line is extended from the plotted position of the magenta filter, through the CIE illuminant C to the spectrum locus. Since the magenta is not a spectral color, its complement (green), which is a spectral color, defines its dominant wavelength. To distinguish this, the magenta is assigned the term complementary dominant wavelength, and value is further distinguished with the letter c. Thus a CC50M has a complementary dominant wavelength of 551c. Other values for this filter are: purity 34%, luminous transmittance (Y) 44. The straightline part of the graph is known as the purple locus, or alychne.

⁸Burnham, R., Hanes, R., and Bartleson, C., 1963, p. 211.

	CIE	(1931) Nota	tions	Munsell	Notation	
Color Names	x	y	Y	Hue	Valuel Chroma	ISCC/NBS Standard Color Names
Red	.54	.31	12	5R	4/12	Strong red
Orange	.51	.41	30	5YR	6/11	Strong orange
Yellow	.45	.47	59	5Y	8/11	Vivid yellow
Dark skin	.40	.35	10	3YR	3.7/3.2	Moderate brown
Light skin	.38	.35	36	2.2YR	6.5/4.1	Light reddish brown
Green	.31	.48	23	0.1G	5.4/9.6	Strong yellowish green
Foliage	.34	.42	13	6.7GY	4.2/4.1	Moderate olive green
Cyan	.20	.25	20	5B	5/8	Strong greenish blue
Blue	.19	.13	6	7.5PB	2.9/12.7	Vivid purplish blue
Blue sky	.25	.25	19	4.3PB	5/5.5	Moderate blue
Magenta	.36	.23	20	2.5PB	5/12	Strong reddish purple
White	.31	.32	90	Ν	9.5/0	White
Gray	.31	.32	20	N	5/0	Medium gray
Black	.31	.32	3	N	2/0	Black

Table 15–6 Color names and notation

15.36 Other Applications

Figure 15–34 shows how the CIE diagram provides a visual reference for different color temperature lamps (blackbody sources). As the color temperature increases from less than 2000 K to over 10,000 K the color shifts from a red, to a reddish orange, yellow, white, and then blue. Located on the curved locus for various color temperatures

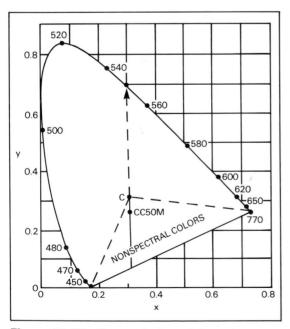

Figure 15–33 Nonspectral colors and the complementary dominant wavelength (551c) for a CC50M filter.

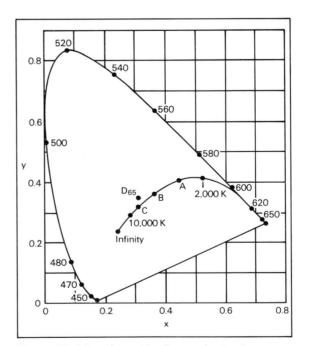

Figure 15–34 Chromaticity diagram showing the positions of various CIE light sources. A, B, and C indicate the positions for CIE light sources having color temperatures of 2856 K, 4870 K, and 6770 K respectively. Note that they are located on the Planckian locus. CIE illuminant D_{65} has a correlated color temperature of 6500 K and is located just above the Planckian locus.

References

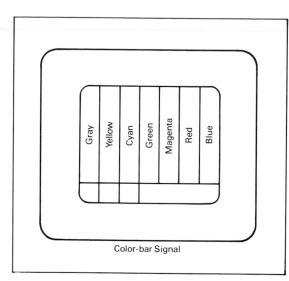

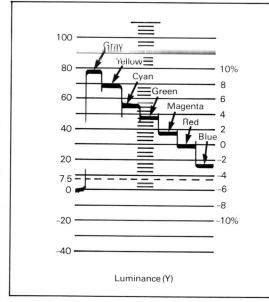

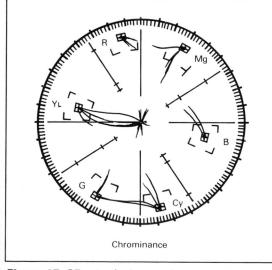

Figure 15–35 A color-bar signal is used to adjust the chromaticity and luminance in a television system. A Vectorscope displays luminance (Y) on one screen and chrominance (hue and chroma) on another.

are the CIE standard light sources; A = 2854 K, B = 4780 K, C = 6770 K and illuminant D_{65} = 6500 K.

15.37 TV Vectorscope

It is evident if one visits a control room in a television studio that the vectorscope used to adjust the colors being transmitted or recorded has its basis in the CIE color system. Figure 15-35 shows a color-bar signal displayed on a television screen and the corresponding luminance and chrominance displayed separately on the vectorscope screen. Notice that the colors gray, yellow, cyan, green, magenta, red, and blue are selected and arranged so that their luminance values progressively decrease. In effect this provides a "grayscale" to test and adjust the luminance range. The chrominance is displayed on a circular screen with positions and markings analogous to a compass. The center of the screen indicates a neutral position. The location of a dot around the screen designates hue (red, magenta, blue, cyan, green, and yellow). The hue positions are arranged so that complementary hues are opposite each other. The distance a dot is from center-neutral indicates chroma (saturation, purity). A line from center neutral to any position on the screen is therefore, a vector which indicates position (hue) and magnitude (chroma). The vectorscope is used to adjust the chrominance of each color-bar signal so that it is positioned within the small squares on the screen. This signifies that the displayed color vectors are within tolerance (in control).

References

- Albers, Interaction of Color, pp. 18, 39-46.
- Baines and Bomback, The Science of Color, pp. 245-50.
- Birren, Munsell: A Grammar of Color, pp. 9-13, 16-34.
- Burnham, Hanes, and Bartleson, Color: A Guide to Basic Facts and Concepts, pp. 123-50, 163-76, 206-19.
- Billmeyer and Saltzman, Principles of Color Technology, pp. 17-23, 31-40, 44-60.
- Bornstein, M., and Marks, L., "Color Revisionism." Psychology Today (January 1982):pp. 64-73.
- Eastman Kodak Company, Kodak Color Films (E-77), pp. 25–29, 50–51.
 - ——, Kodak Filters for Scientific and Technical Uses (B-3), pp. 15–21, 57–58.
- Evans, An Introduction to Color, pp. 205-33.
- Hardy, A Handbook of Colorimetry.
- Hunt, The Reproduction of Colour in Photography, pp. 10–12, 124–39, 231–45.
- Kelly and Judd, Color: Universal Language and Dictionary of Names.
- Kreitler and Kreitler, Psychology and the Arts, pp. 32-39.
- MacAdam, "Maximum Visual Efficiency of Colored Materials." Journal of the Optical Society of America 25 (1935):pp. 361-67.
- McCamy, Marcus, and Davidson, "A Color Rendition Chart." Journal of Applied Photographic Engineering 11:3 (Summer 1976): pp. 95-99.
- Munsell, A Color Notation, pp. 13-24.
- Rainwater, Light and Color, pp. 98-132.
- Rood, Modern Chromatics, pp. 11-15, 72, 82-86, 147-54.

References

Stroebel, Color Filters.

Stroebel, Todd, and Zakia, Visual Concepts for Photographers, pp. 90-91, 130-31, 254-75, 300 ff.

Sheppard, Human Color Perception, pp. 9-19.

Stimson, Photometry and Radiometry for Engineers, pp. 239-43, 278-95.

Thomas, SPSE Handbook of Photographic Science and Engineering, pp. 880-923.

Wright, The Measurement of Colour, pp. 65-71.

Wyszecki and Stiles, Color Science, pp. 131, 144-46, 165.

Zakia and Todd, Color Primer I and II.

Color Reproduction

16.1 Objectives of Color Reproduction

When considering the properties required of color photographic materials, it is necessary to include the purpose for making the photograph. Generally, the objective of color photography is to produce either an accurate color photograph or a pleasing color photograph. Accurate color reproduction implies a certain correspondence of the colors in the photograph to those of an original scene. If it is a photograph of an object or scene with which the viewer is familiar, it would at least be required that the viewer would not name any of the colors in the picture differently from those in the original scene, based upon memory. With a much more demanding form of accurate color reproduction, the photograph is held in the hand and critically compared directly to the original scene or object. Except with very simple subject matter, there are no color photographic systems capable of fulfilling this definition of accurate color reproduction.

There are at least three major reasons why color photographic systems are unable to achieve accurate color reproduction; they are physical, physiological, and psychological in nature. The most troublesome of the physical reasons is that the dyes employed to construct the photographic image are not the same colorants that existed in the original subject. This will affect the range of colors that can be reproduced. Furthermore, the dyes have unwanted absorptions, which limit their ability to accurately simulate the real-life colors.

Among the physiological factors is the fact that the human eye records the original subject colors in a fashion far different from that of a color film. Since the spectral response of color film differs from that of the eye, the various wavelengths of light reflected from the subject will be encoded (analyzed) in a different way. Additionally, since the eye adapts its sensitivity to the current visual field, its spectral response changes frequently.

Finally, it is obvious that a photograph is not an original scene, but rather something derived from it. It is two-dimensional, typically much smaller than the original scene, and viewed under significantly different lighting conditions than the original scene. Thus the perceptual conditions are significantly different when viewing a photograph than they are when viewing the original scene. In other words, the dyes in the photograph may be physically identical to those in the original subject and present in the same quantities, but still not give an accurate color reproduction because of these psychological differences.

Most often the goal is pleasing color reproduction, which can also be defined in a variety of ways. For example, it is possible to differentiate between acceptable color reproduction and excellent color reproduction. Acceptable color prints can be defined as those containing a reasonable resemblance to the colors in the original scene. The color prints produced by amateur photofinishing labs using automated equipment and the color prints from instant cameras are examples of generally acceptable color photography. Every color photographic process has certain defects and limitations, which may work strongly against a particular subject color. However, for every subject, a most pleasing print can be made by whatever process is used.

To obtain such an excellent print without substantial retouching requires a very flexible process such as the dye-transfer process and expert manipulation of its variables. This is the nature of the work performed by professional photographers and custom color-printing laboratories, and these are examples of what is termed excellent color photography. Obviously the differences between acceptable and excellent color reproduction arc a matter of opinion, and as such are highly dependent upon the audience. Thus the definition of pleasing color reproduction will ultimately be determined by the user.

It is safe to say that if accurate color reproduction were the most important objective in color photography, the wide proliferation of color photographic systems would never have occurred. The majority of photographers require only pleasing color reproduction, which is the principle objective of most color photographic endeavors. Cost and convenience may be as important to serve users as the quality in selecting a color system.

16.2 Additive and Subtractive Color Formation

All color reproduction systems operate on the assumption that the human eye contains three different types of color receptors Many experiments show that almost all colors can be produced through the appropriate mixture of red, green, and blue light. Although many theories of color vision have been proposed and used to describe variou visual phenomena, the trichromatic theory of color vision offers the most satisfactory explanation of color perception as it relates to color photography (see Section 15.12). Thus in order for a color photographi system to be successful, it must be capable of recording and controlling the red, green, and blue components of the light being reflected transmitted, or emitted by the subject. There are two basic method for controlling the color of the light produced in a color reproductio system: additive color mixture, which involves combining red, greer and blue light; and subtractive color mixture, which involves colorant that selectively absorb red, green, and blue light.

In the additive system it is possible to produce a wide variet of colors by mixing various amounts of red, green, and blue light. The can be illustrated most directly by considering three identical projector each equipped with a different-colored filter (red, green, and blue) an aimed at a projection screen. When the projector with the blue filte is turned on, this causes blue light to reach the screen; and if th projector is equipped with a variable aperture, the illuminance of th blue light can be increased or decreased, producing lighter or dark colors of blue. If the second projector, employing a green filter, turned on, green light will reach the screen and can be made to part overlap the light from the blue projector, allowing many addition colors to occur. In addition to the scale of greens that can be produce where only the green light is striking the screen, a series of blue-gree (cyans) occurs where the two projector beams overlap. This latter seri of colors could be made not only to differ in lightness by increasing decreasing the size of both apertures simultaneously, but also in greene and blueness by changing the relative amounts of green light and bl light.

The addition of the third projector, utilizing a red filte provides the red light on the screen, which again can be made to partial overlap the other two projected areas. Where the red light overlaps t blue light a new blue-red (magenta) color is produced, which likew can be altered in lightness and blueness-redness. Where the red lig overlaps the green light the color yellow is produced, which can a be manipulated by controlling the individual projectors.

Figure 16–1 Additive mixture of blue, green, and red lights.

Table	16-1	Basic facts	of	additive	color	formation	(the
mixing	of lights,).					

Lights	Produce		
Blue light plus green light	Cyan		
Blue light plus red light	Magenta		
Green light plus red light	Yellow		
Blue light plus green light plus			
red light	White		
No light	Dlack		

Such a triple-projection system is illustrated in Figure 16-1. Each of the three beams of light is falling individually on the screen and also overlaps the other beams. The color cyan appears where the blue and the green beams overlap. The overlapping of the red and blue beams produces the color magenta. That cyan is formed where the blue and green overlap is not surprising, nor is the formation of magenta from the combination of blue and red light. Visually, the colors produced are consistent with the contributions made by the primary colors. However, for the mixture of red light and green light to appear yellow is a somewhat amazing result, since yellow in no way resembles the red light and the green light. This phenomenon, which is related to the theory of color vision, is more fully explained in Section 15.12. Where the beams of the three projectors overlap, the color white is produced. The area of the screen where no direct light from any projector is falling appears black. This illustrates the fundamental method of additive color formation.

The word *additive* implies that different colors are produced by adding together different amounts of the three colors of light. All additive color reproduction systems require the use of the three colors represented in this example: red light, green light, and blue light. Consequently, these colors are referred to as the additive primaries. Table 16–1 lists the basic facts of additive color formation using these three additive primaries.

This table lists only the colors of light that make these combinations, but not the amounts; only a certain amount of red light mixed with a certain amount of green light produces yellow. If the relative amounts of red and green are changed, different colors are produced: red, orange, yellow, yellow-green, and green. The same is true of the red and blue combination and the blue and green combination. Similarly, with a certain amount of red light, white can be produced, but only by using the proper amounts of green light and blue light. The lightest white is limited only by the greatest amounts of light the projectors can put on the screen. The color "black" is produced by reducing the intensities of the projectors so that no light (or nearly none) falls on the screen. Grays are produced by using intermediate but equal amounts of light from each of the three projectors.

By effectively controlling the operation of the three projectors, practically any color can be produced. Thus the attributes of color—hue, lightness, and saturation—can all be controlled by changing the amounts of red, green, and blue light falling on the screen. About the only colors that can't be produced are spectral colors, since they are too saturated to be simulated with this method.

There are two additional ways to employ the principles of additive color formation. A single projector can be used to project three colored images in rapid succession with red, green, and blue following each other so rapidly that the eye cannot distinguish the individual projected colors. Thus the mixing of the three lights is achieved through the perceptual phenomenon known as persistence of vision (see Section 13.1). This technique is referred to as temporal color mixture. In an alternative process, small transparent bits of red, green, and blue are placed side by side to form the picture. The bits are so small that the eye cannot readily distinguish them as colored spots. This is the method used in color television; the picture is composed of small disks of red, green, and blue light from the phosphors coated on the screen. Observed from the proper viewing distance, these discs blend to form the color Image, and with their intensities electronically controlled they repro duce the colors of the original subject. This method is often referred to as spatial color mixture.

In summary, additive color formation is characterized by the mixing of lights. Since the human color visual system has three different types of color receptors (red, green, and blue), the colors of the three lights used must be red, green, and blue. The additive mixture of lights can be achieved through either temporal fusion or spatial fusion, as well as by physically mixing the lights.

The alternative to additive color formation is subtractive color formation. It is characterized by the mixing of colorants (dyes, pigments, paints, and inks). Although subtractive approach involves a significantly different principle, such a system can produce nearly the same range of colors as the additive system. In order for a subtractive system of color formation to be successful, the colorants must be capable of controlling the red, green, and blue light components of the white viewing light. As a result, there are only three colorants that can meet this requirement: cyan, magenta, and yellow. Cyan is used because it absorbs red light and reflects (or transmits) blue and green light, creating its blue-green appearance. Magenta is used because it absorbs green light and reflects (or transmits) blue light and red light, causing its blue-red appearance. Yellow is used because it absorbs blue light and reflects red and green light. As a result, the subtractive primaries of cyan, magenta, and yellow can be summarized as follows:

> cyan = minus red magenta = minus green yellow = minus blue.

Figure 16-2 illustrates the results of mixing various amounts of the cyan, magenta, and yellow colorants. Initially the paper is illuminated by white light, which contains nearly equal amounts of red, green, and blue light. Since the paper is white, it reflects white light, again consisting of nearly equal amounts of red, green, and blue light.

Figure 16-2 The subtractive mixture of yellow, magenta, and cyan pigments.

Where the yellow colorant is mixed with the cyan colorant, the area of overlap produces the color green. In other words, the yellow colorant absorbs the blue portion of the white light while the cyan colorant absorbs the red portion of the white light, leaving only the green to be reflected back to our eyes. Similarly, where the yellow and magenta colorants overlap, the color red appears. This is the result of the blue light absorption of the yellow paint and the green light absorption of the magenta, leaving only the red light to be reflected to our eyes. Finally, where the cyan and magenta colorants overlap, the color blue appears. This occurs because of the red light absorption by the cyan colorant and the green light absorption by the magenta, leaving only the blue light component of the original white light to be reflected to our eyes. In this fashion, a wide variety of hues can be reproduced by mixing varying amounts of these three colorants.

Furthermore, as seen on the righthand side of Figure 16–2, the three subtractive primaries of cyan, magenta, and yellow can be mixed in the proportion required to produce a scale of neutrals from black to white. Table 16–2 summarizes the information contained in Figure 16–2. The use of the term *subtractive color formation* for this system is appropriate since it depends upon the use of substances that termore arrying amounts and colors of light from an initially white source of light.

It is important to point out here that artists and photographers often use different names for the same colorants. Artists and printers often refer to their three primary colors as red, blue, and yellow. However, if the range of colors to be produced is to be as complete as possible, the red paint (or ink) must actually be magenta, and the blue paint (or ink) must actually be a blue-green or cyan. It is unfortunate that the use of the terms *red* and *blue* have been used to describe *magenta* and *cyan*, because their use in this context has undoubtedly limited the understanding of the principles of subtractive color mixture.

The gamut of colors that can be obtained through subtractive mixture of three colorants is very large, making possible the modern processes of color photography that depend upon the subtractive principle. In these processes, the actual function of the subtractive primaries is to control the red, green, and blue light to which the three types of cone receptors in the retina of the human eye are sensitive. In summary, cyan, which subtracts red light from white light, is used in varying amounts to control the amount of red light reaching the eye. Similarly, magenta, which subtracts green light from white light, is used to control the amount of green light reaching the eye. Finally, yellow, which subtracts blue light from white light, is used to control the blue light that reaches the eye. Thus subtractive color formation is characterized by the mixture of colorants.

Table 16-2	Basic facts of	f subtractive color	formation (mixing o	f pigments).
------------	----------------	---------------------	---------------------	--------------

Colorants	Absorbs	Produces		
Cyan	Red	Blue-green (cyan)		
Magenta	Green	Blue-red (magenta)		
Yellow	Blue	Green-red (yellow)		
Cyan plus magenta	Red and green	Blue		
Cyan plus yellow	Red and blue	Green		
Magenta plus yellow	Green and blue	Red		
Cyan plus magenta plus				
yellow	Red, green, and blue	Black		
No colorant	Nothing	White		

16.3 The Recording of Color (Analysis Stage)

All color photographic systems consist of two major stages: analysis and synthesis. First, the colors of light from the subject must be recorded in terms of primary colors—typically, red, green, and blue—which is referred to as the analysis stage. Second, when the photographic image is reconstructed, the process must be able to control the red, green, and blue light that will ultimately reach the viewer of the image. This is referred to as the synthesis stage.

The oldest and perhaps most fundamental method of achieving the first stage is to use red, green, and blue filters with black-andwhite panchromatic film (which is sensitive to red, green, and blue light). Figure 16-3 illustrates this approach to color analysis. The subject is first photographed through each of the filters on three separate sheets of film. After processing, the negatives reveal three separate

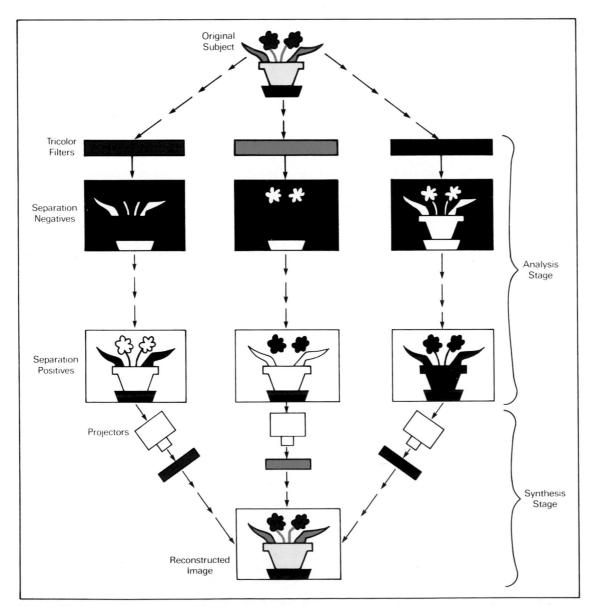

Figure 16-3 The additive system of color photography with both analysis and synthesis stages illustrated.

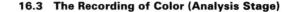

Figure 16-4 Tricolor separations with a black-and-white film. (A) Spectral density curves for tricolor separation filters 47B (blue), 58 (green) and 25 (red). (B) Spectral sensitivity of Eastman Kodak Super XX black-and-white film. (C) Resulting spectral responses when tricolor filters are used with Super XX film.

records of the subject and are referred to as separation negatives. The red separation negative is dense in the areas where red light was reflected from the subject. Similarly, the green and blue separation negatives are records of the green and blue content of the subject. Notice that the yellow patch of the subject is recorded as a dense area in both the red and the green separation negatives. This is because a yellow object absorbs only blue light and reflects both red and green light. Therefore, both the red and green negatives record light from the yellow patch and produce a heavy density.

The exact density information recorded in this tricolor analysis is determined by various factors including the color quality of the illumination; the spectral characteristics of the subject; the transmission characteristics of the red, green, and blue filters; and the spectral sensitivity of the photographic emulsion. A wide variety of tricolor separation filters and photographic emulsion characteristics have been used for tricolor photography. One combination consists of Eastman Kodak Wratten No. 25 (red), No. 58 (green), and No. 47B (blue) filters with Eastman Kodak Super XX black-and-white film. Figure 16–4 illustrates the spectral density curves for these filters and the spectral sensitivity curve of Super XX Figure 16–4 shows the way in which this combination of filters and film would respond to the red, green, and blue components of the light reflected from the scene.

There are a number of methods by which this color analysis can be obtained. The most obvious approach is the use of successive exposures on three different sheets of film, one after the other, using the same camera. A variation of this approach involves what is known as a one-shot tricolor camera, illustrated in Figure 16–5. Here the three separation negatives are made by a single camera exposure employing mirrors and beam splitters. Both of these methods yield three physically separate negatives.

An alternative approach to color analysis involves a black-

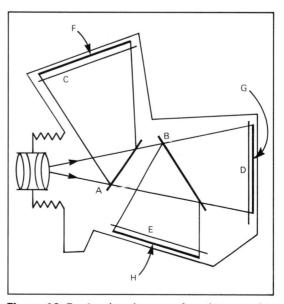

Figure 16-5 One-shot color camera for making a set of red, green, and blue separation negatives. Light enters through the lens and is partially transmitted and partially reflected by partially silvered mirrors A and B. The three heams obtained then pass through the tricolor filters C, D, and E, exposing the three sheets of black-and-white film F, G, and H.

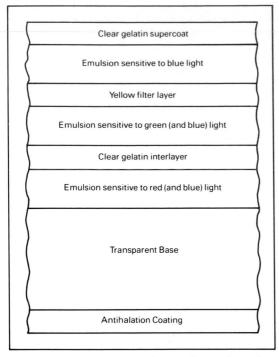

Figure 16-6 Cross-section of a typical integral tripack color film (not drawn to scale).

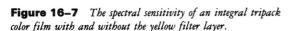

and-white panchromatic emulsion with a lenticular screen consisting of small red, green, and blue filters in contact with it. With one camera exposure the three color bands can be recorded as a mosaic of densities on the film. The total of the developed silver areas behind all of the minute red filters makes up the red record negative. Similarly, the green and blue records exist behind the thousands of small green and blue filters. Therefore, the three separation negatives exist side by side in the emulsion and as a result are physically inseparable.

The color-analysis method used with modern color films is the multilayer approach, whereby three emulsions are coated one above the other on a single base, as illustrated in Figure 16–6. The emulsions are typically separated by interlayers of clear gelatin or colored layers that act as filters. The color analysis is achieved by limiting the emulsion layer sensitivities to the three (red, green, and blue) spectral bands required.

The spectral sensitivities of the multilayer camera speed film are shown in Figure 16–7. On the left are shown the inherent sensitivities of the blue-, green-, and red-sensitive layers, where it is shown that the green- and red-recording layers also have blue sensitivity. This problem is minimized through the use of a yellow filter layer above the green- and red-sensitive layers. The top emulsion is sensitive only to blue light, and the green and red light pass through it without effect, allowing the blue light alone to be recorded in that layer. The yellow filter layer immediately below the top emulsion layer absorbs the blue light and prevents it from reaching the two lower (green and red sensitive) emulsion layers. Thus the effective spectral sensitivities of the three layers are shown on the right of Figure 16-7.

Consequently, multilayer films possess three more or less independently sensitized emulsions. Such a process requires only a single camera exposure to produce the red, green, and blue record negatives.

16.4 The Production of Color (Synthesis Stage)

The three negatives will be stacked on top of each other and, consequently, are inseparable.

At this point it is important to understand what each of the separation negatives represents. The red record negative must contain a record of only one kind of information; the densities in this negative must be present only where there was red light being reflected from the subject, and it must not record the blue or the green light. Similarly, the green and blue record negatives must record only their respective colors and no others.

16.4 The Production of Color (Synthesis Stage)

Once the subject colors have been analyzed, separated into their red, green, and blue components, they must be put back together by some process that re-creates the appearance of the original colors. This step is referred to as the color synthesis stage and may be achieved by either the additive or the subtractive methods of color formation previously described.

In all color photographic processes the viewer is interested in seeing the picture as it originally appeared—as a positive image. This can be achieved by making three silver positive images, one from each of the three silver separation negatives. Since the densities in the red record negative are formed where red light is reflected from the subject, the densities in the positive will have an inverse relationship with the red content of the scene. The red record positive has the greatest density in those areas where the least red light was reflected from the subject. Similarly, the green and blue record positives will have the greatest density in the areas reflecting the least green and blue light, respectively.

The reconstruction of the subject colors by using these three positives is illustrated in the portion of Figure 16–3 labeled the synthesis stage. Here, three projectors are equipped with red, green, and blue filters. The red record positive is placed in the projector equipped with the red filter. Since the red record positive contains the most density in the areas that reflected the least red light, it will in those same areas prevent red light from reaching the screen. This same positive is thin in the areas that reflected much red light from the subject, and will for those areas permit red light to reach the screen. Therefore the red light is reaching the screen in approximately the same relative amounts as red light was reflected from the subject.

Similarly, the green and blue record positives are placed in the projectors equipped with the green and blue filters. The three images are projected on the screen so that they are exactly superimposed. When this procedure is carefully performed, a full-color reproduction of the original subject will be formed on the screen. Since this color formation is the result of mixing lights, it is defined as an additive color reproduction system.

The relationship between the densities of the separation negatives and the densities of the separation positives is summarized in Table 16-3 for the simple subject matter shown in Figure 16-3. Notice that for the yellow pot the absence of density in the red and green record positives allows red and green light to reach the screen, which mix together to produce the color yellow. For the black base, no light

	Densities of Separation Negatives			Densities of Separation Positives		
Subject	Blue Negative	Green Negative	Red Negative	Blue Positive	Green Positive	Red Positive
Red flower	Low	Low	High	High	High	Low
Green leaves	Low	High	Low	High	Low	High
Yellow pot	Low	High	High	High	Low	Low
Black base	Low	Low	Low	High	High	High
White background	High	High	High	Low	Low	Low

 Table 16-3
 The relationships between separation negatives and separation positives in terms of density.

reaches the screen from any of the projectors. For the white background, all three projectors produce light on the screen, creating the color white.

If the color analysis stage involved a single exposure through a color mosaic screen, the separation negatives will exist side by side in the emulsion. A positive image must be obtained with reversal processing or by producing a negative and contact printing it onto another piece of film. The positive is then placed in register with the original color mosaic screen, and the combination is viewed by transmitted light. Such a system is illustrated in Figure 16–8. Again, the synthesis stage of this process involves a mixture of red, green, and blue light transmitted through the filter mosaic; therefore it is described as an additive color reproduction system.

The color analysis method that employs a multilayer film as the recording medium contains a set of separation negatives stacked vertically on top of each other. Because the red, green, and blue records are superimposed and inseparable, it is impossible to employ the active system of mixing red, green, and blue lights to form the color reproduction. Consequently, for multilayer materials an alternative approach to color formation must be used.

In the additive color synthesis, silver positives were used to absorb the appropriate amounts of the red, green, and blue light in the three-projector system. The alternative approach is to substitute colors (dyes), superimposed in the emulsion, for the three silver positives. In the red record it is necessary to use a dye that absorbs only the red part of the spectrum. A properly formed cyan dye image is nearly as effective in absorbing red light as is the red record silver positive image. The cyan dye will allow the blue light and green light to be transmitted. In the green record positive it is necessary to use a dye that absorbs only green light. Thus magenta dye is used since it absorbs green light and transmits blue and red light. In the blue record

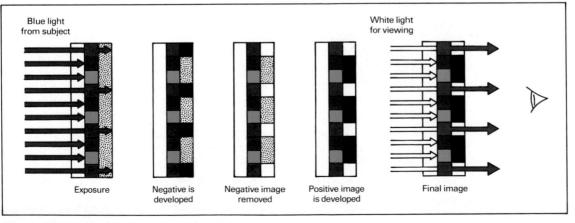

Figure 16-8 The reproduction of color through the use of the mosaic screen process.

positive, yellow dye absorbs only blue light and allows red light and green light to pass.

Therefore, if the multilayer separation positive consists of cyan, magenta, and yellow dyes, the image can be projected using a single projector. This arrangement is illustrated in Figure 16–9. It is successful because the dye images, unlike silver, absorb only one color of light, and allow the other two to be transmitted. Therefore, by combining the three dye images in exact registration a tripack image is produced, necessitating only one source of light for viewing. The red portion of the white light is controlled by the density of the cyan dye image alone, while the green portion of the white light is being controlled by the magenta dye image alone. The blue portion of the white light is controlled by the yellow dye image. In this fashion the cyan, magenta, and yellow dye images act as light valves, absorbing appropriate amounts of red, green, and blue light. Since this system

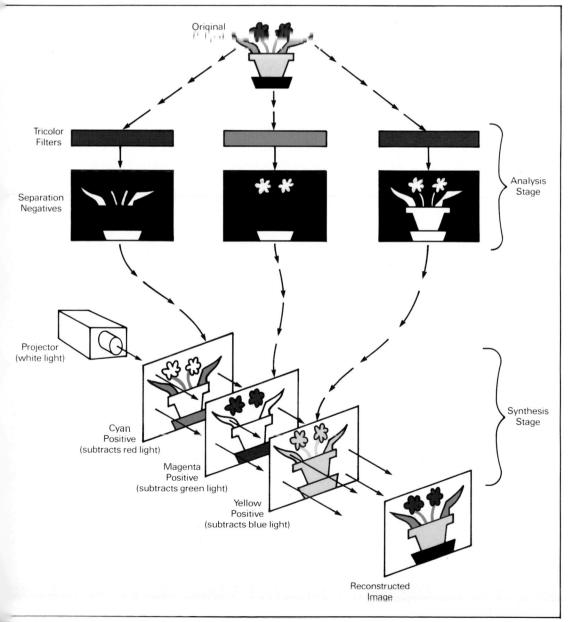

igure 16–9 The subtractive system of color photography ith both the analysis and synthesis stages illustrated.

16.5 Spectral Sensitivity

involves the removal of red, green, and blue light from the initially white viewing light, it is defined as a subtractive color reproduction process.

Table 16-4 summarizes the effects of the three dye positives for the simple subject considered in Figure 16-9. The process affected some of the subject areas in these ways:

- 1. The green leaves. These were recorded only in the green record negative as a heavy density while the other two negatives were thin in the area representing this portion of the subject. When the positives were made, no dye was formed in the magenta positive and a large amount of dye was formed in both the cyan and yellow positive images. In the final reproduction shown in Figure 16-9, the cyan and yellow dyes are superimposed, producing the color green. Since the cyan dye absorbs the red light and the yellow dye absorbs the blue light, the combination absorbs all but the green from the white viewing light.
- 2. The yellow flower pot. This is recorded as a heavy density in both the red and the green record negatives, but as a thin area in the blue record negative. Since the positives are reversed in density, only the blue record positive will contain any dye. The yellow dye absorbs blue from the white viewing light and this area appears yellow (minus blue).
- **3.** The black base of the flower pot. This part of the scene was recorded as a thin area in all three negatives, and as a dense area in all of the positives. This area was therefore recorded as a heavy deposit of all three dyes, which when superimposed absorb red, green, and blue light, leaving very little light to reach the viewer.
- **4.** The white background. This was recorded as a heavy density in all of the negatives and as a thin area in all of the positives. Since no dye was formed in any of the positives, practically none of the white viewing light is absorbed.

Even with a subject as simple and containing as few colors as this, such a process of subtractive color reproduction can produce a tremendous variety of subject colors. Furthermore, the use of the subtractive process allows for the production of both transmission and reflection color images.

16.5 Spectral Sensitivity

For a color photographic system to reproduce colors approx imately as the eye perceives them, the responses to red, green, and blue light must bear the same relationship to each other as do the responses of the eye to these colors. For example, if a reversal colo film has relatively too much sensitivity to blue light, blue objects is

Table 16-4 Analysis of the yellow, magenta, and cyan dye separation positives in terms of the amount of dye formed.

Subject	Yellow Positive	Magenta Positive	Cyan Positive
Red flower	Large	Large	No
Green leaves	Large	No	Large
Yellow pot	Large	No	No
Black base	Large	Large	Large
White background	No	No	No

the scene will appear too light in the color reproduction—assuming the exposure is correct for the green and the red objects—and white objects will appear bluish. Thus one of the requirements for accurate color reproduction is that the red, green, and blue sensitivity of the initial color recording (analysis stage) must match those of the human eye.

Matching the color sensitivity of the three receptor systems involved in human vision is a very complex task, since the human visual system is constantly changing in its response to light. The perceptual phenomena of color adaptation and color constancy (see Section 13.5) are impossible to duplicate with a color film. The human color visual system can adapt to many different forms of color balance, while a color film is limited in its response to a single adaptation level, and therefore has a given color balance that is determined at the time of manufacture. In the negative/positive process, it is relatively easy to adjust the color balance during the printing operation. However, reversal color films provide less opportunity for change, since the image exposed in the camera will be that which is viewed as the final positive.

Since a color film can record the light reflected from the oubject with only one particular set of consitivities, the optimum reproduction of color in a reversal film can be obtained only when the illumination is of the particular color quality for which the film is balanced. As a result, film manufacturers market multilayer camera films of three different spectral responses. Daylight-type color films are designed to be exposed to light with a color temperature of 5500 K, which is the mixture of sunlight and sky light most commonly encountered outdoors. Type A films are designed to be used with light sources operating at 3400 K, which is produced by special photoflood lamps. Type B films are balanced for light sources operating at 3200 K, which is the most commonly encountered type of tungsten lamp in photographic studios.

The difference between color films balanced for 5500 K (daylight) and 3200 K (tungsten lamps) is most easily seen by inspecting the spectral sensitivity curves of the films in Figure 16–10. Such curves indicate the sensitivity to light, wavelength by wavelength, for each of the film's three layers. The principal difference between the responses of the two films is in the red-sensitive (cyan-dye-forming) layer, where the response is much lower in the tungsten film than in the daylight film. This is because tungsten sources produce relatively large amounts of red light compared to blue light, whereas daylight has more nearly equal amounts of blue light and red light (see Section 5.12). Thus the low red sensitivity of the tungsten-balanced film compensates for this high proportion of red light in tungsten sources, producing a correctly balanced color image.

The blue sensitivity of the green (magenta-forming) layer and the red (cyan-forming) layer of both films is essentially eliminated by the yellow filter interlayer that is coated between the top blue-sensitive layer and the bottom two layers in the multilayer films. If the tungsten-balanced film were used with daylight illumination without filtration, the resulting transparencies would show a strong bluish cast. Similarly, if the daylightbalanced film were used with a tungsten source without filtration, the resulting color transparencies would have a reddish cast to them. Therefore, when the color film is to be exposed to light of a color quality other than that for which it was balanced, light-balancing filters must be used (see Section 14.4). Even when appropriate light-balancing filters are used over the camera lens, errors in the rendering of the colors of certain objects may

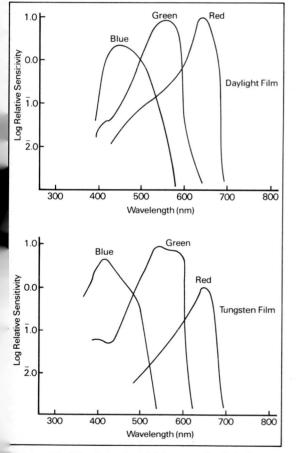

Figure 16–10 Spectral sensitivity curves for daylightalanced and tungsten-balanced color reversal films of the same beed without the yellow filter that is beneath the blue-sensitive mulsion. This filter prevents blue light from reaching the blueind-green sensitive and the blue-and-red sensitive emulsions.

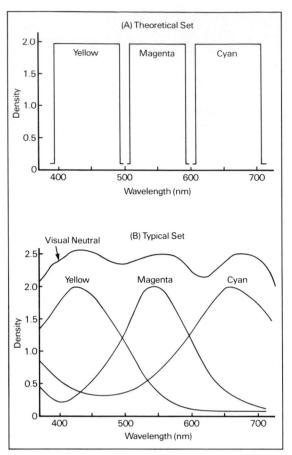

Figure 16–11 Theoretical and typical spectral dye density curves of a color film. (A) Theoretical set. (B) Typical set.

16.6 Dye Characteristics

result, and only a practical test of the film, filters, and light source will determine if the results are suitable. Also, notice that there are no color films balanced for fluorescent lighting. Consequently, all color films invariably require color-correction filters for fluorescent lights. Proper filter use depends upon the film's original color balance and the type of fluorescent lamp used (see Section 5.12.4).

16.6 Dye Characteristics

As discussed previously, subtractive color formation involves the mixture of the three dyes: cyan, magenta, and yellow. The purpose of the dyes is to control the amount of red, green, and blue light that will be reflected (or transmitted) to the viewer. Therefore, each of the dyes should absorb only one color of light: the yellow dye should only absorb blue light; the magenta dye should only absorb green light; and the cyan dye should only absorb red light. In other words, each dye should only absorb its complementary color and allow the other two primary colors of light to be transmitted freely. However, even the best available dyes, pigments, and printing inks absorb some colors of light that they should transmit: (1) Yellow dye absorbs a small amount of green light; (2) magenta dye absorbs a considerable amount of blue light and a smaller amount of red light; (2) cyan dye absorbs significant amounts of green light and blue light.

Perhaps the easiest way to define the dye properties is to examine the spectral dye density curves of a typical set of cyan, magenta, and yellow dyes. Such a graph illustrates the wavelength-by-wavelength density of each dye. In Figure 16–11, graph A illustrates the spectral dye density curves for a theoretically perfect set of dyes. It is shown that each dye should absorb only one-third of the spectrum and allow the other two-thirds to be transmitted; and, therefore, provide for an independent control for each of the red, green, and blue light regions.

Graph B shows the spectral dye density curves for a typical set of cyan, magenta, and yellow dyes. The yellow dye shows a high density to blue light (its primary or "wanted" absorption), a small amount of unwanted absorption in the green region, and practically nc absorption in the red region. The magenta dye shows a high density in the green region (its primary absorption) and a significant amount of unwanted absorption in the blue and the red regions. The cyan dye shows a high density to red light (its primary absorption) and a significant amount of unwanted absorption in the green and blue regions Based upon the amount of unwanted absorptions, it appears that the yellow dye is the purest and the cyan dye is the least pure, giving the greatest amount of unwanted absorptions.

In order to understand the effects of these unwanted ab sorptions, consider the problems of attempting to form a neutral (gray color. Assume that an initial deposit of cyan dye, which has a primar absorption of red light, is produced in the film. Since the cyan dye ha unwanted green light absorption, a lesser amount of magenta dye i required than would otherwise have been used. The magenta dye ha significant unwanted blue light absorption, requiring that a lesser amoun of yellow dye be formed than would otherwise have been necessary Therefore, the neutral is formed from unequal amounts of the thre dyes because of their unwanted absorptions. Although it is possible t produce a visual neutral in this fashion, the reduction in the magent and yellow dyes of the process will influence the rendering of othe colors such as red, since it is formed from magenta and yellow dyes green, which is formed by mixing yellow and cyan dyes; and blue

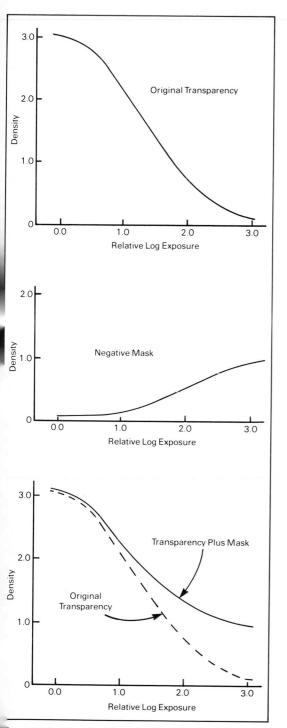

igure 16–12 The effect of a contrast-reducing mask on a sitive transparency image.

which is formed by mixing cyan and magenta dyes. In other words, these colors and others will be reproduced inaccurately.

This illustrates the fact that the nature of the dyes makes it impossible to obtain accurate reproduction of all colors. Fortunately, accuracy in color reproduction is seldom required; pleasing color reproduction is the most obvious goal. Color films are invariably designed so that the dyes produce the most pleasing color renditions of such important subjects as skin, grass, the sky, and others familiar to memory. Since color processes are adjusted to produce pleasing reproductions of these memory colors, it is not surprising that slight departures from neutrality occur in the rendering of grays.

This compromise in color reproduction, which is the result of unwanted dye absorptions, does not seriously degrade the quality of a color print or transparency that is to be viewed directly. However, if the color print or transparency is to be duplicated again with the photographic process, the errors in the original are compounded by the errors due to the colorants used in the duplicate reproduction. Consequently, as the chain of color photographic stages gets longer (a duplicate from a duplicate from a duplicate, etc.), undesirable changes in color rendering as well as contract increase in magnitude.

16.7 Contrast- and Color-Correcting Masks

The most effective method for improving the quality of a color reproduction is the technique known as masking. A mask is simply a photographic image that is superimposed upon another photographic image in order to change its reproduction characteristics. For example, if a color transparency were printed using white light onto panchromatic black-and-white negative material, the resulting black-and-white image would show a high density in the areas that are light in the transparency and a low density in the areas where the transparency was dark. If this image were exactly superimposed upon the original color transparency, the total contrast of the combined images (transparency and the negative image) would be less than that of the transparency alone. This negative image is called a contrast-reducing mask because it reduces the overall contrast of the transparency. Such masks are useful in controlling contrast when making a duplicate transparency or printing an original transparency on a color reversal paper. The effects of a negative mask are illustrated in Figure 16-12, which indicates that the slope of the combined transparency plus mask curve is less than that of the transparency alone.

Although the example cited deals only with the reproduction of neutrals, it is possible to apply the same technique to the reproduction of different hues. Many color-transparency materials reproduce some hues lighter than they should be, while others are reproduced darker than they should be. For example, since cyan dye contains the greatest amount of unwanted absorptions, the colors associated with that dye, such as cyan, greens and blues, typically are reproduced too dark. Since the yellow dye shows the least amount of unwanted absorption, it is reproduced at nearly the correct level or lighter. Consequently, there can be a noticeable change in the contrast between the yellow and blue hues of the transparency.

Such an error in color contrast may be minimized by making a mask: the color transparency is printed on a black-and-white panchromatic film, using a colored filter for the mask exposure. This results in a mask that has varying densities as a function of the color of the

16.7 Contrast- and Color-Correcting Masks

exposing light. The color of the filter used to make the mask should be complementary to the hue that is intended to be lightened in the duplicate. For example, if the photographer desires to make the blue hues print lighter, the mask is exposed through a saturated yellow filter. Since a yellow filter absorbs blue light, the mask will have almost no density for the blue areas of the transparency and varying amounts of density as a function of the green light and red light from the transparency. Where the transparency is white, there will be a high density in the mask.

The negative mask is placed in register with the color transparency and then printed on the color duplicating film. The negative mask adds density to all areas of the transparency except in the regions that were blue. Since the duplicating film involves the reversal process, it will be necessary to increase the exposure given to the duplicating film (beyond what was required without the mask) in order to produce clean white highlights. Because no density was added to the blue areas of the original color transparency, the blue reproduction will be lighter and more pleasing.

Such color-correcting masks can cause the highlight areas in the reproduction to be unacceptably compressed. The highlights in the original transparency are low in contrast, since they were exposed in the toe portion of the characteristic curve. Thus, when printed in conjunction with a contrast-reducing mask, they become washed out and lack detail in the duplicate. This can be avoided by using a highlight mask. The original color transparency is first printed onto a highcontrast black-and-white film, exposing so that only the lightest tones of the original transparency produce densities in the mask. The mask is developed to a high contrast and is placed in register with the original transparency when exposing the color-correcting mask described previously.

Since the highlight mask has high density, in the highlight areas, it prevents the light tones from recording on the color-correcting mask, making these areas clear. When the color-correcting mask is printed in register with the original transparencies, the total contrast is reduced and the highlight detail is retained in the duplicate. This set of procedures is illustrated in Figure 16–13. This approach result: in at least three improvements: (1) the total contrast will not be excessive, as in unmasked duplicates; (2) the color rendering of the hue to be lightened is improved; (3) highlight detail is preserved in the duplicate.

If the hue errors are great, a more complex masking procedure must be used, which involves multiple masks and red, green, and bluseparation negatives made from the original color transparency. In thi procedure, at least two masks are used. The color transparency is printec onto a black-and-white panchromatic film using red light, resulting is a red light mask. The color transparency is also printed onto a black and-white panchromatic film using green light, producing a green ligh mask. The red light mask is superimposed with the transparency where the red record and the green record separation negatives are made. The green light mask is superimposed with the original transparency whe the blue record separation negative is made. Figure 16–14 illustrate these procedures.

The use of the two masks decreases the contrast of the reproduction and minimizes hue errors. The function of these masks is to prevent magenta and yellow dyes from forming in areas where the should not be present. For example, in an unmasked reproduction of the cyan hue, the cyan is reproduced too dark and too blue because of

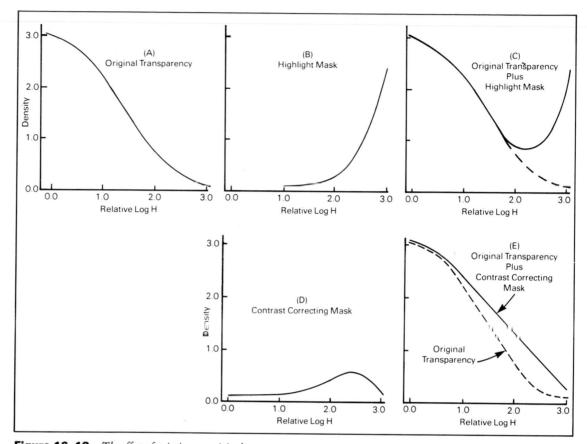

Figure 16–13 The effect of printing an original transparency (A) onto a high-contrast black-and-white film, producing a highlight mask (B). The original transparency is then placed in register with the highlight mask (C) and printed upon a low-contrast black-and-white film, producing a contrast-correcting mask (D). The original transparency is then placed in register with the contrast-correcting mask (without the highlight mask) to give the final masked image (E).

> the unwanted yellow and magenta dyes that have been formed on top of the cyan dye. The two masks will prevent this from occurring by increasing the relative density in those areas of the separation negatives and decreasing the relative densities in those areas of the positive images. This two-mask procedure is at best a compromise between using no masks at all and an extensive masking effort that could require at least six masks (two masks for each dye to compensate for the unwanted absorptions in each). The required quality of the color reproduction and the economics of the situation determine the extent of the masking procedures.

16.8 Color-Negative Masking

Just as the duplicating of a reversal color transparency involves at least two dye sets, so does the printing of a color negative onto a color print material. Therefore, masking is a necessary part of the negative/positive system. Procedures similar to those discussed previously can be used when printing color negatives. However, multilayer color-negative materials commonly employ a color correcting mask that is built into the emulsion. The technique involves the use of colored dye couplers in two of the three emulsion layers as distinct from the colorless dye couplers used in reversal transparency films.

16.8 Color-Negative Masking

Figure 16-14 The generation of multiple masks to minimize hue errors of the cyan dye. This approach requires that separation negatives be made so that individual corrections can be made on each dye.

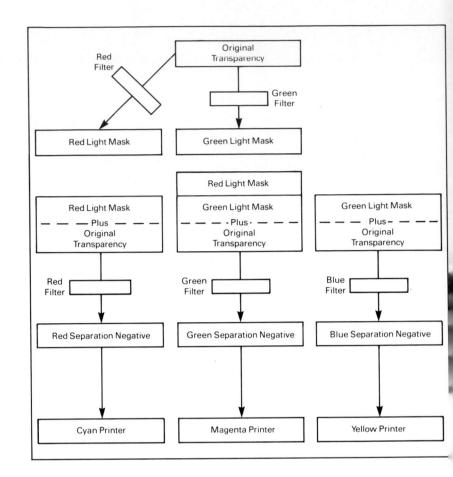

As discussed earlier, the purpose of the dye images in the film's three layers is to control the transmission of the primary color of light (blue, green, and red). Therefore, for proper color reproduction each dye should control only one of the three colors and allow the othe two to be freely transmitted. Since all three of the dyes actually use have unwanted absorptions, color-correcting masks are required. Th major problem with the magenta dye is that it absorbs significan amounts of blue light in addition to its main function of absorbin green light. This means that when the color negative is printed, th magenta dye will influence the blue light when it should ideally onl influence the green light reaching the color print material.

Compensation can be made by employing a yellow mask t absorb the blue light that would otherwise be transmitted by th magenta dye. This can be achieved by making the color couplers i the magenta-forming layer a pale yellow color. In those areas receivin exposure, the light yellow coupler changes to magenta dye during th color development. A green record negative of magenta dye is forme in that layer, in addition to a light yellow positive image, which the result of the remaining color coupler that was not converted to magenta dye. The combination of these two dye images works to absor blue light evenly throughout the green record layer and prevents th magenta dye negative from altering the blue light reaching the colprint material. Therefore, in the magenta dye layer of the color negatithere is a magenta dye negative image and a light yellow dye positiimage.

Additional color errors occur with the cyan dye because has significant absorptions in the blue and green regions where it shou have none. This means that the cyan dye will influence the amount of blue light (which should be controlled only by the yellow dye) and green light (which should be controlled only by the magenta dye) that reach the color-print material and ultimately affect the colors produced. To compensate for these deficiencies, the cyan-forming coupler in the bottom red-sensitive layer is pale red in color to absorb green and blue light in proportion to the unwanted green and blue absorptions of the cyan dye.

After the film has been developed, the unused coupler remains in the film and allows the cyan dye to influence only the red light that will be transmitted to the color print material. Therefore, in the cyan dye layer of the color negative there is a cyan negative dye image and a light red positive image. Figure 16–15 illustrates the effects of using color masks in both the magenta-forming and cyanforming layers of a color-negative film.

The yellow-forming coupler in the top (blue-sensitive) layer is colorless, since the yellow dye formed only minimally absorbs red light and green light. Therefore, color corrections in this layer is less necessary than in the other two. The result of having a pale yellow much in the number of a red mask in the cyan-forming layer is an overall orange appearance in the color negative. Since the color negative is not intended to be viewed, the orange cast is not troublesome. However, it is necessary to print the negative upon a color-print material that is balanced for this orange cast.

If a color print were made from an unmasked color negative, the resulting print would have defective color reproduction. Since the unmasked negative would contain unwanted absorptions of blue and green light by the cyan and magenta dyes, less blue and green light would be transmitted to the color paper. As a result, in the print less yellow and magenta dye would be produced, causing the yellow, red, and magenta image colors to appear lighter and less saturated.

It is important to note that the use of the integral mask in a color negative film compensates for the dye deficiencies of the dyes

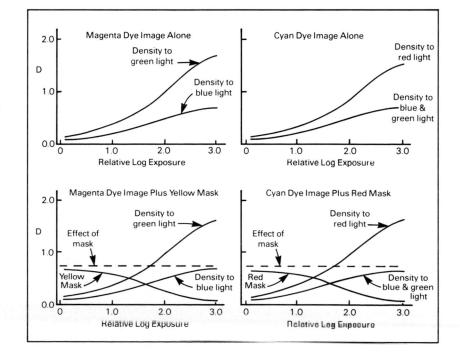

Figure 16-15 The effect of the integral color mask in a color negative. The magenta dye has unwanted density to blue light. The couplers in the magenta-forming layer are yellow and form a pale yellow positive mask during color development. The sum of the unwanted density to blue light and the yellow mask keep the unwanted blue absorption at a constant level. Similarly, the cyan dye has unwanted blue and green absorptions. The couplers in the cyan-forming layer are red and form a pale red positive mask. The sum of the unwanted blue and green densities and the red mask keeps the unwanted blue and green absorptions at a constant level.

in the color negative only. The dyes produced in the color print will be plagued by the same unwanted absorptions that were discussed previously.

16.9 Color Densities

The measurement of density for colored photographic materials is complicated by the nature of the dye images formed. The spectral dye density curves for the three dyes of a typical color process, together with the curve representing the visually neutral image formed when these dyes are superimposed, are shown in Figure 16–11B. As noted previously, each dye has appreciable density to all wavelengths of light. Therefore, every measurement of the density of a color image (either negative or positive) is simultaneously affected by all three dyes. Furthermore, the visual neutral represented by the top curve, which is produced by mixing these three dyes, departs from a "perfect" neutral, which would yield the horizontal straight line. Since the combined densities of the three dyes is not constant at all wavelengths, density measurements of color images will be greatly influenced by the color characteristics of the light source as well as the color response of the receptor in the densitometer.

Since the structure of the dye clouds that comprise the color image is much finer than the grains of silver that comprise the image in a black-and-white material, problems arising from light scattering in color materials are much less serious. Consequently, the differences between specular and diffuse densities for dye images are quite small, with the Q factor approaching 1.0.

Color films consist of three dye layers, each with different spectral characteristics. Since it is possible to generate either one, two, or all three of the dyes in a color image, it is necessary to distinguish between such images. If a color image has all three dyes present, it is referred to as an integral image. If a color image contains only one of the three dyes, it is referred to as an analytical image. The differences in the nature of these images are the source of the following two fundamental classifications of color densities:

- 1. Integral densities. Integral densities are measures of the combined effect of the three superimposed dye layers. Since each dye has significant absorptions to all wavelengths of light, no information about individual contributions of the dyes can be obtained.
- **2.** Analytical densities. Analytical densities are measures of the individual contributions of the dye layers to the total image and indicate the composition of the image in terms of the amounts of the dyes present.

In practice, integral densities are far more useful, since they describe the performance of the image. Therefore, integral density measurements are usually satisfactory for the consumers of photographic materials. However, since they give no direct information about the image composition, integral densities are usually insufficient for the manufacturer of color materials. During their manufacture, color emulsions are made and coated separately, and thus the manufacturer must have insight into the nature of each layer. Analytical images can be obtained by exposing and processing individual coatings of each layer. An alternative method is to expose a multilayer emulsion through a very saturated narrow-band filter, thereby producing dye in only one layer.

If all three dyes are present in the image, it is defined as an integral image, and any density measurement made on it is termed an integral density. Likewise, when only one dye layer is present, it is defined as an analytical image and any measurement made on it is termed an analytical density.

Each of these two types of color densities can be classified in terms of the information supplied by the measurements. The following sub-classifications are typically used:

- Spectral densities. These measure the wavelength-by-wavelength density of the image, and the results are typically displayed as a graph. If all three dyes are present in the image, the resulting data are termed integral-spectral densities, and if only one of the three dye layers is present, the results are termed analytical-spectral densities. Referring to Figure 16–11B, the uppermost curve would be termed an integral-spectral density plot, and the three curves below would be defined as analytical-spectral densities since they relate to each of the three dyes. Such information is fundamental to studies of the dyes used in color photographic materials.
- 2. Wide-band three-filter densities. These densities are based on the use of three arbitrarily chosen red, green, and blue filters. The densities are termed wide-band since the filters have band widths of 30 nm to 60 nm. Thus the data that are derived from a color densitometer, describe the red-, green-, and blue-light-stopping abilities as dictated by the filters that were used in the instrument.

In addition, the spectral response of the densitometer's photo detector can have a significant effect on the resulting measured values. Therefore, for the purposes of standardization, the American National Standards Institute has defined the following two conditions for color densitometry:

- 1. Status A densitometry: A set of red, green, and blue response functions for the measurement of color photographic images intended for direct viewing (either transmission or reflection). The standard response functions for status A are illustrated in Figure 16-16. In order to achieve these aim response functions, densitometer manufacturers must select a light source, a filter set, and a photodetector whose combined response will approximate (within 5%) these response functions. This is most commonly achieved through the use of a tungsten lamp operating at 3000 K, an S-4 photo-detector, and the use of Eastman Kodak Certified AA red, green, and blue filters. The peak responses of these functions correspond fairly closely to the peak densities for each of the three dyes in a typical color-positive material. Furthermore, the response functions are narrow enough to allow fairly high densities (above 2.0) to be measured with good integrity (no cross-talk between the spectral bands). Thus a densitometer equipped with such a set of response functions provides color densities capable of detecting small changes in the densities of the image. It is important to note, however, that such red, green, and blue densities are not a direct indication of the appearance of the colors in the image.
- 2. Status M densitometry: The standard used when reading the densities of color images that are to be printed. The red, green, and blue

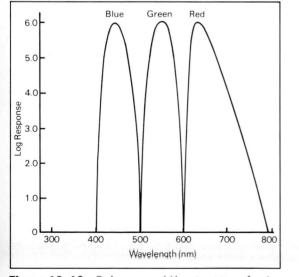

Figure 16–16 Red, green, and blue aim response functions for status A densitometry.

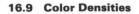

Figure 16-17 Red, green, and blue aim response functions for status M densitometry.

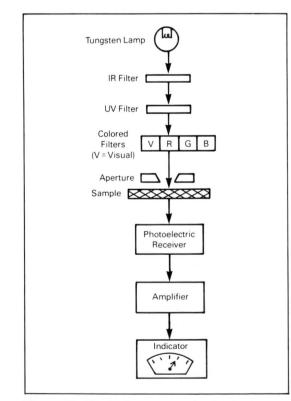

Figure 16–18 Major components of a photoelectric transmission densitometer.

aim response functions for status M densitometry are illustrated in Figure 16–17. Again, densitometer manufacturers must select a combination of lamp, filter set, and photo-detector response that approximates these response functions. The use of a tungsten lamp operating at 3000 K, the S-4 photo-detector, and Eastman Kodak Certified MM filters meets this requirement; and densitometers so equipped are said to read "Status M Density."

Notice that the response functions for status M show considerable overlap when compared to the status A response functions (i.e., they have greater cross-talk). This is intended to simulate the red, green, and blue spectral response functions encountered in color print emulsions. Thus densitometers equipped with these response functions give densities that are descriptive of the printing properties of the image.

The benefit of using densitometers with these standardized response functions is principally a reduction of interinstrument variability. The result is that densitometers from the same manufacturer and densitometers from different manufacturers tend to show better agreement when measuring the same image. As noted above, if the image being measured consists of all three dyes superimposed, the densities are referred to as integral; and if only one of the three dyes is present, such wide-band densities are termed analytical. This type of color densitometry is more commonly employed on integral images to obtain information about the performance of the color materials. Further, such readings are often used in conventional process monitoring where it is necessary to determine significant changes in the processing conditions by using standardized control strips.

Regardless of the use of the readings and the filter set actually employed, it is necessary to check the instrument's behavior periodically by using statistical control methods (see Sections 1.9 through 1.12). Periodic readings should be made on standard control patches to detect unwanted changes in the densitometer's response.

Figure 16–18 is a simplified diagram of the basic components of a transmission color densitometer. The basic parts are (1) a light source that emits light in all regions of the visible spectrum, typically a tungsten lamp operated at 3000 K; (2) a set of wide-band red, green, and blue filters plus a fourth filter that adjusts the instrument response to match that of the eye (visual density); and (3) a photoelectric receiver that senses the light transmitted by the sample being measured. Most commercial color densitometers allow for interchangeable filter sets, so that status A, status M, or nonstatus three-filter color densitometry can be used.

The measurement of reflection color densities requires a significantly different design, as illustrated in Figure 16–19. A tungsten lamp is used to illuminate the sample at an angle of approximately 45° , and the light reflected from the sample is collected over a 5° angle around the perpendicular to the sample. A mirror in the center reflects the light to the receiver after passing through the filter (red, green, or blue) that has been placed in front of the receiver.

Such a design simulates the optimum condition for viewing a reflection image, which is with the illumination striking the image at about a 45° angle with the light that is reflected on the perpendicular being received by the viewer's eye. In practice, however, light reaches the image over a very wide angle as a result of light reflections from the walls, ceilings, floors, etc. Since it is impossible to simulate these

Figure 16–19 Major components of a photoelectric reflection densitometer.

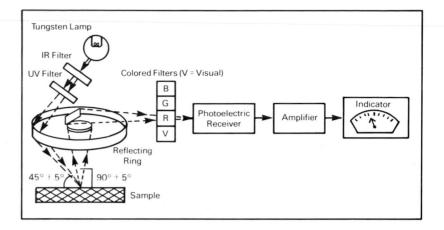

conditions in a reflection densitometer, the values that result do not accurately represent most viewing conditions and, as a result, represent an acceptable compromise.

Reflection densitometers can provide useful information about the light modifying characteristics of reflection photographic images. Additionally, red, green, and blue filters can be used over the receptor to obtain information about the color characteristics of the image.

By far the most commonly used means of determining color densities, integral three-filter densities must be interpreted with great care. For example, it is often assumed that a color film will give a good visual neutral if the red, green, and blue densities are equal. In fact, color images with equal red, green, and blue densities usually show a slight color cast. There are at least two reasons for this discrepancy. First, the three dyes that comprise the image each have unwanted absorptions. Second, the overall red, green, and blue response characteristics of the densitometer are considerably different than those of the human eye.

Table 16–5 illustrates the relationship between the integral densities necessary to give a neutral-appearing image on a variety of color films. In no case were the red, green, and blue densities equal for these visually neutral images. Similarly, one should realize that red, green, and blue integral densities will not provide accurate information about the printing properties of color images. Since the dyes of the image have unwanted absorptions and the spectral response of the color print material is different than those of the densitometer, discrepancies are common. It is possible, however, to determine the relationship between red, green, and blue integral densities and the visual appearance of the images through experimentation. Since the dye sets for different types of color films show varying amounts of unwanted absorptions, such experiments would have to be performed on each film type.

The best method for expressing the appearance of a color

 Table 16-5
 Three-filter integral densities of visually neutral color images from several color emulsions.

Densi	itometer Filters	Kodak Kodachrome	Kodak Ektachrome 64	Fuji Fujichrome	Kodak Ektacolor 74
	Red	1.22	0.98	1.00	0.97
Status A	Green	1.05	1.03	1.06	1.02
	Blue	1.02	1.12	1.15	1.09
W92	Red	1.10	0.99	0.94	1.10
W93	Green	1 04	1.15	1.12	0.97
W94	Blue	1.04	1.09	1.06	1.06

image with densities is the concept called equivalent neutral density. Equivalent neutral densities (END) describe each dye with a single number, which is defined as the density of the visual neutral formed by the dye sample when the proper amounts of the other two dyes of the process are added to it. Thus the number assigned to the sample is the density of the visual neutral the dye can form in the process. A visually neutral patch, as represented by the top curve in Figure 16–11b, would by definition be specified as having equivalent neutral densities for the three combined dyes (i.e., C = 1.0, M = 1.0, and Y = 1.0).

If the patch had a yellow cast to it, the resulting END values might be C = 0.50, M = 0.50, and Y = 0.70. On the other hand, if the sample had a bluish cast to it, the END values might be C = 0.50, M = 0.50, and Y = 0.30. Equivalent neutral densities are usually determined indirectly by mathematically converting integral spectral densities to END values.

There are no commercially available densitometers that will directly measure equivalent neutral densities. For this reason they are not commonly used; however, they provide the best method for specifying the appearance of colors in photographic images. Since the photographic image is specified in terms of the cyan, magenta, and yellow dye components, END values are analytical densities. Whereas a visual neutral is used for the determination of ENDs for color transparencies to be viewed directly, the printing density of a nonselective attenuator that would be matched by adding the proper amounts of the other two colors is used to determine equivalent neutral printing densities when color prints are to be made.

16.10 Sensitometry of Color Photographic Materials

The determination of the sensitometric properties of color photographic films and papers essentially involves the same procedures that were discussed in Chapter 2: exposure, processing, image measurement and data interpretation through the use of characteristic curves. When exposing the film, the sensitometer must be equipped with a light source that produces the color temperature for which the color film was designed. Any attenuators (neutral-density filters and step tablets) must not depart significantly from neutrality, or they will alter the color balance of the light reaching the film.

Figure 16–20 shows the spectral density curves for a variety of neutral attenuators. Notice that the Wratten neutral-density filter shows a higher density at the blue end of the spectrum than the green or red end. Furthermore, photographic silver step tablets also show a slightly higher blue density. When extreme neutrality is required, as when following ANSI standard methods, M-type carbon attenuators are preferred. These attenuators are composed of carbon particles dispersed in gelatin and coated on an acetate base. Additionally, the Inconel coated materials (iron alloys evaporated onto glass) provide excellent neutrality in the visible region.

It is important to note that all four of these attenuators depart considerably from neutrality in the ultraviolet region of the spectrum. Furthermore, only the Inconel coated material shows good neutrality in the infrared regions of the spectrum. Thus when selecting

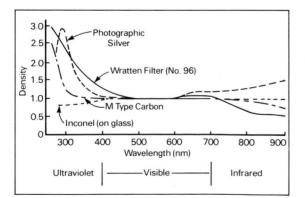

Figure 16–20 Spectral density curves for a variety of neutral attenuators.

filters for specialized work involving either ultraviolet or infrared energy, extreme care must be taken in selecting the attenuators.

The exposure time used in the sensitometer must simulate those times that typically will be used with the material in practice. This is to avoid the problem of reciprocity failure. The processing of the sensitometric samples involves either standardized methods (ANSI methods) or techniques used in practice. The manufacturer of the sensitized material is likely the only one to use the standardized methods since this approach would provide information primarily about the emulsion properties. The photographer, however, requires information about the film and its corresponding processing in order to control the quality of the resulting photographic images.

In both cases, the resulting color photographic image consists of a set of superimposed cyan, magenta, and yellow dyes. As a result, the image-measurement method used typically results in three values: the density to red light (D_r) , the density to green light (D_g) , and the density to blue light (D_b) ; these are referred to as three-filter integral densities. The problems associated with obtaining and interpreting such data have previously been discussed.

The construction of the characteristic curve for a color lifth follows the convention discussed in Chapter 2 for black-and-white materials, except that three curves will be plotted for each image instead of one. In cases where a visual neutral has been formed in the image, it is possible to simply measure the visual density of each step and therefore plot a single curve that is representative of the image. The basic properties of speed and contrast are determined in the evaluation of the resulting curve. The sensitometric characteristics of a variety of color photographic materials follow.

16.11 Reversal Color Films

Examples of these films include Ektachrome, Kodachrome, Fujichrome, and Agfachrome. The visual density curve for a neutrally exposed and processed color reversal image is shown in Figure 16–21. Since this is a reversal material, increasing amounts of exposure produce decreasing amounts of density in the image. In order to obtain adequate contrast and color saturation in the transparency, the midtone slope is generally between 1.8 and 2.0, which is much higher than for negative materials. Far to the right on the curve is the minimum density, which is the combined result of residual color couplers, stain that was picked up during processing, and the density of the supporting base. The minimum density (visual density) of this area is seldom less than 0.20.

Far to the left of the plot is the shoulder of the curve, where the maximum density, representing no exposure, occurs. For most color reversal films, the maximum density obtainable is at least 3.0, and often greater. Consequently, color transparencies are capable of substantially greater output density ranges (near 3.0) than are reflection print materials. The contrast of reversal films is typically measured as the gamma, with these values usually between 1.80 and 2.0. Additionally, average gradient can be determined between any two points on the curve, and as a result will be different from (lower than) the gamma.

The useful log exposure range of the film is the range of log exposures contained between the minimum and maximum useful dens-

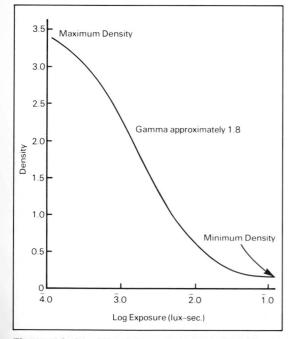

Figuro 16-21 Visual density enrue from a neutrally exposed and processed reversal color film.

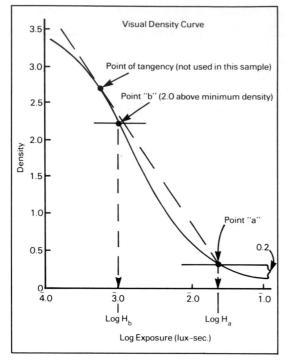

Figure 16–22 Location of the speed points in the ISO (ASA) speed method for a reversal color film.

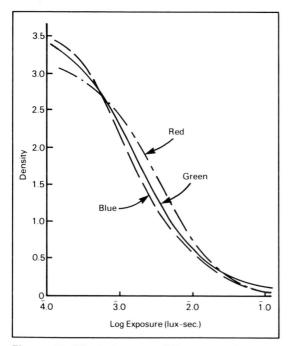

Figure 16–23 Red, green, and blue status A density curves from a neutrally exposed and processed reversal color film. This image is a visual neutral. Since the response of the densitometer is different from that of the human eye, the curves are not superimposed (i.e., the image is not a densitometric neutral).

ities of the curve. Since the slopes of color reversal films are very steep, they are typically characterized by narrow useful log exposure ranges. Most such films do not exceed a useful log range of 1.90, indicating that an exposure ratio of at best 80:1 can be accommodated. As a result, the amount of exposure latitude (margin for exposure error) is usually quite small.

The speed of a color-reversal film is based on the location of two points on the curve that relate to shadow and highlight reproduction, as illustrated in Figure 16–22. Point A relates to highlight reproduction and is located at a density of 0.20 above the minimum density. From this point, a straight line is drawn so that it is tangent to the shoulder of the curve and locates the upper useful point. If this point of tangency falls at a density greater than 2.0, the upper useful point—labeled point B—is simply located at a density of 2.0 above the minimum density. The log exposures are determined for both positions and averaged by adding them and then dividing the sum by 2. The resulting value is termed the minimum log exposure (log H_m). The antilog is taken and used in the following speed formula:

$$\mathsf{ASA} = \frac{\mathsf{I}}{H_{\mathsf{m}}} \times 10^{\circ}$$

Other sensitometric properties of color reversal films can be evaluated by using red, green, and blue density readings and constructing the corresponding curves, as illustrated in Figure 16–23. These curves are the result of reading a visually neutral color film image of a sensitometric strip on a densitometer equipped with the status A response functions. Note that the three curves are not exactly superimposed, indicating that although the image is a visual neutral, it is not a densitometric neutral. Since these curves were derived from a visually neutral strip, they can be used as a reference against which future strips can be compared in order to detect changes in image color.

For example, Figure 16-24 illustrates the red, green, and blue status A curves for a second strip. The shape of the red density curve is considerably different from that in Figure 16-23; the principal difference is an increase in the gamma. Such a condition is referred to as crossed curves and is generally related to problems in the film processing. In this image the shadows would probably appear somewhat cyan because of the high red density, and the highlights would likely contain a red cast because of the lowered red density (indicating less cyan dye) in that region. The resulting color transparency would likely have unacceptable color quality.

Figure 16–25 illustrates the red, green, and blue status A curves for a third strip. In this case, the shapes of all three curves are approximately the same, except the blue density curve is displaced to the right. Thus there is an increase in blue density everywhere in the image. The image corresponding to the curves in Figure 16–25 would likely show an overall yellow-colored cast. Such an image could result from exposing a color reversal film balanced for daylight (5500 K) to a tungsten light source without the proper filtration.

16.12 Negative Color Films

Examples of this kind of film include Kodacolor, Vericolor, Fujicolor, and Agfacolor. Color negative films, sometimes referred to as color print films because prints are made from them, employ the

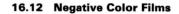

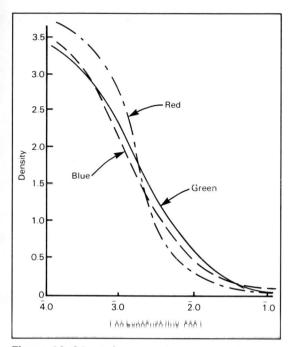

Figure 16–24 Red, green, and blue status A density curves from a non-neutral reversal color image. Since the red curve is significantly higher in the shoulder region, the shadows in the photograph would have a cyan cast. The highlights would show a reddish cast because the red curve is much lower in the toe region.

Figure 16–25 Red, green, and blue status A density curves from a non-neutral reversal color image. The image thous a high density to blue light in all regions and thus would appear yellow.

traditional integral tripack assembly. However, many modern-day films have double-coated emulsions in each of the three spectral bands to improve latitude and film speed. The spectral responses of the emulsions are selected principally for the ability to produce optimum color reproduction in the final color reflection print. Since the color negative represents only an intermediate step in the system, it makes no difference what the actual colors of the negative are, as long as they are matched to the properties of the color print material. This allows for the use of integral color masking, as discussed previously, which gives an overall orange cast to the negative.

The product of a set of neutral exposures and normal processing of the color negative material is a scale of non-neutral densities. The resulting sensitometric strip is evaluated by measuring the red, green, and blue densities on a densitometer equipped with the status M response functions. The red, green, and blue density plots for a sensitometric test of a typical negative color film are shown in Figure 16-26. The graph indicates that increasing amounts of exposure give increasing amounts of density, as is the case for negative-working materials.

Additionally, the clopes of the three surves are considerably less than those of a reversal color film, resulting in an increase in the exposure latitude. The three curves are separated vertically, due to the orange-colored integral mask in the image. The minimum densities for the curves are located at the far left of the graph and consist of the integral mask density, emulsion fog, residual color couplers, processing stain, and base density. The density to blue light is always the highest of the three because of the principal absorption of the yellow dye, the blue absorption of the integral mask, and the unwanted blue absorptions of the magenta and cyan dyes. Since the yellow and magenta dyes have only low absorptions to red light, the density to red light is generally the lowest of the three, resulting mostly from the cyan dye. It is sometimes assumed, erroneously, that the blue curve is the highest because it is the top emulsion layer, and the red curve is the lowest because it is the bottom layer of the three. The order in which the emulsion layers are coated has absolutely no effect upon the red, green,

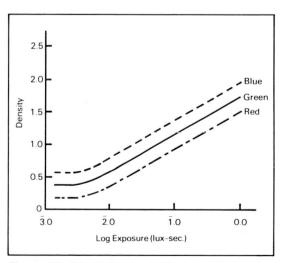

Figure 16–26 Red, green, and blue status M density curves from a neutrally exposed and processed negative color film. The integral color-correcting math gives the image an overall orange cast, causing the curves to be vertically displaced.

and blue light-stopping ability of the image that is formed in the emulsion. This is a result of the nature of the dye-set and the integral color mask in the color negative.

The contrast of color negative films is generally determined by measuring the slope of the straight-line portion (gamma); slopes typically lie between 0.50 and 0.60. As with the black-and-white negative-positive process, the color negative has a relatively low slope, larger the exposure latitude, allowing for a larger subject contrast. The lowered slope of the negative is compensated for in the printing stage by using print materials with steep slopes. Theoretically, the slopes of the three curves should be equal over their entire length to avoid undesirable shifts in color balance between the shadows and the highlights. However, practical experience indicates that some divergence in slopes can be tolerated, depending to a great extent upon the nature of the scene.

The speed of a color negative film is derived from locating the minimum useful points (0.15 above the minimum density) on the green status M density curve and the slowest status M density curve of the three curves. Since the slowest curve inevitably is the red status M density curve, it is the green and red status M density curves that are used. The log exposure (in lux-seconds) at each speed point is determined and averaged. The antilog of the resulting log H value is then used in the following formula:

Speed =
$$\frac{1}{H_m} \times 1.5$$

The blue status M density curve is not used to determine film speed, since it is the fastest of the three and would produce a slightly inflated speed.

Since three filter color densities do not give precise information about either visual appearance or printing characteristics, such data for color negatives must be interpreted with the same care as discussed previously with reversal color images. Nevertheless, it is possible to make meaningful inferences about the printing properties when there are large differences between the aim curve shapes and those actually encountered. For example, the red, green, and blue status M density curves in Figure 16–27 illustrate the sensitometric results of overdevelopment of a color negative. Comparing these curves to those shown in Figure 16–26 (normal processing conditions) reveals that the extended development time produces a noticeably higher contrast in the blue density plot.

Such a change in curve shape would lead to the problem of crossed curves, with the negative producing a color print with a noticeable color shift between the shadows and the highlights (i.e., the shadows would have a yellowish cast, while the highlights would have a bluish cast). This problem can be illustrated graphically by superimposing the red, green, and blue density curves, which is essentially what happens when the negative is printed on conventional color print material using supplementary filtration in the enlarger.

Figure 16–28A illustrates how the red, green, and blue density curves exactly superimpose for a normally exposed and processed color negative. Figure 16–28B illustrates what happens when an attempt is made to balance the color negative shown in Figure 16–27. Notice that the blue density curve is steeper, and if a midtone is printed to a neutral, as shown here, the blue light density in the shadows will

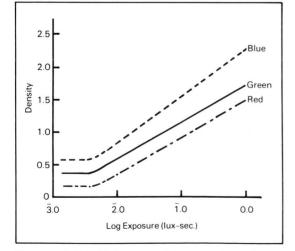

Figure 16–27 Red, green, and blue status M density curves from a neutrally exposed negative color film that was overdeveloped. Notice the increased slope of the blue density curve.

Figure 16–28 The sensitometric effects of printing color negatives in an enlarger using supplementary filtration. The curves in graph A are from a color negative with proper contrast in all three layers. The use of supplementary magenta and yellow filters in the printer brings the curves into nearly exact alignment, as shown in graph A bottom. The curves in graph B are from a negative with high blue contrast and normal green and red contrast. When this negative is printed, there is no combination of filters that can eliminate the mismatch seen in graph B, bottom.

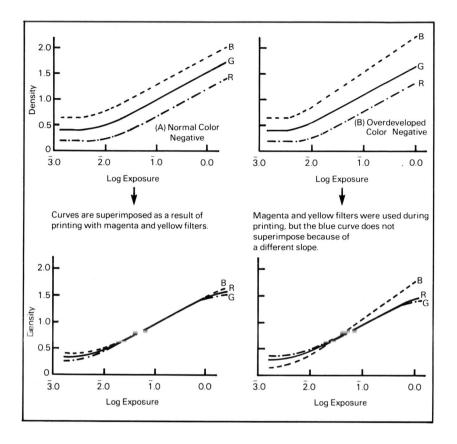

be low, producing larger amounts of yellow dye in the print. The blue density in the highlights will be higher, resulting in a lack of yellow dye (a bluish cast) in the highlights. Thus when the red, green, and blue density curves are severely crossed, excellent color prints cannot be obtained.

16.13 Color Paper

In the other half of the negative-positive process a color reflection print is made from the negative. Therefore, the properties of color photographic papers depend primarily upon the characteristics of the negatives to be printed. For example, the spectral sensitivities of the paper emulsions are typically matched to the spectral absorptions of the dyes in a color negative, thus allowing for optimum color reproduction. The inherent color balance of the color paper emulsion is designed so that using a tungsten enlarging lamp in combination with the red, green, and blue light-stopping abilities of a typical color negative will result in a properly balanced color print with a minimum of supplementary filtration. Furthermore, by making the paper's redsensitive layer the slowest, the use of supplemental cyan filtration with its unwanted absorptions can be avoided.

If a color reflection paper is exposed and processed to produce a scale of visual neutrals, the visual densities of the steps can be measured and a characteristic curve constructed as shown in Figure 16–29. Notice that the curve shape is very similar to that of black-and-white reflection print material. The steep slope in the curve's midsection is necessary to expand the midtones, which were compressed in the negative as a result of the lowered slope in the negative. The result is a print with

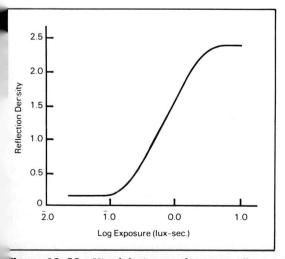

igure 10–29 Visual density curve from a neurally xposed and processed reflection color print material.

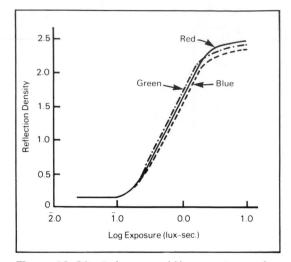

Figure 16–30 Red, green, and blue status A curves from a neutrally exposed and processed reflection color print material. The image is a visual neutral.

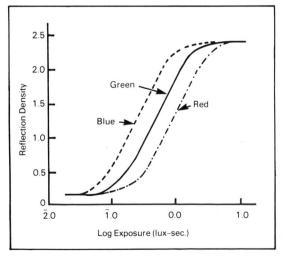

Figure 16–31 Red, green, and blue status A curves from reflection color print paper balanced for an orange mask but printed without it. Thus the actual speeds of the three layers are revealed. The blue- and green-sensitive layers are the fastest, which compensates for the high blue and green densities of the orange negative mask.

the desired tone reproduction characteristics, as discussed in Chapter 11.

Notice that the maximum density of color paper is somewhat greater than that of a black-and-white reflection paper. This is principally due to multiple internal reflections between the emulsion layers in the color paper, which cause less light to be reflected from the print. Since there are no standard methods for determining the speed and contrast of color print materials, there exists no common method for determining these properties. However, since the characteristics of color and black-and-white reflection print materials are similar, the same methods may be used.

On this basis the useful log exposure range for a conventional color reflection print material turns out to be approximately 1.15 to 1.25 (current ANSI standard paper range of 120), indicating that it is similar to a contrast grade 2 black-and-white printing paper. Also, the ANSI standard paper speed is approximately 100, indicating that this is a medium-speed paper. Such information is of little practical use, since color print materials are invariably balanced individually when the negative is printed. In effect, individual tests are performed for each negative/print combination, minimizing the need for standardized values of speed and contrast.

Figure 16–30 illustrates the red, green, and blue status A density curves for the same scale of visual neutrals. Again, notice that the three curves are not exactly superimposed, indicating that a set of visual neutrals is not the same as a set of densitometric neutrals. The inherent sensitivity of the red, green, and blue layers is illustrated in Figure 16–31, where it can be seen that the blue- and green-sensitive layers are faster (displaced to the left) than the red-sensitive layer. This is in part to compensate for the integral mask incorporated in the negative, which has a high density to blue and green light. Also, since the tungsten lamps used in color enlargers are rich in red light, the paper speed in this region can be reduced.

Thus by matching the speeds of the three layers of the color print material to the red-, green-, and blue-light-stopping characteristics of the integral mask in the color negative, minimum amounts of supplementary filtration will be required to obtain optimum color reproduction. In essence, the three curves illustrated in Figure 16-31will be superimposed as they appear in Figure 16-30, as a result of the filtration caused by the integral orange mask and the supplementary filtration in the printer.

16.14 Transmission Color Print Materials

These materials are quite similar to color printing papers, but they are coated on a film base to produce a transparent image instead of a reflection image and are often referred to as color print films. (Note: The term *color print film* is also applied to the origina color negative material.) When such a material is given a set of neutra exposures and normal processing, a scale of visual neutrals results, that can be characterized by the set of red, green, and blue status A density curves illustrated in Figure 16-32.

Notice that these curves are considerably steeper than those of a color reflection print material. This is needed to obtain the proper tone-reproduction characteristics for the resulting transparency, which

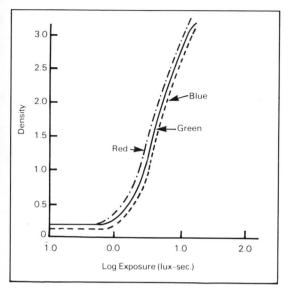

Figure 19 27 Red, group, and blue tensor 4 during curves from a neutrally exposed and processed transmission color print film (for making color transparencies from color negatives).

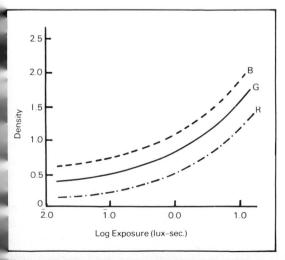

Figure 16–33 Red, green, and blue status M density urves from a neutrally exposed and normally processed internegative color film (for making color negatives from color ransparencies).

are considerably different than those of a reflection print, as discussed in Chapter 11. The steepness of the curves indicates that the useful log exposure range is narrow and, therefore, the exposure latitude is small. Consequently, careful exposure is necessary to produce good color transparencies from this material. When the printing exposures are correct, it is virtually impossible to discern between a transparency that was produced by a camera original film and one that was printed from a negative.

16.15 Internegative Color Films

These films are used to obtain from a color transparency a color negative that can then be printed onto a color paper, yielding a color reflection print. An internegative closely resembles a normal color negative in its general appearance, since it also has the orange integral mask, and in its printing characteristics. However, the sensitometric characteristics of an internegative film are considerably different from those of a conventional color negative film. The red, green, and blue status M density curves for a neutrally exposed and normally processed internegative film are illustrated in Figure 16–33.

Compared to the curves for a conventional color negative film shown in Figure 16–26, the internegative film has a long toe region of relatively low slope that seems to join an upper region that has a considerably steeper slope with the complete absence of any straight-line portion. Thus as the exposure is increased, steeper sections of the curve will be utilized and vice versa.

This provides for the major control of contrast when making an internegative. If the original transparency is somewhat contrasty, the exposure to the internegative film is reduced slightly to lower the contrast. If the original transparency is low in contrast, the exposure to the internegative film is increased to give suitable contrast in the resulting negative.

Further, the upswept portion of the internegative curve in the highlight region serves to maintain separation of tones in the transparency's highlights. Since the highlights in the original transparency have been compressed considerably as a result of being placed in the toe portion of the reversal color film exposed in a camera, it is necessary to print the transparency onto a material (internegative film) having steep slopes to maintain proper separation of highlight detail. If a conventional negative color material were used as an internegative film, the highlights in the resulting negative would have little or no detail. Therefore, the shape of the characteristic curve for an internegative film is intended to compensate for the distortions already introduced as a function of the characteristic curve for the original reversal film used to make the transparency.

There is no standard speed technique for internegative color films, since each emulsion batch is usually tested and balanced (via filtration) by the person making the internegatives. The resulting internegatives can then be printed easily onto either a reflection color print material (as is customary) or onto a color print film to produce another transparency. Internegative color films may also be used in the camera to photograph original color prints and other reflection artwork, resulting in a color negative. However, the reciprocity failure characteristics for this film are quite severe, and exposures shorter than 1 second and longer than 10 seconds tend to cause color-shift problems in the resulting negative.

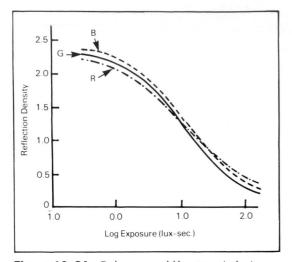

Figure 16–34 Red, green, and blue status A density curves from a neutrally exposed and normally processed reversal reflection color print material (for making reflection color prints directly from color transparencies).

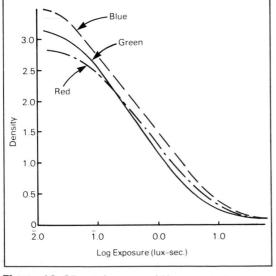

Figure 16–35 Red, green, and blue status A density curves from a reversal color duplicating film (for making color transparencies directly from color transparencies).

16.16 Reversal Reflection Color Print Materials

These materials are used to produce a reflection color print directly from a color transparency. Their operating characteristics are similar in principle to those of a reversal color film but they are coated on an opaque white reflecting base instead of on a film base. Additionally, the characteristic-curve shape is considerably different from that of the reversal color film. The red, green, and blue status A density curves for a typical reversal color print material are shown in Figure 16–34. Notice that the maximum and minimum densities are very similar to those for nonreversal reflection color papers. However, the slopes of the curves are less, resulting in a longer useful log exposure range. This is necessary to accommodate the range of exposures provided by the color transparency when printed onto the reversal color paper.

The typical range of densities in a color transparency is approximately 2.50; and if the color reversal print material is to properly reproduce this range, it must also have an input range of 2.50. However, as illustrated in Figure 16–34, reversal color print materials generally show a useful log exposure range of not greater than 2.0, which results in an inevitable loss of detail in either the shadows or the highlights, depending upon the amount of exposure given the print. A much better quality print can be made from an original transparency that is relatively low in contrast than from a transparency of normal or higher contrast.

Reversal color papers remove the need for the intermediate step of making a color internegative, which adds to both the time and cost involved in making a print from a transparency. However, with most color transparencies, higher-quality color prints can be obtained through the internegative process than through the color reversal print method, although improvements have been made in reversal color papers in recent years. Further, when a reversal color print is made from a color transparency, two dye sets are involved, both of which have unwanted absorptions and neither of which has been corrected by a masking procedure. The result is also a loss of color fidelity in the reproduced colors.

16.17 Reversal Color Duplicating Films

These films are designed to make duplicate color transparencies from an original color transparency. They are intended primarily for exposure with tungsten light sources but can be filtered to give suitable results under other sources. Processing follows the same steps as for the reversal color film materials that produce original transparencies in the camera. However, their characteristic curves are somewhat different from those for the original reversal films, as illustrated in Figure 16–35. The principal difference is that the slopes are lower, with a gamma of approximately 1.0 over a long input range.

This is obviously a desirable feature in a duplicating film. since it is desired that the duplicate be as similar as possible to the original. Excellent color duplicates can be made from transparencies of normal and lower contrasts. However, if the contrast of the origina transparency is high, it will exceed the input capability of the duplicating film, and the rendition of either the highlights or the shadow will suffer. Further, in all cases two dye sets are again being used neither of which is corrected with an integral mask. As noted before this can have an undesirable effect upon the color fidelity in the duplicate. The problem becomes more severe if a duplicate is made from another duplicate.

16.18 Accuracy of Color Reproduction

Since color photographic systems cannot truly reproduce all colors, it is often of interest to compare the accuracy of different systems. In practical photographic systems, the ability of a color material to simulate object colors reasonably well is an important test. However, the original subject is typically not available for comparison to the reproduction. As a result, the viewer compares the reproduction colors to those in his memory. Although most color photographs are evaluated in this fashion, it does not provide a reliable method for comparing the accuracy of the color reproduction of many subjects. Further, when testing a color photographic material for accuracy, the material's ability to reproduce neutrals is not a good indication of its performance with varying hues and saturations. In fact, a color photographic material can give a good visual neutral and simultaneously reproduce object colors ouch an altimeters. Collinger and Ammerica while very new maniferer in the poly of a the use of a sensitometer or a reflection gray scale provides a very limited test of the material.

In assessing the accuracy of color reproduction, real-life colors involving different hues and saturations must be photographed. Highly saturated test objects are not suitable for this purpose, since even inferior color processes will reproduce such colors fairly well. A much more sensitive test involves colors that are light and relatively desaturated. Generally, only excellent color processes will reproduce these colors with good fidelity. Thus, when designing a color test chart, attention must be given to all three attributes of color: hue, saturation, and lightness. The colors in such a test object should represent the real world.

However, there are many problems in working with real subjects such as live models, plants, and food. For example, their colors change with respect to time and environmental conditions and, consequently, are not stable. It is nearly impossible to make objective measurements, such as spectral reflectance, from real-life objects, which limits the information that may be obtained. An appropriate substitute is a set of selected Munsell color patches that are close visual matches to real object colors. The Macbeth ColorChecker Color Rendition Chart, which is manufactured by the Macbeth Division of the Kollmorgan Corporation, is such a color test chart and is shown in Figure 16–36.

This test object has a 4×6 -inch array of patches, each of which is 50 mm (2 inches) square. The patches are made of a mat paint applied to a smooth paper, which is glued to a rigid support. The chart includes spectral simulations of light and dark human skin, foliage, blue sky, and the blue chicory flower. The additive and subtractive primary colors and a six-step neutral scale are also included, plus several other colors, producing a wide gamut. Each patch in this test object is specified by its spectral reflectance; CIE (1931) x, y, and Y; Munsell hue, value and chroma; an Inter-Society Color Council-National Bureau of Standards (ISCC-NBS) standard name; and an assigned name. These specifications are summarized in Table 16–6.

This color rendition chart can be used as the basis for a direct evaluation of color reproduction processes in a variety of ways. Subjective evaluations can be performed simply by comparing the reproduction to

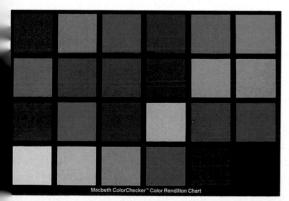

			CIE (1931) ^a		Mut	nsell Notation	
No.	Name	x	у	Y	Hue	Value/Chroma	ISCC/NBS Name
1	Dark skin	.4002	.3504	10.05	3.05YR	3.69/3.20	Moderate brown
2	Light skin	.3773	.3446	35.82	2.2YR	6.47/4.10	Light reddish brown
3	Blue sky	.2470	.2514	19.33	4.3PB	4.95/5.55	Moderate blue
4	Foliage	.3372	.4220	13.29	6.65GY	4.19/4.15	Moderate olive green
5	Blue flower	.2651	.2400	24.27	9.65PB	5.47/6.70	Light violet
6	Bluish green	.2608	.3430	43.06	2.5BG	7/6	Light bluish green
7	Orange	.5060	.4070	30.05	5YR	6/11	Strong orange
8	Purplish blue	.2110	.1750	12.00	7.5PB	4/10.7	Strong purplish blue
9	Moderate red	.4533	.3058	19.77	2.5R	5/10	Moderate red
10	Purple	.2845	.2020	6.56	5P	3/7	Deep purple
11	Yellow green	.3800	.4887	44.29	5GY	7.08/9.1	Strong yellow green
12	Orange yellow	.4729	.4375	43.06	10YR	7/10.5	Strong orange yellow
13	Blue	.1866	.1285	6.11	7.5PB	2.90/12.75	Vivid purplish blue
14	Green	.3046	.4782	23.39	0.1G	5.38/9.65	Strong yellowish green
15	Red	.5385	.3129	12.00	5R	4/12	Strong red
16	Yellow	.4480	.4703	59.10	5Y	8/11.1	Vivid yellow
17	Magenta	.3635	.2325	19.77	2.5RP	5/12	Strong reddish purple
18	Cyan	. 1958	.2519	19.77	5B	5/8	Strong greenish blue
19	White	.3101	.3163	90.01	N	9.5/	White
20	Neutral 8	.3101	.3163	59.10	N	8/	Light gray
21	Neutral 6.5	.3101	.3163	36.20	N	6.5/	Light-medium gray
22	Neutral 5	.3101	.3163	19.77	N	5/	Medium gray
23	Neutral 3.5	.3101	.3163	9.00	N	3.5/	Dark gray
24	Black	.3101	.3163	3.13	N	2/	Black

Table 16-6 Names and specifications of color patches in the Macheth Color CheckerColor Rendition Chart.

"The values listed under Y are % luminous reflectance factors. The chromaticity coordinates are based on CIE Illuminant C.

the original chart or by comparing the reproductions of various systems. In this fashion, the fidelity of the reproduced colors can be judged. Color reflection prints can be visually compared to each other or to the chart, under proper viewing conditions. Color transparencies can be compared to each other by projection in a darkened room simultaneously (side by side) or successively. Color transparencies can also be viewed on an illuminator under appropriate conditions.

The viewing conditions for comparing color transparencies to one another and to color reflection materials have been standardized by the American National Standards Institute and the International Organization for Standardization. Although these standards were intended for use in the printing industry, where ink-on-paper reproductions are compared to reflection original art work or to original transparencies, there is no reason why these standards wouldn't be appropriate for comparing a transparency produced by some photographic process with a reflection chart as the original. Both of these standards call for an illumination source with a correlated temperature of 5000 K.

A more objective method for evaluating the color reproduction properties of a photographic system using this chart requires that measurements be taken of both the reproduction and the original. For example, the spectral photometric curves of the patches in the reproduction could be compared to those in the original test object. An alternative (and more simple) approach is to compare the red, green and blue densities of the reproduced patches to those of the original However, in both cases the resulting information does not provide direct insight into the visual quality of the color reproduction. The Munsell Color Specification System can help bridge the gap between subjective and objective evaluation methods. The color rendition chart is photographed and reproduced in a color reflection print. The reproduced colors are then specified in terms of their hue, value, and chroma as determined by comparison with the color chips in the *Munsell Book of Color*. For each patch, the reproduced hue, value, and chroma can be compared to the original hue, value, and chroma, and differences can be noted. Further, errors in color reproduction can be classified as hue errors, value errors, or chroma errors.

To illustrate this technique, the Macbeth ColorChecker Color Rendition Chart was photographed with a color negative film and printed with filtration that produced an excellent visual neutral. The hue, value, and chroma of the reproduced colors were determined by matching them with patches in the *Munsell Book of Color*, and are listed in Table 16–7. Although each patch is described by three variables, the data can be presented graphically in a two-dimensional plot as illustrated in Figure 16–37. The hues of the Munsell system are represented along the horizontal axis, and the value scale is on the vertical axis. The third dimension of chroma is written on the graph at the point where each color plots. The plotted points in Figure 16–37 are taken from the original color chart.

By plotting the reproduced hue, value, and chroma data on the same graph, the amount of color reproduction error can be determined, as shown in Figure 16–38. Straight lines connect the original point to the reproduced point, and the arrow indicates the direction of the color error. For example, the color labeled magenta on the left side of the plot reproduced as the same hue since the original and the reproduction points are on the same vertical line. The arrow pointing upward indicates that the reproduced color is higher in value (lighter) than the original. The chroma of the original color was 12 and the chroma of the reproduced color is 11, indicating a slight decrease in chroma (saturation). In the case of the color labeled foliage, the hue of the reproduction shifted toward yellow, indicating a hue error. Since the arrow follows the horizontal line, there was no change in the value

No.	Name	Hue	Value/Chroma
1	Dark skin	5.0YR	3.5/6.0
2	Light skin	10.0 R	7.0/4.0
3	Blue sky	2.5PB	5.0/6.0
4	Foliage	10.0Y	4.0/4.0
5	Blue flower	2.5P	6.3/5.0
6	Bluish green	5.0B	6.5/4.0
7	Orange	7.5YR	6.0/11.0
8	Purplish blue	6.0PB	4.0/8.0
9	Moderate red	2.5R	5.0/8.0
10	Purple	5.0P	3.5/8.0
11	Yellow green	5.0Y	6.5/8.0
12	Orange yellow	10.0YR	6.5/10.0
13	Blue	6.5PB	3.0/11.0
14	Green	1.0G	4.5/6.0
15	Red	7.5R	4.0/12.0
16	Yellow	1.5Y	7.0/10.0
17	Magenta	2.5RP	6.0/11.0
18	Cyan	9.0B	4.0/8.0

Table 16–7 Munsell hue, value, and chroma of the color patches (achromatic colors excluded) on the Macbeth ColorChecker Color Rendition Chart as reproduced in a reflection color print.

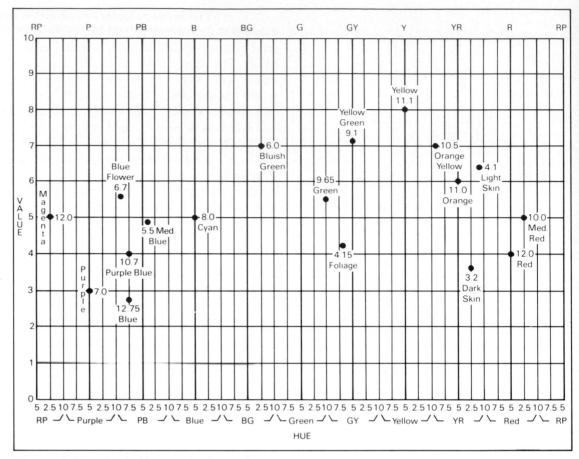

Figure 16–37 Graph of hue vs. value showing the location of color patches from the Macbeth ColorChecker Color Rendition Chart. The chroma of each patch is listed adjacent to its plotted point.

of the color. The chroma of the reproduced color was identical to that of the original.

In this fashion, all of the color patches can be evaluated and the color reproduction errors classified as hue, value, or chroma differences. For this color reproduction system it appears that the red and yellow-red hues reproduced with little error, while the green hues (bluegreen and green-yellow) showed considerable error. It is conceivable that for some color reproduction systems, acceptable limits in hue, value, and chroma errors could be identified for each test object color and applied to such a graph.

Although the patches in the Munsell ColorChecker Color Rendition Chart are close visual matches to real-life colors, they are not spectral matches. Thus it is erroneous to assume that all real objects the same color as a given patch on the chart will be rendered the same color by a color photographic process. This problem plagues all color test charts since the test chart colors are simulations of real-life counterparts. This problem, termed *metamerism*, occurs whenever two colors visually match but have different spectral reflectance characteristics. Since the color response properties of a color film are significantly different from those of the eye, there is no guarantee that two such colors will photograph identically.

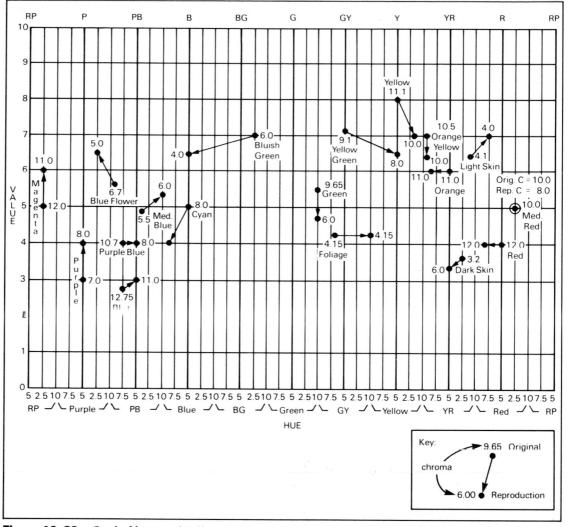

Figure 16–38 Graph of hue vs. value illustrating the shift in hue, value, and chroma of the color patches in the Macbeth ColorChecker Color Rendition Chart when reproduced as a reflection color print.

When selecting test colors, it is necessary to perform photographic tests to determine the amount of photographic metamerism. Such tests are necessarily restricted to the specific spectral responses of the films. They have been performed with the Munsell ColorChecker Color Rendition Chart, and they indicate that the degree of photographic metamerism is small for those colors. Nevertheless, final judgments should always be based on the use of color photographic systems with real subjects.

16.19 False-Color Systems

In conventional color photographic systems employing integral tripack films, the sensitization of each layer is complementary to the color of dye that will be produced (for example, the blue-sensitive layer yields yellow dye, the green-sensitive layer produces magenta dye,

16.19 False-Color Systems

Figure 16–39 Spectral sensitivity of an infrared reversal color film.

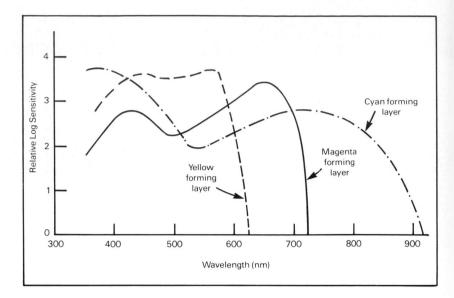

and the red-sensitive layer produces cyan dye). The result is a color positive (either transmission or reflection) in which the reproduced colors adequately simulate the real colors of the subject. In some color photographic systems the sensitization of each layer is not complementary to the dye formed. For example, infrared color films have emulsions sensitized in the green, red, and infrared regions of the spectrum. In processing, the green-sensitive layer yields yellow dye, the red-sensitive layer gives magenta dye, and the infrared-sensitive layer produces cyan dye. The colors in the reproduction will bear no resemblance to the colors of the original subject; such a system is referred to as a false-color photographic system.

The spectral sensitivity of an infrared color reversal film is illustrated in Figure 16–39, which indicates that the sensitivity of the infrared layer extends to approximately 900 nm. With this film, infrared radiation reproduces as red, since yellow dye was formed in the green-sensitive layer, magenta dye was formed in the red-sensitive layer, and no cyan dye was formed in the infrared-sensitive layer (this being a reversal color process). Red in the original subject reproduces as green in this false-color system due to the formation of cyan and yellow dye and a lack of magenta dye in the image. Green in the original subject appears as blue in the image, a result of cyan and magenta dye formation and of the absence of yellow dye. The color blue in the original subject is not recorded, since the saturated yellow filter is used over the camera lens, and is therefore rendered black in the reproduction.

Figure 16–40 contains two photographs of the same subject, one made with conventional color film and the other made with an infrared color film. The reproduction of colors in a false-color system is often difficult to predict since they depend to a great extent upon the infrared-reflecting properties of the objects being photographed.

An alternative approach to producing false-color photographs is the dye-transfer process of color printing. If, for example, the greer record negative were made to produce a cyan printer, and the red recorc negative were used to produce a magenta printer, the resulting colors would no longer bear a simple relationship to the original subject colors Although the colors produced in this fashion appear unnatural, such an approach can be used to produce creative color photographs.

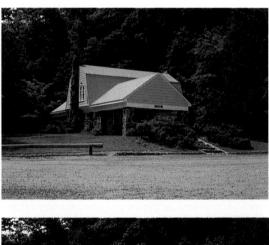

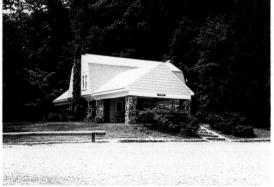

Figure 16–40 Comparison of conventional and infrared (false-color) color photographs of an outdoor scene.

References

American National Standards Institute, Color Contribution of Photographic Lenses, Determining and Specifying (PH3.606-1981).

- ------, Color Negative Films for Still Photography, Determination of ISO (ASA) Speed (PH2.27-1981).
- ——, Color Reversal Camera Films, Determination of ISO Speed (ISO 2240-1982, PH2.21-1983).
- ——, Direct Positive Color Print Materials, Determination of ISO Speed (PH2.45-1979).
- ------, Direct Viewing of Photographic Color Transparencies (PH2.31-1969, R1976).
- ———, Illuminants for Photographic Sensitometry: Simulated Daylight and Incandescent Tungsten (PH2.29-1982).
- —, Photographic Color Prints, Viewing Conditions (PH2.41-1976).
- ——, Photographic Lenses, Method of Testing Spectral Transmittance (PH3.614-1983).
- ——, Small Transparencies with Reproductions, Projection Viewing Conditions for Comparing (PH2.45-1979).
 - ——, Spectral Distribution Index of Camera Flash Sources, Method for Determining and Specifying (PH2.28-19/9).
- Billmeyer and Saltzman, Principles of Color Technology.
- Clerc, Photographic Theory and Practice.

Clulow, Color: Its Principles and Their Applications.

Eastman Kodak Company, Applied Infrared Photography (M-28).

——, Color Printing Techniques (Workshop Series).

——, Identifying E-6 Processing Errors (E-65).

- ———, Introduction to Color Printer Control for Photo-finishers Using Noncomputerized Printers (Z-500).
- —, Introduction to Color Process Monitoring (Z-99).
- ——, Kodak Color Dataguide (R-19).

------, Kodak Color Films (E-77).

—, Kodak Dye Transfer Process (E-80).

- , Kodak Films—Color and Black-and-White (AF-1).
- ——, Kodak Infrared Films (N-17).
- , Laboratory Color Films for Process C-41 (E-24).

——, Medical Infrared Photography (N-1).

——, Printing Color Negatives (E-66).

——, Printing Color Slides and Larger Transparencies (E-96).

- —, Reciprocity Data; Kodak Color Films (E-1).
- ——, Techniques for Making Professional Prints on Kodak Ektachrome Papers (E-87).
- ——, Using Kodak Ektaprint R-100 Chemicals (Z-123).
- ——, Using Kodak Ektaprint 2 Chemicals (Z-122).

——, Using Process C-41 (Z-121).

------, Using Process E-6 (Z-119U).

Engdahl, Color Printing Materials.

Evans, Eye, Film and Camera in Color Photography.

—, An Introduction to Color.

—, The Perception of Color.

Evans, Hanson, and Brewer, Principles of Color Photography.

Eynard, Color: Theory and Imaging Systems.

Hunt, The Reproduction of Colour in Photography, Printing and Television.

Jacobson et al., The Manual of Photography.

James, The Theory of the Photographic Process.

Judd and Wyszecki, Color in Business, Science and Industry.

References

Langford, Advanced Photography. Nadler, Color Printing Manual. Todd and Zakia, Photographic Sensitometry. Wright, The Measurement of Colour. Yule, Principles of Color Reproduction. Zakia and Todd, Color Primer I and II.

Bibliography

Books

Adams, A. The Camera. Boston: New York Graphic Society, 1980.

------. The Negative. Boston: New York Graphic Society, 1981.

- Albers, J. Interaction of Color. New Haven, CT: Yale University Press, 1972.
- Amphoto (Ed.). The Encyclopedia of Practical Photography. Garden City, NY: Amphoto, 1977.
- Arens, H. Color Measurement. London: Focal Press, 1968.
- Arnold, C., Rolls, P., and Stewart, J. Applied Photography. London: Focal Press, 1971.
- Backhouse, D., Marsh, C., Tait, J., and Wakefield, G. Illustrated Dictionary of Photography. Dobbs Ferry, NY: Morgan & Morgan, 1972.
- Baines, H., Bomback, E. (Eds.). The Science of Photography. 3rd ed. New York: Wiley, 1970.
- Berg, W. Exposure: Theory and Practice. 5th ed. London: Focal Press, 1979.
- Besterfield, D. Quality Control: A Practical Athroach Englewood Cliffs, MJ. Humile-Hall, 1979.
- Billmeyer, F., and Saltzman, M. Principles of Color Technology. 2nd ed. New York: John Wiley & Sons, 1981.
- Birren, F. Principles of Color. New York: Van Nostrand Reinhold, 1969.
- (Ed.). Ostwald: The Color Primer. New York: Van Nostrand Reinhold, 1969.
- Blaker, A. Field Photography. San Francisco: Freeman, 1976.
- -------. Photography, Art and Technique. San Francisco: Focal Press, 1980.
- Bloomer, C. Principles of Visual Perception. New York: Van Nostrand Reinhold, 1976.
- Born, M., and Wolf, E. Principles of Optics. Oxford: Pergamon, 1970.
- Bower, T. The Perceptual World of a Child. Cambridge, MA: Harvard University Press, 1977.
 - Brown, E. Modern Optics. New York: Reinhold, 1965.
 - Burden, J. Graphic Reproduction Photography. Garden City, NY: Amphoto, 1973.
 - Burnham, R., Hanes, R., and Bartleson, C. Color: A Guide to Basic Facts and Concepts. New York: John Wiley & Sons, 1963.
- Burr, I. Statistical Quality Control Methods. New York: Barcel Dekker, 1976.
- Carlson, V. and Carlson, S. Professional Lighting Handbook. Stoneham, MA: Focal Press, 1985.
- Carroll, B., Higgins, G., and James, T. Introduction to Photographic Theory. New York: John Wiley & Sons, 1980.
- Carroll, J. Photographic Facts and Formulas. Garden City, NY: Amphoto, 1975.
- -------. Photographic Lab Handbook. Garden City, N.Y.: Amphoto, 1979.
- Carterette, E. and Friedman, M. Handbook of Perception: Perceptual Processing. New York: Academic Press, 1978.
- Clark, F. Special Effects in Motion Pictures. New York: Society of Motion Picture and Television Engineers, 1966.

^{———.} The Print. Boston: Little, Brown & Co., 1983.

Books

- Clerc, L. Photographic Theory and Practice. 2 vols. London: Focal Press, 1971.
- Clulow, F. Color: Its Principles and Their Applications. Dobbs Ferry, NY: Morgan & Morgan, 1972.
- Conover, W. Practical Non-Parametric Statistics. New York: John Wiley & Sons, 1971.
- Consulting Psychologist Press. Embedded Figure Test Manual. Palo Alto, CA: Consulting Psychologist Press 1971.
- Cornsweet, T. Visual Perception. New York: Academic Press, 1970.

Cox, A. Photographic Optics. 15th ed. London: Focal Press 1974.

- Craven, G. Object and Image. Englewood Cliffs, NJ: Prentice-Hall, 1975.
- Crawford, W. The Masters of the Light. Dobbs Ferry, NY: Morgan & Morgan, 1979.
- Daguerre, L. An Historical and Descriptive Account of the Various Processes of the Daguerreotype and the Diorama. London, 1839. Reprint, Introduction by Beaumont Newhall. New York: Winter House, 1971.
- Dainty, J. and Shaw, R. Image Science. New York: Academic Press, 1974.
- Davidoff, J. Differences in Visual Perception. New York: Academic Press, 1975.
- Davis, P. Beyond the Zone System. New York: Van Nostrand Reinhold, 1981.

------. Photography. Dubuque, IA: William C. Brown, 1982.

Dixon, N. Subliminal Perception: The Nature of a Controversy. New York: McGraw-Hill, 1971.

- Dowdell, J., and Zakia, R. Zone Systemizer. Dobbs Ferry, NY: Morgan & Morgan, 1984.
- Duncan, A. Quality Control and Industrial Statistics. 3rd ed. Homewood, IL: Richard D. Irwin, 1965.
- Dunn, J. and Wakefield, G. Exposure Manual. 3rd ed. London: Fountain Press, 1974.
- Eaton, G. Photographic Chemistry. 3rd ed. Dobbs Ferry, NY: Morgan & Morgan, 1980.
- Eggleston, J. Sensitometry for Photographers. Stoneham, MA: Focal Press, 1984.
- Engdahl, D. Color Printing Materials. Garden City, NY: Amphoto, 1977.
- Engel, E. Photography for the Scientist. New York: Academic Press, 1968.
- Evans, R. Eye, Film and Camera in Color Photography. New York: John Wiley & Sons, 1959.
- ------. An Introduction to Color. New York: John Wiley & Sons, 1948 (Out of print).
 - . The Perception of Color. New York: John Wiley & Sons, 1974
- Evans, R., Hanson, W., and Brewer, W. Principles of Color Photography New York: John Wiley & Sons, 1953.
- Eynard, R. (Ed.). Color: Theory and Imaging Systems. Washington, DC Society of Photographic Scientists and Engineers, 1973.
- Feigenbaum, A. Total Quality Control, 3rd Ed. New York: McGraw Hill, 1983.
- Festinger, L. Conflict, Decision and Dissonance. Palo Alto, CA: Stanfor-University Press, 1964.
- Fielding, R. The Technique of Special-Effects Cinematography. New York Hastings House, 1968.

Focal Press. Focal Encyclopedia of Photography. New York: McGraw-Hill, 1969.

Forgus, R. Perception. New York: McGraw-Hill, 1966.

- Freund, J. Statistics: A First Course. Englewood Cliffs, NJ: Prentice-Hall, 1970.
- Friedman, J.F. History of Color Photography. Boston: American Photographic Publishing Co., 1944.
- Frisby, J. Seeing. New York: Oxford University Press, 1979.
- Fritsche, K. Faults in Photography, Causes and Corrections. New York: Focal Press, 1974.
- Frostig, M., Maslow, P., Lefever, D., and Whittlesley, J. The Marianne Frostig Developmental Test of Visual Perception. Palo Alto, CA: Consulting Psychologists Press, 1964.
- Gassan, A. Handbook for Contemporary Photography. 4th ed. Rochester, NY: Light Impressions, 1977.
- Gernsheim, H. and Gernsheim, A. A Concise History of Photography. New York: Grosset & Dunlap, 1965.
- Gibson, J. The Senses Considered as Perceptual Systems. Boston: Hougton Mifflin, 1966,
- Uculbrich, E. Art and Illusion. Princeton: Princeton University Press, 1969.
- Graham, C. (Ed.). Vision and Visual Perception. New York: Wiley, 1965.
- Grant, E. and Leavenworth, R. Statistical Quality Control. 5th ed. New York: McGraw-Hill, 1980.
- Gray, R. (Ed.). Applied Processing: Practices and Techniques. Washington: Society of Photographic Scientists and Engineers, 1969.
- Gregory, R. Eye and Brain: The Psychology of Seeing. New York: McGraw-Hill, 1966.
- Gregory, R., and Gombrich, E. (Eds.). Illusion in Nature and Art. New York: Scribner's, 1973.
- Grum, F., and Bartleson, C. Optical Radiation Measurements. New York: Academic Press, 1980.
- Haber, R. Contemporary Theory and Research in Visual Perception. New York: Rinehart & Winston, 1968.
- Haber, R., and Hershenson, M. The Psychology of Visual Perception. 2nd ed. New York: Holt, Rinehart & Winston, 1980.
- Haist, G. Modern Photographic Processing. 2 vols. New York: Wiley, 1979.
- ------. Monobath Manual. Dobbs Ferry, NY: Morgan & Morgan, 1966.
- Hardy, A. Handbook of Colorimetry. Cambridge, MA: MIT Press, 1936.
- Hebb, D. Textbook of Psychology. Philadelphia: Saunders, 1972.
- Hecht, E., and Zajac, A. Optics. Menlo Park, CA: Addison-Wesley, 1979.
- Hedgecoe, J. The Book of Photography. New York: Knopf, 1976.
- Held, R. (Ed.). Image, Object and Illusion. San Francisco: Freeman, 1974.
- Henney, K. and Dudley, B. (Eds.). Handbook of Photography. NY: McGraw-Hill, 1939 (out of print).
- Henry, R. Controls in Black-and-White Photography. Monterey, CA: Angel Press, 1985.
- Hochberg, J. Perception. Englewood Cliffs, NJ: Prentice-Hall, 1978.
- Hunt, R. The Reproduction of Colour in Photography, Printing and Television. 3rd ed. New York: John Wiley & Sons, 1975.

Hurvich, L. Color Vision. Sunderland, MA: Sinauer Associates, 1981 Ilford, Ilfobrom Galerle. Paramus, NJ: Ilford, Inc., 1979.

Books

Ilford, Cibachrome A-II Manual. Paramus, NJ: Ilford, Inc., 1981.

- Jacobson, K., and Jacobson, R. Developing: The Technique of the Negative. 18th ed. London: Focal Press, 1972.
- Jacobson, K., and Manneheim, L. Enlarging: The Technique of the Positive. 22nd ed. London: Focal Press, 1972.
- Jacobson, R., et al. The Manual of Photography. 7th ed. London: Focal Press, 1978.
- James, T. The Theory of the Photographic Process. 4th ed. New York: Macmillan, 1977.
- Judd, D., and Wyszecki, G. Color in Business, Science and Industry. New York: John Wiley & Sons, 1963.
- Juran, J. Quality Control Handbook. 3rd ed. New York: John Wiley & Sons, 1975.
- Juran, J. and Gryna, F. Quality Planning and Analysis. New York: John Wiley & Sons, 1970.
- Kaufman, L. Sight and Mind: An Introduction to Visual Perception. New York: Oxford University Press, 1974.
- Keefe, L., and Inch, D. The Life of a Photograph. Stoneham, MA: Focal Press, 1984.
- Kelly, K. and Judd, D. Color: Universal Language and Dictionary of Names. (NBS Special Publication 440.) Washington, DC: U.S. Government Printing Office, 1976.
- Klein, M. Optics. New York: John Wiley, 1970.
- Kling, J. and Riggs, L. (Eds.). Woodworth and Schlossberg's Experimental Psychology. New York: Holt, Rinehart & Winston, 1971.
- Knowler, L., et al. Quality Control by Statistical Methods. New York: McGraw-Hill, 1969.
- Koffka, K. Principles of Gestalt Psychology. New York: Harcourt, Brace & World, 1963.
- Kohler, W. The Task of Gestalt Psychology. Princeton, NJ: Princeton University Press, 1969.
- Kowaliski, P. Applied Photographic Theory. New York: John Wiley & Sons, 1973.
- Kreitler, H., and Kreitler, S. Psychology and the Arts. Durham, NC: Duke University Press, 1972.

Langford, M. Advanced Photography. 4th ed. London: Focal Press, 1980. ———. Basic Photography. 3rd ed. London: Focal Press, 1977.

- ------. Professional Photography. London: Focal Press, 1974.
- Lanners, E. (Ed.). Illusions. New York: Holt, Rinehart & Winston, 1977.
- Levi, L. Applied Optics. New York: Wiley, 1968.
- Lindsay, P., and Norman, D. Human Information Processing. New York: Academic Press, 1972.
- Lobel, L., and Dubois, M. Basic Sensitometry. 2nd ed. London: Focal Press, 1967.
- Luckiesh, M. Visual Illusions. New York: Dover, 1965.
- MacAdam, D. Color Measurement. New York: Springer-Verlag, 1981.
- Manning, S. and Rosenstock, E. Classical Psychophysics and Scaling. New York: McGraw-Hill, 1968.
- Mason, L. Photographic Processing Chemistry. 2nd ed. London: Focal Press, 1975.
- McKim, R. Experiences in Visual Thinking. Monterey, CA: Brooks/Cole, 1972.

Mees, C. From Dry Plates to Ektachrome. New York: Ziff-Davis, 1961.

Meyer-Arendt, J. Introduction to Classical and Modern Optics. Englewood Cliffs, NJ: Prentice-Hall, 1972.

Books

Morgan, D., Vestal, D., and Broecker, W. (Eds.). Leica Manual. 15th ed. Dobbs Ferry, NY: Morgan & Morgan, 1973.

Motokawa, K. Physiology of Color and Pattern Vision. New York: Springer-Verlag, 1970.

Munsell, A. A Color Notation. Baltimore: Munsell Color Co., 1967.

Nadler, R. Color Printing Manual. Garden City, NY: Amphoto, 1977.

Neblette, C. Fundamentals of Photography. New York: Van Nostrand, 1970.

Neblette, C. and Murray, A. Photographic Lenses. Dobbs Ferry, NY: Morgan & Morgan, 1973.

- Neisser, U. Cognitive Psychology. New York: Appleton-Century-Crofts, 1967.
- Newhall, B. The History of Photography. New York: Museum of Modern Art, 1984.
- Noemer, F. Handbook of Modern Halftone Photography. 7th ed. Garden City, NY: Amphoto, 1977.
- Ott, E. Process Quality Control New York: McCrew Hill 1971

Palmer, C. Ophies, Experiments and Demonstrations. Baltimore. Johns Hopkins University Press, 1962.

- Penrose, R. Man Ray. Boston: NY Graphic Society, 1975.
- Picker, F. Zone VI Workshop. Garden City, NY: Amphoto, 1974.
- Pittaro, E., (Ed.) The Compact Photo Lab Index, I & II. Dobbs Ferry, NY: Morgan & Morgan, 1977, 1979.
- Rainwater, C. Light and Color. Racine, WI: Golden, 1971 (Out of print).
- Ratliff, F. Mach Bands. San Francisco: Holden Day, 1965.
- Ray, S. The Photographic Lens. Stoneham, MA: Focal Press, 1979.
- Ray, S. The Lens and All Its Jobs. Stoneham, MA: Focal Press, 1977.
- Ray, S. Lens in Action. London: Focal Press, 1976.
- Reynolds, C. Lenses. London: Focal Press, 1984.
- Richardson, A. Mental Imagery. New York: Springer, 1969.
 - Rickmers, A., and Todd, H. Statistics, An Introduction. New York: McGraw-Hill, 1967.
 - Riley, J. The Albumen and Salted Paper Book: The History and Practice of Photographic Printing 1840–1895. Rochester, NY: Light Impressions, 1980.
- Rock, I. An Introduction to Perception. New York: Macmillan, 1975.
- Rood, O. Modern Chromatics. 1879. Reprint. New York: Van Nostrand Reinhold, 1973.
- Rosenblum, N. A World History of Photography. New York: Abbeville Press, 1984.
- Ross, R. Television Film Engineering. New York: John Wiley & Sons, 1966.

Russell, G. Chemical Analysis in Photography. London: Focal Press, 1965.

- Ryan, R. A History of Motion Picture Color Technology. London: Focal Press, 1978.
- Ryan, R. (Ed.). Principles of Color Sensitometry. 3rd ed. Scarsdale, NY: Society of Motion Picture and Television Engineers, 1974.
- Sanders, N. Photographic Tone Control. Dobbs Ferry, NY: Morgan & Morgan, 1977.

Schaffert, R. Electrophotography. New York: John Wiley & Sons, 1975.

Sheppard, J. Human Color Perception, New York: American Elsevier, 1968.

Murch, G. Visual and Auditory Perception. Indianapolis: Bobbs-Merrill, 1973.

Books

- Steiner, R. Ralph Steiner, A Point of View. Middletown, CT: Wesleyan University Press, 1978.
- Sternback, H. Halftone Reproduction Guide. Garden City, NY: Amphoto, 1975.
- Stimson, A. Photometry and Radiometry for Engineers. New York: John Wiley & Sons, 1974.
- Stroebel, L. Photographic Filters. Dobbs Ferry, NY: Morgan & Morgan, 1974.

. View Camera Technique. 4th ed. New York: Focal Press, 1980.

- Stroebel, L., and Todd, H. Dictionary of Contemporary Photography. Dobbs Ferry, NY: Morgan & Morgan, 1974.
- Stroebel, L., Todd, H., and Zakia, R. Visual Concepts for Photographers. New York: Focal Press, 1980.
- Stroke, G. An Introduction to Coherent Optics and Holography. New York: Academic Press, 1969.
- Sturge, J. (Ed.). Neblette's Handbook of Photography and Reprography. 7th ed. New York: Van Nostrand Reinhold, 1977.
- Swedlund, C. Photography. New York: Holt, Rinehart & Winston, 1981.

Technical Education Center. Quality Control: Application and Use in the Graphic Arts Industry, Vol. II. Rochester, NY: Rochester Institute of Technology, 1982. Bibliography.

- Teevan, R., and Birney, R. (Eds.). Color Vision. Princeton, N.J.: Van Nostrand, 1961.
- Thomas, W. (Ed.). SPSE Handbook of Photographic Science and Engineering. New York: John Wiley & Sons, 1973.
- Todd, H. Sensitometry: A Self-Teaching Text. New York: John Wiley & Sons, 1970.
- Todd, H., and Zakia, R. Photographic Sensitometry. 2nd ed. Dobbs Ferry, NY: Morgan & Morgan, 1974.
- Towers, T. Electronics and the Photographer. London: Focal Press, 1976.
- Upton, B., and Upton, J. Photography. 3rd ed. Boston: Little, Brown & Co., 1985.
- Vernon, M. Perception Through Experience. London: Methuen, 1970.
- Vestal, D. The Craft of Photography. New York: Harper & Row, 1975.
- ------. The Art of Black-and-White Enlarging. New York: Harper & Row, 1984.
- Vieth, G. Sensitometric Testing Methods. London: Focal Press, 1974.
- Wade, K. Alternative Photographic Processes. Dobbs Ferry, NY: Morgan & Morgan, 1978.
- Wakefield, G. Practical Sensitometry. London: Fountain Press, 1970.
- Wall, E.J., and Jordan, F.I. Photographic Facts and Formulas. Boston: American Photographic Publishing Co., 1947.
- Walls, H., and Attridge, G. Basic Photo Science. London: Focal Press, 1978.
- Walsh, J. Photometry. 3rd ed. New York: Dover, 1965.
- Wasserman, G. Color Vision. New York: Academic Press, 1978.
- Weber, E. Vision, Composition and Photography. New York: Walter de Gruyter, 1980.
- White, M., Zakia, R., and Lorenz, P. The New Zone System Manual. Dobbs Ferry, NY: Morgan & Morgan, 1984.

Spencer, D. Colour Photography in Practice. 2nd ed. London: Focal Press, 1975.

^{------.} The Focal Dictionary of Photographic Technologies. London: Focal Press, 1973.

ANSI Publications

- Wright, W.D. The Measurement of Colour. 4th ed. New York: Van Nostrand Reinhold, 1969.
- Wyszecki, G., and Stiles, W. Color Science. New York: John Wiley & Sons, 1982.
- Young, H. Fundamentals of Optics and Modern Physics. New York: McGraw-Hill, 1968.
- Yule, J. Principles of Color Reproduction. New York: John Wiley & Sons, 1976.
- Zakia, R. Perception and Photography. Rochester, NY: Light Impressions, 1979.
- -------. Perceptual Quotes for Photographers. Rochester, N.Y.: Light Impressions, 1980.
- Zakia, R., and Todd, H. Color Primer I and II. Dobbs Ferry, NY: Morgan & Morgan, 1976.
- -----. 101 Experiments in Photography. Dobbs Ferry, NY: Morgan & Morgan, 1974.
- Zettle, H. Sight-Sound-Motion. Belmont, CA: Wadsworth, 1973.
- Zusne, L. Visual Perception of Form. New York: Academic Press, 1970.

Zworykin, V.K., and Ramberg, E.G. Photoelectricity and Its Application. New York, Juliu Wiley & Owny 1949

ANSI Publications

A complete list of ANSI publications, including those listed below, is published annually in the ANSI Catalog. The Catalog and the Standards can be obtained from American National Standards Institute, 1430 Broadway, New York, NY 10018.

Photographic Lenses

- Apertures and Related Quantities Pertaining to Photographic Objectives and Projection Lenses, Methods for Designating and Measuring (ANSI PH3.29-1979).
- Color Contribution of Photographic Lenses, Determining and Specifying (ANSI PH3.607-1981).
- Distribution of Illuminance Over the Field of a Photographic Objective, Method of Determining (ANSI PH3.22-1979).
- Focal Length Marking of Lenses (ANSI PH3.601-1981).
- Focal Lengths and Focal Distances of Photographic Lenses, Methods of Designating and Measuring (ANSI PH3.35-1977).

Focusing Camera Lenses, Distance Scales (ANSI PH3.20-1975).

Optical Elements and Assemblies, Definitions, Methods of Testing, and Specifications for Appearance Imperfections (ANSI PH3.617-1980).

- Optical Transfer Function Measurement and Reporting, Guide to (ANSI PH3.57-1978).
- Photographic Lenses, Method of Testing Spectral Transmittance (ANSI PH3.614-1983).
- Photographic Resolving Power of Photographic Lenses, Method for Determining (ANSI PH3.63-1974).
- Resolution Test Target for Photographic Optics, Dimensions (ANSI PH3.609-1980).
- Resolving Power of Lenses for Projectors for 35 mm Filmstrips and Slides in 2×2 Mounts, Method for Determining (ANSI PH3. 16-1972).

Photographic Equipment

Calculation and Preparation of Projected-Image Size and Projection Distance Tables for Audiovisual Projectors, Method for (ANSI PH7.6-1975). Contact Printers (ANSI PH3.8-1977).

Exposure Guide Numbers (ANSI PH3.405-1984).

Exposure-Time Markings for Still-Picture Cameras (ANSI PH3.32-1972).

Flashlamp/Reflector Combinations, Method for Measurement of Light Output (ANSI PH3.407-1980).

General-Purpose Photographic Exposure Meters (Photoelectric Type) (ANSI PH3.49-1971).

Image Distortion, Methods for Testing (ANSI PH3.613-1983).

- Internal Synchronization of Front Shutters, Classifying and Testing (ANSI PH3.18-1957 R 1970).
- Overhead Projectors with 10 × 10 inch (254 × 254 mm) Stage-Test Transparency (ANSI PH-7.504-1982).
- Photographic Contact Printers, Contact Uniformity Test (ANSI PH3.45-1971, R1976).

Photographic Electronic Flash Equipment (ANSI PH3.40-1977).

Photographic Enlargers, Methods for Testing (ANSI PH3.31-1974).

- Photographic Still-Front-Projection Equipment, Illumination Tests (ANSI PH3.705-1980).
- Screen Illumination of Front Projection Audiovisual Equipment, Method for Measuring (ANSI PH7.201-1983).
- Shutter Tests for Still-Picture Cameras (ANSI PH3.48-1972).
- Slide and Filmstrip Projection, Practice (ANSI PH3.41-1972).
- 35 mm Single-Frame Front and Rear Projection Equipment, Test Filmstrip (ANSI PH7.503-1983).

Photographic Film and Paper

Ammonia Processed Diazo Photographic Film, Stability (ANSI PH1.60-1979).

Curl of Photographic Film, Methods for Determining (ANSI PH1.29-1971).

- Comparing the Color Stabilities of Photographs, Method (ANSI PH1.42-1969 R1975).
- Dimensional Change Characteristics of Photographic Films and Papers, Method for Determining (ANSI PH1.32-1973).
- Photographic Film for Archival Records, Silver-Gelatin Type, on Cellulose Ester Base (ANSI PH1.28-1984).
- Photographic Film for Archival Records, Silver-Gelatin Type, on Polyester Base (ANSI PH1.41-1984).
- Photographic Roll Paper, Dimensions (ANSI PH1.11-1981).
- Photographic Sheet Paper for General Use, Dimensions (ANSI PH1.12-1981).
- Processed Films, Plates, and Papers, Filing Enclosures and Containers for Storage (ANSI/ASC PH1.53-1984).
- Scratch Resistance of Processed Photographic Film, Methods for Determining (ANSI PH1.37-1977).
- Storage of Processed Safety Film (ANSI PH1.43-1983).

Storage of Black-and-White Photographic Paper Prints, Practice for (ANS) PH1.48-1974).

Thickness of Photographic Paper, Designation (ANSI PH1.1-1974).

Photographic Sensitometry

- Actinity or the Relative Photographic Effectiveness of Illuminants, Method fo. Determining (ANSI PH2.3-1972).
- Annular 45:0 (or 0:45) Optical Reflection Measurements (Reflection Density (ANSI PH2.17-1977).

Effluents, Identification and Analytical Methods (ANSI PH4.37-1983).

Manual Processing of Black-and-White Photographic Films, Plates, and Papers, Method for (ANSI PH4.29-1975).

Methylene Blue Method for Measuring Thiosulfate and Silver Densitometric Method for Measuring Residual Chemicals in Films, Plates, and Papers (ANSI PH4.8-1978).

Mounting Photographs, Specifications for Thermally-Activated Dry Mounting Tissue (ANSI PH4.21-1979).

pH of Photographic Processing Solutions, and Specifications for pH Meters Used to Measure pH of Photographic Processing Solutions, Method for the Determination (ANSI PH4.36-1978).

Photographic Inertness of Construction Materials Used in Photographic Processing, Specification for Testing (ANSI PH4.31-1962, R1975).

Pictorial Black-and-White Films and Plates, Method for Evaluation of Developers with Respect to Graininess (ANSI PH4.14-1979).

Resistance of Photographic Films to Abrasion During Processing, Methods for Determining (ANSI PH4.35-1972).

Statistical Quality Control

Control Chart Method of Analyzing Data (ANSI Z1.2-1958, R1969). Control Chart Method of Controlling Quality During Production (ANSI

Z1.3-1958, R1969).

Guide for Quality Control (ANSI Z1.1-1958, R1969).

Sampling Procedures and Tables for Inspection by Attributes (ANSI Z1.4-1971, Military Standard 105).

Eastman Kodak Company Publications

A complete list of Kodak publications, including those listed below, is published annually in the *Index to KODAK Information*, Cod-L-5. The *Index* and the publications can be obtained from Eastmar Kodak Company, Department 454, 343 State St., Rochester, NY 14650. The Kodak Code Numbers follow the titles.

Amateur Photography

Astrophotography Basics (AC-48). Creative Darkroom Techniques (AG-18). Electronic Flash (KW-12). Exposure with Electronic Flash Units (AC-37). Filters and Lens Attachments for Black-and-White and Color Pictures (AB-1). Glossary of Photographic Terms (AA-9). KODAK Films—Color and Black-and-White (AF-1). KODAK Guide to 35 mm Photography (AC-95S). KODAK Pocket Photoguide (AR-21). KODAK Pocket Guide to 35 mm Photography (AR-22). Optical Formulas and Their Applications (AA-26). Photographing Television Images (AC-10).

Photographing with Your Automatic Camera (KW-11).

Filters

KODAK Filters for Scientific and Technical Uses (B-3). Using Filters (KW-13).

ANSI Publications

Automatic Exposure Control for Cameras (ANSI PH2.15-1964, R1976).

Camera Flash Sources, Determining and Specifying Spectral Distribution Index (ANSI PH2.28-1981).

- Color Negative Films for Still Photography, Determination of ISO (ASA) Speed (ANSI PH2.27-1981).
- Color Reversal Camera Films, Determination of ISO Speed (ANSI/ISO 2240-1982, ANSI PH2.21-1983).

Continuous-Tone Black-and-White Photographic Films, Method of Measuring the Photographic Modulation Transfer Function (ANSI PH2.39-1977).

Density Measurements, Spectral Conditions (ANSI/ASC PH2.18-1984).

Determination of ISO Resolving Power (ANSI/ISO 6329-1982, ANSI PH2.33-1983).

- Diffuse and Doubly-Diffuse Transmission Measurements (Transmission Density), Conditions for (ANSI PH2.19-1976).
- Direct Positive Color Print Materials, Determination of ISO Speed (ANSI PH2.45-1979).

Direct Viewing of Photographic Color Transparencies (ANSI PH2.31-1969, R1976).

Exposure Guide Numbers for Photographic Lamps, Method for Determining (ANSI PH2.4-1965, R1971).

Geometric Conditions for f/4.5 and f/1.6 Projection Transmission Density (ANSI PH2.20-1984).

Illuminants for Photographic Sensitometry: Simulated Daylight and Incan descent Tungsten (ANSI PH2.29-1982).

Photographic Color Prints, Viewing Conditions (ANSI PH2.41-1976).

Photographic Exposure Guide (ANSI PH2.7-1985).

Photographic Flash Lamps, Method for Testing (ANSI PH2.13-1965, R1971).

Photographic Modulation Transfer Function of Continuous-Tone, Black-and-White Photographic Films, Method of Measuring (ANSI PH2.39-1977).

- Photographic Printing Density (Carbon Step Tablet Method) (ANSI PH2.25-1965).
- Safety Times of Photographic Darkroom Illumination, Methods for Determining (ANSI PH2.22-1978).
- Sensitometry and Grading of Black-and-White Silver Halide Photographic Papers for Continuous Tone Reflection Prints (ANSI PH2.2-1981).
- Small Transparencies with Reproductions, Projection Viewing Conditions for Comparing (ANSI PH2.45-1979).
- Spectral Distribution Index of Camera Flash Sources, Method for Determining and Specifying (ANSI PH2.28-1981).
- Speed of Photographic Negative Materials (Monochrome, Continuous-Tone), Method for Determining (ANSI PH2.5-1979).
- Terms, Symbols, and Notation for Optical Transmission and Reflection Measurements (Optical Density) (ANSI PH2.36-1974).

Photographic Processing

- Black-and-White Photographic Films, Plates, and Papers, Method for Manual Processing (ANSI PH4.29-1975).
- Black-and-White Photographic Papers, Evaluating the Processing with Respect to the Stability of the Resultant Image (ANSI PH4.32-1980).

Determination of Silver in Photographic Films, Papers, Fixing Baths, Sludges, or Residues, Method for (ANSI PH4.33-1975).

Color Photography

Color Printing Techniques (KW-16). The Dye Transfer Process (E-80). Gaseous-Burst Agitation in Processing (E-57). KODAK Color Films (E-77). KODAK Curve-Plotting Graph Paper (25 sheets) (E-64). Practical Densitometry (E-59). Printing Color Negatives (E-66). Reciprocity Data for KODAK Color Films (E-1). Techniques for Making Professional Prints on KODAK Ektachrome Papers (E-87). Using process E-6 (Z-119).

Black-and-White Films

Conservation of Photographs (F-40). Contrast Index—A Criterion of Development (F-14). KODAK Professional Black-and-White Films (F-5). Understanding Graininess and Granularity (F-20).

Black-and-White Papers, Industrial Photography and Instrumentation

The ABCs of Toning (G-23). Direct Positive Photography with KODAK Direct Positive Paper (G-14). High Speed Photography (G-44). KODAK Photosensitive Resist Products for Photofabrication (G-38). KODAK Polycontrast Filter Computer (G-11). Quality Enlarging with KODAK B/W Papers (G-1). Stabilization with KODAK Ektamatic Products (G-25). What Is B/W Quality? (G-4).

Motion-Picture, TV Applications

The Book of Film Care (H-23L). Cinematographer's Field Guide—Motion Picture Camera Films (H-2). Eastman Professional Motion Picture Films (H-1L). TV Questions and Answers (H-8).

Chemicals, Processing, Silver Recovery, and Waste Disposal

B/W Processing for Image Stability (J-19).
Chemical Composition of Photographic Processing Solutions (J-47).
Disposal of Small Volumes of Photographic-Processing Solutions (J-52).
Disposal and Treatment of Photographic Processing Solutions—in Support of Clean Water (J-55).
Glossary of Terms/Index (to Information for a Cleaner Environment) (J-48).
How to Make and Use KODAK Testing Solutions for Print Stop Baths and Print Fixing Baths (J-1A).
KODAK Hypo Estimator (J-11).
The Prevention of Contact Dermatitis in Photographic Work (J-4S).
Processing Chemicals and Formulas (J-1).
Recovering Silver from Photographic Materials (J-10).
Silver in Photoprocessing Effluents (J-51).
The Use of Water in Photographic Processing (J-53).

Darkroom Design and Construction Building a Home Darkroom (KW-14). Construction Materials for Photographic Processing Equipment (K-12). How Safe is Your Safelight? (K-4). Photolab Design (K-13).

Aerial and Applied Photography

Applied Infrared Photography (M-28). Fire and Arson Photography (M-67). Photography from Light Planes and Helicopters (M-5). Photography in Traffic Accident Investigation (M-21). Using Photography to Preserve Evidence (M-2). Viewing a Print in True Perspective (M-15).

Medical and Scientific Photography Medical Infrared Photography (N-1).

Professional Studio Photography Photography with Large-Format Cameras (O-18).

Instrumentation and Industrial Photography

Basic Oscillography (P-130).
Electron Micrography—Using Electrons Effectively (P-317).
Guide to Technical Information (P-124).
High-Speed Photography (G-44).
KODAK Image Test Chart (Film, for microphotography and the graphic arts) (P-301).
KODAK Neutral Density Attenuators (P-114).
KODAK Technical Pan Film 2415 (P-255).
Photofabrication Methods with Kodak Photosensitive Resists (P-246).
Photography Through the Microscope (P-2).
Schlieren Photography (P-11).
Tech Bits (P-3).
Techniques of Microphotography (P-52).

Graphic Arts

Basic Color for the Graphic Arts (Q-7).
Basic Photography for the Graphic Arts (Q-1).
Basic Printing Methods (GA-11-1).
Halftone Methods for the Graphic Arts (Q-3).
KODAK Color-Separation Guide and Gray Scale (Q-13:7-inch), (Q-14: 14-inch).
KODAK Color-Separation Step Tablet (Q-58).
KODAK Filter Selector (Q-44).
KODAK Halftone Negative Computer (Q-15).
KODAK Halftone Positive Calculator (Q-15).
KODAK Reflection Density Guide (24-step) (Q-16).
More Special Effects for Reproduction (Q-171).
Practical Steps to Quality Printing (Q-72).
Silver Masking of Transparencies with Three-Aim-Point Control (Q-7A).
A Visual Flare-Testing Method for Process Cameras (Q-107A).

Exposure and Processing Guides

KODAK Color Print Viewing Filter Kit (R-25). The KODAK Complete Darkroom Dataguide (R-18). KODAK Gray Cards (R-27). KODAK Professional Photoguide (R-28).

Audiovisual Applications

- Cementing Kodachrome and Kodak Ektachrome Transparencies to Glass (S-19).
- A Comparison of Running Times—8 mm, Super 8, 16 mm, and 35 mm Motion Picture Films (S-42).
- KODAK AV Equipment Memo: Choosing Between Curved-Field and Flat-Field Projection Lenses (S-80-8).
- KODAK Projection Calculator and Seating Guide for Single- and Multi-Image Presentations (S-16L).

KODAK Projector Feature Summary—A Guide to Kodak Professional Audiovisual Projectors (S-5).

Legibility—Artwork to Screen (S-24).

Projection Distance Tables and Lamp Data for Kodak Slide and Motion Picture Projectors (S-49)

Sound: Magnetic Sound Recording for Motion Pictures (S-75).

Process-Monitoring Systems

Black-and-White Film and Paper Processing and Process Monitoring (Z-128). Identifying E-6 Processing Errors (Z-119E).

Introduction to Color Printer Control for Photofinishers Using Noncomputerized Printers (Z-500).

Introduction to Color Process Monitoring (Z-99).

Laboratory Color Films for Process C-41 (E-24).

Monitoring System for Processing KODAK Ektachrome Aerial Films, Process EA-5 (Z-113)

Monitoring System for Processing KODAK Ektachrome Slide and Movie Films (Z-111)

Processing and Process Monitoring of KODAK Black-and-White Films (Z-126).

Using KODAK Ektaprint R-100 Chemicals (includes monitoring procedures) (Z-123)

Using KODAK Ektaprint 2 Chemicals (includes monitoring procedures) (Z-122).

Using Process C-41 (includes monitoring procedures) (A-121).

Workshop Series

Black-and-White Darkroom Techniques (KW-15). Building a Home Darkroom (KW-14). Close-Up Photography (KW-22). Color Printing Techniques (KW-16). Darkroom Expressions (KW-21). Electronic Flash (KW-12). Existing-Light Photography (KW-17). Lenses for 35 mm Cameras (KW-18). Photographing with Automatic Cameras (KW-11). Using Filters (KW-13).

Miscellaneous

Creative Darkroom Techniques, 1975. The Joy of Photography, People, Addison-Wesley, 1983.

Periodicals

More Joy of Photography, Addison-Wesley, 1981. The New Joy of Photography, Addison-Wesley, 1985. Professional Photographic Illustration Techniques (O-16). KODAK Video Exchange Cassette Tapes, 1985. Copying and Duplicating in Black-and-White and Color (M-1).

Periodicals

- American Cinematographer, Hollywood, CA: American Society of Cinematographers, 1920-.
- Applied Optics, New York: Optical Society of America, 1962-.
- Color Engineering, New York: Kinelow, 1963-1971.
- Color Research and Application, New York: John Wiley & Sons.
- Exposure, New York: Society for Photographic Education.
- Functional Photography, Hempstead, NY: Photographic Applications in Science, Technology and Medicine, 1975-.
- Industrial Photography, New York: United Business Publications. 1956-.
- Journal of Coatings Technology. "Experimental Origins of the 1931 CII System of Colorimetry," W. Wright, 54:685 (February 1982):65-71.
- Journal of the Illuminating Engineering Society, New York: Illuminating Engineering Society, 1971. Supersedes in part Illuminating Engineering.
- Journal of Imaging Technology, Washington, DC: Society of Photographi-Scientists and Engineers, 1975-.
- Journal of the Optical Society of America, Woodbury, NY: Optical Society of America.
- Journal of Photographic Science, London: Royal Photographic Society o Great Britain, 1953-.
- Modern Photography, New York: Billboard Publications, 1949-.
- Petersen's Photographic Magazine, Los Angeles: Petersen Publishing 1972-.
- Photogrammetric Engineering and Remote Sensing, Washington, DC: Amer ican Society of Photogrammetry, 1934-.
- Photographic Journal, London: Royal Photographic Society of Great Brit ain, 1853-.
- Photographic Processing, Hampstead, N.Y.: Photographic Processing 1965-.
- Photographic Science and Engineering, Washington, DC: Society of Photographic Scientists and Engineers, 1957-.
- Photomethods, New York: Gellert Publishing, 1974-.
- Optical Engineering, Bellingham, WA: Society of Photo-Optical Instrumentation Engineers (SPIE).
- Popular Photography, Chicago: Ziff-Davis, 1937-.
- PSA Journal, Philadelphia, PA: Society of America, 1935-.
- Psychology Today, Del Mar, CA: Psychology Today, 1967-.
- Science, Washington, DC: American Association for the Advancemen of Science, 1895-.
- Scientific American, New York: Scientific American, 1859-.
- Sky and Telescope. "Adventures in Fine-Grain Astrophotography, E. Everhart (February 1981):100-104.
- Society of Motion Picture and Television Engineers Journal (SMPTE Journal Scarsdale, NY: Society of Motion Picture and Televisic Engineers, 1926-.

Periodicals

The Journal of the Society of Photo-Optical Instrumentation Engineers (SPIE), Redondo Beach, CA: Society of Photographic Instrumentation Engineeers, 1962-.

The Professional Photographer, Des Plaines, IL: The Professional Photographers of America, 1934-.

Appendix

-			
Tab	le	Α.	-1

Number	Logarithm
10	1
100	2
1,000	3
10,000	4

Та	ble	A-2	

Number	Logarithm	_
1	0.00	
2	0.30	
3	0.48	
4	0.60	
5	0.70	
6	0.78	
7	0.85	
8	0.90	
9	0.95	
10	1.00	

Basic Logarithms

Both *interval* scales of numbers (1-2-3-4-5-6-etc.) and *ratio* scales of numbers (1-2-4-8-16-32-etc.) are used in photography. Interval scales, for example, are found in thermometers and rulers. Ratio scales, for example, are used for f-numbers (f/2-f/2.8-f/4-f/5.6-f/8) where every second number is doubled, and film speeds (100-125-160-200-250-320) where every third number is doubled. Even though certain quantitative relationships in photography conform naturally to the ratio-type scale, there are disadvantages in using ratio scales of numbers in calculating and graphing. The disadvantages include the difficulty of determining the midpoint or other subdivision between consecutive numbers, and the inconvenience of dealing with very large numbers.

Using the *logarithms* of numbers in place of the numbers eliminates disadvantages of ratio scales by converting the ratio scales to interval scales. Mathematical operations are reduced to a lower level when working with logs, so that multiplication is reduced to addition, division is reduced to subtraction, raising a number to a power is reduced to multiplication, and extracting a root is reduced to division.

Thyalilluna, or logar are derived from a basic ratio series of numbers: 10, 100, 1000, 10,000, 100,000, etc. Since $100 = 10^{\circ}$, $1000 = 10^3$, etc., the above series of numbers can be written as: 10^1 , 10², 10³, 10⁴, 10⁵, etc. The superscripts 1, 2, 3, 4, 5, etc. are called powers, or exponents, of the base 10. If we always use 10 as the base, the exponents are called logs to the base 10. By pairing the original numbers with the exponents, we have the beginning of a table of logs (see Table A-1). This table can be extended indefinitely downward. Since one million contains six tens as factors $(10 \times 10 \times 10 \times 10)$ \times 10 \times 10), the log of 1,000,000 is 6. For any number containing only the digit 1 (other than zero), the log can be found by counting the number of decimal places between the position to the right of the 1 and the position of the decimal point. The log of 1,000,000,000 is therefore 9. The number whose log is 5 is 100,000, and 100,000 is said to be the antilog of 5. If the columns in Table A-1 are extended upward one step, the number 1 is added to the first column and the $\log 0$ is added to the second. Thus the log of 1 is 0 and the antilog of 0 is 1.

We also need the logs of numbers between 1 and 10. Since the log of 1 is 0 and the log of 10 is 1, the logs of numbers between 1 and 10 must be decimal fractions between 0 and 1. The logs of numbers from 1 to 10 are listed in Table A-2. It is customary to write the log of a number to one more significant figure than the number itself. Thus the number 8 has one significant figure, and 0.90 (the log of 8) has two significant figures.

Table A-2 is used to illustrate some basic relationships between numbers and their logs:

- **1.** $6 = 2 \times 3$. Note that the log of 6 is the sum of the logs of 2 and 3. When numbers are *multiplied*, their logs are *added*. The log of 10 equals the sum of the logs of 2 and 5.
- **2.** $4 = 8 \div 2$. Note that the log of 4 is the difference of the logs of 8 and 2. When one number is *divided* by another, the log of the second is *subtracted* from that of the first. The log of 3 equals the difference of the logs of 6 and 2.
- **3.** $4 = 2^2$. Note that the log of 4 is twice the log of 2. When a number is *squared*, the log is *doubled*. Similarly, $8 = 2^3$, and the

4.

log of 8 is three times the log of 2. When a number is raised to a *power*, the log of that number is *multiplied* by the power.

 $\sqrt{9} = 3$. Note that the log of 3 is half the log of 9. Similarly, 2 is the cube root of 8, and the log of 2 is one-third the log of 8. When a *root* is taken of a number, the log of the number is *divided* by the root.

By the multiplication rule, the log of 50 is the log of 5 + the log of 10, or 0.70 + 1.00, or 1.70. Similarly, the log of 500 is 0.70 + 2.00, or 2.70; the log of 5000 is 3.70, etc. Also the log of 200 is 2.30, the log of 300 is 2.48, etc. All numbers in the hundreds have logs beginning with 2, all numbers in the thousands have logs beginning with 3, etc.

From this comes the concept that the log of a number consists of two parts: a whole number, determined by whether the original number is in the tens, hundreds, thousands, etc.; a decimal part determined by the digits. The whole number part of a logarithm is called the *characteristic;* it is solely determined by the location of the decimal point in the original number. The decimal part of a log is called the *mantissa;* it is found from a table of logs. To find the characteristic, count the number of places from a spot just to the right of the first digit of the number to the decimal point. For 500,000, the count is 5, and therefore the log begins with 5. The decimal part of the log, found in Table A-2, is 0.70, and the entire log is thus 5.70.

If a log is given, the antilog (the number corresponding to the log) is found by the reverse process. That is, use the decimal part of the log to find the digits in the number and use the characteristic of the log to place the decimal point in the number. For example, to find the antilog of 3.78, note that 0.78 is the log of the number 6 in Table A-2. Therefore, 6 is the antilog of 0.78. The 3 in the log 3.78indicates that the decimal point is moved three places to the right, changing the number from 6 to 6000.

We will now extend the basic log table to include decimal numbers between 0 and 1. In Table A-3, each number has one-tenth the value of the number just below it, whereas each log is reduced by a value of 1 for each step upward. Thus the next number above 1 wil be one-tenth of 1, or 0.1, and the log will be 1 less than 0, o -1, and so on. The basic log table can now be considered to extence indefinitely in both directions. Note the symmetry in Table A-3 about the number 1: for example, all numbers in the thousands have log containing 3, and all numbers in the thousandths have logs containing -3. (Note that the number column is identified as a ratio scale, which will never reach zero, and that the log column is identified as an interva scale.)

The logs of decimal fractions are found by the same procedur as that used for larger numbers. To find the characteristic (the whol number part of the log), count the number of places from the position to the right of the first nonzero digit to the decimal point. To fine the mantissa (the decimal part of the log), locate the nonzero digit i the number column and note the corresponding value in the log column For example, to find the log of 0.0003, the decimal point is 4 place to the left of the digit 3, so the log has a characteristic of -4. Th mantissa is 0.48, opposite 3 in the number column in Table A-2.

The most awkward thing about logs is that there are sever: ways of writing the logs of numbers between 0 and 1. Most often the

I	a	D	e	A	-3
_	_	_	_		

Number	Logarithm
1 N UILDET	Logartin
—	
0.0001	-4
0.001	- 3
0.01	- 2
0.1	- 1
1.0	0
10.0	1
100.0	2
1000.0	3
10000.0	4

Basic Logarithms

mantissa (a positive value) and the characteristic (a negative value) are kept separate and are written as an indicated unfinished computation. For example, three ways of writing the log of the number 0.004 are:

- a. 0.60 3, where 0.60 is the mantissa and -3 is the characteristic. This is the most direct form, but it is not often used.
- b. 7.60 10, where 0.60 is the mantissa and the combination 7 10 (which is equal to -3) is the characteristic. This form, which is always written as some number minus 10, is the form most commonly used outside photography.
- c. $\overline{3.60}$, where 0.60 is the mantissa and $\overline{3}$ is the characteristic. The minus sign is placed over the 3 to emphasize that only the 3 is negative, not the 0.60. This form is referred to as *bar notation*, and the log above is read "bar three point six zero." This is the form most commonly used in photography.

The procedure for finding the antilog of a log having a negative characteristic is the same as described above for positive logs, except that the decimal will be moved to the left in the number rather than to the right. With 3.60 as the log, for example, the antilog of 0.60 is 4, and moving the decimal three places to the left produces 0.004. Thus, the antilog of $\overline{3.60}$ is 0.004.

An expanded table of logs for numbers from 1.0 to 10.0 to one decimal place, with logs to three decimal places, is provided in Table A-4.

In addition to the three forms of writing negative logs for numbers between 0 and 1 is a fourth, in which both the characteristic and the mantissa are negative numbers. This form is obtained by adding the negative characteristic and the positive mantissa in bar notation logs. To illustrate, the bar notation log of the number 0.2 is $\overline{1.3}$. Adding -1 and +0.3 equals -0.7, a totally negative log. Totally negative logs are used with pocket calculators, which are discussed in the next section. Table A-5 shows a comparison of bar notation logs and totally negative logs of the number 2 in multiples of 10 from 0.0002 to 2000.

Logarithms and the Use of a Calculator

The use of scientific hand calculators greatly eases the tasks of determining logs and anti- (or inverse) logs. To find the log of a number greater than 1, simply enter the number and then press the key labeled "LOG." The answer will appear on the display. To find the antilog of a positive log, simply enter the log value and press the keys labeled "INV" and "LOG" in that order. The answer will appear on the display.

To find the log of a number less than one, the procedure is the same as for numbers greater than one, except that the resulting value will be a totally negative log, since the calculator automatically combines the characteristic and the mantissa.

Example

Problem: Find the log of 0.004.

Solution: Enter the number 0.004 into the calculator and

Logarithms and the Use of a Calculator

Number	Logarithm	Number	Logarithm	Number	Logarithm
1.0	0.000	5.5	0.740	0.0001	-4
1.1	0.042	5.6	0.748	0.001	- 3
1.2	0.080	5.7	0.756	0.01	-2
1.2	0.000	5.8	0.763	0.1	-1
1.26	0.100	5.9	0.771	1	$-1 \\ 0$
1.20	0.100).)	0.771	10	1
1.2	0.114	6.0	0 779	100	1
1.3	0.114	6.0	0.778	1000	1 2 3 4 5
1.4	0.147	6.1	0.785		3
		6.2	0.792	10,000	4
1.414	0.150	6.3	0.799	100,000)
		6.4	0.806		
1.5	0.175			2	0.301
		6.5	0.813	20	1.301
1.6	0.204	6.6	0.819	200	2.301
1.7	0.230	6.7	0.826	2000	3.301
1.8	0.255	6.8	0.832		
1.9	0.278	6.9	0.839		
2.0	0.301	7.0	0.845		(0.301 - 1)
	0.001	7.1	0.851		or
2.1	0.322	7.2	0.857	0.2	$\begin{cases} or \\ 9.301 - 1 \end{cases}$
2.1	0.342	7.3	0.863		or
	0.361	7.4	0.869		$\begin{bmatrix} - \text{or} \\ 1.301 \end{bmatrix}$
2.3		/.4	0.009		< 1.501
2.4	0.390	7 6	0.075		(0.301 - 2)
	0.000	7.5	0.875		
2.5	0.398	7.6	0.881		or
2.6	0.415	7.7	0.886	0.02	$\begin{cases} 8.301 - 1 \end{cases}$
2.7	0.431	7.8	0.892		$\frac{1}{2.301}$ or
2.8	0.447	7.9	0.898		2.301
2.9	0.462				
		8.0	0.903		
3.0	0.477	8.1	0.908		
3.1	0.491	8.2	0.914		
3.2	0.505	8.3	0.919		
3.3	0.518	8.4	0.924		
3.4	0.532	0.1	0.721		
J.4	0.752	8.5	0.929		
2 5	0.544	8.6	0.934		
3.5	0.544				
3.6	0.556	8.7	0.940		
3.7	0.568	8.8	0.944		
3.8	0.580	8.9	0.949		
3.9	0.591		65 par 10 http:		
		9.0	0.954		
4.0	0.602	9.1	0.959		
4.1	0.613	9.2	0.964		
4.2	0.623	9.3	0.968		
4.3	0.634	9.4	0.973		
4.4	0.644				
1. 1	0.011	9.5	0.978		
4.5	0.653	9.6	0.982		
			0.982		
4.6	0.663	9.7			
4.7	0.672	9.8	0.991		
4.8	0.681	9.9	0.996		
4.9	0.690	10.0	1.000		
5.0	0.699	10.0	1.000		
5.1	0.708				
5.2	0.716				
5.3	0.724				
5.4	0.732				

able A-4 Abbreviated Table of Logarithms

Table A-5 Number Bar Log Negative Log 0.0002 4.3 -3.73.3 0.002 -2.72.3 0.02 -1.70.2 1.3 -0.70.3 0.3 20 1.3 1.3 200 2.3 2.3 2000 3.3 3.3

2

Logarithms and the Use of a Calculator

press the key labeled "LOG"; the answer of -2.39794 rounded to -2.40 is shown in the display.

The log of 0.004 is -2.40. Answer:

The answer is a totally negative number, and in a sense is the "true" log of 0.004; it must be carefully distinguished from $\overline{3}.60$, which is part negative and part positive.

To find the antilog of a totally negative log, the above procedure is reversed. The totally negative log is entered into the calculator and the keys labeled "INV" and "LOG," are pushed, in that order.

Example

Problem:	Find the antilog of -2.40
Solution:	Enter the value -2.40 into the calculator and
	press the keys labeled "INV" and "LOG" in
	that order; the number 0.003981 appears in
	the display and is rounded to 0.004.
Answer.	The antilog of -2.40 is 0.004 .

Note: On some calculators, there is no key labeled "INV." For these calculators, the key labeled "10x" should be substituted for the entire "INV" and "LOG" key sequence.

Since the bar notation system is often encountered in photographic publications, a procedure for using a calculator with this system is given below.

To find the log of a number less than 1.0 expressed in bar notation using a calculator:

- 1. Move the decimal point to the right of the first nonzero digit and count the number of places it was moved. The number of spaces moved is the characteristic it will be, but assigned a negative value.
- 2. Enter the number (with the decimal moved) in the calculator and press the button labeled "LOG"; the value that appears in the display is the mantissa of the number and will be a positive value.

Example Number 1

Find the log of 0.2.

- 1. The decimal point is moved one place to locate it to the right of the first nonzero digit (2); thus the characteristic is bar one (1).
 - 2. Enter the number 2.0 in the calculator and press the button labeled "LOG"; the value of 0.30 appears and is the mantissa.

Answer:

Problem:

Solution:

Example Number 2 Problem: Solution:

Find the log of 0.004.

The log of 0.2 is $\overline{1.30}$.

- 1. The decimal point is moved three places to locate it to the right of the first nonzero digit (4); thus the characteristic is bar three (3)
- 2. Enter the number 4.0 in the calculator and

press the button labeled "LOG"; the value of 0.60 appears and is the mantissa.

Answer: The log of 0.004 is $\overline{3}$.60.

To find the antilog (inverse log) of a log expressed in bar notation using a calculator:

1. Enter the mantissa of the log into the calculator and press the buttons labeled "INV" and "LOG," in that order; the value that appears on the display will contain all of the digits of the antilog with the decimal point immediately to the right of the first digit.

2. Locate the decimal point at the correct position by moving it to the left the number of places indicated in the characteristic.

Example Number 3

Problem: Solution: Find the antilog of $\overline{1}.3$.

1. The mantissa of 0.3 is entered in the calculator and the keys labeled "INV" and "LOG" are pushed and the value 1.9952623 appears, which is rounded to 2.0.

2. The characteristic is bar one, indicating that the decimal should be moved to the left one position, giving 0.2.

Answer: The antilog of $\overline{1}$.3 is 0.2.

Example Number 4

Problem: Solution: Find the antilog of $\overline{3}.6$.

- 1. The mantissa of 0.6 is entered in the calculator and the keys labeled "INV" and "LOG" are pushed and the value 3.9810717 appears, which is rounded to 4.0.
- 2. The characteristic is bar three, indicating that the decimal should be moved three positions to the left, giving 0.004.

Answer:

The antilog of $\overline{3}.6$ is 0.004.

Absolute temperature scale. See Kelvin scale Accelerator, developer, 300, 304, 305 Acceptance angle, exposure meter, 114 Acid/base, 240 Adaptation, 423 Additive color films, 258, 341 Additive color formation, 510-511 Additive synthesis, 491 Adjacency effects, 84 Aftereffect, 418 Afterimage, 418 After-ripening of emulsions, 272 Aging of film, 281 Agitation and development, 308 effects, 85-86 methods, 37-39 requirements, 35-36 Aim curve, tone reproduction, 31-32, 356-357 Airy disk, 407 Atlumen paper, 205 Alkalis, 235 Alpha cellulose, 259 Alternative systems, 282 Amateur films, safety base for, 253 Ambrotype, 286 American National Standards, 262 Analysis of developers, 310 Analysis stage in color reproduction, 514-517 Analytical color density, 528-529 Anamorphic image, 144 lens, 181 Angle of coverage, 150, 168 of view, 150 Anode, 241 ANSI, exposure meter acceptance angle, 115 ANSI, Photographic Exposure Guide, 112 Anti-foggants, 305 in developers, 301 in emulsions, 256 Antibiotics in emulsions, 275 Antihalation layers, 255 Antilogs, 569-574 Aperture priority exposure system, 113 Aperture, 93 APEX, 99, 107 aperture value, 118, 120 exposure value, 118 light value, 118, 120 speed value, 118, 120 time value, 118, 120 Archival considerations, 326 Artificial midtone, 114 ASA, 54-56 film speed table, 123

Assembly printing processes, 341

Index

Assignable cause variation, 5-7, 14-15 Assimilation, 427 Astigmatism, 186 Atomic charge, 238 number, 235 weight, 235, 239 Atoms, 235 Attenuators, neutral, 532-533 Average. See Mean Back movements, 168 Back nodal point, 146 Barrel distortion, 187 Base, 240 Base or support subbing, 275 Base plus fog density, 43 Beer's law, 476 Bell-shaped curve. See Normal distribution Benzene and developing agents, 301 Binocular disparity, 431 HIALK = ALINI- WILLIE DEDUDUDEN 311 Blackbody radiator, 201 Bleach and redevelopment toning, 330 Blocking of emulsions, 275 Blueprint process, 284 Blue toner, iron, 331 Blue tones from gold toner, 331 Border effect, 83-84

Bouguer's law, 476

Brewster's law, 459

Brighteners, paper, 260

Bromide streaks, 85-86

Buckle of sheet films, 255

Buffered developers, 304

Cadmium sulfide cell (cds), 113 Calendered paper stock, 259, 260 Callier coefficient, 41-42, 64, 66-68 Calotype process, 283 Camera exposure, 93 exposure latitude, 110 flare. See Flare motion, 99 obscura, 143 Candela, 220-221 Candlepower, 220-221 Carbon process, 286, 287 Casting of film base, 254 Catadioptric lens, 174 Cathode, 241 CDS cell, 113 Cellulose nitrate supports, 253 Center of curvature, 146 Chance-caused variation, 5-7, 13-15 Characteristic curves average gradient, 50 black-and-white continuous tone copy film, 57-58 film positive emulsions, 71

lith copy film, 58 paper, 58-63 pictorial film, 57 reversal film, 72-73 color interimage effect, 85 color internegative film, 539 color negative film, 534-537 color paper, 537-538 color reversal duplicating film, 540 color reversal film, 540 color reversal reflection print paper, 540 color transmission print film, 538-539 contrast index, 51-52 definition of, 42-45 exposure latitude, 47-49 film speed, 52-56 gamma, 49-50 log exposure range, 46-47 long-toe film, 57 masking effects, 523-527 short-toe film, 57 shoulder section, 43 slope, 43-40 straight line section, 43 toe section, 43 Charge-injection devices, 293 Charge-priming devices, 293 Charged coupled devices, 293 Chelating and sequestering agents, 246 Chemical equations, 239 nature of gelatin, 264 reactions, 239 Chemistry, basic, 235 Chromatic aberrations, 186 adaptation, 427 Chromaticity, 473 Chromaticness, 473 Chrominance, 505 Chromogenic color processes, 342 CIE calculations, 497 chromaticity coordinates, 497 chromaticity diagram, 498 colorimeter, 494 color matching functions, 493 color names, 501, 502 dominant wavelength and purity, 499 filter data, 500 history, 492 luminance y, 500, 501 plotting x and y values, 499 standard illuminants, 492 standard observer, 493 tristimulus distribution functions, 493, 494 tristimulus values, 497 Circle of good definition, 166 Circle of illumination, 166 Clayden effect, 78, 288

Closure, 430 Coating finals, 275 Coating techniques for emulsions, 275 Coatings, multiple, of emulsions, 273 Collagen, 263 Collodion process, wet, 251, 285 Colloid, gelatin as, 262 Color acromatic, 479 additive, 478 analyzer, 137 aperture, 476, 477 appearance, 483 attributes, 478, 480 attributes, hue, 421, 478, 484, 485 attributes, brightness/lightness (value), 422, 478, 484, 485 attributes, saturation (chroma), 427, 478, 484, 485 chain, 474, 475 changes due to drying, 325 compensating filters, 450 complementary, 479 couplers, 344, 526-528 definition, 469 densitometer, 471 developers, 303 film infrared sensitive, 545-546 internegative, 539 negative, 534-537 reversal, 533-534 transmission print film, 538-539 films, 257 . filters, 443 illuminant, 476, 477 illumination, 476, 477 intensity, 484 matching, 482, 490 mixing, 482, 491 mode, 474, 476 Munsell, 469, 474 names, 500, 504 names and notations, 484, 504 neutral, 479 nonspectral, 503, 504 notation, 484, 504 paper, 537-538, 540 paper for prints from negatives, 346 photography, 235 primary, 477 print film. See Color film, negative rendering index, 206-207 reproduction accuracy, 509, 541-545 additive, 510-511 analysis stage, 514-517 color-correcting masks, 524 contrast-correcting masks, 523 dye characteristics, 522-523 false-color systems, 545-546 metamerism, 544-545

mosaic screen process, 518 pleasing, 509-510 separation negatives, 515-517 separation positives, 517-520 standard viewing conditions, 542-543 subtractive, 512-513 synthesis stage, 517-520 reversal reflection print paper, 540 scanner, 139 specification, 482 stimulus, 474 subtractive, 478 surface, 475, 476 systems CIE, 492 Munsell, 484 Ostwald, 489 Pantone, 490 television, 350 temperature, 204-205, 504 temperature meter, 135 testing, 480 theory Chevreul, 484 Grassman, 491 Hering, 481 Hurvich-Jameson, 481 Maxwell, 481 Munsell, 483 Newton, 480 opponent-color, 481 Rood, 483-484 Signac, 484 three-component, 481 von Helmholtz, 481 Wright, 494 vision, 480-481 Colorant mixtures, 469, 475, 477, 482, 483, 491 ColorChecker. See Macbeth ColorChecker Colorimeter, 473, 475, 483 Colorimeters photoelectric, 494 visual, 494, 495 Coma, 186 Complexes, 245 Compounds, 238 Concentration of developer, 306 Condenser enlargers, 63-68 Conductivity of films, 257 Conjugate distances, 152 Contrast and film exposure, 112 Contrast control nomograph, 134 Contrast filters, 443 Contrast average gradient, 50, 368-369, 377-379 index, 51-52 gamma, 49-50 grain size, and sensitivity of emulsions, 268 influence of flare, 358-362

masking, 523 of negative, 44-47 of paper, 62 of print, 60 of subject, 30 of transparency, 533 slope, 31-32, 356-357 zone system, 380 Control charts, 11-21, 321 assignable cause patterns, 14-15 based on individual observations, 13-15 based on mean and range, 16-19 coefficients, 16-18 cycling, 14-15 definition of "in control," 12-13 introduction to, 11-13 interpretation of, 14-15 point out of control, 14 preparation of, 13-15 random pattern, 14-15 run, 14 subgroups, 16, 18-19 trend, 14 X and R, 16-19 Control limits, 13, 19-21 Conversion filters, 450 Convertible lens, 178 Copy print tone reproduction system, 374-377 Correction filters, 448 Correlated color temperature, 204 Cosine-corrected meter, 117 Cosine fourth-power law, 187 Cosine law of illumination, 119 Cost factors in processing, 320 Couplers, incorporated color, 343 Couplers, colored, 344 Covering power of emulsions, 255, 268 of lenses, 150, 168 Crystal structure of emulsions, 270 Curl of film and paper, 255 Curvature of field, 185 Cutting reducers, 333 Cyanotype, 284 Daguerreotype, 284 Data sheets, film, 112 Daylight color film, 521 Daylight loading spools, 254 Daylight, 209-210 Defective color vision, 421 Defects in emulsions, 270 Deionized water, 246 Deliming of gelatin, 263 Densitometer filters, 463 Densitometers color, 471

geometry, 41–42 reflection, 530–531 response function, status A, 529 response function, status M, 529–530

transmission, 530 visual, 472 Density of the latent image, 299 Density analytical, 472 black-and-white. See Density, visual color, 472 callier coefficient, 41-42 color analytical, 528-529 equivalent neutral density (END), 531-532 equivalent neutral printing density (ENPD), 532 integral, 528 spectral, 529 wide-band three filter, 529 conditions of measurement, 41 diffuse, 41 integral, 472 printing, 42 Q ALLIUI, 11 10 reflection, 39, 530-531 specular, 41-42 transmission, 39-42 visual. 42 Depth, 431 Depth of field, 160 calculations, 165 controls, 162 and f-number, 163 and focal length, 164 and hyperfocal distance, 161 and object distance, 163 permissible circle of confusion, 160 Depth of focus, 165 Developer agitation, 308 analysis, 310 concentration, 306 formulas compared, 312 modification and tone, 329 pH, 300, 304 reaction, 240 temperature, 307 Developer KODAK DK-50 for Films, 311 KODAK D-76 for Fine Grain, 312 KODAK DK-20 for Finc Grain, 313 KODAK D-72 for Paper, 313 KODAK D-85 for High Contrast, 313 Developers composition of typical, 300 effects of development on, 27.3 Development, 233, 252 agents, 301 agitation methods, 37-39 amplification factor, 299 by-products, 36 and effective film speed, 133 effects on developers, 273 effects on gamma, 49-50

Index

laminar layer, 36 mechanism of, 300 negative, 299 nomograph, 133 process of diffusion, 36 stagnant tank, 36 time, 306 uniformity, 39, 85-86 Diazo, 291 Dichroic filters, 457 fog, 318 Dictionary of color names, 502, 503 Diffraction grating, 471 Diffraction, 96, 184, 188 Diffraction-limited resolving power, 96 Diffuse density, 41 Diffusion enlargers, 63-68 transfer, 293 **DIN**, 56 Direct-positive images, 299 Dissociation constant, 241 Distilled water, 246 Distortion, 186 Distributions, frequency, 5-7 D-log E curves. See Characteristic curves D-log H curves. See Characteristic curves Dry plates, 252 Drving of paper, 260, 324 Drying problems, print, 324 Drying, 234, 324 preparation for, 323 Duplicate negative tone reproduction system, 377-379 Dye bleach color processes, 346 characteristics, 522-523 sensitization of emulsions, 274 toning, 332 transfer, 293, 348 East Coast f/180 School, 96 Edge effects, 83-86 adjacency, 84 border, 83-84 color interimage, 84-85 Eberhard, 84 fringe, 84 Kostinsky, 84 MTF curve influence, 84 Effective aperture, 93 exposure time, 101 f-number, 97 Efficiency, shutter, 102 Eidetic imagery, 419 Eighteen percent reflectance gray card, 114 Electrodes, pH meter, 243 Electrolyte, 241 Electromagnetic spectrum, 198-199 Electromechanical shutter, 105

Electronic flash, 217–219 printer, 138 shutter, 104 shutter tester, 107 Electronic-flash meter, 134 Electrons, 238 Electrophotography, 289 Elements, 235 Embossed paper surfaces, 260 Emulsion after-ripening, 272 composition, 267 characteristics. 267 coating techniques, 275 grain size, sensitivity and contrast, 268 grain composition, 269 making, 266 precipitation, 271 ripening, 271 surface coatings, 256 thickness and processing, 256 washing, 2/2 Emulsions dye sensitization of, 274 multiple coating, 273 photographic, 251 T-grain, 412 thinner, 255 Endothermic reactions, 245 Enlarger lens, 182 Equivalent neutral density (END), 531-532 Exothermic reactions, 245 Expansion and shrinkage of paper, 261 Exponential scale, 23 Exposure effects Claydon, 78 Herschel, 78-79 hypersensitization, intermittency, 78 latensification, 79-80 reciprocity, 73-78 Sabattier, 80-82 solarization, 82 x-ray fog, 86-87 Exposure close-up factor, 98 definition of, 32-33 effective time, 101 factors, 122 formula, 33 guide, 112 latitude, 47-49, 110 log range, 46-47 meter, 112 acceptance angle, 114 aperture priority, 113 artificial midtone, 114 averaging, 117 behind lens, 114, 128 cadmium sulfide (cds), 113

calculator dial, 113 camera meters, 128 camera position reading, 115 cell types, 112 center-weighted, 117 color analyzer, 137 color temperature, 135 cosine corrected, 117 eighteen percent reflectance card, 114, 125 electronic flash, 134 enlarging, 136 fatigue, 113 flash, 134 gallium arsenide phosphide photodiode, 114 hemispherical diffusor, 117 illuminance, 116 incident light, 114 light ratios, 118 luminance, 116 matched-needle, medium tone reading, 114 memory, 113 Norwood, 117 photoconductor, 113 photodiode, 114 photometric units, 117, 132 photovoltaic, 113 printing, 136 reflected light, 114 scales, 117 selenium, 112 shutter priority, 113 silicon, 114 silicon blue, 114 silicon photodiode, 114 spectral sensitivity, 113 spot, 115 variability, 120 video color analyzer, 137 meter methods, 124 artificial midtone, 125 calculated midtone, 127 camera meters, 128 camera-position, 128 incident light, 130 keytone, 126 midtone, 124 photometric measurements, 132 reflected-light, 124 zone system, 124 nomograph, 134 push processing, 122 reciprocity-law failure, 123 relation to characteristic curve, 44-49 relation to film speed, 52-53 sensitometric, 32-35 f/16 rule, 112 table, 112 time, 99 zone system, 381-384

Index

False-color system, 545-546

Fechner's colors, 428 Fechner's law, 425 Felt structure paper, 260 Ferrotyping of paper, 260 Fiber-base papers, 259 Figure-ground, 429 Film base manufacture, 253 base thicknesses, 254 data sheet, 112 friction, 256, 257 and paper chemical retention, 322 speed, ASA, 54-57 black-and-white pictorial, 54-56 black-and-white film positive emulsion, 71 black-and-white reversal film, 72-73 color negative film, 536 color reversal film, 534 definition, 52-53 effective speed, 133 ISO(ASA), 54-57 logarithmic, 56 relation to characteristic curve, 53-54 standard values, 55 structure, 255 Films coated on both sides, 259 Filter, 443 Brewster's law, 459 color, 443 color compensating (CC), 450 color photography, 450 contrast, 443 conversion, 450 correction, 448 densitometer, 463 dichroic, 457 factor, 444 infrared, 448 interference, 455 light balancing, 450 lightening and darkening effects, 444 light-meter, 464 Maxwell triangle, 443 mired nomograph, 452 mired-shift value, 450 neutral density, 121, 453 polarizing, 458 Rayleigh scattering, 449 safelight, 462 spectrophotometric absorption curves, 452 ultraviolet, 448 viewing, 464 Wratten 92 red, 472 Wratten 93 green, 472 Wratten 94 blue, 472 Fisheye lens, 187 Fixing baths, 318 Flare camera, 358-362

curves, 361 enlarger, 64-68 factor, 190, 360 measurement of, 361 percent, 190 testing, 190 Flash guide number, 134 Flash lamps, 216-217 Flash meter, 134 Flicker, 417 Fluorescent lamps, 202, 204, 207, 213-214 Fluorescing screens in x-ray, 259 Fluoroscopic camera, 259 Flux, light, 222 F-number, 93 calculation, 94 effective, 97 intermediate, 97 limitations, 97 maximum, 95 minimum, 95 whole stops, 94 Focal length, 146 Focal plane shutter, 101, 103 Fog, dichroic, 318 Fog, static electricity, 87 Fog, x-ray, 86-87 Footcandles, 223 Footcandle measurement, 132 Footlambert, 226 Frequency distributions, 5-7 Friction, film, 256, 257 Front nodal point, 146 F/16 rule, 112 Front principal focal point, 146 Fungicides in emulsions, 275 Fusion, 430

Gelatin as a colloid, 262 emulsion precipitation, 271 emulsions, 264 in emulsions, 251 isoelectric point, 265 sources, 263 chemical nature of, 264 physical properties of, 264 properties of, 263 Ghost image, 188 Glossy papers, 260 Gold protective solution, 327 Gold toners, 328 Gold toner for blue tones, 331 Gradient formula in tone reproduction, 368-369, 378-379 Grain composition of emulsions, 269 Grain size, sensitivity, and contrast of emulsions, 268 Graininess/granularity, 389 and blending distance, 392 and blending magnification, 392

580

and Callier coefficient, 393 of color films, 397 and density, 392 and filmspeed, 392 and image color, 394 measuring, 392 minimizing, 395 negatives, 390 prints, 390 and projection systems, 394 reducing, 396, 397 transparencies, 390 and resolving power, 403 Granularity, 394 Granularity root mean square (rms), 395 Granularity measurement, 395 Graphical drawing, 148 Grassman's law, 491 Gray scale, 479 reflection, in tone reproduction, 30-31 IF MITTHIN IN AN INTERNAL CARL CONTINUES 35 Group f/64, 95 Guide number, flash, 134 Guide numbers, 218 Gum bichromate process, 287 Gurney-Mott hypothesis for latent-image formation, 277

H and D curves. See Characteristic curves Halation, 255 Halides, 235 Hardener, KODAK SH-1, 336 Hardeners in surface coatings, 256 Hazards of nitrate films, 253 Heliographic drawings, 282 Herschel effect, 78-79, 280 Highlight masks, 338 Histograms, 5-7 Hue, 421 Hydrolysis of gelatin, 263 Hydrometer, 246 Hydroquinone, 302 Hydroxyl radical, 241 Hyperfocal distance, 161 Hypersensitization, 79-80 Hypo Alum toner, 330 Hypo eliminators, 323, 327

Illuminance, in camera, 360–362 definition of, 223 in a sensitometer, 32–33 Image distance, 146 formation conjugate distances, 152 graphical drawing, 148 lens, 146 lens formulas, 151 pinhole, 143 illuminance, 187 intensifier, 95

Index

nodal point, 146 principal focal point, 146 size and object distance, 153 size and focal length, 156 Image-support systems, 251 Imagination imagery, 420 Incandescence, 200-201 Incident-light exposure meter, 114 Indicator stop baths, 317 Infrared filters, 448 Infrared, 274 color film sensitivity, 546 radiation, 198 Inorganic compounds, 238 Integral color density, 528 Integral color mask, 526-528 Integral tripack color film, 516 Intensification and reduction, 234, 332, 333, 336 Intensifier, KODAK In-4, 336 Intensifiers 336 Intensitying screens, x-ray, 259 Intensity, light, definition of, 221-222 Intensity, light, mean horizontal, 221-222 Intensity, light, mean spherical, 221-222 Intensity, light, simple measurement, 221 Interference filters, 455 Interimage effect, color, 84-85 Intermittency effect, 78, 279 Internal latent image and development. 3()() Intersociety Color Council, 489 Interval scale, 22 Inverse logs, 569-574 Inverse square law, 224 Ionization, 241 Ions. 238 Iron blue toner, 331 ISO(ASA), 54-56 Isochromatic sensitization, 274 Isoelectric point of gelatin, 265, 266

Jones diagram. See Tone reproduction Just-noticeable difference (JND), 427

Kallitype, 289 Kelvin scale, 198 Kerr cell, 105 KODACHROME Film, 345 KODAK Developer DK-50 for Films, 311 Developer D-76 for Fine Grain, 312 Developer DK-20 for Fine Grain, 313 Developer D-72 for Paper, 313 Developer D-85 for High Contrast, 313 EKTAFLEX PCT film and paper, 350 Fixing Bath F-5, 319 Gold Protective Solution GP-1, 327 Hardener SH-1, 336 Hypo Eliminator IIE-1, 327 Instant Color Film, 294, 349 Intensifier In-4, 336

Rapid Fixing Bath F-7, 319 Reducer R-2 (Permanganate), 334 Reducer R-5, 335 Reducer R-15, 335 Stop Bath Test Solution, SBT-1, 317

Lamps

color rendering index, 206-207 electronic flash, 217-219 flashlamps, 216-217 fluorescent, 202-203, 207, 213-214 high-intensity discharge, 214-216 tungsten-filament, 210-212 tungsten-halogen, 212 Lasers, 219-220 Latensification, 79-80 Latent image, 233, 240, 299 and development, 233, 240, 300 distribution in emulsions, 278 formation of, 276 stability, 281 Lateral chromacle abarrations 106 Lens angle of coverage, 150 axis, 146 biconvex, 146 circle of good definition, 166 circle of illumination, 166 diaphragm location, 93 flare. See Flare focal length, 146 focal points, 1/16 optical center, 146 plano-convex, 146 positive, 146 positive meniscus, 146 shortcomings, 183 astigmatism, 186 chromatic aberrations, 186 coma, 185 curvature of field, 185 diffraction, 184, 188 distortion, 186 flare, 190 ghost image, 188 spherical aberration, 184 uneven illuminance, 187 shutter, 101 testing, 188 transmittance, 94, 98 types, 173 anamorphic, 181 catadioptric, 174 convertible, 178 enlarger, 182 macro, 180 macro-zoom, 180 process, 180 projector, 183 reversed telephoto wide-angle, 176 soft focus, 181 special supplementary, 176

supplementary, 176 telephoto, 173 wide-angle, 175 zoom, 179 Leveling, 430 Lift and drain processing, 37-38 Light blackbody radiator, 201 coherent, 220 color temperature, 204 definition of, 197, 199 electrical discharge, 202-203 frequency of waves, 198 incandescence, 200-201 luminescence, 203-204 fluorescence, 203 phosphorescence, 203 measurement. See Photometry meters, 116, 199-200 piping in film base, 254 polarization, 207-208 quantum theory, 197 ratio, 118 sources daylight, 209-210 fluorescent lamps, 213-214 high-intensity discharge lamps, 214-216 tungsten-filament lamps, 210-212 tungsten-halogen lamps, 212 speed of, 197-198 temperature dependency, 200-202 vapor sources, 202-203 visible spectrum, 199-200 wavelength, 197-198 wave theory, 197-199 Light-balancing filters, 450 Light-meter filters, 464 Lightness, 422 Limits, control chart, 13, 19-21 Linear perspective, 153 Lipstick colors, 503 Log exposure, 42-43 Log exposure range, 46-47 Logarithms, 569-574 light ratios, 119 Longitudinal chromatic aberration, 186 Lumen, 222 Luminance candelas per square foot, 225 definition of, 225 footlamberts, 226 ratio, 30, 227, 358-362 reflection factor, 226 tone reproduction applications, 29-30, 358-362 Lux, 33, 224 Lux measurement, 132

Macbeth ColorChecker color rendition chart, 541-545

Index

Macro lens, 180 Macro-zoom lens, 180 Masking to modify contrast, 337 Masking color-correcting, 524-525 color negatives, 525-528 contrast-correcting, 523 Masks, highlight, 338 Masks, integral dye, 344 Matched-needle exposure system, 113 Maxwell triangle, 443 Mean, 5, 8, 10-11 Measurement methods, 21-23 objective, 21 scales, 22-23 subjective, 21-25 Mechanism of development, 300 Melting points vs concentration, 265 Metamerism, 544-545 Metercandle, 33, 224 Metol, 302 Micro-reciprocal degrees. See Mired scale Mired nomograph, 452 Mired scale, 205-206 Mired-shift value, 450 Mirror image rule in tone reproduction, 378 Modification of silver images, 234 Modulation transfer function (MTF), 190, 405 measurement, 405, 406 Molar solution, 239 Molecules, 238 Motion picture wear, 326 Motion, 435 Mounting materials and preservation, 326 Movements, view-camera, 166 MQ developers, 303 Multilayer color film, 516 Multiple coatings of emulsions, 273 Munsell book of color, 543 ColorChecker color rendition chart See Macbeth ColorChecker color rendition chart color notation, 503 color system, 483, 489 color tree, 485, 486

Negative color films, 342, 534–537 contrast, 112 development, 299 Negative-positive systems, 233 Negatives black-and-white characteristics, 62–63 duplicate tone reproduction system, 377–379 influence of enlarger, 63–68 printing conditions, 69–71 in tone reproduction, 362–364

total negative contrast, 46 color, 528, 534-537 Neutral colors, 479 density filters, 121, 453, 532-533 solutions, 242 Newton rings, 457 Nitrate films, 253 Nitrogen burst processing, 37, 39 Nodal point, 146 Nodal slide, 147 Nominal scale, 22 Noncurl coatings, 255 Nonspectral colors, 503 Normal distribution, 6-7, 10-11 Normal solution, 242 Norwood, Don, 117 Nucleus of the atom, 238

Object distance, 146 nodal point, 146 principal focal point, 146 Objective data, 21–23 Opacity, 40 Optical bench, 147 Optical center, 146 Orbital shells, 238 Ordinal scale, 22 Organic compounds, 238 Orthochromatic dye sensitization, 274 Ostwald ripening, 271 Oxidation/reduction, 240

Paired comparisons, 24-25 Panchromatic dye sensitization of emulsions, 274 Paper bases, 259 expansion and shrinkage, 261 and film chemical retention, 322 processing, 310 surfaces, 260 weight and thickness, 262 Papers glossy, 260 photographic ANSI paper speed, 68-69 curve shape, 59 effect of development, 60-61 grades, 62-63 standard paper range number, 62 surface properties, 60 total density range, 60 useful log exposure range, 61-62 variable contrast, 274 Parameters, 9 Periodic table of the elements, 235, 236 Permissible circle of confusion, 160 Persistent image, 417 Perspective types, 152

Perspective and viewing distance, 158 Perspective, linear, 153 pH, 241 of developers, 304 effect on chemical processes, 244 indicators, 243, 244 meters, 242, 244 Phi phenomenon, 436 Photo color transfer process, 350 Photoconductor exposure meter, 113 Photoengraving, 253 Photogrammetric papers, 261 Photographic definition, 407 effects, 278 emulsions, 251 exposure, 93 Exposure Guide, ANSI, 112 systems other than silver, 234 Photometric units, 117, 132 Photometry CANAULS, JII candlepower, 221 definition of, 220 flux, 222 footcandle, 222-223 footlambert, 226 illuminance, 222-224 intensity, 221-222 inverse square law, 223 lumen, 222 luminance, 224-227 lux, 224 metercandle, 224 Photopic vision, 424 Photoresists, 282 Phototube, 473 Photovoltaic cell, 113 Physical measurement, 473 nomenclature, 474 properties of films, 255 properties of gelatin, 264 Pincushion distortion, 186 Pinhole anamorphic image, 144 image formation, 143 optimum size, 143 Pixels, 409 film and, 410 human eye and, 410 resolution and, 412 television screen and, 411 Plane of sharp focus, 171 Platinum process, 288 Plumming, 325 Polacolor film, 294, 349 Polar-coordinate graph, 221 Polarization of light, 207-208 Polarizing filters, 458 Polaroid instant photography, 349 Polyester film base manufacture, 254

POP Emulsions, 272 Popping in slides, 255 Populations, 7-8 Positive lens, 146 Post-stimulus perception, 417 P-phenylenediamine developing agents, 303 Precipitate, 245 Precipitation of emulsion, 271 Preference tests, 24-25 Preferred tone reproduction. See Aim curve tone reproduction Preservatives, developer, 300, 304 Preservation of photographs, 325 Primaries additive, 478 subtractive, 478 psychological, 478 Primary colors, 421 Principal focal point, 146 Print modification with reducers and INF/INFITIHIS 19117 Princer, electronie, 138 Printing density, 42 Prints, reflection, black-and-white characteristics of, 31-32, 60-63 conditions in printing, 69-71 copy tone reproduction system, 374-379 influence of enlargers, 63-68 in tone reproduction, 364-365 Process control, 11-21 Process lens, 180 Processing of color films, 258 configurations, 309 method and agitation, 308 cost factors, 320 for archival permanance, 327 methods, 35-39 paper, 310 Projector lens, 183 Proportional reducers and intensifiers, 333 Protection by gelatin, 271 Prussian blue, 284 Psychological measurement, 473 nomenclature, 474 primary colors, 421 Psychophysical measurement, 473 nomenclature, 474 Push processing, 122, 133 Q factor, 41-42, 64, 66-67 Radiant energy, 197-199 Radicals, 238 Radio waves, 198 Random samples, 8

Rayleigh scattering, 407, 449 RC papers, 259 Reciprocal mega-kelvins. See Mired scale Reciprocity effect and x-ray exposure, 279 Reciprocity effects, 73-74, 278 black-and-white paper, 75-76 color film, 76-78 color paper, 76 high illuminance, 74-75 low illuminance, 75 Reciprocity law failure, 279 Reciprocity law failure table, 123 Reducers, 333 Reducing agent, 240 Reduction and intensification, 234, 332 Reduction, chemical, 240 Reflectance, 59 Reflected-light exposure meter, 114 Reflection density, 31, 59 factor, 226 Among coole 30=31 pejusenatha al processi, solutions, juli, 322 Relative aperture, 93 Replenishment of processing solutions, 309 of solutions, 320 Representative samples, 8 Resin coated papers, 259 Resolving power, 399 acutance and, 404, 405 categories, 403 diffraction-limited, 96, 184 graininess and, 403 lens and system, 189 measurement, 399 pixels and, 412 targets, 399, 400 variables, 401 Restrainer in developer, 300, 305 Retina, rods and cones, 410 Retouching capability of films, 256 Reversal color films, 343, 345, 533-534, 540 color paper, 346 processing, 299 Reversed telephoto wide-angle lens, 176 Ripening of emulsion, 271 Roller transport processing, 37, 39 Rotary machine processing, 37-38 Sabattier effect, 80-82, 279, 281 Safelight filters, 462 Safety base films, 253 Salts, 241 Sample size, 5-6 Samples, 7-8 number of, 5-6 random, 8 representative, 8

versus populations, 7-8

Rank order, 25. See also Ordinal scale

Range, 16

Ratio scale, 22-23

Saturated solution, 245 Saturation, 427 Scales exposure meter, 117 interval, 118 ratio, 118 Scattered light, 39, 41-42, 63-68, 528 Scene luminance ratio. See Subject luminance ratio Scheimpflug rule, 171 Scotopic vision, 424 Selective area toning, 332 Selenium cell, 113 toners, 328 Sensitivity, spectral, of emulsions, 269 Sensitization of emulsions, dye, 274 Sensitometer, 33-35 Separating layers in color films, 258 Separation negatives, 514-516 Sepia tones, 329 Sequestering and chelating agents, 246 Setting points vs concentration, 265 Shape, 428 constancy, 430 generalization, 430 Sharpening, 434 Sharpness, 434 Sharpness/acutance, 397 development, 398 measurement, 398, 399 resolving power and, 404, 405 Sheet films, 253 Shrinkage, 255, 325 Shrinkage and expansion of paper, 261, 325 Shutter back, 101 between-the-lens, 101 efficiency, 102 electronic, 104 electromechanical, 105 focal-plane, 101, 103 flash synchronization, 104, 106 front, 101 Kerr cell, 105 priority exposure system, 113 speed, 99, 105 testing, 107 Sigma, 8 Silicon cell, 114 Silicon photodiode, 114 Silver halide crystals, 267 reaction in emulsion making, 267 sensitivity to light, 267 Silver systems, 233 Simultaneous contrast, 427 Sixteen millimeter films, 253 Size, 433 Slope, 45-46

Soft-focus lens, 181 Solarization, 82, 279, 281, 299 Solubility, 245 Solutions, 239, 245 Solvents, 245 Specific gravity, 246 Specifications, 19-21 Spectral density, 529 distribution, 473 sensitivity of emulsions, 269 sensitivity black-and-white separation negatives, 515 daylight color film, 521 densitometers, 529-530 exposure meter, 114 false-color film, 546 integral tripack color film, 516, 521 type A color films, 521 type B color films, 521 tungsten film, 521 Spectrophotometer, 471, 473 Spectrophotometric absorption curves, 452 curves, 471, 473 Spectrum electromagnetic, 198-199 visible, 199-200 Specular density, 41-42 Spherical aberration, 184 Spiral reel processing, 37-38 Spread function chemical, 409 comparison, 409 emulsion, 408 line, 408, 409 point, 407 Stability of the latent-image, 281 Stable process, 11–12 Standard deviation, 7-11 calculation of, 9-10 definition of, 7 use of, 10-11, 13 Standards, paper, 262 Star image, 188 Static decay on films, 257 electricity due to bases, 254 electricity fog, 87 markings on film, 257 Statistics, 9 Status A densitometry, 529 Status M densitometry, 529-530 Steiner, Ralph, 96 Step tablet, 34, 532 Stereopsis, 432 Stevens' law, 425 Stimulus attributes, 420 Stop baths, 317 Storage conditions for photographs, 326

Stresses in gelatin during processing, 266 Stripping of emulsions, 253 Subbing of base or supports, 275 Subgroups in control charts, 16, 18-19 Subject evaluations, test conditions, 25 Subject contrast, 30 log luminance range, 30 luminance ratio, 30 Subjective evaluations, 21-25 confidence level of, 24 paired comparisons, 24-25 Subjective tone reproduction, 355-356 Sub-proportional reducers and intensifiers, 333 Subtractive color formation, 512-513 color photography, 341 or cutting reducers, 333 synthesis, 491 Successive contrast, 427 Sulfide toners, 328 Superproportional reducers and intensifiers, 333 Supersaturated solution, 245 Supplementary lenses, 176-178 Support systems for images, 251 Surface coatings, 256 Surface latent image and development, 300 Symbols for elements, 238 Synthesis stage in color reproduction, 517 T-number, 98 Talbotype process, 283 Technicolor motion pictures, 293 Telephoto lens, 173 Television, 292, 350 chrominance, 505 color bars, 505 luminance, 505 vectorscope, 505 Temperature coefficient of development, 307 Temperature and reciprocity effect, 279 Testing flare, 190 lens, 188 shutter, 107 Thermography, 290 Thickness of emulsion and processing, 256 Thickness and weight of paper, 262 Thinner emulsions, 255 Time plots, 11-13 Time-temperature curve, 307 Time value, 107 Timing layers, 318 Tolerances, 19-21 Tonal range of prints, 32 of subjects, 30 of transparencies, 533

Tone changes due to developer modification, 329 as the result of drying, 325 Tone reproduction aim curves for pictorial system, 31-32, 356-357 black-and-white duplicate negative system, 377-379 black-and-white print copy system, 374-377 flare, 358-362 gradient formula, 368-369, 378-379 introduction to, 29-32 input data, 29-31 mirror image rule, 378 objective, 355-379 output data, 29-31 pictorial system, 366 with different paper grades, 372-373 with excessive flare, 369-370 with a film positive, 373 with a reversal film, 3/3-3/4 with underexposure and overdevelopment of negative, 371-372 with underexposure of negative, 370-371 preferred photographs, 356-357 simple diagram, 31 subjective, 355-356 zone system, 379-385 Toner in Xerography, 289 Toning, 234, 328 by bleach and redevelopment, 330 dye, 332 Tooth, retouching, 256 Total negative contrast, 46 Transmission density, 39-42 Transmittance, 39-40 lens, 98 Tray rock processing, 37-38 Tray shuffle processing, 37-38 Tricolor carbro, 287 photography, 341 Tripack color films, 342 Tube processing, 37-38 Tungsten-filament lamps, 210-212 Tungsten-halogen lamps, 212

Ultraviolet filters, 448 radiation, 198–199 Uneven illumination, lens, 187 Uniform standard system, 99 Universal color language, 502

Universal color names, 503 Valence, 239 Variability, 3-21 assignable cause, 4 chance caused, 4 introduction to, 3 long term, 18 patterns of, 5-7 short term, 18 sources of, 4 time oriented, 11-13 Variable contrast papers, 274 Variables in the photographic process, 234 Vesicular film, 291 Video color analyzer, 137 Vidicon tube, 292 View-camera movements, 166 back and image shape, 168 back and image sharpness, 170 lens and image sharpness, 171 perpendicular, 100 Scheimpflug rule, 171 Viewing color prints, 347 distance, 158 filters, 464 Viscosity of gelatin, 264 Visible spectrum, 199-200 Visual density, 42 Visual memory, 419 Visual perception adaptation, 423-424 aftereffect, 418 afterimage, 418 assimilation, 427 binocular disparity, 431 chromatic adaptation, 427 closure, 430 color hue, 421 color lightness, 422 color saturation, 427 defective color vision, 421 depth, 431 eidetic imagery, 419 Fechner's colors, 428 Fechner's law, 425 figure-ground, 329 flicker, 417, 424 fusion, 430 imagination imagery, 420 just noticeable difference (JND), 427 leveling, 430 motion, 435 persistent image, 417 phi phenomenon, 436 photopic vision, 424

post-stimulus perception, 417 primary colors, 421 psychological primary colors, 421 scotopic vision, 424 shape, 428 shape constancy, 430 shape generalization, 430 sharpening, 430 sharpness, 434 simultaneous contrast, 424, 427 size, 433 stereopsis, 432 Stevens' law, 425 stimulus attributes, 420 successive contrast, 427 visual memory, 419 Weber's law, 425 Visual sensitivity, 424 Vogel and dye sensitization, 274 Washed emulsions, 272 Wunhing, 214, 122 aids, 323 emulsions, 272 procedure of Wratten, 272 Water removed in drying, 325 Water spots, 256 Weber's law, 425 Weight and thickness of paper, 262 Wet collodion, 285 Wet collodion process, 251 Wetting agents, 234 in emulsions, 256 Whole stops, 94 Wide-angle effect, 159 lens, 175 Wratten filters, 472 X and R control charts, 16-19 X-ray energy, 199 films, 259 fog, 86 intensifying screens, 204 Xerography, 289 Yellow filter layer in color films, 258 Zone system exposure zones, 382 n, n+, n- development, 382 overview, 379-385 print values, 382-383 subject values, 380-382 tone reproduction relationship, 383-385 Zoom lens, 179

About the Authors

Leslie Stroebel, Chairman of the Department of Photographic Technology, Rochester Institute of Technology (RIT), is the author, co-author, or contributor of eleven other books on photography, including Focal Press's View Camera Technique and Visual Concepts for Photographers (with Hollis Todd and Richard Zakia). He has taught photography for 39 years.

John Compton, a professor in the School of Photographic Arts and Sciences, RIT, has taught for seventeen years, and is the author of numerous technical papers. He is a consultant for government agencies and the photographic industry regarding photographic image recording systems.

Ira Current teaches Color Printing Theory, as well as Materials and Processes of Photography, at RIT. He has been an associate editor of the *Photographic Society of America (PSA) Journal*, and has authored or co-authored seven other books on photography. A former Chairman of the Professional Photography Department at RIT, he also served, while working for GAF, as an American National Standards Institute (ANSI) coordinator.

Richard Zakia is the Chairman of the Fine Art Photography and Graduate Program, RIT, and is the author of many books, including two on the zone system and four concerning visual perception and photography. A former photographic engineer with Eastman Kodak, he was also the Director of nstructional Research and Development for RIT.